United States Government Documents on Women, 1800–1990

United States Government Documents on Women, 1800–1990

A Comprehensive Bibliography

Volume II: Labor

MARY ELLEN HULS

Bibliographies and Indexes in Women's Studies,
Number 18

Greenwood Press
Westport, Connecticut • London

Z
7964
.U49
H85
1993
V.2
C,1

Library of Congress Cataloging-in-Publication Data
(Revised for vol. 2)

Huls, Mary Ellen.
 United States government documents on women,
1800-1990.

 (Bibliographies and indexes in women's studies,
ISSN 0742-6941 ; no. 18)
 Includes bibliographical references and index.
 Contents: v. 1. Social issues—v. 2. Labor.
 1. Women—United States—History—Sources—
Bibliography. 2. Women—United States—Social conditions—
Sources—Bibliography. 3. Women—Employment—United
States—History—Sources—Bibliography. I. Title.
II. Series.
Z7964.U49H85 1993 [HQ1410] 016.3054 92-38990

ISBN 0-313-29016-4 (alk. paper : set)
ISBN 0-313-26712-X (alk. paper : vol. 1)
ISBN 0-313-28157-2 (alk. paper : vol. 2)

British Library Cataloguing in Publication Data is available.

Library of Congress Catalog Card Number: 92-38990
ISBN: 0-313-29016-4 (set)
ISBN: 0-313-26712-X (vol. 1)
ISBN: 0-313-28157-2 (vol. 2)
ISSN: 0742-6941

First published in 1993

Greenwood Press, 88 Post Road West, Westport, CT 06881
An imprint of Greenwood Publishing Group, Inc.

Printed in the United States of America

To the women of my family

Contents

Acknowledgments

Many people contributed to the completion of this volume and deserve credit for their assistance. Without the advice and support of Marilyn Moody and David Tyckoson this project would never have started. To Lorna Petersen, who kept telling me I would finish and it would be worth the effort, I owe my deepest gratitude. Kathy Parsons lent not only her moral support, but her keyboarding skills as well. The support of Iowa State University during the first three years of work was essential. I would also like to thank Janet Kinney and the staff of the College of St. Catherine Library who put up with a very distracted department head during the final year's work. Thanks also go to the documents department staff at the University of Minnesota and the University of Iowa, and to the interlibrary loan and circulation staff at the Iowa State University Library. Many more people deserve recognition for their assistance and support, among them Pam Williams, Tammy Lusher, Ellie Matthews, Lisa Gilbert, Todd Johnston, Deloris Savard, Mary Bye, and the staff of the Center for Legislative Archives.

Introduction

Public documents of the United States government have covered the problems of American women since the early 1800s. They provide factual information on the status of women, and reflect the government's perception of women's role in society. The nearly 7,000 documents described in the two volumes of this bibliography represent most of the published reports of agencies, commissions, and Congress on women or on topics directly affecting women's health and welfare. The bibliography is intended to facilitate identification of government documents on women past and present. In so doing, it also provides some historical perspective on government interest in contemporary issues such as day care, child support, and women's health. Coverage of the bibliography extends from 1800 through 1990. While an effort was made to identify as many 1990 documents as possible, the significant lag time between publication and listing of a document in the *Monthly Catalog of United States Government Publications* precluded the inclusion of documents from 1991.

SCOPE

Documents were identified using the *Monthly Catalog, The Cumulative Title Index to United States Public Documents, 1789-1976,* the *CIS US Serial Set Index,* the *CIS US Congressional Committee Hearings Index,* the *CIS Annual,* and the *Checklist of U.S. Public Documents, 1789-1976.* Most of the documents identified were obtainable from nearby regional depository libraries. Approximately four hundred documents which could not be located elsewhere were obtained from the National Archives. The National Archives, Center for Legislative Archives, Record Group 287 is the archival collection of the publications distributed through the Government Printing Office.

The decision to include or exclude a document from the bibliography was based on a number of factors. Documents devoted entirely to women or to a closely-related topic were automatically included regardless of length. In many instances, particularly in the case of congressional hearings, the decision to include a document was based on the portion of the document devoted to women's issues. Hundreds of hearings published in the last twenty years which include some discussion of women as part of a longer hearing were not included. These hearings can be easily identified, however, by using the *CIS Annual,* a detailed index to congressional documents. Among the hearings generally excluded from the bibliography were appropriations hearings. Anyone researching government-sponsored programs should check the appropriations hearings for the responsible agency.

Certain classes of documents were automatically eliminated from the bibliography. Publications issued as ERIC documents were excluded since they are fully abstracted and indexed in *Resources in Education* and its widely available electronic versions. Technical reports and most

reprints of journal articles were also eliminated. A few additional documents were dropped after extensive efforts to obtain a copy proved unsuccessful.

ORGANIZATION

The bibliography was initially conceived as one volume of approximately 3,000 entries. When it became obvious that the number of entries would be closer to 7,000, the decision was made to split the bibliography into two volumes. The first volume covers general works and social issues. Among the subjects represented are women's rights, contraception and maternity, health, public assistance, and retirement income. The second volume describes documents related to women in paid employment. Topics covered in volume two include protective labor legislation, affirmative action, federal employment and training programs, vocational counseling, and day care. Persons researching labor issues should consult both volumes, however, since volume one includes the hearings on the Equal Rights Amendment and the general reports on the status of women, many of which discuss labor issues at length.

The documents in each volume are grouped into chapters by subject. A short introduction precedes the bibliographic entries and highlights documents of particular note. Entries within each chapter are arranged first in chronological order and then by issuing agency. Serials are listed at the end of each chapter. Many documents covered more than one topic and could have been included in any of several chapters. In this case the document was listed in the chapter of the predominant topic. Use of the subject index is essential to locate all documents on a topic.

BIBLIOGRAPHIC ENTRIES

To facilitate the arrangement of the bibliography, the governmental body which produced the document is listed as the corporate author for all entries. Personal authors and non-government corporate authors are listed after the title. Information on the number of pages is provided as a convenience to aid in the identification of documents and as a guide in estimating photocopy or interlibrary loan charges. The page numbers do not represent an exact collation. Most entries for agency documents also include a Superintendent of Documents, or SuDoc, number. SuDoc numbers are assigned by the Government Printing Office and are the primary method used to arrange the documents collection in most U.S. depository libraries. Entries for House and Senate reports cite a volume of the *U.S. Serial Set* in lieu of a SuDoc number.

A few documents are cited for which no SuDoc number could be identified. Congressional hearings with no SuDoc number include a number preceded by either Greenwood or CIS. The Greenwood number is a reference number in the microfiche set *U.S. Congressional Committee Hearings on Microfiche*, produced by the CIS Greenwood Press division. Numbers beginning with CIS refer to the microfiche set which accompanies the *CIS Annual*, the *CIS Microfiche Library*.

Abbreviations and initialisms are used throughout the bibliography in order to save space. A separate List of Abbreviations may be found following this Introduction to the Bibliography.

SOME FINAL THOUGHTS

Attempting to provide an overview of nearly two hundred years of government publishing on women within the space of this introduction would be a futile task, but a few general observations are possible. The pre-1900 documents are almost entirely the work of Congress. Although the topics are limited by the legislation under consideration, these documents do provide an interesting glimpse of the congressional view of woman. In particular, the documents on woman suffrage and

on military widows' pensions are revealing in their discussions of good women, bad women, and the proper role of woman in society.

By 1920 the Children's Bureau, the Women's Bureau, and the Office of Education were major producers of documents relating to women. World War Two inspired a wealth of publications from a wide variety of agencies. The 1960s and 1970s were notable for the establishment of special commissions and councils on women, from which a number of excellent documents were issued. During their glory years in the 1970s, the Commission on Civil Rights and the Equal Employment Opportunity Commission produced many substantial documents on the issues affecting women's lives.

In the last decade government publishing on women has come nearly full circle. By the late 1980s the documents were again predominantly congressional, supplemented by a steady stream of reports from the Bureau of the Census and from health-related agencies. Only a trickle of publications were coming out of the Women's Bureau, once a prolific producer of substantial reports, and the embattled Commission on Civil Rights had turned its focus away from women's issues.

In spite of the cutbacks, government documents continue to be an important source of information on women. It is my hope that those who use this bibliography to locate past documents on women will be inspired to seek out and include the newer documents in their future research.

List of Abbreviations

Some of the common abbreviations used in the Bibliography, and other shortened notations are listed below.

AA- affirmative action
AB - Aid to the Blind
ACLU - American Civil Liberties Union
ADAMHA - Alcohol, Drug Abuse, and Mental Health Administration
ADC - Aid to Dependent Children
AFDC - Aid to Families with Dependent Children
AID - Agency for International Development
APTD - Aid to the Permanently and Totally Disabled
BLS - Bureau of Labor Statistics
CETA - Comprehensive Employment and Training Act
CFR - Code of Federal Regulations
CIS - Congressional Information Service
Cong. - Congress
CRS - Congressional Research Service
DAR - Daughters of the American Revolution
DBE - Disadvantaged Business Enterprise
DES - Diethylstilbestrol
Doc. - Document
DoD - Department of Defense
EEO - equal employment opportunity
EEOC - Equal Employment Opportunity Commission
ERA - Equal Rights Amendment
Ex - Executive
FAA - Federal Aviation Administration
FCC - Federal Communications Commission
FDA - Food and Drug Administration
FLSA - Fair Labor Standards Act
FWP - Federal Women's Program
GAO - General Accounting Office
GPO - Government Printing Office
GS - General Schedule
GSA - General Services Administration
H. Rept. - House Report
HEW - Department of Health, Education, and Welfare
HHS - Department of Health and Human Services

HRA - Health Resources Administration
IHS - Indian Health Service
ILO - International Labor Organization
IRS - Internal Revenue Service
JEDI -Jobs for Employable Dependent Individuals program
JTPA - Job Training Partnership Act
LDC - lesser developed country
LEAA - Law Enforcement Assistance Administration
MBE - Minority Business Enterprise
MDTA - Manpower Development and Training Act
MOS - Military Occupational Specialty
NCI - National Cancer Institute
NIAAA - National Institute on Alcohol Abuse and Alcoholism
NICHD - National Institute of Child Health and Human Development
NIDA - National Institute on Drug Abuse
NIH - National Institutes of Health
NIMH - National Institute of Mental Health
NIOSH - National Institute of Occupational Safety and Health
NLRB - National Labor Relations Board
NRA - National Recovery Administration
NSF - National Science Foundation
OAA - Old-Age Assistance
OASDHI - Old-Age, Survivors, Disability, and Health Insurance
OASI - Old-Age and Survivors Insurance
OEO - Office of Economic Opportunity
OFCCP - Office of Federal Contract Compliance Programs
OMB - Office of Management and Budget
OPM - Office of Personnel Management
OWI - Office of War Information
PHS - Public Health Service
PHSA - Public Health Services Act
S. Rept. - Senate Report
SBA - Small Business Administration
sess. - session
SMSA - Standard Metropolitan Statistical Area
SSA - Social Security Act
SSI - Supplemental Security Insurance
Title VII - Civil Rights Act of 1964, Title VII
Title IX - Education Amendments of 1972, Title IX
Title X - Public Health Services Act, Title X
Title XX - Social Security Act, Title XX
UN - United Nations
USDA - United States Department of Agriculture
USIA - United States Information Agency
VA - Veterans Administration
WAAC - Women's Army Auxiliary Corps
WAC - Women's Army Corps
WASP - Women's Airforce Service Pilots
WBE - Women's Business Enterprise
WEEA - Women's Educational Equity Act
WG - Wage Grade
WIC - Supplemental Food Program for Women, Infants and Children
WIN - Work Incentive Program
WPA - Works Progress Administration or Works Projects Administration

United States Government Documents on Women, 1800–1990

1

Women in the Labor Force

Scattered throughout the chapter are reports, speeches, and congressional hearings which highlight the changing attitudes over the years toward the employment of women. These documents reveal the progress of women and describe the problems of women workers from 1900 to 1990. Among the first major documents on women as wage earners were the extensive reports from the Senate-authorized investigation of woman and child wage earners. The summary report of the investigation (12) pulls together the information in the individual reports on specific industries which were issued as Senate documents in 1910 and 1911. Individual reports in the series include the *History of Women in Industry in the United States* (9) and a *History of Women in Trade Unions* (11) as of 1911. The occupational trends of women are charted in numerous Women's Bureau reports including those showing the effect of WWI (16), the trends for 1910 to 1930 (46), from 1870 to 1940 (131), and from 1940 to 1950 (153), and the entry of women into nontraditional occupations in the 1970s (255). A five year longitudinal study of women in the labor market describes the employment patterns of women in the late 1960s and early 1970s (265). A second longitudinal study conducted at the same time focused on the education and labor market experience of young women (282). The 1985 report by the Women's Bureau for the UN Decade for Women reviews the progress of women in relation to employment between 1976 and 1985 (307).

The status of black women in the U.S. work force is covered in major reports from the 1922 Women's Bureau report *Negro Women in Industry* (20), to the 1990 Civil Rights Commission report *The Economic Status of Black Women: An Exploratory Investigation* (323). In the 1950's the documents reflected the shortage of young women in the labor force. The resulting focus on the employment needs of older women is evident in reports such as *Facts on Older Women Workers* (147) and *Entry and Reentry of the Older Woman into the Labor Market* (154).

Major reports providing overviews of working women in America include *Women at Work: A Century of Industrial Change* (48), *Women in the Economy of the United States of America* (66) and the *Report of the Committee on Private Employment to the President's Commission on the Status of Women* (198). A joint report issued by the U.S. Women's Bureau and Japan's Women's and Minor's Bureau examined the role of women workers in the U.S. and Japan (267). Labor market "marginals" are described in a 1977 Employment and Training Administration report, *Women and Work* (273). An overview of women and trade unions is provided in *Workers and Allies: Female Participation in the American Trade Union Movement, 1824-1976* (262). Congressional hearings of note in the 1980's include *American Women: Three Decades of Change* (298), *Problems of Working Women* (302), and *Prospectus of Working Women's Concerns* (312). General reports of a primarily statistical nature are located in Chapter 8.

1. U.S. Congress. Senate. *Memorial of Mary F. Eastman, Henrietta L.T. Woolcott, and Others, Officers of the Association for the Advancement of Women, Praying That the Tenth Census May Contain a Just Enumeration of Women as Laborers and Producers.* S. Misc. Doc. 84, 45th Cong., 2d sess., 1878. 2p. Serial 1786. Memorial of the Association for the Advancement of Women points out deficiencies in the information collected in the ninth census and asks that the tenth census collect accurate numbers on women producers and labors, and record numbers of men and women engaged in disreputable occupations. The memorial also asks that women be employed as census takers in order to reduce errors resulting from the "natural barriers in the way of men as collectors of social and vital statistics."

2. U.S. Congress. Senate. Committee on Education and Labor. *Relations between Labor and Capitol, Report and Testimony Taken by the Committee, Volume III: Testimony.* 47th Cong., 2d sess., 12-23 Oct. 1883. 729p. Y4.Ed8/3:L11/3. Wide ranging hearing on labor and capital includes discussion of women's wages and working conditions, particularly in relation to employment of women in textile mills, scattered throughout the testimony. Female mill hands testify as to the working conditions and unionization in the mills. Other topics covered include temperance, living conditions of workers, and education of workers and their children. Industrial education for women, woman suffrage, and temperance work are also occasional topics of the testimony.

3. U.S. Congress. House. Committee on Labor. *Work and Wages of Women and Children, Report to Accompany H. Res. 94.* H. Rept. 388, 53d Cong., 2d sess., 1894. 1p. Serial 3269. Favorable report with minor amendments on a bill authorizing the Department of Labor to conduct a study of wages and working conditions of women and children wage earners.

4. U.S. Congress. Senate. *Report of Hearing of Wage-Earning Women before Senators Justin S. Morrill, John Sherman, William B. Allison, and Nelson W. Aldrich, Minority Members, Finance Committee, March 29, 1894.* S. Misc. Doc. 160, 53d Cong., 2d sess., 1894. 13p. Serial 3171. Hearing on the "Wilson Bill", a free trade bill, presents testimony of working women who expound on women's role in supporting themselves and their dependents and on the need for a living wage. Questions from the committee members reveal the women's job tenure and wages, and their responsibilities for family support. Comparisons between wages in the U.S. and in "the old country" are made.

5. U.S. Congress. House. *Letter from the Secretary of the Treasury Transmitting a Copy of a Communication from the Secretary of Commerce and Labor Submitting an Estimate of Increase of Appropriation for an Investigation of the Condition of Women Wage-Earners in the United States.* H. Doc. 494, 59th Cong., 1st sess., 1906. 2p. Serial 4987.

6. U.S. Congress. House. Committee on Labor. *Women and Child Labor, Report to Accompany H.R. 17562.* H. Rept. 2745, 59th Cong., 1st sess., 1906. 3p. Serial 4907. Favorable report on a bill authorizing an investigation of the "industrial, social, moral, educational, and physical conditions" of women and child workers in the U.S. reprints excerpts from the President's annual message to Congress regarding the investigation. The report also briefly recounts the evils attributed to women's entry into the labor market noting the need for a scientific and detailed investigation of the effect of women in industry.

7. U.S. Congress. Senate. Committee on Education and Labor. *Investigation of the Industrial, etc., Conditions of Woman and Child Workers in the United States, Report to Accompany S. 5409.* S. Rept. 4245, 59th Cong., 1st sess., 1906. 2p. Serial 4905. Favorable report on the bill authorizing the collection of information for the *Report on*

Woman and Child Wage Earners describes committee expectations of the scope of the investigation and its outcomes.

8. U.S. Congress. House. Committee on Labor. Subcommittee No. 4. *H.R. 1200, 12001, 21322, Competition of Penal Labor, Hearings.* 61st Cong., 2d sess., 8,23 Mar. 1910. 153p. Y4.L11:P37/2. One of the major arguments presented against the current convict labor systems was that it primarily involved industries dominated in the private sector by women workers, thereby causing wage cuts and unemployment which affect women workers hardest. The effect of convict labor on jobs in the garment industry is particularly stressed.

9. U.S. Congress. Senate. *History of Women in Industry in the United States.* by Helen L. Sumner. Report on Condition of Woman and Child Wage-Earners in the United States, vol. IX. S. Doc. 645, 61st Cong., 2d sess., 1910. 277p. Serial 5693. Review of the employment trends of women in industry in the U.S. Examines the number and percentage of employed women by age, race and nativity, and occupation, 1890 and 1900. Most of the data on number and percentage of wage earners by industry covers the period 1850 to 1900. Some wage data for the 1860's is provided for New York. Particular attention is paid to labor conditions in the sewing trades and textile industries. The conditions at Lowell Massachusetts are recounted in some detail. The appendix provides statistics primarily from Census data on the number and percentage of women employed by industry and occupation, 1850-1900; women employed by occupation and marital status, 1890 and 1900; wage-earning women by occupation and race/nativity; and wage-earning women by industry and region, 1870-1900. Also includes a selective list of textile factory strikes on account of reduction in wages between 1829 and 1878.

10. U.S. Congress. Senate. *Wage-Earning Women in Stores and Factories.* Report on Condition of Woman and Child Wage-Earners in the United States, vol. V. S. Doc. 645, 61st Cong., 2d sess., 1910. 384p. Serial 5689. One unique facet of this study of women employed in stores and factories is its focus on women "adrift" or "practically without homes." The earnings of self-supporting women and women's responsibility for the support of others is examined, and the presence or absence of moral guidance and a stable living environment is stressed. Also looks at the role of stores' low wages in encouraging women to supplement their wages through prostitution. Opportunities for advancement and the social environment are closely investigated. Living conditions of women workers in Boston, Chicago, Minneapolis-St.Paul, New York, Philadelphia, and St. Louis are specifically addressed.

11. U.S. Congress. Senate. *History of Women in Trade Unions.* by John B. Andrews and W.D.P. Bliss. Report on Conditions of Woman and Child Wage-Earners in the United States, vol. X. S. Doc. 645, 61st Cong., 2d sess., 1911. 236p. Serial 5694. History of successful and unsuccessful unionization attempts by women workers examines the nature of the unions and the factors effecting their success or failure. The organization and nature of the unions, strikes, and the participation of women in the Knights of Labor and the American Federation of Labor are recounted. Liberally quotes sources of the day with citations to source.

12. U.S. Bureau of Labor Statistics. *Summary of the Report on Conditions of Women and Child Wage Earners in the United States.* Bulletin no. 175. Washington, DC: GPO, 1916. 445p. L2.3:175. Summary report on the characteristics and earnings of women in industry provides data on age and occupation by sex of worker, and marital status of female employees in the cotton textile, men's ready-made clothing, glass, silk, and retail trade industries. Also looks at living and working conditions of women and child employees. Includes short histories of women in industry and in trade-unions, and an examination of causes of death for women and child cotton mill operatives. Also studies

working conditions for women in metal trades and laundries and reviews labor laws and factory conditions. Provides a summary of the report on the relationship between occupation and criminality of women (vol.1 - 3258).

13. U.S. Congress. House. Committee on Labor. *Child-Labor Bill, Hearings on H.R. 8234.* 64th Cong., 1st sess., 10-12 Jan. 1916. 317p. Y4.L11:C43/3. Hearing on a bill concerned with child labor describes the work and wages of girls in the cotton mills and also includes testimony on women's employment. One of the arguments presented contends that child-labor laws prohibiting work of 12 to 14 year olds would cause hardship to widowed mothers. Mill owners describe their philanthropic efforts to provide for their workers. One point discussed is whether working conditions in cotton mills affect a girls future childbearing capacity. Another point of discussion is the proper age to begin work from a health standpoint for boys versus girls. Includes a summary by state of child labor laws noting differences by gender. Many of the case studies of child labor presented involve girls and some reflect the conditions for adult women, particularly in the shellfish industries.

14. U.S. Bureau of Labor Statistics. *Effect of Workmen's Compensation Laws in Diminishing the Necessity of Industrial Employment of Women and Children.* by Mary K. Conyngton. Bulletin no. 217. Washington, DC: GPO, 1918. 170p. L2.3:217. Investigation stressed the condition of families in Connecticut, Ohio, and Pennsylvania whose male head became unable to work due to injury. Provides background data on age and marital status of victims of industrial accidents.

15. U.S. Federal Board for Vocational Education. Employment Management Section. *Employment Management in Relation to Women in Industry.* by Avis Ring. Miscellaneous no. 112. Washington, DC: The Board, 1919. 14p. VE1.15:112. Advice to employment executives and women supervisors in ordinance plants describes the importance of selection and placement of women employees, the desirability of a separate "training school", handling transfers and absenteeism, and medical examinations. Also discusses sources of labor supply, medical care, employment records, and equipment needs including seating requirements of women.

16. U.S. Women's Bureau. *The New Position of Women in American Industry.* Bulletin no. 12. Washington, DC: GPO, 1920. 158p. L13.3:12. Overview of women in American industry examines the effect of WWI on women's entry into the factories and provides detailed statistics on the employment of women during the war. Also reviews the type of work which women moved into during the war years and factory managements' opinion of the women's work compared to the work of the men they replaced. Provides data on the number of men and women employed by industry and the effect of the war on the number of firms hiring women, the number of women hired as substitutes for men, the increase in women employed without substitution, and retention of women workers after signing of armistice by industry.

17. U.S. Bureau of Labor Statistics. *Proceedings of the Seventh Annual Convention of the Association of Government Labor Officials of the United States and Canada held at Seattle, Wash., July 12-15, 1920.* Bulletin no. 266. Washington, DC: GPO, 1921. 168p. L2.3:266. Two sessions of the convention were devoted to a roundtable discussion of women in industry. Most of the discussion focuses on the results of studies and the operation of labor laws in states and cities around the country. Particular emphasis is placed on the operation of hours laws.

18. U.S. Women's Bureau. *When Women Work.* Washington, DC: The Bureau, 1921. [6]p. leaflet. Folder no. 3. L13.7:3. Leaflet illustrates the basic principles of fair treatment of working women including hours, night work, working conditions and equal pay.

19. U.S. Children's Bureau. *Children of Wage-Earning Mothers: A Study of a Selected Group in Chicago.* by Helen Russell Wright. Publication no. 102. Washington, DC: GPO, 1922. 92p. L5.20:102. Study primarily examined the lives of children of working mothers, but also examined the nature of the mother's work, working conditions, and earnings. The problems of black working mothers compared to poor white working mothers were specifically noted.

20. U.S. Women's Bureau. *Negro Women in Industry.* Bulletin no. 20. Washington, DC: GPO, 1922. 65p. L13.3:20. Study of the employment of black women in industry before, during, and after WWI. Examines the extent to which black women were hired as substitutes for white women and for boys. Provides data on hours of work by industry and on occupations, and describes working conditions, employment policies, and education and training. Also presents results of a survey of employer's opinion on the quality of black women's work. A home study was also conducted on black women in the Virginia tobacco industry.

21. U.S. Women's Bureau. *Exhibit Concerning Over 8 Million Women (Designed to Attract Attention and Awaken Interest in Subject of Women in Industry, To Be Loaned by Women's Bureau.)* Folder no. 1. Washington, DC: The Bureau, 1923. [6]p. leaflet. L13.7:1.

22. U.S. Women's Bureau. *Proceedings of the Women's Industrial Conference Called by the Women's Bureau of the United States Department of Labor, Washington, D.C., January 11, 12, and 13, 1923.* Bulletin no. 33. Washington, DC: GPO, 1923. 190p. L13.3:33. Sessions at the conference cover topics such as the role of women workers in industry, home work, health standards, wages, and labor laws and their enforcement. Includes the discussion sessions as well as the text of speeches.

23. U.S. Women's Bureau. *Married Women in Industry.* by Mary N. Winslow. Bulletin no. 38. Washington, DC: GPO, 1924. 8p. L13.3:38. Address by Mary N. Winslow, editor at the Women's Bureau, before the Section on the Home of the National Conference of Social Work, Washington, D.C., May 21, 1923, discusses numbers and trends in employment of married women. The reasons married women work, and the relationship of work and family, are also discussed drawing on Women's Bureau research.

24. U.S. Women's Bureau. *Radio Talks on Women in Industry.* Bulletin no. 36. Washington, DC: GPO, 1924. 34p. L13.3:36. Brief radio talks describe the Women's Bureau, married women in industry, women's work in industry, women's wages, budgets, hours of work, health and hygiene of women at work, posture and seating, and myths about women in industry.

25. U.S. Bureau of Labor Statistics. *Proceedings of the Eleventh Annual Convention of the Association of Governmental Labor Officials of the United States and Canada, Held at Chicago, Illinois, May 19-23, 1924.* Bulletin no. 389. Washington, DC: GPO, 1925. 146p. L2.3:389. Proceedings of a conference on labor legislation has a lengthy discussion of minimum wage laws and women in industry.

26. U.S. Women's Bureau. *Women Workers and Family Support: A Study Made by Students in the Economics Course at the Bryn Mawr Summer School under the Direction of Prof. Amy Hewes.* Bulletin no. 49. Washington, DC: GPO, 1925. 10p. L13.3:49. Study made by the students of the Bryn Mawr Summer School for Women Workers in Industry looked at the contribution to family support made by the women enrolled as students. Factors which effected contributions to family support were studied including age, boarding and living at home, and wages. Also collected data on the extent of full-time work and trade union membership.

27. U.S. Women's Bureau. *Changing Jobs: A Study Made by Students in the Economics Course at the Bryn Mawr Summer School under the Direction of Prof. Amy Hewes.* Bulletin no. 54. Washington, DC: GPO, 1926. 12p. L13.3:54. Study of the industrial experience of students of the Bryn Mawr Summer School for Women Workers in Industry in 1925 describes their earnings in relation to job tenure, and average duration of jobs held by industry and education. Also looks at reasons given for change of job.

28. U.S. Women's Bureau. *Effects of Applied Research upon the Employment Opportunities of American Women.* Bulletin no. 50. Washington, DC: GPO, 1926. 54p. L13.3:50. Reviews advances in industrial technology and avenues for employment opened to women, including typewriting. Appendix provides data on number of women employed in various industries between 1850 and 1919 and percent change, and number of women employed as stenographers and typists 1870 to 1920.

29. U.S. Bureau of Labor Statistics. *Proceedings of the Fourteenth Annual Convention of the Association of Government Labor Officials of the United States and Canada Held in Paterson, N.J., May 31 - June 3, 1927.* Bulletin no. 455. Washington, DC: GPO, 1927. 131p. L2.3:455. Conference proceedings include reports of a session on women and children in industry which reviewed state reports of industrial homework studies.

30. U.S. Women's Bureau. *Short Talks about Working Women.* Bulletin no. 59. Washington, DC: GPO, 1927. 24p. L13.3:59. Scripts for seven short talks highlight women's progress in industry, recognition by the federal government, standards for the employment of women, women's wages, hours of work, and working conditions.

31. U.S. Women's Bureau. *Daughters of America, Nearly 2 Million Girls under 20 at Work, They Have Youth, Have They Opportunities.* Washington, DC: Columbia Planograph, Co., 1928. poster. L13.2:D26.

32. U.S. Women's Bureau. *Negro Women in Industry in 15 States.* Bulletin no. 70. Washington, DC: GPO, 1929. 74p. L13.3:70. Information on the personal characteristics, occupational distribution, hours, earnings and method of payment (time or piece work) of black women industrial workers was drawn from the industry surveys made by the Women's Bureau in 15 states. Presents detailed data on daily and weekly hours by industry and weekly earnings by industry and state.

33. U.S. Women's Bureau. *Selected Reading List on Working Conditions of Women in Industry.* Washington, DC: The Bureau, 1929. 3p. L13.2:W89. Short list of books, articles, and state, federal, and international publications on the working conditions of women in industry. Most citations are from the 1920's.

34. U.S. Women's Bureau. *Standards for the Employment of Women in Industry.* Bulletin no. 3. 4th rev. Washington, DC: GPO, 1929. 8p. L13.3:3/4. Standards recommended by the Women's Bureau to protect the health of women workers in industry cover the areas of hours, wages, working conditions, and employee management. Earlier editions published in 1918, 1919, and 1921.

35. U.S. Women's Bureau. *What the Wage-Earning Woman Contributed to Family Support.* Bulletin no. 75. Washington, DC: GPO, 1929. 21p. L13.3:75. An analysis of data on wage earning women provides information on the role women played in the support of families. The need for women's employment is illustrated by data on the inadequacy of men's wages. Reprints summary data from the Census and other sources on characteristics of wage-earning women and their families. Reprint issued in 1934.

36. U.S. Congress. Senate. Special Committee on Commerce. *Unemployment in the U.S., Hearing in S. 3059, S. 3060, S. 3061.* 71st Cong., 2d sess., 18 Mar. - 1 Apr. 1930. 109p. Y4.C73/2:Un2. Testimony from Helen Hall, director of the University Settlement house in Philadelphia highlights the effect of an unemployed husband on the wife, and tells of women's efforts, through paid employment and thrift, to keep the family alive. The hearing examines the problems of unemployment and the proposed plan for federal and state employment services.

37. U.S. Bureau of Labor Statistics. *Labor Conditions of Women and Children in Japan.* Bulletin no. 558. Washington, DC: GPO, 1931. 102p. L2.3:558. Also issued as House Document 72-114. Overview of the conditions of women and child wage earners in the textile industries in Japan places special emphasis on moves toward protective labor legislation. Examines the recruiting system for women workers, their training, working conditions, wages, and living conditions. Maternity protection and welfare work are also examined.

38. U.S. Children's Bureau. *Children of Working Mothers in Philadelphia, Part 1: The Working Mothers.* Publication no. 204. Washington, DC: GPO, 1931. 39p. L5.20:204. Study looked at characteristics of employed mothers in Philadelphia focusing on race and nationality, age, length of marriage, marital status, and age and number of children. Also documents characteristics of employment in the 6 months preceding the survey, including status of breadwinner, duration and regularity of work, employment at home or away, and occupation.

39. U.S. Women's Bureau. *The Industrial Experience of Women Workers at the Summer Schools, 1928 to 1930.* by Gladys L. Palmer. Bulletin no. 89. Washington, DC: GPO, 1931. 62p. L13.3:89. Profiles the women enrolled at the summer schools for women industrial workers at Bryn Mawr, Barnard, Wisconsin, and the Southern School in North Carolina between 1928 and 1930. The characteristics of these women are described through excerpts from autobiographical material, and statistics are provided on the nativity, country of birth, age, marital status, industry, union membership, age at entering industry, employment history, causes for unemployment, hours worked, earnings, living conditions, and family responsibilities.

40. U.S. Women's Bureau. *Women in Industry: A Series of Papers to Aid Study Groups.* by Mary Elizabeth Pidgeon. Bulletin no. 91. Washington, DC: GPO, 1931. 79p. L13.3:91. Outlines for study group discussions on women in industry provide basic information and suggest readings on the topics of the work of the wage-earning woman, the industrial world in which women work, married women workers, women and unemployment, health standards for women's work, labor legislation for women, what the wage-earning woman earns, women in unusual occupations, and women's labor organizations and their leaders.

41. U.S. Women's Bureau. *Women's Place in Industry in 10 Southern States.* by Mary Anderson. Washington, DC: GPO, 1931. 14p. L13.3:In2. Review of the occupational distribution of women in the South between 1850 and 1920. Looks at manufacturing trends and the percent of women employed by major occupational group. General comparisons are made with northern women's employment patterns. Wages of southern women and factors which keep the wages low are briefly analyzed. Brief summaries are also included of labor legislation and hours of work. Provides data by state on number of men and women gainfully employed, 1870 and 1920; number of women gainfully employed 1890 and 1920 by major occupation category; number of women in manufacturing by industry, 1920; and number and proportion of women in textiles, tobacco, and clothing industries, 1880 and 1920.

42. U.S. Women's Bureau. *Exhibits: List of Motion Pictures, Posters, Maps, Charts and Displays Offered by Women's Bureau for Use by All Groups Interested in Conditions Pertaining to Wage Earning Women.* Washington, DC: The Bureau, 1932. 8p. leaflet. L13.2:Ex4.

43. U.S. Women's Bureau. *Wage-Earning Women and the Industrial Conditions of 1930: A Survey of South Bend.* by Caroline Manning and Arcadia N. Phillips. Bulletin no. 92. Washington, DC: GPO, 1932. 84p. L13.3:92. Study provides information on the effects of economic depression on women workers. Through home interviews data was collected on the age, martial status, earnings, work experience, and unemployment of women in South Bend, Indiana, in 1930. The employment of all family members was also studied. Employers supplied data on hours and wages of women workers in September 1929 and September 1930 and on fluctuations in employment during the year.

44. U.S. Women's Bureau. *The Change from Manual to Dial Operation in the Telephone Industry.* by Ethel L. Best. Bulletin no. 110. Washington, DC: GPO, 1933. 15p. L13.3:110. Study of the effect of technological changes in the employment of women in the telecommunications industry looks at the advance planning by the telephone companies which resulted in minimum layoffs of women operators. Report gives the number of women employed under the old and new system, and describes the attitudes of the women working for the telephone companies.

45. U.S. Women's Bureau. *Employment Fluctuations and Unemployment of Women: Certain Indications from Various Sources, 1928-31.* by Mary Elizabeth Pidgeon. Bulletin no. 113. Washington, DC: GPO, 1933. 236p. L13.3:113. Analysis of statistics on the employment of women between 1928 and 1931 provides data on employment by industry and on unemployment for selected cities and states. Some unemployment data is presented by age, and monthly data from state employment offices on registrations and placements is furnished. Data is primarily on women with some comparison data for men.

46. U.S. Women's Bureau. *The Occupational Progress of Women, 1910 to 1930.* by Mary V. Dempsey. Bulletin no. 104. Washington, DC: GPO, 1933. 90p. L13.3:104. Analysis of trends in the employment of women provides data on the number of women employed in various occupations between 1910 and 1930 and highlights the areas of major shifts. Provides data on number of men and women employed by occupation in 1910, 1920, and 1930, and the number and percentage change by occupations and sex, 1910 to 1930, and 1920 to 1930.

47. U.S. Women's Bureau. *A Study of a Change from 8 to 6 Hours of Work.* by Ethel L. Best. Bulletin no. 105. Washington, DC: GPO, 1933. 14p. L13.3:105. Study examined shift preferences of women who worked in factories changing from 8-hour to 6-hour shifts. Other factors studied were use of leisure time, arrangements for meals, and earnings. Data on the age and marital status of the workers was also collected.

48. U.S. Women's Bureau. *Women at Work: a Century of Industrial Change.* by Eleanor Nelson. Bulletin no. 115. Washington, DC: GPO, 1933. 51p. L13.2:115. Overview of the history of working women in America covers the move from home to factory, the problem of low wages, the fight for better wages, labor legislation, war work, and education and employment opportunities. Chapters specifically address the problems and contributions of black women and immigrant women workers. Although overly simplistic in places and lacking citations to sources of information, the publication still provides an interesting look at the 1930's view of working women. Revised edition published in 1934 and as Bulletin 161 in 1939.

49. U.S. Women's Bureau. *Women Workers in the Third Year of the Depression.* Bulletin no. 103. Washington, DC: GPO, 1933. 16p. L13.3:103. Study of the industrial experience of 109 women and girls enrolled in the Bryn Mawr summer school for women workers in 1932 focuses on the depression years. In addition to providing data on employment, wages, and union membership, the report presents ten case histories showing the effect of job scarcity on women workers and their families.

50. U.S. Federal Emergency Relief Administration. Women's Work Division. *Work-Relief Sewing Rooms.* Washington, DC: GPO, 1934. 9p. Y3.F31/5:2Se8. Describes the organization of work-relief sewing rooms and provides some examples of successful operations. The focus is on the organization and output, rather than on the workers.

51. U.S. Women's Bureau. *The Age Factor as It Relates To Women in Business and the Professions.* by Harriet A. Byrne. Bulletin no. 117. Washington, DC: GPO, 1934. 66p. L13.3:117. Nationwide survey of the membership of the National Federation of Business and Professional Women's Clubs on the effect of age on the progress of business and professional women. Data collected in the survey and analyzed here include age and marital status, family responsibilities, experience, education, special training, industry, employment history, employment status, unemployment, and earnings. A primary focus of the analysis is the effect of various factors on women's earnings.

52. U.S. Women's Bureau. *A Study of a Change from One Shift of 9 Hours to Two Shifts of 6 Hours Each.* by Ethel L. Best. Bulletin no. 116. Washington, DC: GPO, 1934. 14p. L13.3:116. Study of the attitudes of women employed in a plant which switched from a 9 hour shift to two 6 hour shifts. Describes the adjustments in the plant to effect the change, and notes the women's preferences regarding the different shifts. Some of the information surveyed from the women employees include schedule preferences, use of leisure time from the shorter work week, meal arrangements, and earnings changes. Data was also collected on the women's nativity, age, marital status and job tenure.

53. U.S. Federal Emergency Relief Administration. Divisions of Research, Statistics and Finance. *Proportions of White Collar Workers, Unskilled Labor, Building Workers, Servant Classes and Females on the Relief Rolls Varies Markedly from City to City.* Research Bulletin no. D-11. Washington, DC: The Admin.,1935. 3p. Y3.F31/5:29/D-11. Table shows, by city, the percent of total workers who are women, white collar workers, servants, laborers or from the buildings industry on the relief roles.

54. U.S. Women's Bureau. *Potential Earning Power of Southern Mountaineer Handicraft.* by Bertha M. Nienburg. Bulletin no. 128. Washington, DC: GPO, 1935. 56p. L13.3:128. Study of the handicraft industry in the southern Appalachian Mountain region was conducted to ascertain the extent to which the handicraft industry could supplement the income of families in the region. The study revealed a large untapped labor supply in the women of the region and makes recommendations on organizing the work to ensure profit and to avoid exploiting the women workers.

55. U.S. Women's Bureau. *Summaries of Studies on the Economic Status of Women.* by American Association of University Women. Bulletin no. 134. Washington, DC: GPO, 1935. 20p. L13.3:134. Annotated bibliography with summaries of findings provides citations to research on the economic status of college women, business and professional women, and women in industry.

56. U.S. Women's Bureau. *Technological Changes in Relation to Women's Employment.* by Ethel L. Best. Bulletin no. 107. Washington, DC: GPO, 1935. 39p. L13.3:107. Investigation examined the effect of technological changes on the number of women employed and on their wages. Discusses the effect of technology on production and labor

costs, particularly as they relate to women, the substitution of one class of worker for another, and changes in the method of wage payment.

57. U.S. Women's Bureau. *The Effect of the Depression on Wage Earning Families: A Second Survey of South Bend.* by Harriet A. Byrne. Bulletin no. 108. Washington, DC: GPO, 1936. 31p. L13.3:108. Follow-up to a 1930 survey of families in South Bend, Indiana (43) provides additional information on the effect of the Depression in 1932. Some of the information gathered in household interviews include composition of the household, age and nativity of women, marital status of workers, and employment of household members in the previous year. Provides data on the employment and earned income status of women, men, and households.

58. U.S. Women's Bureau. *The Employed Woman Homemaker in the United States: Her Responsibility for Family Support.* by Mary Elizabeth Pidgeon. Bulletin no. 148. Washington, DC: GPO, 1936. 22p. L13.3:148. Analyzes statistics collected in the 1930 Census to create a picture of the dual responsibilities of working homemakers. Data reported includes occupation and age, women as sole wage earners, size of family and occupation, number of children under 10 and occupation, sex of head and occupation in 2-or-more person families, presence of lodgers by occupation and age of homemaker, and distribution of employed homemakers in urban and rural areas.

59. U.S. Women's Bureau. *Gainful Employment of Married Women.* Washington, DC: The Bureau, 1936. 26p. L13:M34/2/936. Summary of data and research on gainful employment of married women lists related Women's Bureau Bulletins, reports 1930 Census data on gainfully employed women by marital condition and gainfully employed women by occupation, and provides one page summaries of research on employment of married women from economic and legal angles, particularly efforts to oust married women from employment. Earlier edition issued in 1934.

60. U.S. Women's Bureau. *A Motion Picture from the Women's Bureau: Behind the Scenes in the Machine Age.* Washington, DC: The Bureau, 1936. poster. L13.9:M11.

61. U.S. Women's Bureau. *Reemployment of New England Women in Private Industry.* by Bertha M. Nienburg. Bulletin no. 140. Washington, DC: GPO, 1936. 118p. L13.3:140. Study of unemployment among New England women examines possible reemployment opportunities in industrial growth areas. First the report analyzes the unemployment problems of the women and their usual occupation in order to identify an employment pool. In the following sections the report analyzes consumer needs that could be translated into jobs for women in both manufacturing and service industries. The appendix provides a detailed analysis of the potential markets for fish products, sporting goods, and wool-gloves. Detailed statistics on age and occupation of unemployed women in the Boston area are furnished.

62. U.S. Women's Bureau. *Women Unemployed Seeking Relief in 1933.* by Harriet A. Byrne. Bulletin no. 139. Washington, DC: GPO, 1936. 19p. L13.3:139. Report of two studies made in 1933 of women applying for relief in Chicago, Cleveland, Minneapolis/St. Paul, and Philadelphia. Provides data on the characteristics of the women. Information surveyed includes age, race, nativity, martial status, length of residence, usual occupation, reason for leaving usual job, time since losing last job, and type of relief granted.

63. U.S. Works Progress Administration. *Analysis of Employment of Women on Works Project Administration Projects, December 1935 through May 1936.* Washington, DC: The Administration, 1936? 18p. Y3.W89/2:2W84. Analysis by sex of WPA employment looks at number of women by state, types of occupations (primarily clerical) and type of projects

(mostly educational or statistical). Also looks at wage rates and actual earnings for women and men on WPA projects by state.

64. U.S. Women's Bureau. *Motion Picture, What's in a Dress.* Washington, DC: The Bureau, 1937. poster. L13.9:M11/3. Reprinted in 1940.

65. U.S. Women's Bureau. *New Movie Produced by Women's Bureau.* Washington, DC: The Bureau, 1937. 1p. L13.2:M86. Describes the movie "What's in a Dress", a history of labor practices in the garment industry.

66. U.S. Women's Bureau. *Women in the Economy of the United States of America: a Summary Report.* by Mary Elizabeth Pidgeon. Washington, DC: GPO, 1937. 137p. L13.2:W84/2. Also issued as Women's Bureau Bulletin no. 155. The main themes of this overview of the role of working women in the United States are employment opportunities and compensation, and the effect of labor legislation on women's opportunities, wages and working conditions. The report analyzes the occupational trends in women's employment and reviews the role of the homemaker in the economy. Unemployment and the responsibility of employed women for the support of others is briefly covered. Considerable attention is given in the report to women's wages and data is provided on men's and women's wages by occupation. Particular attention is also given to the effect of the National Industrial Recovery Act (NRA) on women's hours, wages, and employment, and on the effects of minimum wage laws and hours laws. Provides a brief bibliography.

67. U.S. Women's Bureau. *Women Who Work for Us! Motion Picture, Within the Gates.* Washington, DC: GPO, 1937. poster. L13.9:M11/2. Reprinted in 1941.

68. U.S. Women's Bureau. *Every Morning We Wash Clothes.* by New York. Dept. of Labor. Division of Women in Industry and Minimum Wage. Washington, DC: The Bureau, 1938. poster. L13.9:W27.

69. U.S. Women's Bureau. *The Negro Woman Worker.* by Jean Collier Brown. Bulletin no. 165. Washington, DC: GPO, 1938. 17p. L13.3:165. Review of the available literature on black women workers. Discusses the number of employers and characteristics of employment in domestic and personal service, agriculture, manufacturing, and white collar occupations. Also discussed are ways to improve the economic status of black women workers.

70. U.S. Women's Bureau. *Unattached Women on Relief in Chicago, 1937.* by Harriet A. Byrne and Cecil Hillyer. Bulletin no. 158. Washington, DC: GPO, 1938. 84p. L13.3:158. Detailed survey of non-family women on relief in Chicago in 1937. Information collected covers personal characteristics, education and training, causes of seeking relief, type and duration of relief, living conditions, physical and mental health, and work history. Personal data collected includes age, nativity, race, marital status, and disease, and information is further broken down by usual occupation.

71. U.S. Women's Bureau. *Woman Who Earns Keeping Her Work Place Comfortable.* Washington, DC: The Bureau, 1938. poster. L13.9:W84. Reprinted in 1940.

72. U.S. Women's Bureau. *Women in Industry: A Series of Papers to Aid Study Groups.* by Mary Elizabeth Pidgeon. Bulletin no. 164. Washington, DC: GPO, 1938. 98p. L13.3:164. Revision of Bulletin no. 91 (40). Provides background information on women's employment, married women workers, women and unemployment, health standards for women's work, labor legislation for women, women's earnings, women's labor organizations, and the work of the Women's Bureau.

73. U.S. Works Progress Administration. Division of Women's and Professional Projects. *Exhibition of Selected Skills of Unemployed, as Demonstrated on W.P.A. Nonconstruction Projects, Jan. 10-31, 1938, in National Museum, Washington, D.C., by Works Progress Administration, Division of Women's and Professional Projects.* Washington, DC: The Administration, 1938. 28p. Y3.W89/2:2Ex4. Description of WPA Division of Women's and Profession Projects programs to accompany a National Museum exhibit provides summary information on programs in public health and the arts. Many of the projects, most notably nursing, housekeeping, and weaving projects, involved mostly women.

74. U.S. Office of Education. *Gallant American Women #8, Women in the Law, December 19, 1939.* by Jane Ashman. Washington, DC: The Office, 1939. 23p. FS5.15:8. Women as lawyers, humanizing the law, is the theme of the eighth episode of the "Gallant American Women" radio series.

75. U.S. Office of Education. *Gallant American Women #9, Women of the Sea, December 26, 1939.* by Jane Ashman. Washington, DC: The Office, 1939. 26p. FS5.15:9. Women as sailors, the early superstition against women on ships, and women waiting for their sailor husbands to come home are the feature of this radio script. Includes a list of research sources consulted.

76. U.S. Women's Bureau. *Job Histories of Women Workers at the Summer Schools, 1931-34 and 1938.* by Eleanor M. Snyder. Bulletin no. 174. Washington, DC: GPO, 1939. 25p. L13.3:174. Presents results of a survey of the characteristics and job histories of women workers at the summer schools of the Affiliated Schools for Workers during 1931-1934 and 1938. The structure and purpose of the schools is discussed along with data on nativity, age, and marital status of participants. Job history information reported includes age upon entering industry, years in industry, number of jobs held, and industry of last job held. Also reported is union membership and union status of shop of last job. Earnings data includes median weekly wages by union membership, and earnings in preceding year. Because of the depression years covered, particular attention was paid to unemployment and its causes.

77. U.S. Women's Bureau. *La Mujer Trabajadora en los Estudios Unidos.* Washington, DC: The Bureau, 1939. 8p. L13.2:W84/5/Spanish. See 78 for abstract.

78. U.S. Women's Bureau. *A Mulher no Trabahlo nos Estudos Unidos.* Washington, DC: The Bureau, 1939. 8p. L13.2:W84/5/Portuguese. General overview profiles the status of employed women in the United States, the occupations they enter, and the status of labor laws for women workers. The work of the Women's Bureau is briefly discussed. This leaflet was only published in Spanish and Portuguese.

79. U.S. Women's Bureau. *Standards for Employment of Women in Industry.* Bulletin no. 173. Washington, DC: GPO, 1939? [9]p. leaflet. L13.3:173. Presents Women's Bureau suggestions for employment standards for women in the areas of hours of work, wages, working conditions, and employer-employee relations.

80. U.S. Women's Bureau. *The Woman Wage Earner, Her Situation Today.* by Elizabeth D. Benham. Bulletin no. 172. Washington, DC: GPO, 1939. 56p. L13.3:172. Overview of women's employment in 1937 and changes since 1929 focuses on the number of women employed by industry and occupation. Also discusses average earnings by industry and the cost for women living independently. Briefly covers union participation and unemployment.

81. U.S. Women's Bureau. *Women at Work: A Century of Industrial Change.* by Rebecca Farnham. Bulletin no. 161. Washington, DC: GPO, 1939. 80p. L13.3:161. Reprinted with slight changes in 1942. Revision of Bulletin no. 115 (48).

82. U.S. Office of Education. *Gallant American Women #30, Through Space and Time, May 27, 1940.* by Jane Ashman. Washington, DC: The Office, 1940. 23p. FS5.15:30. Role of women employed in communications, from the postal service to the telephone system of the United States, is the focus of this episode of the "Gallant American Women" radio series.

83. U.S. Women's Bureau. *Minimum Standards for Employment of Women in Industry.* Washington, DC: The Bureau, 1940. poster. L13.9:St2/1-4. Earlier editions printed in 1932, 1936, and 1938.

84. U.S. Women's Bureau. *The Nonworking Time of Industrial Women Workers.* Bulletin no. 181. Washington, DC: GPO, 1940. 10p. L13.3:181. Students of the Hudson Shore Labor School studied their own past experience regarding the use of nonwork time. Some of the routine weekly activities reported include hours spent traveling to and from work, doing housework, shopping, taking classes, engaging in union activities, and taking recreation. The types of recreation participated in were also detailed by number of times per week the worker was engaged in the activity. The study also collected brief information on the extent of annual vacations and how they were used. Includes four case histories of individual women.

85. U.S. Work Projects Administration. *Women in Aeronautics.* Bibliography of Aeronautics, part 47. New York: Federal Works Agency, Work Projects Administration, 1940. 31?p. Y3.W89/2:60, pt. 47.

86. U.S. Women's Bureau. *Women Workers in Their Family Environment.* Bulletin no. 183. Washington, DC: GPO, 1941. 82p. L13.3:183. To ascertain the relationship of women workers to their family environment the Women's Bureau studied a small sample of women workers in Cleveland and in Utah. Specifically, the study looked at characteristics of women workers, family needs, contribution to family support, and the care of children and home. In determining how well the women were able to meet the demands placed on them, the study collected information on work availability, the extent of employment, and monthly earnings. Schooling, experience, and marital status were examined as they related to earnings power. Characteristics on which data was collected include age, marital status, age beginning work, schooling, and number of wage earners by size and type of family. Also provides data on breaks in employment of women who were or had been married and on interruptions to employment caused by childbirth.

87. U.S. Emergency Management Office. War Manpower Commission. *Womenpower is Manpower, Speech by Thelma McKelvey, War Manpower Commission, before Convention of Women's Auxiliary of United Automobile, Aircraft, and Agricultural Implement Workers of American, CIO, Chicago, Ill., Aug. 5, 1942.* by Thelma McKelvey. Washington, DC: The Commission, 1942. 7p. PR32.3507:M195.

88. U.S. Women's Bureau. *Women Workers in Argentina, Chile, and Uruguay.* Bulletin no. 195. Washington, DC: GPO, 1942. 15p. L13.3:195. Report on the employment of women in Argentina, Chile, and Uruguay. Focuses primarily on individual work and the number of women employed in various industries. Hours, wages, and working conditions are highlighted. Industrial homework, labor unions and labor laws are also discussed. Finally, information on educational opportunities for women and women's organizations dealing with women workers are described.

89. U.S. War Department. *You're Going to Employ Women.* Washington, DC: GPO, 1943. 13p. W1.2:W84. Suggestions on utilizing women for war work includes tips on hiring, training, supervising, and working with women.

90. U.S. Women's Bureau. *Absenteeism (Unauthorized Time Away from the Job).* Washington DC: The Bureau, 1943. 7p. L13.2:Ab8. Also issued in April 1944 with minor revision. Report on absenteeism looks at the extent of absenteeism by industry and at the percentage of women in the industry, drawing conclusions on the absenteeism rates of women. Causes of absenteeism are reported by sex. Describes ways employers can effectively address the problem of absenteeism and stresses more convenient working hours or part-time work for women, better plant facilities, and improved morale. Community activities or programs to address the problems of working women, such as shopping, cooking, and day care, are also listed.

91. U.S. Women's Bureau. *When You Hire Women.* Special Bulletin no. 14. Washington, DC: GPO, 1943. 16p. L13.10:14. General guidelines for employers introducing women into their work force covers such topics as gaining the cooperation of the existing male work force, selecting suitable jobs, providing facilities for women, hiring and training approaches, supervising women workers, and equal opportunity. Provides examples of successful applications of the recommendations.

92. U.S. Office of Defense Transportation. *Summary Report, Institute for Supervisors of Women Workers in Transportation, Oct. 12-14, 1943, Chicago.* Washington, DC: The Office, 1944. 42p. Pr32.4902:In7/943.

93. U.S. Office of Defense Transportation. Division of Transport Personnel. *Practical Hints to Employers of Women, with Special Reference to Transportation.* by Dorothy Sells and Cornelia Edge. Washington, DC: The Office, 1944. 19p. Pr32.4902:W84. General information on employing women in wartime is included in this handbook geared toward the recruitment and training of women for employment in the transportation industry. Includes hints to employers on selection, training, and placement of women workers and hints to supervisors on the physical and psychological differences between men and women as they relate to employee management. Also includes "practical hints" relating to clothing, attitude, personal life, and safety for the woman doing a man's job, and comments from transportation employees on their experiences with women workers.

94. U.S. War Dept. *Do You Want Your Wife to Work after the War?* by American Historical Association. Education Manual no. 31. Washington, DC: The Department, 1944. 42p. W1.55:31. Overview of the issues involved in the employment of women, particularly married women is, surprisingly, minimally biased toward homemaking. Presents a fairly clear picture of the reasons women work and also discusses the movement to ensure economic security through government programs so that women won't have to work. Improving the perceived status of homemaking also receives mention.

95. U.S. Women's Bureau. *Employment and Housing Problems of Migratory Workers in New York and New Jersey Canning Industries, 1943.* Bulletin no. 198. Washington, DC: GPO, 1944. 35p. L13.3:198. The first half of the report focuses on the employment of women in New York and New Jersey canneries and on the sources of the seasonal labor supply. Details some of the employment practices related to women revealed in the investigation. The second half of the report describes housing conditions in migratory camps associated with the canneries and provides guidelines on appropriate housing facilities.

96. U.S. Women's Bureau. *The Post-War Role of American Women.* Washington, DC: The Bureau, 1944. 7p. L13.12:W84. Speech by Mary Anderson, Director of the Women's

Bureau, before the American Economic Association, addresses the question of women's continued employment after the war emergency and the jobs they will likely hold.

97. U.S. Women's Bureau. *Reconversion Blueprint for Women, Adopted at Conference of Women's Bureau with Women Representatives of 25 National Organizations, Dec. 5, 1944.* Washington, DC: The Bureau, 1944. 2p. L13.2:R24. Basic statement on the employment of women affirms the need of women to work for family support and sets out a list of basic policies and actions to fairly include women in postwar employment planning.

98. U.S. Women's Bureau. *Suggested Standards for Union Contract Provisions Affecting Women.* Washington, DC: GPO, 1944. 4p. L13.2:W89/3. Suggested standards for union contract provisions affecting women in the areas of equal pay, seniority, rest periods, lunch periods, and maternity leave.

99. U.S. Women's Bureau. *Suggested Standards for Union Contract Provisions Affecting Women.* Washington, DC: The Bureau, 1944. 4p. L13.2:W89/8. Suggested standards for union contract provisions affecting women cover wages, seniority, rest periods, lunch periods, and maternity leave. Also included is a list of Women's Bureau publications on recommended standards for employed women.

100. U.S. Women's Bureau. *Women Workers Today and Tomorrow: A Balance Sheet.* Washington, DC: The Bureau, 1944. 21p. L13.2:W84/11. Planning for women in the postwar period and keeping women in war jobs as long as possible are the main topics of this publication which reviews the changes in women's lives due to the war. Women's preference for postwar employment, occupational shifts during the war, and injurious occupations are reviewed. Wage and hour laws in the transition from war to peace are also discussed. Opposition to ERA as a danger to working women is expressed at some length.

101. U.S. Women's Bureau. *Work for Women after the War.* Washington, DC: The Bureau, 1944. 4p. L13.2:W89/3. Overview of the situation women workers face after the war. Focuses on factors which will help them get or keep jobs and on factors that will create difficulty for women workers.

102. U.S. Bureau of Labor Statistics. *Postwar Employment Prospects for Women in the Hosiery Industry.* Bulletin no. 835. Washington, DC: GPO, 1945. 12p. L2.3:835. Also issued as House Document 223, 79th Congress. Discusses the changes in the proportion of women employed in the hosiery industry and notes changes in the required skill level which may impact the retention of women in these jobs after the war. Discussed the skills required and women's efficiency at these tasks.

103. U.S. War Manpower Commission. Women's Advisory Committee. *Woman in the Postwar.* Washington, DC: The Commission, 1945. 20p. Pr32.5202:W84/9. Recommendation on services for women in the postwar period relate to adequate social security, nursery schools, employment training, and demobilization and women worker layoffs. Presents the committee's opinion on the role of the U.S. Employment Service, labor standards, and unions in reconversion, and on utilization of women's skills. That married women would work out of economic necessity is stressed. The report calls attention to the problems of household employment and the need to evaluate the occupation in terms of financial security and training. Recommendations are also made on child labor, vocational education, and adult education.

104. U.S. Women's Bureau. *Conference of Trade Union Women and Women's Bureau, U.S. Department of Labor, on War and Postwar Problems of Women Workers, April 19-20, 1945, Washington, D.C.* Washington, DC: The Bureau, 1945. 32p. L13.2:Un3.

Recommendations of the conference suggest actions for the Women's Bureau and unions, particularly in relation to labor legislation. Discussions at the conference covered seniority and job opportunities for women, wage problems, working conditions, legislative standards, and women's participation in unions. The discussion section also provides a brief description of maternity policies of selected unions.

105. U.S. Women's Bureau. *Patterns of Women in Industry, Talk by Frieda S. Miller, Director, Women's Bureau, at Women in War Work Session of Greater Chicago Safety Conference, Chicago, May 24, 1945.* by Frieda S. Miller. Washington, DC: The Bureau, 1945. 9p. L13.12:W84/3. Overview of trends in women in industry looks at the movement of women into paid employment between late 1941 and early 1944 and at the occupational distribution of these women. Reviews the safety problems accompanying the movement of young girls and housewives into industrial life, and draws conclusions based on available data on sex differences in injury rates.

106. U.S. Women's Bureau. *Selected References Applying to Woman Employment in the United States after the War.* Washington, DC: The Bureau, 1945. 6p. L13.2:Em7. Lists magazine articles and organization publications related to the future of women's employment and their occupations after WWII.

107. U.S. Women's Bureau. *Status of Women in Unions in War Plants: Seniority.* Union Series 1945, no. 1. Washington, DC: GPO, 1945. leaflet. L13.13:1. Review of seniority provisions of union contracts affecting women in war plants. Reports on the attitudes of the women and the men in the plants regarding retaining women after the war. Two versions of this publication were issued in 1945 with no indication of a revision.

108. U.S. Women's Bureau. *Unemployment Compensation: How It Works for Working Women.* Union Series no. 4. Washington, DC: GPO, 1945. leaflet. L13.13:4. Basic information for women on unemployment compensation.

109. U.S. Women's Bureau. *War and Postwar Adjustments of Women Workers, Opening Address by Frieda S. Miller, Director of the Women's Bureau to a Conference Called by Miss Miller and Attended by Women Representatives of National Organizations, Washington, D.C., Dec. 4-5, 1944.* by Frieda S. Miller. Washington, DC: The Bureau, 1945. 7p. L13.12:W19. Occupational shifts of women during the war and the implications for postwar employment are examined. Briefly touches on the increase of women's wages and union membership during the war. Reconversion and returning veterans are analyzed as factors affecting women employment options after the war. Preliminary results of a Women's Bureau survey of economic responsibilities of women employed in war production centers emphasizes the need for women to work after the war.

110. U.S. Women's Bureau. *Women Union Leaders Speak, Women's Bureau, Union Conference, Apr. 18-19, 1945.* Washington, DC: The Bureau, 1945. 32p. L13.2:Un3

111. U.S. Bureau of Labor Statistics. *Workers' Experience during First Phase Reconversion.* Bulletin no. 876. Washington, DC: GPO, 1946. 18p. L2.3:876. Study of war workers' postwar labor force experience looks at factors of age and sex as they relate to postwar employment. Provides statistics by race, sex, and age on employment status of war and non-war workers, and migration among former war workers.

112. U.S. Dept. of Labor. *Address by Secretary of Labor L.B. Schwellanbach, before the Eleventh Annual Convention of the National Council of Negro Women, Washington, D.C., Nov. 14, 1945.* Washington, DC: The Dept., 1946. 6p. L1.13:N21c/2. General overview of Department of Labor agencies which somehow relate to the lives of black women is presented with an emphasis on Women's Bureau and U.S. Employment Service

studies and policies on black women workers. The question of whether the U.S. Employment Service officers will continue the policy of nondiscrimination in referrals after control returns to the states is discussed. Maternal and child health programs under the Children's Bureau are also described.

113. U.S. Women's Bureau. *Consultation on the Post War Employment of Women, Material for the United States of America Prepared in Response to Questions from the I.L.O., April 1946.* Washington, DC: The Bureau, 1946. 38p. L13.2:Em7/3. Detailed response to questions on the status of women workers prior to WWII, during the war and in the postwar period. Describes trends in women's employment including number of women employed, occupational and industrial distribution, age, and marital status. Particular attention is paid to the postwar adjustment of women in answers to questions on distribution of women in postwar placements. The consideration of women in government manpower planning is also a topic. The trends in the employment of women in the federal service and particularly Civil Service practices which discrimination against women, are described. The situation of women in public employment offices in the postwar period is also reported. Pay discrimination is examined during and after the war with an emphasis on the federal government's ability to influence private sector practice. Policies of the U.S. Employment Service in referring women for jobs is also examined as are unemployment insurance practices. Other questions address women's access to vocational training and apprenticeship, and improving the status of domestic workers.

114. U.S. Women's Bureau. *The Economic Responsibilities of Women Workers as Shown by a Women's Bureau Study of Women War Workers and Their Postwar Employment Plans.* Washington, DC: The Bureau, 1946. 4p. L13.2:W84/14. Reasons given by the 75 percent of women workers who planned to continue working after the war focuses on responsibility for the economic support of themselves and their families. Survey results on reasons for continuing to work are reported separately for widowed or divorced, single, and married women.

115. U.S. Women's Bureau. *Employment of Women in the Early Postwar Period with Background of Prewar and War Data.* Bulletin no. 211. Washington, DC: GPO, 1946. 14p. L13.3:211. Report on the occupations and characteristics of women employed in the first few months after the end of WWII. Reviews industry and occupation, age and marital status for the prewar, wartime, and initial postwar period. Some analysis of trends in the distribution of women workers after the war is provided.

116. U.S. Women's Bureau. *Women Workers in Brazil.* by Mary M. Cannon. Bulletin no. 206. Washington, DC: GPO, 1946. 42p. L13.3:206. Report of a brief investigation of the condition of women workers in Brazil. Looks at number of women employed in manufacturing, retail trade, offices, telephone exchanges, and government printing. Wage and job tenure are briefly covered and labor legislation and social welfare programs affecting women are summarized. Also discusses vocational education, unions, women's organizations, and the political status of women.

117. U.S. Women's Bureau. *Women Workers in Paraguay.* by Mary M. Cannon. Bulletin no. 210. Washington, DC: GPO, 1946. 16p. L13.3:210. Summary report of the condition of women, particularly working women, in Paraguay. Discusses the effect of repeated wars on the proportion of women to men and on the need to accept women workers. Data was collected on the number of women employed by industry, hours and wages, absenteeism and turn-over, plant conditions, and trade unions. Also describes the home industry of lace production with illustrations of the craft. Labor legislation such as minimum wage, maternity benefits, and social security are summarized. In addition, the report describes the employment of women in the professions, agriculture, and government service.

118. U.S. Women's Bureau. *Women's Frontiers in 1946.* Washington, DC: The Bureau, 1946.
 10p. L13.2:W84/16. Summary of women's contributions to the war effort and discussion
 of the need for many women to continue employment after the war for financial reasons.
 The obstacles faced by women in securing employment in the postwar period are reviewed.
 Also discussed are the legislative safeguards for women against discriminatory pay
 practices and the inclusion of women in International Labor Organization resolutions.
 Finally, the document lists women serving as official U.S. delegates to international
 organizations such as the U.N. and the International Labor Conference.

119. U.S. Women's Bureau. *Women's Stake in Unions.* Union Series no. 5. Washington, DC:
 GPO, 1946. leaflet. L13.13:5. Briefly summarizes topics of women in unions, what
 unions can do, what women can do, and women's union membership.

120. U.S. Agricultural Research Administration. *Functional Work Clothes Designed for
 Women.* Research Achievement Sheet 79(H). Washington, DC: The Administration,
 1947. 2p. A77.7:79(H).

121. U.S. Women's Bureau. *Older Women Workers and Their Problems.* Washington, DC:
 The Bureau, 1947. 4p. L13.2:Ol1. Summary profile of the number of women workers 45
 to 64 years old highlights their employment and unemployment problems.

122. U.S. Women's Bureau. *Women Workers in Peru.* by Mary M. Cannon. Bulletin no.
 213. Washington, DC: GPO, 1947. 41p. L13.3:213. Overview of the status of women
 workers in Peru. Looks at the concentration of women in various occupations, the state
 of vocational education, and participation in labor organizations. Labor and social
 legislation as related to women is also reviewed and the activities of major women's
 organizations are summarized. Provides statistics on age of employed persons by industry
 and sex, employed women, and women in specific industries.

123. U.S. Dept. of Labor. *Address of L.B. Schwellenbach, Secretary of Labor, before the
 Women's Bureau Conference on the American Woman, Her Changing Role.* by L.B.
 Schwellenbach. Washington, DC: The Dept., 1948. 7p. L1.13:Am3/8. Progress of
 women as workers in America in the 100 years since the Seneca Falls Convention of 1848
 is the topic of Secretary Schwellenbach's speech. The greater occupational opportunities
 for women are highlighted but areas of needed improvements, such as equal pay and
 minimum wage, are also noted.

124. U.S. Women's Bureau. *Baltimore Women War Workers in the Postwar Period.*
 Washington, DC: The Bureau, 1948. 61p. L13.2:B21. Report of a 1946 survey of women
 workers employed in the war industries in Baltimore in 1944. Results describe the
 employment of these women in the postwar years. Provides detailed information on the
 work experience of women in the two year postwar adjustment period and looks at reasons
 the women were or were not in the labor force. Factors such as earnings and hours in the
 wartime and postwar periods are examined along with information on occupation and
 industry. Information on satisfaction with postwar employment was also gathered.

125. U.S. Women's Bureau. *Employment of Negro Women in White-Collar Positions.*
 Washington, DC: The Bureau, 1948. 3p. L13.2:N31/2. Results of a survey conducted in
 25 cities by the National Urban League document the distribution of black women in white-
 collar positions. Some of the position titles are listed.

126. U.S. Women's Bureau. *Managing Home and Job: Family Responsibilities of Earning
 Women.* Washington, DC: The Bureau, 1948. 9p. L13.12:Am3/6. Address by Hazel
 Kyrk of the University of Chicago, given before the 1948 Women's Bureau Conference,
 "The American Woman, Her Changing Role as Worker, Homemaker, Citizen," focuses

on the household responsibilities of widowed, divorced, separated, and married women. Includes references to the employment problems of displaced homemakers. Much of the speech centers on the extent of "modern" household duties and balancing household and work demands. The address also explores some of the reasons married women don't work.

127. U.S. Women's Bureau. *Report on the 1948 Women's Bureau Conference, the American Woman - Her Changing Role.* Bulletin no. 224. Washington, DC: GPO, 1948. 210p. L13.3:224. Various speakers address topics such as why do women work, women's legislation and working conditions, family responsibilities of working women, women in unions, and women as homemakers.

128. U.S. Women's Bureau. *Role of Women in the National Economy.* Washington, DC: The Bureau, 1948? 9p. L13.12:W84/5. Address by Frieda S. Miller given before the 28th annual convention of Alpha Kappa Alpha, December 29, 1948, describes trends in the employment patterns of women and the forces which have affected the movement of women into the paid labor force. The economic necessity of women's employment is described with special reference to black women and their occupational patterns.

129. U.S. Women's Bureau. *Standards for the Employment of Women.* Leaflet, 1946 Series, no. 1. Washington, DC: GPO, 1948. leaflet. L13.11:946/1. Revision of L13.3:173 (79).

130. U.S. Women's Bureau. *Who Works, Where and Why.* Washington, DC: The Bureau, 1948. 9p. L13.12:Am3. Address given by Frieda S. Miller at the 1948 Women's Bureau Conference, "The American Woman, Her Changing Role as Worker, Homemaker, Citizen," provides an overview of the situation of women workers and highlights areas such as number of working women, earnings, reasons for working, and occupational distribution. Vocational training of women and the need for wider occupational opportunities and equal pay are also discussed.

131. U.S. Women's Bureau. *Women's Occupations through Seven Decades.* by Janet M. Hooks. Bulletin no. 218. Washington, DC: GPO, 1948. 260p. L13.3:218. Analyzes Census data from 1870 to 1940 for trends in women's occupations and in their personal characteristics. In particular, the report studies long-term trends in specific occupations whether industrial, service, white-collar, or professional. Provides detailed statistics on number and proportion of women in the labor force by marital status, 1900-1940; and number and percentage distribution of women by occupation, 1870-1940. Indexed by subject.

132. U.S. Women's Bureau. *Working Women's Gains and Goals.* Washington, DC: The Bureau, 1948. 6p. L13.12:Am3/2. Text of a speech by Gladys Dickensen, of the Amalgamated Clothing Workers of America, at the 1948 Women's Bureau conference, "The American Woman, Her Changing Role as Worker, Homemaker, Citizen." Topics of the speech are progress in the public attitude toward women's status and place in society, the need to extend the protection afforded women and children to all workers, and the role of trade unions in improving the situation of women workers. It is interesting in retrospect that Ms. Dickensen considered the battle over the theoretical equality of women already won by 1948.

133. U.S. Dept. of State. Office of the Military Government for Germany. Manpower Division. *Women in German Industry: Die Arbeitende Frau in Deutschland.* by Sara Southhall and Pauline M. Newman. Visiting Expert Series no. 14. Washington, DC: The Office, 1949. 36p. S1.87:14. Review of the situation of working women in postwar Germany presents the existing, but incomplete, statistics of women workers' hours, wages, and unemployment, and reviews Reich legislation affecting women workers. Site visits with

factory management and trade union representatives form the basis of observations on working conditions and management practices. Some of the areas in which attitudes and opinions were sought include vocational training and apprenticeship, equal pay, housing conditions, and social legislation. The status of women's organizations was also examined.

134. U.S. Women's Bureau. *Women's Jobs: Advance and Growth*. Bulletin no. 232. Washington, DC: GPO, 1949. 88p. L13.3:232. Simplified version of *Women's Occupations through Seven Decades* (131) describes the occupations which employ women and girls and the growth in the number of women in selected occupations. Provides information on the number of women and their percentage in each occupation, but does not give the source of the data presented.

135. U.S. Women's Bureau. *Recommended Standards for Employment of Women*. Washington, DC: GPO, 1950. leaflet. L13.2:St2.

136. U.S. Women's Bureau. *Women in Higher-Level Positions*. Bulletin no. 236. Washington, DC: GPO, 1950. 86p. L13.3:236. Broad-based survey looks at numbers and characteristics of women in management level positions and speculates on the reasons some women are promoted while most are not. Some of the factors discussed include education and training, motivation, and the nature of the industry. The importance of attitudes both on the part of management and employers is discussed. Characteristics of the women who achieve higher level positions, particularly their years of experience and education, are highlighted.

137. U.S. Women's Bureau. *Working Women and Unemployment Insurance*. Washington, DC: GPO, 1950. leaflet. L13.2:Un2.

138. U.S. Human Nutrition and Home Economics Bureau. *Employment of Rural Women, Talk by Pauline S. Taylor, Family Economics Division, at 29th Annual Agricultural Outlook Conference, Washington, D.C., Nov. 1, 1951*. by Pauline S. Taylor. Washington, DC: The Bureau, 1951. 4p. A77.713:T21. Speech reviews statistics on employment of rural farm and nonfarm women in 1950 and discusses the effect of WWII and changing trends. Age, presence of children, and the type of work performed are among the statistics highlighted.

139. U.S. Women's Bureau. *Older Women in the Labor Force, 1900-50*. Washington, DC: GPO, 1951. 1p. graph. L13.2:L11/6/900-50.

140. U.S. Women's Bureau. *Older Women Workers*. by Frieda S. Miller. Washington, DC: The Bureau, 1951. 5p. L13.12:M61/2. Overview of the situation and special problems faced by older women workers accompanies a review of services of the Women's Bureau related to these women.

141. U.S. Women's Bureau. *Older Women Workers*. Washington, DC: The Bureau, 1951. 5p. L13.2:Ol1/951 or L13.2:W89/7. Summary of the labor force status of the population by age and sex for 1940 and 1950 accompanies a concise review of the labor force concerns of mature women.

142. U.S. Women's Bureau. *Percent of All Older Women Who Are Workers, 1900-50*. Washington, DC: GPO, 1951. 1p. graph. L13.2:W84/32/900-50.

143. U.S. Women's Bureau. *Percent of All Older Workers Who Are Women, 1900-1950*. Washington, DC: GPO, 1951. 1p. graph. L13.2:W89/5/900-50.

144. U.S. Women's Bureau. *Why Do Women Work, How Do They Use the Money They Earn, Answers Given by 8,300 Women Workers in 100 Trade Union Locals.* Washington, DC: GPO, 1951. [6]p. leaflet. L13.11:11.

145. U.S. Women's Bureau. *Women's Role in the Manpower Program.* Washington, DC: The Bureau, 1951. 13p. L13.2:M31. Analysis of women's role in the war manpower program highlights factors to consider in planning. Discusses the available female labor force and its characteristics such as marital status, age, and presence and ages of children. Also notes areas of concern including training, occupation, community facilities, state labor laws, and voluntary standards for women workers.

146. U.S. Office of Defense Mobilization. Health Resources Advisory Committee. *Job for Women.* Washington, DC: The Office, 1952. 8p. Pr33.1002:W84. General information on hiring women includes a list of types of work performed particularly well by women, and notes the health and safety problem of women including pregnancy and the effect of work on menstruation. Provides a two page list of references on practical aspects of women and work.

147. U.S. Women's Bureau. *Facts on Older Women Workers.* Washington, DC: The Bureau, 1952. 15p. L13.2:Ol1/2. Demographic information on the population and the labor force is used to illustrate trends in the employment of women. Provides data on the occupational background of women workers by age and discusses the effect of war production on employment of women 45 and older. Provides data on labor force participation of women by age, unemployment rate of women by age, occupational distribution by age, proportion of part-time workers by sex and age, and experience of women workers at their current job by age.

148. U.S. Women's Bureau. *So You're a Woman Over Forty and Looking for a Job? Here Are Pointers to Help Toward Success.* Leaflet no. 13. Washington, DC: GPO, 1952. leaflet. L13.11:13.

149. U.S. Women's Bureau. *Women Workers and Their Dependents.* Bulletin no. 239. Washington, DC: GPO, 1952. 117p. L13.3:239. Two part report on the contributions of women workers to household finances provides a review of existing studies and reports the results of a study of union women and their economic responsibilities. The studies reviewed examined the relationship to dependents, the contribution to family expenses, and reasons for working. Data from the union study includes age, marital status, number of persons supported and living arrangements.

150. U.S. Women's Bureau. *Women's Chances for Advancement in Business and Industry.* Leaflet no. 14. Washington, DC: GPO, 1952. leaflet. L13.11:14. Basic facts and tips on women's career advancement.

151. U.S. Women's Bureau. *The Shortage of Young Women Workers, What it Means to the Nation, to Employers, to the Young Women Themselves.* Leaflet no. 15. Washington, DC: GPO, 1953. 7p. L13.11:15. Outlines the social and demographic factors creating the shortage of geographically mobile women ages 18 to 34, and describes the shortage areas in teaching, nursing and allied health, and social work. Steps to help alleviate the shortage through better salaries, more training opportunities, and loosening of age and licensing restrictions are noted.

152. U.S. Women's Bureau. *Toward Better Working Conditions for Women: Methods and Policies of the National Women's Trade Union League of America.* Bulletin no. 252. Washington, DC: GPO, 1953. 71p. L13.3:252. History of the National Women's Trade Union League of America focuses on the first ten years of the organization. The WTUL's

work in the areas of labor organizing, education of women workers, and labor legislation is highlighted.

153. U.S. Women's Bureau. *Changes in Women's Occupations, 1940-1950.* Bulletin no. 253. Washington, DC: GPO, 1954. 104p. L13.3:253. Analysis of information from the 1940 and 1950 Census on the occupations of gainfully employed women provides statistics on distribution of women and men in occupational groups, and age and marital status of women by occupation.

154. U.S. Women's Bureau. *Entry and Reentry of the Older Woman into the Labor Market.* Washington, DC: The Bureau, 1954. 20p. L13.2:Ol1/4. Two papers presented at the Sixth Annual Conference on Aging, University of Michigan, July 8-10, 1953, discuss mature women in the labor force. The first paper, "Older Women in the Labor Force", by Mary N. Hilton, describes the changing age distribution of women in the labor force and the barriers older women face to entry or reentry. Pearl C. Ravener's "Psychological Barriers to the Employment of Mature Women" reviews the literature on age barriers, employer attitudes, personnel officer and placement agency attitudes, and the attitudes of the older job-seeker.

155. U.S. Women's Bureau. *Negro Women and Their Jobs.* Leaflet no. 19. Washington, DC: GPO, 1954. 10p. L13.11:19. Overview of work characteristics of black women provides information on the age and educational attainment of black women, 1950 and 1940, unemployment, marital status, labor force participation and child care problems. Also provides data on earnings, family income, and fields of work.

156. U.S. Women's Bureau. *New Teachers for the Nation.* Washington, DC: The Bureau, 1954. 4p. L13.2:T22/3. Describes the recommendations of the Committee on New Teachers for the Nation's Classrooms on ways to alleviate the teacher shortage by tapping the resource of mature women who have been housewives but who hold bachelors degrees.

157. U.S. Dept. of Labor. Office of the Secretary. *Women's Affairs.* General Order 80. Washington, DC: The Dept., 1955. 2p. L1.18:80. General order establishes the position of Assistant to the Secretary for Women's Affairs to coordinate program development and policy of the Labor Department with respect to services for women wage earners. Enumerates the responsibilities of the position.

158. U.S. Women's Bureau. *Conference on the Effective Use of Womanpower, March 10-11, 1955, Shortage Occupations; New Opportunities for Women.* by Dr. Irving H. Siegel. Washington, DC: The Bureau, 1955. 3p. L13.2:C76/2/955-5. Summary of address by Dr. Irving H. Siegel of the Council of Economic Advisors outlines favorable factors for women's employment outlook in "humanitarian occupations", and lists fields with expanding opportunities for women.

159. U.S. Women's Bureau. *Conference on the Effective Use of Womanpower, March 10-11, 1955, Welcome.* by Alice K. Leopold. Washington, DC: The Bureau, 1955. 5p. L13.2:C76/2/955-5. Welcoming speech for the Conference on the Effective Use of Womanpower talks about discarding the attitude that a woman's place is in the home. Noting the fact that most women work for economic reasons, Leopold urges the participants to plan for the effective use of women's abilities.

160. U.S. Women's Bureau. *The Effective Use of Womanpower: Report of the Conference, March 10 and 11, 1955.* Bulletin no. 257. Washington, DC: GPO, 1955. 113p. L13.3:257. Transcripts of panel discussions on working women highlight occupational opportunities for women and the attitudes of working women, particularly career oriented women.

161. U.S. Women's Bureau. *New Teachers for the Nation's Children, an Idea for Community Action.* Leaflet no. 23. Washington, DC: GPO, 1955. 10p. L13.11:23. Basics for local communities on recruiting mature liberal arts graduates for teacher training in response to the teacher shortage.

162. U.S. Women's Bureau. *Bibliography on Employment Problems of Older Women: Hiring Restrictions, Psychological Barriers, and Work Performance.* Washington, DC: GPO, 1956. 89p. L13.2:Ol1/5/956. Bibliography lists books, articles, and government publications on hiring restrictions for older women and the reasons for them, the psychological barriers of older workers and potential employers, and the work performance of mature workers. Earlier edition published in 1954.

163. U.S. Women's Bureau. *Employment after College: Report on Women Graduates Class of 1955.* by Vocational Guidance Association, Women's Section. Washington, DC: GPO, 1956. 33p. L13.2:Em7/8. Reports the findings of a survey of employment characteristics of women graduating from college in 1955. Some of the factors studied include number in the labor force, number continuing education beyond the B.A., majors and fields of work, relation of college education to first job, and salary. Tables provide data on age and marital status, employment or school status, employment or school status of married women graduates and their husbands, undergraduate major by employment or school status, type of work, method of finding employment, occupation by undergraduate major, type of work and annual salary, undergraduate major and annual salary, and future employment plans.

164. U.S. Women's Bureau. *Employment of Women College Graduates, Class of 1955, What They Were Doing in Early 1956.* Leaflet no. 26. Washington, DC: GPO, 1956. 6p. leaflet. L13.11:26. Summary of *Employment After College: Report on Women Graduates, Class of 1955* (163).

165. U.S. Women's Bureau. *An Idea in Action: New Teachers for the Nation's Children.* Pamphlet no. 2. Washington, DC: GPO, 1956. 37p. L13.19:2. Describes programs for recruiting and preparing mature college graduates for teaching in response to a shortage of teachers. Charts provide information on individual programs including minimum qualifications for entrance and the nature of the program.

166. U.S. Bureau of Labor Statistics. *Tables of Working Life for Women, 1950.* Bulletin no. 1204. Washington, DC: GPO, 1957. 33p. L2.3:1204. Statistical analysis of worklife patterns for women looks at work life expectancy and changes in patterns of working life between 1940 and 1950. Includes data on female labor force participation by marital status and presence of children; average remaining lifetime and average number of years of work remaining by marital status; and annual accessions and separations of the female labor force by factors of age, childbirth, loss of husband, marriage, and death.

167. U.S. Women's Bureau. *Employment of Older Women, an Annotated Bibliography: Hiring Restrictions, Psychological Barriers, and Work Performance.* Washington, DC: GPO, 1957. 83p. L13.2:Ol1/5/957. Bibliography lists books, articles, and government publications on hiring restrictions for older women and the reasons for them, the psychological barriers of older workers and potential employers, and the work performance of mature workers. Provides lengthy summaries of each entry and a detailed subject index. Earlier edition published in 1954, and in 1956 under a different title (162).

168. U.S. Women's Bureau. *Role of the Mature Woman in the Economy, Address by Mrs. Alice K. Leopold, Assistant to Secretary of Labor for Women's Affairs, before the Westchester County Federation of Women's Clubs, Bronxville, N.Y., Oct. 25, 1957.* Washington, DC: The Bureau, 1957. 8p. L13.12:L55/4. The overall interest of the

administration in utilizing the skills of older workers is described through the example of the Earning Opportunity Forums for mature women. The purpose of the forums, to make local communities aware of the pool of available older workers and to acquaint older women with employment and training options, is highlighted.

169. U.S. Bureau of Labor Statistics. *Number of Working Couples Reaches Record 10.8 Million.* Washington, DC: The Bureau, 1958. 2p. L2.2:C83/2. Summary of Census figures on dual income families reviews the factors of husband's employment and income, women's education, and presence of children as they relate to the likelihood a woman will work.

170. U.S. Employment Security Bureau. *New Horizons for Women, Speech by Roberta Church, Minority Groups Consultant, U.S. Department of Labor, Bureau of Employment Security, Washington, D.C., October 11, 1958, Twenty-Fourth National Convention of the National Association of Negro Business and Professional Women's Clubs, Newark, New Jersey.* Washington, DC: The Bureau, 1958. 20p. L7.33:C47/2. Topics addressed in this speech include the growing demand for skilled labor, the continued entry of women in the labor force, and the need for women to get the education and training to expand their employment opportunities. Employment and occupational distribution of non-white women is reviewed as are general trends in the age and marital status of all women workers. Midway through the speech the focus shifts to the ideal of women as instigators of social change, and urges women and women's organizations to work for world peace and the maintenance of high moral principles in the community.

171. U.S. Women's Bureau. *Additional Programs That Prepare Qualified Mature Women College Graduates to Meet State Certification Requirements for Teaching.* Washington, DC: The Bureau, 1958. 3p. L13.2:T22/4/958. Supplement to Women's Bureau Pamphlet no. 2 (165). Later edition issued July 1958.

172. U.S. Women's Bureau. *College Women Go to Work: Report on Women Graduates, Class of 1956.* Bulletin no. 264. Washington, DC: GPO, 1958. 41p. L13.3:264. Statistical profile of the work experience of women who graduated from college in June 1956 looks at their employment status and salary in 1956-57. Areas analyzed with supporting statistics include age and marital status, relation of undergraduate major to employment and occupation, salary and occupation, salary and undergraduate major, and future employment plans. Some comparison is made to 1955 graduates.

173. U.S. Women's Bureau. *Job-Finding Techniques for the College Woman.* Leaflet no. 27, rev. Washington, DC: GPO, 1958. 9p. leaflet. L13.11:27/2. Earlier edition published in 1956.

174. U.S. Women's Bureau. *Suggestions to Employers...in Regard to Hiring Older Women.* Leaflet no. 12, rev. Washington, DC: GPO, 1958. 8p leaflet. L13.11:12/3. Earlier editions published in 1951 and 1954.

175. U.S. Women's Bureau. *Young Women of the Year: A Report on the Class of 1956...Their Employment after College.* Leaflet no. 30. Washington, DC: GPO, 1958. 7p. leaflet. L13.11:30. Reprinted in late 1958.

176. U.S. Women's Bureau. *First Jobs of College Women: Report of Women Graduates, Class of 1957.* by National Vocational Guidance Association. Women's Section. Bulletin no. 268. Washington, DC: GPO, 1959. 44p. L13.3:268. See *College Women Go to Work: Report on Women Graduates, Class of 1956* (172).

177. U.S. Women's Bureau. *From College to Work: Job Experiences of Women College Graduates, Classes of '55, '56, '57.* Leaflet no. 31. Washington, DC: GPO, 1959. 7p. leaflet. L13.11:31.

178. U.S. Women's Bureau. *What It Takes to Be Tops as a Woman Executive, Outline of Address by Alice K. Leopold, Assistant to Secretary of Labor, before the Great Lakes Regional Conference, American Women in Radio and Television, Detroit, Michigan, January 25, 1959.* by Alice K. Leopold. Washington, DC: The Bureau, 1959. 7p. L13.12:L55/6. Outlines the characteristics of a mythical successful business woman and highlights some of the barriers to achieving promotion of women to top executive positions. The outline ends with Leopold's criteria for whether or not she has been successful.

179. U.S. Women's Bureau. *Womanpower in a Changing World, Address of Mrs. Alice K. Leopold, Assistant to the Secretary of Labor, before the Purdue University Faculty, Townspeople and Students, Loeb Playhouse, Lafayette, Indiana, Mar. 3, 1959.* Washington, DC: The Bureau, 1959. 12p. L13.12:L55/7. The advancement of women in education and wider occupational choice are highlighted with a tendency to encourage the entry of women into scientific fields. Also suggests ways to support the movement of women into leadership positions.

180. U.S. Children's Bureau. *Children of Working Mothers.* by Elizabeth Herzog. Publication no. 382. Washington, DC: GPO, 1960. 38p. FS14.111:382. Why mothers work? which mothers work? and who cares for the children? are among the questions answered by this concise review of gainfully employed women with children under eighteen. One of the more interesting topics of discussion is the possible effect of working mothers on the sex role identification of children and on marital relations. Provides statistics on labor force status of married women by age of children and presence of husband, 1948 and 1958. Other editions issued in 1964 and 1968.

181. U.S. Dept of Labor. *Address by Under Secretary of Labor James T. O'Connell before New Jersey State Federation of Women's Clubs, Trenton, N.J., April 11, 1960.* by James T. O'Connell. Washington, DC: The Dept., 1960. 8p. L1.13:Oc5/19. Speech highlight the Department of Labor's areas of concern which relate to the Federation of Women's Clubs legislative program. In discussing trends in employment of women, O'Connell stresses childbearing as the most important role for women, but also notes that women will work and that much needs to done to widen vocational opportunities for girls and employment opportunities for mature women.

182. U.S. Dept. of Labor. *America's Womanpower Future, Address by Undersecretary of Labor James T. O'Connell before the Opening Session of Conference Commemorating 40th Anniversary of Women's Bureau, Washington, D.C., June 2, 1960.* by James T. O'Connell. Washington, DC: The Dept., 1960. 8p. L1.13:Oc5/22. Speech on the role of women in meeting the nation's manpower needs places emphasis on the need to maintain the idea that childrearing and homemaking is the highest calling of the female sex. Notes that younger women and mature women will be increasing in the labor force and that more attention must be paid to vocational counseling for women and to ending age and sex discrimination in employment.

183. U.S. Women's Bureau. *Highlights, 1920-1960.* Washington, DC: The Bureau, 1960. 10p. L13.2:H53. Charts illustrate changes in employment, occupations, and education of women between 1920 when the Women's Bureau was established and 1960. Age, marital status, occupation, industry, and educational attainment are some of the characteristics of women workers illustrated.

184. U.S. Women's Bureau. *Part-Time Employment for Women.* Bulletin no. 273. Washington, DC: GPO, 1960. 53p. L13.3:273. Study of the part-time employment of women and of the characteristics of part-time employment in the United States. Personal characteristics of part-time workers detailed include age, marital status, children, and religion; and reasons for part-time work are analyzed by age, marital status, and occupation. Data on number of women part-time workers and percent distribution is provided by industry and occupation. Also includes statistics on the number of persons at work by full-time and part-time status, and by age and sex, 1955, with projections for 1960-75.

185. U.S. Women's Bureau. *Today's Woman in Tomorrow's World: Report of a Conference Commemorating the 40th Anniversary of the Women's Bureau.* Bulletin no. 276. Washington, DC: GPO, 1960. 138p. L13.3:276. Proceedings of a conference presents the text of speeches on topics such as America's womanpower future, woman's role in a changing society, achievements and goals of American women, and American women in international programs. Appendix includes a statistical summary in graphs of women's employment, 1920 to 1960, a list of Women's Bureau publications, and a list of major international publications on the status of women.

186. U.S. Women's Bureau. *Address by Esther Peterson, Assistant to the Secretary of Labor and Director of the Women's Bureau, before the National Federation of Business and Professional Women's Clubs, Inc. Annual Convention, Chicago, Ill., July 26, 1961.* by Esther Peterson. Washington, DC: The Bureau, 1961. 18p. L13.12:P44. The legislative program of the National Federation of Business and Professional Women's Clubs is examined noting the areas of agreement with Women's Bureau policy and legal and social changes related to women's equality in the work place. Difference of opinion between the FBPW and the Women's Bureau on the Equal Rights Amendment are expressed with Peterson voicing the opinion that the ERA was not the way to address women's equity in the work place.

187. U.S. Small Business Administration. *Managing Women Employees in Small Business.* Washington, DC: The Administration, 1962. 4p. SBA1.14:75. Discusses the emotional differences between male and female workers and provides tips on how employers can create the right climate for women employees.

188. U.S. Women's Bureau. *Address by Esther Peterson, Assistant Secretary of Labor and Director of the Women's Bureau, before the American Nurses Association's 43d Biennial Convention, Detroit, Michigan, May 15, 1962.* Washington, DC: The Bureau, 1962. 16p. L13.12:P44/2. The need to address questions of wages and working conditions if young women are to be attracted to the nursing profession forms the focal point of this speech which also provides background on women's employment trends. General issues of working women expounded upon include tax treatment of married women's employment expenses, educational needs of women, and general employment outlook for women.

189. U.S. Women's Bureau. *Bibliography on American Women Workers.* Washington, DC: The Bureau, 1962. 20p. L13.18/2:W84. List of books, government publications and journal articles on American women as workers and citizens is divided into categories of general works, employment, education and training, occupations, family status and responsibilities, industrial health and safety, historical developments, unions, wages, and women as citizens. Publications listed are primarily from 1940 through 1960, and a few non-U.S. publications are included.

190. U.S. Women's Bureau. *Changing Status of Women, Report of Chicago Regional Conference Held at Roosevelt University, Chicago, Illinois, May 18-19, 1962.* Washington, DC: The Bureau, 1962? 48p. L13.2:St2/6. The changing status of women

as workers is the primary focus of this report of a meeting of women's service and labor organization representatives from Illinois, Indiana, and Wisconsin. Summaries of speakers comments describe the issues of women in the labor force emphasizing equal job opportunities, the needs of mature women, and day care services. The effect of automation on women workers, and the provisions of the Manpower Development and Training Act which may help or discriminate against women, are noted. The problem of unemployment among women workers is also addressed as is the status of women in labor unions, particularly in the UAW and the Airline Stewards and Stewardesses International Association.

191. U.S. Women's Bureau. *Problems and Prospects of Working Women, Report of a Western Regional Conference Held at University of Southern California, Los Angeles, Calif., Sept. 8 and 9, 1961.* Washington, DC: The Bureau, 1962. 29p. L13.2:W84/3. Overview conference on the status and problems of working women highlights low wages and the need for day care, as well as the need for women to further their education and to accept more technical jobs. Along that same line, the effect of technology on women's employment is also reviewed. Career guidance, retraining of older women workers, equal pay, minimum wage, and protective labor laws are also covered. Sections on hours laws reflect the growing divisiveness among women's groups on the issues of protective labor laws and women's right to work.

192. U.S. Women's Bureau. *Report of Conference on Employment Problems of Working Women, Held at Kellogg Center, Michigan State University, East Lansing, Michigan, September 30, 1961.* Washington, DC: GPO, 1962. 23p. L13.2:Em7/9. Summarizes conference sessions which discussed the role of women in the work force and ways of helping working women through education and legislation.

193. U.S. Women's Bureau. *Why Do Mothers Work?* Washington, DC: The Bureau, 1962. 6p. L13.2:M85. Non-judgmental look at why mothers work at paid employment notes the effect on their children. Reports basic statistics on the income level of families with working mothers and addresses the question of whether children of working mothers are more likely to have problems. Revised edition published in 1963.

194. U.S. Apprenticeships and Training Bureau. *Changing Status of Women, Remarks by Margaret M. Troxell, Chief Information Division, Bureau of Apprenticeship and Training, at Public Affairs Banquet, Fredericksburg Business and Professional Women's Club, Fredericksburg, Va., Jan. 14, 1963.* by Margaret M. Troxell. Washington, DC: The Bureau, 1963. 12p. L23.8:T75. Reviews the progress of women's access to occupations and the economic reasons that women work. The directives to the President's Commission on the Status of Women are reviewed and the importance of the proposed Equal Pay Act is covered.

195. U.S. Dept. of Labor. *Address by Assistant Secretary of Labor Esther Peterson at Seminar on Educational Public Policy, Harvard University, Cambridge, Mass., April 9, 1963.* by Esther Peterson. Washington, DC: The Dept., 1963. 10p. L1.13:P44/3. General overview of the manpower situation also focuses on the role of women in the work force and the growing tendency of older women to work. The need to educate young women for careers, not just jobs, is emphasized, and some of the occupations which will need the skills of women are noted.

196. U.S. Dept. of Labor. *Address by Esther Peterson, Assistant Secretary of Labor [at] Smith College, Northampton, Mass., Feb. 23, 1963.* by Esther Peterson. Washington, DC: The Dept., 1963. 20p. L1.13:P44/2. The myths of the American woman and her changing role in society are the focus of this speech emphasizing the growing role of women in the labor force. The "woman's place is in the home" mentality is berated and the need to value the

contribution of women as volunteers when they enter the job market is emphasized. Peterson talks about the confusion of young women who are raised to compete intellectually with men but also taught to assess their worth in relation to their ability to attract a successful man. Also discusses equal pay for equal work and the need to teach women to demand an equal place in the work force. Other "myths" addressed are the idea that women work for "pin money," that women are only temporary workers, and that men will not work for a woman boss. Finally, Peterson stresses the need for higher education to adapt to the needs of women returning to the labor force and who need to finish or update their degrees.

197. U.S. Dept. of Labor. *Opportunities and Trends in Employment of Women in Business, Summary of Address by Assistant Secretary of Labor Mrs. Esther Peterson, at the International Management Congress, New York, New York, September 19, 1963.* Washington, DC: The Dept., 1963. 3p. L1.13:P44/6. Key themes of this speech are women's contribution to the economy, the need for trained women to meet manpower needs, and the appointment of the President's Commission on the Status of Women to identify barriers to women's full participation in all aspects of America's society.

198. U.S. President's Commission on the Status of Women. *Report of the Committee on Private Employment to President's Commission on the Status of Women.* Washington, DC: GPO, 1963. 55p. Pr35.8:W84/Em7/2. Presents recommendations of the committee for government action relating to employment discrimination, equal pay, and part-time employment. One of the recommendations is for an executive order establishing a President's Committee on Merit Employment of Women to oversee compliance with provisions setting federal policy on equal opportunity for women. Appendix F summarizes barriers to employment, advancement, and equal pay for women workers and Appendix G profiles the present status of women in the work force in the areas of labor force participation, income, and absenteeism.

199. U.S. Women's Bureau. *Everybody's Talking about Trained Workers for the Future.* Washington, DC: GPO, 1963. 7p. leaflet. L13.2:W89/8/963. Earlier edition published in 1960.

200. U.S. Women's Bureau. *Policies of National Governments on Employing Women.* Women in the World Today International Report 3. Washington, DC: GPO, 1963. 20p. L13.23:3. Brief summary, by country, of government policies on employing women notes instances where customs keep women from obtaining positions. Also notes governmental efforts to change patterns and to bring women into civil service positions above the clerical level.

201. U.S. Women's Bureau. *Shortage or Surplus? An Assessment of Boston Womanpower in Industry, Government, and Research.* Washington, DC: GPO, 1963? 70p. L13.2:W84/45. Report of a conference on women workers in Boston examines the Boston labor supply, counseling needs of women, secretarial occupations, part-time workers, and the problem of day care.

202. U.S. Women's Bureau. *Women and Girls in Labor Market Today and Tomorrow, Presented by Jean A. Welis, Acting Chief, Division of Research and Manpower Program Development, at Annual Forum of National Conference on Social Welfare, Cleveland, Ohio, May 21, 1963.* by Jean A. Welis. Washington, DC: The Bureau, 1963. 13p. L13.12:W46. General discussion of labor force trends of women stresses the likelihood for most women of paid employment. The effect of automation on women's employment opportunities is reviewed, playing down the theory that women are fired due to automation but noting the changes in types of jobs available. In closing, Welis notes the need for women to obtain the education and training to fill future demands for skilled workers.

203. U.S. Committee on New Teachers for the Nation's Classrooms. *Highlights of Three Accelerated Teacher-Training Programs for Mature College Graduates.* Washington, DC: The Women's Bureau, 1964. 5p. No SuDoc number. Describes accelerated teacher training programs in Michigan, California and Ohio.

204. U.S. Women's Bureau. *Address by Mary Dublin Keyserling, Director of Women's Bureau, Dept. of Labor, Address at United Packing House, Food, and Allied Workers Convention, Kansas City, Mo., May 25, 1964.* by Mary Dublin Keyserling. Washington, DC: The Bureau, 1964. 13p. L13.12:K52. Toward the end of this speech on poverty, labor, and federal action, the particular problems of women workers, minimum wage, unemployment, and wage discrimination are discussed.

205. U.S. Women's Bureau. *Address by Mrs. Agnes M. Douty, Chief, Field Division, Women's Bureau, U.S. Department of Labor, at Portland State College Conference on Education and Job Opportunities for Women Returning to the Labor Market, October 24, 1964.* Washington, DC: The Bureau, 1964. 5p. L13.12:D74. The trend of women returning to the labor market after the childrearing years, and the need for these women to find more than a low-skill dead-end job, is the theme of this speech. The need for higher education of women and a versatile education which allows future employment flexibility are key points.

206. U.S. Women's Bureau. *Negro Women Workers in 1960.* Bulletin no. 287. Washington, DC: GPO, 1964. 55p. L13.3:287. Examination of the status of black women workers in 1960 with some comparisons to 1940 and 1950. Reports on industries which employ black women, their occupations and earnings, and labor force status. Also examines data on personal and family characteristics of black women workers. Provides statistics on employed women by race and state, by age and race, marital status and race; educational attainment by race and state; and median income and earnings by state and race. Statistics on black women workers by occupation and region, occupation and state, and industry are furnished.

207. U.S. Women's Bureau. *New Opportunities and New Responsibilities for Women, Convocation Address, Mary Dublin Keyserling, Director, Women's Bureau, U.S. Department of Labor, [at] Sweet Briar College, Sweet Briar, Virginia, Sept. 17, 1964.* by Mary Dublin Keyserling. Washington, DC: The Bureau, 1964. 16p. L13.12:K52/5. Broad overview of the status of women and their educational attainment, employment, and occupations discusses historical trends and the increasing likelihood that a woman will enter the labor force. The need for and organization of the President's Commission on the Status of Women is reviewed citing its work for the Equal Pay Act and for the improvement of women's position in the federal civil service. The appointment of state commissions on the status of women is viewed as another step forward as they encourage interest in women's issues. Finally, Keyserling urges the graduates to use their education to contribute to the war on poverty.

208. U.S. Women's Bureau. *Report of a Conference on Unions and the Changing Status of Women Workers Held at Rutgers - the State University, New Brunswick, New Jersey, October 17, 1964.* Washington, DC: The Bureau, 1964? 29p. L13.2:Un3/2. Conference workshops focus on the concerns of working woman particularly as they relate to women's status and involvement in unions. Most of the report is given over to a general summary of the findings of the President's Commission on the Status of Women.

209. U.S. Women's Bureau. *Report of Conference on Women in the Upper Peninsula Economy.* Washington, DC: GPO, 1964? 21p. L13.2:W84/47. Conference speakers highlight the role of women in the Upper Peninsula economy, the problem of low wages

and unskilled jobs, labor legislation and minimum wage, and the problem of child care. Also touched on is the need for vocational training programs for women.

210. U.S. Farmer Cooperative Service. *Directors of Cooperatives and Their Wives - Good Member Relations Team.* Education Circular no. 25. Washington, DC: The Service, 1965. 11p. A89.4/2:25. The theme of this booklet is ways the wife of a cooperative director can help with the public relations aspects of the cooperative. Suggestions include helping with telephone calls, leading family discussions, acting as a welcoming committee at cooperative meetings, and leading the activities of women's auxiliaries.

211. U.S. Women's Bureau. *Address by Mary Dublin Keyserling, Director, Women's Bureau, U.S. Department of Labor, before the YWCA National Affairs Committee Conference, Washington, D.C., May 13, 1965.* Washington, DC: The Bureau, 1965. 13p. L13.12:K52/10. Overview of poverty conditions in the United States notes at intervals the particular place of women among the ranks of the poor. Cites ways to address the problem of disadvantaged women and girls through Job Corps, minimum wage legislation, equal pay and anti-employment discrimination laws, and the role of state commissions on the status of women.

212. U.S. Women's Bureau. *Employment Opportunities for Women, Talk by Mary Dublin Keyserling, Director, Women's Bureau, Department of Labor, at 43rd Annual Agricultural Outlook Conference, Family Living Sessions, Washington, D.C., Nov. 16, 1965.* Washington, DC: The Bureau, 1965. 13p. L13.12:K52/13. Overview of the labor force participation patterns of women stresses the marked increase of older women in the work force and the role of education in determining attachment to the labor force. Analyzes the occupations and earnings of women workers and the need to improve women's economic opportunity. Reviews the outlook for service industries and professions such as nursing, teaching, and clerical and household employment. In closing, Keyserling applauds expanded counseling and job training programs for women.

213. U.S. Women's Bureau. *Facing Facts about Women's Lives Today, Address by Mary Dublin Keyserling, Director, Women's Bureau, U.S. Department of Labor, February 26, 1965, Midwest Regional Pilot Conference on New Approaches to Counseling Girls in the 1960's, Chicago, Illinois.* Washington, DC: The Bureau, 1965. 14p. L13.12:K52/7. Speech focuses on full utilization of the nation's womenpower by encouraging the education of, and wider occupational choices for, young women. The reality of the changing pattern of women's lives, which increasingly includes employment after childrearing, and the factors influencing the employment of older women are described. Stresses the need to address through counseling the underrutilization of women inherent in this concentration in low-skill, low-paying jobs. Enumerates federal legislation enacted to address women's employment equity issues.

214. U.S. Women's Bureau. *International Cooperation and the Economic Advancement of Women, Remarks by Mary Dublin Keyserling, Director, Women's Bureau, Department of Labor, White House Conference on International Cooperation Year, Panel Session on Women, Washington, D.C. Nov. 30, 1965.* by Mary Dublin Keyserling. Washington, DC: The Bureau, 1965. 4p. L13.12:K52/15. Reviews the ILO conventions relating to women workers and maternity, equal pay, work and family responsibilities, and sex discrimination in employment. Summarizes the recommendations of ILO conferences on women's employment problems.

215. U.S. Women's Bureau. *Negro Woman at Work, Gains and Address by Mary Dublin Keyserling, Director, Women's Bureau, Department of Labor, [at] Conference on Negro Women in USA, New Roles in Family and Community Life, Washington, D.C., Nov. 11, 1965.* Washington, DC: The Bureau, 1965. 12p. L13.12:K52/14. General employment

trends for nonwhite women, 93% of whom are black, are compared to trends for white women in the United States. Discusses the theory that the entry of young black women into the labor force is a major causes of family breakdown and stresses the need for black women to contribute to family support. Occupational advances of black women since 1940 are chronicled and the problem of the wage gap between white women and black women, and between all women and white men, is discussed. Explores the contribution of education to the improved status of black women, and rejects the concern that black women have become better educated then black men.

216. U.S. Women's Bureau. *What about Women's Absenteeism and Labor Turnover?* Washington, DC: The Bureau, 1965. 7p. L13.2:Ab8/3. Report and analysis of sex differences in absenteeism and labor turnover looks at factors other than sex, such as age and martial status, which are better predictors of absenteeism and turnover. Also looks at differences in the duration of absences from work by sex. Information is reported from several work force studies which are referenced.

217. U.S. Civil Service Commission. *Unless We Begin Now.* by John W. Macy, Jr. Washington, DC: GPO, 1966. 12p. CS1.60:M25/3. Reprint from *Vital Speeches of the Day*, September 1, 1966, of a speech by John W. Macy, Jr., Chairman of the Civil Service Commission, before the Annual Convention of the National Federation of Business and Professional Women's Clubs, July 25, 1966, describes the federal effort to bring women to full equality in the work force with special reference to the civil service. Also talks about the need to encourage women to seek training and education for professional positions and the need to change occupational stereotypes and societal attitudes towards working women.

218. U.S. Women's Bureau. *The American Woman at Work, New Challenges and New Responsibilities, Address by Mary Dublin Keyserling, Director of Women's Bureau, Department of Labor, May 3, 1966, National Conference on Status of Women in Employment, Melbourne, Australia.* Washington, DC: The Bureau, 1966. 15p. L13.12:K52/19. Speech stresses the changing patterns of women's participation in the work force and notes the significant increase in the employment of older women and married women. The effect of education on women's attachment to the labor force is discussed as is the need to fully utilize the skills women have to offer. Progress in the U.S. in ensuring women a legal right to equal pay and equal employment opportunity are noted.

219. U.S. Women's Bureau. *Fact Sheet on Nonwhite Women Workers.* Washington, DC: The Bureau, 1966. 2p. L13.2:N73/2/966-2. Summary of labor force status, occupation, income, and percentage of working mothers for nonwhite women provides comparison to white women. Earlier editions published in August 1965, November 1965, and April 1966.

220. U.S. Women's Bureau. *Recent Federal Employment Policy Developments, New Progress for Women, Address by Mary Dublin Keyserling, Director of Women's Bureau, Department of Labor, Annual Labor Management Conference, Northeastern University, Boston, Mass., Feb. 5, 1966.* Washington, D.C. : The Bureau, 1966. 15p. L13.12:K52/17. Speech summarizes the information from the Commission on the Status of Women report *American Women* (vol.1 - 58) on women in the work force including personal characteristics, occupation, and income. Federal actions to reduce women's employment barriers are examined including Civil Service directives and the Equal Pay Act of 1963, and administration interpretation of the act's provisions in sample situations. Finally Title VII of the Civil Rights Act of 1964 and its implications for women workers, and EEOC rulings on sex discrimination issues, are reviewed.

221. U.S. Women's Bureau. *Women's Part-Time and Part-Year Employment Patterns in the United States*. Washington, DC: The Bureau, 1966. 19p. L13.2:Em7/11. Analysis and statistics on part-time employment highlights women's work experience in 1963 by age, marital status, major occupational group, race, and age of children. Also reports on the employment of mothers by the presence or absence of the husband.

222. U.S. Agricultural Research Service. *Job-Related Expenditures and Management Practices of Gainfully Employed Wives in North Carolina*. by Emma G. Holms. Washington, DC: GPO, 1967. 39p. A1.87:34. Study of the job related expenditures of urban and rural wives and of how wives earnings are spent also focused on family money management practices. Expenditures are summarized for clothing, personal care, and paid housekeeping services.

223. U.S. Congress. House. *Letter from the Assistant Secretary for Congressional Relations, Department of State, Transmitting the Text of ILO Recommendation No. 123 Concerning the Employment of Women with Family Responsibilities*. H. Doc. 45, 90th Cong., 1st sess., 1967. 5p. Serial 12765-1. Various government agencies and actions related to the problems of women with family responsibilities who work outside the home are reviewed in the introduction to the ILO Recommendation no. 123. The recommendation supports the concept of women working outside the home and recommends government action to ensure the ability of women with families to enter or remain in the work force. Day care, vocational guidance, and support for re-entry women are specifically mentioned.

224. U.S. Dept. of Labor. Office of Manpower Policy, Evaluation and Research. *Seminar on Manpower Policy and Program: Womanpower Policies for the 1970's*. by Wilbur J. Cohen. Washington, DC: GPO, 1967. 41p. L1.2:M31/44. Keynote speech by Wilbur J. Cohen stresses changing patterns in the demand for workers and how women will fit into that pattern. Stress is placed on opportunities for women in part-time employment and in service fields, particularly health fields, and on educational opportunities. The question and answer period which followed raised issues of day care tax credits, women and men in nontraditional fields, and college and medical school admission practices. Also debated is the issue of two-earner families in times of layoffs and the wife as "secondary" earner.

225. U.S. Women's Bureau. *Bibliography Mature Women Workers*. Washington, DC: The Bureau, 1967. 3p. L13.18/2:W84/2. Brief bibliography lists books, pamphlets, government publications, and journal articles published in the early 1960s on the employment of mature women.

226. U.S. Women's Bureau. *Exploding the Myths: A Report of a Conference on Expanding Employment Opportunities for Career Women*. Washington, DC: GPO, 1967. 67p. L13.2:Em7/12. Papers presented at a conference on employment opportunities for career women covers diverse topics such as women in society, career attitude differences between men and women, and prejudice encountered by working women. A panel discussion explored emerging opportunities for career women.

227. U.S. Women's Bureau. *Negro Women in the United States, New Roles, New Challenges*. by Mary Dublin Keyserling. Washington, DC: The Bureau, 1967. 11p. L13.12:K52/23/rev. Speech by Mary Dublin Keyserling, director of the Women's Bureau, at the National Association of Colored Women's Clubs Convention on July 27, 1966 in Oklahoma City, provides updated figures as of March 1967. The talk reviews the war on poverty and trends in the employment and earnings of nonwhite workers compared to white workers by sex. Trends in educational attainment of nonwhite women are also highlighted. Original speech published in 1966.

228. U.S. Women's Bureau. *Your Talents, Let's Not Waste Them, Address by Mary Dublin Keyserling, Director, Women's Bureau, Department of Labor, [at] a Back-to-Work*

Symposium for Women Who Want to Resume Their Careers, Sponsored by Stern Brothers and American Girl Service, June, 25 1967, New York City. by Mary Dublin Keyserling. Washington, DC: The Bureau, 1967. 8p. L13.12:K52/24. General review of the status of women in the labor force and the patterns of women's employment is followed by comments highlighting progress in employment opportunities for mature women and the remaining barriers to their employment.

229. U.S. Women's Bureau. *Where Will You Go When the Go-Go's Gone?* Washington, DC: The Bureau, 1967. 2p. L13.2:W57. Leaflet presents basic facts for teenage girls on women as wage earners.

230. U.S. Women's Bureau. *Fact Sheet on Women in Professional and Technical Positions.* Washington, DC: The Bureau, 1968. 5p. L13.2:P94/5/968. Fact sheet summarizes the number and percentage of women, and the employment outlook for women, in professional and technical positions with related information on degrees conferred to women. Earlier edition published in 1966.

231. U.S. Women's Bureau. *Negro Women...In the Population and in the Labor Force.* Washington, DC: GPO, 1968. 41p. L13.2:N31/3/967. Report pulls together data from numerous sources to provide a statistical profile of the employment status of black women and their characteristics. Some of the areas covered are educational attainment, marital status, poverty status of family by type, working mothers and child care arrangements, and wage or salary income. Also provides data on occupational groups and on education and employment status. Earlier edition published in 1966.

232. U.S. Women's Bureau. *Part-Time Employment of Women.* Washington, DC: The Bureau, 1968. 5p. L13.2:Em7/13. Speculates on why so many women are employed only part-time and presents data on their occupations and earnings. The opportunities for part-time employment and the obstacles to part-time work are discussed, particularly in the area of federal employment.

233. U.S. Women's Bureau. *Women in Poverty: Jobs and the Need for Jobs.* Washington, DC: The Bureau, 1968. 5p. L13.2:P86/3/968. Profile of women in poverty provides data on family income by type of family, the types of jobs held by employed women in poverty, and the situation of unemployed women. The problems of school dropouts and women who live in slums areas are briefly reviewed. Also addresses the question of minimum wage and the exemption of household employees from the law. Earlier edition published in 1967.

234. U.S. Women's Bureau. *Working Wives: Their Contribution to Family Income.* Washington, DC: GPO, 1968. 8p. L13.2:W79/968. Review of the statistics on working wives indicates their effect on family income. Provides data on the number and distribution of husband-wife families by income and labor force participation of wives, and earnings of married women with husband present as a percentage of family income. Earlier edition published in 1967.

235. U.S. Dept. of Health, Education and Welfare. Social and Rehabilitation Service. *Impediments to Employment; Reanalysis of Household Interview Studies.* Washington, DC: Office of Research and Demonstration, 1969. 115p. HE17.2:Em7. Results of a study of impediments to employment based on household interviews with dependent families highlight the multiple barriers faced by families headed by women. Characteristics of households reported include size, composition, sex of family head, income, physical health, mental health, and if family is functioning. Also examines marital status, race, and education of female heads of household by dependency status.

236. U.S. Dept. of Labor. Office of Information. *Remarks of Secretary of Labor George P. Schultz, at the Conference of State Commission on Status of Women Dinner, Washington, D.C., May 6, 1969.* Washington, DC: The Dept., 1969. 5p. L1.13:Sh9/4. Short speech communicates the Department of Labor's commitment to job opportunities for women and specifically addresses strengthening Job Corps and Office of Federal Contract Compliance Programs.

237. U.S. Social Security Administration. Office of Research and Statistics. *Some Facts about Employment of Widowed Mothers.* by Lenore E. Bixby and Judith S. Bretz. Research and Statistics Note 1969, no. 15. Washington, DC: The Office, 1969. 20p. FS3.28/2:969/15. Examination of data on young widows under Social Security analyzes the relationship between age and number of children and the likelihood of the widowed mother's employment after child benefits cease.

238. U.S. Women's Bureau. *Facts about Women's Absenteeism and Labor Turnover.* Washington, DC: GPO, 1969. 9p. L13.2:Ab8/3/969. Analysis of existing studies of sex differences in absenteeism and labor turnover looks at factors beyond gender, such as age, which are better predictors of absenteeism or turnover.

239. U.S. Women's Bureau. *Job Horizons for Women and Girls in the District of Columbia.* Washington, DC: GPO, 1969. 57p. L13.2:W84/48. Report reviews a conference which concentrated on programs to meet the employment needs of disadvantaged women and girls in the District of Columbia. Address by Horace R. Holmes, D.C. Manpower Administrator, describes how current programs in the D.C. area are helping meet these needs. The recommendations of workshop sessions on counseling, training, support services, and employment practices and opportunities are summarized.

240. U.S. Dept. of Commerce. *Remarks by Maurice H. Stans, Secretary of Commerce before the National Alliance of Businesswomen, Washington, D.C., Sept. 15, 1970.* by Maurice H. Stans. Washington, DC: The Dept., 1970. 6p. C1.18:St2/46. Speech makes general observations about unemployment among women and on the need for private institutions and groups such as the National Alliance of Businesswomen to help train unskilled, unemployed women.

241. U.S. Women's Bureau. *American Women at the Crossroads, Keynote Address by Elizabeth Duncan Koontz, at the 50th Anniversary Conference of the Women's Bureau, Washington Hilton Hotel, Washington, D.C., June 12, 1970.* Washington, DC: The Bureau, 1970. 16p. L13.12:K83/2. Speech on working women covers the effects of male and female stereotypes, the problems and attitudes toward working mothers, and discrimination and opportunities in the work place.

242. U.S. Women's Bureau. *Automation and Women Workers.* by Jan A. Wells. Washington, DC: GPO, 1970. 13p. L13.2:Au8. Concise review summarizes available information on the effects of automation on women's employment opportunities. The main focus is on employment trends and occupational categories, although vocational training, hours of work, and safety and health are also touched on. Provides a brief list of selected readings.

243. U.S. Women's Bureau. *Job Finding Techniques for Mature Women.* Pamphlet no. 11. Washington, DC: GPO, 1970. 40p. L13.19:11. Information for mature women returning to the work force or seeking work for the first time includes job hunting tips and application guidelines. Provides a selected reading list and a list of government and professional agencies and organizations related to employment.

244. U.S. Congress. House. Committee on Ways and Means. *Tax Proposals Contained in the President's New Economic Policy, Part 3, Hearing.* 92d Cong., 1st sess., 15,16 Sept.

1971. 733-1065pp. Y4.W36:T19/52/pt.3. Although this hearing primarily focuses on capital investment and corporate taxes it includes statements on the need for an economic reform package which encourages corporations to consider the needs of women workers. Reprinted in the hearing record is *A Matter of Simple Justice* (Vol. I - 616), the report of the President's Task Force on Women's Rights and Responsibilities, and Women's Bureau Bulletin no. 296, *Day Care Services: Industry's Involvement* (3157).

245. U.S. Women's Bureau. *Guide to Conducting a Consultation on Women's Employment with Employers and Union Representatives.* Pamphlet no. 12. Washington, DC: GPO, 1971. 15p. L36.112:12. Outlines sessions conducted by the Women's Bureau to acquaint employers and unions in local areas with information about women's economic status and legislation prohibiting sex discrimination.

246. U.S. Council of Economic Advisors. *Women in the Economy, Remarks by Herbert Stein, Chairman, Council of Economic Advisors, before the Symposium on Women in Economy, San Francisco, Calif., September 21, 1972.* by Herbert Stein. Washington, DC: The Council, 1972. 14p. PrEx6.9:St3/6. Discusses the "economic revolution" for women and reviews the goals of equality and opportunity in the job market. The occupations of women and the wage gap are reviewed and Nixon administration actions to improve the status of women are highlighted. Also discussed is the recently announced Advisory Committee on the Economic Role of Women and some possible areas of inquiry for the committee such as manpower policy, vocational training, and media stereotypes.

247. U.S. Office of Education. ERIC Clearinghouse on Vocational and Technical Education. *Review and Synthesis of Research on Women in the World of Work.* by Mary Bach Kievit. Washington, DC: GPO, 1972. 96p. HE5.2:W84. Reviews research on the work patterns of women, their career development, barriers to employment opportunities, and maximizing opportunities. Literature covered includes journal articles and ERIC documents primarily from the mid-1960s to 1971.

248. U.S. Women's Bureau. *Facts on Women Workers of Minority Races.* Washington, DC: GPO, 1972. 10p. L36.102:M66. Summary data on women workers broken down by white and minority categories includes labor force participation by age and sex, unemployment rates by age and sex, marital status, women heads of poor families, percentage of women in the labor force by age of children and marital status, median years of school completed, employment status of high school dropouts by sex, major occupation groups of employed women, 1960 and 1971, and median wage by sex. Revised edition published in 1974.

249. U.S. Women's Bureau. *Who Are the Working Mothers?* Washington, DC: GPO, 1972. 9p. L36.110:37. [leaflet]

250. U.S. Congress. Senate. Committee on Labor and Public Welfare. Subcommittee on Children and Youth. *American Families: Trends and Pressures, 1973, Hearing.* 93d Cong., 1st sess., 24-26 Sept. 1973. 451p. Y4.L11/2:F21/6. Examination of the state of the American family focuses on growing trends toward female-headed families and the employment of women with pre-school aged children. Government policy on proposed requirements that mothers of children over 3 years of age work in order to receive welfare benefits is debated. The provision of quality day care is a major issue and theories on the psychological impact of working mothers on their children are discussed. Part-time employment is also briefly examined. The responsibility of the government for dependents of servicemen, even in the case of divorce, is reviewed. The effect of unemployment on the family and the alienation of the elderly are also topics covered.

251. U.S. Dept. of Labor. Office of Information. *Speech by Peter J. Brennan, Secretary of Labor, before the American Newspaper Women Club, Washington, D.C., September 12, 1973.* Washington, DC: The Office, 1973. 5p. L1.13:B75/17. Speech on opening opportunities for women in nontraditional fields describes Labor Department plans to widen opportunities.

252. U.S. Veterans Administration. Central Office Library. *Women in the Work Force: A Selected Book List.* Washington, DC: The Administration, 1974. 5p. VA1.22:14-4. Short list of books published in the 1960s and 1970s on women and employment also cites some general books and reports on the status of women in the United States.

253. U.S. Women's Bureau. *Facts on Women Workers of Minority Races.* Washington, DC: GPO, 1974. 9p. L36.102:M66/974. Basic information and statistics on minority women in the labor force covers labor force participation numbers and percentage; age; unemployment by age, race, and sex; work experience of low income women heads of families by race; percentage of mothers in the labor force by race, age of children, and marital status; educational attainment by sex and race; employment status of high school dropouts by sex and race; occupational groups of women by race; and median wage or salary by race and sex.

254. U.S. Women's Bureau. *The Myth and the Reality.* Washington, DC: GPO, 1974. 3p. L36.102:M99/974. Point-by-point examination of misconceptions regarding the role of women in the labor force highlights perceptions that women only work for pocket money, that they have higher absenteeism, that children of working mothers are more likely to be juvenile delinquents, and that men won't work for women supervisors. Earlier edition published in 1971.

255. U.S. Women's Bureau. *Nontraditional Occupations for Women of the Hemisphere: The U.S. Experience.* Washington, DC: The Bureau, 1974. 59p. L36.102:Oc1. Proceedings of a conference sponsored by the U.S. Delegate to the Inter-American Commission of Women and the Women's Bureau examines the status of women in nontraditional occupations in the United States. Specific presentations looked at the role of women in appointive government positions, policies, higher education and administration, law, entrepreneurship, and the construction industry. The second section of the conference looked at the role of government, non-governmental organizations, and volunteer associations in promoting nontraditional employment opportunities for women.

256. U.S. Women's Bureau. *Steps to Opening the Skilled Trades to Women.* Washington, DC: The Bureau, 1974. 8p. L36.102:Sk3. Suggestions on how employers and unions can help women enter and succeed in the skilled trades. Briefly describes special programs across the country which help women enter skilled trades.

257. U.S. Women's Bureau. *Why Women Work.* Washington, DC: GPO, 1974. 3p. L36.102:W84/2/974. Summary of the role women play in the support of themselves and their families supplies brief supporting statistics. Earlier edition was published under SuDoc number L13.2:W84/44/970.

258. U.S. Congress. House. Committee on Education and Labor. Subcommittee on Equal Opportunity. *Equal Opportunity and Full Employment, Part 2, Hearings on H.R. 50.* 94th Cong., 1st sess., 18 Mar. 1975. 62p. Y4.Ed8/1:Em7/16/pt.2. One of a series of hearings on a bill stating a national full employment policy and establishing a "guaranteed" job program focuses on the historical and current role of women in the labor force. The tendency of government programs to ignore women or to reinforce occupational segregation is noted. Sex discrimination in vocational education and job counseling are examined with stress on their effect on women's employment and income prospects.

259. U.S. Congress. House. Committee on Education and Labor. Subcommittee on Equal Opportunities. *Equal Opportunity and Full Employment, Part 4, Hearings on H.R. 50.* 94th Cong., 1st sess., 13 Oct. - 15 Nov. 1975. 355p. Y4.Ed8/1:Em7/16/pt.4. Hearing on unemployment and the government response speaks directly to the employment needs of youth, minorities and women. Strategies for achieving full employment are explored, particularly the area of "make work" programs and industry's responsibility for job creation.

260. U.S. Congress. House. Select Committee on Aging. Subcommittee on Retirement Income and Employment. *Equal Opportunity for Women (Displaced Homemakers and Minority Women), Hearing.* 94th Cong., 1st sess., 12 Nov. 1975. 33p. Y4.Ag4/2:W84. Brief hearing considers legislative measures to ease the problems of women between the ages of 45 and 60 who must support themselves but who lack the education, training, and experience to secure employment.

261. U.S. Congress. Joint Economic Committee. Subcommittee on Economic Growth. *Employment Problems of Women, Minorities and Youth, Hearings.* 94th Cong., 1st sess., 7-8 July 1975. 64p. Y4.Ec7:Em7/15. Hearing explores the recession and unemployment, particularly as it affects women, minorities, and teenagers. Includes program recommendations to address the problems identified.

262. U.S. Smithsonian Institution. *Workers and Allies: Female Participation in the American Trade Union Movement, 1824-1976.* by Judith O'Sullivan and Rosemary Gallick. Washington, DC: The Institution, 1975. 96p. SI1.2:W89/2. Chronology of events in the women's trade union movement accompanies short biographical sketches of women labor activists. Includes a bibliography at the end, and each biography includes a short reference list.

263. U.S. Congress. Senate. Committee on Labor and Public Welfare. Subcommittee on Employment, Poverty, and Migratory Labor. *Changing Patterns of Work in America, 1976, Hearings.* 94th Cong., 2d sess., 7,8 Apr. 1976. 497p. Y4.L11/2:W89/6/976. Hearing examines the feasibility of alternative work schedules with witnesses particularly noting the importance of flexible work schedules, part-time employment, and job sharing to equal employment opportunity for women. The experience of employers in implementing alternative work schedules is described. Related GAO reports, *Contractors' Use of Alternative Work Schedules for Their Employees - How is it Working?*, *Legal Limitations on Flexible and Compresses Work Schedules for Federal Employees*, and *Part-Time Employment in Federal Agencies* are reprinted.

264. U.S. Library of Congress. Science and Technology Division. Reference Section. *Women in the Sciences.* by Constance Carter. LC Science Tracer Bullet 76-2. Washington, DC: GPO, 1976. 11p. LC33.10:76-2. See 299 for abstract.

265. U.S. Manpower Administration. *Dual Careers: A Longitudinal Study of Labor Market Experience of Women.* Manpower Research Monograph 21. Washington, DC: GPO, 1970-1976. 4 vol. L1.39/3:21/v.1-4. Five year longitudinal study examined the labor market behavior of women who were 30 to 44 years of age in 1967. The first volume analyzes the labor market status of the women in 1967. Characteristics studied include marital history, family background, labor force participation, occupation, rate of pay, child care arrangements, occupational and geographic mobility, work attitudes, and job satisfaction. Volume two examines changes in family and labor force status, rates of pay, and job satisfaction between 1967 and 1969. Volume three looks at changes between 1967 and 1971 in family and labor force status and child care arrangement used. Volume four examines the five year cycle from 1967 to 1972 focusing on changes in family characteristics, employment and wages, patterns of female labor force participation, factors

in career orientation and occupational status, the influence of work experience and occupation on women's earnings, patterns of child care utilization, family migration, and voluntary job change.

266. U.S. National Commission on the Observance of International Women's Year. Committee on the Arts and Humanities. *The Creative Woman.* Washington, DC: GPO, 1976. 54p. Y3.W84:2C86. Report on the status of women in the arts and humanities in the U.S. looks at their numbers and salaries, and at gender inequities in federal grants in the arts. Areas reviewed include performing arts, music, architecture, libraries and museums, and teaching.

267. U.S. Women's Bureau and Japan. Ministry of Labor. Women's and Minors' Bureau. *The Role and Status of Women Workers in the United States and Japan.* Washington, DC: GPO, 1976. 247p. L36.102:J27. Extensive discussion of women workers in the United States and Japan begins with an examination of the status of women workers in the U.S. and a review of their personal and employment characteristics. Briefly reviews the social changes that effect women's labor force participation. Government and nongovernmental actions affecting working women are summarized, and the issues facing women workers in the U.S. today are reviewed. The second part of the report profiles women workers in Japan with a focus on changes in their employment status and occupations. Provides information on the characteristics of women workers in Japan and their wages. Government measures affecting women workers are summarized, and issues and problems of women workers in Japan are described. Future needs of working women and areas requiring government actions for both the U.S. and Japan are stated. Appendix furnishes detailed statistics supporting the report and reprints significant legislation for both the U.S. and Japan.

268. U.S. Bureau of Labor Statistics. North Central Region V. *Women Workers: A Bibliography.* Washington, DC: GPO, 1977. 26p. L2.71/4:77-8. Annotated bibliography lists selected government publications, including articles in government periodicals, on women workers. Entries date from 1970 to 1977, and are mostly Women's Bureau and Bureau of Labor Statistics publications.

269. U.S. Congress. Joint Economic Committee. *Achieving the Goals of the Employment Act of 1946: Thirtieth Anniversary Review, Volume 1, Employment. Paper 6: The Impact of Macroeconomic Conditions on Employment Opportunities for Women.* Washington, DC: GPO, 1977. 32p. Y4.Ec7:Em7/14/v.1/paper 6. Study examined the impact of the recession on women's employment. The future outlook for women's employment based on various recovery scenarios is described.

270. U.S. Congress. Joint Economic Committee. Subcommittee on Economic Growth and Stabilization. *American Women Workers in a Full Employment Economy: A Compendium of Papers.* 95th Cong., 1st sess., 15 Sept. 1977. 306p. Y4.Ec7:W84/2. A collection of papers on women and employment covers topics of sex discrimination, underemployment, unemployment among mature women, homemakers, child care, part-time employment, career education, apprenticeship, tax treatment, media impact, and international comparisons.

271. U.S. Congress. Joint Economic Committee. Subcommittee on Economic Growth and Stabilization. *American Women Workers in a Full Employment Economy, Hearing.* 95th Cong., 1st sess., 16 Sept. 1977. 71p. Y4.Ec7:W84/4. Hearing examines the growing labor force participation rates of women and the response of federal manpower and economic policy to this trend. Testimony highlights the problems of women in the labor force and the wage gap between men and women. Provides supporting statistics on women's years of work experience and years out of the labor force by marital status and

race in 1967; unemployment rates of women and men, 1947-1974; and unemployment rates of women by age and race, 1960, 1970, and 1973. Reprints the "NOW Bill of Rights", "NOW Resolution Economic Priority Issues for the Second Decade," and "The First Women's State of the Union Address."

272. U.S. Economic Research Service and U.S. National Agricultural Library. *Women in American Agriculture: A Selective Bibliography.* Library List no. 103. Washington, DC: The Library, 1977. 30p. A17.17:103. Citations to books and periodical articles, some annotated, on all aspects of women and farm work.

273. U.S. Employment and Training Administration. *Women and Work.* R & D Monograph no. 46. Washington, DC: GPO, 1977. 71p. L37.14:46. Overview of issues relating to women and paid employment discusses the earnings gap and the labor market experience of women based on a five year longitudinal study from 1967 to 1972. The specific focus in on "labor market marginals" such as homemakers, the working poor, female-headed families, and migrants. Summarizes Employment and Training Administration projects aimed at upgrading women's employment as well as WIN and CETA programs. Furnishes data on income and wages of women, and reviews job attitudes.

274. U.S. National Commission on the Observance of International Women's Year. *Employment: A Workshop Guide.* Washington, DC: GPO, 1977. 60p. Y3.W84:10/5. Outline for conducting a workshop on women and employment includes fact sheets and lists films, publications, organizations, and possible speakers.

275. U.S. National Commission on the Observance of International Women's Year. *Improving the Status of Women in the Arts and Humanities: Workshop Guidelines.* Washington, DC: GPO, 1977. 125p. Y3.W84:10/1. Guidelines for conducting a state level workshop on the status of women in the arts and humanities provides information on current findings of discrimination, sources for local conference participants, non-workshop activities, equal pay for women faculty members, resolutions supporting arts and culture by U.S. mayors and governors, and women as a percentage of musicians in orchestras and as managers of orchestras.

276. U.S. Office of Education. Bureau of Occupational and Adult Education. *Women in Non-Traditional Occupations - A Bibliography.* Washington, DC: GPO, 1977. 189p. HE19.128:W84. Annotated bibliography of articles, books, ERIC documents, government publications, pamphlets, and dissertations on women in nontraditional occupations includes both materials on women in the work force and sex-role stereotyping, as well as materials on individual women in nontraditional fields.

277. U.S. Women's Bureau. *Minority Women Workers: A Statistical Overview.* Washington, DC: GPO, 1977. 14p. L36.102:M66/2. Statistical overview of the status of minority women workers details labor force participation by age, sex, and race; unemployment by race, age, and sex; distribution of unemployed persons by sex, age, race and reason for unemployment; major occupational group by race; marital status of women in the labor force by race; work experience of low income women heads of families by race; percentage of mothers in the labor force by race, age of children, and marital status; education by sex and race; employment status of high school graduates never enrolled in college and dropouts by sex and race; and median wage or salary in 1974 by race and sex.

278. U.S. Congress. Joint Economic Committee. *Special Study on Economic Change, Hearings, Part 1.* 95th Cong., 2d sess., 31 May -7 June 1978. 473p. Y4.Ec7:St9/2/pt.1. Experts discuss population projections and labor force participation in relation to prospects for economic growth and employment. The problem of predicting women's labor force participation is discussed. Information on labor force participation patterns of immigrants

is examined by country of origin, gender, occupation, and marital status. Also reports is average annual earnings of 1970 immigrants by sex for the years 1970 to 1975.

279. U.S. Dept. of Labor. Office of the Assistant Secretary for Administration and Management. Library. *Women in Management: Selected Recent References*. Washington, DC: GPO, 1978. 29p. L1.34:W84/2. Bibliography of books and articles published between 1975 and 1977 on women in management includes brief annotations for selected entries. Many of the articles cited are from popular magazines and some references to national newspaper articles are included.

280. U.S. Employment and Training Administration. *Placing Minority Women in Professional Jobs*. by Robert W. Glover. R & D Monograph no. 55. Washington, DC: GPO, 1978. 75p. L37.14:55. Report details the outreach strategy of the Minority Women Employment Program which focuses on placing college educated minority women in managerial and professional positions. Includes a list of resource materials for setting up similar programs.

281. U.S. Federal Aviation Administration. Office of Aviation Medicine. *A Comparison of the Vigilance Performance of Men and Women Using a Simulated Radar Task*. by Richard I. Thackray, R. Mark Touchstone, and J. Powell Bailey. Technical report no. FAA-AM-78-11. Washington, DC: FAA, 1978. 9p. TD4.210:78-11. Study of sex differences in alertness of air traffic controllers monitoring a futuristic, highly automated air traffic control radar display over a 2-hour period found an equal decline in alertness for both sexes.

282. U.S. Manpower Administration. *Years for Decision: A Longitudinal Study of the Educational and Labor Market Experience of Young Women*. Manpower Research Monograph no. 24. Washington, DC: GPO, 1971-1978. 4 vol. L1.39/3:24/v.1-4. Five-year longitudinal study examined the educational and labor market experience of young women who were age 14 to 24 in 1968. Volume one establishes the characteristics of the women at the beginning of the study. Characteristics surveyed include age, marital status, school enrollment, educational attainment, and labor force status. Relates labor force status to characteristics and describes employment patterns of nonstudents including child care arrangements. Also looks at educational aspirations. Volume 2 examines changes in enrollment aspirations, job status and rate of pay, and knowledge of the world of work in 1969. The third volume looks at changes in educational and occupational aspirations, changes in labor force status among nonstudents, and changes in job status of employed out-of-school youth between 1968 and 1970.

283. U.S. Women's Bureau. *A Guide to Conducting a Conference with American Indian Women in Reservation Areas*. Washington, DC: GPO, 1978. 17p. L36.108:In2. Information on setting up a conference on employment issues for Native American women draws on the experience of a Women's Bureau cosponsored conference, "Employment Awareness for Indian Women," held on the Navajo Reservation in Shiprock, New Mexico.

284. U.S. Women's Bureau. *Recruitment Sources for Women*. Washington, DC: GPO, 1978. 12p. L36.102:R24. Lists organizations which can provide assistance to employers seeking women candidates for professional, technical, and management positions.

285. U.S. Women's Bureau. *Twenty Facts on Women Workers*. Washington, DC: GPO, 1978. 3p. L36.102:F11/978 Earlier editions published in 1975 and 1974.

286. U.S. Women's Bureau. *WUW: The Washington Union Women's Group*. Washington, DC: GPO, 1978. 25p. L36.102:W27. Briefly describes the Washington Union Women/Women's Bureau Project, an organized information and education program for

women with special staff responsibilities in unions. Also includes guidelines for establishing similar projects which bring together union officials and Women's Bureau personnel.

287. U.S. Women's Bureau. *Young Women and Employment: What We Know and Need to Know about the School-to-Work Transition.* Washington, DC: GPO, 1978. 91p. L36.102:Em7/3. Papers presented at a conference on the transition from high school to work for young women are summarized. Topics covered in the presentations and panel discussions are consequences of teenage childbearing, effect of schools and parents on occupational choice, alternative education for minorities and women, the employer perspective on young women and employment, and federal youth employment programs.

288. U.S. Air Force Systems Command. Air Force Human Resources Laboratory. *Utilizing Women in Industrial Career Fields.* Technical report AFHRL-TR-78-48. Washington, DC: GPO, 1979. 152p. D301.45/27:78-48. As a first step in expanding recruitment of women for nontraditional careers in the Air Force a review of the literature was conducted to assess possible methods and problems with various administrative and personnel policies in this area. Three private companies with significant numbers of women in skilled industrial jobs were surveyed to determine attitudes and policies which affect the success of the programs.

289. U.S. National Commission on Employment and Unemployment Statistics. *The Implications of Changing Family Patterns and Behavior for Labor Force and Hardship Measurement.* Washington, DC: GPO, 1979. 69p. Y3.Em7/2:9/16. The focus of this report is the changing patterns of labor force behavior, particularly in relation to married women, and the implications of these changes for measurement of unemployment and hardship.

290. U.S. National Institute of Education. *A Step Toward Equality: A Progress Report, September 1977 - September 1978.* Washington, DC: GPO, 1979. 10p. HE19.202:Eq2. Reports the first year's activities of the National Commission on Working Women, a group formed to address the needs of women concentrated in "pink collar" and "blue collar" occupations.

291. U.S. Public Health Service. *Patterns of Employment before and after Childbirth, United States.* Washington, DC: GPO, 1980. 50p. HE20.6209:23/4. Report of statistics collected in 1973 on the employment of women before marriage, between marriage and first birth, and between first and second birth analyzes patterns for women married in different time periods and by socioeconomic group.

292. U.S. Women's Bureau. *Adelanta, Mujer Hispana: A Conference Model for Hispanic Women.* Pamphlet no. 20. Washington, DC: GPO, 1980. 39p. L36.112:20. Presentation of a model for a community based conference on meeting the needs of low income and unemployed women, and on the needs of employed women seeking better jobs and upward mobility, focuses on Chicana/Hispanic women. Reprints some of the promotional material from a Women's Bureau sponsored conference on the same topic.

293. U.S. National Institutes of Health. *Women in Biomedical Research.* Washington, DC: GPO, 1981. 45p. HE20.3002:B52/9. Report is drawn from an NIH conference of the same name and focuses on the participation of women in biomedical research and barriers to their participation. Also looks at ways NIH can encourage the participation of women in biomedical research. Includes a selected bibliography.

294. U.S. Smithsonian Institution. National Museum of American History. *Prefect in Her Place: Women at Work in Industrial America.* Washington, DC: Smithsonian Institution

Press, 1981. 23p. SI1.2:W84. Illustrated brief history features the work of women in American industry in the 1800s.

295. U.S. Congress. Senate. Committee on Labor and Human Resources. Subcommittee on Aging, Family and Human Services. *Work Ethic: Materialism and the American Family, Hearing.* 97th Cong., 2d sess., 2 March 1982. 158p. Y4.L11/4:W89/3. Testimony focuses on the dual income family and the related stress on family life. Most of the testimony discusses "what's wrong with the American family" and the contribution of the exodus of women to the work place to family stress. Ways government policy can support the family are examined and the issue of parental consent for birth control services is raised. Also discusses women's attachment to the labor force, day care, and welfare issues.

296. U.S. Administration on Aging. *Employment Concerns of Older Women.* by Janice L. Davidson. National Policy Center On Women and Aging Working Paper no. 2. College Park, MD: The Center, 1983. 78p. HE23.3002:W84/2/wk. paper 2. Review of the status of older women in the labor force, the barriers they face, and their employment needs and opportunities. The issues are examined within the context of current federal policy and future policy options. Provides background statistics on poverty rates, labor force participation, marital status, children, unemployment rates, income and earnings, reasons for leaving the labor force, educational attainment and income, sex-earnings ratios, and occupational distribution by sex and age.

297. U.S. Congress. House. Committee on Technology. Subcommittee on Science, Research and Technology and Committee on the Budget. Task Force on Education and Employment. *Technology and Employment, Joint Hearings.* 98th Cong., 1st sess., 7-23 June 1983. 1397p. Y4.Sci2:98/41. Informative hearing on the effect of technology on employment explores the changing nature of the work place, new opportunities, and displacement of workers due to technology. Testimony specifically addresses the effect of these changes on the employment outlook for women, minorities, older workers, and the disabled. The need to train women in high technology fields is stressed.

298. U.S. Congress. Joint Economic Committee. *American Women: Three Decades of Change, Hearing.* 98th Cong., 1st sess., 9 Nov. 1983. 73p. Y4.Ec7:W84/6. Hearing testimony highlights the trends in women's lives which effect their labor force participation. Factors such as age at marriage, number of children, divorce rates, and educational attainment are related to women's work patterns. The need to reduce employment discrimination to break the pattern of female-headed families living in poverty is also discussed. Theories on the continued wage gap between men and women and a summary in chart form of recent research on the earnings gap are included. Provides statistics on childless women as percent of ever-married women by age, 1950 to 1980; distribution of female civilian labor force by occupation, 1950 to 1980; wage and salary income by sex and major occupation group, 1960 to 1980; and composition of the poverty population, 1959, 1970 and 1980.

299. U.S. Library of Congress. Science and Technology Division. Science Reference Section. *Women in the Sciences.* by Constance Carter. LC Science Tracer Bullet 83-8. Washington, DC: GPO, 1983. 14p. LC33.10:83-8. Bibliography of sources on the history of women in the fields of science and engineering updates LC Science Tracer Bullet 76-2 (264).

300. U.S. Bureau of Labor Standards. *Employment in Perspective, Working Women: Fourth Quarter/Annual Summary 1983.* BLS Report no. 702. Washington, DC: The Bureau, 1984. 3p. L2.71:702. Summary report profiles employment and unemployment among women by age and family status for 1982-1983.

301. U.S. Bureau of Labor Statistics. *Families at Work: The Jobs and the Pay.* Bulletin no. 2209. Washington, DC: GPO, 1984. 58p. L2.3:2209. Six articles reprinted from the December 1983 *Monthly Labor Review* discuss trends in employment and unemployment in families, work and income patterns of married couples, the job market and female-headed households, child care services, and families after retirement. Supplementary tables provide additional detailed statistics on family wage earners and family characteristics in 1983.

302. U.S. Congress. Joint Economic Committee. *Problems of Working Women, Hearing.* 98th Cong., 2d sess., 3 Apr. 1984. 169p. Y4.Ec7:W84/7. Information gathering hearing on the problem of working women explores issues of child care, flextime, and training for better jobs. Also covers the issue of leave for pregnant workers after childbirth. Programs for women under the Job Training Partnership Act, WIN, and the Women in Non-traditional Careers model program are reviewed. A final topic is methods of providing day care for children of mothers in poverty and on the edge of poverty.

303. U.S. Congress. Joint Economic Committee. *The Role of Older Women in the Work Force, Hearing.* 98th Cong., 2d sess., 6 June 1984. 117p. Y4.Ec7:W84/9. Witnesses describe the problems older women face entering or reentering the labor force, pension issues, and health care needs. Federal programs and how their funding and emphasis affect the situation of elderly women is discussed.

304. U.S. Congress. House. Committee on Government Operations. Subcommittee on Employment and Housing. *Work and Poverty: The Special Problems of the Working Poor, Hearing.* 99th Cong., 1st sess., 12 Dec. 1985. 141p. Y4.G74/7:W89. Witnesses describe the characteristics of the working poor and of those expected to work who have low incomes. Analysis by gender reveals demographic trends in the working poor in a stable economy and in recession. The problems of women in low pay, dead end jobs are highlighted and a representative of Wider Opportunities for Women describes approaches to moving women into nontraditional occupations with better pay and opportunities. Comparable worth is also discussed. Results of an eight country study of income supplementation programs and the working poor are also described.

305. U.S. General Accounting Office. Office of Library Services. *Women in the Workplace: The 1980's and Beyond: a Bibliography.* by Guy Wilson and Charlotte Hurley. Washington, DC: The Office, 1985. 48p. GA1.16:W84.

306. U.S. Women's Bureau. *Employment Programs for Rural Women.* Washington, DC: GPO, 1985. 39p. L36.102:Em7/6. Describes of two demonstration programs to address the employment needs of rural women. The Appalachian Women's Employment Information Project provided counseling and job-readiness training for low-income women, and the Women's Opportunity Program, operated by the National Council of Negro Women, Inc., addressed the needs of rural women in Mississippi.

307. U.S. Women's Bureau. *The United Nations Decade for Women, 1976-1985: Employment in the United States.* Washington, DC: The Bureau, 1985. 165p. L36.102:W84/7. Final report on the UN Decade for Women and on the employment of women in the United States reviews the progress of American women and the success of federal policies in encouraging the advancement of women between 1976 and 1985. The report provides a concise analysis of statistics on trends in the economic status of women in the U.S. and focuses on the characteristics of women workers. Federal policies and programs reviewed cover issues such as job training, education, pay equity, education, retirement income and day care. The programs of the Women's Bureau are reviewed in-depth. Initiatives on non-governmental organizations during the decade are also reviewed. Briefly presents an outlook for the future of labor force participation and training needs, and appendix tables

provide statistics on employment, occupations, earnings, education, and characteristics of women maintaining families.

308. U.S. Congress. House. Select Committee on Children, Youth, and Families. *Working in America: Implications for Families, Hearing.* 99th Cong., 2d sess., 17 Apr. 1986. 215p. Y4.C43/2:W89. Hearing to explore the implications of current employment trends on families focuses primarily on the growing role of women in the labor force. Statistics on labor force trends showing the occupation and wages of women and the economic balance of women's role in the family throughout U.S. history are reviewed, and the problems of working wives and mothers are summarized. The issue of AFDC mothers and work requirements is also raised. The economic problems of black families and factors contributing to the welfare dependency cycle are explored.

309. U.S. Congress. Joint Economic Committee. *Working Mothers Are Preserving Family Living Standards: A Staff Study.* 99th Cong., 2d sess., 1986. Committee print. 15p. Y4.Ec7/12:W89/2. Study examines the economic reasons women with children work and concludes that most women are working to preserve the family's standard of living. Background statistics are provided on employment of women with children by age of youngest child, 1969-1985, and earnings of working mothers in two-parent families and in female-headed families. The results of a *New York Times* survey on why women work is also reported.

310. U.S. Congress. Senate. Committee on Labor and Human Resources. *Women in Transition, Hearing on Examining the Human Resources Impact of Reentry of Women into Education and the Labor Force.* 98th Cong., 2d sess., 30 Apr. 1986. 157p. Y4.L11/4:S.hrg.99-836. Review of the needs of women reentering the work force examines how federal manpower training programs can meet these needs.

311. U.S. Congress. Senate. Special Committee on Aging. *Employment Opportunities for Women: Today and Tomorrow, Hearing.* 99th Cong., 2d sess., 21 April 1986. Cleveland, OH. 98p. Y4.Ag4:S.hrg.99-701. The needs of older women for job training and placement, pre-retirement planning, education, and child care are discussed. Providing equal employment opportunities for women now to avoid dependency in old age is stressed.

312. U.S. Congress. House. Committee on Education and Labor. Subcommittee on Employment Opportunities. *A Prospectus of Working Women's Concerns.* 100th Cong., 1st sess., 21,22 July 1987. 259p. Y4.Ed8/1:100-43. Hearing explores the concerns of working women discussing issues of maternity leave, day care, flextime, equal pay, and the entry of women into male dominated fields. Background statistics are provided on the employment status of women by race, 1972-1986; employed women 16 and older by occupation, 1970, 1980, 1986; median earnings of full-time workers by sex, 1955-1985; families by type and number of wage earners; number of children under 18 by type of family and labor force status of mother; number and percentage of women with poverty level income by work experience, 1972-1985; and sex-composition and mean annual earnings of selected occupations.

313. U.S. Congress. House. Select Committee on Children, Youth, and Families. *American Families in Tomorrow's Economy, Hearing.* 100th Cong., 1st sess., 1 July 1987. 274p. Y4.C43/2:Ec7/2. Hearing examines the economic changes pressuring the American family and reviews their impact on family income and spending. Particular attention is paid to the contribution of working mothers to family income. Child care costs and the financing of education and housing are also topics of testimony. The effect of the economy on single parent families is noted and the inadequacy of the minimum wage is discussed.

314. U.S. Congress. Senate. Committee on Labor and Human Resources. Subcommittee on Labor. *Women in the Nontraditional Workforce, Hearing.* 100th Cong., 1st sess., 17 Nov. 1987. 255p. Y4.L11/4:S.hrg.100-447. Hearing examines the problems of women seeking to enter traditionally male dominated fields with an emphasis on construction and high technology industries. Issues discussed include OFCCP enforcement and union activities. Examples of individual women who have succeeded in nontraditional areas and successful programs such as the Women's Technical Institute in Boston are highlighted.

315. U.S. Employment Standards Administration. *Opportunity 2000: Creative Affirmative Action Strategies for a Changing Workforce.* by Hudson Institute. Washington, DC: The Administration, 1988. 181p. L36.2:Op5. Review of strategies to meet the labor force needs of the year 2000 provides a summary profile of the predicted labor force needs and available pool. Innovative approaches practiced by companies to recruit and retain women, minorities, and the disabled are described. The chapter on women focuses on work and family issues but also covers equal pay and upward mobility.

316. U.S. Women's Bureau. *Flexible Workstyles: A Look at Contingent Labor.* Washington, DC: GPO, 1988. 93p. L36.102:W89/6. Summary proceedings of a conference sponsored by the Women's Bureau looks at the contingent workforce, i.e. persons employed on a part-time, temporary, contractual, or leased basis. Papers presented discuss current and historical trends in contingent labor and analyze the forces behind the emergence of contingent labor and the implications of these work arrangements for women.

317. U.S. Congress. House. Committee on Education and Labor. *Hearing on H.R. 2235, Workforce 2000 Employment Readiness Act of 1989.* 101st Cong., 1st sess., 3 Nov. 1989. Los Angeles, CA. 128p. Y4.Ed8/1:101-62. Discussion of a bill to improve the employment outlook of women and minorities through better educational opportunities focuses on the type of education which will be required for workers in the year 2000. The status of women and minorities in education, particularly the path to higher education, and the effect on their labor force status is reviewed. Strengthening of affirmative action by codifying Executive Order 11246 is also stressed.

318. U.S. Congress. House. Committee on Education and Labor. *Hearing on Workforce 2000 and on H.R. 2235.* 101st Cong., 1st sess., 15 June 1989. 304p. Y4.Ed8/1:101-35. The need to improve educational opportunities for minorities and women if the U.S. is to have the skilled workforce it will need in the year 2000 is the theme of hearing testimony. Most witnesses focus on the current education and employment experience of minorities, but the clustering of women in low pay, semi-skilled occupations and the need to educate women for scientific and technical occupations is noted.

319. U.S. Congress. Senate. Committee on Labor and Human Resources. *Nomination, Hearing on Elizabeth Hanford Dole, of Kansas, to Be Secretary of Labor, U.S. Department of Labor.* 101st Cong., 1st sess., 19 Jan. 1989. 106p. Y4.L11/4:S.hrg.101-21. Hearing to consider the nomination of Elizabeth Dole for Secretary of Labor reviews Dole's background including her tenure as Secretary of Transportation, and examines her views on labor force issues. Among the areas of questioning are career opportunities for women, pension issues, and child care. Focus areas for federal jobs training programs are also discussed.

320. U.S. National Agriculture Library. *Women in Agriculture, January 1979 - October 1988: 321 Citations.* by Jerry Rafats. Quick Bibliography Series 89-38. Beltsville, MD: The Dept. of Agriculture, 1989. 29p. A17.18/4:89-38. Bibliography provides book, government document and article citations on women in agriculture from the AGRICOLA database.

321. U.S. Women's Bureau. *La Mujer de Origen Hispano en la Fuerza Laboral.* Facts on
 Working Women No. 89-1S. Washington, DC: The Bureau, 1989. 4p. L36.114/3:90-1S.
 Statistical overview in Spanish details the participation of Hispanic women in the U.S.
 labor force and their unemployment rate, educational attainment, occupation, and income.

322. U.S. Women's Bureau. *Work and Family Resource Kit.* Washington, DC: The Bureau,
 1989? kit. L36.102:F21/ . Folder and materials on balancing work and family life covers
 dependent care options, alternative work schedules, benefits, and choosing options.

323. U.S. Commission on Civil Rights. *The Economic Status of Black Women: A Exploratory
 Investigation.* Washington, DC: GPO, 1990. 171p. CR1.2:B56/3. Detailed comparison
 of the economic status of black and white women examines the occupational and economic
 history of black women from 1940 to 1980 and the current occupational and wage status
 of black women. The economic status of black women in the 1980s is compared to white
 women with similar characteristics. The report documents a narrowing of the gap between
 black women and white women in some areas, but also stresses the continued effect of
 racial discrimination on women and recommends further areas of research. Statistical data
 supporting the report's conclusions is included.

324. U.S. Congress. Senate. Committee on Labor and Human Resources. *Meeting the
 Challenges of a New Work Force, Hearing.* 101st Cong., 2d sess., 19 July 1990. 72p.
 Y4.L11/4:S.hrg.101-888. The need to better educate, train, and accommodate women,
 minorities, and the handicapped to meet the labor force demands of the year 2000 are
 examined. Job training, lifelong learning, and day care services are stressed.

325. U.S. Library of Congress. Science and Technology Division. *Women in the Sciences.*
 Compiled by Rebecca Kennedy and Michelle Cadoree. LC Science Tracer Bullet no. 90-6.
 Washington, DC: The Library of Congress, 1990. 22p. LC33.10:90-6. Update of Tracer
 Bullet 83-8 (299) lists some of the resources in the Library of Congress on women's
 contributions in science, medicine, and engineering. Biographies, vocational guidance
 materials, and juvenile literature are selectively included.

326. U.S. Women's Bureau. *Women in Management.* Facts on Working Women no. 89-7.
 Washington, DC: GPO, 1990. 8p. L36.114/3:89-4. Review of statistics on women in
 management positions notes occupational and industry distribution, the lack of women at
 senior management levels, and racial and ethnic representation.

SERIALS

327. U.S. Dept. of Labor. *Labor Information Bulletin.* Washington, DC: GPO, July 1942 -
 Apr. 1953. Vol. 9 no. 7 - Vol. 20 no. 4. monthly. L1.15:vol./no. Contains articles
 relevant to labor issues including regular articles on labor legislation for women and
 children.

328. U.S. Dept. of Labor. *Women and Work.* Washington, DC: The Dept., 1973 - .
 monthly. L1.20/8:year/issue. Newsletter highlights programs and publications of the
 Department of Labor on women and work and notes legal action of particular interest.

329. U.S. Government Printing Office. *Labor Question, Public Documents Relating Directly
 or Indirectly to Wage-Workers and Their Welfare.* [title varies]. Price list 33. Washington,
 DC: GPO, 1909 - . irregular. GP3.9:33/no.

330. U.S. National Science Foundation. *NSF Visiting Professorships for Women.* Washington,
 DC: The Foundation, 1983 - . annual. NS1.48:year. Guidelines and application form
 for the NSF Visiting Professorships for Women (VPW) program describe the goals and

eligibility criteria and provide specifics on proposal preparation. Other NSF programs of interest to women are also noted.

331. U.S. National Science Foundation. *Research Opportunities for Women.* Washington, DC: The Foundation, 1985? - . NS1.48/2:year. Describes grants, awards and other NSF programs of interest to women researchers.

332. U.S. National Science Foundation. *Women and Minorities in Science and Engineering.* Washington, DC: GPO, 1977-1986. irregular. NS1.2:W84/2/year. Report examines the position of women and minorities in the scientific and engineering workforce and the transition from high school to college and from school to work as they relate to women and minorities in scientific and technical fields. Areas detailed include salaries, field of work, utilization of degrees by sex and race, and reason for not using the science/engineering degree. Provides detailed statistics on scientists and engineers by field, sex, and race; employment and unemployment rates by field, sex and race; salaries of male and female scientists and engineers by field and experience; mathematical and science education by sex; SAT scores by sex and race/ethnicity; and GRE scores by sex, race/ethnicity and undergraduate major. Issued every two years between 1982 and 1986 with much more detailed statistics than in earlier editions.

333. U.S. Women's Bureau. *Activities Affecting Gainfully Employed Women.* Washington, DC: The Bureau, 19??-1937. vol. 1 no. 1 - vol. 16 no. 1. irregular. L13.8:vol./no. News notes from the Women's Bureau describe labor conditions and labor legislation affecting women workers.

334. U.S. Women's Bureau. *Facts on Women Workers.* Washington, DC: The Bureau, no. 1 - 6, Feb. 8 -Mar. 14, 1946. weekly. Later see *Labor Information Bulletin* (327).

335. U.S. Women's Bureau. *What's New about Women Workers? A Few Facts.* [title varies]. Washington, DC: The Bureau, 1954 - 1963. irregular. L13.11:18/no.

336. U.S. Women's Bureau. *The Woman Worker: The Women's Bureau News Letter.* Washington, DC: GPO, 1938-1943. vol. 18 no. 1 - vol. 22 no. 3. bimonthly. L13.8:vol./no. Newsletter reports major findings of the Women's Bureau, bureau activities, news notes, and short articles on current issues affecting women workers. Routinely covers legislative and trade union action.

337. U.S. Women's Bureau. *Women Workers Today.* Washington, DC: GPO, 1971 - 1976. irreg. L36.102:W89/year. Brief statistical profile of women workers reports on age, marital status, children, education, race, husband's income, worklife patterns, occupations, unemployment, earnings, and female-headed families.

2

Employment Discrimination and Affirmative Action

Discrimination against women in employment and efforts to correct past discrimination through affirmative action are described in the documents in this chapter. Most of the documents on equal employment opportunity law and enforcement focus primarily on issues of racial minorities, with gender discrimination a secondary consideration. Among the early documents specifically discussing Title VII of the Civil Rights Act of 1964 includes a 1965 report on women and implementation of Title VII (343).

A good overview of labor force discrimination against women is found in the 1972 EEOC report *Employment Problems of Women, A Classic Example of Discrimination* (363). Also of note from the EEOC is a 1973 study of affirmative action programs for women (366) and a 1977 research report, *Women: The Path to Equal Employment* (398).

Senate hearings held in 1981 examine in depth the problem of sex discrimination in the work place (430). The conservative trend in the Supreme Court and women's employment discrimination issues are examined in a 1986 House hearing (458). The hearings and reports on the Civil Rights Act of 1990 bill primarily deal broadly with issues of employment discrimination and affirmative action, but also discuss specifically the ability of women to seek damages in sex discrimination suits, and feature disagreement over sexual harassment.

Sexual harassment as a general topic is covered in government documents primarily in training materials and informational leaflets. The training a workshop materials are from the Office of Personnel Management (421), the Army (444-445), the Western Area Power Administration (456), and the Bureau of Mines (463-465). Documents on sexual harassment in the federal civil service are covered in Chapter 13. Reproductive hazards and employment discrimination against women are examined in two reports, *Report on the EEOC, Title VII and Workplace Fetal Protection Policies in the 1980s* (484) and *Genetic Screening and the Handling of High-Risk Groups in the Workplace, Hearings* (428). Other documents on gender discrimination are found in Chapter 3, Pay Equity, Chapter 5, Labor legislation, and in Volume I chapters on the status of women and women's rights. Discrimination in the federal civil service is covered in Chapter 13, and discrimination in the armed forces is covered in Chapter 11.

338. U.S. Dept. of Labor. National War Labor Board. *Docket No. 491, Opinion in re Employees (Women Conductors) v. Cleveland Railway Company.* Washington, DC: The Board, 1919. 3p. L10.5:C599/6. Decision of the National War Labor Board in the case of the women employees of the Cleveland Railway Company who were dismissed from their jobs as conductors after the local union threatened to strike over their continued employment. As there were still sufficient vacancies for the 64 women dismissed even

after rehiring returning soldiers, the board ruled that the women should be restored to their positions.

339. U.S. Office of Education. *The Legal Status of Married Women Teachers.* Pamphlet no. 47. Washington, DC: GPO, 1934. 22p. I16.43:47. Presents information on significant court cases and the legal principles involved in the dismissal of women teachers due to marriage.

340. U.S. Women's Bureau. *Statement to the National War Labor Board in Support of Union's Request to Abolish Discrimination against Married Women.* Washington, DC: GPO, 1945. 27p. L13.2:M34/3. Statement prepared by the Women's Bureau supports a suit against a local telephone company whose policy prohibited the employment of married women. Arguments presented highlight the economic reasons married women seek employment and examine the right to work from the standpoint of married women's personal freedom. Provides supporting statistics on labor force participation and earnings of married women and on the income of men.

341. U.S. Congress. House. Committee on Education and Labor. Special Subcommittee on Labor. *Equal Employment Opportunity, Hearings.* 87th Cong., 1st and 2d sess., 23 Oct. 1961- 24 Jan. 1962. 1156p. Y4.Ed8/1:Em7/8/pt.1-2. Two part hearing considers legislation to prohibit discrimination in employment opportunities based on race, color, national origin, ancestry, religion, age, or sex. The primary focus is on race and religion, although part two and the appendices provide some discussion on the sex discrimination issue.

342. U.S. Dept of Labor. *Address by Secretary of Labor Designate W. Willard Wirtz before the Conference on Employment Opportunities for Women, September 24, 1962, Washington, D.C.* by W. Willard Wirtz. Washington, DC: The Dept., 1962. 8p. L1.13:W74/13. Speech highlights the need to recognize the role of women in the work force and to acknowledge that discrimination against women still exists. Generally discusses the facts of women's employment and refutes the concept that employed women contribute to men's unemployment. Equal opportunity in the federal service as a result of the recommendations of the President's Commission on the Status of Women are noted.

343. U.S. Interdepartmental Committee on the Status of Women. *Equal Employment Opportunities for Women under Title 7 of the Civil Rights Act of 1964, Memorandum on Policy for Equal Employment Opportunity Commission, Submitted by Citizens' Advisory Council on Status of Women and Transmitted with Approval of Committee.* Washington, DC: The Committee, 1965. 12p. Y3.In8/21:2Em7. Suggestions to the EEOC from the Citizens' Advisory Council on the Status of Women on implementing Title VII of the Civil Rights Act of 1964 concern the guidelines used by the commission in the area of sex discrimination in employment. Among the topics specifically noted are bona fides, advertising, state labor legislation, and the relationship of the equal pay provision of Title VII to the Fair Labor Standards Act.

344. U.S. White House Conference on Equal Employment Opportunity. *Report of White House Conference on Equal Employment Opportunity, Aug. 19-20, 1965.* Washington, DC: GPO, 1965. 28p. Y3.W58/13:1/965. Summary of a panel discussion touches on topics of employment discrimination, EEOC complaint procedures, record keeping and reporting, apprenticeship and training, hiring and promotion, and affirmative action, with the primary emphasis on race. A separate panel discussion on sex discrimination covers issues of bona fide qualifications, Title VII and state protective labor laws, differentials in benefits and retirement, and dual lines of seniority.

345. U.S. Women's Bureau. *Looking Ahead, Title VII, Equal Employment Opportunity, Address by Mary Dublin Keyserling, Director, Women's Bureau, Department of Labor, Regional Conference on Civil Rights, Sponsored by National Council of Women in United States, Washington, D.C., April 5, 1965.* Washington, DC: The Bureau, 1965. 8p. L13.12:K52/8. Speech on the provisions of Title VII of the Civil Rights Act of 1964 notes that women will anxiously await the interpretation of the exceptions of sex and religion where it is a bona fide job requirement. Some of the questions of interpretation relative to sex discrimination are posed.

346. U.S. Equal Employment Opportunity Commission. *First Annual Digest of Legal Interpretations: July 2, 1965 through July 1, 1966.* Washington, DC: GPO, 1967. 49p. Y3.Eq2:10-2/965-66. Review of decisions of the commission and opinions of the General Counsel on employment discrimination is subdivided by basis of complaint.

347. U.S. Dept. of Labor. *Address by Mrs. Esther Peterson, Assistant Secretary of Labor, Department of Labor, before the Seminar, the Privileged Woman?, Honolulu, Hawaii, November 8, 1968.* Washington, DC: The Dept., 1968. 14p. L1.13:P44/10. Equal opportunity for women in employment and the early EEOC efforts to interpret Title VII are the focus of this speech which also addresses Executive Order 11375, prohibiting sex discrimination in federal employment and employment under federal contracts. The arguments over the discriminatory nature of protective labor laws for women is also explored. Educational opportunity, expanding women's role in the federal government and services to working mothers are briefly covered.

348. U.S. Equal Employment Opportunity Commission. *Help Wanted...Or Is It? a Look at White Collar Job Inequities for Minorities and Women.* Washington, DC: GPO, 1968. 15p. Y3.Eq2:2H36. Summary of hearings held in New York explores the discrimination encountered by minorities and women seeking white collar employment. Industry representatives discuss elements of successful EEO programs.

349. U.S. Federal Aviation Administration. Library Services Division. *Equal Employment Opportunity, Selected References.* by Dorothy J. Peohlman. Bibliographic List no. 16. Washington, DC: The Administration, 1968. 9p. TD4.17/3:16. Lists selected books, pamphlets, government publications, and periodical articles on equal employment opportunity from the FAA Headquarters Library.

350. U.S. Congress. Senate. Committee on the Judiciary. Subcommittee on Administrative Practice and Procedure. *Equal Employment Opportunity Procedures, Hearings Pursuant to S. Res. 39.* 91st. Cong., 1st sess., 27-28 Mar. 1969. 325p. Y4.J89/2:Em7/11. Hearing on EEO enforcement in federal contracts by the OFCCP presents testimony focusing on the lack of enforcement. The discrimination faced by minorities and women is stressed by some witnesses, although the issue of sex discrimination is secondary in most testimony. The lack of enforcement in regard to specific contractors is illustrated with southern textile mills receiving heavy criticism.

351. U.S. Equal Employment Opportunity Commission. *Hearings before the United States Equal Employment Opportunity Commission on Utilization of Minority and Women Workers in Certain Major Industries, Hearing Held in Los Angeles, California, March 12-14, 1969.* Washington, DC: GPO, 1969. 712p. Y3.Eq2:2M66/3. Hearings on the utilization of minorities and women in the major industries of the Los Angeles area primarily deals with the aerospace, entertainment, and banking industries. Industry witnesses answered questions on number of women and minorities employed, salaries, and recruitment and promotion practices.

352. U.S. Equal Employment Opportunity Commission. *Toward Job Equality for Women.*
 Washington, DC: GPO, 1969. 10p. Y3.Eq2:2W84. Overview of the provisions of the
 Civil Rights Act of 1964 as it relates to sex discrimination by employers, unions, and
 employment agencies.

353. U.S. Women's Bureau. *How You Can Help Reduce Barriers to the Employment of Mature
 Women.* Washington, DC: GPO, 1969. 7p. L13.2:Em7/15. Basic information on the
 employment barriers faced by women over 40 and of federal and state laws aimed at
 eliminating age discrimination accompanies ideas for community education projects.

354. U.S. Women's Bureau. *Sex Discrimination in Employment Practices.* Washington, DC:
 GPO, 1969. 34p. L13.2:Em7/14. Proceedings of a conference sponsored by UCLA and
 the bureau reprints papers presented on legislation, compliance procedures, interpretation
 of laws, and women's position in the labor force. Proposes an outline of basic steps to
 eliminate sex discrimination.

355. U.S. Equal Employment Opportunity Commission. *They Have the Power - We Have the
 People: The Status of Equal Employment Opportunity in Houston, Texas, 1970.*
 Washington, DC: GPO, 1970. 103p. Y3.Eq2:2P87. Summary of a hearing on utilization
 of women and minorities in Texas industries includes excerpts from testimony relating to
 equal employment opportunity for women.

356. U.S. Commission on Civil Rights. *Equal Employment Opportunity under Federal Law:
 A Guide to Federal Law Prohibiting Discrimination on Account of Race, Religion, Sex, or
 National Origin in Private and Public Employment.* Clearinghouse Publication no. 17.
 Washington, DC: GPO, 1971. 27p. CR1.10:17. Summary of federal laws prohibiting
 discrimination on the basis of race, religion, or sex accompanies information on how to
 file a compliant.

357. U.S. Congress. House. Committee on Education and Labor. General Subcommittee on
 Labor. *Equal Employment Opportunity Enforcement Procedures, Hearings on H.R. 1746.*
 92d Cong., 1st sess., 3-18 Mar. 1971. 521p. Y4.Ed8/1:Em7/10/971. Hearing considers
 a bill which would establish enforcement procedures for the EEOC and extend the
 commission's jurisdiction to federal, state, county and municipal employees. Testimony
 highlights the inadequacy of the system in place and presents information on discrimination
 in civil service employment and on continued discrimination in the private sector.

358. U.S. Congress. Senate. Committee on Labor and Public Welfare. *Equal Employment
 Opportunities Enforcement Act of 1971, Hearings on S. 2515, S. 2617, H.R. 1746.* 92d
 Cong., 1st sess., 4-7 Oct. 1971. 525p. Y4.L11/2:Em7/16/971. Hearing considers
 legislation to provide enforcement authority to the EEOC, to consolidate federal EEO
 enforcement, to extend coverage to employers with 8 or more employees, and to extend
 coverage to state and local employers and teachers. Discussion centers on whether
 proposed changes would increase enforcement effectiveness. Includes discussion of the
 treatment of sex discrimination cases in federal courts.

359. U.S. Equal Employment Opportunity Commission. *Hearings before the United States
 Equal Employment Opportunity Commission on Utilization of Minorities and Women
 Workers in Certain Major Industries, Hearing Held in Houston, Texas, June 2-4, 1970.*
 Washington, DC: GPO, 1971. 705p. Y4.Eq2:2M66/3/970. EEOC hearing held in
 Houston on the utilization of women and minorities in major industries focuses on oil
 companies but includes company witnesses from U.S. Plywood, Champion Papers,
 Cameron Iron Works, IBM, and a local department store. The hearing examines
 employment practices including recruitment, promotion, salaries, and the role of unions.

Oil companies represented include American Oil Company, Gulf Oil Company, and Shell Oil Company.

360. U.S. Equal Employment Opportunity Commission. Office of Research. *Employment of Minorities and Women in Commercial Banking.* Research Report no. 32. Washington, DC: The Office, 1971. 33p. Y3.Eq2:11/971-32. Analyzes the structure of the banking industry and the federal government's role in enforcing EEO. The dismal track record of banks in hiring minorities and the trend of women bank employees to be clustered in the clerical ranks is described as are regional differences in the employment of minorities and women.

361. U.S. Congress. Senate. Committee on the Judiciary. Subcommittee on Antitrust and Monopoly. *Controls or Competition, Hearings.* 92d Cong., 2d sess., 18-21 Jan. 1972. 313p. Y4.J89/2:Ec7/2. Hearing examining the role of competition in the U.S. economy, particularly as it applies to employment, includes testimony on race and sex discrimination. The theory that increased competition will force large corporations to hire the best talent, including more minorities and women, is discussed. Data on participation of blacks and females in large firms and an analysis of company policies is provided.

362. U.S. Equal Employment Opportunity Commission. *Promise vs. Performance: A Study of Equal Employment Opportunity in the Nation's Electric and Gas Utilities.* Washington, DC: GPO, 1972. 168p. Y3.Eq2:2P94. Hearing examines the employment practices of 14 utility companies in relation to employment of minorities and women. The appendix includes data on employment in utility companies by race, sex, and occupational groups, and occupational distribution of women and minorities.

363. U.S. Equal Employment Opportunity Commission. Office of Research. *Employment Problems of Women, a Classic Example of Discrimination.* Research Report no. 37. Washington, DC: GPO, 1972. 47p. Y3.Eq2:11/972-37. Overview of data on the situation of women in the labor force looks at labor force segregation, wage differentials, and labor union memberships. Also examines the conflict between Title VII and state protective labor laws. Background statistics presented include women by occupational group, 1940 and 1970; portion of family income contributed by working wives; labor force participation rates of mothers, 1940 to 1970; women's income by educational attainment; income by occupation and sex; employment status of female family heads; and unemployment rates of women, 1957-70.

364. U.S. Congress. House. Committee on Interstate and Foreign Commerce. Subcommittee on Communications and Power. *Broadcast License Renewal, Part 1, Hearings.* 93d Cong., 1st sess., 14 Mar. - 18 Sept. 1973. 594p. Y4.In8/4:93-35. Hearing on broadcast license renewal regulations of the FCC explores the absence of women and minorities in the field of communications. Witnesses detail the lack of programming for women and minorities, their stereotyped portrayal, and the failure of stations to employ women and minorities in visible positions. Actions by local and national groups petitioning for denial of broadcast licenses to stations and networks which discriminate against women and minorities are detailed.

365. U.S. Dept. of Housing and Urban Development. *Executive Order 11246 Contract Compliance Handbook.* HUD Handbook 8000. Washington, DC: GPO, 1973. 118p. HH1.6/6:8000.6. Basic statutory, regulatory, policy, and procedural information for HUD office compliance with Executive Order 11246.

366. U.S. Equal Employment Opportunity Commission. *Affirmative Action Programs for Women: A Survey of Innovative Programs.* by Jerolyn R. Lyle. Washington, DC: GPO, 1973. 150p. Y3.Eq2:2W84/2. Review of the literature on women's economic status

accompanies the results of a study of affirmative action in a small group of firms and an empirical study of a large sample of industrial and non-industrial firms. Makes recommendations to the EEOC on promoting more effective affirmative action programs in private industry, and includes a lengthy annotated bibliography on women in society and at work.

367. U.S. Equal Employment Opportunity Commission. *Legal Services Manual for Title VII Litigation.* by National Employment Law Project. New York: National Employment Law Project, 1973. 121p. Y3.Eq2:8SE6. Reviews Title VII and related court cases defining discriminatory employment practices based on race and sex.

368. U.S. Women's Bureau. *Laws on Sex Discrimination in Employment: Federal Civil Rights Act, Title 7, State Fair Employment Practice Laws, Executive Orders.* Washington, DC: The Bureau, 1973. 39p. L36.102:Em7. Summary of Title VII of the Civil Rights Act of 1964 and of state fair employment practice laws as they relate to women reprints the Federal Guidelines on Discrimination Because of Sex. Earlier editions published in 1965 and 1970 under SuDoc number L13.2:Em7/10/year and in 1967 under SuDoc number L13.2:Se9.

369. U.S. Bureau of Intergovernmental Programs. *Equal Employment Opportunity Court Cases.* Washington, DC: GPO, 1974. 85p. CS1.2:Em7/17. Summary of EEO court cases presents the facts of each case and the decision of the court.

370. U.S. Civil Service Commission. *Interviewing Women Candidates.* Washington, DC: GPO, 1974. leaflet. CS1.48:BRE-54. Checklist of the things to avoid when interviewing female job candidates lists inappropriate questions and unacceptable interviewing behavior.

371. U.S. Commission on Civil Rights. *Guide to Federal Laws Prohibiting Sex Discrimination.* Clearinghouse Publication no. 46. Washington, DC: GPO, 1974. 113p. CR1.10:46. Describes federal laws and agency regulations and policies which prohibit discrimination on the basis of sex.

372. U.S. Congress. House. Committee on Education and Labor. Special Subcommittee on Education. *Federal Higher Education Programs Institutional Eligibility.* 93d Cong., 2d sess., 8 Aug. - 25 Sept. 1974. 1418p. Y4.Ed8/1:Ed8/49/pt.2A-2B. Lengthy hearing presents a variety of views on the implementation of affirmative action at colleges and universities. The state of both student admissions and employment are examined in relation to discrimination against women and minorities. The administrative problems of affirmative action and the charges of reverse discrimination are also reviewed. The performance of the government in determining eligibility for federal contracts is severely criticized noting failure to deny contracts to discriminatory institutions and slow approval of affirmative action plans. Part 2B, the appendix to the hearings, provides supporting materials such as excerpts of laws, departmental regulations, statements, and articles. Articles focus on the issue of quotas and university implementation of affirmative action, and describe discrimination against women in higher education.

373. U.S. Congress. Joint Economic Committee. Subcommittee on Fiscal Policy. *Federal Contract Compliance Activities, Hearings.* 93d Cong., 2d sess., 11,12 Sept. 1974. 106p. Y4.Ec7:C73/2. Oversight on federal contract compliance explores charges that government contracts are awarded without review of affirmative action plans and without checking with the EEOC to determine if the potential contractor has outstanding complaints. The status of women in the GSA is explored and activities under the Federal Women's Program at GSA are described. The need for record keeping and reporting to determine the progress of employment of women and minorities by contractors is stressed. In particular the OFCC's slowness to establish guidelines on sex discrimination is explored.

374. U.S. Equal Employment Opportunity Commission. *Affirmative Action and Equal Employment Guidebook for Employers.* 2 vol. Washington, DC: GPO, 1974. Y3.Eq2:2Em7/3/v.1-2. Detailed information for employers on setting up AA/EEO programs provides practical information on areas of focus and a review of past court cases related to employment discrimination. Specifically addresses sex discrimination and related AA/EEO actions. Appendices include sample forms, data sources for utilization analysis, resources for recruitment, and reprints of federal guidelines and regulations.

375. U.S. Manpower Administration. *Equal Employment Opportunity, a Guide for Prime Sponsors under Comprehensive Employment and Training Act of 1973.* Washington, DC: The Administration, 1974. 32p. L1.7/2:Em7/3. Information for CETA prime sponsors on ensuring equal employment opportunity in their programs specifically discusses actions which may be discriminatory toward women applicants. Provides details on planning, implementing and reviewing EEO/AA plans.

376. U.S. Women's Bureau. *Steps to Advance Equal Employment Opportunity for Women.* Washington, DC: The Bureau, 1974. 2p. L36.102:Op6.

377. U.S. Commission on Civil Rights. *Affirmative Action in Employment in Higher Education: A Consultation Sponsored by the United States Commission on Civil Rights, Washington, D.C., Sept. 9-10, 1975.* Washington, DC: The Commission, 1975. 239p. CR1.2:Em7/9. Consultation on affirmative action in higher education looks at the history, case law and HEW enforcement of equal opportunity for minorities and women as faculty. The argument is presented that affirmative action is not necessary in higher education as a whole, because for most institutions there is not a record of past discrimination. Provides data on academic year salaries by sex and marital status, 1968-69.

378. U.S. Congress. House. Committee on Education and Labor. Subcommittee on Equal Opportunities. *Oversight Hearings on Federal Enforcement of Equal Employment Opportunity Laws, Part 1.* 94th Cong., 1st sess., 27 Mar. - 8 July 1975. 301p. Y4.Ed8/1:Em7/18/pt.1. Continued hearings examine federal enforcement of Executive Order 11246 by the Federal Office of Contract Compliance. Testimony centers on contractors' affirmative act efforts and enforcement procedures relating to federal contractors' EEO efforts.

379. U.S. Congress. House. Committee on Education and Labor. Subcommittee on Equal Opportunities. *Oversight Hearings on Federal Enforcement of Equal Employment Opportunity Laws, Part 2.* 94th Cong., 1st sess., 22-30 Sept. 1975. 129p. Y4.Ed8/1:Em7/18/pt.2. Government officials from HEW and EEOC focus on procedures to address the backlog of discrimination cases awaiting action and on actions to ensure federal agency support of EEO/AA.

380. U.S. Congress. House. Select Committee on Aging. Subcommittee on Retirement Income and Employment. *Age and Sex Discrimination in Employment and Review of Federal Response to Employment Needs of the Elderly, Hearing.* 94th Cong., 1st sess., 10 Dec. 1975. 66p. Y4.Ag4/2:Em7. Information gathering hearing on the employment problems of older Americans, particularly older women, notes the double burden of age and sex discrimination. Sex discrimination in Social Security law is also discussed, and enforcement of anti-age discrimination law is reviewed.

381. U.S. Equal Employment Opportunity Commission. Educational Programs Division. Office of Voluntary Programs. *A Directory of Resources for Affirmative Recruitment.* Washington, DC: GPO, 1975. 9p. Y3.Eq2:2R24. Lists publications and organizations which can help in the recruitment of minorities and women. Entries for organizations provide a summary of objectives and services.

382. U.S. Manpower Administration. *Job Title Revisions to Eliminate Sex- and Age-Referent Language from the Dictionary of Occupational Titles, Third Edition.* Washington, DC: GPO, 1975. 363p. L7.2:Oc1/965/title rev. Revisions to the 1965 edition of the *Dictionary of Occupational Titles* eliminates sex specific language from job titles.

383. U.S. Commission on Civil Rights. *The Challenge Ahead: Equal Opportunity in Referral Unions.* Washington, DC: GPO, 1976. 291p. CR1.2:C35. Report looks at membership and discriminatory practices toward minorities and women in referral unions and their effect on the entry of women and minorities into building trades and the surface transportation industry. Federal enforcement efforts are also examined. Provides statistics on wage and salary workers in labor unions and membership rates by occupation, sex, and race, 1970; earnings distribution of year-round, full-time wage and salary workers by occupation, labor union membership, sex and race, 1970; minorities and women in building trade unions and average wage rates, 1972; minorities and women in elective and appointive positions in thirteen local unions, 1973 and 1974; minorities and women in craft and operative occupations, 1970; and median earnings of union members by sex and race, 1970.

384. U.S. Commission on Civil Rights. *Last Hired, First Fired: Informal Hearing before the United States Commission on Civil Rights, Washington, D.C., October 12, 1976.* Washington, DC: The Commission, 1976? 105p. CR1.8:W27/2. Before publishing its report on the "last hired, first fired" issue, the commission convened a panel to discuss the topic from economic, legal, labor relation, and affirmative action perspectives.

385. U.S. Commission on Civil Rights. Colorado Advisory Committee. *Access to the Legal Profession in Colorado by Minorities and Women.* Washington, DC: The Commission, 1976. 108p. CR1.2:L52. Report illustrates the need for the University of Colorado School of Law and the University of Denver College of Law to make progress in hiring minority and women faculty and discusses the need to effectively address harassment and discrimination within the programs. Provides background statistics on the number of women enrolled at the University of Colorado School of Law, 1966 - 1974, and on applications to the Colorado Bar and pass rates by minority group and sex, 1972 - 1975.

386. U.S. Commission on Civil Rights. Montana Advisory Committee. *The Media in Montana: Its Effect on Minorities and Women.* Washington, DC: The Commission, 1976. 70p. CR1.2:M76. Study of the mass media in Montana found that newspapers and television stations had few women and almost no Native Americans in reporter or managerial positions. The image of women and minorities portrayed tended to be stereotyped or to present a negative image. The report highlights the need for training or internship programs.

387. U.S. Commission on Civil Rights. New York State Advisory Committee. *Equal Employment Opportunity at the State University of New York.* Washington, DC: The Commission, 1976. 69p. CR1.2:Em7/8. Failure to comply with federal rules requiring affirmative action plans at educational institutions receiving federal funds at the campuses of the SUNY system is documented in this report. Provides statistics on faculty and administrative staff by sex, administrative staff by sex and grade level, and faculty by sex and tenure status.

388. U.S. Congress. House. Committee on Education and Labor. Subcommittee on Equal Opportunities. *Oversight Hearings on Federal Enforcement of Equal Employment Opportunity Laws, Part 3.* 94th Cong., 2d sess., 20-22 Jan. 1976. 356p. Y4.Ed8/1:Em7/18/pt.3. Testimony from minority and women's groups highlights problems in EEO program enforcement and comments on proposed changes to address these problems. Employment discrimination in both the public and private sectors is

examined with specific reference to the banking industry and to companies who employ personnel overseas.

389. U.S. Congress. Senate. Committee on Banking, Housing, and Urban Affairs. *Treasury Department's Administration of the Contract Compliance Program for Financial Institutions, Hearings.* 94th Cong., 2d sess., 2-3 Aug. 1976. 271p. Y4.B22/3:F49/17. Examination of the Department of the Treasury's enforcement of equal employment opportunity in the banking industry is critical of the contract compliance process and on the department's track record. Witnesses describe the extent of discrimination against minorities and women in the banking industry.

390. U.S. Equal Employment Opportunity Commission. *EEO: Where Do We Go from Here? Seminars on Equal Employment Opportunity.* Washington, DC: GPO, 1976. 203p. Y3.Eq2:2Em7/6. Report on three regional seminars addressing equal employment opportunity and affirmative action provides an overview of the history of EEO/AA legislation and court decisions. Panel sessions explore issues of compliance, enforcement, and the complaint process.

391. U.S. National Institute of Education. *Sex Discrimination in the Selection of School District Administrators: What Can be Done?* by Doris M. Timpano and Louise W. Knight. Papers in Education and Work no. 3. Washington, DC: The Institute, 1976. 65p. HE19.212:3. Report describing the formation and activities of the Council on Women's Education, a Long Island based group working to improve the representation of women in school administrator positions, also serves as a handbook for the organization of similar groups.

392. U.S. Office of Education. *Equal Employment Opportunity.* by National Foundation for the Improvement of Education. Resource Center on Sex Roles in Education. Washington, DC: GPO, 1976. poster. HE1.43:Eq2.

393. U.S. Civil Service Commission. *A List of Speakers on Issues Concerning Hispanic Women.* Washington, DC: GPO, 1977. 38p. CS1.2:H62/2. List of available speakers on issues concerning Hispanic women is followed by recommended actions for federal officials to improve equal employment opportunities for Hispanic women.

394. U.S. Commission on Civil Rights. *Hearing Held in Los Angeles, California, March 16, 1977.* Washington, DC: The Commission, 1977. 174p. CR1.8:L89a/977. Inquiry into affirmative action in the movie industry looks at employment of women and minorities at all levels from stage craft workers to producers.

395. U.S. Commission on Civil Rights. *Last Hired, First Fired: Layoffs and Civil Rights.* Washington, DC: GPO, 1977. 89p. CR1.2:L45. The 1974-1975 economic recession prompted this examination of layoffs and their effect on achieving racial and gender balance in the work force. Strict use of seniority systems in implementing cutbacks was found to result in a disproportionate number of women and minorities among the jobless. Alternative methods of cutbacks are discussed. Provides statistics on labor force participation by age, sex, and race; occupational distribution of Spanish origin population by sex, 1960-1973; and unemployment rates by age, sex, and race.

396. U.S. Commission on Civil Rights. *Window Dressing on the Set: Women and Minorities in Television.* Washington, DC: GPO, 1977. 181p. CR1.2:W72. Study of the employment of women in television found underrepresentation and stereotyped portrayals of women and minorities in television drama. The investigation also found that women were excluded from decision-making positions at local television stations. The report criticizes the FCC for its failure to take steps to correct these situations.

397. U.S. Equal Employment Opportunity Commission. *Questions and Answers Concerning the EEOC Guidelines on Discrimination Because of Sex.* Washington, DC: GPO, 1977? 14p. Y3.Eq2:2Se9. EEOC guidelines on sex discrimination covers topics such as pregnancy and maternity leave.

398. U.S. Equal Employment Opportunity Commission. *Women: The Path to Equal Employment.* by Melvin Humphrey. Research Report no. 56. Washington, DC: GPO, 1977. 211p. Y3.Eq2:11/56. Study examines the occupational status of women between 1966 and 1975, looking at the gap between employment experience and expectations and the economic loss due to discrimination. Provides yearly statistics on occupational distribution, participation rates, and median earnings by occupation, and describes projects for closing the wage and participation gap.

399. U.S. Office of Education. *Selecting Professionals in Higher Education: A Title IX Perspective.* by Emily Taylor and Donna Shavlik, Resource Center for Sex Roles in Education. Washington, DC: GPO, 1977. 25p. HE19.102:P94/3. Guide to gender-fair professional employment practices required by Title IX summarizes the relevant federal laws and executive orders, and examines the current status of women professionals in higher education. General considerations on fair employment practices and on the selection process are reviewed.

400. U.S. Women's Bureau. *Brief Highlights of Major Federal Laws and Orders on Sex Discrimination in Employment.* Washington, DC: The Bureau, 1977. 4p. L36.102:Se9/977. Notes the provisions of the Equal Pay Act of 1963, Title VII of the Civil Rights Act of 1964, the Equal Employment Opportunity Act of 1972, Executive Orders 11246 and 11375, and Title IX of the Education Amendments of 1972 that affect women. Earlier edition published in 1972.

401. U.S. Commission on Civil Rights. California Advisory Committee. *Behind the Scenes: Equal Employment Opportunity in the Motion Picture Industry.* Washington, DC: GPO, 1978. 48p. CR1.2:Em7/12. Study concludes that continued reliance on word-of-mouth recruiting and seniority systems, coupled with weak federal enforcement efforts have resulted in negligible gains for minorities and women at the major motion picture studios between 1969 and 1977. Statistics on industry experience rosters by race and sex and employees of major studios by job category, sex and race supplement the report.

402. U.S. Commission on Civil Rights. Ohio Advisory Committee. *Affirmative Action or Inaction?: The Pursuit of Equal Employment Opportunity in Cleveland.* Washington, DC: GPO, 1978. 77p. CR1.2:Af2. Study of the employment situation of minorities and women in Cleveland found a pattern similar to the nation as a whole. Women and minorities were concentrated in low paying jobs and, even among professional positions, they earned significantly less than white males. Within the Cleveland city government the inequities were even more pronounced. Court cases documenting the discriminatory practice of the city government are reviewed and the adequacy of the city's proposed affirmative action and contract compliance plans are brought into question.

403. U.S. Congress. House. Committee on Education and Labor. Subcommittee on Employment Opportunities. *Oversight on Federal Enforcement of Equal Employment Opportunity Laws, Hearings.* 95th Cong., 2d sess., 28-29 Nov. 1978. 537p. Y4.Ed8/1:Eq2/2/978. Testimony from commission administrators and representatives of civil rights organizations highlight the programs and problems of EEOC's enforcement of equal employment opportunity law. Much of the focus is on EEOC's litigation effectiveness and on the inadequacy of settlements. Also covered are methods of assessing "comparable worth" between male and female job classifications.

404. U.S. Congress. House. Committee on Interior and Insular Affairs. *Further Amending the Mineral Leasing Act of 1920 (30 U.S.C. 201(a)), Authorizing the Secretary of the Interior to Exchange Federal Coal Leases and Encouraging Recovery of Certain Coal Deposits, and for Other Purposes, Report to Accompany H.R. 13553.* H. Rept. 95-1635, 95th Cong., 2d sess., 1978. 17p. Serial 13201-13. One of the amendments to this bill on federal coal leases repeals a clause in the leases prohibiting women from working in underground coal mines.

405. U.S. Dept. of Justice. Task Force on Sex Discrimination. *Interim Report to the President.* Washington, DC: GPO, 1978. 346p. J1.2:In8/2. Review of all federal regulations, guidelines, programs and policies related to sex discrimination also examines issues such as Social Security, taxes and sex discrimination in federally assisted programs.

406. U.S. Employment and Training Administration. *Women in Traditionally Male Jobs: The Experience of Ten Public Utility Companies.* R & D Monograph no. 65. Washington, DC: GPO, 1978. 136p. L37.14:65. Evaluates programs in ten public utility companies which were designed to move women into jobs traditionally held by men and to overcome sex discrimination. Attitudes of supervisors, male coworkers and subordinates were examined, and information on the experience of the 164 women participants was collected.

407. U.S. Women's Bureau. *References and Data Sources for Implementing an Affirmative Action Program.* Washington, DC: The Bureau, 1978. 5p. L36.102:R25. Annotated list of directories and registries for locating affirmative action applicants also references printed material on EEO/AA laws and regulations, and major data sources on educational attainment and labor force analysis.

408. U.S. Commission on Civil Rights. *Window Dressing on the Set: An Update.* Washington, DC: GPO, 1979. 97p. CR1.2:W72/update. Follow-up to a study (396) found little change in the portrayal of women and minorities on television programs or in their presence as correspondents on network news. The report also notes their continued underrepresentation in official and managerial positions at television stations.

409. U.S. Commission on Civil Rights. Nebraska Advisory Committee. *Private Sector Affirmative Action: Omaha.* Washington, DC: GPO, 1979. 40p. CR1.2:Om1. Study examined employment practices in private companies covered by Nebraska's EEO statutes with particular emphasis on recruitment and upward mobility. Also reviewed is the success of Omaha area job training and placement programs in private industry. Provides statistics on utilization of minorities and women by occupation at five Omaha employers.

410. U.S. Congress. Senate. Committee on Labor and Human Resources. Subcommittee on Health and Scientific Research. *Women in Science and Technology Equal Opportunity Act, 1979, Hearing on S. 568.* 96th Cong., 1st sess., 1 Aug. 1979. 105p. Y4.L11/4:W84/2/979. Much of the testimony in this hearing focuses on the treatment of women in the areas of insurance coverage, medical treatment and medical research by a male-dominated health care system. The need to encourage the entry of women into science fields is highlighted as is discrimination against women as faculty in the sciences. Also includes information on women's caucuses in the scientific fields.

411. U.S. Office of Intergovernmental Personnel Programs. *Equal Employment Opportunity Court Cases.* Washington, DC: GPO, 1979. 146p. PM1.2:Em7. Compilation of appellate court level cases on EEO/AA provides a concise summary of each case, highlights the basic facts and central issue in the case, and discusses the court opinion.

412. U.S. Congress. House. Committee on Education and Labor. Subcommittee on Employment Opportunities. *Oversight Hearing on the Federal Enforcement of Equal Employment*

Opportunity Laws, Hearing. 96th Cong., 2d sess., 19 Aug. 1980. 98p. Y4.Ed8/1:Eq2/2/980. Testimony from EEOC, OPM, union, and special interest group representatives explores the effectiveness of EEO/AA practices in federal agencies. The underutilization of women and minorities by all agencies except EEOC, the Commission on Civil Rights, and ACTION are documented. Provides background statistics on number and percentage of women and minorities employed by government agencies by GS and WG level.

413. U.S. Congress. House. Select Committee on Aging. *Media Portrayal of the Elderly, Hearing.* 96th Cong., 2d sess., 26 Apr. 1980. Los Angeles, CA. 99p. Y4.Ag4/2:El2/23. Hearing testimony explores the implications of the portrayal of the elderly in television and movies. The tendency of television to offer few female roles and the stereotypical nature of the roles available are discussed in terms of their impact on the employment prospects of older actresses.

414. U.S. Congress. Senate. Committee on Labor and Human Resources. Subcommittee on Health and Scientific Research. *Women in Science and Technology Equal Opportunity Act, 1980, Hearing on S. 568.* 96th Cong., 2d sess., 3 Mar. 1980. 235p. Y4.L11/4:W84/2/980. Hearing on legislation to encourage education, research, and employment opportunities for women in scientific and technical fields highlights cases of sex discrimination in research and promotion opportunities and presents general trends indicating systematic discrimination. Testimony furnishes a good overview of federal programs supporting women in the sciences. Provides statistics on doctoral scientists and engineers by employment sector and sex; percentage of Ph.D.-holding women employed in industry and percentage available, 1977; four year growth in research and development personnel who hold science and engineering doctorates by industry and increase in number of women; and primary work activities of doctoral scientists and engineers in industry by field and sex, 1977.

415. U.S. Equal Employment Opportunity Commission. *Eliminating Discrimination in Employment: A Compelling National Priority: A Handbook for State, County and Municipal Government.* Washington, DC: GPO, 1980. 172p. Y3.Eq2:8D63. Provides information on federal laws and orders related to employment discrimination written specifically for state, county and municipal government. Covers laws prohibiting discrimination by all employers, prohibiting discrimination as a condition of federal financial assistance, and prohibiting discrimination in specific federally funded programs. Appendix reprints important legal and interpretive documents.

416. U.S. Equal Employment Opportunity Commission. *Hearings before the United States Equal Employment Opportunity Commission on Job Segregation and Wage Discrimination.* Washington, DC: GPO, 1980. 858p. Y3.Eq2:2J57/6. Testimony at hearings on job segregation and wage discrimination highlights the causes and consequences of the predominance of women and minorities in the lowest paying jobs. Issues discussed include comparable worth, education, promotion opportunities, compensation in female dominated occupations, and the role of unions. The effect of existing legislation such as Title VII, the Equal Pay Act, and Title IX are examined, and possible courses of action to address the problem are explored.

417. U.S. General Accounting Office. Comptroller General. *Employment Service Needs to Emphasize Equal Opportunity in Job Referrals.* Washington, DC: The Office, 1980. 40p. GA1.13:HRD-80-95. Study of the U.S. Employment Service found a pattern of referrals of women and minorities to lower paying jobs traditionally held by these groups. Factors which affect this trend and actions the Labor Department could take to address the situation are discussed. Statistics on placement of male and female job seekers by hourly wage are furnished.

418. U.S. National Criminal Justice Reference Service. *Affirmative Action Equal Employment Opportunity in the Criminal Justice System: A Selected Bibliography*. Washington, DC: The Service, 1980. 49p. J28.11:Af2. Annotated bibliography on affirmative action and equal employment opportunity in the criminal justice system includes books, pamphlets, research reports, journal articles and government documents.

419. U.S. Office of Intergovernmental Personnel Programs. *Equal Employment Opportunity Court Cases: 1980 Supplement*. Washington, DC: GPO, 1980. 238p. PM1.2:EM7/supp. Supplement to *Equal Employment Opportunity Court Cases* (411) covers court cases from 1979 to 1980.

420. U.S. Office of Personnel Management. *Workshop on Sexual Harassment: Participant Materials*. Washington, DC: GPO, 1980. 30p. PM1.2:Se9. Participant's manual for a sexual harassment workshop includes statements on sexual harassment, applicable laws and regulations, and workshop exercises to raise awareness of sexual harassment behaviors.

421. U.S. Office of Personnel Management. *Workshop on Sexual Harassment: Trainer's Manual*. Washington, DC: GPO, 1980. 82p. PM1.8:Se9/trainer. Manual for leaders of training sessions on sexual harassment policies for federal employees includes statements on sexual harassment by government officials.

422. U.S. Women's Bureau. *Employment Goals of the World Plan of Action: Developments and Issues in the United States: Report for the World Conference of the United Nations Decade for Women, 1976 - 1985*. Washington, DC: GPO, 1980. 91p. L36.102:Em7/4. Report details actions taken to eliminate discrimination against women in the U.S. from 1975 to 1980 as part of the U.N. Decade for Women's World Plan of Action. The first part of the report provides an excellent overview of the economic role and situation of American women. Current federal and state policy actions are analyzed and set in their historical context in the second part. Some of the policies briefly analyzed include employment training programs such as CETA and WIN, educational equity, and pensions. The initiatives of non-governmental organizations are reviewed in the third section of the report. Provides background statistics on employment and unemployment by sex, 1950-79; labor force participation by sex, age, and race, 1975-79; women's labor force participation by marital status, 1950-79, and by age of children, 1975-79; women employed by industry, 1970-79; and earnings by sex, 1955-78.

423. U.S. Commission on Civil Rights. *Affirmative Action in the 1980s: Dismantling the Process of Discrimination*. Clearinghouse Publication no. 65. Washington, DC: GPO, 1981. 42p. CR1.10:65. In this document the commission analyzes the factors which contribute to the discrimination process and the complex issues of affirmative action. A philosophy of affirmative action for the 1980's is put forward.

424. U.S. Commission on Civil Rights. *Affirmative Action in the 1980s: Dismantling the Process of Discrimination, a Statement of the United States Commission on Civil Rights*. Clearinghouse Publication no. 70. Washington, DC: GPO, 1981. 56p. CR1.10:70. Revised version of Clearinghouse Publication 65 (423) has a new introduction and an appendix, "Guidelines for Effective Affirmative Action Plans."

425. U.S. Commission on Civil Rights. Virginia Advisory Committee. *Sex Discrimination and Title VII in Virginia*. Washington, DC: GPO, 1981. 31p. CR1.2:Se9/2. Study of equal employment opportunity for women in Virginia focuses on the investigation of sex discrimination complaints and the ineffectiveness of regional enforcement due to the absence of any state anti-discrimination laws. Provides statistics for Virginia on labor force participation of women; occupational distribution of female employment, 1940-1977;

occupation of job applicants by sex; educational attainment by income and sex; and labor force participation of women by marital status and number of children.

426. U.S. Congress. House. Committee on Education and Labor. Subcommittee on Employment Opportunities. *Oversight Hearings on Equal Employment Opportunity and Affirmative Action, Part 1.* 97th Cong., 1st sess., 15 July - 7 Oct. 1981. 623p. Y4.Ed8/1:Em7/35/pt.1. Hearing testimony gives a clear picture of the political environment of EEO/AA in the early 1980s. The focus of debate is on proposals by the Reagan administration which undermine affirmative action. The philosophy behind affirmative action is clearly delineated and the issue of reverse discrimination predominates. The construction industry and apprenticeship trades in regard to affirmative action requirements is a recurring topic, particularly in relation to women and training in nontraditional occupations. The views of federal contractors on affirmative action requirements are also presented.

427. U.S. Congress. House. Committee on Education and Labor. Subcommittee on Employment Opportunities. *Oversight Hearings on Equal Employment Opportunity and Affirmative Action, Part 2.* 97th Cong., 1st sess., 11,14 Aug. 1981. Chicago, IL; Los Angeles, CA. 546p. Y4.Ed8/1:Em7/35/pt.2. Hearings on the specific progress and continued problems of women and minorities in the labor force focuses on the situation in Chicago and Los Angeles. Includes employment profiles for major federal contractors in the Chicago area. Testimony indicates both support and lack of support by unions. Many of the statements decry the Reagan administration tactics to weaken affirmative action. EEOC and OFCCP efforts to enforce EEO and affirmative action are also examined. Discrimination against women in the banking industry is specifically highlighted. Includes a concise overview of the position of minority women in the labor force.

428. U.S. Congress. House. Committee on Science and Technology. Subcommittee on Investigations and Oversight. *Genetic Screening and the Handling of High-Risk Groups in the Workplace, Hearings.* 97th Cong., 1st sess., 14,15 Oct. 1981. 319p. Y4.Sci2:97/53. Hearing examines the issues surrounding the use of genetic screening and identification of high-risk individuals as a method of lowering occupational illness. Issues of employment discrimination, particularly the exclusion of fertile women from certain positions due to reproductive hazards, are explored. Concern for the possibility of a shift in focus from eliminating occupational hazards to screening out susceptible individuals is expressed within discussion of the benefits and possible abuses of genetic screening and back x-rays in the workplace.

429. U.S. Congress. Senate. Committee on Labor and Human Resources. *Oversight of the Activities of the Office of Federal Contract Compliance Programs of the Department of Labor, Hearings.* 97th Cong., 1st sess., 8,10 Dec. 1981. 446p. Y4.L11/4:F31/3/pt.2. Continued oversight hearings on enforcement of Executive Order 11246 present testimony on ways the federal government could better promote EEO. A point of debate is the need for goals and timetables to remedy discriminatory practices. Women's rights organizations make a strong case for rigorous enforcement by OFCCP as a means to help establish women's employment in nontraditional occupations.

430. U.S. Congress. Senate. Committee on Labor and Human Resources. *Sex Discrimination in the Workplace, 1981, Hearings.* 97th Cong., 1st sess., 28 Jan., 21 Apr. 1981. 706p. Y4.L11/4:Se9/981. Hearing testimony highlights the concerns of working women including wages and benefits, education and training, and child care. Moving women into higher paying employment is a recurring theme. Also discusses affirmative action and federal contract compliance, comparable worth, discrimination in promotion, sexual harassment, the "pink collar ghetto", and inadequate relief provided by the EEOC.

431. U.S. Forest Service. Pacific Northwest Region. *Understanding Sexual Harassment.* Washington, DC: GPO, 1981. [4]p. leaflet. A13.66/2:Se9.

432. U.S. Commission on Civil Rights. *Nonreferral Unions and Equal Employment Opportunity.* Washington, DC: GPO, 1982. 116p. CR1.2:Un3. A study of labor union actions to ensure nondiscrimination found that most unions have little knowledge of practices of employers which may adversely affect the job advancement of women and minorities. Within unions, few women or minorities were in high level decision-making positions. Union obligations to encourage equal employment opportunity through the collective-bargaining process and the need for the EEOC to encourage unions to move in this direction are noted. Supporting statistics provided include weekly earnings by union representation, race and sex; percentage of union workers by race and sex in selected occupations; and representation of women and minorities in local bargaining units by international union.

433. U.S. Commission on Civil Rights. New Hampshire Advisory Committee. *Sexual Harassment on the Job: A Guide for Employers.* Washington, DC: GPO, 1982. 22p. CR1.6/2:H21. See 446 for abstract.

434. U.S. Commission on Civil Rights. Vermont Advisory Committee. *Sexual Harassment on the Job: A Guide for Employers.* Washington, DC: GPO, 1982. 23p. CR1.6/2:H21/2. See 446 for abstract.

435. U.S. Commission on Civil Rights. Wyoming Advisory Committee. *Corporate Reactions to Workplace Conditions in Wyoming.* Washington, DC: GPO, 1982. 15p. CR1.2:W99/3. Managers and officials of mineral extraction corporations in the Rocky Mountain region were asked to comment on the report *Workplace Conditions in Wyoming: Women and Minorities in the Mineral Extraction Industries*(436). Although some executives rejected the conclusions of the report, others offered suggestions for addressing the problems of sexual harassment and high turnover.

436. U.S. Commission on Civil Rights. Wyoming Advisory Committee. *Workplace Condition in Wyoming: Women and Minorities in the Mineral Extraction Industries.* Washington, DC: The Commission, 1982. 58p. CR1.3:W99/2.

437. U.S. Congress. House. Committee on Education and Labor. Subcommittee on Employment Opportunities. *Report on Affirmative Action and the Federal Enforcement of Equal Employment Opportunity Laws.* 97th Cong., 2d sess., 1982. Committee print. 62p. Y4.Ed8/1:Em7/36. Summary of the background and current status of federal enforcement of EEO laws focuses on affirmative action policy in the early Reagan administration. Graphs illustrate employment of women and minorities in job categories between 1975 and 1979.

438. U.S. Departments of the Army and the Air Force. National Guard Bureau. *Prevention of Sexual Harassment, Guidelines for Commanders, Managers and Supervisors.* Washington, DC: GPO, 1982. 9p. D12.8:600-4. Overview of the legal definitions of sexual harassment furnishes examples from court cases and a review of employer liability for harassment in the work place. Includes a list of do's and don'ts for commanders, managers and supervisors and a policy statement on sexual harassment.

439. U.S. Women's Bureau. *Equal Employment Opportunity for Women: U.S. Policies.* Washington, DC: GPO, 1982. 38p. L36.102:Em7/5. Overview of U.S. laws and regulations promoting women's equality in employment notes continuing barriers to the full utilization of women. Appendix provides a statistical profile of the labor force activity of women, and of the occupations, earnings, and educational attainment of women workers.

440. U.S. Commission on Civil Rights. *Women and Minorities in High Technology: Hearing Held in San Jose, California, September 20-21, 1982.* Washington, DC: GPO, 1983. 274p. CR1.8:Sa5j. Through hearing testimony the position of women and minorities in California's high technology industries is examined.

441. U.S. Congress. House. Committee on Education and Labor. Subcommittee on Employment Opportunities. *Oversight Hearing on the Federal Enforcement of Equal Employment Opportunity Laws, Hearings.* 98th Cong., 1st sess., 26,27 Oct. 1983. 268p. Y4.Ed8/1:Eq2/2/983. Reviews what many witnesses see as the dismantling of past progress made by the EEOC in promoting job equality for minorities and women. Heavy criticism is leveled at the Reagan administration for pursuing a policy of minimal enforcement of Title VII. Although the focus of the hearing is enforcement procedures and reauthorization of EEOC, it includes some specific statements and additional materials on equal pay.

442. U.S. Congress. House. Committee on Education and Labor. Subcommittee on Employment Opportunities. *Oversight Hearings on the OFCCP's Proposed Affirmative Action Regulations, Hearings.* 98th Cong., 1st sess., 15 Apr. - 8 June 1983. 528p. Y4.Ed8/1:Of2/2. Hearing reviews Reagan administration proposals which would weaken contract compliance requirements and obscure discriminatory practices among contractors. Representatives from women's organizations and civil rights groups express their concern over the proposed changes and the dismantling of affirmative action.

443. U.S. National Institute of Justice. *Women Employed in Corrections.* by Jane Roberts Chapman. Washington, DC: GPO, 1983. 149p. J28.2:W84. Major study of the employment status of women in the field of corrections examines the number of women employed and the characteristics of their employment. Information collected in field surveys describe gender differences in career paths, integration into organizations, career goals and job satisfaction, occupational segregation, and upward mobility. The study also examined the extent to which women used anti-discrimination laws to eliminate sex discrimination and the existing laws, such as veterans' preference, which create barriers to women's employment. The issues of inmate privacy and institutional security as they relate to the employment of women is also examined. The report provides a good overview of court cases defining sex discrimination and gender as a bona fide occupational qualification in corrections employment.

444. U.S. Army. *Training in the Prevention of Sexual Harassment: Employee Training.* Washington, DC: GPO, 1984. 78p. D101.6/5:Se9. Training course is designed to help employees identify behaviors which constitute sexual harassment and to deal appropriately and effectively with such behavior.

445. U.S. Army. *Training in the Prevention of Sexual Harassment: Supervisory Training.* Washington, DC: GPO, 1984. 71p. D101.6/5:Se9/super. Training manual provides exercises to help supervisors learn to identify sexual harassment and sex discrimination. Additional exercises focus on appropriate actions to deal with cases of harassment.

446. U.S. Commission on Civil Rights. Massachusetts Advisory Committee. *Sexual Harassment on the Job: A Guide for Employers.* Washington, DC: GPO, 1984. 21p. CR1.6/2:H21/3. The legal basis prohibiting sexual harassment and suggestions for employers to deal with sexual harassment form the core of this guide. Includes a sample sexual harassment policy and a short bibliography.

447. U.S. Congress. House. Committee on Education and Labor. Subcommittee on Employment Opportunities. *Oversight Hearing on the OFCCP's National Self-Monitoring and Reporting System, Hearing.* 98th Cong., 2d sess., 27 June 1984. 138p. Y4.Ed8/1:Of2/3.

Witnesses charge the OFCCP with allowing contractors to cover up weak EEO enforcement. Strong criticism is leveled at OFCCP by representatives of Women Employed and by the NAACP.

448. U.S. Federal Judicial Center. *Manual on Employment Discrimination Law and Civil Rights Actions in the Federal Courts.* Washington, DC: GPO, 1984. 511p. Ju13.10/3:84-1. Contains material for judges highlighting employment discrimination case law and civil rights litigation in the federal courts and presenting guidelines on jury instruction. The Constitution and relevant statutes are discussed in relation to employment discrimination.

449. U.S. Veterans Administration. Office of Equal Opportunity. *Veterans Administration Program Guide, Determining the Acceptability of Discrimination Complaints, a Guide to Field Equal Employment Opportunity Officers.* Washington, DC: The Office, 1984? 49p. VA1.10:D63/2. Guide to factors to consider in accepting a complaint of discrimination in the Veterans Administration based on race, color, sex, religion, age, national origin or handicap. Includes a step-by-step chart to be used in judging the acceptability of a complaint.

450. U.S. Congress. House. Committee on Education and Labor. Subcommittee on Employment Opportunities. *Oversight Hearings on EEOC's Proposed Modification of Enforcement Regulations, Including Uniform Guidelines on Employee Selection Procedures, Hearing.* 99th Cong., 1st sess., 2 Oct. 1985. 331p. Y4.Ed8/1:99-63. Investigation of EEOC's enforcement approach under Clarence Thomas and the Reagan administration voices support for goals and timetables as effective means of addressing past discrimination and criticizes the administration's undermining of cases involving systematic discrimination. Revision of employee selection procedures is also a topic of debate, particularly noting the validity of employment tests.

451. U.S. Congress. House. Committee on Education and Labor. Subcommittee on Employment Opportunities. *Oversight Hearing on the Equal Employment Opportunity Commission's Enforcement Policies, Hearing.* 99th Cong., 1st sess., 18 July 1985. 80p. Y4.Ed8/1:99-27. Criticism of the EEOC's enforcement policy under the Reagan administration provides discussion of discriminatory actions not addressed by the EEOC's approach. The use of statistics and class action suits are specifically addressed.

452. U.S. Congress. House. Committee on Education and Labor. Subcommittee on Employment Opportunities. *Oversight Review of the Department of Labor's Office of Federal Contract Compliance Programs and Affirmative Action Programs, Hearing.* 99th Cong., 1st sess., 18 Sept. 1985. 231p. Y4.Ed8/1:99-62. The continued need for affirmative action to ensure equal opportunity for minorities and women is stressed in this hearing held in response to Reagan administration policy on Executive Order 11246 enforcement. Witnesses present evidence that affirmative action has been effective in improving the situation of women and minorities. The challenge to the use of statistics in evaluating discrimination cases is discussed.

453. U.S. Congress. House. Committee on the Judiciary. Subcommittee on Civil and Constitutional Rights. *Affirmative Action and Federal Contract Compliance, Hearing.* 99th Cong., 1st sess., 7 Nov. 1985. 217p. Y4.J89/1:99:52. The use of statistical evidence in proving discrimination is discussed in this hearing on the federal government's approach to affirmative action. The appropriateness of requiring numerical goals for federal contractors and the oversight of compliance activities are discussed with emphasis on the issue of quotas.

454. U.S. Congress. House. Committee on the Judiciary. Subcommittee on Civil and Constitutional Rights. *Authorization Request for the Civil Rights Division of the*

Department of Justice, Oversight Hearings. 99th Cong., 1st sess., 3-17 April 1985. 606p. Y4.J89/1:99/27. Oversight hearing on the Civil Rights Division of the Department of Justice severely criticizes the department's stance on affirmative action. The department's ultraconservative application of the *Stotts* decision is the focus of testimony.

455. U.S. Congress. House. Committee on the Judiciary. Subcommittee on Civil and Constitutional Rights and U.S. Congress. House. Committee on Education and Labor. Subcommittee on Employment Opportunities. *Affirmative Action, Joint Oversight Hearings.* 99th Cong., 1st sess., 10,11 July 1985. 435p. Y4.J89/1:99/34. Hearing on affirmative action in the wake of the Supreme Court's decision in *Firefighters Local 1784 v. Stotts* includes harsh criticism of the administration's policy on affirmative action. The success of affirmative action in opening employment opportunities for women and minorities is reviewed and arguments for strong enforcement of Title VII are presented. Factors other than overt discrimination which may affect the promotion of women are explored in articles submitted for the record. Numerous related articles and documents are printed in the record including the Commission on Civil Rights publication, *Toward Understanding of Stotts.*

456. U.S. Western Area Power Administration. Office of Equal Opportunity. Federal Women's Program. *Prevention of Sexual Harassment in the Work Place.* Washington, DC: GPO, 1985. 67p. E6.8:Se9. Explores sexual harassment in all its complexity, offers advice on dealing with sexual harassment in the workplace, and reviews related case law.

457. U.S. Congress. House. Committee on Education and Labor. Subcommittee on Employment Opportunities. *Equal Employment Opportunity Commission Policies Regarding Goals and Timetables in Litigation Remedies, Hearings.* 99th Cong., 2d sess., 11,13 Mar. 1986. 311p. Y4.Ed8/1:99-97. EEOC chairman Clarence Thomas defends the commission's antagonistic attitude toward goals and timetables to redress discrimination. Critics of EEOC under the Reagan administration support progress made under affirmative action policies and reject the EEOC's interpretation of the *Stotts* decision. The administration's viewpoint that affirmative action results in reverse discrimination and the hiring of unqualified women and minorities is disputed. A summary of EEOC lawsuits in fiscal year 1985 is provided. The use of statistics in finding for discrimination and in assessing progress is discussed.

458. U.S. Congress. House. Committee on Education and Labor. Subcommittee on Employment Opportunities. *Women in the Work Force: Supreme Court Issues.* 99th Cong., 2d sess., 30 Sept. 1986. 118p. Y4.Ed8/1:99-135. Testimony highlights the changing status of women resulting from their increased representation in the labor force. The primary themes of testimony are affirmative action and the working woman, how affirmative action has made a difference, and how the Supreme Court has interpreted affirmative action. Of major concern is the trend toward a more conservative Supreme Court. The pervasiveness of employment discrimination against women of color is also highlighted through an examination of the their current status in the labor force. Sexual harassment as a form of sex discrimination as defined in case laws is reviewed in depth.

459. U.S. Congress. Senate. Committee on the Judiciary. *Nomination of Justice William Hubbs Rehnquist, Hearings.* 99th Cong., 2d sess., 29 July - 1 Aug. 1986. 1165p. Y4.J89/2:S.hrg.99-1067. Confirmation hearings on the nomination of Justice William Rehnquist to be Chief Justice of the Supreme Court includes lengthy discussion of his position on civil rights. Justice Rehnquist's record in the area of sex discrimination is examined in detail, and strong criticism is leveled in the area of voting rights. Rehnquist's conservative position on issues of homosexual rights and abortion are also attacked by opponents.

460. U.S. Congress. House. Committee on Education and Labor. *Report of the Study Group on Affirmative Action.* by the Study Group on Affirmative Action organized by the University of Pennsylvania Wharton School. 100th Cong., 1st sess., 1987. Committee print. 307p. Y4.Ed8/1:100-L. Report reviews the policy of affirmative action in an effort to bring clarity to the issue. The study group's findings indicate that many people believe women and minorities are still victims of discrimination. The tendency to criticize affirmative action during slow economic periods is documented. The study also notes that affirmative action has helped minorities and women move into occupations, but not into the management ranks. Those things which have worked in affirmative action and the policy's short comings are detailed. In particular, the labor market status of black women under affirmative action is described in a paper by Julianne Malveaux. A paper by James E. Jones provides a historical perspective on affirmative action.

461. U.S. Congress. House. Committee on Education and Labor. Subcommittee on Employment Opportunities. *Oversight Hearings on Office of Federal Contract Compliance Programs, Hearings.* 100th Cong., 1st sess., 3,4 June 1987. 124p. Y4.Ed8/1:100-38. Hearing explores the shortcomings of the Office of Federal Contract Compliance Programs under the Department of Labor. The organization of OFCCP and the Reagan administration's antagonism toward affirmative action and class action cases are covered in testimony.

462. U.S. Congress. House. Committee on Education and Labor. Subcommittee on Employment Opportunities and U.S. Congress. House. Committee on the Judiciary. Subcommittee on Civil and Constitutional Rights. *Affirmative Action in the Work Force, Joint Hearing.* 100th Cong., 1st sess., 8 Oct. 1987. 104p. Y4.Ed8/1:100-49. Witnesses review the arguments for affirmative action primarily focusing on race, but also noting the prevalence of sex discrimination. In particular, the constitutionality of affirmative action is explored with witnesses expressing support for its legality.

463. U.S. Bureau of Mines. *Answers and Feedback for Trouble in the Training Room Exercise.* by Behavioral Research Aspects of Safety and Health Group, Institute for Mining and Minerals Research. Lexington, KY: The Institute, 1988. 12p. I28.2:B39/trouble/answers. See 464 for abstract.

464. U.S. Bureau of Mines. *Trouble in the Training Room Exercise (Paper and Pencil Version), Instructor's Copy.* by the Institute for Mining and Minerals Research. Lexington, KY: The Institute, 1988. various paging. I28.2:B39/trouble/inst. Presents an exercise to train instructors to recognizing and handle sexual harassment in a training situation. The instructor's manual presents the situation of harassment in the training room as it develops and presents scenarios for responding to the audience.

465. U.S. Bureau of Mines. *Trouble in the Training Room (Paper and Pencil Version) Problem Booklet.* by Behavioral Research Aspects of Safety and Health Group, Institute for Mining and Mineral Research. Lexington, KY: The Institute, 1988. 15p. I28.2:B39/trouble/problems. See 464 for abstract.

466. U.S. Congress. House. Committee on Education and Labor. Subcommittee on Employment Opportunities. *Affirmative Action in the California Public Utilities, Hearing.* 100th Cong., 2d sess., 16 Nov. 1988. Commerce, CA. 38p. Y4.Ed8/1:100-110. Witnesses at hearings on affirmative action in utilities companies in the Los Angeles area discuss the track records of Southern Cal Edison, Southern California Gas Co., and Pacific Bell in hiring and promoting minorities and women. The primary focus is on minorities, the failure to promote them to management positions, and the ineffectiveness of the EEOC.

467. U.S. Congress. House. Committee on Energy and Commerce. Subcommittee on Telecommunications and Finance. *Labor Issues in the Telecommunications Industry,*

Hearings on H.R. 292 and H.R. 1090. 100th Cong., 2d sess., 17 May, 16 June 1988. 488p. Y4.En2/3:100-205. Hearing on legislation to promote the employment of women and minorities in broadcast media and telecommunications and to encourage ownership of stations by minorities and women reviews the current representation of these groups. The primary focus of testimony is on the need to improve ownership and employment opportunities for minorities in telecommunications with only passing reference to women. The track records of AT&T and cable companies in hiring and promoting women are also examined.

468.　U.S. Customs Service. *Dealing with Sexual Harassment.* Washington, DC?: The Service, 1988. leaflet. T17.26:528.

469.　U.S. Dept. of Defense. American Forces Information Service. *Which Picture Doesn't Belong?* Alexandria, VA: The Service, 1988? poster. D2.9:P58. Poster discourages sexual harassment.

470.　U.S. Dept. of Education. Office of Civil Rights. *Nondiscrimination in Employment Practices in Education.* Washington, DC: GPO, 1988. 10p. ED1.2:N73. Leaflet reviews the laws governing employment discrimination in educational institutions.

471.　U.S. Veterans Administration. Office of Personnel and Labor Relations. *Supervisory Training Program: The Supervisor and EEO/Affirmative Action - Unit XII.* Washington, DC: The Office, 1988. 55p. VA1.38:05-28-12. Outline for conducting an EEO training program for supervisors covers all of the basics and includes a section on recognizing and preventing sexual harassment.

472.　U.S. Congress. Senate. Committee on Labor and Human Resources. *Civil Rights Act of 1990, Hearing on S. 2104.* 101st Cong., 1st sess., 23 Feb. - 7 Mar. 1989. 1076p. Y4.L11/4:S.hrg.101-649. Hearing on the proposed Civil Rights Act of 1990 consists mostly of legal discussion of the *Wards Cove* decision, the *Griggs* decision, and the state of employment discrimination law under the Reagan Supreme Court. Where the incidence of discrimination is discussed the focus is on race with some discussion of the ability of women to seek damages in sex discrimination cases.

473.　U.S. Dept. of Agriculture. *Sexual Harassment: Sexual Harassment is Prohibited and Can Be Stopped.* Washington, DC: The Dept., 1989. poster. A1.32:Se9.

474.　U.S. General Accounting Office. *Equal Employment Opportunity: Women and Minority Aerospace Managers and Professionals, 1979-86.* Washington, DC: The Office, 1989. 89p. GA1.13:HRD-90-16. Review of EEO data on aerospace industry contractors examines the representation of women and minorities in the aerospace industry between 1979 and 1986. The report examines changes over time, the representation of minorities and women compared to their representation in the labor force, and the comparability of their pay to white males doing similar work. Methodology and results are described in detail with deficiencies in available data noted.

475.　U.S. General Accounting Office. Human Resource Division. *Women and Minority Aerospace Industry Profile, 1979-1986.* by Linda G. Morra. Washington, DC: The Office, 1989. 18p. GA1.5/2:T-HRD-90-4. Analysis of available data on the employment of women and minorities in the aerospace industry looks at their representation compared to that in all companies with 50 or more employees. The report examines representation in managerial and professional positions and salaries, and reports findings for women broken down by race/ethnicity. A profile of minority and women managers and professionals in the Los Angeles and Seattle areas compares aerospace and other industries.

476. U.S. Commission on Civil Rights. *Report of the United States Commission on Civil Rights on the Civil Rights Act of 1990.* Washington, DC: The Commission, 1990. 97p. CR1.2:C49/10. Commission on Civil Rights analysis of the Civil Rights Act of 1990, then pending before Congress, notes weaknesses in the proposed law and provides discussion of the court cases which form the backdrop for its provisions.

477. U.S. Congress. House. *Civil Rights Act of 1990, Conference Report to Accompany S. 2104.* H. Rept. 101-755, 101st Cong., 2d sess., 1990. 21p. Report details conference committee decisions resolving differences between the House and Senate versions of the Civil Rights Act of 1990.

478. U.S. Congress. House. *Civil Rights Act of 1990, Conference Report to Accompany S. 2104.* H. Rept. 101-856, 101st Cong., 2d sess., 1990. 26p. See 477 for abstract.

479. U.S. Congress. House. *Civil Rights Act of 1990, Message from the President of the United States Transmitting Alternative Language to S. 2104 as Passed by the Congress.* H. Rept. 101-251, 101st Cong., 2d sess., 1990. 28p. Brief veto message of President Bush rejects the Civil Rights Act of 1990 as a "quota" bill and suggests revised language.

480. U.S. Congress. House. Committee on Education and Labor. *Civil Rights Act of 1990, Report Together with Minority Views to Accompany H.R. 4000.* H. Rept. 101-644, part 1, 101st Cong., 2d sess., 30 July 1990. 153p. Report provides background on the Civil Rights Act of 1990 focusing on the measure as a response to the Supreme Court's decisions in *Patterson v. McLean Credit Union, Price Waterhouse v. Hopkins, Wards Cove Packing Co. v. Atonio,* and other cases. Much of the discussion centers on the concept of disparate impact and on the ability to discriminate based on race and sex while avoiding Title VII violations by proving that illegal discrimination was not the only factor involved. Also covered is the ability to award damages under Title VII.

481. U.S. Congress. House. Committee on Education and Labor. *Hearing on H.R. 4000, the Civil Rights Act of 1990 - Volume 3, Hearings.* 101st Cong., 2d sess., 25 Apr., 21 May 1990. 667p. Y4.Ed8/1:101-92. The third volume in a series of in-depth hearings on the proposed Civil Rights Act of 1990 continues the preceding hearings' focus on the erosion of employment discrimination laws under the Reagan Supreme Court. At the heart of the debate is where proof of discrimination falls, the issue of quotas, and the ability to seek punitive damages. Evidence of continued employment discrimination against women and minorities is presented and the effect of the *Griggs v. Duke Power* and *Ward's Cove v. Antonio* decisions on civil rights litigation is discussed. Specifically relating to women, the extent of sexual harassment and the ability to seek damages in harassment cases is covered.

482. U.S. Congress. House. Committee on Education and Labor and U.S. Congress. House. Committee on the Judiciary. Subcommittee on Civil and Constitutional Rights. *Hearings on H.R. 4000, the Civil Rights Act of 1990 - Volume 1, Joint Hearings.* 101st Cong., 2d sess., 20,27 Feb. 1990. 811p. Y4.Ed8/1:101-90. Part one of extensive hearings on the Civil Rights Act of 1990 focuses on the weakening of existing anti-discrimination measures by recent Supreme Court decisions. Most of the focus is on racial discrimination, but issues of sex discrimination are discussed. In the area of sex discrimination, the Supreme Court's decision in *Price Waterhouse v. Hopkins* is examined in detail, and the ability to seek damages in discrimination cases is also stressed.

483. U.S. Congress. House. Committee on Education and Labor and U.S. Congress. House. Committee on the Judiciary. Subcommittee on Civil and Constitutional Rights. *Hearings on H.R. 4000, The Civil Rights Act of 1990 - Volume 2, Joint Hearings.* 101st Cong., 2d

sess., 13,20 Mar. 1990. 874p. Y4.Ed8/2:101-91. Continued hearings on the Civil Rights Act of 1990 present more detailed and critical discussion of the proposed legislation and the court decisions which form the backdrop for the bill. Most of the testimony focuses on the ability to seek damages for discrimination and harassment. The ability to seek damages for sexual harassment is particularly stressed by some witnesses.

484. U.S. Congress. House. Committee on Education and Labor. Majority Staff. *A Report on the EEOC, Title VII and Workplace Fetal Protection Policies in the 1980s.* 101st Cong., 2d sess., 1990. Committee print. 56p. Y4.Ed8/1:101-O. The issue of fetal protection policies and women's employment rights are explored in a highly critical report describing the EEOC's failure to address the issue. The discriminatory effect of fetal protection policies on women's employment opportunities and the failure of such policies to consider male reproductive hazards are reviewed noting related court cases. Relevant sections of the *Federal Register* and the text of the "EEOC Policy Guidance on Reproductive and Fetal Hazards" and "EEOC Policy Guidance on Seventh Circuit Decision in *United Auto Workers v. Johnson Controls Inc.*" are reprinted.

485. U.S. Congress. House. Committee on Small Business. *Civil Rights in the Work Force, Hearing.* 101st Cong., 2d sess., 30 July 1990. 71p. Y4.Sm1:101-72. Hearing considers a bill to reinforce anti-discrimination in employment laws in response to the *Wards Cove* Supreme Court decision. The question of proof of discrimination and the ability of victims of gender and religious discrimination to seek damages beyond back pay and reinstitution are primary issues.

486. U.S. Congress. House. Committee on the Judiciary. *Civil Rights Act of 1990, Report Together with Minority and Additional Views to Accompany H.R. 4000.* H. Rept. 101-644, part 2, 101st Cong., 2d sess., 1990. 80p. Report reviews the state of equal employment opportunity law with reference to recent Supreme Court decisions viewed as undermining Title VII. Additional views indicate that the bill goes too far in provisions designed to address the *Price Waterhouse* and *Ward's Cove* decisions and that it would lead to quotas and reverse discrimination. Criticism of the damages section of the bill specifically objects to the inclusion of sexual harassment.

487. U.S. Congress. Senate. Committee on Labor and Human Resources. *The Civil Rights Act of 1990, Report Together with Minority Views to Accompany S. 2104.* S. Rept. 101-315, 101st Cong., 2d sess., 8 June 1990. 124p. Report on the Civil Rights Act of 1990 provides background discussion on the undermining of employment discrimination laws by recent Supreme Court decisions. Lengthy minority views contend that the bill goes too far, would encourage litigation, and opens the door for comparable worth suits. Primary areas of discussion are disparate impact and punitive damage awards.

488. U.S. Dept. of Defense. American Forces Information Service. *It's Shocking! It's Disgusting! It Makes Your Hair Stand on End!: Don't Call It Hands-On Management! It's Sexual Harassment! Let It Go and You Could Create a Monster!* Defense Billboard no. 27. Alexandria, VA: The Service, 1990? poster. D2.9:27.

489. U.S. Equal Employment Opportunity Commission. *Facts about Pregnancy Discrimination.* Washington, DC: The Commission, 1990. 2p. Y3.Eq2:2P91. Concise summary describes the provisions of the Pregnancy Discrimination Act in the areas of hiring, maternity leave, health insurance, and fringe benefits.

490. U.S. Equal Employment Opportunity Commission. *Facts about Sexual Harassment.* Washington, DC: The Commission, 1990. 2p. Y3.Eq2:2Se9/2. Overview of sexual harassment presents examples of harassment and suggests appropriate victim responses.

491. U.S. Equal Employment Opportunity Commission. *Indicators of Equal Employment Opportunity - Status and Trends.* Washington, DC: The Commission, 1990. 81p. Y3.Eq2:2In2. Overview of the status of equal employment opportunity in the U.S. provides brief summaries, tables, and graphs describing employment participation rates, unemployment and discouraged workers, and earnings. Participation rates are highlighted for the private sector, state and local government, federal government, elementary and secondary education, and higher education. Summary reports on occupational patterns of men and women and of blacks and Hispanics are also included.

SERIALS

492. U.S. Civil Service Commission. *Equal Opportunity in Employment.* Personnel Bibliography Series nos. 38, 49, 65, 72, 88, 95, 105, 120, 126. Washington, DC: GPO, 1971 - 1980. irregular. CS1.61/3:no. and PM1.22/2:no. Bibliography lists books and articles held at the library of the U.S. Civil Service Commission relating to EEO. A separate section of each bibliography focuses on women.

493. U.S. Equal Employment Opportunity Commission. *Annual Report.* Washington, DC: GPO, 1966 - . annual. Y3.Eq2:1/year. Annual report reviews agency activities, legislative changes, significant court cases, and trends in number and types of discrimination complaints filed during the year.

494. U.S. Equal Employment Opportunity Commission. *Mission.* Washington, DC: GPO, 1975 - 1979. bimonthly. 1980 - . annual. Y3.Eq2:15/vol.no. Newsletter highlights EEOC activities and personnel and briefly discusses the impact of court decisions on EEO.

495. U.S. Equal Employment Opportunity Commission. *Newsletter.* Washington, DC: GPO, Nov. 1966 - . Vol. 1, no. 1 - . irreg. Y3.Eq2:9/vol.-no. News notes highlight EEOC personnel and activities.

496. U.S. Equal Employment Opportunity Commission. *Semi-Annual Checklist of EEOC Orders.* Washington, DC: The Commission, July 15, 1988 - . semiannual. Y3.Eq2:19/year. Checklist of EEOC orders, notices, field notes, management directives, and management bulletins is a quick reference for locating EEOC policy statements on issues such as maternity benefits, equal pay, sexual harassment, and fetal hazards.

497. U.S. National Science Foundation. *Women and Minorities in Science and Engineering.* Washington, DC: The Foundation, 1982 - . biennial. NS1.49:year or NS1.2:W84/2/year. Statistical report examines the education and employment of women and minorities in science and engineering fields. Data provided includes salary, labor force participation, unemployment, academic positions, primary work activity, years of experience, precollege education, earned degrees, and graduate education.

498. U.S. Women's Bureau. *A Working Woman's Guide to Her Job Rights.* Washington, DC: GPO, 1974 - 1988. revised irregularly. L36.110:55/rev. no. Concise description of the protection from sex discrimination afforded women by law accompanies examples of discrimination cases and the courts' ruling, and information on options available to victims of discrimination.

3

Pay Equity

The battle for equal pay and the continuing debate over comparable worth are documented in government publications from the late 1930s. The first extensive comparison of men's and women's wages was a 1938 Women's Bureau report, *Differences in the Earnings of Women and Men* (500). The entry of large numbers of women into the labor force in WWII prompted numerous agency documents and a series of congressional hearings on proposed legislation to guarantee equal pay for women. Substantial hearings were issued regularly between 1945 (502) and 1963 (530, 532) on the Equal Pay Act and its earlier versions. The Women's Bureau regularly issues documents on the status of equal pay laws in the states (512, 517, 544) and published the text in 1952 of International Labour Organization documents on equal pay for equal work (521-522).

The earnings gap between men and women is documented in various reports over the years (555, 563-564, 589) and it was discussed extensively in congressional hearings on the issue of comparable worth. While the concept of comparable worth is articulated in some of the earlier equal pay hearings, it didn't become a major focus in documents until 1982 when the House held hearings on pay equity (565). A long series of hearings followed which focused on the EEOC's handling of pay equity cases (567-568, 574) and on comparable worth in the federal civil service (570-571, 583). Among the significant documents on comparable worth in the civil service are the GAO report, *Options for Conducting a Pay Equity Study of Federal Pay and Classification Systems* (581), and the Office of Personnel Management's *Comparable Worth for Federal Jobs: A Wrong Turn on the Road Toward Pay Equity and Women's Career Advancement* (584). Other discussions of pay equity are found in Chapter 2, Employment Discrimination and Affirmative Action, and in the Volume I chapter on discrimination and women's rights.

499. U.S. Dept. of Labor. National War Labor Board. *Docket No. 181 Decision of Arbitrators on Appeal in re Women Collectors on Lines of Boston Elevated Railway Company.* Washington, DC: The Board, 1919. 1p. L10.5:B657/2. Decision adjusts the wage of women collectors of the Boston Elevated Railway Company up to 40 cents an hour although agreeing with the examiner that the wage for women collectors is not determined by reference to the minimum limitation of adult male wages.

500. U.S. Women's Bureau. *Differences in the Earnings of Women and Men.* by Mary Elizabeth Pidgeon. Bulletin no. 152. Washington, DC: GPO, 1938. 57p. L13.3:152. Study of statistics on women's wages compares them to men's in the same type of work and to the wages of unskilled men. Also reports on the general level of men's and women's wages in selected industries and occupations.

501. U.S. Women's Bureau. *"Equal Pay" for Women in War Industries.* by Mary Elizabeth Pidgeon. Bulletin no. 196. Washington, DC: GPO, 1942. 26p. L13.3:196. Point-by-point argument in favor of paying women war workers the same rate as their male counterparts touches on subjects such as the nature of the work, productivity, absenteeism and turnover, and the role of women in family support. Also discusses government policy on wage rates for women in wartime and the concept of equal pay in union agreements.

502. U.S. Congress. Senate. Subcommittee of the Committee on Education and Labor. *Equal Pay for Equal Work for Women, Hearing on S. 1178.* 79th Cong., 1st sess., 29-31 Oct. 1945. 222p. Y4.Ed8/3:W84. Rationale presented for this equal pay bill is based on the role of women in industry during the war and after the war with an emphasis on the ability of war widows to earn an appropriate wage. Testimony examines wage discrimination against women and the effect of state equal pay laws, and explores the theory that such a law would result if fewer jobs for women. Also reviews how the National War Labor Board's policy on equal pay worked in practice. The issue of comparable worth is raised, particularly in reference to women's employment at General Electric and Westinghouse.

503. U.S. Women's Bureau. *Differentials in Pay for Women.* Washington, DC: The Bureau, 1945. 17p. L13.2:P29 or L13.2:D56. Reviews documentation of the lower wages paid to women in comparable jobs to men and the generally depressed wages for female dominated occupations. The family support responsibilities of women workers are discussed as are ways to correct inequities through skills evaluation and union action.

504. U.S. Women's Bureau. *The Rate for the Job.* Union Series no. 2. Washington, DC: GPO, 1945. 1p. folded. L13.13:2. Briefly reports the results of a 1944 Women's Bureau survey on unions and equal pay.

505. U.S. Congress. House. Committee on Labor. *Women's Equal Pay Act of 1945, Report to Accompany H.R. 5221.* H. Rept. 2687, 79th Cong., 2d sess., 1946. 8p. Serial 11026. Favorable report with amendments on equal pay for equal work legislation adopts the Senate Report no. 1576 (566) as an explanation for the bill.

506. U.S. Congress. Senate. Committee on Education and Labor. *Women's Equal Pay Act of 1945, Report to Accompany S. 1178.* S. Rept. 1576, 79th Cong., 2d sess., 1946. 10p. Serial 11016. Reports, with amendment, an equal pay for equal work bill for women. The report reviews the need for the bill by describing the practice of wage discrimination, its effect on the economy, and the general injustice of wage differentials. The committee views examine possible problems with the bill such as a resulting unwillingness to hire women, the cost to industry, and the question of determining comparability.

507. U.S. Women's Bureau. *Highlights of the British Equal Pay Report (Royal Commission on Equal Pay, 1944-46).* Washington, DC: The Bureau, 1947. 9p. L13.2:P29/2. Summary provides excerpts of comments on the British Equal Pay Report, a study of the reasons for pay differentials between men and women and the advisability of correcting these differentials through an equal pay law. With several women members dissenting, the commission found women's lower wages in industry justified on grounds of lower efficiency and higher absenteeism, and concluded that the equal pay law would force women out of jobs.

508. U.S. Women's Bureau. *Selected References on Equal Pay for Women.* Washington, DC: The Bureau, 1947. 9p. L13.2:P29. List of selected resources on equal pay for women covers the U.S., Australia, Canada, Great Britain and the International Labor Organization. Sources cited include articles from the popular literature, books, association publications, and publications of state, national and international governmental organizations.

509. U.S. Women's Bureau. *Summary of Proposed Federal Women's Equal Pay Act of 1947.* Washington, DC: The Bureau, 1947. 1p. L13.2:Eq2/2. Section-by-section summary of equal pay bills S. 1556, H.R. 4408, and H.R. 4273 (80th Congress).

510. U.S. Women's Bureau. *What You Don't Want in an Equal Pay Bill.* Washington, DC: The Bureau, 1947. 3p. L13.2:Eq2. Advice on what to avoid in drafting a state equal pay bill, such as coverage of only certain types of employment and justifications for wage differentials, gives examples of some undesirable provisions permitting differentials.

511. U.S. Congress. House. Committee on Education and Labor. Subcommittee no. 4. *Equal Pay for Equal Work for Women, Hearings on H.R. 4273 and H.R. 4408.* 80th Cong., 2d sess., 9-13 Feb. 1948. 306p. Y4.Ed8/1:W84. Hearing testimony highlights instances of wage differentials by sex where no distinction in duties exists and also touches on the issue of comparable worth. The social need behind the bill as well as the administrative and legal aspects are explored. Enforcement of the law and the semantics of "equal work" are other topics of debate, and the argument of women's higher absenteeism and turnover is raised. Support for the bill is found in an examination of equal pay practices during the war years. Supreme Court decisions on state equal pay laws are reprinted.

512. U.S. Women's Bureau. *Movement for Equal Pay Legislation in the United States.* Washington, DC: The Bureau, 1949. 5p. L13.2:Eq2/5. Brief overview of the history of the movement for equal pay highlights progress in the federal civil service, teachers salaries, and state equal pay laws. Reviews proposals for federal legislation and presents the case for equal pay as an important economic factor. Later edition issued in 1950.

513. U.S. Women's Bureau. *Selected References on Equal Pay for Women.* Washington, DC: The Bureau, 1949. 10p. L13.2:Eq2/6. Citations on equal pay for women cover the U.S., Australia, Canada, France, Great Britain and Sweden and intergovernmental organizations.

514. U.S. Congress. House. Committee on Education and Labor. Special Subcommittee on Equal Pay for Equal Work for Women. *Equal Pay for Equal Work for Women, Hearings on H.R. 1584 and H.R. 2438.* 81st Cong., 2d sess., 17-19 May 1950. 141p. Y4.Ed8/1:W84/2. Hearing on a proposed equal pay law presents testimony from the Women's Bureau, labor unions, and state labor departments on pay inequities. Specifically, the communications industry and the United Automobile Workers are examined. The National Association of Manufacturers presents the case for the opposition. A summary of state equal pay laws and of related decisions and settlements by occupation is provided. Most of the discussion focuses on defining work of "comparable character".

515. U.S. Congress. Senate. Committee on Labor and Public Welfare. *Women's Equal Pay Act of 1950, Report on S. 706, Together with the Individual Views of Mr. Taft, Mr. Smith of New York, and Mr. Donnell, Respectively.* S. Rept. 2263, 81st Cong., 2d sess., 1950. 18p. Serial 11371. Favorable report on legislation to ensure equal pay for equal work for women describes wage discrimination against women citing past hearing testimony and noting the negative effects of wage discrimination. Briefly discusses the question of determining "comparability" of jobs under the legislation. Individual views appended to the report reject the legislation on the grounds that it creates another federal bureaucracy, that their is no basis for determining comparability of jobs, and that enforcement would be difficult.

516. U.S. Women's Bureau. *Case Studies in Equal Pay for Women.* Washington, DC: GPO, 1951. 27p. L13.2:Eq2/8. Study of eight firms with from 5 to 25 years of experience with an equal pay policy looks at the development of the equal pay policy and at the continued tendency to have certain female dominated or male dominated job categories which pay

men more. Information is pulled primarily from interviews with some supporting data. Firms visited included retail, manufacturing and service establishments.

517. U.S. Women's Bureau. *Analysis of State Equal Pay Laws.* Washington, DC: The Bureau, Nov. 1952. 2p. L13.2: Eq2/3/952-2. Summarizes in legal chart form the provisions of existing state equal pay laws. Earlier editions issued in 1948 and April 1952.

518. U.S. Women's Bureau. *Equal Pay, What Are the Facts?* by Dorothy S. Brady. Washington, DC: The Bureau, 1952. 3p. L13.2:Eq2/9. Speech given at the 1951 Women's Bureau National Conference on Equal Pay presents an overview of statistics on wages of men and women by occupation. The statistics on wages are examined for evidence of sex-based wage discrimination, taking into account the age of the worker.

519. U.S. Women's Bureau. *Keynote Address by Arthur S. Flemming, Assistant to Director, Office of Defense Mobilization, at National Equal Pay Conference, Mar. 31, 1952.* by Arthur S. Flemming. Washington, DC: The Bureau, 1952. 5p. L13.12:F62. Flemming visualizes a 10 to 15 year defense mobilization period and stresses the need to encourage women with aptitude in shortage occupations to enter these fields. Equal pay for equal work is seen as important to defense mobilization of women. The need for sound job classification plans as an element in enforcing equal pay for equal work principles is noted.

520. U.S. Women's Bureau. *Report of the National Conference on Equal Pay, March 31 and April 1, 1952.* Bulletin no. 243. Washington, DC: GPO, 1952. 25p. L13.3:243. Speeches printed include Maurice J. Tobin on "Equal Pay - Present Reality or Future Dream" and Dr. Dorothy Brady on "Equal Pay- What are the Facts?" Also included are committee recommendations on legislation, education, and collective bargaining. A list of references includes unpublished mimeographs from the Women's Bureau.

521. U.S. Women's Bureau. *Text of the Convention (No. 100) Concerning Equal Remuneration for Men and Women Workers for Work of Equal Value.* Washington, DC: The Bureau, 1952? 5p. L13.2:Eq2/10. Reprints the International Labor Organization's Equal Remuneration Convention of 1951, which states the principle of equal pay for equal work for women and men.

522. U.S. Women's Bureau. *Text of the Recommendation (No. 90) Concerning Equal Remuneration for Men and Women Workers for Work of Equal Value, Submitted by the Drafting Committee.* Washington, DC: The Bureau, 1952? 3p. L13.2:Eq2/12. Recommendation of the General Conference of the International Labour Organization on equal pay for equal work also briefly touches on vocational opportunities for women.

523. U.S. Women's Bureau. *Progress toward Equal Pay in the Meat-Packing Industry.* Bulletin no. 251. Washington, DC: GPO, 1953. 16p. L13.3:251. Report examines the meat-packing industry where a double wage schedule with designated "female" jobs and lower pay schedules for women are common. The role of the union in the continuation of such practices is examined.

524. U.S. Congress. House. Committee on Education and Labor. *Equal Pay Act of 1962, Report to Accompany H.R. 11677.* H. Rept. 1714, 87th Cong., 2d sess., 1962. 9p. Serial 12430. Reports legislation to prohibit sex discrimination in wages by employers engaged in commerce or the production of goods in commerce. The report briefly reviews the need for equal pay legislation and describes the intent of the bill. The measure establishes a system for investigating charges of discriminatory practices and for enforcing the law through civil activities.

525. U.S. Congress. House. Committee on Education and Labor. Select Subcommittee on Labor. *Equal Pay for Equal Work, Hearings on H.R. 8898, H.R. 10226, Part 1.* 87th Cong., 2d sess., 26-28 March 1962. 221p. Y4.Ed8/1:P29/pt.1. Representatives from unions, state and federal labor departments, and women's organizations present testimony on the need for legislation guaranteeing equal pay for equal work for women. Presents considerable discussion on key issues of women's wages and their effect on wages in general and on the economy, on evaluation to establish comparability of jobs, and on the role of unions in securing equal pay. The role of women in the labor force is a common thread throughout the testimony. Includes a summary of state equal pay laws in legal chart form and presents statistics on wage differentials by sex; federal employment by grade and sex; salaries of college graduates by sex; average earnings in manufacturing industries by occupation and sex; hours and earnings of private hospital workers by occupation and sex; and earnings of bank tellers by sex. The international equal pay for equal work situation is also presented.

526. U.S. Congress. House. Committee on Education and Labor. Select Subcommittee on Labor. *Equal Pay for Equal Work, Hearings on H.R. 8898, H.R. 10226, Part 2, Hearings Held in New York.* 87th Cong., 2d sess., 27-28 April 1962. 223-343pp. Y4.Ed8/1:P29/pt.2. Additional hearings on the equal pay bill held in New York focus on unions with additional materials on women in law enforcement. Includes a statement by Bette Davis supporting the bill.

527. U.S. Congress. Senate. Committee on Labor and Public Welfare. Subcommittee on Labor. *Equal Pay Act of 1962, Hearing on S. 2494 and H.R. 11677.* 87th Cong., 2d sess., 1 Aug. 1962. 103p. Y4.L11/2:P29. Statements submitted in lieu of testimony on an equal pay for equal work bill includes statements by labor leaders, women's organizations, and state and federal labor departments supporting the bill and highlighting existing inequities. Supporting statistics detail pay difference by sex, distribution of women in the labor force, and marital status of women in the labor force.

528. U.S. Congress. House. Committee on Education and Labor. *Equal Pay Act of 1963, Report to Accompany H.R. 6060.* H. Rept. 309, 88th Cong., 1st sess., 1963. 10p. Serial 12541. Background on the equal pay principle is included in this report on a bill to prohibit discrimination on account of sex in the payment of wages by employers engaged in commerce or in the production of goods for commerce. The coverage, administration, and enforcement provisions of the measure are summarized. Minority views express opposition to powers given the Department of Labor and argue that the measure would adversely affect women's job opportunities.

529. U.S. Congress. House. Committee on Education and Labor. *Legislative History of the Equal Pay Act of 1963 (Amending Sec. 6 of Fair Labor Standards Act of 1938, as Amended), P.L. 88-38, 88th Congress, H.R. 6060 and S. 1409.* 88th Cong., 1st sess., 1963. Committee print. 114p. Y4.Ed8/1:P29/3. Legislative history of the Equal Pay Act reviews the progress of the law through Congress and summarizes the debate on the measure. House and Senate reports on the bill are reprinted.

530. U.S. Congress. House. Committee on Education and Labor. Special Subcommittee on Labor. *Equal Pay Act, Hearings on H.R. 386, H.R. 4269 and Related Bills.* 88th Cong., 1st sess., 15-27 Mar. 1963. 326p. Y4.Ed8/1:P29/2. Continued hearings on the proposed Equal Pay Act present and discuss opposition arguments based on higher benefit costs, absenteeism, and turnover of women workers. Wage differentials and the role of unions are reviewed in testimony.

531. U.S. Congress. Senate. Committee on Labor and Public Welfare. *Equal Pay Act of 1963, Report to Accompany S. 1409.* S. Rept. 176, 88th Cong., 1st sess., 1963. 6p. Serial

12533. Report on a measure to prohibit gender-based wage discrimination in businesses engaged in interstate commerce discusses the application of the equal pay concept and the administrative and enforcement provisions of the bill. Objections to the bill based on the alleged higher cost to employ women are also addressed in the report.

532. U.S. Congress. Senate. Committee on Labor and Public Welfare. Subcommittee on Labor. *Equal Pay Act of 1963, Hearings on S. 882 and S.910.* 88th Cong., 1st sess., 2-16 April 1963. 200p. Y4.L11/2:P29/963. Senate hearing highlights wage differentials by sex and examines the argument that higher absenteeism and turnover among women makes them more costly to employ. Provides statistics on men's and women's wages by occupation. Also reviews the status of equal pay laws at the state level. Discussion focuses on defining legitimate pay differentials and on the view that state law and collective bargaining are the appropriate channels to address inequities.

533. U.S. Dept. of Labor. Wage and Hour and Public Contracts Division. *Highlights of the Equal Pay Act of 1963.* Washington, DC: GPO, 1963. 3p. leaflet. L22.5:Eq2.

534. U.S. Women's Bureau. *Economic Indicators Relating to Equal Pay.* Pamphlet no. 9. Washington, DC: GPO, 1963. rev. ed. 21p. L13.19:9/2. Information relating to equal pay presented here covers subjects such as wage differentials in job orders by sex, equal pay clauses in union contracts, and the results of two surveys on the pay practices of employers. Data on wage and salary income by sex for selected occupations is presented along with data on occupational distribution of workers by sex and average weekly earnings by sex for selected occupations and employers. Salaries of recent college graduates are reported by occupation, degree, and sex. Also issued in 1962.

535. U.S. Women's Bureau. *Equal Pay in Member Nations of the International Labor Organization.* Women in the World Today International Report no. 4. Washington, DC: GPO, 1963. 9p. L13.23:4. Chart shows, by country, the date ratification was registered on the ILO Convention no. 100 on equal pay, date of constitutional provisions for equal pay, and date of equal pay legislation for private employment, with notes on limitations.

536. U.S. Women's Bureau. *Memorandum to Accompany Suggested Language for a State Act to Abolish Discriminatory Wage Rates Based on Sex.* Washington, DC: The Bureau, 1964. 5p. L13.2:W12/13/964/memo. Explains section-by-section the provisions of the suggested "State Act to Abolish Discriminatory Wage Rates Based on Sex."

537. U.S. Women's Bureau. *Suggested Language for a State Act to Abolish Discriminatory Wage Rates Based on Sex.* Washington, DC: The Bureau, 1964. 7p. L13.2:D63.

538. U.S. Women's Bureau. *Suggested Language for a State Act to Abolish Discriminatory Wage Rates Based on Sex.* Washington, DC: The Bureau, 1964. 6p. L13.2:W12/13/964.

539. U.S. Dept. of Labor. Wage and Hour and Public Contracts Division. *Information on the Equal Pay Act of 1963.* Washington, DC: GPO, 1965. 10p. leaflet. L22.5:Eq2/2. Earlier edition issued in 1963.

540. U.S. Women's Bureau. *Equal Pay for Voluntary Organization.* Washington, DC: The Bureau, 1965. 2p. L13.2:Eq2/22. Lists informational materials included in the "Equal Pay Packet" distributed to women's organizations.

541. U.S. Women's Bureau. *Inventory of State Equal Pay Legislation.* Washington, DC: The Bureau, 1965. 4p. L13.2:Eq2/18. Very brief inventory summarizes provisions of state equal pay laws.

542. U.S. Women's Bureau. *Inventory of State Equal Pay Legislation.* Washington, DC: The Bureau, 1965. 4p. L13.2:Eq2/23.

543. U.S. Women's Bureau. *Action for Equal Pay.* Washington, DC: The Bureau, 1966. 7p. L13.2:Eq2/17/966. Short history of the movement for equal pay legislation provides a chronology of major milestones in the progress toward a federal equal pay law. First edition issued in 1964.

544. U.S. Women's Bureau. *Equal Pay Activity in State Legislatures, 1961-66.* Washington, DC: The Bureau,1966. 1p. L13.2:Eq2/25. Lists states by the year in which equal pay bills were introduced and states in which amendments to existing equal pay laws were introduced. Earlier edition covered the period from 1959 to 1965.

545. U.S. Women's Bureau. *Equal Pay Laws by State, July 1, 1966.* Washington, DC: The Bureau, 1966. 1p. map. L13.6/2:Eq2/966. Earlier edition issued in 1956.

546. U.S. Women's Bureau. *Getting the Facts on Equal Pay.* Washington, DC: The Bureau, 1966. 3p. L13.2:Eq2/20/966. Ideas on where to look for evidence of wage discrimination based on sex includes suggestions for using women's organizations, state agencies, and local universities. Earlier edition issued in 1964.

547. U.S. Women's Bureau. *Why State Equal Pay Laws?* Washington, DC: The Bureau, 1966. 4p. leaflet. L13.2:Eq2/24.

548. U.S. Dept. of Labor. Wage and Hour and Public Contracts Division. *Equal Pay under the Fair Labor Standards Act as Amended in 1966.* Washington, DC: 1967. 10p. leaflet. L22.5:Eq2/3.

549. U.S. Women's Bureau. *What You Want in a State Equal Pay Bill.* Washington, DC: The Bureau, 1969. 3p. L13.2:Eq2/19/969. Provides advice on what to work for and what to avoid in a state equal pay bill. Earlier edition issued in 1966.

550. U.S. Congress. House. Committee on Education and Labor. General Subcommittee on Labor. *To Amend the Fair Labor Standards Act, Part 2, Hearings on H.R. 10948, H.R. 17596, H.R. 15971.* 91st Cong., 2d sess., 29 July - 17 Sept. 1970. 203-908pp. Y4.Ed8/1:L11/10/970/pt.2. Issues discussed in the hearing include extension of the Equal Pay Act to executive, administrative and professional workers and the inclusion of domestic workers under minimum wage provisions. Testimony highlights wage differentials between women and men in management and professional positions. Data on faculty salaries by sex illustrate the wage gap in professional positions.

551. U.S. Congress. House. Committee on Education and Labor. *Fair Labor Standards Amendments of 1971, Report Together with Minority, Separate, Individual and Additional Views, to Accompany H.R. 7130.* H. Rept. 92-672, 92d Cong., 1st sess., 1971. 126p. Serial 12932-5. A bill to amend the Fair Labor Standards Act of 1938 includes provisions to extend the equal pay requirement to executive, administrative, and professional positions, and to include domestic service workers under minimum wage law. These aspects of the bill receive minimal attention in the report.

552. U.S. Congress. Senate. Committee on Labor and Public Welfare. Subcommittee on Labor. *Fair Labor Standards Amendments of 1971, Part 1, Hearings on S. 1861, S. 2259.* 92d Cong., 1st sess., 26 May - 22 June 1971. 468p. Y4.L11/2:F15/971/pt.1. The coverage of domestic workers under minimum wage and the extension of the Equal Pay Act to executive, administrative, and professional positions are major topics of testimony. The extent of gender-based wage discrimination and the wage gap among professionals is

explored in depth, and the cost to corporations of extending equal pay protection to excluded classes is discussed. The effectiveness of the Equal Pay Act in improving the wages of women is stressed in support of its broader coverage.

553. U.S. Employment Standards Administration. Wage and Hour Division. *Equal Pay for Equal Work under the Fair Labor Standards Act.* Washington, DC: GPO, 1971. 25p. L36.209:800. Interpretive bulletin for the application of the equal pay provisions of the Fair Labor Standards Act as provided in 29 CFR 800 cites relevant court cases and legislative documents where appropriate.

554. U.S. Women's Bureau. *The Employment of College Women: 1971 Classes.* Washington, DC: The Bureau, 1971. 3p. L13.2:C69. Report provides information on the number of companies planning to employ women and the average starting salary by field. The comments made by employers as to why women were paid lower salaries are excerpted and summarized.

555. U.S. Women's Bureau. *Fact Sheet on the Earnings Gap.* Washington, DC: GPO, 1971. 6p. L13.2:Ea7/3/971. Data on the earnings gap between men and women provides statistics on median income by sex and occupational group, distribution of earnings by sex, median income by sex and educational attainment, median salary of full-time civilian scientists by sex and field, and average starting monthly salary for college graduates by sex and field. Earlier edition issued in 1970.

556. U.S. Workplace Standards Administration. Wage and Hour Division. *Equal Pay.* Washington, DC: GPO, 1971. 16p. L22.2:Eq2. Overview of the coverage and effects of the Equal Pay Act provides examples of enforcement actions.

557. U.S. Women's Bureau. *Education Act Extends Sex Discrimination and Minimum Wage Provisions.* Legislative Series no. 2. Washington, DC: The Bureau, 1972. 3p. L36.115:2. Summarizes the provisions of Title IX of the Education Amendments of 1972 which relate to women workers, most notably the extension of the Equal Pay Act to cover administrative, executive, and professional employees, extension of minimum wage requirements to preschool employees, and prohibition of sex discrimination in vocational, professional, and graduate education programs.

558. U.S. Dept. of Labor. Office of Information. *Secretary Brennan's Remarks before the Women's National Republican Club, New York City, Wednesday, February 28, 1973.* Washington, DC: The Office, 1973. 6p. L1.13:B75. Speech describes the Department of Labor's enforcement of the Equal Pay Act of 1963.

559. U.S. Employment Standards Administration. Wage and Hour Division. *Equal Pay under the Fair Labor Standards Act as Amended in 1966.* Washington, DC: GPO, 1973. 9p. L36.202:Eq2. Summary information on the equal pay provisions of FLSA defines "equal pay" and "equal work", notes occupations covered, and suggests ways to find out more regarding the applicability of the standards.

560. U.S. National Institutes of Health. Division of Resource Analysis. *Analysis of Sex Differentials among Ph.D.-Holding Bioscientists: Salary, Academic Rank, and Predoctoral Awards.* Washington, DC: The Institutes, 1975. 9p. HE20.3014/2:16. Report analyzes sex differentials to determine if sex discrimination accounts for the earnings gap between male and female bioscientists.

561. U.S. National Institute of Health. Office of Associate Director for Program Planning and Evaluation. Division of Resources Analysis. *Analysis of Sex Differentials among Ph.D.-Holding Bioscientists.* Resource Analysis Memo no. 19. Bethesda, MD: The Institute,

1977. 20p. HE20.3014/2:19. Employment characteristics and salaries of male and female bioscientists are analyzed weighing in factors of years of professional experience and field of degree.

562. U.S. Employment Standards Administration. Wage and Hour Division. *Equal Pay.* Washington, DC: GPO, 1978. 17p. L36.202:Eq2/2/978. Basic information on the Equal Pay Act and its enforcement provides examples of cases where women were underpaid under the act's provisions and describes major court cases. Editions also published in 1973 and 1974.

563. U.S. Women's Bureau. *The Earnings Gap between Women and Men.* Washington, DC: The Bureau, 1979. 22p. L36.102:Ea7/2/979. Presents statistics by sex for 1977 on median earnings; earnings distribution; earnings by occupational group; salaries of scientists and engineers; median income by educational attainment; salary offers to bachelor degree candidates by curriculum; and income by age, marital status, race and Spanish origin. Earlier edition with 1974 data was published in 1976.

564. U.S. Bureau of Labor Statistics. *The Female-Male Earnings Gap: A Review of Employment and Earnings Issues.* Report no. 673. Washington, DC: GPO, 1982. 10p. L2.71:673. Analysis of the available data on the earnings gap between men and women examines factors of industry and occupation for relevance to the wage gap controversy. Data on family status and labor force participation are reviewed. Statistics presented also profile the link between female dominance of a profession and low average earnings.

565. U.S. Congress. House. Committee on Post Office and Civil Service. Subcommittee on Human Resources, Subcommittee on Civil Service, and Subcommittee on Compensation and Employee Benefits. *Pay Equity: Equal Pay for Work of Comparable Value, Joint Hearings.* 97th Cong., 2d sess., 16 Sept. - 2 Dec. 1982. 1829p. 2 vol. Y4.P84/10:97-52/pt.1-2. Extensive hearing on the wage gap and the issue of comparable worth presents testimony from diverse view points on remedies for the undervaluation of occupations dominated by women. The extent of the wage gap and the classification of male and female dominated positions in the federal civil service are treated in depth. The role of collective bargaining in addressing the wage gap is explored and the need for legislation to address the issue is discussed. Both support and opposition to job evaluation proposals is expressed. An extensive variety of data documents the wage disparity between male and female dominated occupations in both the public and private sectors. Part two of the hearings provides a compilation of material submitted for the record. Articles and reports on the comparable worth issue, the Supreme Court decision in *County of Washington v. Gunther*, and major laws on sex discrimination are reprinted.

566. U.S. Bureau of the Census. *Lifetime Earnings Estimates for Men and Women in the United States, 1979.* Current Population Reports Series P-60, Consumer Incomes, no. 139. Washington, DC: GPO, 1983. 37p. C3.186:P60/139. Estimates of lifetime earnings are presented for men and women by years of school completed, age, and selected assumptions for discounted productivity rates.

567. U.S. Congress. House. Committee on Government Operations. *Pay Equity: EEOC's Handling of Sex-Based Wage Discrimination Complaints, Thirty-Ninth Report Together with Additional Views.* H. Rept. 98-796, 98th Cong., 2d sess., 1984. 12p. Serial 13592. Report criticizes EEOC's lack of action in relation to sex-based wage discrimination complaints under Title VII of the Civil Rights Act of 1964. Although the Supreme Court's decision in *County of Washington, Oregon v. Gunther* opened the door for "comparable worth" and "pay equity" actions, the report documents the EEOC's refusal to participate in related court cases. The sex-based wage discrimination complaint backlog is discussed and specific recommendations for the EEOC in relation to these issues are made. Also

discussed is the relationship between EEOC and the Justice Department and the question of EEOC's ability to file an amicus brief.

568. U.S. Congress. House. Committee on Government Operations. Subcommittee on Manpower and History. *Equal Employment Opportunity Commission's Handling of Pay Equity Cases, Hearings.* 98th Cong., 2d sess., 29 Feb., 14 March 1984. 375p. Y4.G74/7:Em7/4. The lack of action by the EEOC on over 200 pay equity complaints due to a lack of policy on comparable worth is critically examined in this hearing. The issue of comparable worth and the implications of the *County of Washington v. Gunther* decision to EEOC's authority to pursue comparable worth issues is discussed.

569. U.S. Congress. House. Committee on Post Office and Civil Service. *Federal Pay Equity and Management Improvement Act of 1984, Report Together with Minority Views to Accompany H.R. 5680.* H. Rept. 98-832, 98th Cong., 2d sess., 1984. 74p. Serial 13593. Reports a bill addressing the issues of women's pay equity by directing the OMB to conduct a study of wage-setting practices and wage differentials. Patterns of women's wages compared to men and the theories on achieving pay equity are reviewed with supporting statistics on federal civil service employees pay by sex. The report explains how the committee expects OMB to conduct its study and mandates coordination of the study with a Pay Equity Study Council made up of representatives of federal employee unions and women's organizations.

570. U.S. Congress. House. Committee on Post Office and Civil Service. Subcommittee on Compensation and Employee Benefits. *Federal Pay Equality Act of 1984, Part 1, Hearings on H.R. 4599, H.R. 5092.* 98th Cong., 2d sess., 3,4 April 1984. 369p. Y4.P84/10:98-29. Hearing on proposed legislation to force the federal government to take positive steps to eliminate sex-based wage discrepancies details the extent of sex-based wage discrimination and the comparable worth issue. Election year politics flavor the hearing which focuses primarily on the failure of the Reagan administration to actively address wage discrimination issues. Considerable discussion surrounds the Supreme Court decision in *County of Washington v. Gunther.* Comparable worth as a threat to the U.S. economy is stressed by opponents.

571. U.S. Congress. House. Committee on Post Office and Civil Service. Subcommittee on Compensation and Employee Benefits. *Federal Pay Equality Act of 1984, Part 2, Hearings on H.R. 4599, H.R. 5092.* 98th Cong., 2d sess., 30 May - 18 Oct. 1984. 198p. Y4.P84/10:98-30. While disparity in pay between female and male dominated occupations is the primary focus of hearing testimony, considerable attention is also paid to actions of the Office of Personnel Management opposing the comparable worth bill and attempts to implement a federal job classification review.

572. U.S. Congress. Joint Economic Committee. *Women in the Work Force: Pay Equity, Hearing.* 98th Cong., 2d sess., 10 April 1984. 210p. Y4.Ec7:W84/8. The wage gap, segregation of women in low-paying jobs, and comparable worth are among the issues explored in this hearing presenting testimony of economists and labor representatives. The report "Women, Work, and Wages: Equal Pay for Jobs of Equal Value," by the National Research Council's Committee on Women's Employment and Related Social Issues, is reviewed and its conclusions are reprinted in the hearing record. Arguments against job comparison methods of addressing pay equity and an explanation of why comparable worth would harm women workers are presented by opponents, and the concept of the wage gap as the result of sex discrimination is detailed. A reprint of "The Wage Gap: Myths and Facts" by the National Committee on Pay Equity provides illustrative statistics on the wage gap with factors of education, experience, and job types taken into account.

573.	U.S. Commission on Civil Rights. *Comparable Worth: Issues for the 80's.* Washington, DC: GPO, 1984-1985. 2 vol. CR1.2: C73/3/v.1-2. Consultation brought together experts representing a variety of viewpoints on the issue of comparable worth. Volume 1 contains the papers presented at the consultation and covers topic such as the earnings gap and occupational segregation, implementing comparable worth, comparable worth initiatives between 1974 and 1984, and the legal perspectives. Volume 2 contains the statements and panel questions to the persons presenting papers.

574.	U.S. Congress. House. Committee on Government Operations. Employment and Housing Subcommittee. *Equal Employment Opportunity Commission Update: Policies on Pay Equity and Title VII Enforcement, Hearing.* 99th Cong., 1st sess., 21 June 1985. 171p. Y4.G74/7:Em7/7. Hearing explores the EEOC's interpretation of the Equal Pay Act and Title VII in relation to comparable worth and criticizes the commission's failure to pursue pay equity cases. The Supreme Court decision in *County of Washington v. Gunther* and the EEOC's reaction to the case are examined as EEOC defends its lack of action on pay equity cases. Affirmative action and the EEOC's interpretation of the *Stotts* decision are also examined.

575.	U.S. Congress. House. Committee on Post Office and Civil Service. *Federal Equitable Pay Practices Act of 1985, Report Together with Minority and Additional Views to Accompany H.R. 3008.* H. Rept. 99-232, 99th Cong., 1st sess., 1985. 43p. Serial 13650. Reports a bill establishing a Commission on Equitable Pay Practices. The proposed commission would oversee a study of federal pay and classification systems to determine if policies or practices exist that are inconsistent with the policies established under Title VII of the Civil Rights Act of 1964 and section 6(d) of the Fair Labor Standards Act of 1938 regarding sex, race, and ethnicity as factors in determining pay of an individual or a position. Testimony from hearings on issues of pay equity and supporting statistics on the wage gap are summarized. The report describes the makeup of the commission and the approaches to conducting the study. Minority views express opposition to the theory of comparable worth and the use of job analysis to identify discriminatory practices.

576.	U.S. Congress. House. Committee on Post Office and Civil Service. Subcommittee on Compensation and Employee Benefits. *Equitable Pay Practices Act of 1985, Hearing on H.R. 3008.* 99th Cong., 1st sess., 23 July 1985. 99p. Y4.P84/10:99-16. Witnesses explore theories explaining the wag gap between women and men. Several witnesses reject the proposed pay equity study of the federal work force contending that the study's premise, that any wage differential between male and female jobs rated as comparable is due to sex discrimination, is flawed. Much of the hearing record is devoted to the U.S. Commission on Civil Rights' response to GAO's criticism of their report on comparable worth.

577.	U.S. Congress. House. Committee on Post Office and Civil Service. Subcommittee on Compensation and Employee Benefits. *Options for Conducting a Pay Equity Study of Federal Pay and Classification Systems, Hearings.* 99th Cong., 1st. sess., 28 March - 18 June 1985. 879p. Y4.P84/10:99-13. Extensive hearings consider the comparable worth issue and the validity of job evaluation approaches to determining pay equity of male and female dominated jobs. Testimony focuses on applications of pay equity in city and state governments and on previous studies of pay equity. Heavy criticism is leveled at the Civil Rights Commission report on comparable worth.

578.	U.S. Congress. Senate. Committee on Governmental Affairs. Subcommittee on Civil Service, Post Office, and General Services. *"Options for Conducting a Pay Equity Study of Federal Pay and Classification Systems" - Report of the General Accounting Office, Hearing.* 99th Cong., 1st sess., 22 May - 25 July 1985. 705p. Y4.G74/9:S.hrg.99-1059. Extensive hearings on the concept of comparable worth focus on a GAO report presenting

options for a pay equity study of the federal work force. Job segregation, the "pink collar ghetto", and the wage gap are recurring themes. The wage gap between men and women in the federal work force and in the labor force in general are illustrated. The validity of approaches to assessing the comparable worth of jobs is debated. Phyllis Schlafly testifies against the bill arguing its unfairness to men. Court decisions and state actions on pay equity are reviewed.

579. U.S. General Accounting Office. *Comments on Report on Comparable Worth by the United States Commission on Civil Rights.* Washington, DC: The Office, 1985. 29p. GA1.13:GGD-85-59. Critical review of the U.S. Commission on Civil Rights' report, *Comparable Worth: Issues for the 80's* (573) highlights inconsistencies in the report. The major criticism centers on the commission's definition of comparable worth and subsequent rejection of comparable worth for the federal employment system. Also discussed is the accuracy of the report's portrayal of the views expressed by comparable worth advocates in commission hearings.

580. U.S. General Accounting Office. *Description of Selected Nonfederal Job Evaluation Systems.* Washington, DC: The Office, 1985. 41p. GA1.13:GGD-85-57. Description of job evaluation methods used in Connecticut, Idaho, and Arizona is accompanied by discussion of the use of job evaluation systems in determining comparable worth. The report focuses on point-factor evaluation systems and their use in practice with a particular focus on Washington and Minnesota. In addition to the report on state systems, a job evaluation method used at JByrons' department stores in Florida is also examined, and the application of the system in the pay adjustment process is documented.

581. U.S. General Accounting Office. *Options for Conducting a Pay Equity Study of Federal Pay and Classification Systems: Report.* Washington, DC: The Office, 1985. 94p. GA1.13:GGD-85-37. Commissioned GAO report on options for studying pay equity in the federal workplace furnishes background information on the comparable worth issue and assess methodologies for a study of the federal pay and classification systems. The experience of several cities and states with conducting comparable worth studies is reviewed as background on study methods. A review of the legal basis of pay equity is provided.

582. U.S. National Center for Education Statistics. *Salary Comparisons of 1979-1980 College Graduates, by Sex, in May 1981.* by Jane L. Crane. Washington, DC: GPO, 1985. 43p. ED1.102:Sa3. Study of sex differences in salaries of college graduates uses both the descriptive approach and regression analysis to determine the factors that influence male and female salaries. Provides statistics on frequency distribution and salaries of 1979-80 college graduates by sex and occupational category, 1981; frequency distributions and salaries of 1979-80 college graduates by sex and major field; and frequency distribution and salaries of 1979-80 college graduates by sex and years of full-time work experience.

583. U.S. Congress. Senate. Committee on Governmental Affairs. Subcommittee on Federal Services, Post Office and Civil Service. *Federal Employee Compensation Equity Act of 1987, Hearing on S. 552.* 100th Cong., 1st sess., 20 Apr. 1987. 218p. Y4.G74/9:S.hrg.100-202. Hearing on the proposed Federal Employee Compensation Equity Act of 1987 focuses on the federal job classification system and allegations of sex discrimination within the system. Testimony discusses job evaluation techniques and the concept of comparable worth. The administration viewpoint that sex discrimination is not a problem and their opposition to the proposed study of the wag gap is presented. The 1985 GAO report *Options for Conducting a Pay Equity Study of the Federal Pay and Classification Systems* (581) is cited repeatedly in support of further examination of sex-bias in the federal classification system. Evidence of the lack of pay equity in the federal system is presented while the administration makes the case that the situation of women

in the federal government had already improved, and that comparable worth would not help women.

584. U.S. Office of Personnel Management. *Comparable Worth for Federal Jobs: A Wrong Turn Off the Road Toward Pay Equity and Women's Career Advancement.* Washington, DC: GPO, 1987. 73p. PM1.2:J57/2. Analysis of the changing trends in the career paths of women in the federal government is used to support the argument against a comparable worth approach to narrowing the wage gap between men and women workers.

585. U.S. Congress. House. Committee on Post Office and Civil Service. *Federal Equitable Pay Practices Act of 1988, Report to Accompany H.R. 387.* H. Rept. 100-914, 100th Cong., 2d sess., 13 Sept. 1988. 42p. Serial 13902. Detailed report reviews the evidence of a wage gap for federally employed women and stresses the need for a review of the civil service job classification system for gender bias. Background on the concept of comparable worth and its relation to the Equal Pay Act and Title VII of the Civil Rights Act of 1964 as interpreted by the courts is provided. Details of the proposed study of the federal classification and wage system is furnished.

586. U.S. Federal Judicial Center. *Manual on Employment Discrimination Law and Civil Rights Actions in the Federal Courts.* by Charles R. Richey. Washington, DC: GPO, 1988. various paging. Ju13.10/3:88-1. Guide to legal action under employment discrimination law. Addresses the right to sue and who can be sued, administrative requirements, time requirements, right to a jury trial, burden of proof, and remedies. Specific topics briefly covered in the Title VII section include pregnancy discrimination, sexual harassment, and comparable worth. The Equal Pay Act is covered in more detail in its own section. Sources of information and related case law are cited.

587. U.S. Equal Employment Opportunity Commission. *Pay: Equal Work, Equal Pay.* Washington, DC: GPO, 1990. leaflet. Y3.Eq2:2P29. Leaflet provides advice on equal pay laws and remedies to wage discrimination.

588. U.S. Equal Employment Opportunity Commission. *Sueldos: Igual Trabajo, Igual Sueldo.* Washington, DC: GPO, 1990. leaflet. Y3.Eq2:2P29/spanish. See 587 for abstract.

589. U.S. Women's Bureau. *Earnings Differences between Women and Men.* Facts on Working Women no. 90-3. Washington, DC: The Bureau, 1990. 7p. L36.114/3:90-3. Report of data on the wage gap between women and men workers. Examines current measures of earnings differentials and probable causes for the slow improvement in the wage gap. Women to men's earnings ratios and women to total employment ratios are provided by occupational class for 1983 and 1989. A reading list for additional information is provided.

SERIALS

590. U.S. Women's Bureau. *Digest of State Equal Pay Laws.* Washington, DC: GPO, 1950-1965. rev. irreg. L13.2:Eq2/7/year. Chart for each state provides information on equal pay laws including enabling legislation, coverage, administrative authority, record keeping and posting, and enforcement.

591. U.S. Women's Bureau. *Equal Pay, [State].* Washington, DC: GPO, 1965-1966. Reprints the text of state equal pay laws.

California. 1965. 2p. L13.6/3:C12.
Missouri. 1965. 3p. L13.6/3:M69o.

New York. 1965. 2p. L13.6/3:N42y.
North Dakota. 1965. 4p. L13.6/3:N81d.
Oklahoma. 1966. 1p. L13.6/3:Ok4/965.
Rhode Island. 1965. 2p. L13.6/3:R34.
West Virginia. 1965. 3p. L13.6/3:W52v.

592. U.S. Women's Bureau. *Equal Pay Facts.* Leaflet no. 2. Washington, DC: GPO, 1946-
 1956. leaflet. irreg. L13.11:2/rev.

593. U.S. Women's Bureau. *Equal-Pay Primer, Some Basic Questions.* Leaflet no. 20.
 Washington, DC: GPO, 1955 -1963. rev. irreg. L13.11:20/no. Good overview of the
 equal pay battle as the situation stood in 1963. Explains the principles of equal pay and
 highlights existing inequities, international interest in equal pay, and state adoption of equal
 pay laws. Describes action at the federal level to enact equal pay legislation and presents
 a chart showing organizations participating in the 1942, 1948, 1950, and 1962
 congressional hearings. Union contracts and equal pay provisions are summarized.

594. U.S. Women's Bureau. *What Equal Pay Principle Means to Women, Some Pertinent
 Quotations and Answers.* Washington, DC: The Bureau, 1963-1966. revised or reissued
 irregularly. L13.2:Eq2/16/year. Review of the provisions of the Equal Pay Act of 1963
 and of the effects of the law provides some background on the history of the act and on
 earlier attempts to legislate equal pay. The status of state equal pay laws are summarized.

4

Minimum Wage

One of the major issues promoted by the Women's Bureau from its inception through 1966 was the enactment of state minimum wage laws. Most of the documents listed are reports detailing the progress of minimum wage in the states. Some of the more substantial documents listed are a review of the development of minimum wage laws between 1912 and 1927 (605) and an examination of the court challenge to the New York minimum wage law (609-610). Also of interest are the recommended budgets for single working women, which were used to set minimum wage rates (646). Several of the documents reflect the goals of minimum laws as they set out the necessary parts of a good minimum wage bill (606, 614). Although minimum wage continued to be a topic of government documents after the 1960's, those documents ceased to provide any significant discussion of the effect of minimum wage laws on women.

595. U.S. Bureau of Labor Statistics. *Minimum-Wage Legislation in the United States and Foreign Countries.* Bulletin no. 167. Washington, DC: GPO, 1915. 335p. L2.3:167. Review of minimum wage legislation in the U.S. and foreign countries furnishes information on minimum wage by occupation. The focus of minimum wage information for the U.S. is on female dominated occupations. Numerous tables show actual wages received by occupation.

596. U.S. Congress. House. Committee on the District of Columbia. *Minimum- Wage Board for the District of Columbia, Report to Accompany H.R. 12098.* H. Rept. 571, 65th Cong., 2d sess., 1918. 5p. Serial 7308. Favorable report on a substitute bill for H.R.10367 establishing a minimum wage board for the District of Columbia summarizes hearing testimony supporting the legislation and reviews the working and legality of the minimum wage board approach.

597. U.S. Congress. House. Subcommittee of the Committee on the District of Columbia. *Minimum Wage for Women and Children, Hearing on H.R. 10367.* 65th Cong., 2d sess., 16 April 1918. 44p. Y4.D63/1:W12. No opposition is presented to this bill providing for the establishment of a minimum wage for women and children employed in the District of Columbia. The constitutionality as proven by past court cases and the trend toward such legislation in the states is highlighted. Data on cost of living and the annual wages of women in Washington is presented in support of the bill. Several witnesses describe the results of similar laws in other states.

598. U.S. Congress. Senate. Committee on the District of Columbia. *Minimum Wage: Adverse Report to Accompany S. 3993.* S. Rept. 488, 65th Cong., 2d sess., 1918. 1p. Serial 7304. Adverse report refers to a favorable report on a similar bill (599).

599. U.S. Congress. Senate. Committee on the District of Columbia. *Minimum Wage, Report to Accompany S. 4548.* S. Rept. 486, 65th Cong., 2d sess., 1918. 8p. Serial 7304. Reports a bill establishing the process for fixing and enforcing a minimum wage for women and children in the District of Columbia. Hearing on the bill is summarized and the need for such a bill to protect the health and morals of women and children is reviewed. Also highlights the spread of the minimum wage movement and the practical working of such laws.

600. U.S. Congress. Senate. Subcommittee of the Committee on the District of Columbia. *Minimum Wage Board, Hearing on S. 3993.* 65th Cong., 2d sess., 17 April 1918. 44p. Y4.D63/2:W12. Hearing considers a bill to "To protect the lives and health and morals of women and minor workers in the District of Columbia" by establishing a minimum wage board. Testimony presents minimum wage board theory and practice both in the U.S. and abroad. The effect of war on the ability of wage earning women to make ends meet is also noted by some witnesses. Several witnesses speak of their experience with minimum wage boards in the states. Specific information is presented on cost of living for women in Washington, D.C. and on the average wages paid. No opposition to the bill is presented.

601. District of Columbia. Minimum Wage Board. *Cost of Living of Wage-Earning Women in the District of Columbia.* Minimum Wage Board Bulletin no. 1. Washington, DC: The Board, 1919. 7p. DC50.3:1.

602. U.S. Women's Bureau. *Minimum Wage Laws for Women.* Baltimore, MD: A. Hoen & Co., 1921. 1p. map. L13.6:5. Also issued in Women's Bureau Bulletin no. 16 (728).

603. U.S. Women's Bureau. *Minimum Wage Legislation in United States, Dec. 31, 1920.* Washington, DC: The Bureau, 1921. [3]p. L13.5:9/2 sec.1-3. Three sections, each a one page chart. Earlier edition covering legislation as of April 1920 was issued under SuDoc number L13.5:9/sec.1-3.

604. U.S. Women's Bureau. *List of References on Minimum Wage for Women in the United States and Canada.* Bulletin no. 42. Washington, DC: GPO, 1925. 42p. L13.3:42. Bibliography cites periodical articles, books, pamphlets, official documents, and court decisions on minimum wage laws in the U.S. and Canada.

605. U.S. Women's Bureau. *The Development of Minimum-Wage Laws in the United States, 1912 to 1927.* Bulletin no. 61. Washington, DC: GPO, 1928. 635p. 76p. L13.3:61. Comprehensive discussion of minimum-wage laws in the U.S. describes the development of the laws and the definitions of classes affected. Provides an overview of the organization of administering and enforcing agencies including information on the representation of women. Detailed information on organization and procedures for setting rates and enforcing them is furnished. Data is provided on changes in the rate paid to women by state in relation to minimum wage laws.

606. U.S. Dept. of Labor. *Suggested Language for Standard Minimum Wage Bill for Women and Minors, as Drafted by Council for National Consumers' League and Approved by Interstate Conference on Labor Compacts and the Department of Labor.* Washington, DC: The Department, 1935. 8p. L16.2:W12/3.

607. U.S. Women's Bureau. *State Minimum Wage Laws, Summary of Occupations Covered and Rates Fixed.* Washington, DC: The Bureau, 1935? 19p. L13.2:W12/6. Charts provide state summaries of minimum wage laws and rates fixed as of June 15, 1935, including occupations or industry covered, minimum wage rates fixed by industry, class of employees covered, and minimum rate.

608. U.S. Women's Bureau. *Why Legislate Living Wages for Women Workers?* Washington, DC: GPO, 1935. 4p. L13.2:W12. Overview of how minimum wage laws operate reviews the benefits to women workers and to industry.

609. U.S. Women's Bureau. *Brief History of New York Minimum Wage Case.* Washington, DC: The Bureau, 1936. 11p. L13.2:W12/2. Complete legal history of the New York minimum wage law follows its challenge in the New York Courts and the Supreme Court. The basic arguments of the case as set forth by both sides and in amici curiae are reviewed and the majority and minority opinion are reviewed.

610. U.S. Women's Bureau. *New Chapter in History of the New York Minimum Wage Case, Supplement to Brief History of New York Minimum Wage Case.* Washington, DC: The Bureau, 1936. 5p. L13.2:W12/2/supp. Supplement reviews the petition for a rehearing of the New York case, which was denied, and the pending Supreme Court decision on the State of Washington minimum wage law and the court ruling on the Ohio minimum wage case.

611. U.S. Women's Bureau. *Special Study of Wages Paid to Women and Minors in Ohio Industries Prior and Subsequent to the Ohio Minimum Wage Law for Women and Minors.* Bulletin no. 145. Washington, DC: GPO, 1936. 83p. L13.3:145. Discussion of the wages paid to women workers in Ohio before and after minimum wage laws examines 30 years of women's employment. The report pays particular attention to data supporting the argument that women workers are not just young women who work until they marry but are, in fact, married women with dependents. Data on the effect of minimum wage laws on women focuses on the laundry industry. Provides earnings data for Ohio by industry and sex. Report points out the lack of a relationship between the value of work and wages paid to women.

612. U.S. Congress. House. *Communication from the President of the United States Transmitting a Recommendation for the Reenactment of Legislation Regarding a Minimum Wage Law in the District of Columbia.* H. Doc. 198, 75th Cong., 1st sess., 1937. 2p. Serial 10126. Letters from President Roosevelt and Attorney General Cummings describe the effect of the Supreme Courts ruling in *Adkins v. Children's Hospital* and *West Coast Hotel v. Parish* on the legality of the District's minimum wage laws.

613. U.S. Women's Bureau. *The Ohio Minimum Wage Law Held Constitutional.* Washington, DC: The Bureau, 1937? 3p. L13.2:W12/4. News report reviews the federal district court ruling that an Ohio minimum wage law for women and minors was constitutional.

614. U.S. Dept. of Agriculture. *Factors to be Considered in Preparing Minimum-Wage Budgets for Women.* Miscellaneous Pub. no. 324. Washington, DC: GPO, 1938. 46p. A1.38:324. In order to provide firm guidelines for establishing a fair minimum wage for women, this publications sets out in detail the necessary expenditures for a single woman to live at a minimal level of comfort. The intended use of the guide is as a basis for states to conduct a survey to establish prices in industrial areas to be used in computing minimum wage orders. Later revised by Misc. Pub. 549 (624).

615. U.S. Women's Bureau. *The Effect of Minimum-Wage Determinations in Service Industries.* Bulletin no. 166. Washington, DC: GPO, 1938. 44p. L13.3:166. Study of the effect of minimum wage legislation on the economic situation of women looks at dry-cleaning establishments in Ohio and power laundries in New York, both states which passed minimum wage legislation during the depression years. Investigators collected and analyzed data on changes in number of employees, hourly earnings, hours worked, and weekly earnings.

616. U.S. Women's Bureau. *Minimum Wage Laws for Women and Minors, 1937.* Washington, DC: U.S. Geological Survey, 1938. 1p. map. L13.6/2:M66.

617. U.S. Women's Bureau. *The High Cost of Low Wages and How to Prevent It.* Washington, DC: GPO, 1939. leaflet. L13.2:W12/3/939. Summary of the evils of low wages promotes the passage of minimum wage laws. Earlier edition published in 1938.

618. U.S. Women's Bureau. *Selected List of Recent References on Minimum Wage for Women in the United States.* by Edna L. Stone. Bulletin no. 42, supplement. Washington, DC: The Bureau, 1939. 9p. L13.3:42/supp. See 604 for abstract.

619. U.S. Women's Bureau. *State Minimum-Wage Laws and Orders: An Analysis.* by Florence P. Smith. Bulletin no. 167. Washington, DC: GPO, 1939. 39p. L13.3:167. Detailed charts provide information on state laws and orders setting minimum wages including occupation and industries covered, class of employees covered, minimum wage rates, and hours. Also details the authority empowered to administer the law, procedures preliminary to setting wage rates, procedures for setting wage rates, means of enforcement, basis of wage rates, occupation or industry covered, employees covered, and legislated exceptions.

620. U.S. Women's Bureau. *State Minimum-Wage Laws and Orders: 1939.* by Florence P. Smith. Bulletin no. 167, supplement 1. Washington, DC: GPO, 1940. 15p. L13.3:167/supp.1. Updates charts in Bulletin 167 (619) for laws passed in 1939.

621. U.S. Women's Bureau. *State Minimum-Wage Laws and Orders: 1940.* by Florence P. Smith. Bulletin no. 167, supplement 2. Washington, DC: GPO, 1941. 13p. L13.3:167/supp.2. Updates charts in Bulletin 167 (619) for laws passed in 1940.

622. U.S. Women's Bureau. *On the Home Front with Minimum Wage.* Washington, DC: GPO, 1942. 7p. L13.2:W12/7. Overview of why minimum-wage laws are needed in all states notes how they have helped so far.

623. U.S. Women's Bureau. *State Minimum-Wage Laws and Orders: 1942, An Analysis.* by Florence P. Smith. Bulletin no. 191. Washington, DC: GPO, 1942. 58p. L13.3:191. Revision of Bulletin no. 167 (619) presents legal charts detailing state minimum wage laws and orders.

624. U.S. Dept. of Agriculture. *Minimum-Wage Budgets for Women: A Guide to Their Preparation.* Miscellaneous Publication no. 549. Washington, DC: GPO, 1944. 42p. L1.38:549. Requirements for a single woman to live comfortably was intended for use by states in figuring local cost of living to determine a fair minimum wage for single women. Revision of Miscellaneous Pub. 324 (614).

625. U.S. Women's Bureau. *Minimum Wage.* Washington, DC: The Bureau, 1944. 2p. leaflet. L13.2:W12/10. Legislative flyer prepared for the National Conference on Labor Legislation.

626. U.S. Women's Bureau. *State Minimum Wage Legislation - A Postwar Necessity.* Washington, DC: The Bureau, 1944. 25p. L13.2:W12/8. Report details the reasons minimum wage legislation would be needed to help ensure prosperity in the postwar period. Discusses the low wages of both men and women in certain industries and occupations, particularly in service industries such as restaurants and hotels. Provides wage rate data by occupation for selected states for workers in power laundries, restaurants and hotels.

627. U.S. Women's Bureau. *Analysis of State Minimum-Wage Orders, Effective Dates, July 1942 - Aug. 1945.* Bulletin no. 191, supplement. Washington, DC: GPO, 1945. 28p. L13.3:191/supp. See 623 for abstract.

628. U.S. Women's Bureau. *Protect Future Wage Levels...Now!* Women's Bureau Leaflet B. Washington, DC: GPO, 1945. leaflet. L13.11:B.

629. U.S. Women's Bureau. *Analysis of State Minimum-Wage Orders, Effective Dates, Nov. 12, 1945 - April 1, 1946.* Bulletin no. 191, supplement 3. Washington, DC: GPO, 1946. 13p. L13.3:191/supp. 3. See 623 for abstract.

630. U.S. Women's Bureau. *Earnings in Maryland Industries.* Washington, DC: The Bureau, 1946. 9p. L13.2:M36. Overview of the experience of women in Maryland industries in the closing months of World War Two points to the very low wages paid women and the need for minimum wage legislation in the state. Most of the women in the survey earned less than 65 cents an hour. The wage surveys for industries summarized here were conducted primarily in 1945 although some were conducted earlier. Wages of women are compared with those of men employed in the same industry. Also summarizes hours of work scheduled for women by industry.

631. U.S. Women's Bureau. *Report of Proceedings of Women's Bureau 12th Minimum Wage Conference, Held in Washington, D.C., Mar. 15-16, 1946.* Washington, DC: The Bureau, 1946. 17p. L13.2:W12/11/946.

632. U.S. Women's Bureau. *Where Do We Stand on Minimum Wage, Address by Frieda S. Miller...before the Missouri Association for Social Welfare, April 23, 1947, St. Louis, Mo.* Washington, DC: The Bureau, 1947. 9p. L13.12:W12. Speech describes the history and status of state minimum wage laws and orders.

633. U.S. Women's Bureau. *Analysis of State Minimum-Wage Orders, Effective Dates, July 1942 - Sept. 1945.* Bulletin no. 191, supplement 1. rev. ed. Washington, DC: GPO, 1948. 34p. L13.3:191/supp.1/rev. See 623 for abstract.

634. U.S. Women's Bureau. *State Minimum-Wage Laws Benefit Workers, by Setting Floor to Their Wages, for Employers by Protecting Them from Unfair Competition, Community, by Sustaining Purchasing Power, Increasing Worker Efficiency, Lowering Relief Costs.* Leaflet, 1948 Series, no. 1. Washington, DC: The Bureau, 1948. 8p. leaflet. L13.11:1/948.

635. U.S. Women's Bureau. *Report on Proceedings of Women's Bureau 14th Minimum Wage Conference, held in Washington, D.C., Dec. 6-8, 1948.* Washington, DC: The Bureau, 1949. 19p. L13.2W12/11/948. Summary reports of state activities on minimum wage and discussion of technical issues and administrative practices characterize this report on the 14th Women's Bureau Minimum Wage Conference. The conference also included reports on women's civil and political status, equal pay legislation, and legislative proposals on minimum wage.

636. U.S. Women's Bureau. *State Minimum-Wage Laws and Orders, July 1, 1942 - Jan. 1, 1949.* Bulletin no. 227. Washington, DC: GPO, 1949. 58p. L13.3:227. Supplement to Bulletin 191 (623) provides state-by-state summary in legal chart form of minimum wage laws and orders issued since July 1942.

637. U.S. Women's Bureau. *State Minimum-Wage Orders Becoming Effective since End of World War II.* Washington, DC: The Bureau, 1949. 20p. L13.2:W12/12/949. Charts provide summary information by state on minimum wage orders becoming effective since

WWII. Information given includes occupations and industries covered, date effective, highest basic wage rate established, and principle working condition standards such as overtime, uniform costs, and deductions for meals and lodging. Earlier edition published in 1948.

638. U.S. Women's Bureau. *Estimated Annual Cost of Adequate Maintenance and Protection of Health for a Woman Worker Living Alone in New Jersey, October 1950.* Washington, DC: The Bureau, 1950? 3p. L13.2:N34. Guide to estimating the annual cost of room and board, clothing, personal care, medical needs, recreation, education, transportation and taxes for a single woman living in New Jersey cites sources of information.

639. U.S. Women's Bureau. *Estimated Annual Cost of Adequate Maintenance and Protection of Health for a Woman Worker Living Alone in Utah, October 1950.* Washington, DC: The Bureau, 1950. 2p. L13.2:B85/3. See 638 for abstract.

640. U.S. Women's Bureau. *Report of Proceedings of the Women's Bureau Fifteenth Annual Conference of State Minimum Wage Administrators Held in Washington, D.C., April 20-21, 1950.* Washington, DC: The Bureau, 1950. 20p. L13.2:M66/2/950. Report of the proceedings of a conference of state minimum wage administrators briefly describes state efforts to extend minimum wage coverage and summarizes reports on operating methods and enforcement activities. The focus is on the practical aspects of minimum-wage issues from an administrator's point of view.

641. U.S. Women's Bureau. *State Minimum-Wage Laws and Orders, July 1, 1942 - July 1, 1950.* Bulletin no. 227, revised. Washington, DC: GPO, 1950? 68p. L13.3:227/2. See 636 for abstract.

642. U.S. Women's Bureau. *Annual Budget for Certain Employed Single Persons in Maine, Dec. 1950.* Washington, DC: The Bureau, 1951. 2p. L13.2:B85/2.

643. U.S. Women's Bureau. *Estimated Annual Cost of Adequate Maintenance and Protection of Health of Woman Worker Living Alone in New Jersey, October 1950.* Washington, DC: The Bureau, 1951. 2p. L13.2:H34.

644. U.S. Women's Bureau. *Provisions in State Minimum-Wage Orders for Mercantile and Retail Trade.* Washington, DC: The Bureau, 1951. 15p. L13.2:M66/4. Charts provide information on provisions of minimum wage orders for mercantile and retail trade in 23 states. Specific information includes order and effective date, class of employees covered, minimum wage rates, and hours.

645. U.S. Women's Bureau. *State Minimum-Wage Laws Benefit...* Washington, DC: GPO, 1951. leaflet. L13.2:M66/3.

646. U.S. Women's Bureau. *Working Women's Budgets in Thirteen States.* Bulletin no. 226, revised. Washington, DC: GPO, 1951. 45p. L13.3:226/2. Report details state determined typical expenditures of single working women used to set minimum wage rates in Arizona, California, Colorado, Connecticut, District of Columbia, Kentucky, Maine, Massachusetts, New Jersey, New York, Pennsylvania, Utah, and Washington. The process of creating a typical working woman's budget, and the budget for each state, are highlighted. Earlier edition published in 1948.

647. U.S. Women's Bureau. *17th Annual Conference of State Minimum Wage Administrators, Sept. 18 and 19, 1952, List of State Representatives Planning to Attend Conference.* Washington, DC: The Bureau, 1952. 2p. L13.2:M66/6.

648. U.S. Women's Bureau. *Estimated Annual Cost of Adequate Maintenance and Protection of Health for Single Employed Women Living as a Member of a Family Group in New York State, September 1951.* Washington, DC: The Bureau, 1952. 2p. L13.2:H34/2.

649. U.S. Women's Bureau. *Estimated Annual Cost of Budget for an Employed Woman in the District of Columbia, May 1952.* Washington, DC: The Bureau, 1952. 2p. L13.2:B85/952. Earlier editions issued in November 1950 and August 1951.

650. U.S. Women's Bureau. *Progress of State Minimum-Wage Legislation, 1950-51.* Washington, DC: GPO, 1952. 14p. L13.2:M66/950-51. Summary of state legislative action on minimum wage laws describes in legal chart form the provisions of wage orders which became effective between July 1950 and June 30, 1951.

651. U.S. Women's Bureau. *Provisions in State Minimum Wage Laws Affecting Preparation of Evidence.* Washington, DC: The Bureau, 1952. 2p. L13.2:M66/7.

652. U.S. Women's Bureau. *State Minimum-Wage Laws and Orders, July 1, 1950 - Jan. 1, 1952.* Bulletin no. 227, supplement 1. Washington, DC: GPO, 1952. 50p. L13.3:227/2/supp.1. See 636 for abstract.

653. U.S. Women's Bureau. *State Minimum-Wage Orders Becoming Effective Since July 1, 1950.* Washington, DC: The Bureau, 1952. 1p. L13.2:M66/5.

654. U.S. Women's Bureau. *Proceedings of the Seventeenth Annual Conference of State Minimum-Wage Administrators, Washington, D.C., September 18 and 19, 1952.* Washington, DC: The Bureau, 1953. 42p. L13.2:M66/2/952. Report on minimum wage issues in 1952 from the state administrator's point of view. Focuses on preparing evidence for wage boards, obtaining support by working with the public, industry, labor, and other governing agencies, and administrative experience with statutory rate amendments.

655. U.S. Women's Bureau. *State Minimum-Wage Laws and Orders, Jan. 1, 1952 - Jan. 1, 1953.* Bulletin no. 227, supplement 2. Washington, DC: GPO, 1953. 20p. L13.3:227/2/supp.2. See 636 for abstract.

656. U.S. Women's Bureau. *State Minimum-Wage Laws and Orders, July 1, 1942 - March 1, 1953.* Bulletin no. 247. Washington, DC: GPO, 1953. 93p. L13.3:247. Revision of Bulletin no. 227 (636).

657. U.S. Women's Bureau. *State Minimum-Wage Order Provisions Affecting Working Conditions, July 1, 1942 - Sept. 15, 1953.* Washington, DC: The Bureau, 1953. 75p. L13.2:M66/8. See 661 for abstract.

658. U.S. Women's Bureau. *State Minimum-Wage Laws and Orders, Mar. 2, 1953 - July 1, 1954, Supplement.* Bulletin no. 247, supplement. Washington, DC: GPO, 1954. 38p. L13.3:247/supp. See 636 for abstract.

659. U.S. Women's Bureau. *Minimum Wage and the Woman Worker.* Washington, DC: The Bureau, 1955. 14p. L13.2:M66/9. General overview of minimum wage laws describes their importance to employers, employees, and the community.

660. U.S. Women's Bureau. *State Minimum-Wage Laws and Orders, July 2, 1954 - May 1, 1955, Supplement 2.* Bulletin no. 247, supplement 2. Washington, DC: GPO, 1955. 33p. L13.3:247/supp 2. See 636 for abstract.

661. U.S. Women's Bureau. *State Minimum-Wage Order Provisions Affecting Working Conditions, July 1, 1942 to June 1, 1955.* Bulletin no. 259. Washington, DC: GPO, 1955. 75p. L13.3:259. Provides information in legal chart form on state labor laws affecting overtime, minimum daily wage, meal and rest periods, tips and gratuities, meals and lodging, and uniforms.

662. U.S. Women's Bureau. *California, Annual Cost of Minimum Budget for Single Working Woman Living in Guest House and Eating Some of Her Meals in Restaurants in California, October 1950, and Estimated June 1955.* Washington, DC: The Bureau, 1956. 2p. L13.2:B85/4.

663. U.S. Women's Bureau. *Estimated Annual Cost of Budget for Employed Woman in District of Columbia, May 1953.* Washington, DC: The Bureau, 1956. 2p. L13.2:B85/5.

664. U.S. Women's Bureau. *State Minimum-Wage Laws, July 1, 1956.* Washington, DC: The Bureau, 1956. 1p. L13.6/2:M66/2/956. map.

665. U.S. Bureau of Labor Standards and U.S. Women's Bureau. *Memorandum to Accompany Suggested Language for a State Bill Establishing Fixed Minimum Wage.* Washington, DC: The Bureau, 1957. 5p. L16.2:W12/8/memo.

666. U.S. Bureau of Labor Standards and U.S. Women's Bureau. *Memorandum to Accompany Suggested Language for a State Bill Establishing Fixed Minimum Wage and Wage Board Procedures.* Washington, DC: The Bureau, 1957. 5p. L16.2:W12/7/memo.

667. U.S. Bureau of Labor Standards and U.S. Women's Bureau. *Suggested Language for a State Bill Establishing Fixed Minimum Wage.* Washington, DC: The Bureau, 1957. 12p. L16.2:W12/8.

668. U.S. Bureau of Labor Standards and U.S. Women's Bureau. *Suggested Language for a State Bill Establishing Fixed Minimum Wage and Wage Board Procedures, Prepared in Response to Resolution of International Association of Governmental Labor Officials in Convention, Miami Beach, Fla., Nov. 1956.* Washington, DC: The Bureau, 1957. 19p. L16.2:W12/7.

669. U.S. Women's Bureau. *Minimum Wage and the Woman Worker.* Women's Bureau Leaflet no. 24, revised. Washington, DC: GPO, 1958. 15p. L13.11:24/2. Basic information on the history of minimum wage laws, how minimum wage laws work, and how they affect the community, the employer, and the employees. In spite of the title, the publication does not really address minimum wage as a woman's issue.

670. U.S. Women's Bureau. *State Minimum-Wage Laws and Orders, July 1, 1942 to July 1, 1958, Part I, Historical Development and Statutory Provisions.* Bulletin no. 267, part 1. Washington, DC: GPO, 1958. 41p. L13.3:267/pt.1. Report provides a general overview of the development of minimum wage laws and orders and of typical provisions. Legal charts provide information on coverage, administrative authority, basis of wage rate, procedures for establishing minimum wage, and enforcement.

671. U.S. Women's Bureau. *State Minimum-Wage Laws and Orders, July 1, 1942 to July 1, 1958, Part II, Analysis of Rates and Coverage.* Bulletin no. 267, part 2. Washington, DC: GPO, 1958. 145p. L13.3:267/pt.2. Legal chart format provides state-by-state analysis of minimum-wage orders. Information provided includes occupations and industries covered, class of employees covered, minimum wage rates, hours, and legal authority. Issued in loose-leaf form for updating. Revised edition issued in 1963.

672. U.S. Women's Bureau. *Pennsylvania, Estimated Annual Cost of Budget for Employed Women in Pennsylvania, May 1957.* Washington, DC: The Bureau, 1959. 2p. L13.2:B85/6.

673. U.S. Women's Bureau. *State Minimum-Wage Law and Order Provisions Affecting Working Conditions, July 1, 1942 to April 1, 1959.* Bulletin no. 269. Washington, DC: GPO, 1959. 141p. L13.3:269. See 661 for abstract.

674. U.S. Women's Bureau. *Minimum Wage and the Women Workers.* Women's Bureau Pamphlet no. 8. Washington, DC: GPO, 1960. 16p. L13.19:8. Brief history of how state minimum wage laws developed and the importance of the minimum wage to women workers.

675. U.S. Women's Bureau. *New Jersey, Estimated Annual and Weekly Cost of Adequate Maintenance and Protection of Health of Women Worker Living Alone in Furnished Room and Eating Meals in Restaurants, September 1958.* Washington, DC: The Bureau, 1960. 2p. L13.2:H34/958.

676. U.S. Women's Bureau. *Report of the National Conference of State Minimum-Wage Administrators, Held at Washington, D.C., November 1-3, 1961, Sponsored Jointly by Women's Bureau and Bureau of Labor Standards.* Washington, DC: The Bureau, 1961. 72p. L13.2:M66/10.

677. U.S. Women's Bureau. *State Minimum-Wage Laws and Order Provisions Affecting Working Conditions, July 1, 1942 to January 1, 1961.* Bulletin no. 280. Washington, DC: GPO, 1961. 147p. L13.3:280. Revision of Women's Bureau Bulletin no. 269 (661).

678. U.S. Congress. House. Committee on the District of Columbia. Subcommittee No. 3. *Amend the Minimum Wage Law of the District of Columbia, Hearing on H.R. 8423.* 88th Cong., 1st sess., 11 Dec. 1963. 99p. Y4.D63/1:W12/3. Hearing considers a bill to expand coverage of the District of Columbia minimum wage law, raise the standards for wages and overtime, and improve enforcement. Expansion would provide coverage for all workers, not just women and children in selected industries. Testimony provides information on minimum wage in reference to selected occupations. The cost-of-living budget for working women with no dependents is used as the basis for setting the minimum wage.

679. U.S. Women's Bureau. *Minimum-Wage Status of 50 States, District of Columbia, and Puerto Rico.* Washington, DC: The Bureau, 1964. 3p. L13.2:M66/11/964. Earlier edition issued in 1963.

680. U.S. Women's Bureau. *Analysis of Coverage and Wage Rates of State Minimum Wage Laws and Orders, August 1, 1965.* Washington, DC: GPO, 1965. 130p. L13.3:291. Revision of Bulletin no. 267, part 2 (671).

681. U.S. Women's Bureau. *Helping People Help Themselves, Attack on Poverty, Talk by Mary Dublin Keyserling, Director, Women's Bureau, Department of Labor, October 29, 1965, Maryland, Virginia, District of Columbia Home Economics Workshop, University of Maryland.* Washington, DC: The Bureau, 1965. 13p. L13.12:K52/18. General discussion of the characteristics of poverty in America specifically notes the need to establish a minimum wage in all states to insure all workers, many of them women, a living wage. The role of federal labor legislation to help women earn a decent wage and the influence of state commissions on the status of women are discussed.

682. U.S. Women's Bureau. *State Minimum Wage Legislation: A Weapon In War on Poverty.* Washington, DC: The Bureau, 1965. 8p. L13.2:M66/12.

683. U.S. Women's Bureau. *State Policy under Minimum Wage Laws and Orders Relative to Handling Tips or Gratuities as Part of Minimum Wage.* Washington, DC: The Bureau, 1965. 5p. L13.2:M66/13. Summary provides a general idea of how various state minimum wage boards take tips into consideration when issuing a minimum wage order for hotel, restaurant, and public housekeeping industries.

684. U.S. Women's Bureau. *Women Wage Earners, New Challenges and Opportunities Remarks by Mary Dublin Keyserling, Director, Women's Bureau, Department of Labor, [at] 4th Western Conference of Governmental Labor Officials, Reno, Nev., Nov. 4, 1965.* by Mary Dublin Keyserling. Washington, DC: The Bureau, 1965. 7p. L13.12:K 52/16. Speech details the progress in extending minimum wage protection to all workers and the significance of the minimum wage for women workers. The problem of women's labor laws and enforcement of Title VII of the Civil Rights Act are reviewed. The desire to continue state protective labor laws for women is strongly indicated.

685. U.S. Women's Bureau. *Fringe Benefit from State Minimum Wage Laws and Orders, September 1, 1966.* Bulletin no. 293. Washington, DC: GPO, 1966. 118p. L13.3:293. State-by-state analysis in legal chart form of state minimum wage laws and orders. Covers overtime pay and daily minimum wage, split shifts and long overall spread of hours, minimum meal and rest periods, pay for waiting time and travel time, handling of tips and gratuities, and maximum deductions for meals, lodging, and uniforms.

686. U.S. Women's Bureau. *Minimum Wage Progress and Current Status.* Washington, DC: The Bureau, 1966. 3p. L13.2:M66/15. Report on state minimum wage laws lists the minimum wage set and the date enacted.

687. U.S. Women's Bureau. *State Minimum Wage Laws: A Summary.* Washington, DC: The Bureau, 1966. 1p. L13.2:M66/14. Brief review of state minimum wage laws notes whether the law set a statutory rate or authorized a wage board.

688. U.S. Women's Bureau. *State Minimum Wage Legislation: A Weapon in War on Poverty.* Washington, DC: The Bureau, 1966. 17p. L13.2:M66/12/966. Basic primer on minimum wage legislation reflects the changing focus from protecting women to protecting all workers. Appendix provides data on workers in selected occupations earning less than $1.25 an hour by region, SMA, and sex as of June 1963. Briefly summarizes existing state minimum wage coverage.

689. U.S. Women's Bureau. *What a Good State Minimum Wage Bill Does.* Washington, DC: The Bureau, 1966. 5p. L13.2:M66/16. Discussion of the characteristics of a good state minimum wage bill. Encourages coverage of all workers and as many industries as possible, a wage floor, minimum wage board procedures, required overtime pay, and effective enforcement.

690. U.S. Women's Bureau. *Role of the Volunteer Organization in the Legislative Process - The Michigan Minimum Wage Campaign.* Washington, DC: The Bureau, 1968. 3p. L13.2:V88. Overview of the process leading up to passage of a minimum wage law in Michigan highlights the role played by the Michigan Council on Employment Problems of Working Women.

691. U.S. Women's Bureau. *State Minimum-Wage Legislation to Help All Workers Especially the Working Poor.* Washington, DC: The Bureau, 1969. 9p. L13.2:M66/17. Concise

overview of the history and current status of state minimum-wage legislation suggests ways that women's organizations can join in the fight for minimum wage laws.

SERIALS

692. U.S. Women's Bureau. *State Minimum-Wage Laws.* Women's Bureau Leaflet no. 4. Washington, DC: GPO, 1955 - 1966. revised irregularly. L13.11:4/no. Leaflet extols the benefits of state minimum wage laws.

5

Protective Labor Legislation

Government documents chronicle the growth and decline of protective labor legislation in the United States. The majority of the documents are the work of the Women's Bureau whose goal of improving conditions for working women is reflected in the publications. Also reflecting the growth of protective labor legislation are congressional documents on District of Columbia laws beginning with the 1894 House and Senate reports on bills requiring seating for female employees (694-695). The establishment of hours laws in the District mirror a national trend, and the 1913 hearing on the legislation reviews the operation of such laws in the other states (703). Two 1921 documents from the Women's Bureau highlight the physiological basis for women's shorter work day (726) and examine the positive and negative effect of state labor laws on women's employment (727). In 1928 the bureau published an extensive review of the effect of state labor laws on employment opportunities (734).

Industrial homework was the focus of many of the documents in the 1930s, particularly in relation to the National Recovery Act codes (747-750, 755). One of the more unique documents on industrial homework is the 1940 radio script which tells the story of a woman forced to accept homework due to unfair competition (776).

The 1940's documents are most notable for their discussions of the demand for women in war production and the necessity of relaxing labor laws. The debate over relaxing laws as a war measure is reflected in the House and Senate reports on amending District of Columbia hours laws (781-782, 788-789). An analysis of wartime modifications of labor laws is provided in a 1945 series of Women's Bureau bulletins (795-798, 802). The question of relaxing labor laws was raised again in 1951 when the Women's Bureau issued a policy statement (810) and reviewed emergency provisions of state labor laws (812).

The 1960s saw a slow change in attitudes toward protective labor legislation as the focus shifted toward extending certain laws to all workers and discussion of conflicts between protective labor laws and the right to work (826, 833). A 1971 Women's Bureau report, *Status of State Hours Laws for Women Since Passage of Title VII of the Civil Rights Act of 1964* (835) reviews court actions on equal employment opportunity and gender-specific labor laws. The progress of labor legislation is documented in a series of state reports issued between 1941 and 1970 (845).

Although protective labor legislation had ceased to be seen primarily as a women's issue by the 1980s, a renewed interest in homework did produce congressional hearings on the home knitting industry (838-839) and home-based clerical work (840) from the perspective of the effect on women workers. Other documents on protective labor laws are found in Chapter 4, Minimum Wage and Chapter 6, Industrial Health and Safety, and in Volume I chapters dealing with the status of women and women's rights.

693. U.S. Congress. Senate. *Memorial of Mrs. Charlotte Smith, President of the Women's Industrial League, Praying Congress to Protect by Legislation the Working Women of the Country.* S. Misc. Doc. 199, 52d Cong., 1st sess., 1892. 2p. Serial 2907. Memorial protests against a law which allowed society women to travel to Europe and purchase clothing, and bring it back to the U.S. duty-free. Women in the dressmaking trade describe the negative effect on their business and employment of the tariff they were required to pay and from which their potential customers were exempt.

694. U.S. Congress. House. Committee on the Judiciary. *Seats for Female Employees, Report to Accompany S. 1841.* H. Rept. 1459, 53d Cong., 2d sess., 1894. 1p. Serial 3272. Favorable report with amendments supports a bill to require seats for female employees in stores, shops, offices, and factories in the District of Columbia.

695. U.S. Congress. Senate. Committee on the District of Columbia. *Report to Accompany S. 1841 [to Provide That All Persons Employing Female Help in Stores, Shops, Offices, or Manufacturer Shall Provide Seats for the Same When Not Actively Employed].* S. Rept. 472, 53d Cong., 2d sess., 1894. 2p. Serial 3183. Supporting correspondence from the Commissioner of the District of Columbia and the Women's Christian Temperance Union are incorporated into this favorable report on a bill to require seats for female employees.

696. U.S. Congress. Senate. Committee on the District of Columbia. *To Provide Seats for Female Help in the District of Columbia, Report.* S. Rept. 437, 57th Cong., 1st sess., 1902. 5p. Serial 4259. Report of an investigation of compliance with an act passed March 2, 1895 requiring seats for female employees of D.C. shops and factories found general compliance.

697. U.S. Bureau of Labor. *Laws Relating to the Employment of Women and Children in the United States.* Washington, DC: GPO, 1907. 150p. C8.2:W84/2. Collection of state laws governing the employment of women and children is accompanied by brief statements on related court opinions where applicable. Most of the laws were too recent to have undergone court challenges. The volume is indexed by subject.

698. U.S. Congress. House. Committee on the Judiciary. *Jurisdiction Authority of Congress over the Subject of Woman and Child Labor, Report to Accompany H. Res. No. 807.* H. Rept. 7304, 59th Cong., 2d sess., 1907. 8p. Serial 5067-D. Discussion of the constitutional authority of congress to take legislative action in regard to the conditions of women and child wage earners comes to the conclusion that such authority rests with the States and not in the federal government. The interstate commerce approach to federal woman and child labor laws is rejected.

699. U.S. Congress. Senate. *Labor Laws and Factory Conditions.* Report on Condition of Women and Child Wage-Earners in the United States, vol. XIX. S. Doc. 645, 61st Cong., 2d sess., 1912. 1125p. Serial 5703. Detailed report of state labor laws examines enforcement, age and prohibited employment provisions, hours and meal period laws, posting of labor laws, safeguards against fire, safeguarding of machinery and elevators, accident reporting, ventilation and sanitation, and provisions for the comfort of employees. The appendix reprints the text of state labor laws and the volume provides a subject index.

700. U.S. Bureau of Labor Statistics. *Ten-Hour Maximum Working-Day for Women and Young Persons.* Bulletin no. 118. Washington, DC: GPO, 1913. 71p. L2.3:118. Report discusses international agreements and laws in foreign countries setting the maximum working day for women to ten-hours and setting break periods during the work day. Distribution of workers by sex and working hours by industry and country are detailed.

701. U.S. Congress. House. Committee on Labor. *Hours of Employment of Females in the District of Columbia, Report to Accompany H.R. 29.* H. Rept. 96, 63d Cong., 2d sess., 1913. 7p. Serial 6558. Favorable report on a bill limiting the number of hours per day and week of women employed in the District of Columbia and prohibiting the employment of women under 18 at night is essentially the same as H. Rept. 1574, 62d Congress (702).

702. U.S. Congress. House. Committee on Labor. *Hours of Employment of Females in the District of Columbia, Report to Accompany H.R. 27281.* H. Rept. 1574, 62d Cong., 3d sess., 1913. 7p. Serial 6334. Report supports setting the women's work week in Washington, D.C. at 8 hours a day and 48 hours a week, and prohibiting the employment of girls under 18 years of age at night. Statements on the adverse effect on women's health of standing continuously and on the operation of the labor laws in California are included. Also provides a summary, based on the 1910 Census, of the number of women employed in the District by occupation.

703. U.S. Congress. Senate. Committee on the District of Columbia. *Employment of Females, Hearing on S. 7723.* 62d Cong., 3rd sess., 31 Jan. - 4 Feb. 1913. 111p. Y4.D63/2:Em7. Hearing on a 8-hour day, 48-hour week law for the employment of women in the District of Columbia presents testimony on the working of similar laws in California. Witnesses also described the hours of work for women in department stores, hotels and laundries in the District. Although the bill did not cover wages, there was some discussion of average wages paid to women, particularly in department stores. Testimony on the health reasons behind the bill recommended that domestic workers be excluded as the variety of exercises in housework made it a healthful occupation. The validity of such laws limiting women's hours of employment as decided by the courts was reviewed. Laundry industry representatives complained that the law was too liberal and that a 9 or 10 hour law would be better. Women workers testified both for and against the measure.

704. U.S. Congress. Senate. Committee on the District of Columbia. *Hours of Employment of Females in the District of Columbia, Report to Accompany S. 1294.* S. Rept. 34, 63d Cong., 1st sess., 1913. 2p. Serial 6510. Report on a bill identical to the amended version of S. 7723, 62d Congress, recommends passage and reprints S. Rept. 1243 (705), the report on the earlier bill.

705. U.S. Congress. Senate. Committee on the District of Columbia. *Hours of Employment of Females in the District of Columbia, Report to Accompany S. 7723.* S. Rept. 1243, 62d Cong., 3d sess., 1913. 2p. Serial 6330. Reports a bill limiting the working hours and night work of women employed in the District of Columbia.

706. U.S. Congress. House. Committee on the District of Columbia. *Hours of Employment of Females in the District of Columbia, Report to Accompany S. 1294.* H. Rept. 224, 63d Cong., 2d sess., 1914. 1p. Serial 6558. See 704r abstract.

707. U.S. Bureau of Labor Statistics. *Labor Laws and Their Administration in the Pacific States.* Bulletin no. 211. Washington, DC: GPO, 1917. 150p. L2.3:211. Discussion of the regulation of labor in the Pacific states devotes a chapter to women's labor.

708. U.S. Bureau of Labor Statistics. *International Labor Legislation and the Society of Nations.* Bulletin no. 254. Washington, DC: GPO, 1919. 135p. L2.3:254. Monograph on international legislation for the protection of labor includes sections on female labor, widow's insurance, night work for women, and homework.

709. U.S. Dept. of Labor. *League of Nations, International Labor Conference, Greek Delegation to International Labor Conference, Employment of Women, Memorandum of Governmental Delegates.* Washington, DC: The Dept., 1919. 2p. L1.10/2:W84/1. French

edition issued under SuDoc number L1.10/2:W84/2. Reviews provisions in Greek law regulating the employment of women in relation to unhealthy industries and night work. Details provisions prohibiting employment of women before and after childbirth, but also protecting the woman's job while on maternity leave.

710. U.S. Dept. of Labor. *League of Nations, Supplemental Report on Certain Countries for Which Information Was Received Too Late for Inclusion in Reports 1 - 3, Prepared by Organizing Committee for International Labor Conference, Washington, 1919.* Washington, DC: GPO, 1919. 39p. L1.10/5:4/1. Report reviews information on labor legislation covering hours of work, unemployment, female labor, and child labor for Argentina, Greece, Guatemala, India, Japan, Nicaragua, Panama, and Peru. This report is a supplement to three earlier reports which were printed in London by Harris & Sons.

711. U.S. Women in Industry Service. *Labor Laws for Women in Industry in Indiana.* Bulletin no. 2. Washington, DC: GPO, 1919. 29p. L13.3:2. Investigation of the working conditions of women employed in manufacturing in Indiana looks at the length of the working day and the reasons for regulating the hours of employment for women. Also, the working conditions and provisions of sanitary facilities was investigated. Other states' laws are briefly reviewed to provide examples for formulating new labor laws in Indiana.

712. U.S. Women's Bureau. *Night-Work Laws in the United States: Brief Summary of State Legislation Regulating Night Work for Women.* Bulletin no. 7. Washington, DC: GPO, 1919. 5p. L13.3:7. Summary notes the various configurations of night-work laws limiting women's employment at night in general and in specific occupations.

713. U.S. Women's Bureau. *Eight-Hour and Eight-and-a-Half-Hour Laws for Women Workers.* Washington, DC: The Bureau, 1920. 1p. chart. L13.5:1.

714. U.S. Women's Bureau. *Home Work in Bridgeport, Connecticut.* Bulletin no. 9. Washington, DC: GPO, 1920. 35p. L13.3:9. Report of investigation of homework in Bridgeport, Connecticut looks at characteristics of women and their families involved in homework, the type of work performed, and weekly earnings and variations in earnings. Other aspects of homework studied include family income, home conditions, and the relationship between homework and unemployment at the factory. Ways to remedy the conditions discussed at a conference of factory representatives, labor union leaders, and representatives of city, federal, and non-profit organizations are reported.

715. U.S. Women's Bureau. *Homework Laws in the United States: Part A, Laws Prohibiting Homework.* Chart 8 [pt A]. Washington, DC: The Bureau, 1920. 1p. L13.5:8/pt A.

716. U.S. Women's Bureau. *Homework Laws in the United States: Part B, Laws Prohibiting Homework.* Chart 8 [pt B]. Washington, DC: The Bureau, 1920. 2p. charts. L13.5:8/pt.B.

717. U.S. Women's Bureau. *Night-Work Laws for Women Workers.* Washington, DC: The Bureau, 1920. 1p. chart. L13.5:7.

718. U.S. Women's Bureau. *Nine-Hour Laws for Women Workers.* Washington, DC: The Bureau, 1920. 1p. chart. L13.5:2.

719. U.S. Women's Bureau. *Ten-and-a-Quarter-Hour, Ten-and-a-Half-Hour, Eleven Hour, and Twelve-Hour Laws for Women Workers.* Washington, DC: The Bureau, 1920. 1p. chart. L13.5:4.

720. U.S. Women's Bureau. *Ten-Hour Laws for Women Workers.* Washington, DC: The Bureau, 1920. 1p. chart. L13.5:3.

721. U.S. Women's Bureau. *Weekly Hour Laws for Women Workers.* Washington, DC: The Bureau, 1920. 1p. chart. L13.5:5.

722. U.S. Women's Bureau. *The Eight-Hour Day in Federal and State Legislation: Summary of the State and Federal "Eight-Hour Laws" in Effect in the United States: 1920.* Bulletin no. 5. Washington, DC: GPO, 1921. 14p. L13.3:5/2. Brief discussion of the various forms of state laws limiting the work day of women in general and in specific industries provides a state-by-state summary of eight-hour laws.

723. U.S. Women's Bureau. *Laws Providing for Day of Rest, Shorter Work Day, Time for Meals, and Rest Periods for Women Workers.* Washington, DC: The Bureau, 1921. 3p. charts. L13.5:6/sec.1-3.

724. U.S. Women's Bureau. *Legal Working Hours for Women, Daily.* Baltimore, MD: A. Hoen & Co., 1921. 1p. map. L13.6:2. Also issued as part of Bulletin no. 16 (728).

725. U.S. Women's Bureau. *Night Work Laws for Women.* Baltimore, MD: A. Hoen & Co., 1921. 1p. map. L13.6:4. Also issued as part of Bulletin no. 16 (728).

726. U.S. Women's Bureau. *A Physiological Basis for the Shorter Working Day for Women.* by George W. Webster. Bulletin no. 14. Washington, DC: GPO, 1921. 20p. L13.3:14. Presents research in support of a shorter working day with particular reference to women workers. Fatigue studies are reviewed with an emphasis on surveys of industrial fatigue in female dominated industries. The legal aspects of hours laws are briefly summarized.

727. U.S. Women's Bureau. *Some Effects of Legislation Limiting Hours of Work for Women.* Bulletin no. 15. Washington, DC: GPO, 1921. 26p. L13.3:15. Investigation examines the effect of a legislated 48-hour work week for women in Massachusetts and the 60-hour week law in New Jersey. Industries studied were involved in the manufacture of rubber goods and electrical appliances. Factors considered include number of women employed, the effect on men's hours of women's decreased hours, and the effect on wages and production. The report also looks at whether the law resulted in discrimination against women.

728. U.S. Women's Bureau. *State Laws Affecting Working Women.* Bulletin no. 16. Washington, DC: GPO, 1921. 63p. L13.3:16. Overview highlights state laws regulating length of the working day and week; providing for a day of rest, one shorter work day, time for meals, and rest periods; regulating night work and homework; and governing minimum wage laws and mothers' pensions. Ten charts summarize state legislation in the areas covered.

729. U.S. Women's Bureau. *Changes Since 1921 in State Laws Affecting Women's Hours and Wages.* Bulletin no. 16, supplement. Washington, DC: GPO, 1924. 10p. L13.3:16/2. Updates charts to reflect laws passed since the original publication (728).

730. U.S. Women's Bureau. *State Laws Affecting Working Women: Hours, Minimum Wage, Homework.* Bulletin no. 40. Washington, DC: GPO, 1924. 64p. L13.3:40. State-by-state summary of labor laws covers daily and weekly hours, day of rest and lunch periods, night work and homework, and minimum wage.

731. U.S. Women's Bureau. *Standard and Scheduled Hours of Work for Women in Industry: A Study Based on Hour Data from 13 States.* Bulletin no. 43. Washington, DC: GPO,

1925. 68p. L13.3:43. Review of the reasoning behind limiting women's working hours accompanies a summary of state laws and labor union agreements regarding women's hours. Investigation provides data on daily and weekly hours for women by industry in 13 states and 2 cities.

732. U.S. Women's Bureau. *State Laws Affecting Working Women: Hours, Minimum Wage, Home Work.* Bulletin no. 63. Washington, DC: GPO, 1927. 57p. L13.3:63. Revision of Bulletins nos. 16 (728) and 40 (730).

733. District of Columbia. Health Dept. *Laws Relating to Hours of Labor for Female Employees and Seats for Female Employees.* Washington, DC: GPO, 1928. 7p. leaflet. DC14.2: Em7/928. Reprints Public Law 63-60 (1914) and No. 125 (1895) regulating hours of labor and seating for female employees. Reissued in 1934.

734. U.S. Women's Bureau. *The Effect of Labor Legislation on the Employment Opportunities of Women.* Bulletin no. 65. Washington, DC: GPO, 1928. 495p. L13.3:65. Detailed report reviews state labor legislation such as hours legislation and night work laws which may limit the employment opportunities of women. The report takes a general look at the employment of women in various industries and specifically looks at the effect of legally reduced hours on women's employment. Industries and occupations studied in-depth include manufacturing, the newspaper industry, restaurants, mercantile establishments, metal trades, elevator operators, street car conductors and ticket agents, and pharmacists. Occupations prohibited to women such as grinding, polishing, buffing, welding, taxicab driving, and meter reading are also examined for their suitability for women. Provides extensive data on numbers of men and women employed in various industries and occupations, scheduled hours, night work, and overtime. The attitudes of employers toward hiring women is reflected in their policy statements, which are included in the appendix.

735. U.S. Women's Bureau. *The Employment of Women at Night.* Washington, DC: GPO, 1928. 86p. L13.3:64. Reviews the legislative history of night work for women in the U.S. and international efforts to regulate night work, specifically the Bern convention of 1906 and the Washington Convention of 1919. The medical, social, and economic reasons for banning night work for women are described through an extensive review of the literature. Appendix includes reprints of the Bern and Washington Conventions and tabular summaries of night-work legislation in foreign countries and the United States. Also includes summary statistics on characteristics of women employed in nightwork.

736. U.S. Women's Bureau. *Summary: The Effects of Labor Legislation on the Employment Opportunities of Women.* Bulletin no. 68. Washington, DC: GPO, 1928. 22p. L13.3:68. Reprint of Chapter 2 of Bulletin no. 65 (734), reviews the scope, method, and conclusions of the investigation by the Women's Bureau into the effects of labor legislation on the employment opportunities of women.

737. U.S. Women's Bureau. *Chronological Development of Labor Legislation for Women in the United States.* by Florence P. Smith. Bulletin no. 66, part 2. Washington, DC: GPO, 1929. 288p. L13.3:66/2/pt.2. State-by-state chronology of labor legislation affecting women is a supplement to Bulletin no. 65 (734).

738. U.S. Women's Bureau. *History of Labor Legislation for Women in Three States.* by Clara M. Beyer. Bulletin no. 66, part 1. Washington, DC: GPO, 1929. 133p. L13.3:66/2/pt.1. Supplement to Bulletin no. 65 (734) on the effect of labor legislation on women describes the history of labor legislation in Massachusetts, New York and California.

739. U.S. Women's Bureau. *Selected Reading List on Hours of Labor of Women in Industry.*
 Washington, DC: The Bureau, 1929. 3p. L13.2:H81. Annotated bibliography of books,
 reports, and articles on women's hours of labor, labor laws, and fatigue studies includes
 U.S, state, and British government reports.

740. U.S. Women's Bureau. *Industrial Home Work.* by Emily C. Brown. Washington, DC:
 GPO, 1930. 20p. L13.3:79. Concise summary of the issue of industrial homework
 describes the extent of homework and the nature of the work. The reasons workers take
 on homework and the ways they receive it are briefly covered. Difficulties in regulating
 homework are discussed. The report of the homework committee of the Association of
 Government Labor Officials and their recommendations are reprinted.

741. U.S. Women's Bureau. *Oregon Legislation for Women in Industry.* by Caroline J.
 Gleason. Bulletin no. 90. Washington, DC: GPO, 1931. 40p. L13.3:90. Summary of
 Oregon legislation affecting women's employment provides information on the distribution
 of women in Oregon industry and on their age and marital status. The major focus of the
 work is the minimum wage legislation, its direct and indirect effects on women, and its
 constitutionality. Legislation affecting women teachers and the right to follow certain
 professions is also discussed.

742. U.S. Women's Bureau. *Labor Laws for Women in the States and Territories: Hours,
 Home Work, Prohibited or Regulated Occupations, Seats, Minimum Wage.* by Florence P.
 Smith. Bulletin no. 98. Washington, DC: GPO, 1932. 72p. L13.3:98. Revision of
 Bulletin no. 63 (732).

743. U.S. Bureau of Labor Statistics. *Comparative Digest of Labor Legislation for the States
 of Alabama, Florida, Georgia, South Carolina, Tennessee.* Bulletin no. 603. Washington,
 DC: GPO, 1933. 66p. L2.3:603. Review of labor legislation for the states of Alabama,
 Florida, Georgia, South Carolina, and Tennessee includes a chapter outlining regulations
 affecting women.

744. U.S. Women's Bureau. *Memorandum on the Practicability of Setting Maximum Standards
 of Work in Cotton Mills Operating under the Stretch-Out System.* by Ethel L. Best.
 Washington, DC: GPO, 1933. 4p. L13.2:C82. Examines the problem related to setting
 standards for the number of machines one woman should work at the same time in cotton
 mills.

745. U.S. Women's Bureau. *Summary of Labor Legislation for Women, Jan. - June 1933.* by
 Florence P. Smith. Bulletin no. 98, supplement. Washington, DC: GPO, 1933. 4p.
 L13.3:98/supp. See 732 for abstract.

746. U.S. Women's Bureau. *Labor Laws for Women in States and Territories, Hours,
 Homework, Prohibited or Regulated Occupations, Seats, Minimum Wage.* by Florence P.
 Smith. Bulletin no. 98, revised. Washington, DC: GPO, 1934. 71p. L13.3:98/2. See
 732 for abstract.

747. U.S. Dept. of Labor. Division of Labor Standards. *Exceptions to the Industrial Home-
 Work Prohibitions of NRA Codes.* Washington, DC: The Dept., 1935. 13p. L16.2:H75/2.
 One aspect of applications for exception from the homework regulations discussed is the
 case of women with young children. Provides data on exception certifications issued by
 state and industry.

748. U.S. Dept. of Labor. Division of Labor Standards. *Newsletter on Industrial Homework.*
 Washington, DC: The Division, 1935. 3p. L16.2:H75. Stories of abuses under the system

of industrial homework accompanies a review of attempts, particularly in New York and under the N.R.A., to abolish the practice.

749. U.S. Women's Bureau. *The Commercialization of the Home through Industrial Homework.* Bulletin no. 135. Washington, DC: GPO, 1935. 49p. L13.3:135. General discussion of the industrial homework system. Provides a detailed description of the various types of homework and lists states in which each type of work was done. Brief anecdotes describe the working conditions of homeworkers in the various industries. Also provides information on the rates of pay and on efforts to establish legislation regulating industrial homework. Details homework which was eliminated by codes.

750. U.S. Women's Bureau. *Employed Women under N.R.A. Codes.* by Mary Elizabeth Pidgeon. Bulletin no. 130. Washington, DC: GPO, 1935. 144p. L13.3:130. Discussion of the effect of National Recovery Act Codes on the situation of employed women in major women-employing industries. Focuses on minimum wage levels and maximum hours of work set by the 491 codes approved by July 1, 1934. Information is provided on minimum wage and maximum hours in retail trade, textile industries, hotel and restaurants, laundries, beauty shops, clothing industries, leather industries, and certain food industries. Among the topics discussed are sex differentials in minimum wage and sub-minimum wages for industrial homeworkers.

751. U.S. Women's Bureau. *Hours of Employment for Women Provided in State Labor Laws, June 1935.* Washington, DC: The Bureau, 1935? 32p. L13.2:H81/3. Charts summarize state labor laws governing hours of work giving basic information on limits per day and per week, overtime provisions, and occupations or industries covered.

752. U.S. Women's Bureau. *Industrial Home Work in Rhode Island with Special Reference to the Lace Industry.* by Harriet A. Byrne and Bertha Blair. Bulletin no. 131. Washington, DC: GPO, 1935. 27p. L13.3:131. Survey conducted to determine the extent of industrial homework in Rhode Island collected data through factory surveys and home interviews. Data reported includes the number of homeworkers, their earnings, and personal and family characteristics including age and sex of workers. Most of the report focuses on the lace industry. The appendix reprints an agreement drawn up by lace manufacturers outlining the terms and conditions of employment for homeworkers.

753. U.S. Women's Bureau. *Women in Industry: Report by Mary Anderson at the Annual Meeting of International Association of Governmental Labor Officials, Oct. 1, 1935.* Washington, DC: The Bureau, 1935. 9p. L13.2: W84/3. Summary of the past year's progress in state labor laws for women. Focuses primarily on hours laws and discusses the trend to exempt women in executive or supervisory positions from the law. The Supreme Court's ruling against the NRA codes is also reviewed in relation to labor standards for women. This report was also printed in BLS Bulletin no. 619 (841).

754. U.S. Children's Bureau. *Factors Affecting an 18-Year Minimum Age for Employment of Girls on Cotton-Textile Manufacturing under the Public Contracts Act.* Washington, DC: The Bureau, 1936. 26p. L5.2:G44. Study of the factors involved in possible restrictions on the work of 16- and 17-year-old girls in cotton-mills under the Public Contracts Act. Examines school attendance issues, the number of girls, the nature of their work, and the attitudes of the employers, the girls, and the community. Most of the girls want to work and would seek employment elsewhere if banned from cotton-mill work.

755. U.S. Children's Bureau. *Industrial Home Work under the National Recovery Administration.* by Mary Skinner. Publication no. 234. Washington, DC: GPO, 1936. 57p. L5.20:234. Investigation examines the effectiveness of regulation of industrial homework under the National Recovery Administration. Provides data on the number of

families involved in industrial homework by industry and information acquired through interviews on the working conditions.

756. U.S. Dept. of Labor. *The Price of Industrial Homework and Why It Should Be Regulated.* Washington, DC: GPO, 1936. [6p]. leaflet. L16.2:H75.

757. U.S. Dept. of Labor. *A Study of Industrial Home Work in the Summer and Fall of 1934; A Preliminary Report to the National Recovery Administration.* Washington, DC: The Dept., 1936? 62p. L16.2:H75/6. Investigation of the conditions of homework in 1934 examined the type of work being done and the number of family members employed. The study also explored the possible effects of NRA codes regulating homework on hours and earnings.

758. U.S. Dept. of Labor. Division of Labor Standards. *Memorandum to Accompany Draft of Suggested State Bill to Regulate and Tax Industrial Homework.* Washington, DC: The Dept., 1936. 6p. L16.2:H75/3/936-2/memo. Memo explains the need for industrial homework legislation and provides a basic overview of the provisions of the model bill.

759. U.S. Dept. of Labor. Division of Labor Standards. *Suggested Language for a State Bill to Regulate and Tax Industrial Homework.* Washington, DC: The Dept., 1936. 12p. L16.2:H75/3/936-2.

760. U.S. Women's Bureau. *A Policy Insuring Value to the Woman Buyer and a Livelihood to Apparel Makers.* Bulletin no. 146. Washington, DC: GPO, 1936. 22p. L13.3:146. The aim of this publication was to educate members of women's organizations and general consumers about efforts to standardize prices and working conditions in the garment and millinery industry. To support the efforts of the National Coat and Suit Industry Recovery Board and the Millinery Stabilization Commission, women were encouraged to buy clothing with the Consumers' Protection label indicating the garment was manufactured under fair labor standards.

761. U.S. Women's Bureau. *Summary of State Hour Laws for Women and Minimum-Wage Rates.* by Mary Elizabeth Pidgeon. Bulletin no. 137. Washington, DC: GPO, 1936. 54p. L13.3:137. Revises charts summarizing state wage and hour laws published in Bulletin no. 98 (742). Briefly presents the background and legal status of these laws.

762. U.S. Dept. of Labor. Division of Labor Standards. *Proceedings, Conference of State Industrial Homework Law Administrators, Washington, D.C., June 16, 1937.* Washington, DC: The Dept., 1937. 42p. L16.2:H75/5. Transcript of the 1937 Conference of State Industrial Homework Law Administrators. Records a dialogue on the problems of minimum wage and industrial homework with particular reference to the administration of homework laws. Some of the issues discussed include setting a higher minimum wage for homework, detecting homework violations, and new techniques for controlling homework in New York.

763. U.S. Dept. of Labor. Division of Labor Standards. *Suggested Draft for State Bill to Regulate Hours of Labor.* Washington, DC: The Division, 1937. 7p. L16.2:H81. Presents suggested language for a bill regulating hours of labor for female workers.

764. U.S. Women's Bureau. *Price of Industrial Home Work and Why It Should Be Regulated.* Washington, DC: The Bureau, 1937. 6p. leaflet. L13.2:H75/937. Also issued in 1936.

765. U.S. Women's Bureau. *Short Hours Pay, 8-Hour Day, 5-Day Week.* Washington, DC: GPO, 1937. leaflet. L13.2:H81/2. Informational leaflet on maximum hours laws for women presents a brief history and the basic philosophy.

766. U.S. Women's Bureau. *State Labor Laws for Women: Hours, Home Work, Prohibited or Regulated Occupations, Seats, Minimum Wage.* Bulletin no. 144. Washington, DC: GPO, 1937. 96p. L13.3:144. Revision of Bulletin no. 98 (742).

767. U.S. Women's Bureau. *Summary of 1937 Labor Laws for Women, July 15, 1937.* Washington, DC: The Bureau, 1937. 4p. L13.2:L11. Presents summary data on state labor legislation affecting women including hours, night work, homework, and minimum wage laws and orders.

768. U.S. Children's Bureau. *Prohibition of Industrial Homework in Selected Industries under the National Recovery Administration.* by Mary Skinner. Publication no. 244. Washington, DC: GPO, 1938. 28p. L5.20:244. Investigation of the results of the prohibition of homework in the men's wear, flower-making, and jewelry-making industries looks at the effect on the manufacturers and on homeworkers taken into the factory after prohibition of homework.

769. U.S. Women's Bureau. *Legal Working Hours for Women, Daily, 1937.* Washington, DC: U.S. Geological Survey, 1938. 1p. map. L13.6/2:W89.

770. U.S. Women's Bureau. *Legal Working Hours for Women, Weekly, 1937.* Washington, DC: U.S. Geological Survey, 1938. 1p. map. L13.6/2:W89/2.

771. U.S. Women's Bureau. *Night Work Laws for Women, 1937.* Washington, DC: U.S. Geological Survey, 1938. 1p. map. L13.6/2:W89/3.

772. U.S. Women's Bureau. *State Labor Laws for Women, March 31, 1938, Part II - Analysis of Hour Laws for Women Workers.* by Florence P. Smith. Bulletin no. 156-II. Washington, DC: GPO, 1938. 45p. L13.3:156-2. Charts provide detailed information on state statutes governing the hours of women workers including weekly hours limitations, overtime, day of rest, rest periods, prohibition or limitation of night work, and occupations and industries covered.

773. U.S. Women's Bureau. *State Labor Laws for Women, December 31, 1937, Part I - Summary.* by Florence P. Smith. Bulletin no. 156-I. Washington, DC: GPO, 1938. 16p. L13.3:156-1. Briefly describes state labor laws by type of regulation.

774. U.S. Women's Bureau. *Women in Industry, Report to Annual Meeting of International Association of Governmental Labor Office, Sept. 8-10, 1938, Charleston, S.C.* Washington, DC: The Bureau, 1938. 8p. L13.2: W84/4. Speech summarizes the year's program in labor legislation for women at the state level, and discusses possibilities for federal responsibility for labor standards. Also printed as part of BLS Bulletin no. 666, *Labor Laws and Their Administration, 1938* (841).

775. U.S. Dept. of Labor. Division of Labor Standards. *Industrial Home-Work Legislation and Its Administration.* Bulletin no. 26. Washington, DC: The Dept., 1939. 133p. L16.3:26. After an overview of the regulation and administration of industrial homework this bulletin provides a state-by-state summary of industrial home-work laws and reprints of the applicable statutes.

776. U.S. Dept. of Labor. *The Sweatshop in the Home - Industrial Homework.* This Might Be You [radio script] no. 10. Washington, DC: The Dept., 1940. 8p. L1.14:10. Radio script tells the story of Mrs. Jackson, who lost her factory job due to unfair competition and was forced to accept homework where, even with her children helping, she couldn't make enough money for food and clothing.

777. U.S. Women's Bureau. *Application of Labor Legislation to the Fruit and Vegetable Canning and Preserving Industries.* Bulletin no. 176. Washington, DC: GPO, 1940. 162p. L13.3:176. Detailed examination of the canning and preserving industries looks at the seasonal nature of the work and at the areas in which they were exempted from certain labor laws. Most of the report focuses on production methods and seasonal variations in employment, but data was also collected on number of employees by occupation, sex, and product, and the number of hours worked by women, by product and state. Data on hourly earnings is given by sex and product, and the distribution of women employees according to hourly earnings by product and state is also provided. The effects of wage regulation is also discussed.

778. U.S. Women's Bureau. *Application of Labor Legislation to the Fruit and Vegetable Canning and Preserving Industry: Salient Facts.* Washington, DC: GPO, 1940. 17p. L13.2:F94. Analysis of the application of state hours and minimum wage laws to the employment of women in canneries examines the effect of the Public Contracts Act and the Fair Labor Standards Act. This report is a summary of Women's Bureau Bulletin no. 176 (777).

779. U.S. Women's Bureau. *Summary of 1938, 1939, and 1940 State Hour Laws for Women.* Bulletin no. 156-II, supplement. Washington, DC: GPO, 1940. 2p. L13.3:156-2/insert. See 772 for abstract.

780. U.S. Civil Service Commission. *Assignment of Female Minors to Night Shifts.* Circular no. 335. Washington, DC: The Commission, 1942. 1p. CS 1.4:335. Brief memo reminds agency and department heads that women under 18 should not be employed on second or third shifts. The recruitment of women under the age of 18 was attributed to a serious shortage of qualified clerical and office workers.

781. U.S. Congress. House. Committee on the District of Columbia. *Amendment of District of Columbia Female 8 Hour Law during National Emergency, Report to Accompany H.R. 7447.* H. Rept. 2662, 77th Cong., 2d sess., 1942. 2p. Serial 10665. Favorable report supports a war measure to allow the Minimum Wage and Industrial Safety Board of the District of Columbia to issue permits allowing employers, under certain conditions, to employ women more than 8 hours a day or 48 hours a week.

782. U.S. Congress. Senate. Committee on the District of Columbia. *Amending an Act to Regulate the Hours of Employment and Safeguard the Health of Females Employed in the District of Columbia, Report to Accompany H.R. 7447.* S. Rept. 1768, 77th Cong., 2d sess., 1942. 2p. Serial 10659. See 781 for abstract.

783. U.S. Dept. of Labor. Division of Labor Standards. *Chart Showing State and Federal Hours Limitations.* Washington, DC: The Division, 1942. chart. L16.2:H81/2.

784. U.S. Dept. of Labor. Wage and Hour and Public Contracts Divisions. Economics Branch. *The Current Status of Home Work in the Embroideries Industry.* Washington, DC: The Dept., 1942. 49p. No SuDoc number. The type of work performed by homeworkers in the embroideries industry and the extent of homework is examined with an emphasis on the industry rather than the workers. Laws regulating homework in the embroideries industry are reviewed and basic statistics on number of workers employed, the operations performed, minimum wage compliance, and violations of the Fair Labor Standards Act are presented.

785. U.S. Dept. of Labor. Wage and Hour Division. *Current Status of Home Work in the Handkerchief Manufacturing Industry.* Washington, DC: The Dept., 1942. 15p. L20.12:H19/3. The prevalence of homework in the handkerchief manufacturing industry

and regulations and laws which curtail the practice are reviewed. Some attempt is made to ascertain compliance with minimum wage orders among handkerchief manufacturers employing homeworkers. The effect of the war and machine operations on the need for homework and the general status of the handkerchief industry are also examined.

786. U.S. Dept. of Labor. Wage and Hour Division. Research and Statistics Branch. *Current Status of Industrial Homework in the Women's and Children's Apparel Industry.* Washington, DC: The Dept., 1942. 146p. L20.12:Ap4/3. Primary focus of this report is the extent of homework in the women's and children's apparel industry. Information is also provided on characteristics of homeworkers, their dependents, and reasons keeping homeworkers from factory employment. Also reports on compliance with the Fair Labor Standards Act and on trends in the discontinuance of homework.

787. U.S. Women's Bureau. *Women's Work in the War.* Bulletin no. 193. Washington, DC: GPO, 1942. 10p. L13.3:193. Four reports briefly discuss the need for women workers, lighting standards for war production plants, industrial homework and the war, and the effect of the war on labor laws.

788. U.S. Congress. House. Committee on the District of Columbia. *Amending an Act Entitled "An Act to regulate hours of employment and safeguard the health of females employed in the District of Columbia", Approved February 24, 1914, Report to Accompany H.R. 777.* H. Rept. 220, 78th Cong., 1st sess., 1943. 3p. Serial 10761. See 789 for abstract.

789. U.S. Congress. Senate. Committee on the District of Columbia. *Safeguarding the Health of Females Employed in the District of Columbia, Report to Accompany H.R. 777.* S. Rept. 249, 78th Cong., 1st sess., 1943. 3p. Serial 10756. Reports legislation giving the Minimum Wage and Industrial Safety Board of District of Columbia temporary authority to issue permits allowing the employment of women for more than 8 hours/day or 48 hours/week when necessary for war production. Safeguards within the law are briefly discussed.

790. U.S. Women's Bureau. *Hours of Work.* Washington, DC: The Bureau, 1944. 2p. L13.2:H81/5. Legislative flyer prepared for the National Conference on Labor Legislation reviews the basics of regulating women's hours of work.

791. U.S. Women's Bureau. *Wartime Status of State Labor Laws for Women.* Washington, DC: The Bureau, 1944. 4p. L13.2:H81/4. Brief report examines the status of state labor laws for women, primarily hours laws, during the war manpower emergency.

792. U.S. Congress. House. Committee on the District of Columbia. *Relating to Females Employed in the District of Columbia, Report to Accompany H.R. 2122.* H. Rept. 192, 79th Cong., 1st sess., 1945. 3p. Serial 10931. Reports a bill extending "An Act to regulate the hours of employment and safeguard the health of females employed in the District of Columbia" for the duration of World War II and six months thereafter. The law in question gave the Minimum Wage and Industrial Safety Board of the District of Columbia authority to exempt employers from hours laws.

793. U.S. Congress. Senate. Committee on the District of Columbia. *Relating to Females Employed in the District of Columbia, Report to Accompany H.R. 2122.* S. Rept. 121, 79th Cong., 1st sess., 1945. 3p. Serial 10925. See 792 for abstract.

794. U.S. Women's Bureau. *Report on 1945 Labor Legislation.* Washington, DC: The Bureau, 1945. 7p. L13.2:L11/4/945. Review of actions in the state legislatures in 1945 on labor legislation summarizes trends in the introduction of bills and notes laws passed

affecting hours, minimum wage, equal pay, home work, and occupational health and safety.

795. U.S. Women's Bureau. *State Labor Laws for Women with Wartime Modifications, December 15, 1944, Part I - Analysis of Hour Laws.* Bulletin no. 202, part 1. Washington, DC: GPO, 1945. 110p. L13.3:202-1. Charts provide state-by-state analysis of state labor laws governing hours, meal and rest periods, and night work, and indicate the industries covered and any special provisions for the duration of the war.

796. U.S. Women's Bureau. *State Labor Laws for Women with Wartime Modifications, December 15, 1944, Part II - Analysis of Plant Facilities Laws.* Bulletin no. 202, part 2. Washington, DC: GPO, 1945. 43p. L13.3:202-2. Summary in legal chart form of state laws governing the provision of sanitary and other plant facilities in establishments employing women covers laws on seating, lunchrooms, dressing rooms and rest rooms, and toilet rooms.

797. U.S. Women's Bureau. *State Labor Laws for Women with Wartime Modifications, December 15, 1944, Part III - Analysis of Regulatory Laws, Prohibitory Laws, Maternity Laws.* Bulletin no. 202, part 3. Washington, DC: GPO, 1945. 12p. L13.3:202-3. Overview of state laws governing women's employment covers tasks requiring weight lifting or other working conditions such as constant standing, prohibited employment in certain industries such as mining or selling alcohol, and employment before and after childbirth. A special note is made of wartime modifications.

798. U.S. Women's Bureau. *State Labor Laws for Women with Wartime Modifications, December 15, 1944. Part IV - Analysis of Industrial Home-Work Laws.* Bulletin no. 202-4. Washington, DC: GPO, 1945. 26p. L13.3:202-4. State-by-state analysis of industrial homework laws in chart form provides information on coverage, prohibited work, permits required, persons who may be employed, working conditions, and record keeping.

799. U.S. Dept. of Labor. Division of Labor Standards. *Industrial Home Work.* Washington, DC: The Division, 1946. 2p. L16.2:H75/6/946. Briefly presents the arguments for a homework law and describes the components of an effective law. Earlier edition published in 1944.

800. U.S. Women's Bureau. *Bibliography on Night Work for Women.* Washington, DC: The Bureau, 1946. 39p. L13.2:N56. Lengthy excerpts from the works cited in this bibliography provide information on night work of women in the U.S., Great Britain and Australia. Includes government publications and some publications of the International Labour Organization.

801. U.S. Women's Bureau. *Industrial Homework in the United States.* Washington, DC: The Bureau, 1946. 8p. L13.2:H75/2. Mimeographed report describes the history of industrial homework in the U.S., its harmful effects, and the history of efforts by states and the federal government to control the practice. Methods of curbing industrial homework are recommended.

802. U.S. Women's Bureau. *State Labor Laws for Women with Wartime Modifications, December 15, 1944, Part V - Explanation and Appraisal.* Bulletin no. 202, part 5. Washington, DC: GPO, 1946. 66p. L13.3:202-5. Final report on state labor laws for women as of December 15, 1944 describes the history of the laws covered in the four previous reports and cites relevant court decisions. Changes and modifications to the laws as a result of the war are highlighted and basic peacetime standards are discussed.

803. U.S. Dept. of Labor. Wage and Hour and Public Contracts Division. *Industrial Home Work and the Fair Labor Standards Act.* Washington, DC: The Division, 1947. 9p. L22.2:In2. Review of the legislative history of the regulation of industrial homework at the federal level discusses the authority to restrict homework under the Fair Labor Standards Act.

804. U.S. Women's Bureau. *State Laws Relating to Night Work for Women.* Washington, DC: The Bureau, 1947. 4p. L13.2:N56/2. Summary of the status of state labor laws prohibiting or regulating night work for women gives information on regulated hours and industries by state.

805. U.S. Women's Bureau. *The Role of Women's Legislation in Meeting Basic Problems of Working Conditions.* Washington, DC: The Bureau, 1948. 5p. L13.12:Am3/3. Address given by Elizabeth S. Magee of the National Consumers League at the 1948 Women's Bureau Conference, "The American Woman, Her Changing Role as Worker, Homemaker, Citizen", reviews the early attempts to legislate a shorter workday by the Lowell Female Reform Association and the existing state of labor legislation. Discusses the effect of trade unions, federal legislation, and WWII on labor legislation, and touches on the role of women's organizations in promoting further progress in labor legislation.

806. U.S. Women's Bureau. *Night Work for Women in Hotels and Restaurants.* Bulletin no. 233. Washington, DC: GPO, 1949. 59p. L13.3:233. Excellent summary of night work legislation reviews the logic behind such restrictions for women and the scientific evidence which supports or refutes the arguments. In relation to the call for easing night work regulations, the use of women in night work in hotels and restaurants is studied focusing on the number of men and women employed, their ending hour of work, and the conditions under which night work is performed. Interviews with the women working night shifts are conducted to determine why women work at night and their attitudes toward night work. Includes fifteen brief case studies. Appendices summarize existing night work regulations.

807. U.S. Congress. House. *Messages from the President of the United States Transmitting a Message on the International Labor Organization.* H. Doc. 676, 81st Cong., 2d sess., 1950. 20p. Serial 11425. Transmittal from the President includes the text of ILO Convention no. 89 concerning night work for women employed in industry and no. 90 concerning minors employed in industry, both adopted at the 31st Industrial Labor Conference. Correspondence from the Department of Labor and the Department of State recommended no federal legislative action in relation to the conventions.

808. U.S. Women's Bureau. *Convention (No. 89) Concerning Night Work of Women Employed in Industry (Revised 1948).* Washington, DC: The Bureau, 1950. 5p. L13.2:N56/3/948. Revised version of the International Labor Organization's Convention no. 89 on night work of women prohibits night work for women in industrial positions, but exempts managerial, health and welfare workers, and undertaking.

809. U.S. Women's Bureau. *Recommended Standards for Employment of Women.* Washington, DC: GPO, 1950. 8p. leaflet. L13.2:Em7/5. The recommended standards for the employment of women are accompanied by a brief list of references.

810. U.S. Dept. of Labor. *Policy Statement Regarding Relaxation of State Labor Standards.* Washington, DC: The Dept., 1951. 3p. L27.7:10. Policy statement addresses arguments for relaxing labor laws based on the need to increase production and hence draw more women into the labor force for defense production. The Women's Bureau recommends against the relaxation of state labor laws protecting women and children, and states that at the time there did not appear to be justification for night work for women.

811. U.S. Women's Bureau. *Digest of State Laws Relating to Night Work for Women, Nov. 1, 1950.* Washington, DC: GPO, 1951? 11p. L13.2:N56/4. Charts summarize state regulations on night work noting the industries covered or exempted.

812. U.S. Women's Bureau. *Emergency Provisions of State Laws Regulating Hours of Employment of Women in Manufacturing.* Washington, DC: The Bureau, 1951. 20p. L13.2:L44/2. State-by-state summary of state laws regulating women's hours of employment reviews normal emergency provisions and special wartime and defense provisions in response to the Korean conflict.

813. U.S. Women's Bureau. *Maintaining Labor Standards, Production Safeguard, Summary of Address by Frieda S. Miller, Director, Women's Bureau, Department of Labor, before the 28th Annual Conference, New York Women's Trade Union League, New York, N.Y.* Washington, DC: The Bureau, 1951. 3p. L13.12:M61. Summary of a speech by Women's Bureau director Frieda S. Miller stresses the need to maintain hour laws protecting women even in war industry areas.

814. U.S. Women's Bureau. *State Hour Laws for Women.* Bulletin no. 250. Washington, DC: GPO, 1953. 114p. L13.3:250. Provides information in legal chart form on laws covering daily and weekly hours of work, day of rest, requirements as to meal and rest periods, and the employment of women at night. Includes citations to statutory authority and information on occupations and industries covered.

815. U.S. Women's Bureau. *Maximum Weekly Hours Set by State Labor Laws for Women, July 1, 1955.* Washington, DC: The Bureau, 1955. 1p. map. L13.6/2:H81.

816. U.S. Women's Bureau. *Maximum Daily Hours Set By State Labor Laws for Women, July 1, 1956.* Washington, DC: The Bureau, 1956. 1p. map. L13.6/2:H81/2/956.

817. U.S. Women's Bureau. *National Consumers League- Women's Bureau Joint Conference in State Labor Legislation Affecting Women, Washington, D.C., Dec. 4 and 5, 1958.* Washington, DC: The Bureau, 1959. 48p. L13.2.:L52/3/958. Conference on state labor legislation affecting women gets down to details on administering laws on minimum wage, equal pay, and hours of work. The report is a transcript of those proceeding where representatives of 17 state labor departments, officers of the Consumer League, and Women's Bureau officials discussed the adequacy of existing laws and methods of their enforcement.

818. U.S. Women's Bureau. *State Labor Laws Affecting Women: Highlights of 1959 Enactments.* Washington, DC: The Bureau, 1959. 3p. L13.2:L44/3/959. Brief notes highlight state laws passed in 1959 on minimum wage, hours, equal pay, and industrial homework.

819. U.S. Women's Bureau. *40 Years of Progress in Labor Legislation for Women Workers, 1920-1940.* Washington, DC: The Bureau, 1960. 4p. leaflet. L13.2:L11/10. Chart illustrates the differences in the status of state labor legislation affecting women in 1920 and in 1960.

820. U.S. Women's Bureau. *State Hours Laws for Women.* Bulletin no. 277. Washington, DC: GPO, 1961. 105p. L13.3:277. Revision of Women's Bureau Bulletin no. 250 (814) updates information to October 1, 1960.

821. U.S. President's Commission on the Status of Women. *Report of the Committee on Protective Labor Legislation to President's Commission on the Status of Women.* Washington, DC: GPO, 1963. 38p. Pr35.8:W84/P94. Presents committee

recommendations on extension of minimum wage to all workers, equal pay for comparable work, hours of work laws, maternity protection, and workmen's compensation.

822. U.S. Women's Bureau. *Protective Labor Legislation for Women in 91 Countries.* Women in the World Today International Report no. 5. Washington, DC: GPO, 1963. 37p. L13.23:5. Chart provides a summary, by country, of protective labor legislation for women governing daily and weekly hours of work, night work, and hazardous work. Information for the U.S. only gives the number of states with legislation in an area.

823. U.S. Bureau of Labor Standards. Division of State Services. *Brief Summary of State Laws Regulating Industrial Homework.* Fact Sheet no. 8. Washington, DC: The Division, 1964. 3p. L16.50:8. Briefly summarizes state laws prohibiting or regulating industrial homework.

824. U.S. Women's Bureau. *State Labor Laws for Women.* Washington, DC: The Bureau, 1964. 2p. L13.2:L44/4. Chart provides a quick overview of areas covered by state labor laws including hours, minimum wage, equal pay, homework, employment before and after child birth, limits on occupation, and working condition. No details of the statutes are provided.

825. U.S. Bureau of Labor Standards. *Summary of State Laws Regulating Industrial Homework.* Fact Sheet no. 8. Washington, DC: The Bureau, 1965. 3p. L16.50:8/2. See 823 for abstract.

826. U.S. Women's Bureau. *Labor Standards Legislation and Equal Employment Opportunity, Remarks by Mary Dublin Keyserling, Director, Women's Bureau, Department of Labor, Third National Conference of Commissions on the Status of Women, June 29, 1966, Washington, D.C.* Washington, DC: The Bureau, 1966. 10p. L13.12:K52/21. Review of progress at the federal and state level in ensuring adequate labor standards and equal employment opportunity cites progress in equal pay, minimum wage, and hours laws. The conflict between the right to work and the limiting effect of protective labor laws on women's employment opportunities is examined at greater length.

827. U.S. Women's Bureau. *Maximum Daily Hours for Women, by State, July 1, 1966.* Washington, DC: The Bureau, 1966. 1p. L13.6/2:H81/2/966. Coded map also issued as L13.2:H81/2/966.

828. U.S. Women's Bureau. *Maximum Weekly Hours for Women, by Sate, July 1, 1966.* Washington, DC: The Bureau, 1966. 1p. L13.6/2:H81/966. map.

829. U.S. Women's Bureau. *Remarks by Margaret F. Ackroyd, Chief, Division of Women and Children, Rhode Island Department of Labor, [at] Third National Conference of Commissions on the Status of Women, Panel on Labor Standards and Equal Employment Opportunity for Women, June 29, 1966.* Washington, DC: The Bureau, 1966. 5p. Pr35.8:W84/Ac5. Ackroyd discusses the move to loosen restrictions on the length of women's work day and work week in Rhode Island and cites individual cases where women wished to be exempted. The fears expressed by some people regarding the effect of lifting the 48 hour work week on women who don't want to work overtime are addressed.

830. U.S. Women's Bureau. *Remarks by Mary Dublin Keyserling... Third National Conference of Commissions on the Status of Women, Panel on Labor Standards and Equal Employment Opportunities for Women, June 29, 1966.* Washington, DC: The Bureau, 1966. 6p. L13.12:K52/22. Speech reviews the recommendations of the President's Commission on the Status of Women relating to labor legislation and equal opportunity. The actions of

state commissions in the areas of minimum wage, overtime, and the conflict between the right to work overtime and protection of women through maximum hour laws, and similar conflicts between equal opportunity and protective labor laws, are briefly examined.

831. U.S. Dept. of Labor. *Growth of Labor Law in the United States.* Washington, DC: GPO, 1967. 311p. L1.2:L41. History of the development of labor laws in the United States covers protective laws, job training, minimum wage, and insurance systems. Of particular relevance to women are sections on hours legislation, equal pay laws, and industrial homework.

832. U.S. Women's Bureau. *Highlights of 1966 State Legislation of Special Interest to Women: Labor Laws.* Washington, DC: The Bureau, 1967. 4p. L13.2:L11/11/966. Short summary of laws enacted in 1966 relating to the employment of women covers laws on minimum wage, hours of work, equal pay, and employment discrimination.

833. U.S. Citizen's Advisory Council on the Status of Women. *Report of the Task Force on Labor Standards.* Washington, DC: GPO, 1968. 58p. Y3.In8/21:2L11. The Task Force on Labor Standards studied issues related to women in the labor force, identified problems, and made recommendations in the areas of hours of work, earnings, minimum wage and overtime, equal pay, and maternity benefits. Separate statements of some task force members reflect differing opinions on minimum wage, overtime, and protective labor legislation.

834. U.S. Women's Bureau. *Weightlifting Provisions for Women by State.* Washington, DC: GPO, 1969. 9p. L13.2:W42/969. State-by-state summary reviews laws regulating weightlifting by women workers. Earlier edition issued in 1966.

835. U.S. Women's Bureau. *Status of State Hours Laws for Women Since Passage of Title VII of the Civil Rights Act of 1964.* Washington, DC: GPO, 1971. 4p. L36.102:H81. Summary notes states which repealed maximum hours laws for women, where Attorney General opinions ruled hours laws were not applicable to employees covered under Title VII of the Civil Rights Act of 1964, where court decisions held that state hours laws conflicted with Title VII, and where hours laws were changed since passage of Title VII.

836. U.S. Women's Bureau. *State Hours Laws for Women: Changes in Status Since the Civil Rights Act of 1964.* Washington, DC: GPO, 1974. 7p. L36.102:H81/3. Summarizes the effect of the Civil Rights Act of 1964 on state laws limiting women's hours of work.

837. U.S. Women's Bureau. *State Labor Laws in Transition: From Protection to Equal Status for Women.* Pamphlet no. 15. Washington, DC: GPO, 1976. 22p. L36.112:15. Summary of state labor laws affecting women highlights the trends between 1960 and the mid-1970s. Briefly discusses state minimum wage, equal pay, and fair employment practices legislation and their relation to federal legislation.

838. U.S. Congress. House. Committee on Education and Labor. Subcommittee on Labor Standards. *The Reemergence of Sweatshops and the Enforcement of Wage and Hour Standards, Hearing on H.R. 6103.* 97th Cong., 1st and 2d sess., 19 May 1981 - 12 May 1982. 321p. Y4.Ed8/1:Sw3. Hearings examine the condition of sweatshops operating in violation of regulations and focus on the actions of Secretary of Labor Donovan to eliminate homework restrictions. The issue of women who wish to work at home while caring for young children is discussed in relation to homework legislation and the Vermont home knitters. Results of an investigation of violations of homework laws involving record keeping and facilities are reported. Included in the hearing is background information on the emergence of homework regulations in the 1930s.

839. U.S. Congress. Senate. Committee on Labor and Human Resources. Subcommittee on Labor. *Amending the Fair Labor Standards Act to Include Industrial Homework, Hearing on S. 2145.* 98th Cong., 2d sess., 9 Feb. 1984. 161p. Y4.L11/4:S.hrg.98-633. Hearing on amending the Fair Labor Standards Act of 1938 to facilitate industrial homework focuses on how homework could help women earn income when they could not or preferred not to work outside the home. The historical reasons for the homework prohibition are reviewed and the ability to prevent unfair labor practices in the current labor market are discussed.

840. U.S. Congress. House. Committee on Government Operations. Subcommittee on Employment and Housing. *Pros and Cons of Home-Based Clerical Work, Hearing.* 99th Cong., 2d sess., 26 Feb. 1986. 130p. Y4.G74/7:P94/17. The enforcement of protective labor laws and the eligibility for benefits in the situation of "telecommuters" or home-based clerical workers is examined. The idea of home-based clerical work as an answer to child care is analyzed, and the concept of the home-based clerical worker as entrepreneur is also examined. Part of the argument against clerical homework was that companies pay the same wages without paying the benefits, and that while such arrangements might be convenient for all concerned, in the end the women suffer. Witnesses also noted the lack of career advancement opportunities for homeworkers and the tendency of piecework payment methods to encourage overly long hours of work.

SERIALS

841. U.S. Bureau of Labor Statistics. *Labor Laws and Their Administration, Proceedings of the Convention of the International Association of Governmental Labor Officials.* BLS Bulletin Washington, DC: GPO, 1935 - 1943. annual. L2.3:nos. Conference topics cover women in industry, minimum wage, and industrial homework. Bulletins 619 (1935), 629(1936), 653(1937), 666(1938), 678(1939), 690(1940), 721(1941), and 795(1943).

842. U.S. Bureau of Labor Statistics. *Labor Legislation of [year].* BLS Bulletin. Washington, DC: GPO, 1915 - 1933. annual. L2.3:nos. Annual report details state and federal labor legislation passed during the year. Provides cumulative indexes. Bulletins 111(1912), 166(1914), 186(1915), 213(1916), 244(1917), 257(1918), 277(1919), 292(1920), 308(1921), 330(1922), 403(1925), 434(1926), 470(1927), 486(1928), 528(1929), 552(1930), 590(1931-1933).

843. U.S. Employment Standards Administration. Wage and Hour Division. *Regulations, Part 530: Employment of Homeworker in Certain Industries.* Washington, DC: GPO, 1964 - . rev. irreg. L22.9:530/year; L36.206/2:530/year. Reprints 29 CFR 530, the regulations governing employment of homeworkers in the women's apparel, women's and children's underwear, body-supporting garments, infant and children's outerwear, jewelry, knitted garments, gloves and mittens, handkerchief, and embroidery industries.

844. U.S. Women's Bureau. *Digest of State Legislation of Special Interest to Women Workers.* [title varies] Washington, DC: The Bureau, 1952 - 1963. annual. L13.14/3:year. Digests for 1952 through 1955 issued under SuDoc number L13.2:L52/2/year. Summary of legislation for the year affecting women workers covers minimum wage, hours of work, industrial homework, and relaxation of labor laws in emergency situations.

845. U.S. Women's Bureau. *Labor Laws Affecting Women, Capsule Summary: [State].* Washington, DC: The Bureau, 1941-1970. rev. irreg. L13.14:

 Alabama. 3p. 1964-1965. L13.14:Al1b/year.
 Alaska. 4p. 1959, 1960, 1964. L13.14:Al1s/year.
 Arizona. 3p. 1952, 1956, 1960, 1962, 1965. L13.14:Ar4i/year.

Arkansas. 3p. 1952-1953, 1956, 1961, 1963-1965. L13.14:Ar4k/year.
California. 10p. 1959-1962, 1965-1966. L13.14:C12/year.
Colorado. 5p. 1957, 1962, 1965. L13.14:C71/year.
Connecticut. 5p. 1950, 1954, 1957, 1962, 1965. L13.14:C76/year.
Delaware. 3p. 1955, 1957, 1960, 1962, 1964, 1967. L13.14:D37/year.
District of Columbia. 3p. 1956, 1960, 1962, 1964. L13.14:D63/year.
Florida. 2p. 1956, 1964. L13.14:F66/year.
Georgia. 2p. 1956, 1965. L13.14:G29/year.
Hawaii. 3p. 1959, 1962, 1965. L13.14:H31/year.
Idaho. 2p. 1956, 1964-1965. L13.14:Id1/year.
Illinois. 30p. 1941, 1955, 1957, 1960, 1962, 1964. L13.14:Il6/year.
Indiana. 3p. 1956-1958, 1962, 1964, 1966. L13.14:In2/year.
Iowa. 2p. 1957, 1962, 1966. L13.14:Io9/year.
Kansas. 6p. 1961, 1962. L13.14:K13/year.
Kentucky. 27p. 1941, 1952, 1957, 1959. L13.14:K41/year.
Louisiana. 3p. 1957, 1962, 1965. L13.14:L93/year.
Maine. 5p. 1956, 1964, 1966. L13.14:M28/year.
Maryland. 25p. 1941, 1953, 1957-1959, 1961, 1962, 1966. L13.14:M36/year.
Massachusetts. 31p. 1941, 1950, 1957, 1960, 1962, 1964, 1966. L13.14:M38/year.
Michigan. 27p. 1941, 1960-1963, 1965-1966. L13.14:M58/year.
Minnesota. 4p. 1962, 1965-1966. L13.14:M66/year.
Mississippi. 4p. 1964. L13.14:M69i/year.
Missouri. 3p. 1951, 1957, 1962, 1964. L13.14:M69o/year.
Montana. 3p. 1950, 1957. L13.14:M76/year.
Nebraska. 3p. 1956, 1962. L13.14:N27/year.
Nevada. 3p. 1962. L13.14:N44/year.
New Hampshire. 5p. 1957, 1964, 1966. L13.14:N42h/year.
New Jersey. 29p. 1941, 1957, 1965. L13.15:N42j/year.
New Mexico. 3p. 1951, 1965, 1966. L13.14:N42n/year.
New York. 40p. 1941, 1954, 1958, 1965, 1966. L13.14:N42y/year.
North Carolina. 26p. 1941, 1953, 1957, 1964-1965. L13.14:N81c/year.
North Dakota. 4p. 1957-1958, 1960, 1962, 1964-1966. L13.14:N81d/year.
Ohio. 32p. 1941, 1957-1964, 1966-1970. L13.14:Oh3/year.
Oklahoma. 3p. 1957, 1964. L13.14:Ok4/year.
Oregon. 7p. 1950, 1956-1961, 1965. L13.14:Or3/year.
Pennsylvania. 29p. 1941, 1954, 1959, 1965-1966. L13.14:P38/year.
Rhode Island. 7p. 1957, 1958, 1965. L13.14:R34/year.
South Carolina. 3p. 1953, 1957, 1965. L13.14:So8c/year.
South Dakota. 4p. 1965. L13.14:So8d/year.
Tennessee. 25p. 1941, 1953, 1957, 1964-1965. L13.14:T25/year.
Texas. 25p. 1941, 1951, 1962, 1965. L13.14:T31/year.
Utah. 5p. 1957, 1962, 1964, 1966. L13.14:Ut1/year.
Vermont. 2p. 1950, 1957, 1964, 1966. L13.14:V59/year.
Virginia. 3p. 1953, 1957, 1962, 1965-1966. L13.14:V81/year.
Washington. 8p. 1958, 1965. L13.14:W27/year.
West Virginia. 5p. 1964, 1966. L13.14:W52v/year.
Wisconsin. 5p. 1957-1958, 1962, 1965. L13.14:W75/year.
Wyoming. 3p. 1956, 1962, 1965. L13.14:W99/year.

846. U.S. Women's Bureau. *State Labor Legislation of Special Interest to Women.*
Washington, DC: The Bureau, 1946 - 1947. annual. L13.2:L11/4/year. Annual summary
of state laws passed during the year covers topics of equal pay, minimum wage, hours,
industrial homework, domestic workers, migratory workers, and disability compensation.

847. U.S. Women's Bureau. *Summary of State Labor Laws for Women.* Washington, DC: GPO, 1945 - 1953. annual. L13.2:L11/3. Continued by L13.14/2:year.

848. U.S. Women's Bureau. *Summary of State Labor Laws for Women.* Washington, DC: GPO, 1956-1967. irregular. L13.14/2:year. Summary of state labor legislation reviews topics of minimum wage, overtime compensation, hours of work, equal pay, industrial homework, occupational limitations, facilities requirements, and employment before and after childbirth.

6

Industrial Health and Safety

Industrial injuries and occupational health were the focus of documents mostly issued by the Bureau of Labor Statistics, the Women's Bureau, and Congress. The dangers of employment in the metal trades and cotton mills for women are detailed in two of the reports in the Report on the Condition of Woman and Child Wage-Earners in the United States series (849-850). The experience in Great Britain with the employment of women in World War One munitions factories are detailed in reports on efficiency and fatigue (852-853).

A series of Women's Bureau reports analyze state reported data on industrial injuries by gender (864, 870-871, 877) and a 1934 report compares state reported injury rates to data gathered in Women's Bureau investigations (868). Two of the more general reports on the health of women workers include the 1944 Women's Bureau Special Bulletin, *The Industrial Nurse and the Woman Worker* (884) and the 1965 Public Health Service Report, *The Health of Women Who Work* (890).

Between 1950 and 1980 there were only scattered reports on the occupational health of women, but the 1980s brought a renewed interest in the protection of employee health. The impact of video display terminals (VDTs) on office workers was examined in congressional hearings held in the 1980s (891-892, 895). The possible reproductive health hazards for women and the issues of gender discrimination and employer liability are explored in an 1985 Office of Technology Report (893). Other documents discussing the health of women workers are found in Chapter 5, Labor Legislation.

849. U.S. Congress. Senate. *Employment of Women in the Metal Trades.* by Lucian W. Chaney. Report on the Condition of Woman and Child Wage-Earners in the United States, vol. XI. S. Doc. 645, 61st Cong., 2d sess., 1911. 107p. Serial 5695. Report on the employment of women in the metal trades focuses on factory conditions and potential dangers to women workers. Individual industries and the operations which utilize women are described. Some data is provided on industrial injuries by sex, by time of day, and by time in industry. Also given are statistics on the nature of injuries to press hands by sex, nature of injury, and time on the job.

850. U.S. Congress. Senate. *Causes of Death among Woman and Child Cotton-Mill Operatives.* by Arthur R. Perry. Report on Condition of Woman and Child Wage-Earners in the United States, vol. XIV. S. Doc. 645, 61st Cong., 2d sess., 1912. 430p. Serial 5698. Detailed analysis of death rates by cause among women and children cotton-mill operatives examines age and race/nativity and provides comparative data for men. The data was collected in studies of cotton-mill operatives in Fall River, Mass., Manchester, N.H., and Pautucket, R.I.

851. U.S. Bureau of Labor Statistics. *Employment of Women in Power Laundries in Milwaukee: A Study of Working Conditions and of the Physical Demands of the Various Laundry Occupations.* Bulletin no. 122. Washington, DC: GPO, 1913. 92p. L2.3:122. Examination of the working conditions in Milwaukee power laundries furnishes additional data on the age, race, marital status, hours, and wages of laundry workers.

852. U.S. Bureau of Labor Standards. *Industrial Efficiency and Fatigue in British Munitions Factories.* Bulletin no. 230. Washington, DC: GPO, 1917. 203p. L2.3:230. Report and memoranda of the British Health of Munitions Workers Committee look at the efficiencies of day work and night work by sex. Also reprints an investigation of the health of women engaged in munitions factories.

853. U.S. Bureau of Labor Statistics. *Industrial Health and Efficiency: Final Report of the British Health of Munitions Workers' Committee.* Bulletin no. 249. Washington, DC: GPO, 1919. 374p. L2.3:249. Much of this report on the health of workers in British war industries focuses on women and the appendices include several reports on the health of women munitions workers.

854. U.S. Bureau of Labor Statistics. *Preventable Death in Cotton Manufacturing Industry.* by Arthur Reed Perry. Bulletin no. 251. Washington, DC: GPO, 1919. 534p. L2.3:251. Investigation into causes of death in the cotton manufacturing industry provides data on deaths by cause, sex, age, marital status, and country of origin. For women the report also provides data on years of childbearing, offspring, and miscarriages. Includes a subject index.

855. U.S. Bureau of Labor Statistics. *Women in the Lead Industries.* by Alice Hamilton. Bulletin no. 253. Washington, DC: GPO, 1919. 38p. L2.3:253. Investigation of the incidence of lead poisoning among women exposed to lead in the work place looks at factors which may increase women's susceptibility to lead poisoning, particularly their low wages and resulting impoverished state. In particular the dangers to women in the printing trades, the manufacture of white lead, the painting trades, the manufacture of storage batteries, and the pottery glazing trades are examined.

856. U.S. Women's Bureau. *The Employment of Women in Hazardous Industries in the United States: Summary of State and Federal Laws Regulating the Employment of Women in Hazardous Occupations: 1919.* Bulletin no. 6. Washington, DC: GPO, 1921. 8p. L13.3:16/3. Overview of state and federal protective legislation relating to women's employment in industry identifies industries which present particular hazards to women. First edition published in 1919, reprinted with slight changes.

857. U.S. Women's Bureau. *Women Workers and Industrial Poisons.* by Alice Hamilton. Bulletin no. 57. Washington, DC: GPO, 1926. 5p. L13.3:57. Address given at the Women's Industrial Conference, held January 18-21, 1926, provides information on industries which expose women to poisonous materials with a particular emphasis on changes in industry since WWI.

858. U.S. Women's Bureau. *Industrial Accidents to Women in New Jersey, Ohio, and Wisconsin.* Bulletin no. 60. Washington, DC: GPO, 1927. 316p. L13.3:60. Comprehensive study examined death and disability benefits legislation in New Jersey, Ohio and Wisconsin. The application of the legislation is illustrated through case histories and data is provided on the number of disability cases by cause and characteristics of disability. Extensive case histories describe industrial accidents to women.

859. U.S. Bureau of Labor Statistics. *Activities and Functions of a State Department of Labor.* Bulletin no. 479. Washington, DC: GPO, 1928. 159p. L2.3:479. A section of the report,

"The Relation of Women in Industry to the Accident Ratios," analyzes industrial accidents suffered by women in New York State. Examines compensated accidents by age and sex, and accidents to females by age and industry. Also analyzes data on common causes and types of disabilities.

860. U.S. Women's Bureau. *Selected References on the Health of Women in Industry.* by Emily C. Brown. Bulletin no. 71. Washington, DC: GPO, 1929. 8p. L13.3:71. Lists journal articles and federal and state agency publications on the health of women in industry and on specific occupations and conditions hazardous to women.

861. U.S. Women's Bureau. *Industrial Accidents to Men and Women.* by Emily C. Brown. Bulletin no. 81. Washington, DC: GPO, 1930. 48p. L13.3:81. Analysis of existing data on industrial accidents by sex is based on information provided by state workmen's compensation boards. Although data is incomplete, what data does exist in analyzed by sex, industry, state, cause of accident, and age. Also discussed are accident prevention measures of various states.

862. U.S. Women's Bureau. *Sanitary Drinking Facilities with Special Reference of Drinking Fountains.* by Marie Correll. Bulletin no. 87. Washington, DC: GPO, 1931. 28p. L13.3:87.

863. U.S. Women's Bureau. *The Employment of Women in Vitreous Enameling.* by Ethel L. Best. Bulletin no. 101. Washington, DC: GPO, 1932. 64p. L13.3:101. Study examines lead poisoning and other health problems among women employed in vitreous enameling. Data collected and analyzed includes the age and marital status of workers by occupation, and the number of women reporting symptoms of lead poisoning by occupation. Absences and separations of women in the industry are reported by age, marital status, and cause of separation. Also reports findings on hours and wages of women and on employment policies to safeguard employee health.

864. U.S. Women's Bureau. *State Requirements for Industrial Lighting: A Handbook for the Protection of Women Workers, Showing Lighting Standards and Practices.* by Marie Correll. Bulletin no. 94. Washington, DC: GPO, 1932. 65p. L13.3:94. Handbook on industrial lighting requirements was compiled in response to findings of inadequate lighting during past industry surveys.

865. U.S. Women's Bureau. *Industrial Injuries to Women in 1928 and 1929 Compared with Injuries to Men.* by Marie Correll. Bulletin no. 102. Washington, DC: GPO, 1933. 36p. L13.3:102. Data compiled from state industrial accident reports provides a profile of the types, causes, and extent of resulting disability by sex for the years 1928 and 1929. Also examined is the relationship of age to the cause and seriousness of injury and a review of industries in which injuries occur.

866. U.S. Women's Bureau. *The Installation and Maintenance of Toilet Facilities in Places of Employment.* Bulletin no. 99. Washington, DC: GPO, 1933. 103p. L13.3:99. Provides information on existing state requirements for toilet facilities in places of employment and gives the suggested standards for the installation and maintenance of toilet facilities.

867. U.S. Women's Bureau. *Women's Industrial Injuries, Every State Should Publish Its Accident Data by Sex.* Washington, DC: The Bureau, 1933. poster. L13.9:In2.

868. U.S. Women's Bureau. *State Reporting of Occupational Disease Including a Survey of Legislation Applying to Women.* by Margaret Thompson Mettert. Bulletin no. 114. Washington, DC: GPO, 1934. 99p. L13.3:114. Reports results of an investigation of state occupational disease reporting efforts, and reviews compensation laws, particularly

as they affect women. Information from state records, when set against data collected in special surveys on occupational illness to women, revealed the inadequacy of state efforts. Provides what statistics exist on occupational disease by sex, age, and industry.

869. U.S. Women's Bureau. *The Health and Safety of Women in Industry.* by Harriet A. Byrne. Bulletin no. 136. Washington, DC: GPO, 1935. 23p. L13.3:136. General discussion of standards for the health and safety of women workers supported by the Women's Bureau. Covers topics of factory conditions; washing, toilet and rest facilities; industrial hazards; wages; hours of work; and industrial homework.

870. U.S. Women's Bureau. *Industrial Injuries to Women in 1930 and 1931 Compared with Injuries to Men.* by Margaret T. Mettert. Bulletin no. 129. Washington, DC: GPO, 1935. 57p. L13.3:129. Report pulls together data for 1930 and 1931 on industrial injuries and looks specifically at rates for women compared to men. Data reported by sex includes extent of disability, number of days lost, nature and location of injury, distribution of injuries by age and by cause and extent of disability, industrial distribution of injuries, and distribution of injuries by wage rate. Also includes statistics on marital status and number of dependents under 16 years of age by average wage.

871. U.S. Women's Bureau. *Summary of State Reports of Occupational Diseases with a Survey of Preventive Legislation 1932 to 1934.* by Margaret T. Mettert. Bulletin no. 147. Washington, DC: GPO, 1936. 42p. L13.3:147. Report on the occurrence of occupational disease among women presents information based on the small number of states which collected occupational disease data by sex. The nature of the reports varied greatly from state to state, allowing for limited general conclusions. Presents some data on occupational disease by sex, age, and industry in selected states. Briefly reviews protective labor legislation proposed and enacted by the states.

872. U.S. Women's Bureau. *Injuries to Women in Personal Service Occupations in Ohio.* by Margaret T. Mettert. Bulletin no. 151. Washington, DC: GPO, 1937. 23p. L13.3:151. Analysis of unpublished statistics gathered by the Ohio Department of Industrial Relations. Examines the incidence and characteristics of occupational injuries to women employed in service occupations in laundries, hotels, restaurants, barber and beauty shops, and households. Statistics reported by sex include extent of disability, nature of injury, location of injury, age of injured person, number of dependents, and weekly wage at time of injury.

873. U.S. Women's Bureau. *Industrial Injuries to Women and Men, 1932 to 1934.* by Margaret T. Mettert. Bulletin no. 160. Washington, DC: GPO, 1938. 37p. L13.3:160. Report on industrial injuries to women presents available statistics on industrial injuries to women and men for the years 1932 to 1934. Provides data on the number and extent of injuries and resulting disability by sex and on the personal characteristics of injured workers including age, marital status, and number of dependents. Also provides information on wages at the time of injury and on the amount of compensation paid by sex.

874. U.S. Women's Bureau. *Woman Who Earns Keeping Her Work Place Safe.* Washington, DC: The Bureau, 1938. poster. L13.9:W84/2. Also reprinted in 1940.

875. U.S. Women's Bureau. *Safety Shoes for Women Workers.* Special Bulletin no. 3, supplement. Washington, DC: GPO, 194? 4p. L13.10:3/supp.

876. U.S. Women's Bureau. *Lifting Heavy Weights in Defense Industries: Methods for Conserving Health of Women Workers.* Special Bulletin no. 2. Washington, DC: GPO, 1941. 11p. L13.10:2. Discussion notes the physical characteristics of women which affect their ability to lift heavy weights and identifies factors for industries to consider in hiring

women for work requiring lifting. Briefly describes some of the types of work requiring
lifting which women may encounter in defense work and discusses training women to lift
weights properly. Revised in 1946 (885).

877. U.S. Women's Bureau. *The Occurrence of Occupational Disease among Women 1935 to
1938.* by Margaret T. Mettert. Bulletin no. 184. Washington, DC: GPO, 1941. 46p.
L13.3:184. Update of Bulletins 114 (868) and 147 (871). Provides data from the states
on the occurrence of occupational diseases and the extent of disabilities by sex from 1935
to 1938. Also presents an evaluation of the level of exposure of women to toxic substances
in Pennsylvania, Illinois, and Iowa, and in specific industries including pottery and
asbestos textile manufacturing, the shoe industry, dry cleaning establishments, and the
nursing profession.

878. U.S. Women's Bureau. *Safety Clothing for Women in Industry.* Special Bulletin no. 3.
Washington, DC: GPO, 1941. 11p. L13.10:3. Guidelines for proper clothing for women
in industry. Highlights safety measures such as requiring goggles and headcoverings.

879. U.S. Women's Bureau. *Safety Caps for Women in War Factories.* Special Bulletin no.
9 Washington, DC: GPO, 1942. leaflet. L13.10:9.

880. U.S. Women's Bureau. *Washing and Toilet Facilities for Women in Industry.* Special
Bulletin no. 4. Washington, DC: GPO, 1942. 11p. L13.10:4.

881. U.S. Women's Bureau. *Safety Caps for Women Machine Operators.* Special Bulletin no.
9, supplement. Washington, DC: GPO, 1943. 4p. L13.10:9/supp.

882. U.S. Women's Bureau. *Work Clothes for Safety and Efficiency.* Washington, DC: The
Bureau, 1943. poster. L13.9:C62.

883. U.S. Women's Bureau. *Educating Women for Safety and Health, Talk Given by Jennie
Mohr, Research Associate in Health and Safety, Women's Bureau, Department of Labor,
before the West Virginia State-Wide Safety Conference, Charleston, March 24, 1944.*
Washington, DC: The Bureau, 1944. 7p. L13.12:W84/2. Characteristics of industrial
safety programs which are of particular relevance to the employment of women are
reviewed. Includes topics such as education for safety as part of job training, physical
limitations of women, importance of selection and placement of women, and possible
neglect of good health due to family responsibilities outside of work. The strangeness of
factory life as a factor in women's industrial safety is noted frequently.

884. U.S. Women's Bureau. *The Industrial Nurse and the Women Worker.* by Jennie Mohr.
Special Bulletin no. 19. Washington, DC: GPO, 1944. 47p. L13.10:19. The ways in
which the industrial nurse can improve the health of women workers is discussed in
relation to the common health problems of factory women. Fatigue, nutrition, and the
physical demands of the job are discussed as they affect women workers. Also covered
are "special health problems" of women such as menstruation, pregnancy, and menopause.
Briefly discusses the role of the nurse in plant health and safety programs.

885. U.S. Women's Bureau. *Lifting and Carrying Weights by Women in Industry.* Special
Bulletin no. 2, revised. Washington, DC: GPO, 1946. 12p. L13.10:2/2. See 876 for
abstract.

886. U.S. Women's Bureau. *Industrial Injuries to Women.* Bulletin no. 212. Washington,
DC: GPO, 1947. 20p. L13.3:212. Special data collected from 20,000 manufacturing and
nonmanufacturing firms in 1945 provides information on number of injuries, frequency of
injuries, and kinds of disabilities by sex and industry.

887. U.S. Women's Bureau. *The Industrial Nurse and the Woman Worker.* Bulletin no. 228. Washington, DC: GPO, 1949. 48p. L13.3:228. Revision of Special Bulletin no. 19 (884). Examines the role of the industrial nurse in ensuring the health of women workers. The negative aspects of industrial work on women's health, as indicated by research, is reviewed. Includes references and a bibliography of additional readings.

888. U.S. Dept. of State. *La Enferma Industrial y la Obrera.* Washington, DC: GPO, 1950. 54p. S16.7:293. Spanish version of Women's Bureau Special Bulletin 19 (884).

889. U.S. Dept. of State. *A Enfermeira dos Estabelecimentos Industrialis e a Operaria.* Washington, DC: GPO, 1951. 54p. S16.7:298. Spanish version of Women's Bureau Special Bulletin no. 19, *Industrial Nurse and the Woman Worker* (884).

890. U.S. Public Health Service. *The Health of Women Who Work.* Washington, DC: GPO, 1965. 62p. FS2.2:W84. Review of the literature on the health of women workers. Looks at health concerns in the areas of working environment, standards and laws governing women's employment, industrial health services, and work during pregnancy. Provides detailed statistics on work-loss days by employment, sex, and age; work-loss days by family income, sex, and age; work-loss days by chronic condition and sex; the incidence of acute conditions by type of condition, sex, and year of occurrence, 1959 -1963; mean age and illness rates by type of manufacturing and sex; and days of sick absence per person by marital status, age, and sex. Also presents statistics on the largest occupations for women, number of women in manufacturing and selected nonmanufacturing industries, and rate of job change by age and sex in 1955 and 1961.

891. U.S. Congress. House. Committee on Education and Labor. Subcommittee on Health and Safety. *OSHA Oversight - Video Display Terminals in the Workplace, Hearings.* 98th Cong., 2d sess., 28 Feb. - 12 June 1984. 623p. Y4.Ed8/1:Oc1/12. The health problems suffered by VDT operators, primarily women, are described by witnesses voicing differences of opinion on the level of risk. Needed changes in the work place environment to correct the problems are stressed. Research reports on VDT radiation are included in the hearing record.

892. U.S. Congress. House. Committee on Education and Labor. Subcommittee on Health and Safety. *A Staff Report on Oversight of OSHA with Respect to Video Display Terminals in the Workplace.* 99th Cong., 1st sess., 1985. Committee print. 90p. Y4.Ed8/1:Oc1/15. Summary of information gathered at subcommittee hearings on the negative health effects of working at VDTs. Research and surveys on the health of VDT operators is reviewed. While radiation was not considered a hazard, concerns were expressed over the lack of information on the effects of low frequency energy waves. Reported problems of eye strain, backaches, and adverse pregnancy outcomes are examined and workstation ergonomics is reviewed.

893. U.S. Office of Technology Assessment. *Reproductive Health Hazards in the Workplace.* Washington, DC: GPO, 1985. 422p. Y3.T22/2:2R29. Detailed overview of reproductive hazards in the workplace. Reviews the evidence of such hazards for both males and females and examines the regulatory process. Chapters explore sex discrimination and ethical issues, and the liability of employers for reproductive harm. Provides a good overview of reproductive biology and of assessment of reproductive risk factors.

894. U.S. Office of Technology Assessment. *Reproductive Health Hazards in the Workplace, Summary.* Washington, DC: GPO, 1985. 43p. Y4.T22/2:2R29/sum. Summary of an OTA report on reproductive health hazards in the workplace focuses on issues of sex discrimination, ethics, and assessment of risk.

895. U.S. Congress. House. Committee on Education and Labor. Subcommittee on Health and Safety. *National Institute for Occupational Safety and Health Oversight: OMB Involvement in VDT Study, Hearing*. 99th Cong., 2d sess., 4 June 1986. 62p. Y4.Ed8/1:99-128. Oversight hearing on the pending NIOSH study of VDT safety for pregnant women focuses on the need for and structure of such a study. The role of the Office of Management and Budget in delaying the study is explored.

7

Employee Benefits and Maternity Leave

The reports described below primarily document the evolution of maternity leave policies in U.S. industry. Some of the earliest documents, from 1919, focus primarily on international aspects of the protection of a woman's employment rights during pregnancy (897, 898). Interest in maternity leave policies was revived again during World War Two, when the Children's Bureau conducted a survey of maternity policies in industry (899). The question of maternity leave for federal employees was debated in 1948 congressional hearings (906). A good overview of the status of laws for the protection of employed women in the U.S. and internationally is provided in the 1952 Women's Bureau report *Maternity Protection and Employed Women* (909), which was updated in 1960 (912). Maternity benefits in 93 countries are detailed in a 1963 Women's Bureau report (913). Legislation to prohibit employment discrimination on the basis of pregnancy was considered in 1977 (916-917, 919) and resulted in passage of the Pregnancy Discrimination Act of 1978.

Starting in 1985 Congress began what would become regular hearings on legislation to require employers to provide unpaid leaves for maternity and for the serious illness of a child. Legislative action on the proposed Family and Medical Leave Act between the 98th and the 101st Congresses is reviewed in the 1989 House report on the measure (938). The cost of such leaves was examined in a 1989 GAO report (944). The employment patterns of women before and after pregnancy between 1961 and 1985 are documented in a 1990 Census Bureau report (945). Maternity policies for military personnel are covered in Chapter 11, and some additional documents on pregnancy and employment were included in Volume I.

896. U.S. Bureau of Labor Statistics. *Proceedings of the Conference on Social Insurance Called by the International Association of Industrial Accidents Boards and Commissions, Washington, D.C., December 5 to 9, 1916.* Bulletin no. 212. Insurance and Compensation Series no. 10. Washington, DC: GPO, 1917. 935p. L2.3:212. Conference papers cover all aspects of employee benefits including maternity leave and mothers' pensions.

897. U.S. Children's Bureau. *Maternity Benefit Systems in Certain Foreign Countries.* by Henry J. Harris. Publication no. 57. Washington, DC: GPO, 1919. 206p. L5.20:57. Summary of the various systems in Australia, Austria, Denmark, France, Germany, Great Britain, Italy, Luxembourg, the Netherlands, New Zealand, Norway, Russia, Sweden and Switzerland for providing benefits, cash and otherwise, to working women at the time of childbirth. Includes statistics on benefits granted in each country.

898. U.S. Dept. of Labor. *League of Nations, International Labor Conference, Draft Convention Concerning Employment of Women before and after Childbirth.* Washington, DC: The Dept., 1919. 4p. L1.10/2:W84/3. Draft ILO convention on maternity leave includes provisions guaranteeing paid maternity leave and protecting the woman's job while on leave.

899. U.S. Children's Bureau. *Maternity-Leave and Maternity-Care Practices in Industry.* Washington, DC: The Bureau, 1943. 36p. L5.2:M41/6. Results of a survey of maternity-leave and maternity care practices in industry conducted in 1942 and early 1943 describe termination and leave policies, policies on unmarried pregnant women, unemployment compensation, and working conditions. Provides some specific examples and discusses how state laws affect the employment of pregnant women in industry.

900. U.S. Children's Bureau. *A Maternity Policy for Industry.* Washington, DC: The Bureau, 1943. 4p. L5.2:M41/1. See 901 for abstract.

901. U.S. Children's Bureau. *A Maternity Policy for Industry.* Folder no. 30. Washington, DC: GPO, 1944. 4p. L5.22:30. Outlines the arguments for implementing a program of maternity leave rather than dismissing women workers automatically when they become pregnant.

902. U.S. Women's Bureau. *Union Provision for Maternity Leave for Women's Members.* Union Series no. 3. Washington, DC: GPO, 1945. leaflet. L13.13:3. Brief report highlights findings of a maternity leave study in war industries.

903. U.S. Army. *Civilian Employees: Employment of Pregnant Women, Sept. 16, 1947.* Washington, DC: GPO, 1947. 8p. W1.6/1:620-90. Regulations for the employment of civilian women during pregnancy covers when the woman must stop working and when she can return to work, and states the Army's policy on job security and seniority.

904. U.S. Women's Bureau. *Maternity Benefits under Union Contracted Health Insurance Plans.* Bulletin no. 214. Washington, DC: GPO, 1947. 19p. L13.3:214. Presents results of a study which examined the experience of women with maternity benefits under union contract health insurance plans. Looks at such areas as kinds of assistance under the plans, use of health plans for maternity needs, and the extent of compensation for economic loses incurred by not working as a result of maternity.

905. U.S. Congress. Senate. Committee on the Post Office and Civil Service. *Providing Maternity Leave for Government Employees, Report to Accompany S. 784.* S. Rept. 1525, 80th Cong., 2d sess., 1948. 10p. Serial 11208. Favorable report on legislation to provide up to 60 days paid maternity leave to married female employees of the federal government or of the District of Columbia summarizes hearing testimony on the desirability of maternity leave benefits. A chart provides an overview of maternity leave provisions in the laws of six states and 34 foreign countries.

906. U.S. Congress. Senate. Committee on Post Office and Civil Service. Subcommittee on S. 784. *Maternity Leave for Government Employees, Hearings on S. 784.* 80th Cong., 2d sess., 17-18 Feb. 1948. 82p. Y4.P84/11:M41. Testimony and discussion on a proposal for 60 days paid maternity leave for civil service employees centers on whether it was possible to accumulate sufficient sick leave to cover maternity. Most witnesses address the experience of individual agencies with past maternity leave policies. The question of whether unmarried women would be eligible, hence encouraging illegitimacy, is explored. Also discussed by health officials is the time period a woman should stop working before the birth and the time necessary to recover after the birth. Reprints Women's Bureau Bulletin no. 214, *Maternity Benefits under Union Contract Health Insurance Plans.* (904).

907. U.S. Air Force. *Medical Service: Maternity Care of Women Discharged or Relieved from Active Duty, May 5, 1950.* Air Force Regulation 160-34. Washington, DC: GPO, 1950. 2p. D301.6:160-34.

908. U.S. Women's Bureau. *Bibliography on Maternity Protection.* Washington, DC: The Bureau, 1951. 59p. L13.2:M34/4. Extensive annotations of articles and reports on maternity coverage in health insurance and employee benefit plans characterize this 82-item bibliography. Also included are citations to works on maternity protection in foreign countries.

909. U.S. Women's Bureau. *Maternity Protection of Employed Women.* Bulletin no. 240. Washington, DC: GPO, 1952. 50p. L13.3:240. Report in two parts on maternity protection reviews legislative provisions in the U.S. and summarizes the results of a study of practices in 43 firms. Part II looks at the international movement for maternity protection. The International Labor Organization Maternity Convention of 1919 is analyzed, and national legislation in other countries is reviewed.

910. U.S. Bureau of Labor Statistics. *Analysis of Health and Insurance Plans under Collective Bargaining, Late 1955.* Bulletin no. 1221. Washington, DC: GPO, 1957. 87p. L2.3:1221. Provides information and data on health and insurance plans including a description of maternity benefits and data on vacation and health insurance benefits by sex.

911. U.S. Bureau of Labor Statistics. *Health and Insurance Plans under Collective Bargaining; Hospital Benefits, Early 1959.* Bulletin no. 1274. Washington, DC: GPO, 1960. 37p. L2.3:1274. Review of health and insurance plans describes characteristics of maternity benefits coverage for women workers and dependent wives.

912. U.S. Women's Bureau. *Maternity Benefit Provisions for Employed Women.* Bulletin no. 272. Washington, DC: GPO, 1960. 50p. L13.3:272. Review of the state of maternity benefits for employed women in the U.S. examines benefits under voluntary benefit plans and union negotiated benefit plans. Also looks closely at federal and state legislation and regulations relating to maternity and employment, and at the 1959 move by Congress to provide health insurance, including maternity benefits, to federal workers. Public maternal health services are briefly discussed. International standards of maternity protection are also covered. Provides statistics on availability of maternity benefits and on benefits paid.

913. U.S. Women's Bureau. *Maternity Protection and Benefits in 92 Countries.* Women in the World Today International Report no. 6. Washington, DC: GPO, 1963. 46p. L13.23:6. Summary, by country, of maternity protection and benefits under labor law and under social insurance highlights prohibitions from working, leaves, protection from due to pregnancy, lump-sum grants, and maternity benefits based on of a percentage of earnings.

914. U.S. Civil Service Commission. *Maternity Benefits for the Federal Employee.* Federal Employee Facts no. 9. Washington, DC: GPO, 1969. leaflet. CS1.59:9/rev. no. Use of leave for pregnancy and confinement, salary and benefits during leave, and return to work are the major areas covered in the several revisions of this pamphlet. Later editions published in 1975 and 1977.

915. U.S. Citizens' Advisory Council on the Status of Women. *Job-Related Maternity Benefits.* Washington, DC: The Council, 1970. 5p. Y3.In8/21:2J575. Point-by-point analysis profiles existing approaches to maternity leaves and insurance benefits.

916. U.S. Congress. House. Committee on Education and Labor. Subcommittee on Employment Opportunities. *Legislation to Prohibit Sex Discrimination on the Basis of Pregnancy, Hearing on H.R. 5055 and H.R. 6075.* 95th Cong., 1st sess., 6 April 1977. 303p.

Y4.Ed8/1:Se9/3. Considers legislation prompted by *Gilbert v. General Electric*, the Supreme Court decision which held that exclusion of pregnancy from disability plans was not sex discrimination. Testimony against the legislation focuses on the cost of mandatory coverage of pregnancy in disability and health insurance plans. Statements in favor of the bill focus on the discriminatory effect on women of the *Gilbert* decision.

917. U.S. Congress. House. Committee on Education and Labor. Subcommittee on Employment Opportunities. *Legislation to Prohibit Sex Discrimination on the Basis of Pregnancy, Part 2, Hearing on H.R. 5055 and H.R. 6075.* 95th Cong., 1st sess., 29 June 1977. 186p. Y4.Ed8/1:Se9/3/pt.2. Continued hearing considers an amendment to Title VII of the Civil Rights Act of 1964 to specifically prohibit discrimination based on pregnancy. Testimony, statements, and correspondence from union leaders are included along with testimony on pregnancy benefits in New Jersey.

918. U.S. Congress. Senate. Committee on Human Resources. *Amending Title VII, Civil Rights Act of 1964, Report Together with Supplemental Views to Accompany S. 995.* S. Rept. 95-331, 95th Cong., 1st sess., 1977. 17p. Serial 13168-6. Favorable report on amendment of Title VII of the Civil Rights Act of 1964 to prohibit discrimination on the basis of pregnancy reviews past court decisions on pregnancy discrimination with particular reference to *Gilbert v. General Electric* and coverage of pregnancy under company disability plans. The report also documents a failed attempt to exclude non-therapeutic abortions from the definitions of "pregnancy and related medical conditions" under the act.

919. U.S. Congress. Senate. Committee on Human Resources. Subcommittee on Labor. *Discrimination on the Basis of Pregnancy, 1977, Hearings on S. 995.* 95th Cong., 1st sess., 26-29 Apr. 1977. 582p. Y4.H88:P81/977. Hearing considers S. 995, a bill to amend Title VII of the Civil Rights Act of 1964 to prohibit sex discrimination on the basis of pregnancy, childbirth,or related medical conditions. Testimony focuses on the negative effect on women's wage earning ability of the Supreme Court's decision in *Gilbert v. The General Electric Co.*, which allowed employers to exclude pregnancy and related conditions from disability plans. The changing role of women wage earners is stressed. Testimony against the measure centers on administration and cost issues.

920. U.S. National Commission on the Observance of International Women's Year. *Insurance: A Workshop Guide.* Washington, DC: GPO, 1977. 42p. Y3.W84:10/19. Guide for conducting a workshop on women and insurance includes fact sheets, workshop goals, NAIC model regulation, and lists print and film resources and possible speakers.

921. U.S. Congress. House. Committee on Education and Labor. *Pregnancy Disability, Conference Report to Accompany S. 995.* H. Rept. 95-1786, 95th Cong., 2d sess., 1978. 5p. Serial 13201-16. The conference report substitute for the differing House and Senate versions of a bill to include pregnancy under the definition of sex discrimination under Title VII of the Civil Rights Act of 1964 includes an amendment exempting employer insurance plans from covering abortions except where the mother's life is threatened.

922. U.S. Congress. House. Committee on Education and Labor. *Prohibition of Sex Discrimination Based on Pregnancy, Report Together with Dissenting Views to Accompany H.R. 6075.* H. Rept. 95-948, 95th Cong., 2d sess., 1978. 18p. Serial 13201-2. Reports, with amendments, a bill to add sex discrimination on the basis of pregnancy to the practices prohibited by Title VII of the Civil Rights Act of 1964. One of the amendments to the bill would give employers the right to exclude abortions from benefit plans except where it is necessary to save the life of the mother. The bill is primarily aimed at nullifying the decision in *Gilbert v. The General Electric Co.* in which the Supreme Court ruled that excluding pregnancy-related disabilities from company insurance plans did not constitute sex discrimination. The report reviews the implications of the *Gilbert* case and

the effect of the proposed bill, specifically discussing the issue of abortion. The dissenting view of Ted Weiss expressed disagreement over the anti-abortion rider.

923. U.S. Office of Personnel Management. *Maternity Benefits for Federal Employees.* Fed Facts no. 9. Washington, DC: GPO, 1979. 8p. leaflet. PM1.25:9. Revised edition issued in 1980.

924. U.S. Congress. Senate. Committee on Labor and Human Resources. *Legislative History of the Pregnancy Discrimination Act of 1978, Public Law 95-555.* 96th Cong., 2d sess., 1980. Committee print. 212p. Y4.L11/4:P91/3. Legislative history of the Pregnancy Discrimination Act of 1978 reprints *Congressional Record* excerpts, texts of bills H.R. 5055, S. 995, and H.R. 6075, Senate Report 95-331, House Report 95-948, the conference committee report House Report 95-1786, and P.L. 95-555.

925. U.S. Congress. House. Committee on Post Office and Civil Service. Subcommittee on Civil Service and Subcommittee on Compensation and Employee Benefits and U.S. Congress. House. Committee on Education and Labor. Subcommittee on Labor-Management Relations and Subcommittee on Labor Standards. *Parental and Disability Leave, Joint Hearing.* 99th Cong., 1st sess., 17 Oct. 1985. 73p. Y4.P84/10:99-36. Witnesses describe existing maternity leave programs and the value of such leaves for child development. The number of working mothers and the need for guaranteed parental leave is documented.

926. U.S. Congress. House. Committee on Education and Labor. *Family and Medical Leave Act of 1986, Report Together with Dissenting and Separate Dissenting Views to Accompany H.R. 4300.* H. Rept. 99-699, part 2, 99th Cong., 2d sess., 1986. 57p. Serial 13704 Reports a bill requiring employers to an allow unpaid leave of up to 18 weeks for parents upon the birth or adoption of a child, or to care for a dependent child or parent with a serious health condition. Hearing testimony on the need for such leaves and on employers ability to accommodate such leaves is reviewed. Amendments adopted by the committee to address employer concerns include a limitation on the amount of leave allowed in one year and an expanded small business exemption. Objections voiced in dissenting views express the opinion that the bill goes to far and would place an undue burden on small business, and that it would cause subtle discrimination against women likely to become pregnant.

927. U.S. Congress. House. Committee on Education and Labor. Subcommittee on Labor-Management Relations and Subcommittee on Labor Standards. *Parental and Medical Leave Act of 1986, Joint Hearing.* 99th Cong., 2d sess., 22 Apr. 1986. 248p. Y4.Ed8/1:99-101. Parents and business representatives present the case for and against a bill requiring the availability of a leave of absence and job security for parents of infants and seriously ill children, and for employees with a serious medical condition. Family stress, company hardship, and costs are the major themes explored.

928. U.S. Congress. House. Committee on Post Office and Civil Service. *Parental and Medical Leave Act of 1986, Report to Accompany H.R. 4300.* H. Rept. 99-699, part 1, 99th Cong., 2d sess., 1986. 21p. Serial 13704 The need for maternity/paternity leave is stressed in this favorable report on legislation to require employers to allow unpaid leaves for parents on the birth or adoption of a child, the serious illness of a child, or the serious illness of the employee. The bill provides for the protection of the employment and benefit rights during the period of the leave. The need for this legislation in addition to the Pregnancy Discrimination Act of 1978 is described.

929. U.S. Congress. House. Committee on Post Office and Civil Service. Subcommittee on Civil Service and Subcommittee on Compensation and Employee Benefits. *Parental and*

Medical Leave Act of 1986, Hearing on H.R. 4300. 99th Cong., 2d sess., 10 April 1986, 102p. Y4.P84/10:99-56. Testimony on a bill to require unpaid paternal leave and extended medical leave furnishes personal accounts of working parents coping with newborn or seriously ill children. The prejudice against career women who have children and the pressure to return to work quickly following the birth of a child is described. Maternity and paternal leave policies in various countries are described, and the trend toward working mothers is stressed. Child development theory relating to bonding with parents is reviewed.

930. U.S. Congress. House. Committee on Education and Labor. Subcommittee on Labor-Management Relations and Subcommittee on Labor Standards. *Family and Medical Leave Act of 1987, Joint Hearings.* 100th Cong., 1st sess., 5 Mar. 1987. 447p. Y4.Ed8/1:100-20. Continued hearings on proposals to mandate unpaid leave for parents of newborn, recently adopted, or severely ill children includes testimony from parents on the need for such leaves. Witnesses describe the extent of existing parental leave policies and the experience of companies offering maternity leave. Opposition testimony comes primarily from industry representatives who assert that the bill would cause hardship for small businesses.

931. U.S. Congress. House. Committee on Post Office and Civil Service. Subcommittee on Civil Service and Subcommittee on Compensation and Employee Benefits. *Family and Medical Leave Act of 1987, Joint Hearing on H.R. 925.* 100th Cong., 1st sess., 2 Apr. 1987. 139p. Y4.P84/10:100-8. Discussion of a bill requiring unpaid parental leave for new parents and parents of seriously ill children centers on the costs to business and the benefits to families.

932. U.S. Congress. House. Committee on Small Business. *Parental Leave, Hearing.* 100th Cong., 1st sess., 4 Aug. 1987. 141p. Y4.Sm1:100-19. Hearing explores the pros and cons of a national policy on parental leave with a particular focus on the impact on small business. The importance to working mothers of maternity leave and the ability to take leave to care for a sick child is stressed. Among the points debated are the length of leave requirements and the size of businesses to which the bill would apply. The extent to which maternity leave is voluntarily available in private sector employment is reviewed.

933. U.S. Congress. Senate. Committee on Labor and Human Resources. Subcommittee on Children, Family, Drugs and Alcoholism. *Parental and Medical Leave Act of 1987, Hearings on S. 249, Part 1.* 100th Cong., 1st sess., 19 Feb. - 15 June 1987. 499p. Y4.L11/4:S.hrg.100-438/pt.1. Hearings held in Washington and Boston consider legislation to require companies with more than 15 employees to provide unpaid leave upon the birth, adoption, or serious illness of a child and to allow temporary medical leave when a serious health condition prevents an employee from working. Testimony focuses on the philosophy behind parental leave, successful parental leave programs, and concerns of business and professional organizations regarding the cost of mandatory leave benefits to employers.

934. U.S. Congress. Senate. Committee on Labor and Human Resources. Subcommittee on Children, Family, Drugs and Alcoholism. *Parental and Medical Leave Act of 1987, Hearings on S. 249, Part 2.* 100th Cong., 1st sess., 20 July - 29 Oct. 1987. 685p. Y4.L11/4:S.hrg.100-438/pt.2. Hearings held in Los Angeles, Chicago, Atlanta and Washington provide additional testimony on the need for parental leaves and on the cost of such leaves to employers.

935. U.S. Congress. House. Committee on Education and Labor. *Family and Medical Leave Act of 1988, Report Together with Minority, Supplemental, Additional Dissenting, and Additional Views to Accompany H.R. 925.* H. Rept. 100-511, part. 2, 100th Cong., 2d

sess., 1988. 71p. Serial 13890. Favorable report with numerous dissenting views on a bill to require employers to provide employees with unpaid leave for the birth or adoption of a child, to care for a seriously ill child, or when the employee in seriously ill for an extended period, without loss of employment or benefit rights. A commission to study the effects of such leaves on small business is also authorized. Labor force changes and the need for such legislation is summarized as background for the bill.

936. U.S. Congress. House. Committee on Post Office and Civil Service. *Family and Medical Leave Act, Report to Accompany H.R. 925.* H. Rept. 100-511, part 1, 100th Cong., 2d sess., 1988. 38p. Serial 13890. Background on the theories supporting an extended parental leave policy for the birth or adoption of a child is included in this report on a bill requiring employers to grant unpaid maternity/paternity leave and medical leave for employees with serious illnesses.

937. U.S. Congress. Senate. Committee on Labor and Human Resources. *Parental and Medical Leave Act of 1988, Report Together with Minority Views to Accompany S. 2488.* S. Rept. 100-447, 100th Cong., 2d sess., 1988. 75p. Serial 13864. Information gathered at hearings on the need for parental and medical leave legislation is summarized in support of this measure which would require businesses with twenty or more employees to grant unpaid maternity/paternity leave or medical leave and to protect employment and benefit rights during the leave. The extent of maternity leave policies among U.S. businesses and the cost to employers of this legislation is reviewed.

938. U.S. Congress. House. Committee on Education and Labor. *Family and Medical Leave Act of 1989, Report Together with Minority, Supplemental, Additional, and Individual Views to Accompany H.R. 770.* H. Rept. 101-28, part 1, 101st Cong., 1st sess., 1989. 86p. The need for a federal family and medical leave bill is described in a favorable report with many separate views. Legislative action on family leave bills since the 98th Congress is reviewed and material from past hearings is cited in support of the bill. Changes made in the bill to accommodate the concerns of employers are noted.

939. U.S. Congress. House. Committee on Education and Labor. Subcommittee on Labor-Management Relations. *Hearing on H.R. 770, the Family and Medical Leave Act of 1989, Hearing.* 101st Cong., 1st sess., 7 Feb. 1989. 426p. Y4.Ed8/1:101-2. Hearing on a compromise Family and Medical Leave Act presents further testimony on the strain placed on families as they attempt to balance family care needs and work demands. The need for uniform availability of maternity/parental leave is stressed through both expert testimony and case histories of individuals affected by the lack of maternity leave benefits. The cost of such programs for employers and possible discrimination against hiring women if such leave is mandated are also considered. The economic effect on women of denial of maternity leave is stressed.

940. U.S. Congress. House. Committee on House Administration. *Family and Medical Leave Act of 1989, Report to Accompany H.R. 770.* H. Rept. 101-28, part 3, 101st Cong., 1st sess., 1989. 6p. Favorable report describes a bill to provide family leave to House of Representatives employees following the birth or adoption of a child, or during the serious illness of a child or parent.

941. U.S. Congress. House. Committee on Post Office and Civil Service. *Family and Medical Leave Act of 1989, Report to Accompany H.R. 770.* H. Rept. 101-28, part 2, 101st Cong., 1st sess., 1989. 36p. Report on a family and medical leave bill provides background on the need to provide job security for women who take time off from work to care for an infant, a seriously ill child, or a parent. Information gathered at past hearings on family leave bills is summarized with relevant quotes. Departmental correspondence against the bill is reprinted.

942. U.S. Congress. Senate. Committee on Labor and Human Resources. *Family and Medical Leave Act of 1989, Report to Accompany S. 345.* S. Rept. 101-77, 101st Cong., 1st sess., 1989. 68p. Details of a bill requiring employers to provide unpaid leave for employees on the birth, adoption, or serious illness of a child, or serious illness of a parent are provided. Information gathered at hearings on the need for time off to deal with a seriously ill child or parent is summarized. The extent of existing family leave policies is presented in support of the bill.

943. U.S. Congress. Senate. Committee on Labor and Human Resources. Subcommittee on Children, Family, Drugs, and Alcoholism. *Family and Medical Leave Act of 1989, Hearing on S. 345.* 101st Cong., 1st sess., 2 Feb. 1989. 325p. Y4.L11/4:S.hrg.101-71. Support and opposition to legislation requiring employers to provide unpaid maternity or medical leaves centers on the cost of the measure to business. Supporters describe the need for job security for working women who wish to have children and point to the operation of mandatory maternity leave laws in the states. Opponents claim that the measure would force companies to cut back other benefits to cover the cost of the leaves.

944. U.S. General Accounting Office. *Parental Leave: Revised Cost Estimate Reflecting the Impact of Spousal Leave.* Washington, DC: The Office, 1989. 13p. GA1.13:HRD-89-68. Report details estimated costs to employers under H.R. 770, the Family and Medical Leave Act of 1989. Costs are estimated for each situation set out in the bill, i.e., newborn child, seriously ill child, seriously ill parent, etc.

945. U.S. Bureau of the Census. *Work and Family Patterns of American Women: The Family Life Cycle, 1985: Maternity Leave Arrangements, 1961-85.* Current Population Reports Series P-23, no. 165. Washington, DC: GPO, 1990. 57p. C3.186:P-23/165. Two statistical analyses, one on the family life cycle, the other on maternity leaves, provides insight into the changing patterns of women's lives. The first paper looks at changing patterns in marriage, divorce and childbearing. The second paper examines data on the employment patterns of women during and after pregnancy between 1961 and 1985. Factors of race, age at first pregnancy, and leave arrangements by characteristics of the mother are examined. Detailed statistical tables accompany the report.

946. U.S. Congress. House. Committee on Rules. *Providing for the Consideration of H.R. 770, Report to Accompany H.Res. 388.* H Rept. 101-479, 101st Cong., 2d sess., 1990. 50p. Report presents the substitute text of the Family and Medical Leave Act of 1990.

947. U.S. Women's Bureau. *State Maternity/Paternal Leave Laws.* Facts on Working Women, no. 90-1. Washington, DC?: The Bureau, 1990. 8p. L36.114/3:90-1. Charts and tables provide a brief overview of state laws related to maternity leave or family leave.

8

Statistical Reports
and Industry Studies

Hundreds of statistical reports and industry studies issued primarily by the Census Bureau, the Women's Bureau, and the Bureau of Labor Statistics are described below. Many hundreds more reports also provide significant work force data broken down by gender, but were not included for lack of space.

The first significant statistical report on women workers was the 1907 Census report *Statistics of Women at Work: Based on Unpublished Information Derived from the Schedules of the Twelfth Census: 1900* (948). Six of the volumes of the Report on the Condition of Woman and Child Wage-Earners in the United States are listed here, while others are scattered throughout the volume under more specific subjects. The six listed here provide detailed information on the characteristics of women in selected industries (957), and in the cotton textile (949), laundry (950), glass (951), men's ready-made clothing (952), and silk (953) industries.

Most states are represented in individual reports which are scattered throughout the chapter. In addition, brief statistical reports on women workers in each state were issued by the Women's Bureau between 1962 and 1974. (1187). Statistics on working women as of 1920 are graphically presented in *Facts about Working Women* (991), and a detailed analysis of the personal and occupational characteristics of women from 1870 to 1920 was issued by the Census Bureau in 1929 (1105). The major statistical report from 1948 to the present is the *Handbook on Women Workers* (1184). A very detailed statistical profile of women workers between 1940 and 1950 is provided by *Women as Workers...A Statistical Guide* (1103), and the employment of women between 1950 and 1979 is detailed in an extensive statistical report, *Perspectives on Working Women: A Databook* (1157). The 1975 document *U.S. Working Women: A Chartbook* presents statistics on the characteristics of employed women in a series of charts (1139). The chartbook was updated in 1977 (1143) and in 1983 (1164).

Data from the 1930 Census formed the basis of reports on the responsibility of employed women for family support (1056) and on types of families and gainful workers (1060). The employment and family characteristics are reported in detail on the 1943 Census report (1072). Data on working mothers is provided in a series of BLS reports (1129, 1133, 1137-1138, 1149, 1162), as are statistics on the marital and family characteristics of workers (1130, 1142, 1148, 1150-1151, 1156, 1163).

Immigrant women were the focus of a 1930 Women's Bureau report which described their personal characteristics and employment experience (1012). The effect of World War One and the Great Depression on employment trends on men and women were explored in a 1930 Women's Bureau report (1014). The effect of World War One is also charted in *The Occupational Progress of Women: In Interpretation of Census Statistics of Women in Gainful Occupations* (976). The

economic status of women with bachelor's or higher degrees was reports based on a 1939 study of the membership of the American Association of University Women (1059).

The part-time employment of women in ten cities was the subject of a series of detailed statistical reports issued in 1951 (1085-1095). The employment characteristics of women and minorities in the largest metropolitan areas are provided in EEOC reports issued between 1972 and 1976 (1140). Also in EEOC reports is data on the employment of women in referral unions (1135, 1145, 1177), in private industry (1144, 1169, 1178), in higher education (1160, 1168), and in elementary and secondary education (1176). Other statistical reports on women workers are scattered throughout the volume in chapters on more specific subjects.

948. U.S. Bureau of the Census. *Statistics of Women at Work: Based on Unpublished Information Derived from the Schedules of the Twelfth Census: 1900.* Washington, DC: GPO, 1907. 399p. C3.5:W84. Very detailed statistical profile of women employed outside the home provides information on occupation, ancestry, marital and family situation, age and race. Based on unpublished data from the 1900 Census. Includes a subject index.

949. U.S. Congress. Senate. *Cotton Textile Industry.* Report on Condition of Woman and Child Wage-Earners in the United States, vol. I. S. Doc. 645, 61st Cong., 2d sess., 1910. 1044p. Serial 5685. Very detailed examination of the hours, earnings and working conditions of women and girls employed in cotton textile mills also reports on family conditions, family income, housing, and availability of education for families with female mill operatives. Data is the presented by sex, occupation, age, and state or region. For female employees, data on marital status and age of children was also gathered. Employment of children is examined by race/nativity, sex, age, occupation, earnings, literacy, months of school attended, occupation of father and mother, size of family, and family income. Also provides state data on single women over 16 at work by race/nativity, age, occupation, days worked per year, past years' earnings, literacy, occupation or condition of father and mother, size of family and family income. Data by state for married women at work includes race/nativity of husband, years married, age, occupation, days worked in past year, condition of husband, number of children by age, and income of family by earner. The report has 32 detailed tables, numerous text tables and a subject index.

950. U.S. Congress. Senate. *Employment of Women in Laundries.* Report on Condition of Woman and Child Wage-Earners in the United States, vol. XII. S. Doc. 645, 61st Cong., 2d sess., 1911. 121p. Serial 5696. The most interesting aspect of this report on the conditions of women employed in the laundry trades are the 539 case summaries of female laundry workers. These summaries describe the age, nativity, marital status, and family condition of the women, how much they earn and the cost and condition of their lodgings. The work history and general health of each woman is also described. Provides some summary data of health complaints by marital status and character of occupation.

951. U.S. Congress. Senate. *Glass Industry.* Report on Condition of Woman and Child Wage-Earners in the United States, vol. III. S. Doc. 645, 61st Cong., 2d sess., 1911. 970p. Serial 5687. Part II of this report details the hours, earnings and working conditions of women and girls employed in the glass industry. Occupation, working conditions and hazards, hours of labor and nightwork, and earnings are examined. Age, race, and conjugal condition of female employees are reported as are family condition, family income, and housing and living conditions. A particular emphasis is placed on marital status and the economic conditions of the family. Also examines literacy and school attendance of workers by sex, nativity, and age. Provides profiles by state for individual families surveyed. Family and work data given for single women over sixteen includes

race/nativity and years in the U.S. of father; age; occupation or condition of father and mother; total wage earners in the family and number and ages of children in family; and family income by contributor. Family and work data given for families with a married working woman include race/nativity, years in U.S. and occupation or condition of husband, years married, age, occupation or industry, number and ages of children, and family earnings by family member.

952. U.S. Congress. Senate. *Men's Ready-Made Clothing.* Report on Condition of Women and Child Wage-Earners in the United States, vol. II. S. Doc. 645, 61st Cong., 2d sess., 1911. 878p. Serial 5686. In-depth study of women and child wage-earners in the men's ready-made clothing industry profiles the workers by sex, age, race, nativity, country of origin and marital status. Also examines hours of labor and overtime, earnings, home work, family conditions and income. An analysis of the organization and development of the clothing industry is also provided. Detailed statistics are presented on earnings by sex, nativity, and occupation for selected cities. For single women data is reported on individual cases by nativity of father, age, occupation, days worked, earnings, literacy, occupation or condition of father and mother, size of family, and family income. Data on individual families with married women at work includes nativity of husband, years in the U.S., years married, age, occupation, days worked, condition of husband, number and ages of children, total family wage earners, and family income by earner.

953. U.S. Congress. Senate. *The Silk Industry.* Report on Condition of Woman and Child Wage-Earners in the United States, vol. IV. S. Doc. 645, 61st Cong., 2d sess., 1911. 592p. Serial 5688. Investigation of hours, wages and working conditions in the silk industry focuses on the employment of women and children at New Jersey and Pennsylvania mills. Characteristics of age, marital status, family condition, and race/nativity are examined in detail. General tables provide details for each family studied. For single women the tables report father's nativity and years in the U.S., the woman's age, occupation, previous years' earnings and days worked, literacy, educational attainment, occupation or condition of father and mother, number and ages of children, and family income and number of wage earners. Similar information is provided for families with a married or formerly married woman worker.

954. U.S. Bureau of Labor Statistics. *Hours, Earnings, and Duration of Employment of Wage-Earning Women in Selected Industries in the District of Columbia.* Bulletin no. 116. Washington, DC: GPO, 1913. 68p. L2.3:116. Study examined working hours, duration of employment, and weekly earnings of women in retail trade, manufacturing, and mechanical establishments, and in hotels and restaurants in Washington, D.C. Also provides data on manner of living, ages, and occupations of women employees in the District.

955. U.S. Bureau of Labor Statistics. *Working Hours of Women in the Pea Canneries of Wisconsin.* by Marie L. Obenauer. Bulletin no. 119. Washington, DC: GPO, 1913. 54p. L2.3:119. The nature of the pea canning industry in Wisconsin and its effect on the work hours of women is examined.

956. U.S. Congress. House. Committee on Rules. *Investigation of Canneries, Hearings on H. Res. 738.* 62d Cong., 3d sess., 11 Jan. 1913. 42p. Y4.R86/1:C16. The working conditions of women and children and the unsanitary conditions in fruit and vegetable canneries in the U.S. are described in testimony on a resolution to establish an investigatory House committee. Testimony also describes the wages, hours, and living conditions of cannery workers, many of whom are women and children.

957. U.S. Congress. Senate. *Employment of Women and Children in Selected Industries.* Report on Condition of Woman and Child Wage-Earners in the United States, vol. XVIII.

S. Doc. 645, 61st Cong., 2d sess., 1913. 531p. Serial 5702. Detailed report on the employment of women and children in industry is arranged by industry and provides data on the number, age, race, and marital status of the workers. Each operation within the industry which employs women or children is described in detail noting the wages and health conditions. Eight detailed tables provide industry employment data by sex, race, and age; by sex, age, and marital status; and by sex, race, and marital status; and distribution of earnings by sex, age, industry, and state. Provides a subject index.

958. U.S. Bureau of Labor Statistics. *Hours, Earnings, and Conditions of Labor of Women in Indiana Mercantile Establishments and Garment Factories.* Bulletin no. 160. Washington, DC: GPO, 1914. 198p. L2.3:160. Investigation into the working conditions, hours, and wages of women employed in retail stores and in garment factories in Indiana provides data on age, manner of living, and marital status of women workers. Other data collected includes working hours, rates of pay and earnings by occupation, earnings related to age and experience, duration of employment and unemployment, sick benefits, and working conditions and facilities.

959. U.S. Bureau of Labor Statistics. *The Boot and Shoe Industry in Massachusetts as a Vocation for Women.* Bulletin no. 180. Women in Industry Series no. 7. Washington, DC: GPO, 1915. 109p. L2.3:180. Detailed study of women in the shoe and boot industry in Massachusetts provides a profile of the number and characteristics of women employed in the trade and the nature of the work performed. Discusses the training for this type of work and the wages women receive by type of work. Also studies the utilization of foreign-born women in the shoe industry and the relation of women to labor unions.

960. U.S. Bureau of Labor Statistics. *Dressmaking as a Trade for Women in Massachusetts.* Bulletin no. 193. Women in Industry Series no. 9. Washington, DC: GPO, 1916. 180p. L2.3:193. In-depth examination of the nature of the dressmaking trade in Massachusetts. Describes the history of the business in the U.S. and the organization of the industry in the early 1900s. Explains the type of work involved in each occupation and the average wage paid, the working conditions, the regularity of the work, and the stability of the work force. Also examines the business problems of dressmaking establishments. Provides a bibliography and an index.

961. U.S. Bureau of Labor Statistics. *Unemployment among Women in Department and Other Retail Stores of Boston.* Bulletin no. 182. Women in Industry Series no. 8. Washington, DC: GPO, 1916. 72p. L2.3:182. Study of employment and unemployment among women working in retail trade in the Boston area examined both women who were considered regular employees, and those who worked only as "extras" during busy seasons. Investigation provided data on causes of unemployment such as sickness and layoffs, and periods of unemployment in a given year. Factors of age and marital status of women employees, and the degree of dependency of families on the earnings of women, were also considered.

962. District of Columbia. Minimum Wage Board. *Wages of Women in Hotels and Restaurants in District of Columbia.* Bulletin no. 3. Washington, DC: The Board, 1919. 23p. DC50.3:3. Results of a survey of wages paid to women employed in hotels, restaurants, apartment houses, and hospitals, excluding nurses, in the District of Columbia during the months of June, July and August 1919. Also examined turnover, the practice of tipping, and non-monetary compensation in addition to wages. Data on wages of hotel, restaurant, and hospital employees is broken down by occupation and whether room or meals were provided. In general the study concluded that a substantial number of women employees were receiving inadequate wages.

963. U.S. Women in Industry Service. *Wages of Candy Makers in Philadelphia in 1919.* Bulletin of the Women in Industry Service no. 4. Washington, DC: GPO, 1919. 46p. L13.3:4. Investigation of the wages and working conditions of women in the confectionery industry. Looks at the number and ages of the women, their nativity, number of years in the trade, and weekly earnings by age. The irregularity of the employment in the trade and variations in hours worked in a one week payroll period are noted. Also discusses conditions in work rooms.

964. U.S. Bureau of Labor Statistics. *Industrial Survey in Selected Industries in the United States, 1919.* Bulletin no. 265. Washington, DC: GPO, 1920. 509p. L2.3:265. Provides statistics on the number of employees, average hours worked per week day, and average earnings per hour worked by occupation and sex for selected states and industries.

965. U.S. Federal Board for Vocational Education. *Statistics of Women Workers in States of Pacific Region.* Washington, DC: The Board, 192? 2p. VE1.15:857. Reports data for Arizona, California, Idaho, Montana, Nevada, New Mexico, Oregon, Utah, Washington, Wyoming, and Colorado on female workers in 1920. Statistics given include total female population, number of females 10 years of age and over in gainful occupations, number between 10 and 20 years of age in school, and distribution of women workers in industrial employment in the U.S. by industry.

966. U.S. Interstate Commerce Commission. *Employment of Women.* Statistical Series Circular no. 9. Washington, DC: The Commission, 1920. 4p. IC1.4/3:9. Notice to steam companies with operating revenues over $1,000,000 informs them that they must furnish information on the employment of women and provides the 3-page reporting form listing the occupations.

967. U.S. Women's Bureau. *Hours and Conditions of Work for Women in Industry in Virginia.* Bulletin no. 10. Washington, DC: GPO, 1920. 32p. L13.3:10. Investigation and recommendations for enforcement of labor laws in Virginia focuses on hours of work and working conditions of women employed in industry. Home responsibilities, wages, and labor turnover are also investigated through interviews with women workers. The appendix outlines the need for new labor legislation in the state.

968. U.S. Women's Bureau. *Preliminary Report of a Survey of Wages, Hours, and Conditions of Work of the Women in Industry in Atlanta, Georgia.* Washington, DC: GPO, 1920. 31p. L13.2a:At62. Report of an investigation of wages, hours, and working conditions in Atlanta industries. Presents information broken out for stores, factories, and laundries. Data collected includes worker's age, weekly wages, distribution of employees by wage and time in trade, and distribution of employees by wage and by age. Also reports on general working conditions.

969. U.S. Interstate Commerce Commission. Bureau of Statistics. *Bulletin Concerning the Employment of Women on Large Steam Roads in 1920.* Washington, DC: GPO, 1921. 5p. IC1ste.2:W84. Presents data on employment of women on class 1 railroads by occupation and district for 1918 and 1919, and quarterly for 1920.

970. U.S. Women's Bureau. *Preliminary Report of a Survey of Wages, Hours, and Conditions of Work of the Women in Industry in Georgia, 1920-21.* Washington, DC: GPO, 1921. 63p. L13.2:G29. Reports results of a survey, conducted between May 1920 and April 1921, of women's wages, hours, and working conditions in Georgia. Major industries covered include department stores; 5 and 10 cent stores; textile, knit goods, garment, cigar and food manufacturing; and laundries. Describes working conditions in detail and briefly covers nativity, age, marital status, home responsibilities, and education of workers. Provides data on number of employees by sex, race, and industry; median earnings by

years in trade and type of employment; weekly hours by sex, race, and industry; weekly earnings distribution by age and type of employment; and weekly earnings of women living at home and of women boarding.

971. U.S. Women's Bureau. *Women Street Car Conductors and Ticket Agents.* Bulletin no. 11. Washington, DC: GPO, 1921. 90p. L13.3:11. Presents results of a study of the hours, wages, and working conditions of women employed as conductors and ticket agents on street car lines in Detroit, Kansas City, Boston, and Chicago. Hours of men and women are compared and special regulations for women are highlighted. In addition to data on hours of runs, the report includes excerpts of comments from women on why they liked this type of work.

972. U.S. Women's Bureau. *Women's Wages in Kansas.* Bulletin no. 17. Washington, DC: GPO, 1921. 104p. L13.3:17. Report of an investigation of women wage earners in Kansas examines wages, earnings, and the women's dependents and home responsibilities. Includes data on the number of women employed by industry and nativity, age, and average earnings; earnings by age and years in the trade; hours worked by industry; living arrangements by age; marital status by age; family composition; number of women contributing to the family by age and amount contributed; and amount earned per week by number of dependents.

973. U.S. Children's Bureau. *Child Labor and the Work of Mothers in Oyster and Shrimp Canning Communities on the Gulf Coast.* by Viola I. Paradise. Publication no. 98. Washington, DC: GPO, 1922. 114p. L5.20:98. Study of child labor in the oyster and shrimp canning industries in the gulf coast looks at the families of these children as well as at child labor. Some of the family factors considered include marital status, occupation and earnings of mothers, and migratory labor.

974. U.S. Women's Bureau. *The Family Status of Breadwinning Women: A Study of Material in the Census Schedules of a Selected Locality.* Bulletin no. 23. Washington, DC: GPO, 1922. 43p. L13.3:23. Data from the 1920 Census was analyzed to provide information on the nationality, marital status, age, family composition and living arrangements, age of children, industry, and occupation of breadwinning women.

975. U.S. Women's Bureau. *Iowa Women in Industry.* Bulletin no. 19. Washington, DC: GPO, 1922. 73p. L13.3:19. Investigation into working conditions of women employed in Iowa industry was conducted to support legislation enacting an 8-hour law for women workers. Areas investigated include hours, regularity of employment, home responsibilities, and working conditions. In addition, industrial opportunities and training for women in Iowa were explored. Provides data on number of employees, hours worked, method of payment, and seasonal fluctuations.

976. U.S. Women's Bureau. *The Occupational Progress of Women: An Interpretation of Census Statistics of Women in Gainful Occupations.* Bulletin no. 27. Washington, DC: GPO, 1922. 37p. L13.3:27. Study of data on the employment of women from the 1910 and 1920 Census. Identifies occupations with a significant number of women and trends in women's occupations between 1910 and 1920. Data on number of women employed by occupation and number of employees by sex in female dominated industries, for the continental U.S. and its territories, is furnished.

977. U.S. Women's Bureau. *Preliminary Report on Hours and Wages of Women in Industry in Missouri, 1922.* Washington, DC: The Bureau, 1922. 23p. L13.2:M69.

978. U.S. Women's Bureau. *Women in Georgia Industries.* Bulletin no. 22 Washington, DC: GPO, 1922. 89p. L13.3:22. Presents results of an investigation of the characteristics of

women employed in Georgia industries and their hours, wages, and working conditions. Provides data on scheduled and actual hours; distribution by earnings; weekly earnings by hours worked and years in trade; yearly earnings by pay period; and nativity, age, marital status and living conditions by industry.

979. U.S. Women's Bureau. *Women in Maryland Industries: A Study of Hours and Working Conditions.* Bulletin no. 24. Washington, DC: GPO, 1922. 96p. L13.3:24. Report on a study of the hours and working conditions in Maryland industries and restaurants. Examines facilities and employment and training. Provides data on daily, weekly, and Saturday hours, rest intervals and vacation. Also reports statistics on workers nativity, age, time in trade, tenure with present employer, marital status, and living conditions.

980. U.S. Women's Bureau. *Women in Rhode Island Industries.* Bulletin no. 21. Washington, DC: GPO, 1922. 73p. L13.3:21. Results of an investigation into the hours, wages, and working conditions of women employed in Rhode Island industries. Provides data on number of employees by sex and industry; weekly hours and daily hours of women by industry; median earnings by timework and piecework and by industry; yearly earnings by industry; and age, nativity and marital status by industry.

981. U.S. Children's Bureau. *Child Labor and the Work of Mothers in the Beet Fields of Colorado and Michigan.* Publication no. 115. Washington, DC: GPO, 1923. 122p. L5.20:115. Although the primary focus of this study was child labor in the beet fields of Colorado and Michigan, the work of mothers in the industry as it affects child welfare was also examined.

982. U.S. Women's Bureau. *The Share of Wage-Earning Women in Family Support.* Bulletin no. 30. Washington, DC: GPO, 1923. 170p. L13.3:30. Study of women in the Massachusetts shoe industry combined with information from other published data. Provides a profile of the family responsibilities and contributions of women wage earners. Data on earnings of workers by sex, contribution to family household by family relationship, family earnings and size, family sources of income, wage earning mothers by marital status and ages of children, and contribution of family members by age and sex is furnished.

983. U.S. Women's Bureau. *Women in Arkansas Industries: A Study of Hours, Wages, and Working Conditions.* Bulletin no. 26. Washington, DC: GPO, 1923. 85p. L13.3:26. Investigation into the characteristics and working conditions of women employed in Arkansas industry examines their hours, wages, and working conditions. Provides data on weekly earnings by industry, hours worked, days worked, time in the trade, and method of payment; and detailed earnings data for telephone industries and hotels and restaurants. Personal data on women employees includes nativity, age, marital status, and living conditions.

984. U.S. Women's Bureau. *Women in Kentucky Industries: A Study of Hours, Wages, and Working Conditions.* Bulletin no. 29. Washington, DC: GPO, 1923. 114p. L13.3:29. Report of an investigation of employed women in Kentucky industries analyzes data on number of women employed, and on their personal characteristics, hours, wages, and working conditions. Provides data on scheduled hours by industry; earnings by industry, race, and time in trade; number of weeks lost per year by industry; weekly earnings in telephone industry; and nativity, age, marital status and living conditions by industry.

985. U.S. Women's Bureau. *Women in South Carolina Industries: A Study of Hours, Wages, and Working Conditions.* Bulletin no. 32. Washington, DC: GPO, 1923. 128p. L13.3:32. Investigation of the condition of women employed in South Carolina industries provides data on scheduled and actual hours, wages and earnings, working conditions, and

characteristics of workers. Briefly looks at hours and wages of black women. Data presented includes hours by industry, wages by nativity, age, marital status, and living conditions of women workers.

986. U.S. Women's Bureau. *Women in the Candy Industry in Chicago and St.Louis: A Study of Hours, Wages and Working Conditions in 1920-1921*. Bulletin no. 25. Washington, DC: GPO, 1923. 72p. L13.3:25. Study of the working conditions of women in the confectionery industry. Describes the types of work performed by women, their hours, wages, and working conditions. Data on characteristics of the workers including nativity, age, length of time in the trade, marital status, home responsibilities, and living conditions is also presented.

987. U.S. Children's Bureau. *Child Labor and the Work of Mothers on Norfolk Truck Farms*. Publication no. 130. Washington, DC: GPO, 1924. 27p. L5.20:130. Although the focus of this study was on child labor on Norfolk, Virginia truck farms, the working conditions of mothers and the effect of mother's work on the welfare of their children was also examined.

988. U.S. Women's Bureau. *Women in Alabama Industries: A Study of Wages, Hours, and Working Conditions*. Bulletin no. 34. Washington, DC: GPO, 1924. 86p. L13.3:34. Study of wage earning women in Alabama, a state where hours and wages of women were not regulated, provides data on number of employees, weekly and daily hours by industry, occupations of women and seating provided, sanitary facilities, earnings by race, age, nativity, time in trade, marital status, living conditions, financial responsibilities, and number of wage earners in family.

989. U.S. Women's Bureau. *Women in Missouri Industries: A Study of Hours and Wages*. Bulletin no. 35. Washington, DC: GPO, 1924. 127p. L13.3:35. Investigation of wages of women employed in Missouri industries specifically notes wages of workers by race. In addition to data on wages and hours worked, the report presents statistics on workers' nativity, age, marital status, and living conditions by industry and race.

990. U.S. Women's Bureau. *Women in New Jersey Industries: A Study of Wages and Hours*. Bulletin no. 37. Washington, DC: GPO, 1924. 99p. L13.3:37. Investigation of conditions of women employed in New Jersey industries. Provides data on earnings and time worked, experience, and nativity; earnings of night workers; scheduled hours and actual hours worked; and characteristics of workers including age, nativity, marital status, living conditions, and education. Most of the data is presented by industry.

991. U.S. Women's Bureau. *Facts about Working Women: Graphic Presentation Based on Census Statistics and Studies of the Women's Bureau*. Bulletin no. 46. Washington, DC: GPO, 1925. 64p. L13.3:46. Tables and charts illustrate characteristics of working women in 1920 such as occupation, age, nativity, race, marital status, hours, and earnings.

992. U.S. Women's Bureau. *Family Status of Breadwinning Women in Four Selected Cities*. Bulletin no. 41. Washington, DC: GPO, 1925. 145p. L13.3:41. Study of the characteristics of wage earning women in Jacksonville, Florida; Wilkes-Barre and Hanover Township, Pennsylvania; Butte, Montana; and Passaic, New Jersey looked at occupational distribution, country of birth and age, marital status, children, economic responsibilities, and home ownership.

993. U.S. Women's Bureau. *Women in Ohio Industries: A Study of Hours and Wages*. Bulletin no. 44. Washington, DC: GPO, 1925. 137p. L13.3:44. Report of an investigation of the status of women employed in Ohio industries. Provides data on nativity, age, educational attainment, martial status, living conditions, and time in trade of women workers. Also

details daily and weekly hours, night work, earnings by characteristics of workers, and earnings in specific industries.

994. U.S. Bureau of Labor Statistics. *Unemployment in Columbus, Ohio 1921 to 1925.* Bulletin no. 409. Washington, DC: GPO, 1926. 35p. L2.3:409. Presents statistics on the duration and cause of unemployment of persons and heads of households by sex for single years 1921-1925.

995. U.S. Interstate Commerce Commission. *Employment of Women [Circular] to Class 1 Carriers [Blank Form], August 10, 1926.* Statistical Series Circular no. 16. Washington, DC: The Commission, 1926. 4p. IC1.4/3:16.

996. U.S. Women's Bureau. *Lost Time and Labor Turnover in Cotton Mills: a Study of Cause and Extent.* Bulletin no. 52. Washington, DC: GPO, 1926. 203p. L13.3:52. Investigation of the causes of lost time and labor turnover in the cotton industry looks at the nature of the industry and characteristics of the labor force. Provides data on women mill workers including age, nativity, marital status, living condition, size of family and years in the industry. The amount and causes of lost time are reported and the causes of lost time are related to personal characteristics of workers. Details of labor turnover and its causes are also explored as is lost time and labor turnover for black workers.

997. U.S. Women's Bureau. *Women in Illinois Industries: A Study of Hours and Working Conditions.* Bulletin no. 51. Washington, DC: GPO, 1926. 108p. L13.3:51. Study of the hours and working conditions of women employed in industry in Illinois and the City of Chicago. Describes scheduled and actual hours worked by industry and working conditions by industry. Details hours of work for hotel and restaurant workers, and provides data on characteristics of workers by industry including age, marital status, living conditions, and nativity.

998. U.S. Women's Bureau. *Women in Mississippi Industries: A Study of Hours, Wages, and Working Conditions.* Bulletin no. 55. Washington, DC: GPO, 1926. 89p. L13.3:55. Investigation of wages, hours and working conditions of women employed in Mississippi industries provides data on earnings by time worked, earnings of black women, hours scheduled, and hours worked. Describes the number of employers providing acceptable standards of working conditions and facilities. Also provides statistics by industry and race on nativity, age, marital status, living condition, educational attainment, and time in trade.

999. U.S. Women's Bureau. *Women in Oklahoma Industries: A Study of Hours, Wages, and Working Conditions.* Bulletin no. 48. Washington, DC: GPO, 1926. 118p. L13.3:48. General investigation of the hours, wages, and working conditions of women employed in manufacturing, retail trade, laundries, and telephone exchanges. Describes the women's wages in relation to time worked, experience, and age, and their hours and working conditions. The wages and hours of women employed in hotels and restaurants are also detailed. In addition, the report provides data on characteristics of the workers including age, nativity, marital status, education, living conditions, and home responsibilities. Most data is broken down by race.

1000. U.S. Women's Bureau. *Women in the Fruit-Growing and Canning Industries in the State of Washington: A Study of Hours, Wages, and Conditions.* Bulletin no. 47. Washington, DC: GPO, 1926. 223p. L13.3:47. Investigation details the hours, wages, living conditions and working conditions of women field and orchard workers and of women employed in canneries in Washington state. Personal and family characteristics of the workers including age, marital status, nativity, living condition, family relationship and responsibilities, and reasons for working are described. Data on earnings and time worked in fields and orchards, and hours, wages, and working conditions in fruit, vegetable, fish and clam

canneries, and apple and pear warehouses is furnished. Also discusses labor turnover and industrial accidents and disease, and describes the occupational histories of the women workers. Describes in some detail the housing conditions of these workers who were often migrants.

1001. U.S. Women's Bureau. *Women in Delaware Industries: A Study of Hours, Wages, and Working Conditions.* Bulletin no. 58. Washington, DC: GPO, 1927. 156p. L13.3:58. Hours, wages, and working conditions of women employed in Delaware industries was the topic of this study. Detailed information is provided on hours, earnings, and working conditions in factories, stores, laundries, vegetable canneries, and hotel and restaurants. Also provides statistics on characteristics of the workers and their families including nativity, age, marital status, living conditions, source of family support, number of wage earners and size of family, and industrial history of the women.

1002. U.S. Women's Bureau. *Women in Tennessee Industries: A Study of Hours, Wages, and Working Conditions.* Bulletin no. 56. Washington, DC: GPO, 1927. 120p. L13.3:56. Reports results of a study of the characteristics, hours, earnings, and working conditions of women employed in Tennessee industries. Provides data on earnings and time worked for black women and earnings by age, experience, and industry for all women workers. Data is presented by industry on characteristics of women workers including age, nativity, marital status, living condition, and education.

1003. U.S. Women's Bureau. *Women's Employment in Vegetable Canneries in Delaware.* Bulletin no. 62. Washington, DC: GPO, 1927. 47p. L13.3:62. Report of an investigation of the hours, wages, and working conditions of women employed in Delaware vegetable canneries. Also examines living conditions and provides background statistics on worker characteristics including age, nativity, literacy, ability to speak English, marital status, living condition, and size of family. In addition the study collected information on the employment history of the women such as age at first job, time in trade, number of industries engaged in, and jobs held before and after marriage. Reprint issued in 1934.

1004. U.S. Bureau of Labor Statistics. *History of Wages in the United States from Colonial Times to 1928.* Bulletin no. 499. Washington, DC: GPO, 1929. 527p. L2.3:499. Report provides historical date on rates of pay and hours per week by occupation and sex for states. Years covered varies by industry.

1005. U.S. Bureau of the Census. *Women in Gainful Occupations, 1870-1920, Study of the Trend of Recent Changes in Numbers, Occupational Distribution, and Family Relationship of Women Reported in Census as Following Gainful Occupation.* by Joseph A. Hill. Census Monograph no. 9. Washington, DC: GPO, 1929. 416p. C3.30:9. Detailed statistical report on the employment and occupations of women from 1870 to 1920. Examines factors of age, race, nativity, marital status, and family relationships. Some of the data is reported for states and cities of 100,000 or more inhabitants.

1006. U.S. Congress. Senate. Committee on Manufacturers. *Working Conditions of the Textile Industry in North Carolina, South Carolina, and Tennessee, Hearings on S. Res. 49.* 71st Cong., 1st sess., 8-20 May 1929. 159p. Y4.M31/2:T31. Hearing on working conditions and labor disturbances in southern textile mills. Discusses hours and wages, and considers reports from union and management on the causes of and support for the strikes. The resolution which prompted the hearing calls for an investigation of conditions at the textile plants. The focus of the proposed investigation of conditions would center on the hours and wages of women and child workers and on the stretch-out system.

1007. U.S. Women's Bureau. *Causes of Absence for Men and Women in Four Cotton Mills.* Bulletin no. 69. Washington, DC: GPO, 1929. 24p. L13.3:69. Study examined sex

differences in lost time due to illness, accidents, domestic and personal reasons, and layoffs in two northern and two southern cotton mills.

1008. U.S. Women's Bureau. *Conditions of Work in Spin Rooms.* Bulletin no. 72. Washington, DC: GPO, 1929. 41p. L13.3:72. Purpose of this study was to determine the extent to which labor conditions contribute to high absenteeism and turnover among women employed in cotton mill spin rooms. Four mills employing a new method were chosen for the study of the effect of the new method on absence and turnover rates. Data on temperature and humidity readings of spin rooms was also gathered.

1009. U.S. Women's Bureau. *A Study of Two Groups of Denver Married Women Applying for Jobs.* Bulletin no. 77. Washington, DC: GPO, 1929. 11p. L13.3:77. Study analyzed data from records kept on married women seeking employment through the Young Women's Christian Association and at a large department store, both in Denver, between May and August of 1928. Data collected includes reason for seeking work and, for YWCA applicants, placement, age, marital status, education and training, and occupational history.

1010. U.S. Women's Bureau. *Women Workers in Flint, Mich.* Bulletin no. 67. Washington, DC: GPO, 1929. 80p. L13.3:67. Study of the characteristics, hours, earnings and working conditions of women employed in Flint also examined employment opportunities in the automobile industry. Provides data by industry, occupation, age, job tenure, time in trade, and education for women employed in the automobile industry. Also gives daily and weekly hours worked for women employed in factories and stores, and hours and earnings data for women employed in restaurants. Other information gathered includes working conditions and characteristics of workers including nativity, age, educational attainment, marital status, wartime work, living conditions, and housing.

1011. U.S. Women's Bureau. *The Employment of Women in the Pineapple Canneries of Hawaii.* by Caroline Manning. Bulletin no. 82. Washington, DC: GPO, 1930. 30p. L13.3:82. Investigation of the employment of women in the pineapple canning industry in Hawaii collected data on the workers' ethnic and racial decent, age, and educational attainment. The industry itself was examined noting the working conditions and seasonal nature of the industry. Provides data on the wages and the extent of overtime in the industry.

1012. U.S. Women's Bureau. *The Immigrant Woman and Her Job.* Bulletin no. 74. Washington, DC: GPO, 1930. 179p. L13.3:74. Interviews with immigrant women and their employers form the basis of a study to ascertain the personal characteristics and economic responsibilities of immigrant women. The study focused on the Philadelphia area and collected data on race, nativity, year of arrival in the U.S., reasons for coming to the U.S., ability to speak and read English, literacy, family size, age and number of children, and employment of husbands and fathers. Information was gathered on child care arrangements and the economic and home responsibilities of mothers. Information on work experience was also gathered with a focus on finding and adjusting to a job, and on industrial homework.

1013. U.S. Women's Bureau. *A Survey of Laundries and Their Women Workers in 23 Cities.* by Ethel L. Best and Ethel Erickson. Bulletin no. 78. Washington, DC: GPO, 1930. 166p. L13.3:78. A survey of 290 large laundries in major cities provided data on the working conditions, hours, and wages of women laundry workers. In addition, the report presents a profile of the personal characteristics of women employed in laundries including nativity, race, age, marital status, job tenure, age and occupation, reason for working, and work experience. Most of the statistics are given by city.

1014. U.S. Women's Bureau. *Variations in Employment Trends of Women and Men.* Bulletin no. 73. Washington, DC: GPO, 1930. 195p. L13.3:73. Detailed analysis of statistics examines the number of men and women employed by industry for single years 1914 to 1924. Discusses the effect of WWI and the depression of 1920-21 and the various factors that influence variations in men's and women's employment trends.

1015. U.S. Women's Bureau. *Women in 5-and-10-Cent Stores and Limited-Price Chain Department Stores.* by Mary Elizabeth Pidgeon. Bulletin no. 76. Washington, DC: GPO, 1930. 58p. L13.3:76. Report pulls information from past state industry surveys to create a profile of hours and earnings of women employed in limited-price chain stores. Information on age, nativity, living condition, marital status, and time in trade of workers is presented by state, and weekly earnings are reported by state and by size of city.

1016. U.S. Women's Bureau. *Women in Florida Industries.* Bulletin no. 80. Washington, DC: GPO, 1930. 115p. L13.3:80. Investigation studied the hours, wages, and working conditions of women employed in factories, stores, and laundries in Florida. Provides data on hours, wages, nativity, age, marital status, living condition, and time in trade by industry and race. The survey also collected statistics on the hours and wages of hotel and restaurant employees.

1017. U.S. Women's Bureau. *Fluctuation of Employment in the Radio Industry.* by Caroline Manning. Bulletin no. 83. Washington, DC: GPO, 1931. 66p. L13.3:83. Investigation examined the irregularity of employment in the manufacture of radios, an industry which employed a fairly large number of women.

1018. U.S. Women's Bureau. *Wages of Women in 13 States.* by Mary Elizabeth Pidgeon. Bulletin no. 85. Washington, DC: GPO, 1931. 213p. L13.3:85. Wage data for 101,000 white women and 6,100 black women workers is analyzed by industry, hours, and other industrial factors, and by age, nativity, and experience of the employees.

1019. U.S. Children's Bureau. *Employed Boys and Girls in Milwaukee.* by Alice Channing. Publication no. 213. Washington, DC: GPO, 1932. 71p. L5.20:213. Study of the employment of minors in the Milwaukee area provides data by sex on school attendance and age at leaving school, occupation, wages, and regularity of employment.

1020. U.S. Women's Bureau. *The Effect on Women of Changing Conditions in the Cigar and Cigarette Industries.* by Caroline Manning and Harriet A. Byrne. Bulletin no. 100. Washington, DC: GPO, 1932. 187p. L13.3:100. Study of the displacement of women by changes in the cigar and cigarette industries examined the effect of consolidation of plants to one location and the introduction of machine operations. Interviews with 1,400 displaced women workers provided information on their age, employment, and earnings history before and after separation. Information on women still employed was also collected including age, nativity, marital status, and time in industry. Wage data was also collected and reported by age, method of payment, and time in trade. Working conditions were briefly reported on. Most wage data is reported by race.

1021. U.S. Women's Bureau. *The Employment of Women in Slaughtering and Meat Packing.* by Mary Elizabeth Pidgeon. Bulletin no. 88. Washington, DC: GPO, 1932. 210p. L13.3:88. Detailed study of the employment of women in the slaughtering and meat packing industries describes the number and occupations of women employed in the cities studied, the working conditions, and the characteristics of the workers. Also examines weekly earnings and breaks in employment, and profiles the characteristics and economic status of women workers.

1022. U.S. Women's Bureau. *The Employment of Women in the Sewing Trade of Connecticut: Preliminary Report.* Bulletin no. 97. Washington, DC: GPO, 1932. 13p. L13.3:97. Study of payroll data from 106 Connecticut firms in the weaving-apparel industry provides information on hours and earnings of women and on the number of employees by sex for industries. Information on hours worked and age distribution are reported by occupation.

1023. U.S. Children's Bureau. *Employed Boys and Girls in Rochester and Utica New York.* by Alice Channing. Publication no. 218. Washington, DC: GPO, 1933. 74p. L5.20:218. Study of employed minors in Rochester and Utica New York provides data by sex on educational attainment and training in relation to work, age at leaving school, occupation, wage, and regularity of employment.

1024. U.S. Women's Bureau. *Hours, Earnings, and Employment in Cotton Mills.* by Ethel L. Best. Bulletin no. 111. Washington, DC: GPO, 1933. 78p. L13.3:111. Survey of the employment of women in cotton mills in South Carolina, Maine, and Texas reports on the number of women employed with details on hours, shifts, and wages. Also reports on the age, marital status and length of service of workers, and on the employment changes in the industry in 1931. Gives detailed statistics on weekly earnings and time worked by department.

1025. U.S. Women's Bureau. *Number of Men and Women with Gainful Occupations, 1870-1930.* Washington, DC: The Bureau, 1933. poster. L13.9:Oc1/3. Reprinted in 1938 and 1939.

1026. U.S. Women's Bureau. *Occupations of Women, 1930.* Washington, DC: The Bureau, 1933. poster. L13.9:Oc1. Reprinted in 1938 and 1939.

1027. U.S. Women's Bureau. *Proportion of Men and Women with Gainful Occupations, 1870 - 1930.* Washington, DC: The Bureau, 1933. poster. L13.9:Oc1/4. Reprinted in 1938 and 1939.

1028. U.S. Women's Bureau. *Women with Gainful Occupations, 1910-30.* Washington, DC: The Bureau, 1933. poster. L13.9:Oc1/2. Reprinted in 1938 and 1939.

1029. U.S. Bureau of Labor Statistics. *History of Wages in the United States from Colonial Times to 1928: Revision with Supplement, 1929 - 1933.* Bulletin no. 604. Washington, DC: GPO, 1934. 574p. L2.3:604. Revisions of Bulletin 499 (1004).

1030. U.S. Women's Bureau. *The Employment of Women in Puerto Rico.* by Caroline Manning. Bulletin no. 118. Washington, DC: GPO, 1934. 34p. L13.3:118. Survey of employment of women in Puerto Rico focuses on the needle trades and particularly looks at industrial homework. Data collected includes the number of women employed in homework and their hours and wages, as well as summary information on their living conditions. Information was also collected on hours and earnings of women employed in other Puerto Rican industries.

1031. U.S. Women's Bureau. *Hours and Earnings in the Leather-Glove Industry.* by Rebecca G. Smaltz and Arcadia N. Phillips. Bulletin no. 119. Washington, DC: GPO, 1934. 32p. L13.3:119. Report results of an investigation of the hours and earnings of women employed in the leather-glove industry in Fulton County, N.Y., the Midwest and California. The New York study paid particular attention to the use of industrial homework in the glove industry. Earnings and hours data is provided by occupation and sex, and the New York study also gives data on age of homeworkers.

1032. U.S. Women's Bureau. *Hours and Earnings in Tobacco Stemmeries.* by Caroline Manning. Bulletin no. 127. Washington, DC: GPO, 1934. 29p. L13.3:127. Reports results of a study of hours of work and average hourly earnings of women employed in tobacco stemming in Virginia and North Carolina. Briefly discusses the ability of the industry to pay a living wage, standards since the President's Reemployment Agreement, and fluctuation in industry employment in late 1933 and early 1934.

1033. U.S. Women's Bureau. *Employment Conditions in Beauty Shops:A Study of Four Cities.* by Ethel Erickson. Bulletin no. 133. Washington, DC: GPO, 1935. 46p. L13.3:133. Study of the employment of women in beauty shops between December 1933 and April 1934 in the cities of Philadelphia, New Orleans, St. Louis, and Columbus. Provides hour and wage data for women employed in white shops and black shops. Also provides information on age, marital status, experience, training, and time with the shop. Information on white beauty operators also looks at men's age, experience, and training.

1034. U.S. Women's Bureau. *The Employment of Women in the Sewing Trades of Connecticut: Hours and Earnings, Employment Fluctuation, Home Work.* Bulletin no. 109. Washington, DC: GPO, 1935. 45p. L13.3:109. Report of an investigation into the characteristics and working conditions of women employed in the sewing trades of Connecticut provides data on the personal characteristics, hours, earnings, method of payment, age, marital status, nativity, and time with the firm. Home interviews and factory payroll data are analyzed to profile the earnings in homework and the reasons for choosing homework. Finally, the report discusses lighting in clothing factories.

1035. U.S. Women's Bureau. *A Survey of the Shoe Industry in New Hampshire.* by Agnes L. Peterson. Bulletin no. 121. Washington, DC: GPO, 1935. 100p. L13.3:121. Investigation into the employment of women in the boot and shoe industry in New Hampshire collected information on the number of women employees and their occupations, and on the regularity of their employment including overtime and the number of weeks worked in 1932. The investigation looked in depth at the earnings of the women by type of shoe, occupation, and time with firm, and information on piecework rates is provided. Working conditions were also studied with particular attention to possible health hazards. The structure of management and personnel policies at the plants are briefly discussed.

1036. U.S. Women's Bureau. *Variations in Wage Rates under Corresponding Conditions.* Bulletin no. 122. Washington, DC: GPO, 1935. 57p. L13.3:122. Information from studies of the Women's Bureau conducted in 1932 and 1933 on the employment of women in various industries point to the wide variation in wages paid to women performing similar work. Wages rates in laundries and cotton mills are given the most scrutiny with clothing industries, shoe factories, the hosiery and underwear industry, and department stores also covered.

1037. U.S. Women's Bureau. *Women in Arkansas Industries.* by Bertha Blair. Bulletin no. 124. Washington, DC: GPO, 1935. 45p. L13.3:124. Investigation of the employment of women in Arkansas industry includes data by industry on weekly earnings and hours worked by race. Scheduled weekly hours and length of work day in the hotel and restaurant industry is provided by occupation. A study was also made of 288 unemployed women in Little Rock collecting information on employment history and on the composition and employment status of the women's households.

1038. U.S. Women's Bureau. *Women's Wages in Michigan Industries.* Washington, DC: The Bureau, 1935. 29p. L13.2:W12/5. Results of a survey of wages and hours of women employed in Michigan industries under NRA codes presents data by industry on median earnings, hours worked, average hourly earnings, and annual earnings. The report

compared conditions before and after NRA codes and under the President's Reemployment Agreement. Covers manufacturing, retail trade, and laundries with most data for 1934.

1039. U.S. Women's Bureau. *Conservation of the Woman Power of Texas.* Washington, DC: The Bureau, 1936. 22p. L13.2:T31. Reports results of a Women's Bureau investigation of the hours, wages and working conditions of women employed in Texas. Earnings and hours data for women in Texas are reported by industry and occupation.

1040. U.S. Women's Bureau. *The Economic Problems of the Women of the Virgin Islands of the United States.* by Ethel L. Best. Bulletin no. 142. Washington, DC: GPO, 1936. 24p. L13.3:142. Report details the employment opportunities, hours of work, and earnings of women on the islands of St. Thomas, St. Croix, and St. John. Characteristics of inhabitants reported include race, nativity, and sex, and the economic position of women is discussed. Also briefly covered are living conditions and costs.

1041. U.S. Women's Bureau. *Employment Conditions in Department Stores in 1932-33: A Study in Selected Cities of Five States.* by Mary Loretta Sullivan. Bulletin no. 125. Washington, DC: GPO, 1936. 24p. L13.3:125. Study examined the hours and earnings of saleswomen employed in department stores in Denver, Los Angeles, San Francisco/Oakland, Seattle, Little Rock and Fort Smith, Arkansas, and ten cities in New Jersey. The report provides information on worker's age, marital status, and time with the firm. Data on scheduled hours, hours worked, median earnings and personal information is presented by locality.

1042. U.S. Women's Bureau. *Employment in Hotels and Restaurants.* Bulletin no. 123. Washington, DC: GPO, 1936. 105p. L13.3:123. Report of a study of the hours and wages of women employed in hotels and restaurants provides data for New York City and for selected states and regions on the number of employees, weekly pay rates and weekly earnings. Statements of employers on the effect of the President's Reemployment Agreement and policies on overtime and part-time work, tips, and uniforms are briefly presented.

1043. U.S. Women's Bureau. *Factors Affecting Wages in Power Laundries.* by Bertha M. Nienburg and Bertha Blair. Bulletin no. 143. Washington, DC: GPO, 1936. 82p. L13.3:143. Detailed study of the power-laundry business looks at the characteristics of the business and its workers. Provides data on occupation; sex and race of workers; and weekly earnings by occupation, sex, and race of workers. Also investigated hours, amount of work, and regularity of employment in 1934. From the employers viewpoint, the report discusses prices of laundry service compared to wage scales, operating expenses, and worker productivity.

1044. U.S. Women's Bureau. *Piecework in the Silk-Dress Industry: Earnings, Hours and Production.* Bulletin no. 141. Washington, DC: GPO, 1936. 68p. L13.3:141. Detailed report on the silk-dress industry explains the method of setting piece rates and the effect on earnings, hours, and production rates of minimum weekly wage and maximum hour laws. Data is provided by occupation for earnings, production rates, and piece prices, and is further broken down the cost of the dress under construction.

1045. U.S. Women's Bureau. *Women in Texas Industries: Hours, Wages, Working Conditions, and Home Work.* by Mary Loretta Sullivan and Bertha Blair. Bulletin no. 126. Washington, DC: GPO, 1936. 81p. L13.3:126. Report of an investigation into the hours, wages, working conditions and homework of women in Texas provides data for white, Hispanic, and black women on wages and hours in factories, stores, laundries, hotels and restaurants, and telephone exchanges, and on personal characteristics such as age, marital status, and time with firm. Working conditions for each of 13 industries are briefly

covered. Information gathered on women engaged in homework in the children's garment and nut shelling industries includes age, marital status, and family size.

1046. U.S. Women's Bureau. *Employment of Women in Tennessee Industries.* by Ethel Erickson. Bulletin no. 149. Washington, DC: GPO, 1937. 63p. L13.3:149. Survey of the hours and earnings of women in Tennessee manufacturing, mercantile, laundry, and hotel and restaurant establishments in 1935. Provides data by race on hourly and yearly earnings, hours scheduled, and hours worked. Limited information on men's earnings and hours in large women-employing industries is also provided. The effect of the revocation of the NRA on wages and hours is also studied. The report briefly discusses working conditions in the major women employing industries and provides detailed data for white women on weekly and hourly earnings by industry.

1047. U.S. Women's Bureau. *Women's Employment in West Virginia.* by Harriet A. Byrne. Bulletin no. 150. Washington, DC: GPO, 1937. 27p. L13.3:150. Report of an investigation into the hours and wages of women in West Virginia looks at 1936 and briefly at 1935 when NRA codes were in effect. Hours and earnings data is presented and analyzed by industry for factories, stores, laundries and dry cleaners, and hotels and restaurants. The problems in particular industries are highlighted.

1048. U.S. Women's Bureau. *Women's Hours and Wages in the District of Columbia in 1937.* by Ethel L. Best and Arthur T. Sutherland. Bulletin no. 153. Washington, DC: GPO, 1937. 44p. L13.3:153. Report of data collected on women's hours and weekly and hourly earnings in the District of Columbia. Covers employment in laundries, dry-cleaning, manufacturing, beauty shops, hotels and restaurants, telephone exchanges, and offices. Provides statistics on hours and earnings of retail store employees by full-time and part-time status.

1049. U.S. Women's Bureau. *Hours and Earnings in Certain Men's-Wear Industries: Knit Underwear, Woven Cotton Underwear.* Bulletin no. 163-2. Washington, DC: GPO, 1938. 10p. L13.3:163-2. Presents results of an investigation of weekly earnings, hours worked, and distribution of hourly earnings by state and sex for the men's knit underwear and men's woven underwear industry.

1050. U.S. Women's Bureau. *Hours and Earnings in Certain Men's-Wear Industries: Seamless Hosiery.* Bulletin no. 163-3. Washington, DC: GPO, 1938. 8p. L13.3:163-3. Presents data showing averages and distribution of weekly earnings, weekly hours, average hourly earnings, and distribution of hourly earnings by sex and state for the men's seamless hosiery industry.

1051. U.S. Women's Bureau. *Hours and Earnings in Certain Men's-Wear Industries: Welt Shoes.* Bulletin no. 163-4. Washington, DC: GPO, 1938. 9p. L13.3:163-4. Investigation of the men's welt shoe industry reports on the number of employees, weekly earnings, hours worked, and average hourly earnings by sex and state. Also compares earnings by union status of establishment.

1052. U.S. Women's Bureau. *Hours and Earnings in Certain Men's-Wear Industries: Work Clothing, Work Shirts, Press Shirts.* Bulletin no. 163-1. Washington, DC: GPO, 1938. 27p. L13.3:163-1. Report on hours and earnings by state for men and women employed in the manufacture of men's work clothing provides limited data for women only in the work shirt and dress shirt industries.

1053. U.S. Women's Bureau. *Trends in the Employment of Women, 1928-36.* by Mary Elizabeth Pidgeon. Bulletin no. 159. Washington, DC: GPO, 1938. 48p. L13.3:159. Study of employment trends of women between 1928 and 1936 profiles the percentage of

workers who are women in manufacturing and nonmanufacturing industries chiefly in Illinois, Massachusetts, Ohio, Virginia, and New York.

1054. U.S. Women's Bureau. *Women in Kentucky Industries, 1937.* Bulletin no. 162. Washington, DC: GPO, 1938. 38p. L13.3:162. Investigation of the employment of women in Kentucky industries. Reports on hours of work and weekly earnings of women employed in factories, retail stores, laundries, dry-cleaning establishments, and hotels and restaurants. Provides data on the number of employees, hours, and earnings by industry.

1055. U.S. Women's Bureau. *Conditions in the Millinery Industry in the United States.* Bulletin no. 169. Washington, DC: GPO, 1939. 128p. L13.3:169. In-depth study of the millinery industry and its workers. Looks at the organization and problems of the industry and characteristics of companies, as well as characteristics and employment conditions of the workers. Provides data on earnings by occupation, occupation by sex, and number of weeks worked by occupation.

1056. U.S. Women's Bureau. *Employed Women and Family Support.* by Mary Elizabeth Pidgeon and Margaret Thompson Mettert. Bulletin no. 168. Washington, DC: GPO, 1939. 57p. L13.3:168. Detailed examination of 1930 Census data for the cities of Fort Wayne, Indiana; Bridgeport, Connecticut; and Richmond, Virginia provides an overview of the contribution of married women to family support. Characteristics of employed women surveyed were occupation, age, marital status, and nativity. Responsibility for family support is examined by marital status, occupation, age, and family size.

1057. U.S. Women's Bureau. *Hours and Earnings in Certain Men's-Wear Industries: Caps and Cloth Hats, Neckwear, Work and Knit Gloves, Handkerchiefs.* Bulletin no. 163-6. Washington, DC: GPO, 1939. 22p. L13.3:163-6. Data by sex and state show weekly earnings, hours worked, and hourly earnings in the men's caps and cloth hats, neckwear, work and knit gloves, and handkerchief industries. Also examines hourly earnings and unionization and, for the handkerchief industry, compares hourly earnings and occupation.

1058. U.S. Women's Bureau. *Wages and Hours in Drugs and Medicines and in Certain Toilet Preparations.* Bulletin no. 171. Washington, DC: GPO, 1939. 19p. L13.3:171. Study of wages in the drug and medicine industry. Looks at weekly and hourly earnings by state and sex, and at hours worked per week by state and sex. Also gives hourly earnings by occupation and state.

1059. U.S. Women's Bureau and The American Association of University Women, Committee on Economic and Legal Status of Women. *Economic Status of University Women in the U.S.A.* by Susan M. Kingsbury. Bulletin no. 170, revised. Washington, DC: GPO, 1939. 70p. L13.3:170/2. Study of employed women holding bachelors degrees or higher in 1934 was based on the membership of the American Association of University Women. The survey collected information on degrees, age and marital status, occupation and unemployment between 1925 and 1935, earnings during the Depression, family responsibilities, and cases of discrimination encountered. Data presented covers schooling, age, marital status, employment by marital status, type of position by degree, earnings by age, highest salary achieved by degree and training, highest salary by occupation, fluctuation in salary, and responsibility for dependents.

1060. U.S. Bureau of the Census. *Types of Families in United States by Number of Gainful Workers, 1930.* Washington, DC: The Bureau, 1940. 11p. C3.37/2:F21/3. Previously unpublished data from the 1930 Census provides a profile of family employment. Statistics reported include gainful workers by sex and marital condition of family head. Trends in the number of gainful workers in female headed households are analyzed by number of children under two, and factors of race/nativity and place of residence are also examined.

1061. U.S. Women's Bureau. *Earnings and Hours in Hawaii Woman-Employing Industries.* Bulletin no. 177. Washington, DC: GPO, 1940. 53p. L13.3:177. Survey of the earnings and hours of women in Hawaii. Looks specifically at pineapple canning and garment manufacturing, retail trade, laundries, barber and beauty shops, hotels and restaurants, and office and telephone workers. Most data is for hourly and weekly earnings with additional data on number of employees by sex and race. Household employment and dressmaking are briefly discussed.

1062. U.S. Women's Bureau. *Earnings in the Women's and Children's Apparel Industry in the Spring of 1939.* Bulletin no. 175. Washington, DC: GPO, 1940. 91p. L13.3:175. Reports data collected in a 1939 survey of earnings of workers employed in the manufacture of women's dozen-priced dresses, women's unit priced dresses, women's blouses, children's and infants' outerwear, corset and allied garments, and underwear and nightwear. Women represented 85 percent of the workers in these industries. The structure of the industry is examined and data provided for each industry includes hours worked, weekly earnings, hourly earnings by occupation and state, and occupation by sex.

1063. U.S. Women's Bureau. *Employment in Service and Trade Industries in Maine.* Bulletin no. 180. Washington, DC: GPO, 1940. 30p. L13.3:180. Study of the service and trade industries in Maine. Reports on hours and weekly and yearly earnings by sex for employees in retail stores, beauty shops, laundries and dry-cleaning plants, hotels and restaurants, and office workers. Information is also provided on uniforms and tips where applicable.

1064. U.S. Women's Bureau. *Hours and Earnings in Certain Men's-Wear Industries: Raincoats, Sport Jackets.* Bulletin no. 163-5. Washington, DC: GPO, 1940. 29p. L13.3:163-5. Report details hourly and weekly earnings and hours worked by sex and state in the raincoat industry. More detailed examination of the sport jacket industry also gives hourly and weekly earnings and hours worked by type of jacket, sex, and state, and details policies covering learners.

1065. U.S. Women's Bureau. *Women's Wages and Hours in Nebraska.* Bulletin no. 178. Washington, DC: GPO, 1940. 51p. L13.3:178. Results of a survey of women's hours and earnings in Nebraska in 1938. Focuses specifically on the meatpacking, egg and poultry processing, and laundry and dry cleaning industries, and on creameries, retail trade, hotels and restaurants, beauty parlors and office employment. Earnings data is weekly and hourly by industry and is presented for the state and for Omaha. Information on tips was collected for the personal service industries.

1066. U.S. Women's Bureau. *Earnings and Hours in Pacific Coast Fish Canneries.* Bulletin no. 186. Washington, DC: GPO, 1941. 30p. L13.3:186. Report on fish canneries in California and Washington. Discusses the work flow characteristics of the industry and the products canned, and their effect on workers employment. The steps in the canning process are described and operations performed by women are highlighted. Data is provided on occupation and sex of cannery workers, the distribution of weeks worked in 1937 by sex and product canned, the distribution of hours worked by sex and product, the distribution of hourly and weekly earnings by sex and product, and the distribution of yearly earnings by sex, weeks worked and product.

1067. U.S. Women's Bureau. *Labor Standards and Competitive Market Conditions in the Canned Goods Industry.* Bulletin no. 187. Washington, DC: GPO, 1941. 34p. L13.3:187. Study of the effect of wage rates on market competition in the canned goods industry. Provides data on hourly earnings by state, occupation, and product canned, but does not break down the data by sex.

1068. U.S. Women's Bureau. *The Migratory Labor Problem in Delaware.* by Arthur T. Sutherland. Bulletin no. 185. Washington, DC: GPO, 1941. 24p. L13.3:185. Summary report furnishes information collected on the conditions of migratory labor in Delaware where most migratory workers were blacks from southern states. Data provided includes size of family, sex of workers, rates of pay, age and sex of migrants, state of residence, state last visited, number of states visited in 1939 and 1940 by family status, method of transportation, and average earnings and weeks worked for families and individuals.

1069. U.S. Women's Bureau. *Primer of Problems in the Millinery Industry.* Bulletin no. 179. Washington, DC: GPO, 1941. 47p. L13.3:179. Simplified version of Bulletin 169 (1055), written for distribution to workers and interested civic groups, includes charts illustrating data from the original report.

1070. U.S. Women's Bureau. *The Work That Women Do.* Washington, DC: GPO, 1942. 2p. L13.2:W89/2. Summary occupational data by age from the 1940 Census is compared to 1930 data.

1071. U.S. Bureau of Labor Statistics. Employment and Occupational Outlook Branch. *Employment of Women in the Petroleum Industry.* Washington, DC: The Bureau, 1943. 13p. L2.19:P44. Report of data from the Petroleum Administration for War details the number of women employed in all aspects of the petroleum industry. Detailed occupations of the women are reported for refineries and for all other industry divisions by PAW district.

1072. U.S. Bureau of the Census. *Population: Labor Force (Sample Statistics), Employment and Family Characteristics of Women.* 16th Census of Population. Washington, DC: The Census, 1943. 212p. C3.940-2:P81/18. Very detailed report of statistics on women from the 1940 Census examines labor force participation by age, marital status, number and ages of children, and urban/rural residence, and presents separate figures for nonwhite women in the South. Economic characteristics of the family are also presented by women's labor force status and include rental value of home, income of husband, and employment and occupation of husband. Employment status and occupational group of married women is reported by age, race, and presence of children under 10 years old.

1073. U.S. Women's Bureau. *Labor Conditions in the Peanut Cleaning and Shelling Industry.* Washington, DC: GPO, 1943. 21p. L13.2:P31. Report of a study of working conditions, hours, and wages in the peanut cleaning and shelling industry describes the health and safety concerns, and hours and earnings by sex in Virginia and North Carolina. Provides statistics on occupations by sex and state; distribution of hourly earnings by unionization, sex, and state; distribution of hours worked and weekly earnings by sex and state; and earnings in 1940 by weeks worked and sex.

1074. U.S. Bureau of Labor Statistics. *Absenteeism, Female Employment, and Average Hours and Earnings in Private U.S. Shipyards, by Region, January 1943 - September 1944.* Washington, DC: The Bureau, 1944. 3p. L2.2:Sh6/2/943-44. Reports monthly data on absence rates, ratio of females to total wage earners, average weekly hours, and average weekly earnings in private shipyards, by region.

1075. U.S. Women's Bureau. *Marital Status of Employed Women, 1940.* Washington, DC: The Bureau, 1944. 2p. L13.2:M33. Bar graphs illustrate the occupations of women and the marital status of employed women by occupation in 1940.

1076. U.S. Women's Bureau. *Occupations of Women Workers, 1944, by Former Activity.* Washington, DC: GPO, 1944. 2p. bar graphs. L13.2:W84/12/944.

1077. U.S. Women's Bureau. *Preliminary Report on Women Workers in the Traffic, Accounting, and Commercial Departments of Six Telephone Companies.* Washington, DC: The Bureau, 1945. 23p. L13.2:T23/prelim. Investigation of women workers in telephone companies focused on the traffic department. The hiring, training, and working conditions of telephone operators are described. Personal data collected includes age, education, marital status, and length of service. The rates and earnings of telephone employees are compared with the rates of clerical workers in other industries. Also discusses upgrading rates and equal pay.

1078. U.S. Women's Bureau. *The Woman Telephone Worker.* Bulletin no. 207. Washington, DC: GPO, 1946. 38p. L13.3:207. Detailed report of the employment of women in the telephone industry provides descriptions of the various types of jobs in the industry. The survey collected data on the percentage of women in each job classification, men's and women's wages, and working conditions. Also compiled data on the educational attainment, age, marital status, and length of service of workers.

1079. U.S. Women's Bureau. *Women Workers after VJ-Day in Our Community - Bridgeport, Connecticut.* Bulletin no. 216. Washington, DC: GPO, 1947. 37p. L13.3:216. Survey of women working in Bridgeport, Connecticut collected information on the employment situation of women during the war and on post-war employment opportunities for women. Information was also collected on reasons women work, occupational changes, weekly earnings, and personal characteristics. The experience of women with unemployment compensation is also analyzed. Provides statistics on distribution of employed women by industry, 1940 and 1945; proportion of women to all workers by industry, 1940 and 1945; weekly and daily hours of women, 1946; and personal characteristics of women workers and women job seekers.

1080. U.S. Women's Bureau. *Workers in Power Laundries.* Bulletin no. 215. Washington, DC: GPO, 1947. 71p. L13.3:215. A 1945 survey of women workers in 258 power laundries provides data on occupations in laundries and intra- and intercity variations in earnings. Also looks at prices and productivity of laundries. Other information collected includes hours, rest periods and holidays, and physical facilities.

1081. U.S. Women's Bureau. *Earnings of Women in Selected Manufacturing Industries, 1946.* Bulletin no. 219. Washington, DC: GPO, 1948. 14p. L13.3:219. Analysis of data from BLS Bulletins provides an overview of women's earnings in industries where women constitute 40 percent of more of the work force. Provides data by industry and region on average hourly and weekly earnings, and on regional and occupational differences in earnings. Also looks at minimum entrance rates and job rates by industry, and analyzes data on average hourly wages by occupation in union and nonunion plants.

1082. U.S. Women's Bureau. *Summary Data on Employment of Women.* Washington, DC: The Bureau, 1948. 19p. L13.2:Em7/4. Good overview of the employment of women provides tables and summaries of statistical data on trends in the employment of women since 1870, changes in occupational groups between 1940 and 1947, and women as a proportion of occupational groups in 1947. Also reviews the number of women employed in individual industries and women as a percentage of workers in an industry. Finally, the report compares prewar and postwar employment of women production workers in manufacturing industries and provides statistics on age and marital status distribution of women in the population and in the labor force.

1083. U.S. Bureau of the Census. *Current Population Reports: Labor Force, Marital Status of Women in the Labor Force, April 1951.* Washington, DC: GPO, 1951. 2p. C3.186:P-50/37. Brief report shows the percentage of women in the labor force by marital status, noting the presence or absence of a husband for the years 1949 to 1951.

1084. U.S. Women's Bureau. *Median Age of Women in Labor Force, 1900-50.* Washington, DC: GPO, 1951. 1p. bar graph. L13.2:L11/7/900-50.

1085. U.S. Women's Bureau. *Part-Time Jobs for Women, a Study in 10 Cities.* Bulletin no. 238. Washington, DC: GPO, 1951. 82p. L13.3:238. Study of part-time workers in business and community service occupations in ten cities explores the reasons for hiring part-time workers and the reasons for working part-time. The skills required in part-time work were studied as were employer recruiting methods. Data was collected on hours, earnings, and fringe benefits, and on educational level, marital status, and age by occupation. Some excerpts from interviews are provided.

1086. U.S. Women's Bureau. *Part-Time Jobs for Women in Dallas, Tex., 1949, Tables to Supplement Women's Bureau Bulletin 238.* Washington, DC: GPO, 1951. 6p. L13.3:238/supp.-1. Study report furnishes detailed industry breakdowns on number of establishments regularly employing women part-time, total number of women employees, number of women part-time employees, and women part-time employees as a percent of total women.

1087. U.S. Women's Bureau. *Part-Time Jobs for Women in Denver, Colo., 1949, Tables to Supplement Women's Bureau Bulletin 238.* Washington, DC: GPO, 1951. 8p. L13.3:238/supp.-2. See 1086 for abstract.

1088. U.S. Women's Bureau. *Part-Time Jobs for Women in Des Moines, Iowa, 1949, Tables to Supplement Women's Bureau Bulletin 238.* Washington, DC: GPO, 1951. 7p. L13.3:238/supp.-3. See 1086 for abstract.

1089. U.S. Women's Bureau. *Part-Time Jobs for Women in Milwaukee, Wis., 1950, Tables to Supplement Women's Bureau Bulletin 238.* Washington, DC: GPO, 1951. 8p. L13.3:238/supp.-4. See 1086 for abstract.

1090. U.S. Women's Bureau. *Part-Time Jobs for Women in New York, N.Y., 1950, Tables to Supplement Women's Bureau Bulletin 238.* Washington, DC: GPO, 1951. 5p. L13.3:238/supp.-5. See 1086 for abstract.

1091. U.S. Women's Bureau. *Part-Time Jobs for Women in Providence, R.I., 1950, Tables to Supplement , Women's Bureau Bulletin 238.* Washington, DC: GPO, 1951. 8p. L13.3:238/supp.-6. See 1086 for abstract.

1092. U.S. Women's Bureau. *Part-Time Jobs for Women in Richmond, Va., 1949, Tables to Supplement Women's Bureau Bulletin 238.* Washington, DC: GPO, 1951. 7p. L13.3:238/supp.-7. See 1086 for abstract.

1093. U.S. Women's Bureau. *Part-Time Jobs for Women in San Francisco, Calif., 1949, Tables to Supplement Women's Bureau Bulletin 238.* Washington, DC: GPO, 1951. 7p. L13.3:238/supp.-8. See 1086 for abstract.

1094. U.S. Women's Bureau. *Part-Time Jobs for Women in Syracuse, N.Y., 1950, Tables to Supplement Women's Bureau Bulletin 238.* Washington, DC: GPO, 1951. 8p. L13.3:238/supp.-9. See 1086 for abstract.

1095. U.S. Women's Bureau. *Part-Time Jobs for Women in Worcester, Mass., 1950, Tables to Supplement Women's Bureau Bulletin 238.* Washington, DC: GPO, 1951. 8p. L13.3:238/supp.-10. See 1086 for abstract.

1096. U.S. Women's Bureau. *Percentage Distribution of Women in Labor Force, by Age Group, 1900 - 1950.* Washington, DC: GPO, 1951. 1p. bar graph. L13.2:L11/8/900-50.

1097. U.S. Women's Bureau. *Selected Tables - Labor Force Characteristics of the Total and Nonwhite Population in the United States: 1950 and 1940.* Washington, DC: The Bureau, 1951. 12p. L13.2:P81. Separate tables for 1950 and 1940 give statistics by sex and race on population, employment status, age of employed persons, major industry group of employed persons, and major occupation of employed persons.

1098. U.S. Women's Bureau. *Selected Tables - Labor Force Characteristics of Women in the United States: 1950 and 1940.* Washington, DC: The Bureau, 1951. 4p. L13.2:C37. Presents data on the employment status of females in 1940 and 1950 by major industry group, major occupational group, type of employer, and age of employed women.

1099. U.S. Women's Bureau. *Selected Tables - Labor Force Status of Women by Marital Status and Age and with Own Children and No Children, March 1950 and Median Income in 1949 for Women in the Population.* Washington, DC: The Bureau, 1951. 4p. L13.2:St2. Tables provide statistics on marital status of women in the labor force, 1940 and 1950; labor force status of women by marital status and age, 1950; labor force status of women by presence of children, 1950; and distribution of women with income by source of income, 1949.

1100. U.S. Women's Bureau. *Major Sources of Statistical Data on Employed Women.* Washington, DC: The Bureau, 1952. 12p. L13.2:St2/2. Guide to major sources of statistical data published by the U.S. government on employed women.

1101. U.S. Women's Bureau. *Earnings and Hours of Women Employed in Retail Trade and Service Industries in Maine, 1952.* Washington, DC: The Bureau, 1953. 23p. L13.2:R31. Report of hours and earnings of women employed in retail and service industries in Maine in 1952 provides detailed data by industry on hourly earnings, weekly earnings, and hours worked. Also reports on the prevalence of part-time work, compares the earnings of full-time and part-time workers, and details overtime and uniform requirements.

1102. U.S. Women's Bureau. *Percent of Women in the Population Who Worked, by Age Group, 1890-1950.* Washington, DC: The Bureau, 1953. 1p. chart. L13.9:W84/3/890-950.

1103. U.S. Women's Bureau. *Women as Workers...A Statistical Guide.* Washington, DC: GPO, 1953. 118p. L13.2:W84/29/953. Statistical compilation with limited commentary provides data on trends in the number and ages of working women, 1890-1950; occupations of women, 1940-1953; occupations by age; marital status of women in the labor force, 1940-1952; occupation of women by marital status; marital status of working mothers, 1946-1952; part-time work by age; wages and salaries of workers by sex, 1939 - 1951; wages by occupational group and sex, 1939 and 1951; family income and sex of head; wives in the labor force by husband's income; age and marital status of women not in the labor force; and educational attainment by sex.

1104. U.S. Office of Education. *Ratio of Men to Women Teachers in Public Secondary Schools: A Report on Status and Trends.* by Ellsworth Tompkins. Office of Education Circular no. 413. Washington, DC: GPO, 1954. 14p. FS5.4:413. Data drawn from the *Biennial Survey of Education in the United States* shows the number and percentage of male and female teachers in secondary education, 1890-1952, and the percentage of men and women teachers by states and race, 1937/38, 1945/46 and 1951/52.

1105. U.S. Women's Bureau. *Age Distribution of Women Workers, 1940, 1945, 1950, 1952.* Washington, DC: The Bureau, 1954. poster. L13.9:Ag3.

1106. U.S. Women's Bureau. *Employed Men and Women by Major Occupational Group, United States, April 1952.* Washington, DC: The Bureau, 1954. poster. L13.9:Oc1/5.

1107. U.S. Women's Bureau. *Marital Status of Women in Population and Labor Force 1940, 1944, 1947-1953, Percent Distribution.* Washington, DC: The Bureau, 1954? poster. L13.9:M33.

1108. U.S. Women's Bureau. *Marital Status of Women Workers: 1910, 1930, 1940, 1950, Women 14 Years of Age and Over.* Washington, DC: The Bureau, 1954. poster. L13.9:M33/2.

1109. U.S. Women's Bureau. *Women in Civilian Labor Force: 1940-1953.* Washington, DC: The Bureau, 1954. poster. L13.9:C49.

1110. U.S. Bureau of Labor Statistics. *Women Production Workers in Machinery Industries, Employment Distribution, Earnings.* Washington, DC: GPO, 1956. 11p. L2.71:98. Data on wages of men and women in machinery manufacturing details wage rates by operation and payment system. Patterns of employment of women in machine manufacturing industries reveal that women are usually only employed in one operation in the factory.

1111. U.S. Bureau of Labor Statistics. *Monthly Labor Turnover Rates for Men and Women in Selected Manufacturing Industry Groups for Selected Periods.* Washington, DC: GPO, 1957. 12p. L2.2:M31/14/950-57. Furnishes data on turnover rates by sex and manufacturing industry group from 1950 to April 1957.

1112. U.S. Bureau of the Census. *Women Past Thirty-Five in the Labor Force: 1947 -1956.* Current Population Reports Series P-50, no. 75. Washington, DC: GPO, 1957. 19p. C3.186:P-50/75.

1113. U.S. Bureau of Labor Statistics. *Population and Labor Force Projections for the United States, 1960 to 1975.* Bulletin no. 1242. Washington, DC: GPO, 1959. 56p. L2.3:1242. Statistical profile of the labor force by sex, age, and full-time/part-time status.

1114. U.S. Women's Bureau. *Membership of American Women in Radio and Television.* Washington, DC: The Bureau, 1959. 4p. L13.2:W84/36. Basic statistics on women in radio and television was compiled from the information in the American Women in Radio and Television Membership Directory. Gives a breakdown by state on employment by or related to radio and television, and a breakdown by occupation.

1115. U.S. Women's Bureau. *Notes on Trends in Radio and Television Broadcasting Occupations.* Washington, DC: The Bureau, 1959. 3p. L13.2:R11/2. Basic statistics on women's employment in radio and television provides outlook data for employment in the industry through the 1960s.

1116. U.S. Social Security Administration. *Working Mothers and Their Children.* Research and Statistics Note 1962, no. 14. Washington, DC: The Administration, 1962. 4p. FS3.28/2:962/14. Presents summary statistics on working mothers and their dependents in 1961 and notes recent trends. Some of the factors examined are age of children and age of mother, marital status of mother, family support, race, and work experience. In profiling children of working mothers, the report provides data on number of children with working mothers, family type, and age of children.

1117. U.S. Women's Bureau. *Women Workers in 1960 - Geographical Differences.* Bulletin no. 284. Washington, DC: GPO, 1962. 17p. L13.3:284. Analysis of Census data on working women in 1950 and 1960 looks at number of women workers, number of married

women in the work force, median earnings, and income of women workers by state. Also provides data by region on age distribution and occupational distribution of women workers.

1118. U.S. Women's Bureau. *Notes on Women's Employment in the United States and Nine European Countries.* Women in the World Today Informational Report no. 7. Washington, DC: GPO, 1963. 5p. L13.23:7. Report reviews the number and percentage of women employed and the employment of married women in the U.S, Great Britain, France, Germany, Belgium, Norway, Sweden, the Netherlands, Italy, and Denmark. Shows total employed women, women as percent of total workers and clerical workers, married women as percent of all women workers, and percent of girls and women who work.

1119. U.S. Women's Bureau. *Women Telephone Workers and Changing Technology.* Bulletin no. 286. Washington, DC: GPO, 1963. 46p. L13.3:286. Report describes a study of the effect of technology, specifically direct dialing, on the employment of women by telephone companies. Information on the proportion of women in the various types of positions is presented and the effect of future technological advances on employment opportunities is assessed. Provides statistics on women's employment with telephone carriers by major occupational group, number and distribution of total employees and women, and weekly earnings and scheduled weekly hours by occupational group.

1120. U.S. Women's Bureau. *Current Data on Nonwhite Women Workers.* Washington, DC: The Bureau, 1964. 12p. L13.2:N73. Presents data on labor force participation of nonwhite and white women by age; marital status; presence of children by age of child, occupation and full-time/part-time status; work experience in 1963 by age, median income and educational attainment; and black women in the population and in the labor force and median years of school completed for selected states. Revised editions issued in June, August, and November 1965.

1121. U.S. Women's Bureau. *Fact Sheet on the Relative Position of Women and Men Workers in the Economy.* Washington, DC: The Bureau, 1966. 4p. L13.2:W89/10. Presents basic statistics on labor force status and income by sex, and statistics on the number of women in the labor force by marital status and income of husband.

1122. U.S. Bureau of Labor Statistics. *Some Facts on Women in the World of Work.* Washington, DC: The Bureau, 1967. 15p. L2.92:W84. Charts and tables illustrate trends in the labor force participation of women noting changes in number, ages, marital status, and presence of children. Also describes the distribution of working women by race, educational attainment, husband's income, and occupation.

1123. U.S. Women's Bureau. *Women and Teenage Workers in Selected States and Metropolitan Areas, 1969.* Washington, DC: The Bureau, 1970? 4p. L13.2:W89/13/969. Statistics provide a profile of the labor force status of women over 20 and teenagers 16 to 19 years in California, Florida, Illinois, Massachusetts, Michigan, New Jersey, New York, Ohio, Pennsylvania, and Texas, and in the SMSA's of Chicago, Detroit, Los Angeles, New York, Philadelphia, and San Francisco.

1124. U.S. Bureau of the Census. *Differences between Income of White and Negro Families by Work Experience of Wife and Region: 1970, 1969, and 1959.* Current Population Reports Series P-23, no. 39. Washington, DC: GPO, 1971. 15p. C3.186:P-23/39. Provides data on employment, occupation, and earnings of wives by age and race of husbands.

1125. U.S. Women's Bureau. *Underutilization of Women Workers.* Washington, DC: The Bureau, 1971. 25p. L36.102:Un1. A series of charts with accompanying summaries

illustrate the position of women in the U.S. work force. The economic needs of working women, women's earnings, the earnings gap, women's occupational segregation, women's share of professional and technical work, representation of women in leading professions, starting salaries of college graduates by sex, underutilization of women based on educational achievement, and unemployment among minority teenagers and adult women are described. Earlier editions published in 1966 and 1967 under SuDoc number L13.2:W89/11/year.

1126. U.S. Women's Bureau. *Women Workers Today.* Washington, DC: GPO, 1971. 7p. L13.2:W89/12. Basic data on women workers in 1970 covers age, marital status, educational attainment, work patterns, occupations, and unemployment.

1127. U.S. Equal Employment Opportunity Commission. *Employment Profiles of Minorities and Women in the SMSA's of Sixteen Large Cities, 1970.* Research Report no. 38. Washington, DC: GPO, 1972. 202p. Y3.Eq2:11/970-38. Report presents summary data on industry and occupational distribution of black, Spanish-surname, and female employment in 16 SMSAs. Includes a narrative summary for each city and tables showing employment by industry and by occupation. Cities covered are Atlanta, Baltimore, Chicago, Cleveland, Dallas, Detroit, Houston, Los Angeles, Memphis, Newark, New Orleans, New York, Philadelphia, San Francisco, St. Louis, and Washington, D.C.

1128. U.S. Women's Bureau. *Women Workers in Regional Areas and in Large States and Metropolitan Areas, 1971.* Washington, DC: The Bureau, 1972. 6p. L36.102:R26/971. Summarizes labor force participation and unemployment rates of women 17 and over for Census regions, 10 states, and 20 SMSAs, and reports employment data for minority women.

1129. U.S. Bureau of Labor Statistics. *Children of Working Mothers, March 1973.* Special Labor Force Report no. 154. Washington, DC: The Bureau, 1973. 8p. L2.2:C43. Study of the number and characteristics of working mothers is a reprint from the *Monthly Labor Review* with supplementary tables. Provides data on family type and employment status of parents by median family income, age of children, and race. A more complete edition was issued in 1974 as Special Labor Force Report no. 165 (1133).

1130. U.S. Bureau of Labor Statistics. *Marital and Family Characteristics of Workers, March 1973.* Washington, DC: GPO, 1973. 6p. L2.98:M33.

1131. U.S. Dept. of Health, Education, and Welfare. Office for Civil Rights. *Availability Data: Minorities and Women.* Washington, DC: The Office, 1973. 76p. HE1.2:M66. Presents statistics reprinted from various sources on the number of women and minorities in various professional fields, primarily law, medicine and higher education.

1132. U.S. Equal Employment Opportunity Commission. *Employment Profiles of Minorities and Women in the SMSA's of 17 Large Cities, 1971.* Research Report no. 41. Washington, DC: GPO, 1973. 106p. Y3.Eq2:11/973-41. Analysis of statistics on employment characteristics of minorities and women in Atlanta, Baltimore, Chicago, Cleveland, Dallas, Denver, Detroit, Houston, Los Angeles, Memphis, Newark, New Orleans, New York, Philadelphia, St. Louis, San Francisco, and Washington, D.C. examines education, occupation, industry and income.

1133. U.S. Bureau of Labor Statistics. *Children of Working Mothers, March 1973.* Special Labor Force Report no. 165. Washington, DC: The Bureau, 1974. 16p. L2.98:165. Presents basic data on the employment of mothers including the size and type of family by labor force status of mother, work experience of married women by presence and age of children and race, and family income by type of family and race.

1134. U.S. Equal Employment Opportunity Commission. *Employment Profiles of Minorities and Women in 20 Large SMSA's.* Research Report no. 43. Washington, DC: GPO, 1974. 193p. Y3.Eq2:11/43. Data on employment of minorities and women in companies with 100 or more employees covers occupational distribution and participation by industry. Cities included are Atlanta, Baltimore, Boston, Chicago, Cleveland, Dallas, Denver, Detroit, Houston, Los Angeles-Long Beach, Memphis, Miami, Newark, New Orleans, New York, Philadelphia, St. Louis, San Francisco-Oakland, Seattle-Everett, and Washington, D.C. Each city profile includes a narrative summary of population and employment characteristics.

1135. U.S. Equal Employment Opportunity Commission. *Minorities and Women in Referral Units in Building Trade Unions, 1972.* Washington, DC: GPO, 1974. 69p. Y3.Eq2:11/44. Analysis presents data on minority and women building trade union members by international, i.e. asbestos workers, boilermakers, etc.

1136. U.S. Social Security Administration. Office of Research and Statistics. *Wife's Earnings as Source of Family Income.* by Donald Cymrot and Lucy B. Mallan. Research and Statistics Note 1974, no. 10. Washington, DC: The Office, 1974. 22p. HE3.28/2:974/10. Report on working wives provides a summary of changes in the labor force participation of wives between 1940 and 1970 and reviews the characteristics of working wives. Also examines family income by characteristics of husband's and wife's income. Provides data on labor force participation of women by age and marital status, 1940 to 1970; working wives by marital status, age, race and presence of children under 6; part-time work by marital status, age, race, and presence of children under 6; median income by age and race of husband; and wife's earnings as percent of family income.

1137. U.S. Bureau of Labor Statistics. *Children of Working Mothers, March 1974.* Special Labor Force Report no. 174. Washington, DC: GPO, 1975. 12p. L2.98:174. See 1133 for abstract.

1138. U.S. Bureau of Labor Statistics. *Children of Working Mothers, March 1975.* Washington, DC: The Bureau, 1975. 5p. L2.98/2:C43/975.

1139. U.S. Bureau of Labor Statistics. *U.S. Working Women: A Chartbook.* Bulletin no. 1880. Washington, DC: GPO, 1975. 66p. L2.3:1880. Chartbook provides information on working women's employment and unemployment, marital and family status, income, education, and personal characteristics.

1140. U.S. Equal Employment Opportunity Commission. *Employment Profiles of Women and Minorities in 23 Metropolitan Areas: 1974.* Research Report no. 49. Washington, DC: GPO, 1976. 314p. Y3.Eq2:11/49. Profiles the employment of women and minorities by industry and occupation in 23 SMSA's in 1974. Data varies by city but generally includes participation rates by occupation and industry, and occupational distribution in private industry and in state and local government. Cities covered are Atlanta, Baltimore, Birmingham, Chicago, Cincinnati, Cleveland, Detroit, El Paso, Fresno, Houston, Los Angeles-Long Beach, Memphis, Miami, Mobile, New Orleans, New York, Newark, Norfolk, Philadelphia, St. Louis, San Antonio, San Jose, and Tucson.

1141. U.S. Women's Bureau. *Mature Women Workers: A Profile.* Washington, DC: GPO, 1976. 12p. L36.102:W89/3. Statistical profile of mature women in the labor force provides data on labor force status, education, marital status, occupations, income, and unrelated women living alone.

1142. U.S. Bureau of Labor Statistics. *Marital and Family Characteristics of the Labor Force in March 1976.* Special Labor Force Report no. 206. Washington, DC: The Bureau,

1977. 49p. L2.89:206. Reprints a June 1977 article "Labor force participation of married women, March 1976" from the *Monthly Labor Review* and provides supplemental tables showing employment status by marital status, sex, race and Hispanic origin; major occupation by full-time or part-time status, marital status, sex and race; labor force status and marital status of women by age and presence and age of children; work experience of married women by income of husband and presence of children; and contribution of wife's earnings to family income.

1143. U.S. Bureau of Labor Statistics. *U.S. Working Women: A Databook.* Bulletin no. 1977. Washington, DC: GPO, 1977. 67p. L2.3:1977. Collection of charts and tables profile characteristics of working women including labor force participation, employment and unemployment, marital and family characteristics, education, income and earnings, race and ethnicity, and job tenure. Also looks at job search strategies and projections of labor force participation.

1144. U.S. Equal Employment Opportunity Commission. *Minorities and Women in Private Industry, 1975.* Research Report no. 54. Washington, DC: GPO, 1977. 53p. Y3.Eq2:11/54. Analysis of data on the employment characteristics of minorities and women in private industry covers occupational distribution, industry employment patterns, employment at headquarters establishments, and employment by size of reporting unit. For the earlier report see 1178, for later reports see 1169.

1145. U.S. Equal Employment Opportunity Commission. *Minority and Female Membership in Referral Unions, 1974.* Washington, DC: GPO, 1977. 103p. Y3.Eq2:11/55. Analysis of trends in minority and female referral union membership provides data on distribution of membership in referral unions by race/ethnicity/sex and international, and participation in apprenticeship programs in the construction industry by trade and race/ethnicity/sex.

1146. U.S. National Center for Education Statistics. *Salaries, Tenure, and Fringe Benefits of Full-Time Instructional Faculty in Institutions of Higher Education, 1975-76.* Washington, DC: GPO, 1977. 157p. HE19.302:Sa3/975-76. State data documents tenure status and salaries of faculty at institutions of higher education by academic rank and by sex, enrollment, level, and control of institutions.

1147. U.S. Women's Bureau. *Working Mothers and Their Children.* Washington, DC: GPO, 1977. 11p. L36.102:W89/4. Statistical report on mothers in the work force provides data on trends in labor force participation, minority mothers, age, work experience, occupations, employment, income of husbands, number and ages of children, and child care arrangements.

1148. U.S. Bureau of Labor Statistics. *Marital and Family Status of Workers by State and Area.* Report no. 545. Washington, DC: The Bureau, 1978. 71p. L2.71:545. Provides data on labor force status and marital status of workers by sex for geographic regions, states and 10 SMSAs; women in the labor force by presence of children for regions, states, and SMSAs; women's contribution to family income; employment status of family members by race; presence and age of children by employment status of husbands and wives; and labor force status of women heading families by race and presence of children.

1149. U.S. Bureau of Labor Statistics. *Children of Working Mothers, March 1977.* Special Labor Force Report no. 217. Washington, DC: GPO, 1979. 35p. L2.98:217. Trends in working mothers and characteristics of families with the mother in the labor force are discussed in this article reprinted from the *Monthly Labor Review.* Supplementary tables provide data on number of children and family income by age of children, type of family and employment status of parents; and number of families with children under 18 and family income by age of children, type of family, employment status of parents, and race.

1150. U.S. Bureau of Labor Statistics. *Marital and Family Characteristics of Workers, 1970 to 1978.* Special Labor Force Report no. 219. Washington, DC: GPO, 1979. 78p. L2.98:219. Reprinted April 1979 article from the *Monthly Labor Review* analyzes the changing patterns in the composition of American families and in the number and percentage of working mothers. Supplementary tables provide detailed data for 1978 on the labor force status of the population by marital status, sex, race, and age; occupation by full- or part-time status, marital status, sex and race; labor force and marital status of women by presence of children; number of children and family income by type of family, employment status of parents and race; and contributions of wife's income to family income.

1151. U.S. Bureau of Labor Statistics. *Marital and Family Characteristics of Workers, March 1977.* Special Labor Force Report no. 216. Washington, DC: GPO, 1979. 52p. L2.98:216. See 1152 for abstract of earlier edition.

1152. U.S. Bureau of Labor Statistics. *Women in the Labor Force: Some New Data Series.* BLS Report no. 575. Washington, DC: GPO, 1979. 9p. L2.71:575. Overview of the changing labor force market conditions for women highlights the efforts of BLS to collect relevant statistics. Includes summary data on women in the labor force, 1900-1978; marital and family status of women workers; occupational distribution, 1950-78; and women's earnings, 1967-78.

1153. U.S. Dept. of Agriculture. Economic Development Division. *Labor Force Activity of Women in Metropolitan and Nonmetropolitan America.* by David L. Brown and Jeanne M. O'Leary. Rural Development Research Report no. 15. Washington, DC: GPO, 1979. 33p. A105.40:15. Trends and changes in women's participation in the labor force for metropolitan and nonmetropolitan areas from 1960 to 1970 are described. Nonmetropolitan women were less likely to be in the labor force and more likely to hold low wage clerical and service jobs than their metropolitan counterparts.

1154. U.S. Women's Bureau. *Economic Responsibilities of Working Women.* Washington, DC: The Bureau, 1979. 5p. L36.102:Ec7. Summary statistics highlight the contribution of working women to family support.

1155. U.S. Bureau of Labor Statistics. *Distribution of Occupational Employment in State and Areas by Race and Sex, 1978.* Bulletin no. 2053. Washington, DC: GPO, 1980. 31p. L2.3:2053. Occupational and employment distribution of the working-age population and the labor force is reported by race and sex for the U.S., states, and 30 large SMSA's.

1156. U.S. Bureau of Labor Statistics. *Marital and Family Characteristics of the Labor Force, March 1979.* Special Labor Force Report no. 237. Washington, DC: GPO, 1980. 51p. L2.98:237. See 1142 for abstract of earlier edition.

1157. U.S. Bureau of Labor Statistics. *Perspectives on Working Women: A Databook.* Bulletin no. 2080. Washington, DC: GPO, 1980. 105p. L2.3:2080. Examination of statistics on women and work looks at labor force participation of women from 1950 to 1979, the strength of women's attachment to the labor force, their marital, family and child status, and changing patterns in enrollment and educational attainment. Also examines the earnings and income of women and families and provides work force data by race and Hispanic origin. Job tenure, moonlighting, and employment patterns for the outset of 1980 are also examined.

1158. U.S. Bureau of Labor Statistics. *Where to Find BLS Statistics on Women.* BLS Report no. 612. Washington, DC: The Bureau, 1980. 10p. L2.71:612. Guide to major series and recently published documents of the BLS with statistics on women.

1159. U.S. Women's Bureau. *20 Facts on Women Workers*. Washington, DC: The Bureau, 1980. 3p. L36.102:W89/5.

1160. U.S. Equal Employment Opportunity Commission. *Minorities and Women in Institutions of Higher Education, 1979*. Washington, DC: GPO, 1981. 182p. Y3.Eq2:2M66/8/979. Data from form EEO-6 details participation rates by occupational category and salary and occupational distribution for minorities and women employed in higher education. All data is reported by race/ethnicity and sex for the U.S. and states excluding Alaska, Hawaii, and Nevada. Later reports include breakdowns by control of institution (1168).

1161. U.S. Economic Research Service. *Women Farmers in America*. Washington, DC: GPO, 1982. 4p. A93.21:679. Overview of the status of women engaged in farming in the U.S. notes that 5 percent of farms are operated by women with the largest percentage of female-operated farms found in southern states. Most of the women were full owners of small farms and one third of them were 65 years or older. Tables present data on female farm operators by state and race, and characteristics of farm operators by region and sex.

1162. U.S. Bureau of Labor Statistics. *Children of Working Mothers*. Bulletin no. 2158. Washington, DC: GPO, 1983. 13p. L2.3:2158.

1163. U.S. Bureau of Labor Statistics. *Marital and Family Patterns of Workers: An Update*. Bulletin no. 2163/2. Washington, DC: GPO, 1983. 34p. L2.3:2163/2. Reprint from the *Monthly Labor Review* with additional tabular material and explanatory notes examines changes in labor force activity of women and men and family earnings over the course of 1981. Tables provide data for 1981 and 1980 on women's employment and marital status, age, race, occupation, and presence of children under 18.

1164. U.S. Bureau of Labor Statistics. *Women at Work: A Chartbook*. Bulletin no. 2168. Washington, DC: GPO, 1983. 29p. L2.3:2168. Charts illustrate labor force participation of women, their occupational grouping, unemployment, marital status, family status and earnings.

1165. U.S. Bureau of Labor Statistics. *Employment in Perspective: Working Women: Fourth Quarter/Annual Summary 1983*. BLS Report no. 702. Washington, DC: The Bureau, 1984. 3p. L2.71:702. Summary review of the employment and unemployment status of women focuses on changes between 1982 and 1983. Table provides data for 1982, 1983 and third quarter 1983 for labor force participation by age, labor force participation by race, employment status by age, unemployment rates by age and race, duration of unemployment, and family status.

1166. U.S. Bureau of the Census. *Earnings in 1981 of Married-Couple Families, by Selected Characteristics of Husbands and Wives*. by Robert W. Cleveland and Mary F. Henson. Current Population Reports Series P-23, no. 133. Washington, DC: GPO, 1984. 41p. C3.186:P-23/133. Reports data on earnings of husbands and wives by factors such as work experience, occupation of longest job, years of school completed, and age and presence of children. Also provides data on characteristics of wives who earn more than their husbands.

1167. U.S. Bureau of the Census. *Women in the American Economy*. by Cynthia M. Treuber and Victor Valdisera. Current Population Reports Series P-23, no. 146. Washington, DC: GPO, 1986. 45p. C3.186:P-23/146. Presents data on women's participation in the labor force by age, race and Spanish origin, marital status, children, full-time or part-time work, job turnover, education, unemployment, occupation and industry, money income, alimony and child support, and poverty status. Includes an analysis of the earnings gap between male and female architects as a case study.

1168. U.S. Equal Employment Opportunity Commission. *Minorities and Women in Higher Education, 1983.* Washington, DC: GPO, 1987. 339p. Y3.Eq2:12-6/983. Report of data from the EEO-6 report on employment of minorities and women in higher education provides statistics on participation rates, salary and faculty rank by sex, race/ethnicity, and control of institution; and part-time and temporary employees and new hires by job category, sex, race/ethnicity and control of institution. State data on participation rates and salary distribution broken down by sex, race/ethnicity and control of institution is also presented. For earlier reports see 1160.

1169. U.S. Equal Employment Opportunity Commission. *Job Patterns for Minorities and Women in Private Industry, 1985.* Washington, DC: GPO, 1988. 634p. Y3.Eq2:12-7/985. Statistical report on employment of women and minorities in private industry. Details occupational employment in private industry by race/ethnicity and sex and by industry; and employment in private industry by race/ethnicity/sex and by state and industry. For earlier reports see 1144.

1170. U.S. Bureau of Labor Statistics. *Where to Find BLS Statistics on Women.* BLS Report 762. Washington, DC: GPO, 1989. 10p. L2.71:762. Index to sources of statistics on women from the Bureau of Labor Statistics includes regularly issued reports as well as one time reports in the *Monthly Labor Review.* Includes current and some limited historical data. Update of a 1980 document 58.

SERIALS

1171. U.S. Bureau of Labor Statistics. *Employment and Unemployment Statistics for the United States, 1909 - [year].* Bulletin no. 1312. Washington, DC: GPO, 1960 - . annual. L3.2:1312-no. Provides data on number of female employees by 3-digit SIC code.

1172. U.S. Bureau of Labor Statistics. *Handbook of Labor Statistics.* Washington, DC: GPO, 1924/26- . irreg. L2.3:nos. Early editions include sections on women in industry and on industrial homework. Later editions provide data by sex on labor force participation and marital status, educational attainment, family status, part-time employment, employees by industry division, manufacturing employees by industry group, and employment by martial status, age, race, and occupational group.

1173. U.S. Bureau of Labor Statistics. *News: Employment and Earnings Characteristics of Families.* Washington, DC: The Bureau, 198? - . quarterly. L2.118/2:date. Quarterly report on employment, unemployment, and earnings of families provides data on two parent families and female-headed families by race/ethnicity.

1174. U.S. Bureau of Labor Statistics. *Women Employees in Manufacturing Industries.* Washington, DC: The Bureau, 1949/53 - 1956/58. irregular. L2.2:W84/4/years. Presents data on number of women employed and percent of total employment by manufacturing industry for selected months.

1175. U.S. Bureau of Labor Statistics. *Women in Factories: Estimated Number of Women Production Workers Employed in Manufacturing Industries...* Washington, DC: The Bureau, 1939/47 - 1939/45. annual. L2.2:W84/3/year. Provides statistics on the number of women production workers in manufacturing by major manufacturing industry group, and number of women per 100 production workers in manufacturing industries and groups, selected months from 1939.

1176. U.S. Equal Employment Opportunity Commission. *Employment Opportunity in the Schools: Job Patterns of Minorities and Women in Public Elementary and Secondary Schools.* Washington, DC: GPO, 1974 - 1979. annual. Y3.Eq2:11/51; Y3.Eq2:2Em7/7;

Y3.Eq2:12-3/979; Y3.Eq2:2M66/7/978. Report provides data for the U.S. and states on employment in elementary and secondary schools by job category and race/ethnicity/sex group; racial/ethnic employment by sex and job category; participation rates by sex and racial/ethnic group; and occupational distribution by sex and racial/ethnic group. Also provides U.S. data on staff characteristics by race/ethnicity/sex of principle.

1177. U.S. Equal Employment Opportunity Commission. *Equal Employment Opportunity Report, Minorities and Women in Apprenticeship Programs and Referral Unions.* Washington, DC: GPO, 1978-1979?. annual. Y3.Eq2:2M66/6; Y3.Eq2:12-2/979. Equal employment opportunity data on apprenticeships details the number of apprentices, graduates, dropouts, and applicants by trade or craft, by industry, by state, and by SMSA. Also gives statistics on referral union membership in internationals by state and by SMSA.

1178. U.S. Equal Employment Opportunity Commission. *Job Patterns for Minorities and Women in Private Industry.* Washington, DC: GPO, 1966 - 1973. annual. Y3.Eq2:12/year. Detailed statistical tables on employment of women and minorities provides data by industry and occupation for states and SMSA's. Statistics are presented on occupational distribution and participation rates by race/ethnicity and sex. Report for 1970 issued under SuDoc number Y3.Eq2:2Eq2/970 and for 1974 under SuDoc number Y3.Eq2:11/50. Later see 1144.

1179. U.S. Federal Aviation Administration. Office of Civil Rights. External Division. *The Employment of Minority Group Members and Women in the Airline Industry: A Report on Government Contractors, December 31, 1977.* Washington, DC: The Office, 1976 - 1977. annual. TD4.2:Em7/2/year. Report analyzes airline employment by sex and race/ethnicity in major job categories. Examines trends over the year in hiring and provides statistics on employment by job category.

1180. U.S. Interstate Commerce Commission. *Number of Females Employed by Class 1 Steam Railways (Excluding Switching and Terminal Companies), January 1943.* Washington, DC: The Commission, 1943 - 1948. quarterly. IC1ste.43:year/no. and IC1ste.19:year/no. Detailed statistics on women employed by class 1 railways reports number of female employees and percent of females by detailed occupational class.

1181. U.S. Railroad Administration. Labor Divisions. Women's Service Section. *Number of Women Employed and Character of Their Employment, Jan. 1, April 1, July 1, Oct. 1, [Year] (Class 1 Roads), Eastern, Southern and Western Territories by Road.* Washington, DC: The Administration, 1919-1920. annual. Y3.R13/2:52W84/no. Detailed quarterly statistics on the employment of women on class 1 railroads gives number of women employed by railroad line and detailed occupation and, for some positions, the data is further broken down by day work and night work.

1182. U.S. Women's Bureau. *Background Facts on Women Workers in the United States.* Washington, DC: The Bureau, 1964 - 1970. irregular. L13.2:W84/39/year and L13.22/2:year. Mostly annual report of basic statistics on women workers presents data on labor force status, unemployment rates by age, major industry group, occupation, full-time and part-time employment, work experience by marital status, and labor force status of mothers. Also provides statistics on income by sex, educational attainment by sex for the labor force and the population, and educational attainment by sex and occupational group.

1183. U.S. Women's Bureau. *Facts on Women Workers.* Washington, DC: The Bureau, 1946 - 1961. irregular. L13.15:year. Report provides illustrative statistics on women's employment, occupations, wages, and union status.

1184. U.S. Women's Bureau. *Handbook on Women Workers.* Bulletin nos. 225, 261, 266, 275, 285, 290, 294, 297, 298. Washington, DC: GPO, 1948 - . irregular. title varies. L13.3:no. Statistics on working women details ages, marital status, family responsibilities, income, wages, industry and occupation, old age and survivors insurance, and educational attainment. Later editions provide very detailed statistics. Earlier editions also review standards for women's employment, state labor laws, and political and civil status of women, and list major women's organizations.

1185. U.S. Women's Bureau. *Who Are the Working Mothers?* Leaflet no. 37. Washington, DC: The Bureau, 1961-1970. rev. irreg. L13.11:37/rev. no. Leaflet presents some basic facts on the number and proportion of working mothers, the age of working mothers and their children, the proportion of black mothers in the labor force, child care arrangements, characteristics of women, and family income of working mothers with husband present.

1186. U.S. Women's Bureau. *Why Women Work.* Washington, DC: GPO, 1946 - 1974. revised irregularly. L13.2:W84/18 (1946); L13.2:W84/44/year (1966-1971); L36.102:W62 (1973); L36.102:W81/year (1971-1974). Presents basic data on income of women by marital status and husband's income and interprets this data to show that most women work out of economic necessity.

1187. U.S. Women's Bureau. *Women Workers in [State], [Year].* Washington, DC: The Bureau, 1962 - 1974. L13.22:(cutter no.)/year; L36.114:(cutter no.)/year. State report series provides data on women workers. The first series reported data for 1940 to 1960, the second series extended the statistics to include 1970 Census data. Statistics reported include employment status of women; employment status and major occupational groups by race; age distribution; marital status; educational attainment; occupational groups; industry of employed women; earnings of experienced women workers; median earnings in selected occupations; income by race; occupations of private wage and salary workers; and industries of private wage and salary workers.

Alabama, 1960 [1963. 14p.] L13.22:A*l*1b/960; 1970 [1973. 8p.] L36.114:A*l*1.
Alaska, 1970 [1974. 5p.] L36.114:A*l*1/2.
Arizona, 1960 [1964. 14p.] L13.22:Ar4i/960
Arkansas, 1960 [1964. 14p.] L13.22:Ar4k/960; 1970 [1973. 9p.] L36.114:Ar4.
California, 1960 [1962, rev. 1965. 12p.] L13.22:C12/960-no.; 1970 [1973. 9p.] L36.114:C13.
Colorado, 1960 [1963. 14p.] L13.22:C71/960; 1970 [1973. 9p.] L36.114:C71.
Delaware, 1960 [1964. 14p.] L13.22:D37/960; 1970 [1974. 9p.] L36.114:D37.
District of Columbia, 1960 [1964. 14p.] L13.22:D63/960; 1970 [1973. 8p] L36.114:D63.
Florida, 1960 [1965, rev. 1966. 14p] L13.22:F66/960-no.; 1970 [1973. 9p.] L36.114:F66.
Georgia, 1960 [1963, rev. 1966. 14p.] L13.33:G29/960-no.
Hawaii, 1970 [1973. 8p.] L36.114:H31.
Idaho, 1970 [1974. 8p.] L36.114:Id1.
Illinois, 1960 [1963. 14p.] L13.22:I*l*1b/960; 1970 [1973. 9p.] L36.114:I*l*6.
Indiana, 1960 [1963, rev. 1965. 12p.] L13.22:In2/960-no.; 1970 [1974. 9p.] L36.114:In3.
Iowa, 1960 [1963, rev. 1964, 1965. 12p.] L13.22:Io9/960-no.; 1970 [1973. 9p.] L36.114:Io9.
Kansas, 1960 [1966. 14p.] L13.22:K13/960; 1970 [1974. 9p.] L36.114:K13.
Kentucky, 1960 [1964. 14p.] L13.22:K41/960; 1970 [1973. 8p.] L36.114:K42.
Louisiana, 1970 [1974. 9p.] L36.114:L92.
Maine, 1960 [1964. 14p.] L13.22:M28/960; 1970 [1974. 5p.] L36.114:M28.
Maryland, 1960 [1964. 14p.] L13.22:M36/960; 1970 [1973. 8p.] L36.114:M36.

Massachusetts, 1960 [1963, rev. 1963, 1965. 12p.] L13.22:M38/960-no.; 1970 [1973. 9p.] L36.114:M38.

Michigan, 1960 [1964. 14p.] L13.22:M58/960; 1970 [1974. 9p.] L36.114:M58.

Minnesota, 1960 [1963, rev. 1966. 12p.] L13.22:M66/960-no.; 1970 [1973. 9p.] L36.114:M66.

Mississippi, 1970 [1974. 8p.] L36.144:M68.

Missouri, 1960 [1964, rev. 1966. 14p.] L13.22:M69o/960-no.

Montana, 1960 [1964. 14p.] L13.22:N81d/960.

Nebraska, 1960 [1963, rev. 1965. 12p.] L13.22:N27/960-no.; 1970 [1974. 8p.] L36.114:N24.

Nevada, 1970 [1974. 9p.] L36.114:N41.

New Hampshire, 1960 [1963. 14p.] L13.22:N42h/960; 1970 [1974. 6p.] L36.114:N42/4.

New Jersey, 1970 [1973. 9p.] L36.114:N42/1.

New Mexico, 1970 [1974. 9p.] L36.114:N42/2.

New York, 1960 [1963, rev. 1966. 12p.] L13.22:N42y/960-no.; 1970 [1973. 9p.] L36.114:N42/3.

North Carolina, 1960 [1963, rev. 1966. 14p.] L13.22:N81c/960-no.; 1970 [1974. 8p.] L36.114:N82/1.

North Dakota, 1960 [1964. 14p.] L13.22:Ok4/960; 1970 [1974. 5p.] L36.114:N81d.

Ohio, 1960 [1963, rev. 1966. 12p.] L13.22:Oh3/960-no.; 1970 [1974. 9p.] L36.114:Oh3.

Oklahoma, 1960 [1964, rev. 1966. 14p.] L13.22:Ok4/960-no.; 1970 [1974. 9p.] L36.114:Ok4.

Oregon, 1960 [1963, rev. 1964, 1966. 12p.] L13.22:Or3/960-no.; 1970 [1974. 9p.] L36.114:Or3.

Pennsylvania, 1960 [1963, rev. 1966. 12p.] L13.22:P38/960-no.; 1970. [1973. 9p.] L36.114:P38.

Puerto Rico, 1960 [1964, rev. 1966. 13p.] L13.22:P96r/960-no.; 1970 [1974. 5p.] L36.114:P96.

Rhode Island, 1960 [1963. 14p.] L13.22:R34/960; 1970 [1974. 8p.] L36.114:R34.

South Carolina, 1960 [1964. 14p.] L13.22:So8c/960; 1970 [1973. 8p.] L36.114:So8c.

Tennessee, 1960 [1963, rev. 1964. 12p.] L13.22:T25/960-no.; 1970 [1974. 9p.] L36.114:T25.

Texas, 1960 [1963. 14p.] L13.22:T31/960; 1970 [1973. 9p.] L36.114:T31.

Utah, 1960 [1963. 14p.] L13.22:Ut/960; 1970 [1973. 8p.] L36.114:Ut1.

Vermont, 1960 [1964. 14p.] L13.22:V59/960.

Virgin Islands, 1960 [1966. 9p.] L13.22:V81i/960.

Virginia, 1960 [1963. 14p.] L13.22:V81/960; 1970 [1973. 9p.] L36.114:V82.

Washington, 1960 [1963, rev. 1965. 12p.] L13.22:W27/960-no.; 1970 [1974. 9p.] L36.114:W27.

Washington, D.C., Standard Metropolitan Statistical Area, 1970. [1973. 9p.] L36.114:W27/2.

West Virginia, 1960 [1964. 14p.] L13.22:W52v/960; 1970 [1974. 8p.] L36.114:W52.

Wisconsin, 1960 [1963, rev. 1964, 1966. 14p.] L13.22:W75/960-no.; 1970 [1974. 9p.] L36.114:W75.

Wyoming, 1960 [1964. 14p.] L13.22:W99/960; 1970 [1974. 7p.] L36.114:W97.

9

Women in
Medical Professions

Documents on nursing were selectively included in this bibliography because the profession is so thoroughly dominated by women and because the discussions of supply and demand for nurses are clearly set within the context of the problems inherent in a female dominated profession. Assumptions regarding women's career goals and employment patterns are evident in documents issued throughout the twentieth century. The documents in this chapter essentially fall into three categories, the licensure of nurses in the District of Columbia, the supply and demand for nurses, and nurse recruitment. A small minority of documents address the lack of women physicians, and a few documents deal with women in allied health fields. Because of the large number of documents on the health care professions, they have been split into two chapters. This chapter deals with nursing and other health providers in civilian positions and the more general education reports. Documents chronicling the role of women as health care providers in the military are found in Chapter 10.

It is interesting to note that the first government document relating to nurses outside the military setting, a 1900 House document (1188), and the 1990 documents on the ability to attract and retain nurses (1506) both identify salary as a key issue. The most intense focus on nursing is found during periods of military action. Recruiting information for World War One stressed national service by becoming a nurse (1194), and World War Two saw the establishment of the Cadet Nurse Corps to promote the recruitment and training of student nurses (1232, 1345, 1512). An excellent review of the Cadet Nurse Corps is found in *The United States Cadet Nurse Corps and Other Federal Nurse Training Programs* (1298). Most of the documents issued between 1940 and 1950 are recruitment materials. Some documents of substance include the BLS Bulletin *The Economic Status of Registered Professional Nurses, 1946-47* (1294) and the Women's Bureau report, *The Outlook for Women in Occupations in the Medical and Other Health Services: Trends and Their Effect on the Demand for Women Workers* (1287).

Federal support of nursing education was the topic of congressional hearings starting in 1943 and continuing as programs were reauthorized and amended over the years. Many of these hearings reflect the same common themes, primarily the need to improve salaries and status in order to attract and retain women in the profession. The 1943 hearings focus on the competition for young women with high-paying war industries (1226). Other hearings in 1951 (1300), 1960 (1335), 1964 (1352), and 1971 (1390, 1395) are fairly routine discussions of the supply of nurses and the need for federal support for nursing education. By 1975 the need to continue federal assistance was questioned in hearings (1411), and in 1978 the Department of Health, Education, and Welfare was directed the conduct a study of the continuing need for federal support (1438, 1448). The 1978 congressional hearings also marked a shifting focus to support specialize training of nurse anesthetists, nurse midwives, and nurse practitioners (1439). Regular hearings on federal nursing assistance programs from 1980 on focus on the expanded role of nurses, particularly nurse

practitioners, and on the geographical distribution of nursing personnel (1454, 1457, 1462, 1476, 1482, 1487).

The particular problems of the Veterans Administration in recruiting and retaining nursing personnel is also clearly reflected in documents as early as 1930 (1206). In 1973 the VA published an analysis of job satisfaction among VA nurses (1401), and in 1987 and 1989 Congress considered the VA's nurse recruitment problems in hearings (1479, 1496-1497).

The role of the nurse-midwife is examined in numerous documents. Some of the publications discussing midwifery include 1964's *Women in Medicine* (1353) and 1965's *The Practice of Nurse-Midwifery in the United States* (1354). The political issues surrounding the practice of nurse-midwives in the 1980s are clearly described at a 1980 House hearing (1455), and the obstacles to practice are also reviewed in the 1986 Office of Technology Assessment report, *Nurse Practitioners, Physicians Assistants, and Certified Nurse-Midwives: A Policy Analysis* (1474). The expanded role of nurses, particularly nurse practitioners, is examined in numerous documents including significant reports such as the proceedings of a 1977 conference on NPs (1443), the *Longitudinal Study of Nurse Practitioners* (1415, 1446, 1453), the OTA policy analysis (1474), and an OTA report on their cost effectiveness (1464).

Other significant documents relating to the field of nursing include reports on the Professional Nurse Traineeship Program (1320-1329, 1347), a 1963 Public Health Service review of nurse education, supply, and demand (1348), the 1970 HEW report on progress in nurse training (1380), the reports of the Nurse Career Pattern Study (1398, 1406), and the 1957 report, *Evaluation of Employment Opportunities for Newly Licensed Nurses* (1407). Several 1980's documents are of note, including *The Recurrent Shortage of Registered Nurses: A New Look at the Issues* (1460), a 1987 Senate hearing, *Vanishing Nurses: Diminishing Care* (1489), and a 1988 hearing, *Nursing Shortage: Strategies for Nursing Practice and Education* (1490). The social and economic characteristics of nurses are described in the 1990 Bureau of Health Professions report, *The Registers Nurse Population: Findings from the National Sample Survey of Registered Nurses, March 1988* (1502).

The subject of women as physicians has received much less attention in government documents than the field of nursing. The outlook for women as physicians is described in a 1945 Women's Bureau Bulletin (1282). The need to better utilize women in the medical professions and to eliminate educational barriers is examined in *The Fuller Utilization of the Woman Physician: Report of a Conference on Meeting Medical Manpower Needs* (1374). Educational barriers were also the focus of the 1976 Civil Rights Commission report, *Access to the Medical Profession in Colorado by Minorities and Women* (1416). Also in 1976, the Department of Health, Education and Welfare issued a series of reports on improving the recruitment and educational experience of women in health professional schools (1418-1427). Students planning careers in medical fields were the focus of 1977 reports on career plans of college freshmen (1429-1432). Other documents on medical careers are described in Chapter 10, Military Nurses and Health Care Professionals. The practice of nurse-midwifery is also covered in documents included in Volume I chapters on maternal health.

1188. U.S. Congress. House. *Letter from the Secretary of the Treasury, Transmitting a Copy of a Communication from the Commissioners of the District of Columbia Submitting an Estimate for Increase of Salary of Superintendent of Nurses at the Washington Asylum.* H. Doc. 224, 56th Cong., 2d sess., 1900. 2p. Serial 4148. Correspondence requesting an increase in salary for the Superintendent of Nursing indicated an inability to attract the quality of nurse required for less than $600 a year.

1189. U.S. Congress. House. Committee on the District of Columbia. *Registration of Nurses, etc., in the District of Columbia, Report to Accompany H.R. 12690.* H. Rept. 6740, 59th

Cong., 2d. sess., 1907. 2p. Serial 5064. Favorable report reviews the need for registration of nurses to protect nursing standards, and provides a section-by-section summary of the proposed act.

1190. U.S. Congress. Senate. Committee on the District of Columbia. *Registration of Nurse, etc., in the District of Columbia, Report to Accompany H.R. 12690.* S. Rept. 5990, 59th Cong., 2d sess., 1907. 2p. Serial 5060. See 1189 for abstract.

1191. U.S. Bureau of Education. *Educational Status of Nursing.* by M. Adelaide Nutting. Bulletin 1912 no. 7. Washington, DC: GPO, 1912. 97p. I16.3:912/7.

1192. U.S. Congress. Senate. Committee on the District of Columbia. *American Nurses' Association, Report to Accompany S. 6667.* S. Rept. 738, 64th Cong., 1st sess., 1916. 1p. Serial 6899.

1193. U.S. Council of National Defense. General Medical Board. Committee on Nursing. *Nursing, National Service in This Time of Stress, Field of Greatest Social Usefulness in Times of Peace, Opening Door to Professional Career Full of Satisfaction and Distinction.* Washington, DC: The Council, 1917. 4p. leaflet. Y3.C83:42N93/1.

1194. U.S. Council of National Defense. General Medical Board. Committee on Nursing. *Nursing, National Service.* Washington, DC: The Council, 1918. 14p. Y3.C83:42N93/2. Recruiting information for the field of nursing was aimed at college graduates.

1195. U.S. Bureau of Education. *Nurse Training Schools, 1917-18.* Bulletin no. 73. Washington, DC: GPO, 1920. 99p. I16.3:919/73. Reports on the number and sex of pupils, requirements for admission, and remuneration granted students of nurse training schools in 1917-18.

1196. U.S. Bureau of Education. *Statistics of Nurse Training Schools, 1919-1920.* by H.R. Bonner. Bulletin 1921, no. 51. Washington, DC: GPO, 1922. 19p. I16.3:921/51. Presents data on admission requirements, daily hours of duty required, remuneration granted, and pupils by state and sex for nurse training schools. A later edition covering 1926-27 was issued as Bureau of Education Bulletin 1928, no. 2.

1197. U.S. Department of the Interior. St. Elizabeth's Hospital. *Training School for Nurses, Session of 1924-25, Announcement and Calendar.* Washington, DC: The Hospital, 1924. 27p. I1.14/2:N93/3/924.

1198. U.S. Congress. Senate. Committee on Public Building and Grounds. *Construction of a Nurses' Home for the Columbia Hospital for Women and Lying-In Asylum, Report to Accompany S. 3153.* S. Rept. 1041, 68th Cong., 2d sess., 1925. 1p. Serial 8388. Due to the unsafe and unsanitary condition of the nurses living accommodations, which had been condemned by the D.C. Fire Marshall, the committee favorably reported this bill for the construction of a new nurses' home, although they drastically reduced the appropriation.

1199. U.S. Congress. House. Committee on the District of Columbia. *Nurses' Home for Columbia Hospital, Report to Accompany H.R. 10355.* H. Rept. 1235, 69th Cong., 1st sess., 1926. 2p. Serial 8534. See 1200 for abstract.

1200. U. S. Congress. Senate. Committee on the District of Columbia. *To Authorize the Construction of a Nurses' Home for the Columbia Hospital for Women and Lying- In Asylum, Report to Accompany S. 4393.* S. Rept. 1077, 69th Cong., 1st sess., 1926. 2p. Serial 8526. Favorable report on the authorization of funds to build nurses quarters at the

hospital. The former building had been closed as a fire hazard and, as a consequence, the school of nursing at the hospital was discontinued.

1201. U.S. Congress. Senate. *Additional Facilities for Housing at the Freedman's Hospital in the District of Columbia: Communication from the President of the United States, Transmitting Supplemental Estimates of Appropriations for the Department of the Interior, to Provide Additional Facilities for Housing Nurses at the Freedman's Hospital in the District of Columbia, Amounting to $165,000.* S. Doc. 232, 69th Cong., 2d sess., 1927. 2p. Serial 8713

1202. U.S. Congress. Senate. Committee on the District of Columbia. *Increase of Nurses' Registration Fee in the District of Columbia, Report to Accompany S. 5766.* S. Rept. 1628, 69th Cong., 2d. sess., 1927. 2p. Serial 8685.

1203. U.S. Congress. Senate. Committee on the District of Columbia. Subcommittee on Public Health. *Practice of Medicine and Midwifery in the District of Columbia, Hearing on S.4441.* 69th Cong., 2d sess., 5 Jan. 1927. 19p. Y4.D63/2:M46. Hearing on a bill to govern the licensing of medical practice in the District of Columbia does not discuss the practice of midwifery although the bill under consideration would license midwives.

1204. U.S. Congress. House. Committee on the District of Columbia. *To Define "Registered Nurse" and to Provide for the Registration of Nurses in the District of Columbia, Report to Accompany H.R. 15387.* H. Rept. 2301, 70th Cong., 2d sess., 1929. 4p. Serial 8979. Favorable report on amendment to the District of Columbia law governing the use of the term registered nurse expands the scope of the law to include the titles graduate nurse, certified nurse, and trained nurse.

1205. U.S. Congress. Senate. Committee on the District of Columbia. *Registration of Nurses in the District of Columbia, Report to Accompany H.R. 15387.* S. Rept. 1980, 70th Cong., 2d sess., 1929. 4p. Serial 8977. Reports a bill broadening the coverage of the nurse registration laws to include those calling themselves certified, graduate, or trained nurses, as well as registered nurses.

1206. U.S. Congress. House. Committee on World War Veterans Legislation. *Proposed Medical Personnel Legislation, Hearings on H.R. 6996.* 71st Cong., 2d sess., 6 Mar. 1930. 60p. Y4.W89:M46/2. Hearing on a bill to improve the status of medical personnel through the establishment of a commissioned medical service in the Veterans Bureau includes testimony on the problems of recruiting qualified medical personnel including nurses. The salary and status of nurses under the civil service system is examined as one cause of low morale and high turnover. The problem of nursing related disability is noted, particularly in relation to tuberculosis.

1207. District of Columbia. Gallinger Municipal Hospital. *Capital City School of Nursing, Announcement, 1931.* Washington, DC: The Hospital, 1931. 7p. DC54.2:N93. Later see DC54.2:N93/year.

1208. U.S. Office of Education. *Gallant American Women, [#20], Women in Medicine, March 12, 1940.* by Jane Ashman. Washington, DC: The Office, 1940. 26p. FS5.15:20. Women as early healers and later as medical doctors are presented in the radio script which provides a glimpse into the careers of Elizabeth Blackwell and others.

1209. U.S. Office of Education. *Gallant American Women, [#22], Women in Nursing, April 2, 1940.* by Jane Ashman. Washington, DC: The Office, 1940. 22p. FS5.15:22. Nurses as women of strength, compassion, and courage is the theme of this episode of the *Gallant American Women* radio series. The organization of military nursing in the Civil War and

the Red Cross is revealed through vignettes. A list of sources consulted for the script is appended.

1210. U.S. Public Health Service. *Number of Public Health Nurses Who, on January 1, 1940, Had Completed One or More Years of Public Health Training in an Approved University Course of Study.* Washington, DC: The Service, 1940? 9p. FS2.2:N93/15/940. Details, by state, the number of public health nurses on duty and number employed by type of agency and education.

1211. U.S. Public Health Service. *Total Number of Public Health Nurses Employed in the United States and in the Territories of Hawaii and Alaska on January First of the Years 1937, 1938, and 1939.* Washington, DC: The Service, 1940? 6p. FS2.2:N93/11/937-39. Reports the number of nurses employed in official and non-official (Red Cross) agencies in rural and urban areas by state.

1212. U.S. Civil Service Commission. *Opportunities and Work of Nurses in Federal Civil Service.* Washington, DC: The Commission, 1941. 26p. CS1.2:N93. Basic information on nursing opportunities in the federal civil service accompanies copies of related civil service examination announcements and application forms.

1213. American National Red Cross. *Enroll to Serve.* Washington, DC: The Red Cross, 1942. 2p. leaflet. W102.2:N93/2/942.

1214. American National Red Cross. *Serve Your Country as a Red Cross Volunteer Nurses' Aide.* Washington, DC: The Red Cross, 1942. poster. W102.5:N93.

1215. American National Red Cross. *Volunteer Nurses' Aides Needed in Civilian Defense.* Washington, DC: The Red Cross, 1942. [4]p. leaflet. W102.2:N93/5/942.

1216. U.S. Federal Security Agency. *Notes on the Need for Nurses.* Washington, DC: The Agency, 1942. 43p. FS1.2:N93/2/942. Collection of materials for radio program directors to use in the nurse recruitment campaign.

1217. U.S. Federal Security Agency. *Notes on the Need for Nurses, July 1942.* Washington, DC: The Agency, 1942. 50p. FS1.2:N93/2/942-2. Revision of (1216).

1218. U.S. Federal Security Agency. Radio Bureau. *Student Nurses.* Washington, DC: The Bureau, 1942? 53p. FS1.2:N93/2/942-3. Fact sheets and radio scripts for use in recruiting student nurses for the war effort.

1219. U.S. Office of Defense Health and Welfare Services. Health and Medical Committee. *Acceleration of Education Program in Schools of Nursing.* Washington, DC: The Office, 1942. 4p. Pr32.4502:N93. Memo to directors of nursing schools stresses the need to accelerate the nurse education program to ensure a sufficient supply of nurses to meet military and civilian needs. Plans for acceleration of nurse education programs are attached.

1220. U.S. Office of War Information. *Become a Nurse, Your Country Needs You, Write Nursing Information Bureau, 1790 Broadway, New York City.* Washington, DC: The Office, 1942. poster. Pr32.5015:22.

1221. U.S. Public Health Service. *Become a Nurse, Your Country Needs You, Write Nursing Information Bureau, 1790 Broadway, New York City.* Washington, DC: The Service, 1942. poster. FS2.26:N93. Also issued in a larger size as OWI poster 22, Pr32.5015:22.

1222. U.S. Public Health Service. *General Information, Federal Aid to Nursing Education.* Washington, DC: The Service, 1942. 3p. FS2.2:N93.

1223. American National Red Cross. *Information for Nurses Concerning Public Health Nursing.* Washington, DC: The Red Cross, 1943. 6p. W102.2:P96/3/943.

1224. U.S. Congress. House. *Supplemental Estimate of Appropriation for the Federal Security Agency, Communication from the President of the United States, Transmitting Supplemental Estimate of Appropriation for the Federal Security Agency for the Fiscal Year 1944, Amounting to $10,000,000.* H. Doc. 311, 78th Cong., 1st sess., 1943. 2p. Serial 10793. Supplemental estimate of appropriation for the training of nurses is put forward as a national defense measure.

1225. U.S. Congress. House. Committee on Interstate and Foreign Commerce. *Program for Recruiting and Training Nurses, Report to Accompany H.R. 2664.* H. Rept. 442, 78th Cong., 1st sess., 1943. 4p. Serial 10762. Favorable report on a bill to encourage nurse recruitment and training through grants to nursing schools and recruiting organizations reviews the anticipated demand for nurses in military and civilian capacities.

1226. U.S. Congress. House. Committee on Interstate and Foreign Commerce. *Recruiting and Training of Nurses, Hearing on H.R. 2326.* 78th Cong., 1st sess., 6 May 1943. 51p. Y4.In8/4:N93. Hearing considers a bill to provide grants to institutions which train nurses and to create a Student War Nursing Reserve under the Public Health Service. Testimony highlights the need for nurses and the effect of high paying jobs for women in war industries and opportunities in military auxiliary corps on the recruitment of women to nursing schools. The general feeling was that a government sponsored nursing program would make women entering nursing feel like they were doing more for the war effort.

1227. U.S. Congress. Senate. *Revised Estimate of Appropriation for the Federal Security Agency: Communication from the President of the United States Transmitting Revised Estimate of Appropriation for the Federal Security Agency, Fiscal Year 1944, Amounting to $45,000,000.* S. Doc. 70, 78th Cong., 1st sess., 1943. 2p. Serial 10773. Request for additional appropriation for nurse training programs for national defense.

1228. U.S. Congress. Senate. Committee on Education and Labor. *Providing for the Training of Nurses, Reports to Accompany H.R. 2664.* S. Rept. 263, 78th Cong., 1st sess., 1943. 4p. Serial 10756. Favorable report provides a section-by-section description of legislation to encourage the recruitment and training of nurses in response to military and civilian needs.

1229. U.S. Office of Civilian Defense. *Victory Speakers Present the Case for Recruiting 65,000 Student Nurses.* Washington, DC: The Office, 1943. 4p. Pr32.4402:N93/2. Four themes identified for victory speakers to stress in recruiting graduating girls to the nursing profession include the urgent need for nurses, nursing as "war work with a future," nursing as an honored career, and development of the individual in nursing. Briefly reviews the facts on the need for nurses and how to become a student nurse.

1230. U.S. Office of Defense Health and Welfare Services. *Estimates of Supply and Demand for Nurses.* Washington, DC: The Office, 1943. 7p. Pr32.4502:N93/2. Estimates the number of nurses needed for both civilian and military service and presents data on the number of nursing students.

1231. U.S. Office of War Information. *Basic Program Plan on National Nurse Mobilization Week.* Washington, DC: The Office, 1943. 6p. Pr32.5002:N93/3. Media plan for National Nurse Mobilization Week provides background information on the demand for

nurses and areas of resistance in registration of nurses. National and local information campaigns are outlined.

1232. U.S. Office of War Information. *Information Program for Cadet Nurse Corps.* Washington, DC: The Office, 1943. 14p. Pr32.5002:N93/2. Background information on the nurse shortage and the Cadet Nurse Corps program is followed by a media plan to sell the Cadet Nurse Corps. Two themes are suggested, one pushing nursing as a proud service profession, the other stressing the financial and career aspects of nursing. Appendix includes statements of government officials on the existing and future demand for nurses.

1233. U.S. Office of War Information. *Information Program for Recruitment of 65,000 Student Nurses during 1943.* Washington, DC: The Office, 1943. 11p. Pr32.5002:N93. Media campaign for the recruitment of student nurses centers around the "save his life...find your own" slogan. Five basic themes with accompanying informational approaches are suggested. The themes are the urgent need for nurses, war work with a future, nursing as a respected career, development of the individual, and how to become a student nurse.

1234. U.S. Office of War Information. *Save His Life, and Find Your Own, Be a Nurse.* Washington, DC: The Office, 1943. poster. Pr32.5015:49.

1235. U.S. Public Health Service. *Enlist in a Proud Profession! Join Cadet Nurse Corps.* Washington, DC: The Service, 1943. poster. FS2.26:N93/2 and FS2.26:N93/5. Cardboard editions from the Office of War Information issued under SuDoc numbers FS2.26:N93/3, FS2.26:N93/4, and FS2.26:N93/6.

1236. U.S. Public Health Service. *Get Free Training with Pay in the World's Proudest Profession, Join the U.S. Cadet Nurse Corps.* Washington, DC: The Service, 1943. leaflet. FS2.2:N93/8.

1237. U.S. Public Health Service. *Information Program for the United States Cadet Nurse Corps.* by Office of War Information. Washington, DC: The Service, 1943. 14p. FS2.2:N93/2a. Information on the Cadet Nurse Corps highlights the nurse shortage and the Cadet Nurse Corps program. The publication was intended for recruiters and tells them how to appeal to women to encourage them to enter nurse training. Quotes from government officials on the present and postwar need for nurses are furnished. Provides statistics on number of student nurses and salary ranges for nurses by type of employer.

1238. U.S. Public Health Service. *Negro Nurses and the War Effort.* by Pearl McIver. Washington, DC: The Service, 1943. 3p. FS2.2:N31/5. Mimeograph prepared for National Negro Health Week stresses the quality of black nurses participating in public health nursing and their contributions to the war effort. Black women's participation as Red Cross volunteer nurse aides and as nurses in the Army Nurse Corps is also highlighted.

1239. U.S. Public Health Service. *Questions and Answers about Cadet Nurse Corps, for Use by Commentators.* Washington, DC: The Service, 1943. 3p. FS2.2:N93/5.

1240. U.S. Public Health Service. *U.S. Cadet Nurse Corps, Now You Can Train with Pay to Be a Nurse.* Washington, DC: The Service, 1943. 2p. FS2.2:N93/4.

1241. U.S. Public Health Service. *Your School and Cadet Nurse Corps.* Washington, DC: The Service, 1943. 7p. FS2.2:N93/3.

1242. U.S. Public Health Service. Division of Nurse Education. *Enlist in a Proud Profession - Train as a Nurse.* Washington, DC: The Service, 1943? 19p. FS2.2:N93/12. Recruiting booklet describes the duties and qualifications for nursing and the nursing school experience. Tales of exceptional nurses are presented to inspire recruits.

1243. U.S. Public Health Service. Division of Nurse Education. *U.S. Cadet Nurse Corps: Origin and Plan of Operation.* Washington, DC: The Service, 1943? 5p. FS2.2:N93/6. Summary information on the U.S. Cadet Nurse Corps covers the war nursing shortage and the early organization and operation of the corps.

1244. U.S. Congress. House. Committee on Interstate and Foreign Commerce. *Amending the Act Approved June 15, 1943, Providing for the Training of Nurses, Report to Accompany S. 1633.* H. Rept. 1151, 78th Cong., 2d sess., 1944. 8p. Serial 10844. Reports a bill amending the Nurses Training Act of 1943 to facilitate the participation of government hospitals and institutions in the program. Letters from the Navy Department, the Federal Security Agency, the War Department, and the Veterans Administration express support for the bill.

1245. U.S. Congress. House. Subcommittee of the Committee on Intestate and Foreign Commerce. *Amendments to the Nurses' Training Act, Hearing on H.R. 4002 and S.1633.* 78th Cong., 2d sess., 2 Feb. 1944. 18p. Y4.In8/4/:N93/2. Amendment to the Nurses' Training Act would facilitate transfer of senior cadet nurses to federal hospitals for their last six months of training by providing stipends. Discussion centers on the need to speed up the provision of uniforms, which is seen as a key to boosting moral and recruitment in the Cadet Nurse Corps.

1246. U.S. Congress. Senate. *Communication from the President of the United States Transmitting Proposed Provision Pertaining to an Appropriation for the Federal Security Agency Contained in the Federal Security Appropriation Act, 1944.* S. Doc. 177, 78th Cong., 2d sess., 1944. 2p. Serial 10862. Proposed provision makes St. Elizabeth and Freedman's Hospitals eligible for participation in the United States Cadet Nurses Corps program.

1247. U.S. Congress. Senate. Committee on Education and Labor. *Providing for the Training of Nurses, Report to Accompany S. 1633.* S. Rept. 633, 78th Cong., 2d sess., 1944. 4p. Serial 10841. Reports a bill to facilitate participation of government hospitals in the nurse training program.

1248. U.S. Office of Education. *Professional Nurses are Needed.* Vocational Division Leaflet no. 13. Washington, DC: GPO, 1944. 30p. FS5.129:13. Leaflet provides guidance to secondary school counselors in recruiting suitable candidates for nursing schools. Earlier edition issued in 1942 as Vocational Division Leaflet no. 10.

1249. U.S. Public Health Service. *Information Regarding the Granting of Scholarships from Federal Funds to Graduate Nurses in Advanced Nursing Education Programs in Universities.* Washington, DC: The Service, 1944. 3p. FS2.2:N93/15a. Information on selection of students for nursing scholarships.

1250. U.S. Public Health Service. *July 1, 1944, 1st Birthday, Cadet Nurse Corps: An Informal Report.* Washington, DC: The Service, 1944. 6p. FS2.2:N93/18/944. Collection of quotes from reports, newspaper accounts, and editorials praise the Cadet Nurse Corps on its first anniversary.

1251. U.S. Public Health Service. *Nursing in Public Health Service.* Washington, DC: GPO, 1944. 8p. FS2.8:176. History of public health nursing in the U.S. focuses on how the war

expanded the role of the public health nurse and created a greater demand for public health nurses.

1252. U.S. Public Health Service. *Only 5,416 Opportunities to Enlist This Month, Join Cadet Nurse Corps, There Are Now More Than 100,000 Cadet Nurses.* Washington, DC: The Service, 1944. poster. FS2.26:N93/7.

1253. U.S. Public Health Service. *U.S. Cadet Nurse Corps, 1944 [Publicity Kit].* Washington, DC: The Service, 1944. 255p. FS2.2:N93/17/944.

1254. U.S. Public Health Service. *U.S. Cadet Nurse Corps, Local Publicity Ideas.* Washington, DC: The Service, 1944. 2p. FS2.2:N93/16.

1255. U.S. Public Health Service. Division of Nurse Education. *So Proudly We Hail! Cadet Nurse Corps.* Washington, DC: The Service, 1944. 8p. leaflet. FS2.46:3.

1256. U.S. Public Health Service. Division of Nurse Education. *U.S. Cadet Nurse Corps Fact Sheet.* Washington, DC: The Service, 1944. 6p. leaflet. FS2.2:N93/2/944. Three earlier editions published in 1943.

1257. U.S. Public Health Service. Division of Nurse Education. *U.S. Marine Hospitals of Public Health Service Need Senior Cadets, Cadet Nurse Corps.* Washington, DC: The Service, 1944. 6p. FS2.46:2.

1258. U.S. Public Health Service. Division of Nurse Education. *You...In Professional Nursing.* by the National Nursing Council for War Service, Inc. Washington, DC: GPO, 1944. leaflet. FS2.2:N93/14.

1259. U.S. Public Health Service. War Information Office. *Cadet Nurse, the Girl with a Future, a Lifetime Education for High School Graduates Who Qualify.* Washington, DC: The Office, 1944. 39.9 x 28.3 in. poster. FS2.26:N93/8. Smaller version issued under SuDoc number FS2.26:N93/9.

1260. U.S. Public Health Service and U.S. Office of War Information. *How Advertisers Can Cooperate with the U.S. Cadet Nurse Corps.* Washington, DC: GPO, 1944? 10p. FS2.2:N93/13. Advises advertisers of ways to help sell the Cadet Nurse Corps to prospective nurses.

1261. U.S. Civil Service Commission. *Nurses Are Needed to Serve Those Who Served.* Washington, DC: GPO, 1945. leaflet. CS1.2:N93/2/945-2.

1262. U.S. Civil Service Commission. *Serve Those Who Served.* Washington, DC: GPO, 1945. [7]p. leaflet. CS1.2:N93/2. Recruiting leaflet for VA hospital nurses.

1263. U.S. Congress. House. *Communication from the President of the United States Transmitting for the Consideration of Congress a Proposed Provision Pertaining to Appropriation of the Federal Security Agency for the Fiscal Years 1944 and 1945.* H. Doc. 46, 79th Cong., 1st sess., 1945. 2p. Serial 10969. Proposed change in the appropriation for the nurse training program makes funds available for travel expenses not previously designated.

1264. U.S. Congress. House. Committee on the District of Columbia. *Increasing the Salary of the Executive Secretary of the Nurses' Examining Board of the District of Columbia, Report to Accompany H.R. 2839.* H. Rept. 435, 79th Cong., 1st sess., 1945. 2 p. Serial 10932.

1265. U.S. Congress. Senate. Committee on the District of Columbia. *Increasing the Salary of the Executive Secretary of the Nurses' Examining Board of the District of Columbia, Report to Accompany H.R. 2839.* S. Rept. 289, 79th Cong., 1st sess., 1945. 1p. Serial 10926.

1266. U.S. Office of War Information. *Nurses are Needed, Cadet Nurse Corps, Public Health Service, Offers Girls Extraordinary Opportunity for Free Professional Nursing Education, Be a Cadet Nurse, the Girl with a Future.* Washington, DC: The Office, 1945. 8p. Pr32.5002:N93/4/945. Earlier edition issued in 1944.

1267. U.S. Public Health Service. *Effect of the Cadet Nurse Corps on Nurse Education and the Future of Nursing.* Washington, DC: The Service, 1945. 5p. FS2.2:N93/19. The positive contributions of the U.S. Cadet Nurse Corps in pushing advances in nursing education are highlighted and the hope that the impetuous for advancement would continue after the war is expressed. The role of the nurse in postwar public health nursing describes an increasing professional role.

1268. U.S. Public Health Service. *Your Front-Line Post in Student Nurse Recruitment, 1945 Handbook for Local Nursing Councils for War Service.* Washington, DC: The Service, 1945. [8]p. FS2.6:N93/4/945. Information on how recruitment for Cadet Nurse Corps works for local nursing councils.

1269. U.S. Public Health Service. Division of Nurse Education. *The Girl with a Future, Be a Cadet Nurse.* Washington, DC: The Service, 1945. 2p. leaflet. FS2.46:4.

1270. U.S. Public Health Service. Division of Nurse Education. *A Lifetime Education Free for High School Graduates Who Qualify, U.S. Cadet Nurse Corps.* Washington, DC: The Service, 1945. poster. FS2.26:N93/10.

1271. U.S. Public Health Service. Division of Nurse Education and The National Nursing Council for War Service. *You and Professional Nursing.* Washington, DC: GPO, 1945. [2]p. leaflet. FS2.2:N93/20.

1272. U.S. Veterans Administration. *Serve Those Who Served.* Washington, DC: GPO, 1945. 2p. leaflet. VA1.2:Se6. Recruiting leaflet for VA nurses.

1273. U.S. Veterans Administration. *Serve Those Who Served, Nurses Are Needed in Veterans Administration Hospitals.* Washington, DC: The Administration, 1945. poster. VA1.16:N93.

1274. U.S. Women's Bureau. *The Outlook for Women in Occupations in the Medical Services: Dental Hygienists.* Bulletin no. 203-10. Washington, DC: GPO, 1945. 17p. L13.3:203/no.10. See 1278 for abstract.

1275. U.S. Women's Bureau. *The Outlook for Women in Occupations in the Medical Services: Medical Laboratory Technicians.* Bulletin no. 203-4. Washington, DC: GPO, 1945. 10p. L13.3:203/no.4. See 1278 for abstract.

1276. U.S. Women's Bureau. *The Outlook for Women in Occupations in the Medical Services: Medical Record Librarians.* Bulletin no. 203-6. Washington, DC: GPO, 1945. 9p. L13.3:203/no.6. See 1278 for abstract.

1277. U.S. Women's Bureau. *The Outlook for Women in Occupations in the Medical Services: Occupational Therapists.* Bulletin no. 203-2. Washington, DC: GPO, 1945. 15p. L13.3:203/no.2. See 1278 for abstract.

1278. U.S. Women's Bureau. *The Outlook for Women in Occupations in the Medical Services: Physical Therapists.* Bulletin no. 203-1. Washington, DC: GPO, 1945. 14p. L13.3:203/no.1. Report describes the employment outlook for women in medical service occupations after WWII, the pre-war situation, and effect of the war on the employment outlook. Women with special employment problems, e.g. older, married, and black women, are discussed in relation to the outlook for the field.

1279. U.S. Women's Bureau. *The Outlook for Women in Occupations in the Medical Services: Practical Nurses and Hospital Attendants.* Bulletin no. 203-5. Washington, DC: GPO, 1945. 20p. L13.3:203/no.5. See 1278 for abstract.

1280. U.S. Women's Bureau. *The Outlook for Women in Occupations in the Medical Services: Professional Nurses.* Bulletin no. 203-3. Washington, DC: GPO, 1946. 66p. L13.3:203/no.3. See 1278 for abstract.

1281. U.S. Women's Bureau. *The Outlook for Women in Occupations in the Medical Services: Women Dentists.* Bulletin no. 203-9. Washington, DC: GPO, 1945. 21p. L13.3:203/no.9. See 1278 for abstract.

1282. U.S. Women's Bureau. *The Outlook for Women in Occupations in the Medical Services: Women Physicians.* Bulletin no. 203-7. Washington, DC: GPO, 1945. 28p. L13.3:203/no.7. See 1278 for abstract.

1283. U.S. Women's Bureau. *The Outlook for Women in Occupations in the Medical Services: X-Ray Technicians.* Bulletin no. 203-8. Washington, DC: GPO, 1945. 14p. L13.3:203/no.8. See 1278 for abstract.

1284. U.S. Congress. House. *Letter from Administrator, Federal Security Agency, Transmitting a Draft of a Proposed Bill, "To exempt certain student nurses and other student- employees of hospitals of the federal government from the Classification Act, and other laws relating to compensation and benefits of federal Employees."* H. Doc. 703, 79th Cong., 2d sess., 1946. 5p. Serial 11056. Letter explains the desire of the Federal Security Agency to exempt student nurses and other interns from laws governing federal employees, such as overtime, retirement, and sick leave laws.

1285. U.S. Congress. Senate. Committee on the District of Columbia. *Amending the Act of February 9, 1907, as Amended with Respect to Certain Fees, Report to Accompany S. 2408.* S. Rept. 1803, 79th Cong., 2d sess., 1946. 1p. Serial 11017. Reports a bill changing fees collected by the Nursing Examining Board of the District of Columbia.

1286. U.S. Public Health Service. *Set Your Cap for Public Health Service.* Washington, DC: The Service, 1946. leaflet. FS2.2:H34/3.

1287. U.S. Women's Bureau. *The Outlook for Women in Occupations in the Medical and Other Health Services: Trends and Their Effect Upon the Demand for Women Workers.* Bulletin no. 203-12. Washington, DC: GPO, 1946. 55p. L13.3:203/no.12. Summary report pulls together information from the first eleven reports detailing the outlook for women in the various health-related occupations (1274-1283, 1288). Also covers the basic training required for each occupation and provides data on the number of women employed in relation to the total employment in selected medical and other health occupations in 1940.

1288. U.S. Women's Bureau. *The Outlook for Women in Occupations in the Medical Services: Physicians' and Dentists' Assistants.* Bulletin no. 203-11. Washington, DC: GPO, 1946. 15p. L13.3:203/no.11. See 1278 for abstract.

1289. U.S. Bureau of Labor Statistics. *Earnings and Working Conditions of Registered Professional Nurses.* Washington, DC: The Bureau, 1947. 3p. L2.2:N93. Preliminary report of a study to determine factors affecting the shortage of nurses indicates that nurses primarily left the profession for marriage and that major sources of dissatisfaction were employment security, rates of pay, and promotion opportunities. Summary data on monthly hours and earnings is reported.

1290. U.S. Public Health Service. *Recruitment Ideas for Industrial Nurses.* Washington, DC: The Service, 1947. [4]p. FS2.51:N93.

1291. U.S. Veterans Administration. *VA Nurse on Duty.* Washington, DC: GPO, 1947. [6]p. leaflet. VA1.19:10-8.

1292. U.S. Women's Bureau. *Opportunities for Negro Women in the Medical and Other Health Services.* Washington, DC: The Bureau, 1947. 8p. L13.2:N31. Career information for black girls on opportunities in nursing and allied health services. Describes training requirements and lists places which accepted black students. Provides insight into the status of blacks in the medical service fields in 1947.

1293. U.S. Bureau of Labor Statistics. *Economic Status of Nurses, Talk before the 10th Meeting of the National Conference of Hospital Administrators, Freedman's Hospital, Washington, D.C.* Washington, DC: The Bureau, 1948. 4p. L2.26:D28. Analysis of the results of a survey of nurses on their earnings and working conditions. Attempts to determine the effect of low salaries on nurse recruitment and retention. The lack of retirement plan coverage was a major point of dissatisfaction for hospital nurses. Most nurses leaving the profession did so to marry and salary was not a major factor.

1294. U.S. Bureau of Labor Statistics. *The Economic Status of Registered Professional Nurses, 1946-47.* Bulletin no. 931. Washington, DC: GPO, 1948. 69p. L2.3:931. Study of characteristics, wages, and working conditions of registered nurses. Examines number of nurses, their geographic distribution, employers, age, experience, and education. Provides data on veteran status and marital status of active and inactive nurses, average monthly and hourly earnings, hours of duty, overtime work and pay, night-shift pay, living arrangements, paid sick and vacation leaves, and insurance and retirement plans.

1295. U.S. Federal Security Agency. Freedmen's Hospital. *Introducing You to Freedman's Hospital School of Nursing.* Washington, DC: GPO, 1950. [20]p. FS2.54/2:N93.

1296. U.S. National Institutes of Health. *Nurses.* Washington, DC: GPO, 195?. 16p. FS2.22:N93. Describes the nurses role in the mental health program.

1297. U.S. Public Health Service. *Introducing You to Freedmen's Hospital School of Nursing.* Washington, DC: GPO, 1950. 18p. FS2.54a:N93. Provides information on nurse training at the Freedmen's Hospital School of Nursing which trains black women for nursing careers.

1298. U.S. Public Health Service. *The United States Cadet Nurse Corps and Other Federal Nurse Training Programs.* Washington, DC: GPO, 1950. 100p. FS2.2:N93/22. The Cadet Nurse Corps was formed to encourage recruitment to the nursing profession during the WWII nurse shortage. The development of the corps, the training of nurses, and federal aid to nursing education are among the topics covered. Provides statistics on the number of girls graduated from high school who enrolled in schools of nursing by year, 1935-48; enrollment in the Cadet Nurse Corps; and new admissions to the corps, 1943-1948.

1299. U.S. Veterans Administration. *Opportunity for You in VA Nursing.* Washington, DC: GPO, 1950. 27p. VA1.19:10-30. Revised editions issued in 1954 and 1956.

1300. U.S. Congress. House. Committee on Interstate and Foreign Commerce. *Assistance to Nursing Education, Hearing on H.R. 910.* 82d Cong., 1st sess., 12-13 Sept. 1951. 96p. Y4.In8/4:N93/3. Hearing testimony focuses on the shortage of nurses and the need to graduate more nurses. Discusses the need for scholarships and money to expand training facilities, and briefly touches on the role of low salaries in the shortage.

1301. U.S. Public Health Service. *The Public Health Nurse in Your Community.* Washington, DC: GPO, 1951? 13p. FS2.2:N93/23. Review of the duties, qualifications, and job security of public health nurses.

1302. U.S. Civil Service Commission. *Nurse in Federal Service, Employment Procedure, Duties and Salaries, Location of Positions.* Washington, DC: GPO, 1952. 16p. CS1.48:27. Earlier edition published in 1950 and 1948, title varies.

1303. U.S. Congress. Senate. Committee on the District of Columbia. *Amending the Act Entitled "An Act to define the term 'Registered Nurse' and to provide for the registration of nurses in the District of Columbia", Approved February 9, 1907, as Amended, Report to Accompany S. 3401.* S. Rept. 1722, 82d Cong., 2d sess., 1952. 3p. Serial 11568. Reports a bill to raise the registration fee for nurses to cover administrative costs.

1304. U.S. Public Health Service. *A Time Study: Nursing Services in Small Manufacturing Plants.* by Eleanor C. Bailey and Elizabeth S. Frasier. Washington, DC: The Service, 1952. 37p. FS2.2:N93/26. Report of a study of the responsibilities and daily activities of industrial nurses in small manufacturing plants provides data on health service personnel in manufacturing, and distribution of nursing time by activity.

1305. U.S. Public Health Service. Division of Occupational Health. *Salaries for Professional Registered Industrial Nurses in 37 Cities and Surrounding Areas, September 1951 - May 1952.* Washington, DC: The Service, 1952. 6p. FS2.2:Sa3/6. Community wage survey results provide earnings data for registered industrial nurses in 37 cities. Statistics presented are average weekly earnings, number of nurses according to weekly earnings, and percentage of nurses according to weekly earnings.

1306. U.S. Women's Bureau. *The Outlook for Women as Occupational Therapists.* Bulletin 203-2 revised. Washington, DC: GPO, 1952. 51p. L13.3:203/no.2/2. Revision of *The Outlook for Women in Occupations in the Medical Services: Occupational Therapists* (1277).

1307. U.S. Women's Bureau. *The Outlook for Women as Physical Therapists.* Bulletin 203-1 revised. Washington, DC: GPO, 1952. 51p. L13.3:203/no.1/2. Revision of *The Outlook for Women in Occupations in the Medical Services: Physical Therapists* (1278).

1308. U.S. Women's Bureau. *The Outlook for Women as Practical Nurses and Auxiliary Workers on the Nursing Team.* Bulletin 203-5 revised. Washington, DC: GPO, 1953. 62p. L13.3:203/no.5/2. Revision of *The Outlook for Women in Occupations in the Medical Services: Practical Nurses and Hospital Attendants* (1279).

1309. U.S. Women's Bureau. *The Outlook for Women in Professional Nursing Occupations.* Bulletin 203-3 revised. Washington, DC: GPO, 1953. 80p. L13.3:203/no.3/2. Revision of *The Outlook for Women in Occupations in the Medical Services: Professional Nurses* (1280).

1310. U.S. Congress. House. Committee on the Judiciary. *Designating National Nurse Week, Report to Accompany H.J. Res. 359.* H. Rept. 2039, 83rd Cong., 2d sess., 1954. 2p. Serial 11741.

1311. U.S. Congress. Senate. Committee on the Judiciary. *Designating National Nurse Week, Report to Accompany H.J. Res. 359.* S. Rept. 2251, 83rd Cong., 2d sess., 1954. 2p. Serial 11732.

1312. U.S. Women's Bureau. *The Outlook for Women as Medical Technologists and Laboratory Technicians.* Bulletin 203-4 revised. Washington, DC: GPO, 1954. 54p. L13.3:203/no.4/2. Revision of *The Outlook for Women in Occupations in the Medical Services: Medical Laboratory Technicians* (1275).

1313. U.S. Women's Bureau. *The Outlook for Women as X-Ray Technicians.* Bulletin 203-8 revised. Washington, DC: GPO, 1954. 53p. L13.3:203/no.8/2. Revision of *The Outlook for Women in Occupations in the Medical Services: X-Ray Technicians* (1283).

1314. U.S. National Institutes of Health. *Nursing at the Clinical Center.* Bethesda, MD: The Institutes, 1956? 10p. FS2.22:N93/2/956. Reviews the duties and appointment of public health nurses at the National Institutes of Health.

1315. U.S. Public Health Service. *Opportunities for Nurses in the U.S. Public Health Service Hospitals and Clinics.* Washington, DC: GPO, 1956. 11p. leaflet. FS2.2:N93/30.

1316. U.S. Veterans Administration. *Opportunity for You in VA Nursing.* VA Pamphlet 10-30. Washington, DC: GPO, 1956. 21p. VA1.19:10-30/3. Earlier editions published in 1950 and 1954. For later editions under different title see 1349.

1317. U.S. Bureau of Labor Statistics and U.S. Women's Bureau. *Earnings and Supplementary Benefits in Hospitals.* Bulletin no. 1210. Washington, DC: GPO, 1957. 16 vol. L2.3:1210-part no. Study of earnings and benefits of hospital employees provides data on weekly hours, earnings, and distribution of workers by earnings, by sex, and by occupation for professional, technical, office, and other nonprofessional personnel. Also provides data by occupation on other benefits such as room and board, laundry, uniform allowances, paid vacations, paid holidays and sick leave, insurance and pension plans. Part 1 - St. Louis; part 2 - Portland,OR; part 3 - Buffalo; part 4 - Baltimore; part 5 - Chicago; part 6 - Boston; part 7 - Cleveland; part 8 - Dallas; part 9 - Cincinnati; part 10 - Philadelphia; part 11 - Atlanta; part 12 - Memphis; part 13 - San Francisco-Oakland; part 14 - Los Angeles-Long Beach; part 15 - Minneapolis-St.Paul; part 16 - New York.

1318. U.S. Public Health Service. *Your Career as a Trained Practical Nurse.* Washington, DC: GPO, 1957. leaflet. FS2.2:N93/37.

1319. U.S. Public Health Service. Division of Nursing Resources. *Traineeships for Nurses.* Washington, DC: GPO, 1957. leaflet. FS2.2:N93/38.

1320. U.S. Public Health Service. Division of Public Health Methods. *Health Manpower Chart Book.* by George St.J. Perrott and Maryland Y. Pennell. Washington, DC: GPO, 1957. 57p. FS2.2:M31/3. Collection of data on physicians, dentists, and professional nurses focuses on manpower related data but also provides considerable data on income disparities by sex in health care occupations.

1321. U.S. Office of Education. Division of Vocational Education. *Basic Preparatory Programs for Practical Nurses by States and Changes in Number of Programs from 1956 to 1957.* Washington, DC: The Office, 1958. 4p. FS5.122:N93.

1322. U.S. Public Health Service. *Nursing Resources: A Progress Report of the Program of the Division of Nursing Resources.* Washington, DC: GPO, 1958. 43p. FS2.2:N93/36. Chart book provides a summary of the nursing supply, nurse employment, hospital personnel, nursing school enrollment, nursing student graduation rates, enrollment in advanced programs, federal nursing research, nurse turnover rates, and nurse aide training programs.

1323. U.S. Public Health Service. Division of Personnel. *First Job.* Washington, DC: The Service, 1958. leaflet. FS2.87:10.

1324. U.S. Congress. House. Committee on Interstate and Foreign Commerce. *Extension of Traineeship Programs for Health Personnel and Professional Nurses, Report to Accompany H.R. 6325.* H. Rept. 590, 86th Cong., 1st sess., 1959. 9p. Serial 12161. Reports a bill extending the program for advanced training of professional nurses authorized by the Health Amendments Act of 1956 for an additional 5 years.

1325. U.S. Congress. Senate. Committee on the District of Columbia. *Providing for Examination, Licensing, Registration and for Regulation of Professional and Practical Nurses, and for Nursing Education in the District of Columbia, and for Other Purposes, Report to Accompany S. 1870.* S. Rept. 915, 86th Cong., 1st sess., 1959. 12p. Serial 12153. Favorable report on legislation revising the District of Columbia laws governing the licensing of nurses and schools of nursing in the District provides an overview of hearing testimony and correspondence on the bill. The primary focus of the bill was to change the regulations relative to practical nurses.

1326. U.S. Office of Education. Division of Vocational Education. *Basic Preparatory Programs for Practical Nurses by States and Changes in Number of Programs, 1957-58.* Washington, DC: The Office, 1959. 4p. FS5.133:957-58.

1327. U.S. Public Health Service. *Health Manpower Source Book: Sec. 9, Physicians, Dentists, and Professional Nurses.* Washington, DC: GPO, 1959. 80p. HE2.2:M31/sec.9. Compilation of data provides a detailed profile of the number, personal characteristics, and employment characteristics of physicians, dentists, and professional nurses.

1328. U.S. Public Health Service. *Professional Nurse Traineeships, Part 1: A Report of the National Conference to Evaluate Two Years of Training Grants for Professional Nurses.* Washington, DC: GPO, 1959. 62p. FS2.2:N93/41/pt.1. Report on the accomplishments of the Professional Nurse Traineeship Program. Looks at the nursing shortage and at the success and shortcomings of the federal attempt to encourage professional nurses to obtain advanced education. Includes data on the nurse supply; number of nurses needed in administration, supervision, and teaching; hospital vacancies and reasons for vacancy; academic preparation of nursing faculty; and education of supervisors in public health work.

1329. U.S. Public Health Service. *Professional Nurse Traineeships, Part 2: Facts about the Nurse Supply and the Educational Needs of Nurses.* Washington, DC: GPO, 1959. 49p. FS2.2:N93/41/pt.2. Reports data on nursing trainees, nursing school enrollments and faculty, nursing vacancies, nursing supply, academic preparation of nurses, qualifications of nursing faculty, qualifications of public health nurses, nursing needs in nursing homes, and nurse trainee employment status.

1330. U.S. Public Health Service. *The Public Health Nurse in Your Community*. Washington, DC: GPO, 1959. 14p. FS2.2:N93/23/959. Basic information describes job tasks, education, and the employment future for public health nursing.

1331. U.S. Congress. House. Committee on Education and Labor. *The Practical Nurse Training Extension Act of 1960, Report to Accompany H.R. 11893*. H. Rept. 2015, 86th Cong., 2d sess., 1960. 6p. Serial 12247. Favorable report on extending for four years the practical nurse training program authorized by Title II of the Vocational Education Act of 1946. Reviews the accomplishments made under the law and the need for high caliber practical nurse training programs.

1332. U.S. Congress. House. Committee on Education and Labor. Subcommittee on Special Education. *Extension of Practical Nurse Training Program, Hearings on H.R.10622, H.R. 10750, H.R. 11893*. 86th Cong., 2d sess., 27 Apr. 1960. 63p. Y4.Ed8/1:N93. Hearing on support for practical nurse training programs provides information on the training, duties and licensing of practical nurses.

1333. U.S. Congress. House. Committee on the District of Columbia. *Providing for Examination, Licensing, Registration, and for Regulation of Professional and Practical Nurses and for Nursing Education in the District of Columbia, Report to Accompany S. 1870*. H. Rept. 2154, 86th Cong., 2d sess., 1960. 11p. Serial 12248. Reports, with amendments, a bill which completely rewrites the existing laws regulating nursing in the District of Columbia.

1334. U.S. Congress. Senate. Committee on Labor and Public Welfare. *Practical Nurse Training, Report to Accompany S. 3025*. S. Rept. 1411, 86th Cong., 2d sess., 1960. 5p. Serial 12235. Reports a bill extending for four years the federal-state program for training practical nurses under the authority of Title II of the Vocational Education Act of 1946.

1335. U.S. Congress. Senate. Committee on Labor and Public Welfare. Subcommittee on Health. *Practical Nurse Training, Hearing on S. 3025*. 86th Cong., 2d sess., 28 Apr. 1960. 63p. Y4.L11/2:N93/2. Hearing on whether to continue funding for practical nurse training examines the supply and demand for practical nurses and the need for and type of federal assistance. Also discusses the availability of practical nurse training and the education process for practical nurses.

1336. U.S. Public Health Service. *Facts about Professional Nurse Traineeship Program*. Washington, DC: GPO, 1960. 2p. leaflet. FS2.2:N93/38/960.

1337. U.S. Bureau of Labor Statistics. *Earnings and Supplementary Benefits in Hospitals, Mid-1960*. Bulletin no. 1294. Washington, DC: GPO, 1961. 80p. L2.3:1294. Details weekly earnings and average hourly earnings of hospital personnel in 15 cities by occupation and sex for government and nongovernment hospitals, and earnings distribution for occupations by sex in governmental and nongovernmental hospitals. Also gives data on paid holidays, paid vacations, and health insurance and pension plans.

1338. U.S. Congress. House. Committee on Education and Labor. *The Practical Nurse Training Extension Act of 1961, Report to Accompany H.R. 4104*. H. Rept. 199, 87th Cong., 1st sess., 1961. 6p. Serial 12338. Reports legislation to extend the practical nurse training programs authorization under Title II of the Vocational Education Act of 1946.

1339. U.S. Congress. Senate. Committee on Labor and Public Welfare. *Practical Nurse Training, Report to Accompany S. 278*. S. Rept. 57, 87th Cong., 1st sess., 1961. 5p. Serial 12321. Favorably reports a bill extending, until June 30, 1965, the practical nurse

training programs authorized by Title II of the Vocational Education Act of 1946. Accomplishments of practical nurse training are reviewed.

1340. U.S. Women's Bureau. *Memo To Communities, Re the Nurse Shortage, Ideas, Studies, Programs.* Leaflet no. 29. Washington, DC: GPO, 1961. 6p. leaflet. L13.11:29/2. Earlier editions published in 1958.

1341. U.S. Women's Bureau. *Nurses and Other Hospital Personnel: Their Earnings and Employment Conditions.* Pamphlet no. 6. Washington, DC: GPO, 1961. 41p. L13.19:6/2. Report discusses the demand for nurses and the measures being taken to increase their number. Also reports on a survey of hospitals which collected data on hours of work, benefits, vacations, and salaries. Provides statistics on weekly salaries by hospital-related occupation, sex, and ownership of hospital, 1956-57 and mid-1960 in 16 metropolitan areas. Earlier edition issued in 1958.

1342. U.S. Congress. House. Committee on the District of Columbia. *Amending the Act of February 9, 1907, Entitled "An Act to define the term 'Registered Nurses' and to provide for the registration of nurses in the District of Columbia," as Amended, with Respect to the Minimum Age Limitation for Registration, Report to Accompany H.R. 12964.* H. Rept. 2446, 87th Cong., 2d sess., 1962. 3p. Serial 12434. Favorable report explains the reasons for lowering the minimum age for registered nurses from 21 to 19 years in the District of Columbia.

1343. U.S. Public Health Service. *Facts about the Professional Nurse Traineeship Program.* Washington, DC: GPO, 1962. leaflet. FS2.2:N93/46.

1344. U.S. Congress. House. Committee on the District of Columbia. *Amend the District of Columbia Practical Nurses' Licensing Act, Report to Accompany S. 933.* H. Rept. 880, 88th Cong., 1st sess., 1963. 4p. Serial 12544. See 1346 for abstract.

1345. U.S. Congress. House. Committee on the District of Columbia. *Lowering Age Limit for Registered Nurses, Report to Accompany H.R. 1933.* H. Rept. 75, 88th Cong., 1st sess., 1963. 2p. Serial 12540. Reports a bill lowering the minimum age for registered nurses in the District of Columbia from 21 to 19 years since nurses were graduating at a younger age.

1346. U.S. Congress. Senate. Committee on the District of Columbia. *Amending the District of Columbia Practical Nurses' Licensing Act, and for Other Purposes, Report to Accompany S. 933.* S. Rept. 445, 88th Cong., 1st sess., 1963. 4p. Serial 122534. The bill reported makes technical amendments to the District of Columbia Nurses' Licensing Act (P.L. 86-708). The amendment would extend the exemption for the written examination to include nurses practicing in the D.C. metropolitan area one year prior to the act, but who were outside of the District of Columbia.

1347. U.S. Public Health Service. *Nurses for Leadership: The Professional Nurse Traineeship Program, Report of the 1963 Evaluation Conference.* Washington, DC: GPO, 1963. 53p. FS2.2:N93/48. Conference report describes the effectiveness of the Professional Nurse Traineeship Program and recommends program changes to enhance effectiveness in program areas. Provides statistics on nursing education, traineeships, and areas of practice.

1348. U.S. Public Health Service. *Toward Quality in Nursing: Needs and Goals.* Washington, DC: GPO, 1963. 73p. FS2.2:N93/47. Overview of nursing education and the supply and demand for nurses looks at the return of inactive nurses to the profession, enrollment of

nurses, advanced nursing education, and nursing research. Provides data on admissions to and graduation from nursing programs and on number of practicing nurses.

1349. U.S. Veterans Administration. *There's a Star in Your Future.* Washington, DC: GPO, 1963. 14p. VA1.19:10-30/5. Recruiting pamphlet for VA nurses was also issued in 1959. For earlier editions under a different title see 1316.

1350. U.S. Congress. House. Committee on Interstate and Foreign Commerce. *Nurse Training Act of 1964, Report to Accompany H.R. 11241.* H. Rept. 1549, 88th Cong., 2d sess., 1964. 54p. Serial 12619-3. Lengthy favorable report, with amendments, describes legislation to amend the Public Health Services Act to authorize grant and loan programs to increase the nursing supply.

1351. U.S. Congress. Senate. Committee on Labor and Public Welfare. *Nurse Training Act of 1964, Report to Accompany H.R. 11241.* S. Rept. 1378, 88th Cong., 2d sess., 1964. 47p. Serial 12616-4. Favorable report on the establishment of several federal aid programs to increase the supply of nurses in the U.S. Reviews the extent of the nurse shortage. Approaches to increasing the supply includes nursing school grant programs and student loan programs.

1352. U.S. Congress. Senate. Committee on Labor and Public Welfare. Subcommittee on Health. *Nurse and Graduate Public Health Training, Hearing on H.R. 11241 and H.R. 11083.* 88th Cong., 2d sess., 6 Aug. 1964. 86p. Y4.L11/2:N93/5. Hearing considers a bill related to federal funding for construction of nurse teaching and training facilities, strengthening nursing programs, expanding advanced training programs for professional nurses, and nursing student loan programs. Provides information on various types of nursing education and career opportunities.

1353. U.S. Medical Museum of Armed Forces Institute of Pathology. *Women in Medicine.* Washington, DC: GPO, 1964. 4p. D1.16/2:W84. The contributions of women in medicine are briefly recounted in this short history which describes the difficulty of obtaining a midwife license in 17th century England and highlights the contributions of Florence Nightingale, Clara Barton, Dorothea Linde Dix, and Mary Edwards Walker.

1354. U.S. Children's Bureau. *The Practice of Nurse-Midwifery in the United States.* Publication no. 436. Washington, DC: GPO, 1965. 61p. FS14.111:436. The extent of the practice of nurse-midwifery in the U.S. and attitudes of physicians toward nurse-midwives are detailed in this study.

1355. U.S. Public Health Service. *Nurse Training Act of 1964.* Washington, DC: GPO, 1965. 11p. FS2.2:N93/53/965-2.

1356. U.S. Public Health Service. *Professional Nurse Traineeship Program.* Washington, DC: GPO, 1965. 6p. FS2.2:N93/38/965.

1357. U.S. Bureau of Health Manpower. Division of Nursing. *Nurse Supply and Needs 1967: Current Nursing Statistics in Brief.* Washington, DC: GPO, 1966. leaflet. FS2.2:N93/59/967.

1358. U.S. Bureau of Labor Statistics. *Industry Wage Survey: Nursing Homes and Related Facilities, April 1965.* Bulletin no. 1492. Washington, DC: GPO, 1966. 72p. L2.3:1492. Statistical report on hours and wages of employees in nursing homes and related facilities details number of employees by sex, average weekly hours and average hourly earnings by occupation, scheduled weekly hours, and benefits. Data is presented for selected cities and for regions by type of facility. Later see 1375.

1359. U.S. Congress. House. Committee on the District of Columbia. *Amending the District of Columbia Practical Nurses' Licensing Act, Report to Accompany H.R. 8337.* H. Rept. 1653, 89th Cong., 2d sess., 1966. 6p. Serial 12713-3. See 1360 for abstract.

1360. U.S. Congress. Senate. Committee on the District of Columbia. *Amending the District of Columbia Practical Nurses' Licensing Act, Report to Accompany H.R. 8337.* S. Rept. 1364, 89th Cong., 2d sess., 1966. 4p. Serial 12710-3. Favorable report on amending the District of Columbia Practical Nurses' Licensing Act to include in the exemption from the written examination requirement practical nurses residing in D.C. but working outside of D.C. for the year preceding the act.

1361. U.S. Public Health Service. *Nurses - A New Career Opportunity in Psychiatric-Mental Health Nursing in the U.S. Public Health Service.* Washington, DC: GPO, 1966. 11p. FS2.22:N93/6/966. Earlier edition published in 1965.

1362. U.S. Bureau of Labor Statistics. *Industry Wage Survey: Hospitals, July 1966.* Bulletin no. 1553. Washington, DC: GPO, 1967. 107p. L2.3:1553. Statistical report on wages of hospital personnel provides data on number of employees, average weekly hours, and average weekly earnings by occupation and sex, type of hospital, region, and city. Also gives data on average earnings by occupation, sex, and size of hospital and community, and on benefits.

1363. U.S. Public Health Service. *Career in the U.S. Public Health Service: Nurse.* Washington, DC: GPO, 1967. leaflet. FS2.2:N93/60.

1364. U.S. Public Health Service. *Community Planning for Nursing in the District of Columbia Metropolitan Area.* Washington, DC: GPO, 1967. 149p. FS2.2:C73/13. Compilation of data useful in planning nursing services in the District of Columbia includes socioeconomic data, hospital utilization, health expenditures, nurse supply, nurse characteristics, and nursing education for U.S. and the Washington, D.C. metro area.

1365. U.S. Public Health Service. *Nurse Training Act of 1964: Program Review Report.* Washington, DC: GPO, 1967. 78p. FS2.2:N93/62. Summary of current forces affecting the nursing profession assesses the impact of the Nurse Training Act of 1964 on nursing education and supply. Provides statistics on nursing program enrollment and payments made under the Nurse Training Act of 1964.

1366. U.S. Public Health Service. *Nursing Careers among the American Indians.* Washington, DC: GPO, 1967. 9p. leaflet. FS2.2:N93/33/967. Earlier editions published in 1955, 1959, 1961, and 1963.

1367. U.S. Public Health Service. *U.S. Public Health Service: Nutritionist, Dietician.* Washington, DC: GPO, 1967. 19p. leaflet. FS2.2:N95.

1368. U.S. Public Health Service. Nurse Career Development Committee. *Nurse Career Planning, Administration, Clinical Specialization, Consultation, Research.* Washington, DC: The Service, 1967. 37p. FS2.6/2:N93/15. Charts illustrate career ladders for nurses with the Public Health Service. The educational program or institutional experience required and the rational for the career preparation recommendations are described.

1369. U.S. Veterans Administration. *Practical Nursing in VA, Forward Step in Your Career.* VA Pamphlet 10-52. Washington, DC: GPO, 1967. 12p. VA1.19:10-52/4. Earlier editions published in 1961, 1963, and 1964. Title changed with later editions, see 1400.

1370. U.S. Dept. of Health, Education and Welfare. Office of the Assistant Secretary for Planning and Evaluation. *Human Investment Programs: Nursing Manpower Programs.* Program Analysis 1968, no. 14. Washington, DC: GPO, 1968. 54p. FS1.29:968/14. Analyzes possible methods of recruiting more female high school students to the nursing profession and for bringing nonactive nurses back into the work force.

1371. U.S. Office of Education. Division of Manpower Development and Training. *Good Training, Good Jobs, MDTA from Nurse Aide to Licensed Practical Nurse, a Step Up.* Washington, DC: GPO, 1968. [8]p. leaflet. FS5.287:87031.

1372. U.S. Office of Education. Division of Manpower Development and Training. *Good Training, Good Jobs, MDTA Upgrading Practical Nurses.* Washington, DC: GPO, 1968. [8]p. leaflet. FS5.287:87028.

1373. U.S. Public Health Service. *Public Health Nursing in Industry.* Washington, DC: GPO, 1968. 6p. leaflet. FS2.2:N93/25.

1374. U.S. Women's Bureau. *The Fuller Utilization of the Woman Physician: Report of a Conference on Meeting Medical Manpower Needs.* Washington, DC: The Bureau, 1968. 104p. No SuDoc number. Conference sponsored by the American Medical Women's Association, the President's Study Group on Careers for Women, and the Women's Bureau covers the barriers to fuller recruitment of women to the medical profession, concentrating on the problems of the inflexibility of the educational process and the demands of home and family. Discussed are ways to encourage women to complete medical training by offering more part-time programs and increased financial support. Also discusses the early socialization process for girls and how this can discourage entry into the medical profession. Mary I. Bunting, president of Radcliffe College, reported on studies of women in college, their decision to enter medical school, and their success rate in medical school. Speakers also discuss balancing medical practice and family life.

1375. U.S. Bureau of Labor Statistics. *Industry Wage Survey: Nursing Homes and Related Facilities, October 1967 and April 1968.* Bulletin no. 1638. Washington, DC: GPO, 1969. 74p. L2.3:1638. See 1358 for abstract.

1376. U.S. National Institute of Mental Health. *Nursing Careers in Mental Health.* Washington, DC: GPO, 1969. 16p. FS2.22:N93/4/969. Earlier editions published in 1963 and 1968.

1377. U.S. Public Health Service. *Health Manpower Source Book: Sec. 2, Nursing Personnel.* Washington, DC: GPO, 1969. 144p. HE20.3109:2. Compilation of data on number, personal characteristics, and employment characteristics of nurses, enrollment in and characteristics of nursing programs, and estimate of the supply and demand for nurses. Earlier editions issued in 1953 and 1956 under SuDoc number FS2.2:M31/sec.2/year.

1378. U.S. Public Health Service. *Professional Nurse Traineeship Program.* Washington, DC: GPO, 1969. 11p. FS2.2:N93/38/969. Earlier editions published in 1965 and 1966.

1379. U.S. Bureau of Health Professions Education and Manpower Training. Division of Nursing. *Nursing Personnel in Hospitals, 1968.* Washington, DC: GPO, 1970. 382p. HE20.3102:N93/9/968. Statistical report provides detailed data on nursing personnel by state, hospital size, and hospital ownership.

1380. U.S. Dept. of Health, Education and Welfare. *Report to the President and the Congress: Progress Report on Nurse Training - 1970.* Washington, DC: GPO, 1970. 88p. HE1.39:970. Report for 1970 reviews nurse training advances under the Nurse Training Act of 1964 and the Health Manpower Act of 1968, Title II. Provides a history of federal

support for nursing, data on assistance to students, and a summary of nurse training projects. Also gives brief data on characteristics of students, reasons for failure to complete the program, and credentials of faculty.

1381. U.S. Federal Health Programs Service. *Careers for Nurses in Federal Health Programs Service.* Washington, DC: GPO, 1970. 8p. HE20.2702:N93.

1382. U.S. Health Services and Mental Health Administration. *Careers for Nurses in the Federal Health Programs Service.* Washington, DC: GPO, 1970. 9p. FS2.2:N93/67. Reviews opportunities for nurses and how appointments are made to the Federal Health Programs Service.

1383. U.S. National Institutes of Health. *Traineeship for Registered Nurses under Public Health Traineeship Program, Section 306, Public Health Service Act.* Washington, DC: GPO, 1970. 6p. leaflet. HE20.3002:N93.

1384. U.S. Bureau of Health Manpower Education. Division of Nursing. *Nurse Supply & Needs: Current Nursing Statistics in Brief.* Washington, DC: GPO, 1971. leaflet. HE20.3102:N93/18/971.

1385. U.S. Bureau of Health Manpower Education. Division of Nursing. *Present and Future Supply of Registered Nurses.* Washington, DC: GPO, 1971. 158p. HE20.31102:N93/19. Analyzes factors of nursing education, characteristics of nurse training entrants, and labor force participation of nurses as a basis for determining the future supply of nurses.

1386. U.S. Congress. House. *Nurse Training Act of 1971, Conference Report to Accompany H.R. 8630.* H. Rept. 92-577, 92d Cong., 1st sess., 1971. 31p. Serial 12932-5. Conference report replaces the Senate amendments to the bill with new language. The majority of differences between the House and Senate versions related to the size of appropriations, eligibility requirements for grants, and administrative provisions.

1387. U.S. Congress. House. Committee on Interstate and Foreign Commerce. *Health Professions Student Loan and Scholarship Extension, Report to Accompany H.R. 7736.* H. Rept. 92-249, 92d Cong., 1st sess., 1971. 10p. Serial 12932-2. Favorable report on legislation extending for one year the existing authorization of appropriations for student loans and scholarships under the Nurse Training Act of 1964.

1388. U.S. Congress. House. Committee on Interstate and Foreign Commerce. *Nurse Training Act of 1971, Report to Accompany H.R. 8630.* H. Rept. 92-259, 92d Cong., 1st sess., 1971. 55p. Serial 12932-2. Reports a bill continuing nurse training programs and modifying programs to increase the supply and improve the distribution of nursing personnel. Report reviews the need for more nurses and the accomplishments under the programs established by the Nurse Training Act of 1964 and extended and amended by the Health Manpower Act of 1968. Includes supporting statistics on enrollment and on institutions offering nursing programs.

1389. U.S. Congress. House. Committee on Interstate and Foreign Commerce. *Select Information on Nursing Manpower in the United States.* 92d Cong., 1st sess., 1971. Committee Print. 59p. CIS71-H502-12. Data on nursing manpower includes supply and demand estimates, reasons for nursing shortages, nursing education enrollment, and federal support of nursing education. Most data is provided for the late 1950s through 1970.

1390. U.S. Congress. House. Committee on Interstate and Foreign Commerce. Subcommittee on Public Health and Environment. *Health Professions Educational Assistance Amendments of 1971, Part 2, Hearings.* 92d Cong., 1st sess., 21-29 April, 1971. 523-

1076pp. Y4.In8/4:92-11. Second part of hearings on numerous bills dealing with health manpower distribution and training focuses primarily on the need to increase minority enrollment in medical schools. The state of nursing education and the need for federal support is also discussed. Minority enrollment in nursing degree programs and the need to encourage black high school girls to consider college nursing programs are highlighted.

1391. U.S. Congress. Senate. *Nurse Training Act of 1971, Conference Report to Accompany H.R. 8630.* S. Rept. 92-399, 92d Cong., 1st sess., 1971. 31p. Serial 12929-4. See 1386 for abstract.

1392. U.S. Congress. Senate. Committee on Labor and Public Welfare. *Nurse Training Amendments of 1971, Report to Accompany S. 1747.* S. Rept. 92-252, 92d Cong., 1st sess., 1971. 92p. Serial 12929-2. Report supports expanding Title VIII of the Public Health Service Act to provide greater assistance to nursing education through grants to institutions and students. The history of nurse training legislation is reviewed from the 1930s through the Cadet Nurse Corps in the 1940s and the Health Manpower Act of 1968. Accomplishments under existing legislation and the need for more nurses are described with supporting statistics. Changes made by the bill in existing programs are described.

1393. U.S. Congress. Senate. Committee on Labor and Public Welfare. Subcommittee on Health. *Health Manpower Legislation, 1971, Hearing.* 92d Cong., 1st sess., 3-10 May 1971. 925p. Y4.L11/2:M31/14. Hearing on bills supporting health professions education includes testimony urging support for schools of nursing. The expanding role of nurses and the continued demand are highlighted in support of federal capitation grants and loan programs. Federal support for education of physicians and dentists is also discussed.

1394. U.S. Dept. of Health, Education and Welfare. Secretary's Committee to Study Extended Roles for Nurses. *Extending the Scope of Nursing Practice, Report of the Secretary's Committee to Study Extended Roles for Nurses.* Washington, DC: GPO, 1971. 17p. HE1.2:N93/3. Conclusions and recommendations in this report on extending the scope of nursing practice deal with issues of education, the physician-nurse relationship, and the impact on health care delivery. Identifies primary care, acute care, and long term care activities which could be preformed by nurses.

1395. U.S. Health Services and Mental Health Administration. *Career as a Practical Nurse, Indian School of Practical Nursing, Albuquerque, New Mexico.* Washington, DC: GPO, 1971. 6p. leaflet. HE20.2002:In2.

1396. U.S. Indian Health Service. *Nursing Careers among American Indians.* Washington, DC: GPO, 1971. 11p. leaflet. HE20.2652:N93/971. Earlier edition published in 1970.

1397. U.S. Veterans Administration. *Changing Dimensions: Nursing Opportunities in the Veterans Administration.* Washington, DC: GPO, 1971. [12]p. leaflet. VA1.19:10-30/6.

1398. U.S. Bureau of Health Manpower Education. Division of Nursing. *From Student to RN: Report of the Nurse Career-Pattern Study.* by Lucille Knopf. Washington, DC: GPO, 1972. 154p. HE20.3102:St9/3. Study of the educational path to an RN and the students who drop out before completing the degree details personal characteristics of incoming students and reasons for choosing a nursing career. Analyzes the characteristics of students who withdrew including sex and marital status and subsequent education and employment.

1399. U.S. Congress. Senate. Committee on the Judiciary. *National Nurse Week, Report to Accompany S.J. Res. 168.* S. Rept. 93-502, 93d Cong., 1st sess., 1973. 1p. Serial 13017-7.

1400. U.S. Veterans Administration. *Practical Nursing in VA, Career Opportunities in Veterans Administration Hospitals Nationwide.* VA Pamphlet 10-52. Washington, DC: The Administration, 1973. 10p. VA1.19:10-52/5. Heavily illustrated recruiting booklet describes career opportunities, pay, and benefits for nurses with the VA. For earlier editions see 1369.

1401. U.S. Veterans Administration. *Survey of Factors Relating to Job Satisfaction among VA Nurses, 1960 - 1970.* Information Bulletin no. 11-40. Washington, DC: GPO, 1973. 67p. VA1.22:11-40. Report of survey results on satisfaction with Veterans Administration policies and practices among VA nurses. Compares results among nurses who stay and nurses who leave VA employment. Reasons for leaving given in a 1960 study are compared with the results of the 1970 study. Issues of staffing, promotion, and professional development are analyzed by management status of respondent.

1402. U.S. Bureau of Health Manpower Education. Division of Nursing. *Nurse Supply and Needs 1973: Current Nursing Statistics in Brief.* Washington, DC: GPO, 1974. leaflet. HE20.6102:N93/2/973.

1403. U.S. Bureau of Health Resources Development. Division of Nursing. *Report to Congress, Nurse Training, 1974: Report of the Secretary, Health, Education and Welfare on Administration of Title VIII of Public Health Service Act as Required by Sec.12, Public Law 92-158.* Washington, DC: GPO, 1974. 53p. HE20.6102:N93/6/974. Report on trends in nursing education and nursing manpower highlights the administration of Title VIII nurse training programs.

1404. U.S. Congress. House. Committee on Interstate and Foreign Commerce. *Nurse Training Act of 1974, Report to Accompany H.R. 17085.* H. Rept. 93-1510, 93d Cong., 2d sess., 1974. 56p. Serial 13061-10. Reports a bill continuing loan and grant programs to schools of nursing and establishing a program to assist nursing schools in the creation of programs for advanced nurse training and training of nurse practitioners. The report includes a history of nurse training legislation and details of the program authorized by the bill.

1405. U.S. National Library of Medicine. *Witchcraft and Medicine (1483-1793).* by Jaroslav Nemec. Bethesda, MD: The Library, 1974. 10p. HE20.3002:W77/1484-1793. Brief history describes the relationship between witchcraft and the early field of medicine between 1484 and 1793. Includes a brief list of references.

1406. U.S. Bureau of Health Manpower. Division of Nursing. *Graduation and Withdrawal from RN Programs: A Report of the Nurse Career-Pattern Study.* Washington, DC: GPO, 1975. 130p. HE20.6602:N93/7. The characteristics of students in RN programs are examined in relation to graduation and withdrawal from programs. Compares withdrawal rates for nursing school students with non-nursing students and details reasons for withdrawal and activities after leaving nursing school. Characteristics surveyed include age, marital status, family income, and mother's and father's occupation.

1407. U.S. Bureau of Health Resources Development. Division of Nursing. *Evaluation of Employment Opportunities for Newly Licensed Nurses.* Washington, DC: GPO, 1975. 135p. HE20.6102:N93/9. Study of the first employment experience of registered nurses and licensed practical nurses provides basic data on new nurses by age, sex, ethnicity, marital status, and children under 6. Factors studied include plans to continue education, employment prior to and during nursing school, employment between graduation and licensure, availability of employment, compromises made in first job, geographic mobility, job mobility, type of employer, income of newly licensed nurses, and job satisfaction.

1408. U.S. Bureau of Health Resources Development. Division of Nursing. *Survey of Registered Nurses Employed in Physicians' Offices, Sept. 1973.* Washington, DC: GPO, 1975. 98p. HE20.6102:N93/8. Report on characteristics of nurses and their duties in physicians' offices presents data on pay and benefits.

1409. U.S. Bureau of Medical Services. *Chance to Grow, Careers for Nurses in Bureau of Medical Services.* Washington, DC: GPO, 1975. 16p. HE20.5402:G91.

1410. U.S. Congress. House. Committee on Interstate and Foreign Commerce. *Nurse Training Act of 1975, Report Together with Additional Views and Minority Views to Accompany H.R. 4115.* H. Rept. 94-143, 94th Cong., 1st sess., 1975. 72p. Serial 13099-3. Favorable report on continuing the nurse training programs of Title VII of the Public Health Service Act without change for fiscal year 1975 and to extend their authorization for fiscal years 1976, 1977, and 1978 also provides new authority for establishing advanced nurse training programs and nurse practitioner programs.

1411. U.S. Congress. House. Committee on Interstate and Foreign Commerce. Subcommittee on Health and the Environment. *Health Manpower Programs, Hearings on H.R. 2956, H.R. 2957, H.R. 2958, and H.R. 3279.* 94th Cong., 1st sess., 20,21 Feb. 1975. 714p. Y4.In8/4:94-3. Witnesses discuss the relative need for federal support for medical education programs with some witnesses indicating that nurse education programs are no longer needful of assistance. The primary focus of the hearing is on funding physician training and the use of incentives to encourage specialization in certain fields and to promote primary care practitioners. The desire to encourage nurses to become nurse practitioners or physician's assistants is also explored.

1412. U.S. Congress. Senate. Committee on Labor and Public Welfare. *Nurse Training and Health Revenue Sharing and Health Services Act of 1975, Report to Accompany S. 66.* S. Rept. 94-29, 94th Cong., 1st sess., 1975. 307p. Serial 13098-4. Programs included in the bill favorably reported here include revised and extended nurse training programs and family planning programs. The report presents the arguments for overriding the pocket veto of the two bills from the 93rd Congress which were incorporated into S. 66. The report provides background information and statistics in support of the programs. The rape prevention and control measures of the earlier bills are incorporated as Part D of the revised Community Mental Health Center Act.

1413. U.S. Bureau of Health Manpower. *Minorities & Women in the Health Fields: Applicants, Students, and Workers.* Washington, DC: GPO, 1976. 101p. HE20.6602:M66. See 1465 for abstract.

1414. U.S. Bureau of Health Manpower. *Proceedings of the International Conference on Women in Health, June 16-18, 1975, Washington, D.C.* Washington, DC: GPO, 1976. 204p. HE20.6602:W84. Presentations at an international conference on the utilization of women in health care delivery cover topics such as correcting the underrepresentation of women in health professions in the USSR and Scandinavia, improving the utilization of nurses and allied health personnel in Sweden and Columbia, the organization of nurses and allied personnel in Australia, new roles for women in health care delivery in China and Cameroon, the role of women in health care decision-making in Poland and the Philippines, and women as producers of services in the health sector in the United States. A United States response follows papers on foreign countries.

1415. U.S. Bureau of Health Manpower. Division of Nursing. *Longitudinal Study of Nurse Practitioners, Phase I.* by Harry A. Sultz, Marie Zeilezrey, and Louis Kinyon. Washington, DC: GPO, 1976. 144p. HE20.6602:N93/14. Results of a study on nurse practitioner programs and students provides data on program characteristics, financial

support and tuition, faculty characteristics, program length, and curriculum content. Student data includes characteristics, financial problems and sources of support, factors influencing entrance into NP programs, and professional expectations. Most data is presented by type of program.

1416. U.S. Commission on Civil Rights. *Access to the Medical Profession in Colorado by Minorities and Women.* Washington, DC: GPO, 1976. 91p. CR1.2:M46. A commission study found that women and minorities were severely underrepresented among physicians in Colorado in 1975. Aspects of the educational system which discouraged women and minorities from entering medical school and successfully completing medical training are examined. Statistics presented include enrollment, applications, test scores, and faculty characteristics at University of Colorado School of Medicine.

1417. U.S. Dept. of Health, Education and Welfare. Office of the Assistant Secretary for Planning and Evaluation. Office of Special Concerns. The Women's Action Program. *Exploratory Study of Women in the Health Professional Schools, Executive Summary.* Washington, DC: The Dept., 1976. 13p. HE1.2:W84/3/summ. See 1418 for abstract.

1418. U.S. Dept. of Health, Education and Welfare. Office of the Assistant Secretary for Planning and Evaluation. Office of Special Concerns. The Women's Action Program. *Exploratory Study of Women in the Health Professional Schools, Vol. I: Data Analysis, Findings, Conclusions, Recommendations.* Washington, DC: The Dept., 1976. 422p. HE1.2:W84/3/v.1. Study explores the barriers to entry and success in schools of medicine, dentistry, veterinary medicine, optometry, podiatry, pharmacy, and public health for women. The purpose of the study was to develop models for the recruitment, admission, and educational systems in order to improve women's opportunities in the health professional schools. Most volumes contain statistics on professional school enrollment and number of practitioners by sex. Much of the information is based on interviews which are excerpted.

1419. U.S. Dept. of Health, Education and Welfare. Office of the Assistant Secretary for Planning and Evaluation. Office of Special Concerns. The Women's Action Program. *Exploratory Study of Women in the Health Professional Schools, Vol. II: Women in Medicine.* Washington, DC: The Dept., 1976. 217p. HE1.2:W84/3/v.2. See 1418 for abstract.

1420. U.S. Dept. of Health, Education and Welfare. Office of the Assistant Secretary for Planning and Evaluation. Office of Special Concerns. The Women's Action Program. *Exploratory Study of Women in the Health Professional Schools, Vol. III: Women in Osteopathic Medicine.* Washington, DC: The Dept., 1976. 93p. HE1.2:W84/3/v.3. See 1418 for abstract.

1421. U.S. Dept. of Health, Education and Welfare. Office of the Assistant Secretary for Planning and Evaluation. Office of Special Concerns. The Women's Action Program. *Exploratory Study of Women in the Health Professional Schools, Vol. IV: Women in Dentistry.* Washington, DC: The Dept., 1976. 126p. HE1.2:W84/3/v.4. See 1418 for abstract.

1422. U.S. Dept. of Health, Education and Welfare. Office of the Assistant Secretary for Planning and Evaluation. Office of Special Concerns. The Women's Action Program. *Exploratory Study of Women in the Health Professional Schools, Vol. V: Women in Veterinary Medicine.* Washington, DC: The Dept., 1976. 101p. HE1.2:W84/3/v.5. See 1418 for abstract.

1423. U.S. Dept. of Health, Education and Welfare. Office of the Assistant Secretary for Planning and Evaluation. Office of Special Concerns. The Women's Action Program. *Exploratory Study of Women in the Health Professional Schools, Vol. VI: Women in Optometry.* Washington, DC: The Dept., 1976. 113p. HE1.2:W84/3/v.6. See 1418 for abstract.

1424. U.S. Dept. of Health, Education and Welfare. Office of the Assistant Secretary for Planning and Evaluation. Office of Special Concerns. The Women's Action Program. *Exploratory Study of Women in the Health Professional Schools, Vol. VII: Women in Podiatry.* Washington, DC: The Dept., 1976. 90p. HE1.2:W84/3/v.7. See 1418 for abstract.

1425. U.S. Dept. of Health, Education and Welfare. Office of the Assistant Secretary for Planning and Evaluation. Office of Special Concerns. The Women's Action Program. *Exploratory Study of Women in the Health Professional Schools, Vol. VIII: Women in Pharmacy.* Washington, DC: The Dept., 1976. 80p. HE1.2:W84/3/v.8. See 1418 for women.

1426. U.S. Dept. of Health, Education and Welfare. Office of the Assistant Secretary for Planning and Evaluation. Office of Special Concerns. The Women's Action Program. *Exploratory Study of Women in the Health Professional Schools, Vol. IX: Women in Public Health.* Washington, DC: The Dept., 1976. 78p. HE1.2:W84/3/v.9. See 1418 for women.

1427. U.S. Dept. of Health, Education and Welfare. Office of the Assistant Secretary for Planning and Evaluation. Office of Special Concerns. The Women's Action Program. *Exploratory Study of Women in the Health Professional Schools, Vol. X: Annotated Bibliography.* Washington, DC: The Dept., 1976. 108p. HE1.2:W84/3/v.10. See 1418 for abstract.

1428. U.S. Health Resources Administration. *Women in Health Careers: Status of Women in Health Careers in the United States and Other Selected Countries.* by Maryland Pennell and Shirlene Showell. Washington, DC: GPO, 1976. 147p. HE20.6002:W89/chartbook. Statistical report on women in health careers. Provides data by sex on employers, industry, educational attainment, occupation, and health careers education for the U.S. and selected countries.

1429. U.S. Bureau of Health Manpower. *Women and Minorities in Health Fields: A Trend Analysis of College Freshman. Volume 1: Freshman Interested in the Health Professions.* Washington, DC: GPO, 1977. 255p. HE20.6602:W84/2/v.1. Study of aspiring health professionals among 1966, 1972, and 1974 freshman looks at students planning careers as physicians, dentists, pharmacists, optometrists, and veterinarians by sex and race. Data on these students by sex and race includes age, marital/dating status, parental income, father's and mother's education and occupation, financial support, self-rating, life goals, reasons for college choice, degree plans, and reasons for career choice.

1430. U.S. Bureau of Health Manpower. *Women and Minorities in Health Fields: A Trend Analysis of College Freshman. Volume 1: Freshman Interested in the Health Professions: A Summary Report.* Washington, DC: GPO, 1977. 47p. HE20.6602:W84/2/v.1/summ. See 1429 for abstract.

1431. U.S. Bureau of Health Manpower. *Women and Minorities in Health Fields: A Trend Analysis of College Freshman, Volume 2: Freshman Interested in Nursing and Allied Health Professions.* Washington, DC: GPO, 1977. 236p. HE20.6602:W84/2/v.2. Study looks at college freshman indicating an interest in pursuing careers as nurses, dietitians,

health technicians, and therapists in 1966, 1972, and 1974. Data analyzed includes trends by sex and race in mother's and father's occupation and education, age, marital/dating status, financial support, self-ratings, life goals, reason for college choice, and degree plans. Detailed statistics are analyzed to identify possible trends.

1432. U.S. Bureau of Health Manpower. *Women and Minorities in Health Fields: A Trend Analysis of College Freshman, Volume 2: Freshman Interested in Nursing and Allied Health Professions: A Summary Report.* Washington, DC: GPO, 1977. 44p. HE20.6602:W84/2/v.2/summ. See 1431 for abstract.

1433. U.S. Health Resources Administration. Office of Health Resources Opportunity. *An Historical Review of Women in Dentistry: An Annotated Bibliography.* by Constance Boquist and Jeannette V. Haase. Washington, DC: GPO, 1977. 107p. HE20.6016:W84. Annotated bibliography of literature on women in dentistry from 1865 to 1976. Provides a brief summary of the historical status of women in dentistry as revealed in the literature.

1434. U.S. Health Resources Administration. Office of Health Resources Opportunity. *A Study of the Participation of Women in the Health Care Industry Labor Force, Executive Summary.* Rockville, MD: The Administration, 1977. 15p. HE20.6002:W84. Information gathered on career paths of women in the health care fields of nursing, dental hygiene technician, dentistry, and health care administration. Provides insight into factors influencing career choices, career options, family and child care responsibilities, and employment benefits. Includes policy recommendations for encouraging female participation in the health care industry.

1435. U.S. Bureau of Health Manpower. *Student Selection and Retention in Nursing Schools.* by Patricia M. Nash. Washington, DC: GPO, 1978. 75p. HE20.6602:N93/21. Results of a study of nursing school students details characteristics of students, why students are rejected, why students fail to enroll, and why students drop out. Also reports on selection criteria used by nursing schools.

1436. U.S. Bureau of Health Manpower. Division of Nursing. *Nurse Practitioners and the Expanded Role of the Nurse: A Bibliography.* Nursing Planning Information Series 5. Hyattsville, MD: The Bureau, 1978. 247p. HE20.6613:5. Annotated bibliography cites English language books, articles, and reports on the expanded role of the nurse and on the acceptance and effectiveness of nurse practitioners. Also includes related materials on health care delivery and manpower planning.

1437. U.S. Congress. House. *Nurse Training Amendments of 1978, Conference Report to Accompany S. 2416.* H. Rept. 95-1785, 95th Cong., 2d sess., 1978. 11p. Serial 13201-16. Committee report resolves difference between House and Senate versions of a bill to amend the Public Health Services Act by extending nurse training assistance programs for two years. Differences related to traineeship programs for nurse anesthetists, support for nursing education, and other areas.

1438. U.S. Congress. House. Committee on Interstate and Foreign Commerce. *Nurse Training Amendments of 1978, Report to Accompany H.R. 12303.* H. Rept. 95-1189, 95th Cong., 2d sess., 1978. 29p. Serial 13201-7. Report on expansion of nurse training programs under Title VIII of the Public Health Services Act explains program changes in regard to nursing student loans. The legislation also directs the Secretary of HEW to conduct a study of the need to continue federal support programs for nursing education.

1439. U.S. Congress. House. Committee on Interstate and Foreign Commerce. Subcommittee on Health and the Environment. *Nurse Training Amendments of 1978, Hearing on H.R. 11434, H.R. 512 and H.R. 2797, H.R. 2799.* 95th Cong., 2d sess., 20 March 1978.

129p. Y4.In8/4:95-96. Several nurse training measures are considered in this hearing which reviews funding levels, the distribution and supply of nurses, the expanded role of nurses in health care, and the need for nurse practitioner and nurse anesthetist training support.

1440. U.S. Congress. Senate. Committee on Human Resources. *The Nurse Training Amendments Act of 1978, Report to Accompany S. 2416.* S. Rept. 95-859, 95th Cong., 2d sess., 1978. 17p. Serial 13197-5. Reports legislation extending the provisions of the Nurse Training Act for two more years with some minor changes in institutional grant programs. The continued need for federal support of nurse training programs is summarized with arguments supported by excerpts from committee hearings. A brief history of federal support of nurse training is provided.

1441. U.S. Congress. Senate. Committee on Human Resources. Subcommittee on Health and Scientific Research. *Nurse Training Amendments of 1978, Hearing on S. 2416.* 95th Cong., 2d sess., 5 Apr. 1978. 83p. Y4.H88:N93/978. Witnesses at a hearing on a two year extension of federal nurse training programs discusses concern over a predicted over supply of nurses by 1980, the problems of unequal geographic distribution of nurses, and the need to continue to support advanced nurse training programs. The current employment situation for nurses and the improved role of nurses as part of the health care team are cited as reasons for nurses to continue practicing.

1442. U.S. Congressional Budget Office. *Nursing Education and Training: Alternative Federal Approaches.* by Cherly Smith. Washington, DC: GPO, 1978. 77p. Y10.12:N93 Budget issue paper reviews the current nurse supply and projects future supply and demand. Expansion of the nurse's role, national health insurance, and HMO's are among the factors considered. Problems of specialization and geographic distribution are examined. The current status of federal aid to nursing is examined, and alternatives for federal programs are explored.

1443. U.S. National Center for Health Services Research. *Nurse Practitioners and Physicians Assistants, a Research Agenda: Summary of the Proceedings of a Conference Held June 21-22, 1977, Warrenton, Virginia.* Hyattsville, MD: NCHSR Publications and Information Branch, 1978. 20p. HE20.6512/2:N93/2. Summary of a conference on nurse practitioners and physicians assistants presents research agendas and policy recommendations of conference task groups. The primary topics are practice setting variations related to provider performance, cost containment, reimbursement, interpersonal communication, and the impact of training programs on practitioner development as they relate to physicians assistants and nurse practitioners.

1444. U.S. Bureau of Health Manpower. *Health Womenpower: Attaining Greater Influence of Women in the Health Care System, Report of a Regional Conference.* Washington, DC: GPO, 1979. 69p. HE20.6602:W84/3. Speakers and panel presentations highlight the lack of women in administrative and educational positions which can influence the delivery of health care. Ways to move women into positions of influence are discussed.

1445. U.S. Bureau of Health Manpower. *Minorities & Women in the Health Fields: Applicants, Students, and Workers.* Washington, DC: GPO, 1979. 122p. HE20.6602:M66/979. See 1465 for abstract.

1446. U.S. Bureau of Health Manpower. Division of Nursing. *Longitudinal Study of Nurse Practitioners, Phase II.* Washington, DC: GPO, 1979. 178p. HE20.6602:N93/14/phase 2. Detailed data on demographic and employment characteristics of nurse practitioner graduates by type of program is accompanied by brief analysis. Characteristic surveyed include regional location, employment status, role, employment histories, reasons not

employed, income, graduates not functioning as NPs by employment setting, practice setting location, income categories of patients, time spent in NP functions, employment relationship to physician, type of service provided by category of patient, reason for choosing present position, employer's reason for employing NPs, acceptance of the NP role, barriers to NP role development, and job satisfaction.

1447. U.S. Congress. House. *Extension and Revision of Nurse Training and Other Health Programs, Conference Report to Accompany S. 230.* H. Rept. 96-419, 96th Cong., 1st sess., 1979. 15p. Serial 13299. Among the House and Senate differences in a nurse training program extension bill were the House inclusion of a nurse anesthetists program and minor differences in provisions calling for a study of continued federal support of nursing education.

1448. U.S. Congress. House. Committee Interstate and Foreign Commerce. *Nurse Training Amendments of 1979, Report Together with Minority Views to Accompany H.R. 3633.* H. Rept. 96-183, 96th Cong., 1st sess., 1979. 59p. Serial 13293. Reports a bill extending authorization for nurse training programs under Title VIII of the Public Health Service Act and adding a grant program for nurse anesthetists. The bill also makes changes in student nurse loan programs and directs the Secretary of HEW to make a study of the continued need for federal assistance to nurse training. Some history of federal support of nursing education is included. Dissenting views present the argument that there was an adequate supply of nurses and that most of the programs were no longer needed.

1449. U.S. Congress. House. Committee on Interstate and Foreign Commerce. Subcommittee on Health and the Environment. *Nurse Training Act Amendments of 1979, Hearing on H.R. 1143, H.R. 1337, H.R. 1651.* 96th Cong., 1st sess., 22 Mar. 1979. 145p. Y4.In8/4:96-6. Witnesses discuss the nurse supply and demand situation with particular emphasis on geographic distribution and shortage areas, and on the expanded role of nurses. The extent and type of federal aid for nurse education and training is debated.

1450. U.S. Congress. Senate. *Extension and Revision of Nurse Training and Other Health Programs Conference Report to Accompany S. 230.* S. Rept. 96-313, 96th Cong., 1st sess., 1979. 15p. Serial 13244. See 1447 for abstract.

1451. U.S. Congress. Senate. Committee on Labor and Human Resources. *Nurse Training Amendments of 1979, Report to Accompany S. 230.* S. Rept. 96-101, 96th Cong., 1st sess., 1979. 30p. Serial 13238. Recommends legislation extending the nurse training provisions of Title VIII of the Public Health Services Act through 1980, when a study of the country's nursing supply was due for completion. The committee views express a desire to continue nurse training programs and reviews past federal leadership in answering the demand for an adequate nurse supply.

1452. U.S. Congress. Senate. Committee on Labor and Human Resources. Subcommittee on Health and Scientific Research. *Legislative Hearings on S. 544 - Health Planning Amendments of 1979; S. 230 -Nurse Training Amendments of 1979; and S. 590 - Clinical Laboratory Improvements Act of 1979.* 96th Cong., 1st sess., 16 Mar. 1979. 755p. Y4.L11/4:L52. Lengthy hearing on bills extending various health personnel training and health planning measures provides brief testimony in support of nurse training legislation. The current nursing supply and projections for future supply and demand are examined.

1453. U.S. Bureau of Health Manpower. Division of Nursing. *Longitudinal Study of Nurse Practitioners, Phase III.* Washington, DC: GPO, 1980. 221p. HE20.6602:N93/14/phase 3. Survey results and analysis describe nurse practitioner programs and aspects of nurse practitioner practice. Provides detailed data on programs and faculty, financial support, and student characteristics; nurse practitioner graduates and their employment status,

employment experience, income, employment setting, role, and motivational influences; acceptance of the nurse practitioners and barriers to their practice; and job satisfaction.

1454. U.S. Congress. House. Committee on Interstate and Foreign Commerce. Subcommittee on Health and the Environment. *Health Professions Educational Assistance and Nurse Training Act of 1980, Hearing on H.R. 6802, H.R. 6800.* 96th Cong., 2d sess., 20-26 Mar. 1980. 1023p. Y4.In8/4:96-148. Nurse staffing patterns, nursing demand, advanced nurse training, and the practice of nurse-midwifery are among the topics discussed in extensive hearings on health education assistance programs. The nurse shortage and financial aid to nurse education are discussed in relation to the need to provide primary care services. Support of education for physicians and other health professionals is also discussed, particularly in relation to primary care practice and geographic distribution.

1455. U.S. Congress. House. Committee on Interstate and Foreign Commerce. Subcommittee on Oversight and Investigations. *Nurse Midwifery: Consumers' Freedom of Choice, Hearing.* 96th Cong., 2d sess., 18 Dec. 1980. 180p. Y4.In8/4:96-236. Hearing on nurse midwifery devoted much of the time to discussions of dissatisfaction with the current status of obstetrics, with particular reference to cesarean section rates. The testimony on nurse midwifery highlights the politics of this issues as well as current practice.

1456. U.S. Congress. Senate. Committee on Labor and Human Resources. *Health Professions Training and Distribution Act of 1980, Report to Accompany S. 2375.* S. Rept. 96-936, 96th Cong., 2d sess., 1980. 372p. Serial 13330. History and accomplishments of nurse training programs under the Public Health Service Act are reviewed in this favorable report on continued authorization of health personnel training programs. The supply of nurses and the nursing shortage are highlighted. Programs to advance nursing careers through clinical specialist administration or nurse practitioner career paths are noted.

1457. U.S. Congress. Senate. Committee on Labor and Human Resources. Subcommittee on Health and Scientific Research. *Health Professions Education and Distribution Act of 1980, Hearings on S. 2375, S. 2144, S. 2378.* 96th Cong., 2d sess., 10,12 Mar. 1980. 1034p. Y4.L11/4:H34/5. Hearing on bills to amend the PHSA relative to training health professionals explores problems with the supply and distribution of physicians, nurses, and other health professionals. Discussion of ways to provide primary care includes an examination of the role of nurses and nurse practitioners. The role of federal student loan and scholarship programs in allowing low income students to enter the field of nursing is stressed. The need for advanced nurse training and career opportunities in order to retain nurses is also noted.

1458. U.S. National Library of Medicine. *Nurse Practitioners and Physicians' Assistants.* Washington, DC: GPO, 1980. 14p. HE20.3614/2:80-11. Citations from MEDLINE and MEDLARS Health Planning and Administration databases address the economic and legal aspects of the utilization of nurse practitioners and physicians' assistants.

1459. U.S. Public Health Service. *Characteristics of Visits to Female and Male Physicians, the National Ambulatory Medical Care Survey, United States, 1977.* Washington, DC: GPO, 1980. 40p. HE20.6209:13/49. Report on clinical and patient characteristics of visits to office-based physicians analyzes the utilization of practitioners by sex of the physician. Also examines sex differences in the medical practices of physicians.

1460. U.S. Bureau of Health Professions. *The Recurrent Shortage of Registered Nurses: A New Look at the Issues.* Washington, DC: GPO, 1981. 28p. HE20.6602:N93/28. Analysis of patterns of entrance into nursing careers looks at demographics and wages as they relate to the nurse supply and compares nurse labor patterns to patterns in other female dominated professions. Also looks at the reality of the nurse shortage in terms of staffing

and reported vacancies. Furnishes data on salaries for nurses and other female dominated professions, 1960-1978; distribution of RNs according to age, employment status and presence of children; work history of women classified as professional, technical and kindred workers; and monthly starting salaries of general duty nurses, 1952-1976.

1461. U.S. Bureau of Health Professions. Division of Nursing. *Student Selection and Retention in Nursing Schools: Entry into Nursing Part II.* by Patricia M. Nash. Washington, DC: GPO, 1981. 81p. HE20.6602:N93/23/pt.2. Presents data from a survey of nursing schools which examined student backgrounds, application decision factors, reasons for failure to enroll and reasons for dropping out, and employment while enrolled in nursing programs. Follow-up report to 1435.

1462. U.S. Congress. House. Committee on Energy and Commerce. Subcommittee on Health and the Environment. *Health Manpower Legislation, Hearings on H.R. 2004 and H.R. 2056.* 97th Cong., 1st sess., 4,12 Mar. 1981. 670p. Y4.En2/3:97-5. Hearing on bills to fund education of health professionals discusses access to medical care among the poor and ways to support the demand for physicians and nurses. Most of the testimony focuses on physicians, however, witnesses do appear in support of nursing programs. Substantial testimony is presented on the role of nurse-midwives and the obstacles they face in practice. Some discussion is also included on paths for moving women into public health management positions. Support for training in allied health fields and ways to improve minority representation in health professions are also discussed.

1463. U.S. Congress. Senate. Committee on Labor and Human Resources. *Health Professions Education/Nurse Training and National Health Service Corps, 1981, Hearing on S. 799, S. 801.* 97th Cong., 1st sess., 8 Apr. 1981. 563p. Y4.L11/4:H34/14. Information on the supply, demand, and distribution of health care professionals, particularly in nursing and allied health fields, is provided in hearings on federal support for health professions education. The merits of student aid and construction grants as approaches to strengthening health education and ways to encourage graduates to serve in shortage areas are discussed.

1464. U.S. Office of Technology Assessment. *The Implications of Cost-Effectiveness Analysis of Medical Technology, Background Paper #2: Case Studies of Medical Technologies. Case Study #16: The Cost and Effectiveness of Nurse Practitioners.* by Lauren LeRoy and Sharon Solkowitz. Washington, DC: GPO, 1981. 37p. Y3.T22/2:2C82/no.2/case.16. Overview of the utilization of nurse practitioners and other physician extenders also reviews nurse practitioners' effect on health care costs and their employment outlook.

1465. U.S. Bureau of Health Professionals. *Minorities and Women in the Health Fields.* Washington, DC: GPO, 1984. 191p. HE20.9302:M66. Statistical report presents data on enrollment and graduation of women and minorities in allopathic medicine, osteopathic medicine, dentistry, optometry, pharmacy, podiatry, veterinary medicine, nursing, public health, and allied health. The report is divided into two parts, one showing racial/ethnic data and the second presenting gender data. Includes enrollment and graduation data for various years from 1960 through 1983 and some graduation data for individual schools. For earlier editions see 1445.

1466. U.S. Congress. House. *Revising and Extending Title VIII of the Public Health Services Act, Conference Report to Accompany S. 2574.* H. Rept. 98-1143, 98th Cong., 2d sess., 1984. 69p. Serial 13602. Conference report settles differences in House and Senate amendments to a bill extending Title VIII of the PHSA. Title VIII programs affected included the Nurse Training Act and its system of grants for special projects, advanced nurse education, nurse practitioner programs, nurse anesthetists programs, and student loans.

1467. U.S. Congress. Senate. Committee on Labor and Human Resources. *Nurse Education Amendments of 1984, Report to Accompany S. 2574.* S. Rept. 98-492, 98th Cong., 2d sess., 1984. 40p. Serial 13559 Authorization of nurse training programs focuses on continuing education and on encouraging nurses to work in areas with a health manpower shortage. The bill revises the authority for nurse practitioner, nurse midwife, and nurse anesthetist programs. The Bureau of Nursing is also established in the Health Resources and Services Administration.

1468. U.S. Congress. House. Committee on Energy and Commerce. *Health Research Extension Act of 1985, Report Together with Additional Views to Accompany H.R. 2409.* H. Rept. 99-158, 99th Cong., 1st sess., 1985. 170p. Serial 13648 The proposed Health Research Extension Act of 1985 created an Institute of Nursing within the National Institutes of Health to serve as the central nursing research agency. Nursing research conducted under the auspices of the Health Resources and Services Administration Division of Nursing was transferred to the newly created institute.

1469. U.S. Congress. House. Committee on Energy and Commerce. *Nurse Education Act of 1985, Report Together with Additional Views to Accompany H.R. 2370.* H. Rept. 99-161, 99th Cong., 1st sess., 1985. 33p. Serial 13648. Nurse education programs extended by the bill reported here include program and student support for nurse practitioner and nurse midwife training, and traineeships for advanced nurse training and nurse anesthetist programs. The question of the existing and projected supply and demand in the nursing field is briefly explored.

1470. U.S. Congress. House. Committee on Government Operations. Subcommittee on Employment and Housing. *Oversight of the National Labor Relations Board, Hearing.* 99th Cong., 1st sess., 18 June 1985. 161p. Y4.G74/7:N21/3. Oversight hearing on the problem of delays in deciding cases before the NLRB examines the collective bargaining problems of the American Nurses' Association.

1471. U.S. Congress. House. Committee on Post Office and Civil Service. Subcommittee on Compensation and Employee Benefits. *Direct Reimbursement for Nonphysician Health Professionals, Hearing.* 99th Cong., 1st sess., 15 Apr. 1985. 337p. Y4.P84/10:99-58. Witnesses discuss the advantages of authorizing medical insurance direct payments to nonphysician health care providers. Among those lobbying for direct reimbursement are nurse practitioners, nurse-midwives, and nurse anesthetists. Arguments against direct reimbursement, such as predicted cost increases, are examined.

1472. U.S. Congress. Senate. Committee on Labor and Human Resources. *Nurse Education Amendments of 1985, Report to Accompany S. 1284.* S. Rept. 99-106, 99th Cong., 1st sess., 1985. 53p. Serial 13620. Reports a bill authorizing nurse education funds for advanced nurse education, nurse practitioner, nurse midwife, and nurse anesthetists programs, nursing student loans, and traineeships for nurses in masters' and doctoral degree programs. Also included are programs to increase opportunities for individuals from disadvantaged backgrounds and to improve the supply and distribution of nurses by geographic area or specialty group.

1473. U.S. Congress. House. Committee on Post Office and Civil Service. *Direct Reimbursement of Certain Health Care Providers under the Federal Employees' Health Benefits Program, Report to Accompany H.R. 4825.* H. Rept. 99-710, 99th Cong., 2d sess., 1986. 15p. Serial 13704. Reports a bill to allow, when appropriate, direct payment to nurse practitioners, nurse-midwives, nurses, clinical social workers, and other health care professionals under the Federal Employees' Health Benefits Program.

1474. U.S. Office of Technology Assessment. *Nurse Practitioners, Physician Assistants, and Certified Nurse-Midwives: A Policy Analysis.* Health Technology Case Study no. 37. Washington, DC: GPO, 1986. 88p. Y3.T22/2:2C82/2/case 37. Review of the literature shows that nurse practitioners, physician assistants, and certified nurse-midwives provide equivalent care to that of physicians, and that nurse practitioners and nurse-midwives communicate more effectively with patients. Physician acceptance is discussed noting their reservations about the utilization of nurse practitioners and nurse-midwives. Evidence of the effect of nonphysician providers on physician productivity, costs, and access to health care are examined. The issue of payment for services to non-physician providers is also reviewed. An extensive bibliography is furnished.

1475. U.S. Congress. House. Committee on Veterans' Affairs. *Veterans' Omnibus Health Care Amendments of 1987, Report to Accompany H.R. 3449.* H. Rept. 100-373, 100th Cong., 1st sess., 1987. 31p. Serial 13807. Among the provisions of the bill reported is an authorization for incentive pay for nurses who agreed to work for the Veterans Administration in shortage areas for two to four years. Some of the problems faced by the VA in recruiting nurses are summarized.

1476. U.S. Congress. Senate. Committee on Finance. Subcommittee on Health. *Nurse Shortages, Hearing.* 100th Cong., 1st sess., 30 Oct. 1987. 132p. Y4.F49:S.hrg.100-530. Causes of the nurse shortage are examined in this hearing which is characterized by recurring themes of low wages and poor treatment. Also discusses Medicare and Medicaid reimbursement for nurse practitioners and government support for nurse education. Testimony reveals the politics of hospital and medical school financing as it relates to nursing programs. Also discusses the baccalaureate degree as the minimum professional nursing degree and its effect on the ability of women from low income families to enter the field. The earnings potential for RN's is viewed as a serious problem. Trends in the employment of nurses and the extent of the nurse shortage are detailed with limited suggestions on government methods of addressing the problem.

1477. U.S. Congress. Senate. Committee on Labor and Human Resources. *Nursing Shortage Reduction Act of 1987, Report to Accompany S. 1402.* S. Rept. 100-132, 100th Cong., 1st sess., 1987. 14p. Serial 13735. Provisions of a bill designed to address the shortage of nurses include the establishment of an advisory committee charged with developing a plan to address the nurse supply problems and grants for demonstration programs to reduce hospital nursing vacancies and to design and operate model professional nurse recruitment centers. Brief background on the nurse shortage is provided.

1478. U.S. Congress. Senate. Committee on Labor and Human Resources. *Public Health Service Act Infant Mortality Amendments of 1987, Report to Accompany S. 1441.* S. Rept. 100-137, 100th Cong., 1st sess., 1987. 22p. Serial 13735. Bill aimed at reducing infant mortality in areas with high mortality rates includes a nursing school grant program to assist schools in training nurse-midwives and pediatric, family, obstetric and gynecologic nurse practitioners.

1479. U.S. Congress. Senate. Committee on Veteran's Affairs. *Various Bills Relating to Veterans' Health Care, Hearing on S. 6, S. 105, S. 216, S. 631, S. 713, S. 894, S. 1195, and Related Bills.* 100th Cong. 1st sess., 21 May 1987. 575p. Y4.V64/4:S.hrg.100-427. One of the major topics addressed in this hearing is the ability of the Veterans Administration to recruit and retain qualified personnel, particularly nurses. The factors such as pay and treatment which contribute to the nurse recruitment problems of the VA are examined and actions to address these problems are discussed. The inadequacy of the bonus pay program to recruit and retain nurses is noted. Support of nursing education in the VA is evaluated and the personnel rules relating to nurses are examined.

1480. U.S. Bureau of Health Professions. Division of Nursing. *Analysis of the Environment for the Recruitment & Retention of Registered Nurses in Nursing Homes.* by Dale C. Jones, et al. Washington, DC: GPO, 1988. 464p. HE20.9302:R26/2. Detailed report examines the working environment for registered nurses employed in nursing homes. Data collected and examined includes the utilization, retention, and recruitment of RN's in the nursing home setting and comparisons to RN's employed in non-nursing home settings. The majority of the report presents questionnaire results on factors affecting recruitment and retention of nursing personnel.

1481. U.S. Congress. House. Committee on Energy and Commerce. *Nurse Shortage Reduction and Education Extension Act of 1988, Report Together with Additional Views to Accompany H.R. 4833.* H. Rept. 100-762, 100th Cong., 2d sess., 1988. 38p. Serial 13898. Legislation to revise and extend nurse education programs under Title VIII of the Public Health Service Act includes scholarships for needy students and grants to develop innovative nursing practice models. Also supports nurse practitioner, nurse-midwife, and nurse anesthetist programs, and professional nurse traineeships. Brief background on the nurse shortage situation is provided.

1482. U.S. Congress. House. Committee on Energy and Commerce. Subcommittee on Health and the Environment. *Health Manpower, Hearings.* 100th Cong., 2d sess., 19 Jan. - 18 Apr. 1988. 945p. Y4.En2/3:100-150. Hearing focusing primarily on the shortage of nurses includes testimony on the low pay, lack of benefits, and poor working conditions. The need to improve the professional recognition of nurses if young women are to be recruited to the field is stressed. Reauthorization of the Nurse Education Act and discussion of foreign medical school graduates is also included.

1483. U.S. Congress. House. Committee on the Judiciary. Subcommittee on Immigration, Refugees, and International Law. *Legal Immigration Legislation, Hearing on H.R.1683, H.R. 2478, H.R. 2705, H.R. 3143, H.R. 4079, H.R. 4081, and H.R. 4428.* 100th Cong., 2d sess., 21 July 1988. 52p. Y4.J89/1:100/54. Among the bills discussed is a measure to improve foreign recruiting of nurses to help address the U.S. nursing shortage. The existing one year blanket extension of visas for nurses is examined and possibilities for providing citizenship opportunities for female nurses after ten years of nursing service in the U.S. is discussed.

1484. U.S. Congress. House. Select Committee on Aging. *Health Care in the 21st Century: Who Will Be There to Care? a Report by the Chairman of the Select Committee on Aging.* 100th Cong., 2d sess., 1988. Committee print. 26p. Y4.Ag4/2:H34/42/prt. Overview of information from hearings describes the outlook for the health professions and specifically notes contributing factors in the nurse shortage.

1485. U.S. Congress. House. Select Committee on Aging. *Health Care in the 21st Century: Who Will Be There to Care? Hearing.* 100th Cong., 2d sess., 20 Sept. 1988. 129p. Y4.Ag4/2:H34/42. Witnesses discussing health care provider shortages primarily explore the utilization, compensation, and working conditions of nurses and their effect on recruitment and retention. The inadequacy of pouring more money into training as a solution is noted.

1486. U.S. Congress. Senate. Committee on Labor and Human Resources. *National Research Institute Reauthorization Act of 1988, Report to Accompany S. 2222.* S. Rept. 100-362, 100th Cong., 2d sess., 1988. 116p. Serial 13860. One of the institutes expanded under this bill reauthorizing the National Research Institutes established under Title IV of the Public Health Service Act is the National Center for Nursing Research. New NCNR programs include grants for demonstration projects aimed at improving recruitment and retention of nurses and the quality of the in-hospital nursing role.

1487. U.S. Congress. Senate. Committee on Labor and Human Resources. *Nurse Education Reauthorization Act of 1988, Hearing on S. 2231.* 100th Cong., 2d sess., 14 Apr. 1988. 159p. Y4.L11/4:S.hrg.100-841. Hearing on reauthorization of Title VIII of the Public Health Service Act presents testimony on the shortage of nurses and the role of federal support of nursing education. The problem of low salaries as it relates to the nurse shortage is also highlighted.

1488. U.S. Congress. Senate. Committee on Labor and Human Resources. *Nurse Education Reauthorization Act of 1988, Report to Accompany S. 2231.* S. Rept. 100-476, 100th Cong., 2d sess., 1988. 29p. Serial 13865. Extension of nurse education programs under Title VIII of the Public Health Service Act includes new authority for nurse retention and recruitment demonstration grants and scholarships for undergraduate nurse education programs. Nurse practitioner, nurse midwife, and nurse anesthetist programs are also extended. Trends in the nursing supply and recent efforts to cut nurse education programs are briefly summarized in the explanation of the need for this legislation.

1489. U.S. Congress. Senate. Special Committee on Aging. *Vanishing Nurses: Diminishing Care, Hearing.* 100th Cong., 2d sess., 6 Apr. 1988. Philadelphia, PA. 115p. Y4.Ag4:S.hrg.100-942. The problems in the nursing supply and ways to address the recruitment and retention of nursing personnel are addressed by hearing witnesses. Trends in the nursing labor force and the working conditions of nurses are the main topics. The effect of Medicare caps on hospital costs and the resulting shift of housekeeping and other nonprofessional service tasks to nurses is also discussed.

1490. U.S. Health Resources and Services Administration. *Nursing Shortage: Strategies for Nursing Practice and Education, Report to the National Invitational Workshop, February 22-24, 1988.* Washington, DC: GPO, 1988. 161p. HE20.9302:N93/8. Papers presented at a conference on strategies for addressing the nurse shortage review the state of nursing manpower, and examine recruitment and retention strategies for nursing education and practice. Participants stress the need to enact long-term solutions, not just stop-gap measures.

1491. U.S. National Institutes of Health. *Practice Nursing at the Leading Edge.* Bethesda, MD: The Institutes, 1988. 16p. HE20.3002:N93/9. Recruiting booklet describes opportunities for nurses at the Clinical Center of the National Institutes of Health.

1492. U.S. National Library of Medicine. *Resources for the History of Nursing in the National Library of Medicine History of Medicine Division.* Bethesda, MD: The Library, 1988. 2p. HE20.3621:N93.

1493. U.S. Congress. House. Committee on the Judiciary. *Immigration Nursing Relief Act of 1989, Report to Accompany H.R. 3259.* H. Rept. 101-288, 101st Cong., 1st sess., 1989. 16p. Reports a bill allowing nurses on H-1 nonimmigrant visas to remain in the U.S. and authorizing a pilot program for admitting alien nurses to work in shortage areas. The features of the bill, which attempts to balance concerns of the nursing profession and health care providers having difficulty recruiting nurses, are described.

1494. U.S. Congress. House. Committee on the Judiciary. Subcommittee on Immigration, Refugees, and International Law. *Immigration Nursing Relief Act of 1989, Hearing on H.R. 1507 and H.R. 2111.* 101st Cong., 1st sess., 31 May 1989. 318p. Y4.J89/1:101/13. Hearing considers a bill to create a separate immigration category for nurses to ensure a longer term solution to the nursing shortage in the United States. Provisions of the bill to protect the domestic labor supply and to treat the nonimmigrant status of nurses fairly are explored. The long term nature of the nursing shortage and the reliance of urban hospitals on nonimmigrant status nurses is discussed.

1495. U.S. Congress. House. Committee on Veterans' Affairs. *Improving Recruitment and Retention of Nurses in the Department of Veterans Affairs and to Authorize Procreative Services for Certain Disabled Veterans, Report to Accompany H.R. 1199.* H. Rept. 101-106, 101st Cong., 1st sess., 1989. 24p. Report details the problems of the Department of Veteran's Affairs in recruiting nurses and presents the provisions of a bill to provide more flexibility in the pay schedule for nurses. The bill also authorizes reproductive services for disabled veterans.

1496. U.S. Congress. House. Committee on Veterans' Affairs. Subcommittee on Hospitals and Health Care. *H.R. 901 and H.R. 1199, and Other Health Care Initiatives, Hearing.* 101st Cong., 1st sess., 12 Apr. 1989. 233p. Y4.V64/3:101-6. A major part of this hearing on veterans' health care proposals is discussion of the critical shortage of nurses and solutions to recruit and retain nurses in VA hospitals. The effect on patient care and nurse working conditions of the nurse shortage and VA hospital staff cutbacks is discussed. One of the proposals would provide more flexibility for nursing salaries at VA hospitals.

1497. U.S. Congress. Senate. Committee on Veterans' Affairs. *Consideration of VA Health-Care Legislation, Hearing on S. 13 (Sections 211, 213-215, and 222-225), S. 165, S. 573, S. 574, S. 748, S. 899, S. 900, S. 947, and S. 1004.* 101th Cong., 1st sess., 18 May 1989. 432p. Y4.V64/4:S.hrg.101-443. Considers various VA health care legislative proposals with discussion of ways to address the nurse shortage. The focus of proposals is on better utilization of nursing personnel and greater flexibility in nurse pay scales.

1498. U.S. Congress. Senate. Committee on Veterans' Affairs. *Veterans Benefits and Health Care Act of 1989, Report to Accompany S. 13 Together with Additional Views.* S. Rept. 101-126, 101st Cong., 1st sess., 1989. 583p. Lengthy report details the provisions of the Veterans Benefits and Health Care Act of 1989 and provides discussion of the retention of nursing personnel and their wage rates. Education benefits for survivors and dependents are also covered.

1499. U.S. National Center for Health Services Research and Health Care Technology Assessment. *Nursing Shortage in the Hospital Sector, 1982-87.* Washington, DC: GPO, 1989. 45p. HE20.6502:N93/2. Analysis of data on the nursing shortage in the hospital sector examines labor markets and regional factors, nursing salaries, staff mix, case mix, and hospital utilization.

1500. U.S. Public Health Service. *Nurses in the PHS Celebrate Proud History.* by Cynthia Bender. Rockville, MD: The Service, 1989. 3p. HE20.2:D36/3. Concise overview of nursing in the Public Health Service provides some historical background on PHS nursing, the Cadet Nurse Corps, support for nursing education and research, and current assignments of Civil Service and Commissioned Corps nurses.

1501. U.S. Veterans Health Services and Research Administration. *Licensed Practical/Vocational Nurses in the Department of Veterans Affairs: Nationwide Opportunities.* Washington, DC: The Administration, 1989. 4p. VA1.22:10-21/989.

1502. U.S. Bureau of Health Professions. Division of Nursing. *The Registered Nurse Population: Findings from the National Sample Survey of Registered Nurses, March 1988.* by Evelyn B. Moses. Washington, DC: The Bureau, 1990. 111p. HE20.9302:R26/988. Detailed report profiles registered nurses in the U.S. and examines social and economic characteristics, educational background, characteristics of employment, and geographic distribution.

1503. U.S. Congress. House. Committee on Energy and Commerce. Subcommittee on Health and the Environment. *Wage Rates for Nursing Facilities Personnel, Hearing on H.R.*

1649. 101st Cong., 2d sess., 20 July 1990. 169p. Y4.En2/3:101-180. Hearing considers a bill to require Medicaid participant nursing homes to pay nursing personnel a wage rate equal to the average rate paid non-nursing home nursing personnel. The effect of low wages on the shortage of nursing personnel and the lower quality of nursing personnel at nursing homes is noted. Factors such as low wages and poor working conditions which are generally considered to contribute to the nurse shortage are examined.

1504. U.S. Congress. House. Committee on Veterans' Affairs. *Department of Veterans Affairs Health Professional Compensation and Labor-Relations Act of 1990, Report to Accompany H.R. 4557.* H. Rept. 101-466, 101st Cong., 2d sess., 1990. 90p. Report on a bill addressing recruitment and retention of health professionals for VA hospitals details a provision adjusting pay grades and pay administration for VA nurses. Background materials and discussion of each of the bills' provisions are provided.

1505. U.S. Congress. Senate. Select Committee on Indian Affairs. *Indian Health Service Nurse Shortage, Hearing.* 101st Cong., 2d sess., 14 June 1990. 173p. Y4.In2/11:S.hrg.101-1004. Hearing explores the status of nurses and nursing care in the Indian Health Service. Although salary issues are addressed, the primary focus of testimony is on the working conditions and status of nurses. The need for adequate nursing staff and support services to relieve nurses of non-nursing duties is stressed. The sense of many nurses that they need more recognition and more power within hospital administration is also a common theme. The lack of understanding of tribal culture at IHS facilities is also noted as is the need for IHS support for nursing education for Native Americans.

1506. U.S. General Accounting Office. *VA Health Care: Nursing Issues at the Albuquerque Medical Center Need Attention.* Washington, DC: The Office, 1990. 34p. GA1.13:HRD-90-65. Review of concerns expressed by nursing staff at the Albuquerque Medical Center identifies problems in pay and staff levels and suggests remedial action. The need for management and the nurses' union to form a better working relationship to address the nurses' concerns is stressed. Actions already taken by management to address compensation issues are detailed.

1507. U.S. Veterans Health Services and Research Administration. *VA Nursing: The New Department of Veterans Affairs.* Washington, DC: The Administration, 1990. 16p. VA1.22:10-11/990. Glossy booklet describes nursing career opportunities with the Department of Veterans Affairs.

SERIALS

1508. District of Columbia. Gallinger Municipal Hospital. *Prospectus, Capital City School of Nursing of Gallinger Municipal Hospital, Washington.* Washington, DC: The Hospital, 1931 - 1936. irregular. DC54.2:N93/year. Edition for 1931 called *Capital City School of Nursing, Announcement.*

1509. U.S. Public Health Service. *Bulletin of the Freedman's Hospital School of Nursing.* Washington, DC: GPO, 1957/58 - 1967/68. irregular. FS2.54/3:years. Edition for 1957/58 issued under SuDoc number FS2.54/2:N93/2/957-58.

1510. U.S. Public Health Service. *The Nurse in the U.S. Public Health Service.* Washington, DC: GPO, 1949-1961. irregular. FS2.2:N93/21/year. Basic information on nursing careers with the government lists appointment requirements for Public Health Service nurses in the civil service, commissioned corps (regular), and commissioned corps (reserve).

1511. U.S. Public Health Service. *Total Number of Public Health Nurses Employed in the United States, in the Territories of Hawaii and Alaska and in Puerto Rico and the Virgin Islands on January First of the Years...* Washington, DC: The Service, 1937-41 - 1941-45. annual. FS2.2:N93/11/years. Presents yearly data on the number of nurses employed by state agencies and rural and urban agencies by state and by education. Title varies with earlier versions lacking data on Puerto Rico and the Virgin Islands. For later title see 1513.

1512. U.S. Public Health Service. Division of Nursing. *Cadet Nurse Corps News.* Washington, DC: GPO, Apr. 1945 - Jan. 1948. vol. 1 no. 1 - vol. 2 no. 4. irregular. FS2.48:vol./no. Photos, news notes, marriage notices and short articles on corps activities are found in this newsletter which chronicles the Cadet Nurse Corps from 1945 through the first graduating class in 1948. Most issues are four pages long and include photographs.

1513. U.S. Public Health Service. Division of Public Health Nursing. *Annual Census of Nurses Employed for Public Health Work in the United States and Territories on January 1, 1953.* Washington, DC: The Service, 1954? 14p. FS2.81:953. For later title see 1515 and for earlier title see 1511.

1514. U.S. Public Health Service. Division of Public Health Nursing. *Nurses in Public Health, Number and Educational Preparation of Nurses Employed in Public Health Work in United States, Puerto Rico, and Virgin Islands on ...* Washington, DC: GPO, 1960-1966. biennial. FS2.81:960-966. State data on public health nurses includes type of employer, full-time or part-time status, and educational preparation. For earlier title see 1515.

1515. U.S. Public Health Service. Public Health Nursing Branch. *Census of Nurses Employed for Public Health Work in the United States, in the Territories of Alaska and Hawaii, and in Puerto Rico and the Virgin Islands, on January 1, 1955.* Washington, DC: The Service, 1956? 24p. FS2.81:955. For earlier title see 1513, and for later title see 1514.

1516. U.S. Superintendent of Documents. *Nurses and Nursing Care.* Washington, DC: GPO, 1982? - . irreg. GP3.22/2:019/year. Lists selected documents available from the Superintendent of Documents on the nursing profession and nursing care.

10

Military Nursing and Health Care Providers

The reports on military nursing document the slow gains in status and recognition of nurses serving in the armed forces. The earliest documents, House and Senate reports issued between 1892 and 1896, praise the role of female nurses in the Civil War and request compensation for their services. A bill to establish a permanent civilian nurse corps for service with the Army was reported in 1899 (1530), and the establishment of a Navy nurse corps was considered in hearings and reports between 1903 and 1908.

Two issues dominate the congressional documents on the various nurse corps through World War Two. The first is the question of retirement pensions, which centered on the issue of years of service required and the age of retirement (1568), and on disability retirement (1585). The pay and rank of nurses in the Army Nurse Corps was debated at length in 1942 in relation to a temporary measure to raise the nurse compensation to equal that of male officers of the same rank (1602). One of the most debated issues was the granting of actual rank to nurse corps members (1637). A selective service for nurses was supported in 1945 House and Senate reports (1642, 1647) and the recruitment of nurses and military pay was discussed at length in hearings on the proposed nurses draft (1649). The lifestyle and concerns of Army nurses during World War Two are nicely reflected in *The Army Nurse*, a newsletter issued between early 1944 and late 1945 (1768). The most extensive revision of the status of military nursing came as the result of the Army Navy Nurses Act of 1947, an act which established a permanent Nurse Corps (1661-1662).

The difficulty in recruiting young women in the early 1950's is reflected in a series of measures to temporarily raise the maximum age limit for appointments. The difficulty in recruiting nurses is also seen in discussions of the 1957 Nurse and Medical Specialists Career Incentive Act (1717-1720). The recruiting materials listed in the bibliography are interesting in the way they reveal the military establishment's view of what would appeal to women. Of special interest is the 1983 Army Nurse Corps recruiting handbook, which tells recruiters how to sell the corps to potential recruits (1751).

The appointment of women as physicians is also covered in hearings and reports. Among the more interesting of these is a 1950 hearing at which it was suggested that female physicians be placed in the WAC in order to avoid treating them equal to male Army officers (1684).

A history of the Army Nurse Corps through World War One was published in 1927 (1574) and in 1987 the Army Center of Military History published *Highlights in the History of the Army Nurse Corps* (1757). A brief history of the Navy Nurse Corps is provided in the 1945 document, *White Task Force: The Story of the Nurse Corps, United States Navy* (1645). Additional documents relating to military nursing are located in Chapter 9, Women in Medical Professions, in Chapter 11, Women in the Armed Forces, and in Chapter 12, War Work and Civil Defense.

1517. U.S. Congress. House. *Payment of Female Nurses: Letter from the Secretary of War in Answer to Committee on Military Affairs, Relative to Payment of Female Nurses for Services during the Late War.* H. Ex. Doc. 270, 42d Cong., 2d sess., 1872. 1p. Serial 1515. Factual letter describes amounts paid to nurses during the Civil War.

1518. U.S. Congress. House. Committee on Pensions, Bounty, and Back Pay. *Payment of Female Nurses during the War, Report to Accompany Bill H.R. 307.* H. Rept. 1292, 48th Cong., 1st sess., 1884. 1p. Serial 2257. Reports, with amendments, a bill to provide compensation to women who served as nurses in the Civil War.

1519. U.S. Congress. House. Committee on War Claims. *Payment of Female Nurses, Report to Accompany Bill H.R. 8322.* H. Rept. 1940, 49th Cong., 1st sess., 1886. 2p. Serial 2441. Favorable report briefly describes the service of female nurses in the Civil War and their present state of fiscal and physical health, and asks that they be granted monetary compensation for their services.

1520. U.S. Congress. House. Committee on War Claims. *Female Nurses Who Served in the War of the Rebellion, Report to Accompany Bill H.R. 7392.* H. Rept. 285, 50th Cong., 1st sess., 1888. 2p. Serial 2600. Favorable report reprints H. Rept. 1940, 49th Congress (1519) as an explanation of the bill and of the committee's reasoning.

1521. U.S. Congress. Senate. Committee on Pensions. *Report to Accompany Bill S. 373 [for the Relief of Women Enrolled as Army Nurses].* S. Rept. 569, 50th Cong., 1st sess., 1888. 3p. Serial 2520. Favorable report on a pension bill for Army nurses consists primarily of a letter from the Army Nurses Association stating the justification for the pension amount requested.

1522. U.S. Congress. House. Committee on Invalid Pensions. *Women Enrolled as Army Nurses, Report to Accompany H.R. 11256.* H. Rept. 2632, 51st Cong., 1st sess., 1890. 2p. Serial 2814. Favorable report reviews the total number of women who served as nurses in the Civil War by the authority under which they served. The report further attempts to estimate the number and ages of surviving women who would be eligible for pensions under this act.

1523. U.S. Congress. House. Committee on War Claims. *Female Nurses in the War of the Rebellion, Report to Accompany Bill H.R. 6469.* H. Rept. 282, 51st Cong., 1st. sess., 1890. 2p. Serial 2807. Favorable report describes the sacrifice of the women who served as nurses in the Civil War and recommends that those who were old, infirm, and with no means of support be granted pensions.

1524. U.S. Congress. Senate. Committee on Pensions. *Report to Accompany Bill S. 945 [For the Relief of Women Enrolled as Army Nurses, etc.]* S. Rept. 326, 51st Cong., 1st sess., 1890. 2p. Serials 2704. Reports, with amendments, a bill to provide pensions to women serving as Army nurses during the Civil War.

1525. U.S. Congress. House. Committee on Invalid Pensions. *Army Nurses, Report to Accompany H.R. 7294.* H. Rept. 802, 52d Cong., 1st sess., 1892. 2p. Serial 3044. Favorable report on a bill to pension the women who served as Army nurses in the Civil War briefly reviews the number of women who would be pensioned and applauds the service these women provided. This report is also reprinted in S. Rept. 1031 (1526).

1526. U.S. Congress. Senate. Committee on Pensions. *Report to Accompany H.R. 7294 [for Pensions to Army Nurses].* S. Rept. 1031, 52d Cong., 1st sess., 1892. 2p. Serial 2915. The committee reports S. 945, 31st Congress, in substitute of H.R. 7294, both bills

designed to provide pensions to Army nurses who served in the Civil War. The House Report 802 (1525), which summarizes the case for the pensions, is appended.

1527. U.S. Congress. House. Committee on Invalid Pensions. *Pensions to Army Nurses, Report to Accompany H.R. 6891.* H. Rept. 1585, 54th Cong., 1st sess., 1896. 2p. Serial 3462. Favorable report on a bill amending the act granting pensions to Army nurses who served in the Civil War points out the problems encountered by former nurses attempting to qualify under the existing law.

1528. U.S. Congress. House. Committee on Military Affairs. *Burials in National Cemeteries, Report to Accompany H.R. 8443.* H. Rept. 2127, 54th Cong., 1st sess., 1896. 2p. Serial 3465. Appended to this favorable report on a bill to permit the burial of Army nurses at Arlington National Cemetery is correspondence from the Secretary of War detailing the War Department's past response to a request to allow the burial of a former Army nurse in a national cemetery.

1529. U.S. Congress. Senate. Committee on Military Affairs. *Burials in National Cemeteries, Report to Accompany H.R. 8443.* S. Rept. 1447, 54th Cong., 2d sess., 1897. 2p. Serial 3475. Report supports a bill amending the criteria for burial in Arlington National Cemetery to include honorably discharged nurses. The negative reply of the Secretary of War to Mrs. S.O. Ver Planck, who had requested that a portion of Arlington be set aside for members of the Army Nurses Association, is appended.

1530. U.S. Congress. House. Committee on Military Affairs. *Women Nurses in Military Hospitals of the Army, Report to Accompany H.R. 11770.* H. Rept. 1905, 55th Cong., 3d sess., 1899. 4p. Serial 3840. Favorable report with amendments on a bill to establish a permanent civilian nurse corp within the Army reviews the details of the corps' organization and regulations.

1531. U.S. Congress. Senate. *Traveling Expenses of Army Nurses: Letter from the Secretary of War, Transmitting a Letter and Signed Memorandum from the Surgeon-General of the Army Urging that Provision Be Made in the General Deficiency Bill for the Traveling Expenses of Army Nurses.* S. Doc. 368, 56th Cong., 1st sess., 1900. 3p. Serial 3875. Requests amendment of the Army deficiency bill to allow payment of travel expenses to nurses who were called to duty by telegram before signing their government contract.

1532. U.S. Congress. Senate. *Letter from the Secretary of War, Transmitting a Letter from the Commission-General of Subsistence of the Army Relative to Commutation of Rations for Members of the Nurse Corps.* S. Doc. 181. 56th Cong., 2d sess., 1901. 2p. Serial 4042.

1533. U.S. Congress. House. Committee on Naval Affairs. *Hearing on Appropriation Bill Subjects No. 30, Surgeon-General Rixey's Recommendations on Personnel, Nurse Corps, Dental Corps, Fort Bayard Hospital and Hospital Naval Academy.* 57th Cong., 2d sess., 7 Jan. 1903. 2p. Greenwood H71-0.31. Letter of transmittal for no. 30-2, the Nurse Corps Bill.

1534. U.S. Congress. House. Committee on Naval Affairs. *Hearing on Appropriation Bill Subjects No. 30-2, Personnel - Medical Corps -Surgeon-General Rixey.* 57th Cong., 2d sess., 6 Jan. 1903? 2p. Greenwood H71-0.33. Page two contains the text of a bill to establish a Nurse Corps in the Navy.

1535. U.S. Army. *Circular of Information Relative to Appointment in Army Nurse Corps, Qualifications, Examination of Applicants, etc.* Washington, DC: The Department, 1905. 6p. W44.5:N93. Later see W44.5:N93/no.

1536. U.S. Congress. House. Committee on Naval Affairs. *Hearings ... Appropriation Bill Subjects 1907, No. 3, To Reorganize and Increase Hospital Corps of the Navy.* 59th Cong., 1st sess., 15 Dec. 1905. 13-15pp. Greenwood HN59-C.3. Letter of transmittal from Surgeon General P.M. Rixey accompanies three proposed bills, one of which would establish the Navy Nurse Corps. Essentially the same as No. 39 (1537) which merged the three bills.

1537. U.S. Congress. House. Committee on Naval Affairs. *Hearings...Appropriation Bill Subjects 1907, No. 39, Draft of Bill Regarding Personnel of Navy - Department Letter.* 59th Cong., 1st sess., 24 Jan. 1906. 293-294pp. Greenwood HN59.C.39. Transmittal of a draft bill which would, among other things, establish the Navy Nurse Corps. The bill sets the pay, appointment provisions, and basic organization of the corps.

1538. U.S. Congress. Senate. Committee on Pensions. *Pensions of Army Nurses, Report to Accompany S. 695.* S. Rept. 4809, 59th Cong., 2d sess., 1907. 3p. Serial 5060. Favorable report on raising the pensions granted to Army nurses who served in the Civil War also presents views of the minority which stress the fact that most of the nurses served less than a year, and that the soldiers and their widows received less consideration relating to pensions.

1539. U.S. Congress. House. *Estimate for Quarters for Officers and Nurses at Fort Bayard, New Mexico; Letter from the Acting Secretary of the Treasury, Transmitting a Copy of a Communication from the Secretary of War Submitting an Estimate of Appropriations for Construction at Fort Bayard, New Mexico, for Quarters for Officers and Nurses.* H. Doc. 436, 60th Cong., 1st sess., 1908. 3p. Serial 5375.

1540. U.S. Congress. House. Committee on Naval Affairs. *For the Establishment and Organization of a Corps of Trained Women Nurses for the United States Navy, Report to Accompany H.R. 15438.* H. Rept. 1309, 60th Cong., 1st sess., 1908. 5p. Serial 5225. Favorable report on a bill to establish a Navy female nurse corps equivalent to the Army's nurses corps includes correspondence noting the superiority of trained female nurses in the care of the sick and wounded. The need for female nurses in time of war mobilization is also noted.

1541. U.S. Congress. House. Committee on Naval Affairs. *Hearings on Estimates Submitted by the Secretary of the Navy, 1908-1909, No. 38, for the Establishment and Organization of a Corps of Trained Women Nurses for the United States Navy - Department Letter.* 60th Cong., 1st sess., 3 Mar. 1908. 841-842pp. Y4.N22/1:Es8/2. Letter from Rixey addresses the problem of lower pay for male nurses vis-a-vis other enlisted men and only mentions the establishment of a female nurse corps in passing.

1542. U.S. Congress. Senate. Committee on Pensions. *Pensions of Army Nurses, Report to Accompany S. 185.* S. Rept. 1801, 60th Cong., 2d sess., 1909. 2p. Serial 5380. Favorable report on a bill to raise the pension rates for female nurses who served in the Civil War adopted the report (1538) of the previous Congress on a similar bill.

1543. U.S. Congress. Senate. Committee on Pensions. *Pensions of Nurses in Certain Cases, Report to Accompany S. 185.* S. Rept. 1096, 60th Cong., 2d sess., 1909. 3p. Serial 5380. Favorable report on a bill to extend eligibility for pensions to volunteer Civil War nurses who could prove their service provides a breakdown by age of pensioned Army nurses.

1544. U.S. Navy. Bureau of Medicine and Surgery. *Regulations and Instructions for Nurse Corps, Navy, 1909.* Washington, DC: The Bureau, 1909. 19p. N10.13:N93.

1545. U.S. Congress. House. Committee on Naval Affairs. *Estimates Submitted by the Secretary of the Navy, Hearing, 1910, No. 49, Nurse Corps, Quarters for.* 61st Cong., 2d sess., 19 Jan. 1910. 669-670pp. Y4.N22/1:Es8/4. Letter transmitted proposed legislation to take care of a problem in paying Nurse Corps officers an allowance for housing. The problem was the result of a lack of government quarters for nurses.

1546. U.S. Congress. Senate. Committee on Pensions. *Army Nurses in the Civil War, Report to Accompany S. 5251.* S. Rept. 564, 61st Cong., 2d sess., 1910. 3p. Serial 5583. Favorable report on S. 5251, a bill to add women who served as voluntary nurses during the Civil War to the pension rolls, adopts S. Rept. 1096 (1543) on a similar bill.

1547. U.S. Congress. House. Committee on Invalid Pensions. *Pensions for Volunteer Army Nurses, Report to Accompany H.R. 21721.* H. Rept. 1006, 62d Cong., 2d sess., 1912. 2p. Serial 6133. Reports a bill to grant pensions to nurses who served on a voluntary basis during the Civil War on an equal bases with enlisted Army nurses.

1548. U.S. Congress. House. Committee on Military Affairs. *Leave of Absence for Female Nurse Corps, Report to Accompany H.R. 18781.* H. Rept. 285, 62d Cong., 2d sess., 1912. 2p. Serial 6129. The bill reported provided for cumulative leaves of absence for members of the Female Nurse Corps serving outside the U.S. or in Alaska, the same as to male Army officers. Similar in intent to S.4749, favorably reported in the Senate (1549).

1549. U.S. Congress. Senate. Committee on Military Affairs. *Female Nurse Corps in Alaska, etc., Report to Accompany S. 4749.* S. Rept. 243, 62 Cong., 2d sess., 1912. 2p. Serial 6120. Report supports a bill to equalize provisions for leaves of absence between Army officers and nurses serving outside the limits of the United States.

1550. U.S. Congress. Senate. Committee on the Library. *Monument to Memory of Members of Various Orders of Sisters, Nurses in Civil War, Report to Accompany S.J.Res. 143.* S. Rept. 747, 64th Cong., 1st sess., 1916. 2p. Serial 6899. The resolution reported would allow the erection of a monument in Arlington National Cemetery to the women who served as nurses in the Civil War.

1551. U.S. Army. *Army School of Nursing Announcement, 1918-19.* Washington, DC: The Department, 1918. 5p. W44.2:N93.

1552. U.S. Congress. House. Committee on Invalid Pensions. *Increasing Pensions of Army Nurses, Report to Accompany H.R. 7738.* H. Rept. 318, 65th Cong., 2d sess., 1918. 1p. Serial 7307. Recommends passage of a bill equalizing the pensions of Civil War nurses with those of widows of that war.

1553. U.S. Congress. House. Committee on Military Affairs. *Appropriation for Support of the Army, Report to Accompany H.R. 13035.* H. Rept. 824, 65th Cong., 2d sess., 1918. 2p. Serial 7308. Favorable report on a bill to correct the unintended reduction in the pay of chief nurses of the Army Nurse Corps which was included in the Army appropriation bill.

1554. U.S. Congress. House. Committee on Military Affairs. *Pay for Army and Navy Nurses Corps during Involuntary Captivity, Reports to Accompany H.R. 12860.* H. Rept. 816, 65th Cong., 2d sess., 1918. 2p. Serial 7308. Favorable report on a bill to allow members of the Army and Navy Nurses Corps to receive pay if held captive by the enemy.

1555. U.S. Congress. House. Committee on Military Affairs. *Pay to Chief Nurses; Letter from the Secretary of War, Transmitting Tentative Draft of Proposed Bill to Amend Section 4 of Chapter V of "An Act making appropriation for the support of the Army for the fiscal*

year ending June thirteenth, nineteen hundred and nineteen". H. Doc. 1259, 65th Cong., 2d sess., 1918. 2p. Serial 7448. Draft legislation to correct the assumed inadvertent reduction in the appropriation bill of the pay of chief nurses.

1556. U.S. Congress. House. Committee on Military Affairs. *Proposed Legislation Affecting the Medical Corps of the United States Army, Hearing on Suggested Changes in Medical Reserve Corps, Nurse Corps, and Other Changes Relating to the Medical Department.* 65th Cong., 2d sess., 16 Apr.- 7 June 1918. 88p. Y4.M59/1:M46/4. Discussion of proposals for the reorganization of the Army Nurse Corps covers topics of pay, rank, and retirement. Particularly stressed is the need for rank, thereby giving the nurses clear authority over hospital corpsmen on the wards. In relation to rank, one of the issues is granting relative rank versus absolute rank. Testimony describes the status of Canadian and Australian military nurses and statements from representative nurses express their reasons for desiring rank.

1557. U.S. Congress. House. Committee on the Library. *Memorial to Orders of Sisters Who Served as Nurses in the Civil War, Report to Accompany H.J. Res. 154.* H. Rept. 281, 65th Cong., 2d sess., 1918. 2p. Serial 7307. Bill authorizing the erection of a memorial to Sisters who served as nurses in the Civil War is favorably reported. Quotes from Abraham Lincoln and Jefferson Davis note the respect paid to the work of the Sisters.

1558. U.S. Congress. Senate. Committee on Military Affairs. *Army Nurses Corps, Report to Accompany S. 3693.* S. Rept. 259, 65th Cong., 2d sess., 1918. 1p. Serial 7304. Favorable report on the bill prescribing the personnel, pay, and retirement of the Army Nurse Corps.

1559. U.S. Congress. Senate. Committee on Military Affairs. *Increase the Pay of a Chief Nurse in the Army Nurse Corps, Report to Accompany S. 4892.* S. Rept. 568, 65th Cong., 2d sess., 1918. 2p. Serial 7304. Favorable report on a bill to increase the pay of chief nurses in the Army Nurses Corps explains how their pay came to be reduced under the fiscal year 1918/19 Army appropriation bill.

1560. U.S. Congress. Senate. Committee on Military Affairs. *Status of the Army Nurse Corps, Report Pursuant to S. Res. 185.* S. Rept. 299, 65th Cong., 2d sess., 1918. 2p. Serial 7305. Report of the Secretary of War on the status of the Army nursing supply discusses the proposal to conduct nurse training schools in connection with Army hospitals, and the question of training nurses enrolled in the Army Nurse Corps.

1561. U.S. Congress. Senate. Committee on Naval Affairs. *Pay of Members of Army and Navy Nurse Corps and Others While in Captivity, Report to Accompany H.R. 12860.* S. Rept. 622, 65th Cong., 3d sess., 1918. 1p. Serial 7452. See 1554 abstract.

1562. U.S. Congress. House. *Retirement of Members of Army Nurses Corps (Female); Letter from the Secretary of War, Transmitting a Proposed Bill Authorizing the Retirement of Members of the Army Nurses Corps (Female).* H. Doc. 1627, 65th Cong., 3d sess., 1919. 2p. Serial 7582. Letter from the War Department, dated 12 December 1918, proposes legislation to provide for the retirement of Army nurses (female) after twenty years of service.

1563. U.S. Congress. Senate. Committee on Military Affairs. *Retirement of Members of the Army Nurses Corps, Report to Accompany S. 2496.* S. Rept. 93, 66th Cong., 1st sess., 1919. 1p. Serial 7590.

1564. U.S. Congress. House. *Include Navy Nurses in Bill to Grant Six Month's Pay to Dependents of Officers, etc.; Letter from the Secretary of the Navy, Transmitting*

Amendment to Draft of Proposed Legislation so as to Include Navy Nurses in the Proposed Bill to Grant Six Month's Pay to Dependents of Officers and Enlisted Men of the Navy. H. Doc. 634, 66th Cong., 2d sess., 1920. 1p. Serial 7768.

1565. U.S. Congress. Senate. Committee on Pensions. *Equalization of Pensions to Former Soldiers, Marines and Army Nurses, Hearing on S. 472 and H.R. 4.* 67th Cong., 2d sess., 1 Feb. 1922. 8p. Y4.P38/2:Eq2. The primary issue of this pension bill was bringing the nurses employed in the War with Spain under the pension laws on a equal basis with nurses of the Army Nurse Corps.

1566. U.S. Congress. House. Committee on Naval Affairs. *Hearing on the Bill (H.R. 10685) to Authorize the Secretary of the Navy to Extend the Nurses' Quarters at the Naval Hospital, Washington, D.C. and to Construct Necessary Additional Buildings at Certain Naval Hospitals.* 68th Cong., 2d sess., 16 Dec. 1924. 121-136pp. Greenwood (68) H375-10. Discussion of naval hospital construction plans includes extension of the nurses' quarters at the Washington, D.C. naval hospital. The philosophy behind having all of the nurses live at the hospital compound, and the lack of proper nurses quarters at other hospitals, is described.

1567. U.S. Congress. Senate. Committee on Military Affairs. *Retirement for Members of Nurses Corps of the Army and Navy, Report to Accompany S. 3285.* S. Rept. 556, 68th Cong., 1st sess., 1924. 4p. Serial 8221. Favorable report accompanies the letter from the Secretary of War dated 5 May 1924 setting forth the need for retirement provisions for members of the Army and Navy Nurse Corps upon 20 years of service or at the age of 50. The details of the retirement plan are laid out.

1568. U.S. Congress. House. Committee on Military Affairs. *Army and Navy Nurse Corps Retirement, Hearings on H.R. 8953.* 69th Cong., 1st sess., 5 Mar. 1926. 27p. Y4.M59/1:N93. Hearing on establishing retirement provisions for Army and Navy Nurses discusses the expected working life of a nurse and reviews the history of service of the nurses of the Army and Navy. The compensation received by nurses and their devotion to duty are noted in arguments for the bill. Includes the names and dates of service of nurses who would be immediately eligible for retirement. Careers of some of the nurses are highlighted. The only opposition is to the 50 years of age/20 years of service provision, which one congressman felt would allow nurses to draw military retirement pay while working in the private sector.

1569. U.S. Congress. House. Committee on Military Affairs. *Retirement for the Nurses Corps of the Army and Navy, Report to Accompany H.R. 8953.* H. Rept. 611, 69th Cong., 1st sess., 1926. 5p. Serial 8532. Letter from the Secretary of War appended to this favorable report outlines the need for legislation providing for the retirement of members of the Army and Navy Nurses Corps.

1570. U.S. Congress. House. Committee on Naval Affairs. *To Provide Retirement for the Nurse Corps of the Army and Navy (H.R. 8953).* Sundry Legislation Affecting the Naval Establishment, 1925-1926, no. 147. 69th Cong., 1st sess., 25 Feb. 1926. 1251-1252pp. Y4.N22/1:L52/925-26/147. Letter from the Secretary of the Navy stated that the concept of retirement provisions for nurses met the approval of the Department but that the computation of retired pay should be 2.5 per cent of base pay as was granted to other naval officers. The proposed bill set the rate at 3 percent.

1571. U.S. Congress. House. Committee on Naval Affairs. *To Provide Retirement for the Nurse Corps of the Army and Navy (H.R. 8953), Referred to the Committee on Naval Affairs.* Sundry Legislation Affecting the Naval Establishment, 1925-1926, no. 250. 69th Cong., 1st sess., 5 Apr. 1926. p.2161. [1p.] Y4.N22/1:L52/925-26/250. Letter from the

Secretary of the Navy provides revised figures on the cost of retirement pay for nurses over the next 10 years and changes the Navy's stand to support the computation of retirement pay at the rate of 3 percent of active duty pay for each year of service.

1572. U.S. Congress. Senate. Committee on Military Affairs. *Retirement for Members of Nurses Corps of the Army and Navy, Report to Accompany S. 3037.* S. Rept. 376, 69th Cong., 1st sess., 1926. 4p. Serial 8524. Favorable report on a bill providing for the retirement of members of the Nurses Corps includes the letter from the Secretary of War regarding the bill and Senate Report 556, 68th Congress (1567) on a similar bill.

1573. U.S. Congress. Senate. Committee on Military Affairs. *Six Months' Pay for Dependent Relatives of Army Nurses in Case of Death, Report to Accompany S. 3514.* S. Rept. 909, 69th Cong., 1st sess., 1926. 2p. Serial 8526. Letter from the Secretary of War dated March 8, 1926, gives the reasons for the bill which would put Army nurses on an equal bases with male officers and enlisted men in the matter of death gratuities.

1574. U.S. Army. Medical Department. *Army Nurse Corps.* by Julia C. Stimson. The Medical Department of the United States Army in the World War, vol. 13, pt. 2. Washington, DC: GPO, 1927. 287-351pp. W44.19:13. History of the Army Nurse Corps reviews the legislative basis and regulations for the organization and function of the corps. Details the expansion of the corps during World War I and the appointment of black and Cuban nurses. Summarizes the assignments of nursing units outside the U.S. and reviews the history of status, rank, pay, and benefit issues. In addition, the report describes the work of American nurses with the British Expeditionary Force in France and with the American Expeditionary Force, and details their embarkation after the armistice.

1575. U.S. Congress. House. Committee on Military Affairs. *Appropriation for Construction of Military Posts, Report to Accompany H.R. 7932.* H. Rept. 647, 70th Cong., 1st sess., 1928. 2p. Serial 8836. Reports on an appropriation bill for the construction of nurses quarters at Schofield Barracks, Hawaii.

1576. U.S. Congress. House. Committee on Military Affairs. *To Include Army Nurses in the Law Granting Six Months' Pay to Beneficiaries, Report to Accompany H.R. 238.* H. Rept. 441, 70th Cong., 1st sess., 1928. 2p. Serial 8835. See 1579 for abstract.

1577. U.S. Congress. House. Committee on World War Veteran's Legislation. *World War Veterans' Legislation, Hearings.* 70th Cong., 1st sess., 24 Feb. - 12 Apr. 1928. 282p. Y4.W89:L52/6. Among the bills covered by this hearing is H.R. 5775, a bill to provide for the hospitalization of nurses who were injured or contracted a disease thorough their duties as nurses with the Veteran's Bureau.

1578. U.S. Congress. Senate. Committee on Military Affairs. *Appropriation for Construction at Schofield Barracks Hawaii, Report to Accompany H.R. 7932.* S. Rept. 562, 70th Cong., 1st sess., 1928. 2p. Serial 8830. Favorable report on a bill to authorize appropriations for the construction of nurses' quarters at Schofield Barracks, Hawaii includes explanatory correspondence.

1579. U.S. Congress. Senate. Committee on Military Affairs. *To Include Army Nurses in the Law Granting Six Months' Pay to Beneficiaries, Report to Accompany H.R. 238.* S. Rept. 396, 70th Cong., 1st sess., 1928. 2p. Serial 8829. The House Report 441 (1576), is incorporated in this favorable report on including Army nurses in the class of personnel whose beneficiaries receive a death gratuity equal to six months' pay.

1580. U.S. Navy. Supplies and Accounts Bureau. *Instructions for Carrying into Effect Joint Service Pay Bill (Act of June 10, 1922) Sec. C: Pay and Allowances of Female Nurses, Navy.* Washington, DC: The Bureau, 1928. 2p. N20.13:P29/5/C/rev.

1581. U.S. Congress. House. Committee on Naval Affairs. *To Provide for Retirement of Disabled Nurses of the Navy.* Sundry Legislation Affecting the Naval Establishment, 1929-1930, no. 17. 71st Cong., 1st sess., 28 Sept. 1929. 53-54pp. Y4.N22/1:L52/929-30/no.17. Clarification by the Secretary of the Navy on H.R. 3798. Describes the current provisions for the retirement of members of the Navy Nurse Corps and outlines the cost of the proposed disability retirement legislation. The letter also transmits the Navy Department's recommendation against enactment.

1582. U.S. Congress. House. Committee on Naval Affairs. *To Provide for the Retirement of Disabled Nurses of the Army and the Navy (H.R. 15010) Referred to Committee on Military Affairs.* Sundry Legislation Affecting the Naval Establishment, 1928-1929, no. 149. 70th Cong., 2d sess., 25 Feb. 1929. 853-854pp. Y4.N22/1:L52/928-29/149. Letter from the Secretary of the Navy describes retirement and disability provisions relevant to the Navy Nurse Corps and recommends against a proposed bill granting retirement pay at 75 percent of pay received at time of retirement due to disability.

1583. U.S. Navy. Medicine and Surgery Bureau. *Uniform Regulations, Navy Nurse Corps, 1929.* Washington, DC: The Bureau, 1929. 19p. N10.13:N93/4. Earlier revisions issued in 1925 and in 1928.

1584. U.S. Congress. House. Committee on Military Affairs. *Purchase and Sale of Real Estate, and Other Public Bills, Hearing on H.R. 3869, H.R. 8159, H.R. 3594, H.R. 7722, S. 3965, S. 64, H.R. 2030, H.R. 11406, H.R. 7876.* 71st Cong., 2d sess., 7 April - 17 June 1930. 68p. Y4.M59/1:R22/6. Buried in these hearings on land acquisitions is a statement by General M.W. Ireland, Surgeon General, Army on a bill relating to disability retirement of Army and Navy nurses. Questions reflect the relatively low pay of Army nurses compared to those in the civilian labor force.

1585. U.S. Congress. House. Committee on Naval Affairs. *A Hearing on (H.R. 10375) to Provide for the Retirement of Disabled Nurses in the Navy.* Sundry Legislation Affecting the Naval Establishment, 1929-1930, no. 383. 71st Cong., 2d sess., 13 Mar. 1930. 1473-1496pp. Y4.N22/1:L52/929-30/383. In addition to discussing disability retirement, hearing testimony covers many aspects of the Navy Nurse Corps including pay, recruitment, and the incidence of resignations.

1586. U.S. Congress. House. Committee on Naval Affairs. *Retirement of Navy Nurses (H.R. 3798).* Sundry Legislation Affecting the Naval Establishment, 1929-1930, no. 353. 71st Cong., 2d sess., 28 Feb. 1930. 1305-1306pp. Y4.N22/1:L52/929-30/353. Comments related to H.R. 3798 briefly state that the retirement provisions of the bill are what is fairly due to Navy nurses and point out that the Navy Department's negative recommendation was based on the Bureau of the Budget's disapproval.

1587. U.S. Congress. House. Committee on Naval Affairs. *To Provide for the Retirement of Disabled Nurses in the Navy, Report to Accompany H.R. 10375.* H. Rept. 922, 71st Cong., 2d sess., 1930. 4p. Serial 9191. Favorable report on making members of the Navy Nurse Corp eligible for disability retirement outlines the quality of the Nurse Corps and the risks to which the women were exposed. The rates at which they would retire under the bill and the number expect to be retired due to disability are summarized.

1588. U.S. Congress. Senate. Committee on Military Affairs. *To Provide for the Retirement of Disabled Nurses of the Navy, Report to Accompany H.R. 10375.* S. Rept. 863, 71st

Cong., 2d sess., 1930. 5p. Serial 9186. Favorable report on a bill to provide for the retirement of Army and Navy nurses disabled in the line of duty prints supporting correspondences from the War Department and the House Report 922 (1587).

1589. U.S. Army. *Annual Physical Examination of Women.* Army Circular no. 25. Washington, DC: The Department, 1931. 2p. W44.4/2:25.

1590. U.S. Congress. House. Committee on Military Affairs. *Mileage Allowance to Members of the Army and Navy Nurses Corps, Report to Accompany H.R. 87.* H. Rept. 2708, 71st Cong., 3d sess., 1931. 2p. Serial 9327.

1591. U.S. Congress. House. Committee on Military Affairs. *To Amend the Act Providing for the Retirement of Disabled Nurses of the Army and Navy, Report to Accompany H.R. 17259.* H. Rept. 2882, 71st Cong., 3d sess., 1931. 3p. Serial 9327. Reports a bill clarifying the act relating to the disability retirement pay of Army and Navy nurses. Under the clarified act the nurses would receive 75 percent of their actual pay at the time of disability retirement, rather than 75 percent of the base pay as the original act was interpreted.

1592. U.S. War Dept. *Finance Department: Pay and Allowances of Army Nurses and Hospital Matrons; Aug. 10, 1931.* Army Regulation 35-2020. Washington, DC: GPO, 1931. 4p. W1.6:35-2020/3. Earlier regulations issued in 1925 and 1926, for later regulations see 1611.

1593. U.S. Congress. House. Committee on Military Affairs. *Amending the Act to Authorize the Secretary of War to Permit Allotments from the Pay of Military Personnel and Permanent Civilian Employees under Certain Conditions, Report to Accompany H.R. 9760.* H. Rept. 2176, 75th Cong., 3d sess., 1938. 2p. Serial 10234. Reports a bill clarifying the eligibility of certain groups, particularly members of the Army Nurse Corps, to make allotments from their pay for the support of their families or relatives.

1594. U.S. Congress. House. Committee on Pensions. *Pensions - Regular Establishment: Pensions and Increased Pensions to Veterans, Widows, and Dependents of Veterans of the Regular Establishment, Hearings on H.R. 8948 (Also S. 3503).* 75th Cong., 3rd sess., 8 June 1938. 114p. Y4.P38/1:V64. Military pension bill provided for increased pensions to veterans, widows, and dependents. Specifically related to women in the military, the bill brought benefits for nurses up to the same level as benefits paid to veterans. Hearing testimony focuses on non-wartime service-connected disabilities. Attached statements include a concise summary of past pension legislation.

1595. U.S. Congress. Senate. Committee on Military Affairs. *Amending the Act, as Amended, to Authorize the Secretary of War to Permit Allotments from the Pay of Military Personnel and Permanent Civilian Employees under Certain Conditions, Report to Accompany S. 3589.* S. Rept. 1601, 75th Cong., 3d sess., 1938. 2p. Serial 10229. Among other things, the bill reported added the Army Nurses Corps to the list of those eligible to have pay withheld for the support of "wife, children or dependent relatives."

1596. U.S. Congress. Senate. Committee on Pensions. *Pensions to Soldiers, Sailors, and Nurses of the War with Spain, the Philippine Insurrection, or the China Relief Expedition, Report to Accompany H.R. 5030.* S. Rept. 1564, 75th Cong., 3d sess., 1938. 2p. Serial 10229.

1597. U.S. War Dept. *Finance Department: Pay Accounts of Commissioned Officers, Army Nurses, Warrant Officers and Contract Surgeons; Nov. 15, 1939.* Washington, DC: GPO, 1939. 7p. W1.6/1:35-1360/7.

1598. U.S. Congress. House. Committee on Military Affairs. *Amending the Act to Provide for the Retirement of Disabled Nurses of the Army and Navy, Report to Accompany H.R. 8613.* H. Rept. 2813, 76th Cong., 3d sess., 1940. 5p. Serial 10444. Reports legislation to amend the Retirement Act of June 20, 1930 by placing disabled nurses who were incapacitated prior to the act on the retired list of the Nurse Corps.

1599. U.S. Congress. Senate. Committee on Military Affairs. *Amending Act to Provide for Retirement of Disabled Nurses of the Army and Navy, Report to Accompany H.R. 8613.* S. Rept. 2191, 76th Cong., 3d sess., 1940. 7p. Serial 10432. See 1598 for abstract.

1600. U.S. War Dept. *Finance Department: Subsistence and Rental Allowance for Commissioned Officers, Army Nurses, Warrant Officers, and Contract Surgeons; Nov. 19, 1941.* Army Regulation 35-4220. Washington, DC: GPO, 1941. 14p. W1.6/1:35-4220/4. Later regulations see 1629.

1601. American National Red Cross. *Uncle Sam Needs Nurses.* Washington, DC: American National Red Cross, 1942. [24]p. leaflet. W102.2:N93/3/942. Earlier edition issued in 1941.

1602. U.S. Congress. House. Committee on Military Affairs. *Increase the Pay of the Army Nurse Corps, Etc., Hearings on H.R. 7633.* 77th Cong., 2d sess., 7 Oct. - 17 Nov. 1942. 52p. Y4.M59/1:N93/2. Hearing considers a bill to raise the compensation for females in the Army Nurse Corps to equal that of male Army officers of the same rank. Provides information on the compensation of the Nurse Corps by rank and highlights the massive recruitment of nurses in the year preceding the hearing. Much of the discussion centered on whether the change would result in pay cuts and on the transfer from civil service to military status of dieticians and physical therapists. The temporary nature of the measure was another topic of debate in relation to the status of nurses. Also discussed is the question of whether such female personnel would be allowed to draw dependent allowances for children.

1603. U.S. Congress. House. Committee on Military Affairs. *Increasing Pay and Allowance of Members of the Army Nurses Corps, Report to Accompany H.R. 7633.* H. Rept. 2636, 77th Cong., 2d sess., 1942. 4p. Serial 10665. Report supports a bill to provide relative rank and increased pay and allowances to members of the Army Nurse Corps during the war and for six months after. Provision for the appointment of female dietitians and physical therapists in the Medical Department of the Army was also included. The expansion of the Nurses Corps for the war and the pay and allowances under the 1942 Pay Act and under H.R. 7633 are summarized.

1604. U.S. Congress. House. Committee on Naval Affairs. *Hearing on S. 2454, to Prescribe the Relative Rank of Members of the Navy Nurse Corps in Relation to Commissioned Officers in the Navy, and for Other Purposes.* Sundry Legislation Affecting the Naval Establishment, 1942, no. 250. 77th Cong., 2d sess., 30 June 1942. 3303-3305pp. Y4.N22/1a:941-42/250. Hearing is basically a reprint of the text of S. 2454, the letter from the Navy Dept. requesting the bill, and of a statement by the Surgeon General of the Navy endorsing the establishment of relative rank for members of the Navy Nurse Corps.

1605. U.S. Congress. House. Committee on Naval Affairs. *Prescribing the Relative Rank of Members of the Navy Nurses Corps in Relation to Commissioned Officers of the Navy, Report to Accompany S. 2454.* H. Rept. 2304, 77th Cong., 2d sess., 1942. 3p. Serial 10664. Reports a bill granting members of the Navy Nurse Corps relative rank and putting the corps on an equal footing with the Army Nurse Corps.

1606. U.S. Congress. House. Committee on Naval Affairs. *To Proscribe the Relative Rank of Members of the Navy Nurse Corps in Relation to Commissioned Officers of the Navy, and for Other Purposes (H.R. 6929).* Sundry Legislation Affecting the Naval Establishment, 1942, no. 223. 77th Cong., 2d sess., 31 Mar. 1942. 3161-3162pp. Y4.N22/1a:941-42/223. Letter from the Navy Department requested that members of the Navy Nurse Corps be granted relative rank as was prescribed for the Army Nurse Corps.

1607. U.S. Congress. Senate. Committee on Military Affairs. *Pay and Allowances of Members of the Army and Navy Nurses Corps, Report to Accompany H.R. 7633.* S. Rept. 1778, 77th Cong., 2d sess., 1942. 6p. Serial 10659. Report supports a temporary war measure to increase relative rank, pay, and allowances of members of the Army and Navy Nurses Corps and to provide for the recruitment of female dieticians and physical therapy aides in the Medical Department of the Army. A chart shows the pay and allowance provisions under the 1942 Pay Act and under H.R. 7633.

1608. U.S. Congress. Senate. Committee on Naval Affairs. *Prescribing the Relative Rank of Members of the Navy Nurses Corps in Relation to Commissioned Officers of the Navy, Report to Accompany S. 2454.* S. Rept. 1316, 77th Cong., 2d sess., 1942. 2p. Serial 10657. Reports a bill to clarify the status of members of the Navy Nurse Corps by granting them relative rank similar to the Army Nurse Corps.

1609. U.S. War Dept. *Finance Department: Aviation Pay, Officers, Army Nurses, Warrant Officers, and Enlisted Men; Oct. 10, 1942.* Army Regulation 35-1480. Washington, DC: GPO, 1942. 8p. W1.6/1:35-1480/5. Change sheets issued Aug. 26, 1943; Feb. 8, 1944; Mar. 16, 1944.

1610. U.S. War Dept. *Finance Department: Foreign Service and Sea Duty, Increases in Pay, Officers, Army Nurses, Warrant Officers, and Enlisted Men; Aug. 31, 1942.* Army Regulation 35-1490. Washington, DC: GPO, 1942. 3p. W1.6/1:35-1490. Change sheets issued Mar. 31, 1943; Aug. 27, 1943.

1611. U.S. War Dept. *Finance Department: Pay and Allowances of Army Nurses; Aug. 31, 1942.* Washington, DC: GPO, 1942. 5p. W1.6/1:35-2020/5. Earlier edition under same title issued Nov. 17, 1939, W1.6/1:35-2020/4; for 1931 edition see 1592. For later editions see 1628.

1612. U.S. War Dept. Adjutant General's Dept. *Pay Guide for Officers, Army Nurses, and Warrant Officers on Change of Station.* Washington, DC: The Department, 1942. 2p. W3.2:P29/2/942.

1613. U.S. War Dept. Adjutant General's Dept. *Personnel of Army of United States, Information Regarding Appointment, Enlistment, and Induction of Commissioned Officers, Army Nurses, Warrant Officers, Cadets, Officer Candidates, and Enlisted Men; March 26, 1942.* Washington, DC: The Department, 1942. 42p. W3.2:Ar5/15.

1614. U.S. Congress. Senate. Committee on Military Affairs. *Providing for the Appointment of Female Physicians and Surgeons in the Medical Corps of the Army and Navy, Report to Accompany H.R. 1857.* S. Rept. 160, 78th Cong., 1st sess., 1943. 2p. Serial 10755. Reported favorably is a bill authorizing the appointment of female physicians and surgeons to the Medical Corps of the Army and Naval Reserve for the duration of the war and for six months thereafter.

1615. U.S. Congress. Senate. Committee on Naval Affairs. *Granting Military Rank to Certain Members of the Navy Nurses Corps, Report to Accompany H.R. 2976.* S. Rept. 617, 78th Cong., 1st sess., 1943. 2p. Serial 10757. Reports a bill to give the members of the Navy

Nurses Corps actual rank as was the case with the Women's Reserves of the Navy, Marine Corps, and Coast Guard.

1616. American National Red Cross. *Fighting Men Need Nurses: What are Requirements for Army and Navy Nurse Corps.* Washington, DC: American National Red Cross, 1943. 6p. W102.2:N93/4.

1617. American National Red Cross. *You are Needed Now, Join the Army Nurse Corps, Apply at Your Red Cross Recruiting Station.* n.p, 1943. poster. W102.5:Ar5.

1618. U.S. Army. *Information Concerning the Army Nurse Corps.* Washington, DC: The Department, 1943. 3p. W44.2:N93/3.

1619. U.S. Congress. House. Committee on Military Affairs. *Commissioning of Female Physicians and Surgeons, Report to Accompany H.R. 1857.* H. Rept. 295, 78th Cong., 1st sess., 1943. 2p. Serial 10761. Reports a measure to enable the appointment of female physicians and surgeons to the Medical Corps of the Army and Navy. The committee removed a restrictive clause in the original bill restricting the women to assigned duty only where female nurses are employed.

1620. U.S. Congress. House. Committee on Military Affairs. Subcommittee No. 3. *Appointment of Female Physicians and Surgeons in the Medical Corps of the Army and Navy, Hearings on H.R. 824 and H.R. 1857.* 78th Cong., 1st sess., 10-18 March 1943. 101p. Y4.M59/1:P56. Hearing examines bills to authorize the temporary commission of female doctors in the Army and the Navy. Testimony and questions focus on whether female doctors would be better utilized in combat zones or on the home front, and on the contradiction between the use of nurses in combat zones and the restriction on female doctors. Part of the argument is that women make better anesthetists, radiologists, bacteriologists, physiotherapists, and dieticians than men, and that the Army should recruit the best.

1621. U.S. Congress. House. Committee on Naval Affairs. *Granting Military Rank to Certain Members of the Navy Nurses Corps, Report to Accompany H.R. 2976.* H. Rept. 740, 78th Cong., 1st sess., 1943. 2p. Serial 10763. Report supports a measure granting actual rank to members of the Navy Nurses Corps for the duration of the war. The bill put the Nurse Corps in the same status as regards to rank, as the members of the Women's Reserves of the Navy, Marine Corps, and Coast Guard.

1622. U.S. Congress. House. Committee on Naval Affairs. *Hearing on H.R. 2976 to Grant Military Rank to Certain Members of the Navy Nurse Corps.* Sundry Legislation Affecting the Naval Establishment, 1944, no. 252. 78th Cong., 2d sess., 6 Oct. 1943. 2423-2428pp. Y4.N22/1a:943-44/252. Brief hearing considers a bill to grant military rank to members of the Navy Nurse Corps, who only had relative rank.

1623. U.S. Congress. House. Committee on Naval Affairs. *To Grant Military Rank to Certain Members of the Navy Nurse Corps (H.R. 2976).* Sundry Legislation Affecting the Naval Establishment, 1943, no. 143. 78th Cong., 1st sess., 23 Sept. 1943. p.1081. [1p.] Y4.N22/1a:943-44/143. Report from the Navy Department approves a bill to grant members of the Navy Nurse Corps actual rank as opposed to their existing status of relative rank.

1624. U.S. Federal Security Agency. *Save His Life...and Find Your Own, Become a Nurse.* Washington, DC: GPO, 1943. 2p. leaflet. Pr32.4502:N93/3.

1625.　U.S. Navy. Bureau of Medicine and Surgery. *Enlist in the WAVES, Service in the Hospital Corps.* Washington, DC: GPO, 1943. 13p. N10.2:W36. Recruiting information for women encouraged them to enlist in the WAVES as part of the Hospital Corps. The booklet was aimed at women with some hospital experience and describes the duties, pay, and promotion opportunities in the Hospital Corps.

1626.　U.S. Navy. Bureau of Medicine and Surgery. *Navy Nurse Corps.* Washington, DC: GPO, 1943. 23p. N10.2:N93/2. States requirements for acceptance into the Navy Nurse Corps and answers to questions about rank, promotion, uniforms, and duty assignments.

1627.　U.S. Navy. Bureau of Medicine and Surgery. *Navy Nurse Corps, Relative Rank and Uniform Regulations.* Washington, DC: GPO, 1943. 10p. N10.13:N93/5/943.

1628.　U.S. War Dept. *Finance Department: Pay and Allowances of Army Nurse Corps and Other Female Personnel of Medical Department; Feb. 25, 1943.* Washington, DC: GPO, 1943. 6p. W1.6/1:35-2020/6. Change sheets issued May 4 and June 4, 1943. Earlier see 1611.

1629.　U.S. War Dept. *Finance Department: Subsistence and Rental Allowance for Commissioned Officers, Members of the Army Nurse Corps and Other Female Personnel of Medical Department, Warrant Officers, Flight Officers, and Contract Surgeons; April 20, 1943.* Washington, DC: GPO, 1943. 13p. W1.6/1:35-4220/5. Change sheets issued Sept. 13, 1943; Nov. 11, 1943; and Jan. 8, 1944. Earlier see 1600.

1630.　U.S. War Dept. *Personnel: Prescribed Service Uniform, Army Nurse Corps, Physical Therapy Aides, and Hospital Dieticians; July 29, 1943.* Washington, DC: GPO, 1943. 19p. W1.6/1:600-37. Change sheets issued Dec. 15, 1943 and Jan. 20, 1944.

1631.　U.S. Army. *Army Needs You! Cadet Nurse Corps, Senior Cadet Period, Army Hospitals.* Governors Island, NY?: Recruiting Publicity Bureau, 1944. 8p. leaflet. W3.2:N93/4.

1632.　U.S. Army. *The Army Nurse.* Governors Island, NY?: Recruiting Publicity Bureau, 1944. 32p. W3.2:N93. Brief illustrated history of American military nursing highlights both official and unofficial nursing from the revolutionary war through WWII.

1633.　U.S. Army. *Army Nurse's Prayer.* Governors Island, NY?: Recruiting Publicity Bureau, 1944. 2p. leaflet. W3.2:N93/2.

1634.　U.S. Army. *Give Us Healing Hands and a Courageous Heart (Yes, United States Army Urgently Needs Your Skill, Nurse!).* Governors Island, NY?: Recruiting Publicity Bureau, 1944? poster. W3.2:N93/3.

1635.　U.S. Army. *I Serve, Be an Army Nurse.* N.p., 1944. poster. W44.20/1:N93.

1636.　U.S. Army. *Pledge of the Army Nurse.* Governors Island, NY?: Recruiting Publicity Bureau, 1944. poster. W3.46/1:N93.

1637.　U.S. Congress. House. Committee on Military Affairs. *Army Nurse Corps, Hearings on H.R. 3718, H.R. 3761, and H.R. 4445.* 78th Cong., 2d sess., 27 Apr. 1944. 30p. Y4.M59/1:N93/3. Hearing on a bill to bring rank, pay, and benefits of members of the Army Nurse Corps up to equivalency with the WAC provides information on the organization and manpower of the corps and points out the discrepancy in benefits. A drawback of the proposed legislation was its temporary nature. Army Nurse Corps representatives and supporting statements from veteran's organizations point out the need

for a permanent measure. The proposed bill also provided for dieticians and physical therapy aides in the military organization structure.

1638. U.S. Congress. House. Committee on Military Affairs. *Temporary Appointment as Officers in the Army of the United States of Members of the Army Nurses Corps and Certain Other Female Persons, Report to Accompany H.R. 4445.* H. Rept. 1512, 78th Cong., 2d sess., 1944. 6p. Serial 10846. Favorable report on a bill to provide for the temporary appointment as commissioned officers of female nurses, dieticians and physical therapists who held only relative rank under existing laws. An explanation of the bill by section and a supporting letter from the Secretary of War are included.

1639. U.S. Congress. Senate. Committee on Military Affairs. *Temporary Appointment as Officers in the Army of the United States of Members of the Army Nurses Corps and Certain Other Female Persons, Report to Accompany S. 1808.* S. Rept. 840, 78th Cong., 2d sess., 1944. 2p. Serial 10841. Reports a bill to temporarily commission female officers for the Army Nurse Corps and the Medical Department. The purpose of the bill was to give nurses, dieticians and physical therapists actual rank in the Army and to give them the same benefits as other Army personnel.

1640. U.S. War Dept. *Medical Department: Army Nurses Commissioned in Army of United States; Nov. 27, 1944.* Army Regulation 40-21. Washington, DC: GPO, 1944. 4p. W1.6:40-21. Change sheet issued May 7, 1946.

1641. U.S. Army. Adjutant General's Dept. *"The Army Nurse is the Symbol to the Soldier of Help and Relief in His Hour of Direst Need," Douglas MacArthur.* Governors Island, NY?: Recruiting Publicity Bureau, 1945. poster. W3.46/1:N93/2. Statements by MacArthur support the work of the Army Nurse Corps.

1642. U.S. Congress. House. Committee on Military Affairs. *Nurses Selective Service Act of 1945, Report to Accompany H.R. 2277.* H. Rept. 194, 79th Cong., 1st sess., 1945. 7p. Serial 10931. Reports a replacement for H.R. 1284, a bill establishing a selective service for nurses. The need for nurses and the recruitment problems are briefly reviewed as is the constitutionality of the measure. Correspondence from President Franklin Roosevelt and the Secretary of War emphasize the need for a draft for nurses.

1643. U.S. Congress. House. Committee on Naval Affairs. *Adjusting the Pay and Allowances of Members of the Navy Nurses Corps, Report to Accompany H.R. 4411.* H. Rept. 1160, 79th Cong., 1st sess., 1945. 4p. Serial 10935. Reports a temporary war measure to make members of the Navy Nurse Corps eligible for the active-duty pay and retirements benefits of commissioned officers. The difference in the benefits given Army nurses and Navy nurses, and the enacting legislation, are briefly reviewed. Examples illustrate the inequalities.

1644. U.S. Congress. House. Committee on Naval Affairs. *Hearing on H.R. 4411, to Adjust the Pay and Allowances of Members of the Navy Nurse Corps, and for Other Purposes.* Sundry Legislation Affecting the Naval Establishment, 1945, no. 121. 79th Cong., 1st sess., 24 Oct. 1945. 1661-1675pp. Y4.N22/1a:945-46/121. Hearing considers a bill to give members of the Navy Nurse Corps the same disability retirement benefits as commissioned officers in the Navy. The question of relative rank assigned to Navy Nurse Corps members is again discussed. Comparisons with the status of nurses in the Army is frequent in the course of testimony. Also discussed is the requirement that nurses resign upon marriage.

1645. U.S. Congress. House. Committee on Naval Affairs. *To Adjust the Pay and Allowances of Members of the Navy Nurse Corps, and for Other Purposes (H.R. 4411).* Sundry

Legislation Affecting the Naval Establishment, 1945, no. 114. 79th Cong., 1st sess., 12 Oct. 1945. 1507-1508pp. Y4.N22/1a:945-46/114. Transmits draft legislation to change pay and allowances of the Navy Nurse Corps to credit service for purposes of advancement to higher pay grades, to increase subsistence and rental allowances payable to officers having dependents, and to provide retirement pay for disability incurred in the line of duty computed on the basis of temporary higher pay provided by the act of December 22, 1942.

1646. U.S. Congress. House. Committee on Naval Affairs. *To Amend the Act Regarding the Qualifications for the Navy Nurse Corps (H.R. 1572).* Sundry Legislation Affecting the Naval Establishment, 1945, no. 55. 79th Cong., 1st sess., 1 June 1945. 741-742pp. Y4.N22/1a:945-46/55. Report from the Department of the Navy explains the qualifications for appointment to the Navy Nurse Corps and rejects a bill to lower those qualifications by eliminating the requirement for a state license.

1647. U.S. Congress. Senate. Committee on Military Affairs. *Nurses for the Armed Forces Report to Accompany H.R. 2277, a Bill to Insure Adequate Nursing Care for the Armed Forces.* S. Rept. 130, 79th Cong., 1st sess., 1945. 12p. Serial 10925. Reports legislation providing for the drafting of nurses into the armed forces. The need for a nurse selective service is described in the message from the President and in the committee report. The extent and awareness of the nurse shortage is reviewed as are recruitment efforts to date. The constitutionality of the measure is covered in some detail.

1648. U.S. Congress. Senate. Committee on Naval Affairs. *Adjusting the Pay and Allowances of Members of the Navy Nurse Corps, Report to Accompany S. 1491.* S. Rept. 695, 79th Cong., 1st sess., 1945. 2p. Serial 10927. Reports a bill to allow length of service increases in subsistence and rental allowances, and to provide for disability retirement at the pay of commissioned officers of the Navy Nurse Corps. The measure is temporary, covering only the duration of the war.

1649. U.S. Congress. Senate. Committee on Naval Affairs. *Nurses for the Armed Forces, Hearings on H.R. 2277.* 79th Cong., 1st sess., 19-26 Mar. 1945. 127p. Y4.M59/2:N93. Hearing on a proposed selective service for nurses includes a summary of a similar hearing held in the House and a discussion of the shortage of nurses and of recruitment efforts. The question of handling the drafting of married women and rules relating to their exception are discussed. Also much discussed was the Cadet Nurse Corps, whether the women in the program were volunteering for military nursing, and whether the Army offered the compensation and career benefits equivalent to civilian nursing. Included in the hearing is a review of the place of black nurses in the American Nurses' Association and treatment of black nurses in the Army Nurse Corps. The extent of discrimination against Japanese-American nurses is also discussed. Finally, the need for nurses in veterans hospitals and the subprofessional rating given nurses by the civil service is examined.

1650. U.S. Navy. *Instructions to Applicants, Commission in Nurse Corps and Reserve Nurse Corps, Navy.* Washington, DC: The Department, 1945. 2p. leaflet. N10.13:N93/6/945.

1651. U.S. Navy. *Instructions to Applicants for Commission in Nurse Corps and Reserve Nurse Corps, Navy.* Washington, DC: The Department, 1945. 8p. leaflet. N10.13:N93/8/945.

1652. U.S. Navy. *Instructions to Applicants for Commission in Nurse Corps, Reserve Nurse Corps, Navy.* Washington, DC: The Department, 1945. 6p. leaflet. N10.13:N93/3/945.

1653. U.S. Navy. *Your Name Has Been Submitted, Instructions to Applicants for Commission in Nurse Corps and Reserve Nurse Corps, Navy.* Washington, DC: The Department, 1945. 2p. leaflet. N10.13:N93/7/945.

1654. U.S. Navy. Bureau of Medicine and Surgery. *White Task Force, the Story of the Nurse Corps, United State Navy.* Washington, DC: GPO, 1945. 23p. N10.2:N93/4. Illustrated history of the role of nurses in the Navy describes their volunteer beginning in the Civil War through the Navy Nurse Corps' role in WWI and WWII. The history of training and expansion of duties is described as well as the change to permanent military status in 1942. A list of Navy medals awarded to nurses is given and notable Navy nurses are pictured. Also includes a bibliography on the Navy Nurse Corps and some basic statistics on the size of the corps and on deaths by conflict.

1655. U.S. Congress. House. Committee on Naval Affairs. *To Authorize the Appointment of Members of the Navy Nurse Corps as Commissioned Officers in the Naval Reserve (H.R. 4706).* Sundry Legislation Affecting the Naval Establishment, 1946, no. 253. 79th Cong., 2d sess., 10 June 1946. 3495-3496pp. Y4.N22/1a:945-46/253. Report from the Office of the Judge Advocate General of the Navy opposes a bill to authorize appointments as commissioned officers in the Naval Reserve for members of the Navy Nurse Corps. Opposition to the bill was based on method, not intent, with reference made to a forthcoming Navy Department sponsored reorganization plan.

1656. U.S. Army. *Finance Department: Pay and Allowances of Officers of Army Nurse Corps and Women's Medical Specialist Corps of Regular Army; Oct. 3, 1947.* Army Regulation 35-2025. Washington, DC: GPO, 1947. 4p. M101.9:35-2025. Change sheet issued Oct. 4, 1948.

1657. U.S. Congress. House. Committee on Armed Services. *Establishing a Permanent Nurse Corps of the Army and the Navy and to Establish a Permanent Women's Medical Specialist Corps in the Army, Report to Accompany H.R. 1943.* H. Rept. 81, 80th Cong., 1st sess., 1947. 9p. Serial 11118. Favorable report presents numerous amendments to a bill to establish a permanent Nurse Corps in the Army and the Navy, and a Women's Medical Specialist Corps in the Army. The majority of the report consists of correspondence from the War and Navy departments outlining the purpose of the bill.

1658. U.S. Congress. House. Committee on Armed Services. *Full Committee Hearings on H.R. 1943, H.R. 1366, H.R. 1359, H.R. 1365, H.R. 1377 (H.R. 1806).* Sundry Legislation Affecting the Naval and Military Establishment, 1947, no. 60. 80th Cong., 1st. sess., 25 Feb. 1947. 695-718pp. Y4.Ar5/2a:947-48/60. Report on a bill to establish permanent Nurse Corps in the Army and the Navy presents brief discussion of retirement provisions.

1659. U.S. Congress. House. Committee on Armed Services. *To Equalize Retirement Benefits among Members of the Nurse Corps of the Army and the Navy, and for Other Purposes (H.R. 4090).* Sundry Legislation Affecting the Naval and Military Establishments, 1947, no. 171. 80th Cong., 1st sess., 2 July 1947. 3963-3964pp. Y4.Ar5/2a:947-48/171. Letter transmitting a draft bill to equalize computation of retirement benefits between the Nurse Corps of the Army and the Navy highlights the inequalities which prompted the bill.

1660. U.S. Congress. House. Committee on Armed Services. *To Reorganize the Nurse Corps of the Navy and the Naval Reserve (H.R. 1373).* Sundry Legislation Affecting the Naval and Military Establishment, 1947, no. 3. 80th Cong., 1st sess., 20 Jan. 1947. 19-24pp. Y4.Ar5/2a:947-48/3. Transmittal of a draft bill to establish the Nurse Corps as a staff corps of the Navy and to provide for the appointment of nurses to permanent commissions lists proposed pay scales by length of service.

1661. U.S. Congress. House. Committee on Armed Services. Subcommittee No. 9. *Subcommittee Hearing on H.R. 1373 to Reorganize the Nurse Corps of the Navy and of the Naval Reserve; H.R. 1673 to Revise the Medical Department of the Army, and H.R. 1943 to Establish a Permanent Nurse Corps of the Army and the Navy and to Establish a*

Women's Medical Specialist Corps in the Army. Sundry Legislation Affecting the Naval Establishment, 1947, no. 50. 80th Cong., 1st sess., 6-7 Feb. 1947. 197-420pp. Y4.Ar5/2a:947-48/50. Hearing considers a bill to establish a permanent nurse corps in the Army and the Navy with commissioned officers, and to establish a Women's Medical Specialist Corps in the Army to commission dieticians, physical therapists and occupational therapists. Testimony focuses on the role nurses and allied medical specialists played in WWII and on the need to commission the women as permanent officers in order to attract quality applicants. The bills cover issues of benefits, number and rank, and retirement. One point of discussion is the earlier mandatory retirement age for nurses as opposed to regular Navy officers and another is the relationship between the Nurse Corps and the WAVES. Also provides insight into the hours, duties, and pay of nurses in the military as opposed to civilian hospitals. A comparison chart indicates differences in age, qualifications, authority, pay, promotion, retirement, and reserve sections of the Army and the Navy bills.

1662. U.S. Congress. Senate. Committee on Armed Services. *Army-Navy Nurse Corps, Hearing on H.R. 1943.* 80th Cong., 1st sess., 24 Mar. 1947. 20p. Y4.Ar5/3:N93. Hearing testimony provides a concise overview of the proposed reorganization of the Army Nurse Corps, the Navy Nurse Corps, and the Women's Medical Specialist Corps.

1663. U.S. Congress. Senate. Committee on Armed Services. *Army-Navy Nurses Act of 1947, Report to Accompany H.R. 1943.* S. Rept. 77, 80th Cong., 1st sess., 1947. 8p. Serial 11114. Report supports a bill to establish a permanent nurse corps in the Army and the Navy, and a permanent Women's Medical Specialist Corps in the Army. Without the legislation the nurses would have reverted to relative rank and lower pay as special war measures expired. Appended correspondence from the Army and the Navy details the need for, and provisions of, the bill.

1664. U.S. Army. *Commissioned Officers: Appointment in Medical Service, Army Nurse and Women's Medical Specialist Corps, Regular Army; June 11, 1948.* Army Regulation 605-20. Washington, DC: GPO, 1948. 8p. M101.9:605-20.

1665. U.S. Army. *Commissioned Officers: Permanent Promotion in Army Nurse Corps and Women's Medical Specialist Corps, Regular Army; July 16, 1948.* Army Regulation 605-51. Washington, DC: GPO, 1948. 7p. M101.9:605-51.

1666. U.S. Army. *Medical Department: Army Nurse Corps, General Provisions; April 22, 1948.* Army Regulation 40-20. Washington, DC: GPO, 1948. 8p. M101.9:40-20. Change sheets issued Nov. 30, 1948; May 12, 1950; and Oct. 3, 1950. Later see 1698.

1667. U.S. Army. *Medical Department: Women's Medical Specialist Corps, General Provisions; Jan. 22, 1948.* Army Regulation 40-25. Washington, DC: GPO, 1948. 7p. M101.9:40-25. Change sheets issued June 16, 1948. Oct. 20,1948, Nov. 30, 1948, Sept. 6, 1950.

1668. U.S. Congress. House. Committee on Armed Services. *Equalization of Nurse Retirement Benefits, Report to Accompany H.R. 4090.* H. Rept. 1429, 80th Cong., 2d sess., 1948. 4p. Serial 11209. Reports a bill to raise the retirement pay of Army and Navy nurses who retired prior to the establishment of the Army and Navy Nurse Corps as a unit of the Regular Army and Navy with full military rank. Inequities under the existing conditions are described. Supporting correspondence from the War and Navy Departments is appended.

1669. U.S. Congress. House. Committee on Armed Services. *Subcommittee Hearing on H.R. 4090, to Equalize Retirement Benefits among Members of the Nurse Corps of the Army and the Navy, and for Other Purposes.* Sundry Legislation Affecting the Naval and Military

Establishments, 1948, no. 234. 80th Cong., 2d sess., 18 Feb. 1948. 5543-5556pp. Y4.Ar5/2a:947-48/234. Hearing considers a bill to provide relief for some retired nurses who were receiving lower benefits due to an oversight in earlier legislation.

1670. U.S. Congress. Senate. Committee on Armed Services. *Equalizing Retirement Benefits among Members of the Nurse Corps of the Army and the Navy, Report to Accompany H.R. 4090.* S. Rept. 1156, 80th Cong., 2d sess., 1948. 4p. Serial 11207. Reports a bill to raise retirement pay of members of the Army and Navy Nurse Corps who retired under the lower pay scale in effect before nurses were considered commissioned officers. The different pay scales in effect are reviewed along with some of the history behind the pay scales for nurses.

1671. U.S. Congress. Senate. Subcommittee of the Committee on Armed Services. *Summary Termination of Employment of Civilian Employees and to Equalize Retirement Benefits among Members of the Army-Navy Nurse Corps, Hearing on S. 1561, S. 1570.* 80th Cong., 2d sess., 27 Feb. 1948. 34p. Y4.Ar5/3:C49. Second part of the hearing deals with a bill to correct retirement benefit inequities for retired nurses of the Army and Navy Nurse Corps which resulted from the 1946 amendment to the Pay Readjustment Act of 1942. Lists by name, grade, and length of service those nurses whose retirement pay would increase.

1672. U.S. Navy. Bureau of Naval Personnel. *Permanent Appointments for Officers of the Nurse Corps of the United States Naval Reserve.* Washington, DC: GPO, 1948. 55p. M206.2:N93. Lists, by name and permanent grade, women officer appointments to the Nurse Corps of the Naval Reserve.

1673. U.S. Army. *Officers: Training Program for Women's Medical Specialist Corps, Officer Procurement; Feb. 4, 1949.* Army Special Regulation 605-60-50. Washington, DC: GPO, 1949. 7p. M101.32:605-60-50. Change sheet issued Feb 12, 1952.

1674. U.S. Congress. House. Committee on Armed Services. *Amending the Army and Navy Nurses Act of 1947, to Provide for Additional Appointments, Report to Accompany H.R. 5876.* H. Rept. 1375, 81st Cong., 1st sess., 1949. 13p. Serial 11301. Reports a bill to allow women over the age of 35 to be commissioned into the Army Nurses Corps if they had previously served in the Nurse Corps prior to passage of the Army-Navy Nurses Act of 1947. The legislation also provided for an increase in the eligibility for, and strength of, the Women's Medical Specialist Corps, and included other provision affecting retirement and promotion in the Nurse Corp and the Women's Medical Specialist Corps.

1675. U.S. Congress. House. Committee on Armed Services. *Providing for Appointment of Female Doctors and Specialists in the Medical Department of the Army, Report to Accompany H.R. 4384.* H. Rept. 625, 81st Cong., 1st sess., 1949. 3p. Serial 11298. Report on a bill to provide for the commissioning of female doctors, dentists and medical specialists in the Army presents correspondence from the Department of the Army supporting the legislation.

1676. U.S. Congress. House. Committee on Armed Services. *To Amend the Army-Navy Nurses Act of 1947 to Provide for Additional Appointments, and for Other Purposes (H.R. 5876).* Sundry Legislation Affecting the Naval and Military Establishments, 1949, no. 107. 81st Cong., 1st. sess., 2 Aug. 1949. 3817-3820pp. Y4.Ar5/2a:949-50/107. Letter transmitted draft legislation to provide for additional appointments to the Army and Navy Nurse Corps and Women's Medical Specialist Corps by increasing the age for appointments, changing the number of majors, crediting certain civilian service, and equalizing retirement benefits.

1677. U.S. Congress. House. Committee on Armed Services. *To Provide for the Appointment of Female Doctors and Specialists in the Medical Department of the Army, and for Other Purposes (H.R. 4384).* Sundry Legislation Affecting the Naval and Military Establishments, 1949, no. 42. 81st Cong., 1st sess., 21 Apr. 1949. 1321-1322pp. Y4.Ar5/2a:949-50/42. Letter from the Department of the Army recommended legislation to provide for the appointment of female physicians, dentists and veterinarians.

1678. U.S. Congress. House. Committee on Armed Services. Subcommittee No. 3. *Subcommittee Hearings on H.R. 4384, to Provide for the Appointment of Female Doctors and Specialists in the Medical Department of the Army, and for Other Purposes.* Sundry Legislation Affecting the Naval and Military Establishments, 1949, no. 65. 81st Cong., 1st sess., 10 May 1949. 2349-2354pp. Y4.Ar5/2a:949-50/65. Brief hearing on the appointment of women as physicians, dentists, veterinarians, and in allied health fields to the Army as commissioned officers mainly focuses on the shortage of doctors.

1679. U.S. Congress. House. Committee on Armed Services. Subcommittee No. 3. *Subcommittee Hearing on H.R. 5876, to Amend the Army-Navy Nurses Act of 1947, to Provide Additional Appointments, and for Other Purposes.* Sundry Legislation Affecting the Naval and Military Establishments, 1949, no. 125. 81st Cong., 1st sess., 17 Aug. 1949. 4157-4177pp. Y4.Ar5/2a:9949-50/125. In light of an inability to recruit young nursing school graduates, the Department of Defense sponsored this bill to raise the age for appointment from 28 to 35 years for a period of one year. The bill also included technical changes affecting the number of majors, promotions, crediting civilian employment with the Army, and changing minor retirement provisions. One point discussed is corps pay versus civilian nurse pay.

1680. U.S. Air Force. *Commissioned Officers: Designation of Aviation Medical Examiner, Flight Surgeon, and Flight Nurse; May 31, 1950.* Air Force Regulation 36-32. Washington, DC: The Dept.,1950. 2p. D301.6:36-32. Change sheet issued Nov. 28, 1950.

1681. U.D. Army. *Medical Service: Army Health Nursing Service; June 27, 1950.* Army Regulation 40-50. Washington, DC: GPO, 1950. 2p. D101.9:40-50.

1682. U.S. Congress. Senate. Committee on Armed Services. *Amending the Army-Navy Nurses Act of 1947, to Provide for Additional Appointments and for Other Purposes, Report to Accompany H.R. 5876.* S. Rept. 1267, 81st Cong., 2d sess., 1950. 14p. Serial 11367. Report supports a bill to reopen for one year the integration program of the Regular Army Nurse Corps and the Women's Medical Specialists Corps, and to temporarily raise the age limit for appointment to the Nurse Corps to allow women over 35, who had previously served in military nursing during the war, to be appointed to the new permanent corps. Most of the report describes technical changes in the organization of the Army and Navy Nurse Corps.

1683. U.S. Congress. Senate. Committee on Armed Services. *Amendments to Army-Navy Nurses Act of 1947, Hearing on H.R. 5876.* 81st Cong., 2d sess., 6 Feb. 1950. 31p. Y4.Ar5/3:N93/2. Hearing examines a bill to provide additional appointments to the Army and Navy Nurse Corps by temporarily raising the maximum age for appointment and by crediting service in a civilian status with the Army or Navy toward rank. Includes a section-by-section comparison of the existing law and the proposed law. The bill also makes technical corrections relating to retirement.

1684. U.S. Congress. Senate. Committee on Armed Services. *Appointment of Female Physicians and Specialists in the Medical Service of the Army and Air Force, Hearing on H.R. 4384 (Part 2).* 81st Cong., 2d sess., 9 Aug. 1950. 20p. Y4.Ar5/3:P56/2. Hearing on legislation providing for the appointment of women as physicians and specialists in the

medical services of the Army and Air Force ended up as a discussion of whether women officers in the Army should be treated the same as Army men. Expanding the WAC to include female physicians is suggested as a way to avoid having to treat women equally with men.

1685. U.S. Congress. Senate. Committee on Armed Services. *Providing for the Appointment of Female Doctors and Specialists in the Medical Department of the Army, Report to Accompany H.R. 4384.* S. Rept. 2379, 81st Cong., 2d sess., 1950. 5p. Serial 11371. Reports a bill to provide for the appointment of female doctors and dentists in the Regular Army and Air Force on the same basis as men. The legislation was in response to the shortage of qualified doctors, and to existing provisions which placed the Army at a disadvantage vis-a-vis the Navy in the appointment of female physicians. Correspondence from the Secretary of Defense and the Secretary of the Army supporting the bill is appended.

1686. U.S. Army. *Officers: Women's Medical Specialist Corps Procurement - Physical Therapy Clinical Practice Program; June 15, 1951.* Army Special Regulation 605-60-51. Washington, DC: GPO, 1951. 5p. D101.10:605-60-51.

1687. U.S. Army. *Officers: Women's Medical Specialist Corps Procurement - Occupational Therapy Course; March 5, 1952.* Army Special Regulations 605-60-52. Washington, DC: GPO, 1952. 5p. D101.10:605-60-52.

1688. U.S. Congress. House. *Authorizing Appointment of Women as Physicians and Specialists in the Armed Services, Conference Report to Accompany S. 2552.* H. Rept. 2169, 82d Cong., 2d sess., 1952. 3p. Serial 11577. In the conference report the House agreed to withdraw its amendment to include osteopathic physicians under the provisions of the bill.

1689. U.S. Congress. House. Committee on Armed Services. *Authorizing the Appointment of Qualified Women as Physicians and Specialists in the Medical Services of the Army, Navy, and Air Force, Report to Accompany S. 2552.* H. Rept. 1677, 82d Cong., 2d sess., 1952. 3p. Serial 11576. Reports a bill to provide for the appointment of female physicians and related specialists as commissioned officers in the Army, Navy, and Air Force in order to alleviate the shortage of medical personnel.

1690. U.S. Congress. House. Committee on Armed Services. *Subcommittee Hearing on H.R. 6288 to Authorize the Appointment of Qualified Women as Physicians and Specialists in the Medical Services of the Army, Navy and Air Force.* 82d Cong., 2d sess., 21 Feb. 1952. 3095-3098pp. Y4.Ar5/2a:951-52/61. Statements of Army, Army Medical Services, and Navy Department Bureau of Medicine and Surgery representatives support the appointment of women physicians, dentists, and veterinarians.

1691. U.S. Congress. Senate. Committee on Armed Services. *Authorizing the Appointment of Qualified Women as Physicians and Specialists in the Medical Services of the Army, Navy and Air Force, Report to Accompany S. 2552.* S. Rept. 1220, 82d Cong., 2d sess., 1952. 3p. Serial 11566. Report supports a bill designed to help ease the shortage of physicians, dentists, and other medical specialists in the armed forces by uniformly providing for the appointment of qualified women.

1692. U.S. Air Force. *Officer Personnel: Appointment of Certain Nurse, Women Medical Specialists, Veterinary, or Medical Service Officers in Regular Air Force; Dec. 8, 1953.* Air Force Regulation 36-31. Washington, DC: The Department, 1953. 9p. D301.6:36-31/3.

1693. U.S. Air Force. *Officer Personnel: Designation of Aviation Medical Examiner, Flight Surgeon, and Flight Nurse; Aug. 3, 1953.* Air Force Regulation 36-32. Washington, DC: The Department, 1953. 2p. D301.6:36-32/2. Change sheet issued Nov. 8, 1954.

1694. U.S. Army. *Officers: Appointment in Medical, Dental, Veterinary, Medical Service, Army Nurse, and Women's Medical Specialist Corps, Regular Army; Nov. 12, 1952.* Army Special Regulation 605-25-10. Washington, DC: GPO, 1953. 14p. D101.10:605-25-10/3. Change sheet issued July 15, 1954.

1695. U.S. Army. *Officers: Army Nurse Corps Procurement Registered Nurse Student Program; Dec. 30, 1953.* Army Special Regulation 605-60-53. Washington, DC: GPO, 1953. 4p. D101.10:605-60-53. Change sheet issued Apr. 24, 1956.

1696. U.S. Congress. House. Committee on Armed Services. *Amending the Army-Navy Nurses Act of 1947, Report to Accompany S. 1530.* H. Rept. 386, 83d Cong., 1st sess., 1953. 6p. Serial 11665. A bill intended to expand recruitment of women for nursing and medical specialist positions in the Army and Navy by raising the age limit and authorizing appointment at a higher grade is reported.

1697. U.S. Congress. Senate. Committee on Armed Services. *Amending the Army-Navy Nurses Act of 1947 to Authorize the Appointment in the Grade of First Lieutenant of Nurses and Medical Specialists in the Regular Army and Regular Air Force and Appointment with Rank of Lieutenant (Junior Grade) of Nurses in the Regular Navy, Report to Accompany S. 1530.* S. Rept. 149, 83d Cong., 1st sess., 1953. 5p. Serial 11659. Favorable report presents a bill which addressed the military nursing shortage by raising the age limit for appointment and authorizing appointment at a higher rank.

1698. U.S. Army. *Medical Services: Army Nurse Corps; Oct. 14, 1954.* Army Regulation 40-20. Washington, DC: GPO, 1954. 7p. D101.9:40-20. Change sheet issued Aug. 9, 1955. Earlier see 1666.

1699. U.S. Army. *Medical Services: Women's Medical Specialist Corps; Dec. 15, 1954.* Army Regulation 40-7. Washington, DC: GPO, 1954. 2p. D101.9:40-7.

1700. U.S. Congress. House. Committee on the Judiciary. *Providing for the Relief of Certain Army and Air Force Nurses, Report to Accompany H.R. 9740.* H. Rept. 2300, 83d Cong., 2d sess., 1954. 3p. Serial 11742. Reports a bill to allow Army and Air Force nurses to count civilian services in the U.S. Public Health Service as creditable services for the purposes of calculating longevity pay. Such credit was already allowed for Navy nurses.

1701. U.S. Dept. of Defense. Recruiting Publicity Bureau. *Four Futures, Nursing Has a Future for You, Physical Therapy, Service and Career, Dieticians in Demand, Occupational Therapy, Pioneering Profession, Pick Professional Career and Plan with Purpose.* Washington, DC: The Bureau, 1954. 20p. D1.2:F98. Information on careers for women as nurses, dieticians, physical therapists, and occupational therapists is followed by a pitch for future service in the Armed Forces.

1702. U.S. Army. *Medical Services: Army Health Nursing Program; Aug. 17, 1955.* Army Regulation 40-551. Washington, DC: GPO, 1955. 2p. D101.9:40-551.

1703. U.S. Army. *Personnel Procurement: Appointment in Medical, Dental, Veterinary, Medical Service, Army Nurse, and Women's Medical Specialist Corps, Regular Army; Aug. 11, 1955.* Army Regulation 601-124. Washington, DC: GPO, 1955. 19p. D101.9:601-124. Change sheets issued Jan. 16, 1956, Jan. 18, 1957, and Apr. 10, 1957.

1704. U.S. Congress. House. Committee on Armed Services. *Amend Section 106 of the Army-Navy Nurses Act of 1947, Report to Accompany H.R. 2150.* H. Rept. 1135, 84th Cong., 1st sess., 1955. 5p. Serial 11824. Reports legislation to correct inequalities which arose from a change in the law governing years of service required for promotion to captain for Army and Air Force nurses.

1705. U.S. Congress. House. Committee on Armed Services. *Authorizing the Crediting, for Certain Purposes, of Prior Active Federal Commissioned Service Performed by a Person Appointed as a Commissioned Officer under Section 101 and 102 of the Army-Navy Nurses Act of 1947, as Amended, Report to Accompany H.R. 4106.* H. Rept. 1136, 84th Cong., 1st sess., 1955. 7p. Serial 11824. See 1708 for abstract.

1706. U.S. Congress. House. Committee on the Judiciary. *Providing for the Relief of Certain Army and Air Force Nurses, Report to Accompany H.R. 4051.* H. Rept. 287, 84th Cong., 1st sess., 1955. 2p. Serial 11822. Reports a bill clarifying the issue of longevity for the Army and Air Force nurses who also served as commissioned officers of the Public Health Service.

1707. U.S. Congress. Senate. Committee on Armed Services. *Amending Section 106 of the Army-Navy Nurses Act of 1947, Report to Accompany H.R. 2150.* S. Rept. 1076, 84th Cong., 1st sess., 1955. 5p. Serial 11817. Reports proposed legislation to eliminate inequities arising out of a change in rules governing years of service required for promotion to captain between Apr. 6, 1947 and Dec. 31, 1947.

1708. U.S. Congress. Senate. Committee on Armed Service. *Authorizing the Crediting, for Certain Purposes, of Prior Active Federal Commissioned Service Performed by a Person Appointed as a Commissioned Officer under Section 101 or 102 of the Army-Navy Nurses Act of 1947, as Amended, Report to Accompany H.R. 4106.* S. Rept. 1077, 84th Cong., 1st sess., 1955. 7p. Serial 11817. Report supports a measure to change rules governing the crediting of federal commissioned service for the purpose of promotion in the Army and Navy Nurse Corps.

1709. U.S. Army. *Personnel Procurement: Army Student Nurse Program; April 18, 1956.* Army Regulation 601-18. Washington, DC: GPO, 1956. 6p. D101.9:601-18. Change sheets issued Oct. 2, 1956 and Apr. 15, 1957.

1710. U.S. Congress. House. Committee on Armed Services. *Authorizing the Appointment of Nurses or Women Medical Specialists to be Members of the Army or Air Force National Guard of the United States, Report to Accompany H.R. 7290.* H. Rept. 2372, 84th Cong., 2d sess., 1956. 5p. Serial 11899. Presents proposed legislation to permit female Reserve Officers of the Army or Air Force, who were appointed as nurses or medical specialist, to be members of the National Guard.

1711. U.S. Congress. House. Committee on Armed Services. *Authorizing the Transfer of Officers of the Navy Nurses Corps to the Medical Service Corps of the Navy, Report to Accompany H.R. 9838.* H. Rept. 1945, 84th Cong., 2d sess., 1956. 3p. Serial 11897. Recommends legislation to facilitate the transfer of officers of the Navy Nurses Corps who are dieticians, physicians, and therapists to the Navy Medical Service Corps.

1712. U.S. Congress. Senate. Committee on Armed Services. *Authorizing the Appointment of Nurses or Women Medical Specialists as Members of the Army or Air National Guard of the United States, Report to Accompany H.R. 7290.* S. Rept. 2669, 84th Cong., 2d sess., 1956. 5p. Serial 11890. Reports a bill to authorize appointment of female Reserve Officers of the Army or the Air Force as nurses or women medical specialists in the National Guard or the Air National Guard.

1713. U.S. Congress. Senate. Committee on Armed Services. *Authorizing the Transfer of Officers of the Navy Nurses Corps to the Medical Service Corps of the Navy, Report to Accompany H.R. 9838.* S. Rept. 2166, 84th Cong., 2d sess., 1956. 3p. Serial 11888. Report supports a measure to facilitate transfer of members of the Navy Nurse Corps who were qualified as dieticians, physical therapists, and occupational therapists to the Medical Service Corps, if they so desired.

1714. U.S. Congress. Senate. Committee on the Judiciary. *Providing for the Relief of Certain Army and Air Force Nurses, Report to Accompany H.R. 4051.* S. Rept. 1945, 84th Cong., 2d sess., 1956. 2p. Serial 11892. The bill reported put Army and Air Force nurses on an equal footing with Navy nurses in regard to credit for civilian service with the Public Health Service in the computation of longevity pay.

1715. U.S. Navy. Bureau of Medicine and Surgery. *Honored as a Nurse, Respected as an Officer, Join the Navy Nurse Corps.* Washington, DC: GPO, 1956. 25p. D206.2:N93. Recruiting booklet gives an overview of career and recreational opportunities in the Navy Nurse Corps.

1716. U.S. Army. Medical Service. *Army Nurse Corps.* Washington, DC: GPO, 1957. 3p. D104.2:N93. Highlights career and educational opportunities in the Army Nurse Corps and the Army Reserve.

1717. U.S. Congress. House. Committee on Armed Services. *Armed Force Nurses and Medical Specialists Career Incentive Act, Report to Accompany H.R. 2460.* H. Rept. 141, 85th Cong., 1st sess., 1957. 84p. Serial 11984. Favorable report presents numerous amendments to legislation to elevate grade attainment expectations of Army and Navy nurses in order to encourage careers in military nursing. The bill raised the expected retirement grade from captain to major in the Army and from senior lieutenant to lieutenant commander in the Navy. The limitations in existing laws and the need for change are reviewed in the committee report and in appended correspondence from the Department of the Army.

1718. U.S. Congress. House. Committee on Armed Services. Subcommittee No. 2. *Subcommittee Hearings on H.R. 2460, To Improve Career Opportunities of Nurses and Medical Special Specialists of the Army, Navy, and Air Force.* 85th Cong., 1st sess., 2 Feb. 1957. 255-356pp. Y4.Ar5/2a:957-58/10. Hearing considers a bill intended to improve the opportunity for nurses and medical specialists in the Army, Navy, and Air Force by raising appointment grades, eliminating limits on number of nurses at the grade of major, placing members of Medical Service Corps on selection boards, and establishing separate promotion lists for nurses and medical specialists. Testimony focuses on the positive effect of recruiting women to armed forces nursing.

1719. U.S. Congress. Senate. Committee on Armed Services. *Armed Forces Nurses and Medical Specialists Career Incentive Act, Report to Accompany H.R. 2460.* S. Rept. 841, 85th Cong., 1st sess., 1957. 43p. Serial 11978. Reports a bill to make military careers more attractive to nurses by allowing nurses to achieve higher rank and by making the mandatory retirement requirements equal to those of non-nurse women in the Armed Forces. The need for the legislation to encourage nurses to make a career of military nursing is highlighted in correspondence from the Secretary of the Army.

1720. U.S. Congress. Senate. Committee on Armed Services. *Nurses and Medical Specialist Career Incentive Act, Hearing on H.R. 2460.* 85th Cong., 1st sess., 1 July 1957. 75p. Y4.Ar5/3:N93/3. Testimony supports H.R. 2460, a bill to provide wider opportunities for career advancement of nurses, dieticians, and physical and occupational therapists in the

armed forces. Includes data on the number and grades of nurses and medical specialists and discusses the need to recruit young women graduates in these fields.

1721. U.S. Navy. Bureau of Medicine and Surgery. *Navy Nurse Corps.* Washington, DC: GPO, 1958. 14p. D208.2:N93. Career opportunities and benefits of becoming a Navy nurse and qualification for each rank are presented.

1722. U.S. Surgeon General. *Highlights in the History of the Army Nurse Corps.* Washington, DC: GPO, 1958. 11p. D104.2:N93/2. Chronology of events in the history of the Army Nurse Corps from the Civil War to 1958.

1723. U.S. Navy. *Navy Nurse Corps.* Washington, DC: GPO, 1960. 15p. D208.2:N93/960.

1724. U.S. Navy. Bureau of Medicine and Surgery. *Join a Skillful Team, Navy Nurse Corps.* Washington, DC: GPO, 1960. 3p. D208.2:N93/2/960.

1725. U.S. Air Force. Recruiting Service. *Walk Proudly into the Future...as an Air Force Nurse.* Washington, DC: GPO, 1962. 14p. D301.2:N93.

1726. U.S. Army. *Education Opportunities for Students in the Field of Nursing.* Washington, DC: GPO, 1962. 8p. D104.2:N93/7. The requirements, benefits, and program structure of three Army Student Nurse Programs and the Registered Student Nurse Program are given.

1727. U.S. Army. *A New Career...U.S. Army Nurse Corps.* Washington, DC: GPO, 1962. 22p. D104.2:N93/962. The Army nurse lifestyle is described through the words of Army nurses representing various specialties and years in the corps.

1728. U.S. Congress. House. Committee on Merchant Marine and Fisheries. *Providing for the Registration of Professional Nurses as Staff Officers in the U.S. Merchant Marines, Report to Accompany H.R. 11903.* H. Rept. 2450, 87th Cong., 2d sess., 1962. 4p. Serial 12432. Legislation favorably reported would establish the classification of nurses as staff officers on Coast Guard ships together with pursers and ships' surgeons. Without the legislation they would be classed with oilers and wipers.

1729. U.S. Congress. House. Committee on Merchant Marine and Fisheries. *Providing that Professional Nurses Shall be Registered as Staff Officers in the U.S. Merchant Marine, Report to Accompany H.R. 5781.* H. Rept. 364, 88th Cong., 1st sess., 1963. 3p. Serial 12541. Reports a bill to reclassify professional nurses making them staff officers on merchant marine vessels.

1730. U.S. Congress. Senate. Committee on Commerce. *Registering Professional Nurses as Staff Officers in the U.S. Merchant Marines, Report to Accompany H.R. 5781.* S. Rept. 478, 88th Cong., 1st sess., 1963. 6p. Serial 12534. Reports a measure to recognize the professional status of nurses by classifying them as staff officers aboard vessels. The legislation was necessary because of a Coast Guard reclassification system which would have placed nurses in the same class as wipers, oilers, stewards and ordinary seamen. Correspondence from related agencies approving the measure is appended.

1731. U.S. Dept. of Defense. Medical Museum of Armed Forces Institute of Pathology. *Army Nurse Corps.* Washington, DC: GPO, 1964. 3p. D1.16/2:Ar5/2. Brief history of the Army Nurse Corps looks at military nursing from the Revolutionary War through the Korean Conflict.

1732. U.S. Navy. *Honored as a Nurse...Respected as an Officer.* Washington, DC: GPO, 1964. 10p. D208.2:N93/964.

1733. U.S. Army Medical Service. *Facts about the Army Nurse Corps.* Washington, DC: GPO, 1965. 9p. D104.2:N93/5/965. Recruiting booklet reviews appointment, duties, wages, and benefits of the Army Nurse Corps. Earlier editions published in 1961 and 1964.

1734. U.S. Bureau of Naval Personnel. *You, Your Country, and Navy Nurse Corps.* Washington, DC: GPO, 1966. 16p. D208.2:N93/966.

1735. U.S. Air Force. *The Professional Nurse in the United States Air Force.* Washington, DC: GPO, 1967. 17p. D301.2:N93/2. Overview of the history and duties of the Air Force nurse pays particular attention to the flight nurse program.

1736. U.S. Army. *Fact Sheet, Army Health Nursing.* Washington, DC: GPO, 1967. 3p. D104.2:N93/8. Recruiting booklet for public health nursing in the Army Nurse Corps.

1737. U.S. Navy. *Navy Nurse Corps Candidate Program.* Washington, DC: GPO, 1967. 3p. D208.2:N93/967. Presents specifics of the Nurse Corps Candidate Program which subsidized nursing education in return for a commitment to serve in the Navy Nurse Corps upon graduation.

1738. U.S. Air Force. *An Important Medical Discovery.* Washington, DC: GPO, 1968. 21p. D301.2:M46/2. Recruiting brochure on Air Force nursing focuses on opportunities in flight nursing and aerospace nursing.

1739. U.S. Army. *The Bright Adventure of Army Nursing.* Washington, DC: GPO, 1969. 28p. D104.2:N93/9.

1740. U.S. Army. *Educational Opportunities and Financial Assistance for Nursing.* Washington, DC: GPO, 1969. 7p. D101.2:N93.2. Recruiting booklet for the Army Student Nurse and Registered Nurse Programs.

1741. U.S. Army. *Financial Assistance and Educational Opportunities for Student Nurses and Registered Nurses, United States Army.* Washington, DC: GPO, 1970. 8p. D101.2:F49.

1742. U.S. Army. *Personnel Procurement, Army Student Nurse, Dietician, and Occupational Therapist Program; Jan. 15, 1970.* Army Regulation 601-19. Washington, DC: GPO, 1970. 15p. D101.9:601-19. Changes issued Apr. 10, 1970; Aug. 20, 1970; Mar. 2, 1971; May 21, 1971; July 2, 1971; Feb. 14,. 1972; and May 17, 1972. Change 4, issued May 21, 1971, removes discriminatory language.

1743. U.S. Army. *What It's Like to Be a U.S. Army Nurse.* Washington, DC: GPO, 1970. 12p. D101.2:N93/3.

1744. U.S. Air Force. *Find Yourself in a New World of Nursing.* Washington, DC: GPO, 1971. [6]p. leaflet. D301.2:N93/4. Recruiting pamphlet highlights opportunities in the Air Force Nurse Corps.

1745. U.S. Air Force. *Find Yourself: The Exciting World of Air Force Nursing.* Washington, DC: GPO, 1971. 13p. D301.2:N93/3.

1746. U.S. Army. *Financial Assistance for Nursing Students, College or University.* Washington, DC: GPO, 1971. leaflet. D101.2:N93/4. Summary information describes the Army Collegiate Program, a program providing financial assistance to juniors and

seniors in B.S. nursing degree programs in return for a two to three year Army Nurse Corps commitment.

1747. U.S. Army. *Financial Assistance for Nursing Students, Hospital School.* Washington, DC: GPO, 1971. pamphlet. D101.2:N93/5.

1748. U.S. Army. *Personnel Procurement: Registered Nurse Student Program; Oct. 19, 1971.* Army Regulation 601-135. Washington, DC: GPO, 1971. 4p. D101.9:601-135.

1749. U.S. Air Force Recruiting Service. *Open Up Your World in Air Force Reserve.* Washington, DC: GPO, 1974. 8p. D301.2:Op2. Illustrated recruiting booklet for the Air Force Nurse Corps.

1750. U.S. Army. *Medical Services: Army Nurse Corps; Oct. 26, 1977.* Army Regulation 40-6. Washington, DC: GPO, 1977. 7p. D101.9:40-6.

1751. U.S. Army. Headquarters United States Army Recruiting Command. *Personnel Procurement, Army Nurse Corps: Recruiting Handbook.* USAREC Pamphlet no. 601-10. Fort Sheridan, IL: Headquarters United States Army Recruiting Command, 1983. 103p. D101.6/5:N93. Specific information for Army Nurse Corps recruiters reviews the requirements of candidates and where to find them, how to sell the corps, and information on completing the application.

1752. U.S. Army. *A Professional Team, Army Nurse Corps.* Washington, DC: GPO, 1984. 14p. D101.N93/7. Describes the specialization programs of the Army Nurse Corps.

1753. U.S. Air Force. *An Air Force Invitation to Registered Nurses.* Washington, DC: The Department, 1987? [5]p. leaflet. D301.2:N93/5.

1754. U.S. Army. *Discover a Different Kind of Nursing: The Army Reserve Health Care Team.* Washington, DC: GPO, 1987. [10]p. D101.43/2:767. Recruiting booklet promotes Army Reserve nursing opportunities. Reprinted with minor revisions in 1989 and 1990.

1755. U.S. Army. *A Good Place for a BSN to Start: The Army Health Care Team.* Washington, DC:GPO, 1987. 17p. D101.43/2:565/987. Recruiting booklet reviews the benefits of jointing the Army Nurse Corps. Revision issued in 1990.

1756. U.S. Army. *Some Challenging Choices in Army Nursing.* Washington, DC: GPO, 1987. 21p. D101.43/2:590. Recruiting booklet describes specialization opportunities in the Army Nurse Corps. Revised edition issued in 1990.

1757. U.S. Army Center of Military History. *Highlights in the History of the Army Nurse Corps.* Washington, DC: The Center, 1987. 94p. D114.2:N93/987. Chronology of the Army Nurse Corps from 1775 to 1985 includes illustrations of uniforms and lists of monuments and memorials to Army nurses. Earlier edition issued in 1981.

1758. U.S. National Guard Bureau. *Fact Sheet, Air National Guard Flight Nurses.* Washington, DC: The Bureau, 1988? 4p. D12.15:N96/988. Describes eligibility requirements, benefits, pay, and retirement benefits for Air National Guard flight nurses.

1759. U.S. National Guard Bureau. *Fact Sheet, Air National Guard Nurses.* Washington, DC: The Bureau, 1989? 3p. D12.15:N93/2/988.

1760. U.S. Reserve Officers' Training Corps. *Anesthesia Nursing.* Washington, CD: The Corps, 1989? leaflet. D101.2:An3.

1761. U.S. Reserve Officers' Training Corps. *Ob/Gyn Nursing.* Washington, CD: The Corps, 1989? leaflet. D101.2:Ob7.

1762. U.S. Air Force. *Take Nursing to New Heights When You Service Part-Time in the Air National Guard.* Edgewood, MD: Advertising Support Center, Dept. of the Air Force, 1990? leaflet. D12.11:88-151.

1763. U.S. Army. *Today's Army Nurse Corps: A Tradition of Leadership in Health Care.* Washington, DC: The Dept., 1990. 28p. D101.43/2:573. Promotional booklet for career counselors details the career benefits for registered nurses in the Army Nurse Corps. The history of the corps, career opportunities, education, salary and benefits, and recruitment and training are briefly reviewed.

SERIALS

1764. U.S. Army. Army School of Nursing. *Annual Announcement of Army School of Nursing, Army Medical Center, Walter Reed General Hospital, Washington, D.C.* [title varies] Washington, DC: The Department, 1917? - 1930-31. annual. W44.23/2:N93/year.

1765. U.S. Army. Medical Department. *Circular of Information Concerning Army Nurse Corps, and Regulations Governing Admission to Same.* Washington, DC: The Department, 1911-1917. irreg. W44.5:N93/no.

1766. U.S. Navy. *Circular of Information for Persons Desiring Appointment as Officers, Aviation Cadets or Nurses, or Enlistments in Naval Reserve.* [title varies] Washington, DC: The Department, 1939 -1942. annual. N25.8:Ap6/year.

1767. U.S. Navy. *Circular of Information for Persons Desiring Appointment in Nurse Corps, Navy.* [title varies] Washington, DC: The Department, 1914 - 1928. irregular. N10.2:N93/year.

1768. U.S. Office of the Surgeon General. Nursing Division. *The Army Nurse.* Washington, DC: The Office, Jan. 1944 - Aug. 1945. v. 1, no. 1 - v. 2, no. 8. monthly. W44.29:vol./no. Newsletter printed notes about the activities of the Army Nurse Corps and about issues affecting them. Included a question and answer column which regularly discussed regulations and proper uniforms.

1769. U.S. War Dept. *Medical Department: Army Nurse Corps, General Provisions, May 1, 1925.* Army Regulation 40-20. Washington, DC: GPO, 1925 - 1947. revised irregularly. W1.6:40-20/rev.no.

11

Women in the Armed Forces

While documents on military nursing date back to the 1870s, government publications on the role of women in the armed forces in non-medical capacities begin with World War Two. The documents in this chapter are primarily a mixture of recruiting materials and congressional documents. The hearings and reports on the establishment of the Women's Army Auxiliary Corps (WAAC) and the Navy Women's Reserve (WAVES) are found in 1942 (1778, 1781, 1788-1789, 1793). These documents stress the desire for military control of female personnel and the need to free men for combat duty while utilizing women for clerical tasks. A major issue in the establishment of the WAAC was the comparability of pay to male personnel, and the authority of WAAC officers over male soldiers (1788). By 1943 Congress was already considering the replacement of the WAAC with the Women's Army Corps (WAC), a change from an auxiliary corps to a corps within the Army (1815-1816, 1823). One of the issues considered was whether the noncombat WACs should receive benefits equal to the officers in the Regular Army. Integration of WAVES into naval aviation activities was the focus of a 1943 Navy report which discusses the treatment of WAVES and proper etiquette for social contact between WAVES and male officers (1830).

The status of the Women's Air Service Pilots (WASP) and attempts to grant them military status are recorded in congressional documents from 1944. These hearings and reports describe the work performed by the WASPs while rejecting the continued utilization of female pilots (1863-1864, 1867). The status of the WASPs was considered again in the 1970's in relation to eligibility for VA benefits (2061, 2063).

Some of the more interesting documents from the World War Two period include *P.F.C. Mary Brown, a WAC Musical Revue*, a musical production on WAC life (1854), and *G.I. Jane Writes Home from Overseas*, a recruiting booklet based on excerpts of WAC letters (1843). Other significant documents on WAC life include a handbook on rules and regulations (1894) and a WAC officer leadership guide (1895). The leadership guide is particularly interesting with its advice on setting moral standards and dealing with lesbians.

The integration of women into the Regular Army, Navy and Marine Corps was examined in congressional hearings held in 1947 and 1948 (1906, 1911), and integration into the Coast Guard on a permanent basis was considered in 1949 (1922-1923). Paving the way for the acceptance of WACs by male personnel was the subject of *Leave It to the WAC*, one of a series of "troop topics" issued in 1951 (1934). The rule eliminating women with children under 18 from serving with the armed forces was considered in a 1953 Senate hearing at which the Director of the WAC opposed its elimination (1946).

By the 1960s Congress began to consider the equality of women's opportunity in the armed forces and reported legislation in 1966 and 1967 to remove restrictions on the promotion opportunities of women (2003, 2006-2008). Hearings held in 1971 discussed the utilization of women (2036), and the 1972 *Report of the Special Subcommittee on the Utilization of Manpower in the Military* (2037) called the existing utilization of women tokenism. In 1977 the Joint Economic Committee of Congress held two days of hearings on *The Role of Women in the Military* (2062) at which the utilization of women and the barriers to their advancement were examined. Regular hearings on military manpower continued to examine the role of women in the armed services and to debate the combat exclusion provisions (2066). Moves to reinstate the selective service in 1979 and 1980 brought about more congressional hearings focusing on the role of women in the military with an even greater emphasis on eliminating the combat exclusion (2069-2076). The combat exclusion laws were again the topic of hearings in 1988 on *Women in the Military* (2106) and of a GAO report on opening more opportunities for women (2110). A limited test of the assignment of women to combat positions was explored in a 1990 hearing where the performance of women in Operation Just Cause in Panama was used in supporting arguments (2118). The utilization of women in the armed forces is presented in a series of graphs in the report *Military Women in the Department of Defense*, issued annually since 1983 (2119).

Specific branches of the armed forces are examined in the various reports. The extensive report in 1982 of the Women in the Army Policy Review Group provides a detailed examination of the assignment of women to Military Occupational Specialties (2080). The report is interesting when examined in relation to a 1974 study which found that the majority of soldiers only considered "rifle-carrying foot soldier" to be an inappropriate occupational assignment for military women (2068). A detailed Air Force study published in 1985 examined the effect of increased utilization of women in the Air Force, with an eye toward shifting male applicants to the other branches of the service (2092-2094). A 1990 Coast Guard report examined all aspects of women's role in the Coast Guard and specifically addressed the treatment of women and issues of sexual harassment and child care (2117).

The admission of women to the military academies is covered in a number of documents. In 1945 the House Committee on Naval Affairs considered a bill to establish a Women's Naval Academy, although the measure was rejected on the grounds that women did not need extensive military training (1884). The admission of women to the Coast Guard Academy was considered in 1973 (2047), and a bill to require nondiscrimination in military academy admissions was considered in 1975 (2050). A nondiscrimination clause in Coast Guard Academy appointments was again considered in 1976 (2057-2058).

The characteristics and concerns of female veterans are the focus of numerous reports. The readjustment problems of World War Two veterans were the focus of a 1946 VA study (1900). Very little attention was given to female veterans until 1983 when House and Senate committees held hearings on VA health care for women veterans (2082-2083). The Senate report on the Veteran's Health Care and Programs Improvement Act of 1983 includes significant information on health care and women veterans (2084). Studies of the female veteran population include VA reports on *The Female Veteran Population* (2091), *The Aging Female Veteran* (2090), *Demographic and Socioeconomic Data on Female Veterans : A Study of Needs, Attitudes and Experiences of Female Veterans* (2097), and the periodically issued statistical report *Data on Female Veterans* (2120). Congressional hearings held in 1987 and 1989 also considered the *Status and Concerns of Female Veterans* (2103, 2113).

A number of documents provide histories of women in the armed forces. The role of women in the Civil War is recounted in *Our Women of the Sixties* (1998). An extensive examination of the development of women's uniforms through 1945 is provided in *Wardrobe for Women of the Army* (1886). The history of women in the Army through World War Two is detailed in *The Women's Army Corps* (1952) and a history from 1945 to 1978 was published by the Center for Military History (2111). The Coast Guard Women's Reserve was the subject of a

detailed history published in 1945 (1897). Three histories were published on the Women Marines covering World War One (2053), World War Two (2015), and the period from 1946 to 1977 (2102). A brief history of women in the armed forces from the Revolutionary War through the early 1960s can be found in *Women in the Armed Forces* (2000). The role of women in the armed forces in a health care capacity is covered in the documents in Chapter 10. Equal opportunity and the combat exclusion is also covered in Volume I documents on the Equal Rights Amendment.

1770. U.S. Adjutant General's Department. *How You Can Help Your Country in the WAAC.* Governors Island, NY: Recruiting Publicity Bureau, 1942. poster. W3.2:P84/3.

1771. U.S. Adjutant General's Department. *My Jim Would Be Proud of Me!* Governors Island, NY: Recruiting Publicity Bureau, 1942. poster. W3.2:P94/2.

1772. U.S. Adjutant General's Department. *Women's Army Auxiliary Corps, United States Army.* Governors Island, NY: Recruiting Publicity Bureau, 1942. [9]p. leaflet. W3.2:W84/2. Concise information on eligibility and duties of WAAC personnel.

1773. U.S. Adjutant General's Department. *Women's Army Auxiliary Corps, WAAC, United States Army.* Governors Island, NY: Recruiting Publicity Bureau, 1942. [11]p. leaflet. W3.2:W84/942.

1774. U.S. Bureau of Naval Personnel. *General Information Concerning Women's Reserve, U.S.N.R.* Washington, DC: The Bureau, 1942. 4p. N17.2:W84. Recruiting booklet highlights opportunities in the WAVES.

1775. U.S. Congress. House. *Establishing a Women's Auxiliary Reserve in the Navy, Conference Report to Accompany H.R. 6807.* H. Rept. 2349, 77th Cong., 2d sess., 1942. 2p. Serial 10664. The House receded from its disagreement to the Senate amendments to H.R. 6807, a bill to establish the WAVES, in this conference committee report.

1776. U.S. Congress. House. *Women's Army Auxiliary Corps Grades and Pay, Conference Report to Accompany S. 2751.* H. Rept. 2524, 77th Cong., 2d sess., 1942. 2p. Serial 10665. Conference report withdraws the amendment of the House which provided lower relative rank and pay for the director, assistant director, and field director of the WAAC.

1777. U.S. Congress. House. Committee on Military Affairs. *Women's Army Auxiliary Corps Act Amendments, Report to Accompany H.R. 7539.* H. Rept. 2475, 77th Cong., 2d sess., 1942. 12p. Serial 10664. Favorable report highlights proposed changes in the WAAC including adding grades in recognition of the fact that WAACs replaced existing enlisted men in technical positions and raising the pay and allowances of the corps members to bring them in line with the pay of enlisted men under the Pay Readjustment Act of 1942. Correspondence from the Secretary of War details the problems addressed by this bill.

1778. U.S. Congress. House. Committee on Military Affairs. *Women's Army Auxiliary Corps, Hearings on H.R. 6293.* 77th Cong., 2d sess., 20-21 Jan. 1942. 56p. Y4.M59/1:W84/2. Hearing considers the establishment of the Women's Army Auxiliary Corps. The organization of the corps and the type of work women would be expected to perform are outlined. Some witnesses debated the need for the WAAC, but most of the discussion centered on the need for military control of women volunteers.

1779. U.S. Congress. House. Committee on Military Affairs. *Women's Army Auxiliary Corps, Report to Accompany H.R. 6293.* H. Rept. 1705, 77th Cong., 2d sess., 1942. 4p. Serial 10661. Favorable report on legislation providing for the establishment of a Women's Army Auxiliary Corps recognizes that women can perform some noncombat service better

than men. The need for a women's corps under military discipline is described with special reference to the Aircraft Warning Service. Correspondence from the Army Chief of Staff and the War Department further stresses the need for a women's corps.

1780. U.S. Congress. House. Committee on Naval Affairs. *Establishing a Women's Auxiliary Reserve in the Navy, Report to Accompany H.R. 6807.* H. Rept. 2028, 77th Cong., 2d sess., 1942. 2p. Serial 10662. Favorable report on legislation providing for the establishment of a Women's Auxiliary Reserve in the Navy stresses the serious shortage of seagoing officers and men, and notes that, with proper training, women can perform many shore duties as efficiently as men.

1781. U.S. Congress. House. Committee on Naval Affairs. *Hearings on H.R. 6807 to Establish a Women's Auxiliary Reserve in the Navy, and for Other Purposes.* Sundry Legislation Affecting the Naval Establishment, 1942, no. 208. 77th Cong., 2d sess., 15 Apr. 1942. 3037-3041pp. Y4.N22/1a:941-42/208. Description and brief hearing on a bill to establish a Women's Auxiliary Reserve considers the creation of a special branch of the Navy for women performing coding and statistical work during wartime. The Women's Auxiliary Reserve was proposed as a temporary measure for the duration of the war. Proposed ranks, types of work, enlistment strength, and age requirements are discussed.

1782. U.S. Congress. House. Committee on Naval Affairs. *To Establish a Women's Auxiliary Reserve in the Navy and for Other Purposes (H.R. 6807).* Sundry Legislation Affecting the Naval Establishment, 1942, no. 228. 77th Cong., 2d sess., 16 Apr. 1942. p.3171. [1p.] Y4.N22/1a:941-42/228. Letter from the Navy Department expresses approval of the employment of women by the Navy in non-civil service capacities, but requests a temporary Naval Reserve as opposed to the establishment of an Auxiliary Corps.

1783. U.S. Congress. House. Committee on Naval Affairs. *To Permit Members of the Women's Reserve of the Naval Reserve to Serve in the Territories of Alaska and Hawaii (H.R. 7475).* Sundry Legislation Affecting the Naval Establishment, 1942, no. 278. 77th Cong., 2d sess., 14 Sept. 1942. p.3405. [1p.] Y4.N22/1a:941-42/278. Report from the Navy Department on a bill to allow women in the Naval Reserve to serve in Alaska and Hawaii recommends that all restrictions be removed, and that the Naval Reserve Act of 1938 be amended to preclude women from assigned duty on board vessels or in combat aircraft.

1784. U.S. Congress. House. Committee on the Merchant Marine. *Establishing a Women's Reserve in the Coast Guard Reserve, Report to Accompany H.R. 7629.* H. Rept. 2525, 77th Cong., 2d sess., 1942. 9p. Serial 10665. Favorable report on the establishment of a Women's Coast Guard Reserve stresses the need to utilize women in administrative, clerical, fiscal, and other types of duties, thus freeing men for sea duty.

1785. U.S. Congress. Senate. Committee on Commerce. *Establishing a Women's Reserve in the Coast Guard Reserve, Report to Accompany H.R. 7629.* S. Rept. 1657, 77th Cong., 2d sess., 1942. 9p. Serial 10659. Reports a bill to provide for the establishment of a women's reserve in the Coast Guard in order to free men for duty at sea. H. Rept. 2525 (incorrectly identified as S. Rept. 2525) is reprinted as explanation for the bill.

1786. U.S. Congress. Senate. Committee on Military Affairs. *Women's Army Auxiliary Corps Grades and Pay, Hearing on S. 2751.* 77th Cong., 2d sess., 4 Sept. 1942. 13p. Y4.M59/2:W84/4. Hearing examines a bill to bring WAAC pay grades into line with the pay of enlisted officers in the Regular Army and to add pay grades to the WAAC to ensure that WAAC personnel have grades equivalent to Army personnel performing similar duties. Much of the discussion focused on the number of WAAC's at the higher command levels. Also briefly mentioned are statistics on the educational attainment and marital status of the first WAAC class.

1787. U.S. Congress. Senate. Committee on Military Affairs. *Women's Army Auxiliary Corps Grades and Pay, Report to Accompany S. 2751.* S. Rept. 1603, 77th Cong., 2d sess., 1942. 6p. Serial 10658. Report supports a bill setting the grades and pay of members of the Women's Army Auxiliary Corps as equal to that of enlisted men in the Regular Army, and expanding the numbers of grades authorized by law in order to reflect the responsibilities of corps administration and of technicians.

1788. U.S. Congress. Senate. Committee on Military Affairs. *Women's Army Auxiliary Corps, Hearings on H.R. 6293.* 77th Cong., 2d sess., 1,4 May 1942. 51p. Y4.M59/2:W84/2. Hearing considers amendments to H.R. 6293, a bill to establish the Women's Army Auxiliary Corps. The amendment prohibited discrimination on the basis of race and made the WAAC a unit in the Army as opposed to a unit with the Army. First part of discussion focuses on differences in duties between the WAAC and the Women's Auxiliary Naval Reserve in connection with the question of organization of the corps. Also covered is the question of combat duty and whether women officers in the WAAC would have authority outside the WAAC, i.e. authority over male soldiers. Includes a section-by-section analysis of the proposed WAAC bill. On the race issue, the Army's opinion was that it did not discriminate, therefor the amendment was unnecessary.

1789. U.S. Congress. Senate. Committee on Military Affairs. *Women's Army Auxiliary Corps, Hearings on S. 2240.* 77th Cong., 2d sess., 6 Feb. 1942. 33p. Y4.M59/2:W84/3. Hearing on a bill to establish a Women's Army Auxiliary Corps to serve with the Army during WWII includes newspaper editorials endorsing the bill. Testimony defines the size, enlistment requirements, and duties of the corps and discusses grades and pay. The need for the corps versus using civilian volunteers is a major point of testimony. Approval of the work of the British WAAC's in WWI is also expressed in support of a similar corps in the United States.

1790. U.S. Congress. Senate. Committee on Military Affairs. *Women's Army Auxiliary Corps, Report to Accompany H.R. 6293.* S. Rept. 1320, 77th Cong., 2d sess., 1942. 4p. Serial 10657. Favorable report on a bill to establish a Women's Army Auxiliary Corps notes that the bill is essentially the same as S. 2240, favorably reported in S. Rept. 1051 (1701), with the addition of a 150,000 cap on the strength of the corps. The House Rept. 1705 (1779) is appended by way of explanation of the bill.

1791. U.S. Congress. Senate. Committee on Military Affairs. *Women's Army Auxiliary Corps, Report to Accompany S. 2240.* S. Rept. 1051, 77th Cong., 2d sess., 1942. 4p. Serial 10656. Favorable report provides details of a bill providing for the establishment of a Women's Army Auxiliary Corps which would recruit women for non-combat duties, particularly the Aircraft Warning Service. The rationale for the corps stresses the need to place women employed in some capacities under military rule and discipline. Communication from the Secretary of War describes the need for the corps.

1792. U.S. Congress. Senate. Committee on Naval Affairs. *Establishing a Women's Auxiliary Reserve in the Navy, Report to Accompany H.R. 6807.* S. Rept. 1511, 77th Cong., 2d sess., 1942. 5p. Serial 10658. Favorable report on a bill to establish a Women's Reserve in the Navy details the objections to the House version and offers amendments to the act to clarify military authority, non-replacement of civil service positions, and prohibition against combat or shipboard duty.

1793. U.S. Congress. Senate. Committee on Naval Affairs. *Women's Auxiliary Naval Reserve, Hearings on S.2527.* 77th Cong., 2d sess., 19 May, 23 June 1942. 39p. Y4.N22/2:W84. Hearing considers a bill to establish a Women's Auxiliary Naval Reserve to temporarily fill specialist positions in the Navy so that men could be placed shipboard. Most of the hearing centers on marital status and age of recruits, duties, grades, and pay. An

interesting proposed amendment to the bill would prohibit race discrimination in the Women's Auxiliary Naval Reserve.

1794. U.S. Office of Education. *Military Service.* Vocational Division Bulletin no. 221. Washington, DC: GPO, 1942. 48p. FS5.123:221. Basic information on the various branches of the armed forces covers the Women's Army Auxiliary Corps (WAAC), the Women's Reserve of the Naval Reserve (WAVES), and the Navy and Army Nurse Corps.

1795. U.S. War Dept. *Enlisted Men Initial Classification, Supplement, Instructions for Women's Army Auxiliary Corps Initial Classification; July 31, 1942.* Army Regulations 615-25/supplement. Washington, DC: GPO, 1942. 21p. W1.6:615-25/2/supp. Instructions for filling out the WAAC qualification card which records personal and employment data.

1796. U.S. War Dept. *Women's Army Auxiliary Corps: Operations Company, Aircraft Warning Service, Regional; July 4, 1942.* Table of Organization 35-67. Washington, DC: GPO, 1942. 3p. W1.25:35-67.

1797. U.S. War Dept. *Women's Army Auxiliary Corps Regulations (Tentative), 1942.* Washington, DC: GPO, 1942. 21p. W1.12:W84.

1798. American National Red Cross. *Red Cross and the WAC.* Washington, DC: American National Red Cross, 1943. [4]p. leaflet. W102.2:W84.

1799. American National Red Cross. *Red Cross and the Women's Reserves.* Washington, DC: American National Red Cross, 1943. [4]p. leaflet. W102.2:W84/2.

1800. U.S. Adjutant General's Dept. *73 Questions and Answers about the WAC.* Governors Island, NY: Recruiting Publicity Bureau, 1943. 17p. W3.2:W84/5. Answers questions on training, opportunities, pay, uniforms, and use of cosmetics.

1801. U.S. Adjutant General's Dept. *The Air Forces Need Thousands of WAAC Members to Help with Ground Duties.* Governors Island, NY: Recruiting Publicity Bureau,1943. poster. W3.2:P84/1.

1802. U.S. Adjutant General's Dept. *Are You a Girl with a Starspangled Heart? Join the WAC Now! Thousands of Army Jobs Need Filling!* Recruiting Publicity Bureau Poster no. 9. Governors Island, NY: Recruiting Publicity Bureau, 1943? poster. W3.46/8:9.

1803. U.S. Adjutant General's Dept. *Back of the Fighting Front, Women's Army Auxiliary Corps, Army.* Governors Island, NY: Recruiting Publicity Bureau, 1943. 32p. W3.2:W84/3/943.

1804. U.S. Adjutant General's Dept. *Facts You Want to Know about the WAC.* Governors Island, NY: Recruiting Publicity Bureau, 1943. 25p. W3.2:W84/4. Illustrated recruiting booklet for the WAC describes what duties are performed by WACs, how they live, and what the uniforms are like.

1805. U.S. Adjutant General's Dept. *This is Our War...* Governors Island, NY: Recruiting Publicity Bureau, 1943. W3.2:W84/2/943-1. Recruiting leaflet for the WAC.

1806. U.S. Bureau of Naval Personnel. *Enlist in Coast Guard SPARS, Release a Man to Fight at Sea, Apply to Your Nearest Navy Recruiting Station or Office of Naval Officer Procurement.* Washington, DC?: Navy Recruiting Bureau, 1943. poster. N17.23/2:Sp2.

1807. U.S. Bureau of Naval Personnel. *Enlist in the WAVES, Apply to Your Nearest Navy Recruiting Station or Office of Naval Officer Procurement.* Washington, DC?: Navy Recruiting Bureau, 1943. poster. N17.23/2:W36.

1808. U.S. Bureau of Naval Personnel. *How to Serve Your Country in the WAVES or SPARS.* Washington, DC: The Bureau, 1943. 28p. N17.2:W36. Illustrated recruiting booklet covers the basics of qualifications, training, duties, pay, WAVES lifestyle, and uniforms.

1809. U.S. Bureau of Naval Personnel. *It's a Woman's War Too! Join the WAVES, Your Country Needs You Now.* Washington, DC?: Navy Recruiting Bureau, 1943. poster. N17.23/2:W36/2.

1810. U.S. Bureau of Naval Personnel. *On the Same Team, Enlist in the WAVES.* Washington, DC?: Navy Recruiting Bureau, 1943. poster. N17.23/2:W36/4.

1811. U.S. Bureau of Naval Personnel. *Story of You in Navy Blue.* Washington, DC: The Bureau, 1943. 49p. N17.2:W36/3/943. Recruiting booklet describes the qualifications, pay, training, and job assignments for the WAVES noting requirements for officer rank and promoting the WAVES lifestyle.

1812. U.S. Bureau of Naval Personnel. *Women 20 to 36, Earn a Navy Rating, Join the WAVES.* Washington, DC?: Navy Recruiting Bureau, 1943. poster. N17.23/2:W36/3.

1813. U.S. Coast Guard. *A Message to You from Coast Guard SPARS, with Hopes That You Are Qualified To Become One of Them.* Washington, DC: GPO, 1943. leaflet. N24.2:Sp2.

1814. U.S. Congress. House. *Establishing a Women's Army Corps for Service in the Army of the United States, Conference Report to Accompany S. 495.* H. Rept. 595, 78th Cong., 1st sess., 1943. 4p. Serial 10762. Conference report offers reworded versions of House amendments.

1815. U.S. Congress. House. Committee on Military Affairs. *Establishing a Women's Army Corps for Service in the Army of the United States, Report to Accompany S. 495.* H. Rept. 267, 78th Cong., 1st sess., 1943. 11p. Serial 10761. Report supports a bill to establish, for the duration of the war plus six months, the WAC as a corps within the Army, as opposed to its status as an auxiliary unit. The change provided for more effective utilization of the corps and granted the women comparable benefits to those received by the soldiers they replaced.

1816. U.S. Congress. House. Committee on Military Affairs. *To Make the Women's Army Auxiliary Corps a Part of the Regular Army, Hearings on S. 495.* 78th Cong., 1st sess., 9 Mar. 1943. 40p. Y4.M59/1:W84/3. Hearing considers a bill to make the WAAC a part of the Army, as opposed to its original status as a corps with the Army. Testimony focused on how WAACs were being utilized and differences in benefits between the WAAC and the regular Army. A major point of contention was payment of subsistence and dependent allowances, specifically women's eligibility to receive benefits to support husbands, children, and parents, and the cost of such benefits to the government. Also debated was whether WAACs deserved the same benefits as regular Army since they were a noncombat unit.

1817. U.S. Congress. House. Committee on Naval Affairs. *Amending the Naval Reserve Act of 1938, as Amended, Report to Accompany H.R. 1364.* H. Rept. 307, 78th Cong., 1st sess., 1943. 4p. Serial 10761. Favorable report on a bill to remove limitations on the strength, duties, and overseas assignments of the Navy Women's Reserve reprints correspondence from the Navy Department supporting the bill.

1818. U.S. Congress. House. Committee on Naval Affairs. *Amending the Naval Reserve Act of 1938, as Amended, Report to Accompany H.R. 2859.* H. Rept. 527, 78th Cong., 1st sess., 1943. 5p. Serial 10762. Favorable report on legislation to remove restrictions placed on the strength, duties and benefits of the WAVES provides background on the organization and pay structure.

1819. U.S. Congress. House. Committee on Naval Affairs. *To Amend the Acts Providing for the Establishment of a Women's Reserve of the Navy and a Women's Reserve of the Coast Guard, to Permit the Enlistment of Women Who Have Attained the Age of 18 Years (H.R. 502).* Sundry Legislation Affecting the Naval Establishment, 1943, no. 52. 78th Cong., 1st sess., 8 Mar. 1943. p.615. [1p.] Y4.N22/1a:943-44/52. Report of the Navy Department comes out against a measure to lower the age limit from 20 to 18 for the Women's Reserve Corps of the Navy and the Coast Guard stating only that the need has not been demonstrated.

1820. U.S. Congress. House. Committee on the Merchant Marines. *Amending Coast Guard Auxiliary and Reserve Act of 1941, Relating to Women's Reserve, Report to Accompany H.R. 1616.* H. Rept. 359, 78th Cong., 1st sess., 1943. 4p. Serial 10761. Reports a bill to eliminate restrictions on the distribution of officers within grades, the duties, and the assignments of SPARS, and to provide benefits as afforded enlisted men as opposed to civil service employees. Many of the amendments offered are for the purpose of placing SPARS on equal footing with WAVES.

1821. U.S. Congress. Senate. Committee on Commerce. *Amending Coast Guard Auxiliary and Reserve Act of 1941, Relating to Women's Reserve, Report to Accompany H.R. 1616.* S. Rept. 572, 78th Cong., 1st sess., 1943. 2p. Serial 10757. Report supports a bill to provide for the expansion of the size of SPARS and to increase the number of commissions to the grade of lieutenant and lieutenant, junior grade.

1822. U.S. Congress. Senate. Committee on Military Affairs. *Establishing a Women's Army Auxiliary Corps for Service in the Army of the United States, Report to Accompany S. 495.* S. Rept. 45, 78th Cong., 1st sess., 1943. 3p. Serial 10755. Favorable report on legislation to establish a Women's Army Auxiliary Corps includes amendments clarifying the temporary status of the corps. The bill here reported places the WAAC within the Army as opposed to their status under the act of May 14, 1942 as serving with the Army.

1823. U.S. Congress. Senate. Committee on Military Affairs. *Women's Army Auxiliary Corps, Hearing on S. 495.* 78th Cong., 1st sess., 3 Feb. 1943. 20p. Y4.M59/2:W84/5. The duties and unit strength of the WAAC is examined in relation to a bill which would incorporate the WAAC into the Army, as opposed to its original auxiliary status. Questions center on training facilities, anticipated number of recruits, ability of women to replace men and at what ratio of women to men, and the age and screening of recruits.

1824. U.S. Congress. Senate. Committee on Naval Affairs. *Amending the Naval Reserve Act of 1938, as Amended, Report to Accompany H.R. 2859.* S. Rept. 426, 78th Cong., 1st sess., 1943. 3p. Serial 10756. Favorable report on legislation to remove many of the restrictions placed on benefits and unit strength identifies deployment of WAVES overseas as a problem in passage of the legislation.

1825. U.S. Marine Corps. *Be a Marine...Free a Marine to Fight.* Washington, DC: The Corps, 1943. [20]p. N9.2:M33/6/943. Recruiting information for the Marine Corps Women's Reserve describes qualifications, pay and rank, and training, and provides answers to most often asked questions.

1826. U.S. Marine Corps. *Be a Marine, Free a Marine to Fight, Join Marine Corps Women's Reserve.* Washington, DC?: Marine Corps Publicity Bureau, 1943. counter card. N9.17:M33/5.

1827. U.S. Marine Corps. *Personal Facts.* Washington, DC?: Marine Corps Publicity Bureau, 1943. [4]p. leaflet. N9.2:P43. Recruiting leaflet for Marine Corps Women's Reserve.

1828. U.S. Marine Corps. *United States Marine Corps Women's Reserve: Women of America, Release a Marine to Drive That Tank, Man That Gun, Down That Plane.* Washington, DC: The Corps, 1943. 36p. N9.2:M33/6/943-2.

1829. U.S. Navy. *How Navy Girls Live in Washington Government Residence Halls.* Washington, DC: The Department, 1943. poster. N1.31:G44.

1830. U.S. Navy. Aeronautics Bureau. Training Divisions. *WAVES in Naval Aviation Activities.* Washington, DC: GPO, 1943. 16p. N28.2:W36. Guidelines on integrating WAVES into naval aviation activities promotes the philosophy of treating the women as the men are treated, except in special circumstances. Modifications to discipline, uniform regulations, advancement in rating, and social contact and etiquette between WAVES and male officers and cadets are reviewed. Includes a list of tentative number of WAVES assigned by naval air station, general information on practices already proved satisfactory, and a sample of instructions issued to WAVES.

1831. U.S. Office of the President. *Statement of the President Relative to Women's Army Auxiliary Corps, May 15, 1943.* Washington, DC: The Office, 1943. 1p. Pr32.2:W842/3. Statement of Franklin Delano Roosevelt praises the Women's Army Auxiliary Corps on its first anniversary.

1832. U.S. Office of War Information. *Information Program for Women's Reserve of Navy.* by Bureau of Naval Personnel. Washington, DC: The Office, 1943. 15p. Pr32.5002:W84/4. Information for the media on selling the Navy Women's reserve to young women discusses the background and requirements of the Women's Reserve, major objections of women to joining the military, and suggested media approaches to recruitment. Training opportunities and uniforms are described and a list of quotes from military personnel and WAVES on the worth of the Women's Reserve is provided.

1833. U.S. War Dept. *W.A.C. Field Manual: Physical Training.* Field Manual 35-20. Washington, DC: GPO, 1943. 130p. W1.33:35-20. Illustrated field manual describes exercises for WAC recruits from the feet up.

1834. U.S. War Dept. *Women's Army Auxiliary Corps; January 1, 1943.* Washington, DC: GPO, 1943. 3p. W1.27:35. Change sheets issued May 29, 1943 and August 16, 1943.

1835. U.S. War Dept. *Women's Army Auxiliary Corps: Filter Company, Aircraft Warning Service; Feb. 24, 1943.* Tables of Equipment 35-57. Washington, DC: GPO, 1943. 3p. W1.26:35-57.

1836. U.S. War Dept. *Women's Army Auxiliary Corps, Filter Company, Aircraft Warning Service; Feb. 24, 1943.* Tables of Organization 35-57. Washington, DC: GPO, 1943. 4p. W1.25:35-57/2. Earlier tables issued July 4, 1942.

1837. U.S. War Dept. *Women's Army Auxiliary Corps: Operations Company, AWS, Regional, or AAAC; Feb.24, 1943.* Tables of Equipment 35-67. Washington, DC: GPO, 1943. 3p. W1.26:35-67. Change sheet issued May 29, 1943.

1838. U.S. War Dept. *Women's Army Auxiliary Corps Regulations, 1943.* Washington, DC: GPO, 1943. 110p. W1.12:W84/943. Regulation manual of the WAAC covers enrollment, officer candidates, appointment, promotion, rank, demotion, rating, discharge, and discipline. Includes regulations on training, uniforms and insignia, benefits, and pay and allowances. Also describes utilization of WAAC personnel and the organization of the corps.

1839. U.S. Army. *Are You Missing a Chance Like This? One of 239 Important Jobs WACs are Doing in the Army, Working in an Army Air Forces Sector Control Room.* Governors Island, NY?: Recruiting Publicity Bureau, 1944. 6p. leaflet. W3.2:W84/8.

1840. U.S. Army. *Army Ground Forces, Army Services Forces, There's a Job for You in the WAC.* Governors Island, NY?: Recruiting Publicity Bureau, 1944. 2p. leaflet. W3.2:W84/13.

1841. U.S. Army. *A Book of Facts about the WAC, Women's Army Corps.* Governors Island, NY?: Recruiting Publicity Bureau, 1944. 26p. W3.2:W84/14. Recruiting booklet describes WAC life and duties and give quotes from ranking officers on the WAC.

1842. U.S. Army. *College Women in the WAC.* Governors Island, NY?: Recruiting Publicity Bureau, 1944. 14p. W3.2:W84/11. Describes work opportunities for women college graduates in the WAC.

1843. U.S. Army. *G.I. Jane Writes Home from Overseas.* Governors Island, NY?: Recruiting Publicity Bureau, 1944. 19p. W3.2:W84/17. Quotes from WAC letters home from overseas postings form the basis of this recruiting booklet.

1844. U.S. Army. *Improve Your Skill or Learn a New One in a Vital Army Job: 239 Types of Army Jobs Need Women Like You.* Governors Island, NY?: Recruiting Publicity Bureau, 1944. 8p. leaflet. W3.2:W84/7.

1845. U.S. Army. *News for You, Your Opportunities in the WAC.* Governors Island, NY?: Recruiting Publicity Bureau, 1944. 6p. leaflet. W3.2:W84/9.

1846. U.S. Army. *Someone to Be Proud of, Your Daughter in the WAC.* Governors Island, NY?: Recruiting Publicity Bureau, 1944. 15p. W3.2:W84/15. Information slanted toward parental concerns tells of the opportunities and wholesome influence of enlistment in the WAC.

1847. U.S. Army. *There's a Job for You in the WAC.* Governors Island, NY?: Recruiting Publicity Bureau, 1944. 12p. leaflet. W3.2:W84/6.

1848. U.S. Army. *The WAC with the Army Ground Forces.* Governors Island, NY?: Recruiting Publicity Bureau, 1944. 33p. W3.2:W84/10. Recruiting booklet describes the WAC at work.

1849. U.S. Army. *While You Delay, They Die!: Vital Army Job Needs You, Join the WAC Now!* Governors Island, NY?: Recruiting Publicity Bureau, 1944. [6]p. leaflet. W3.2:W84/18.

1850. U.S. Army. *Women in the WAC, Here's Your G.I. Bill of Rights.* Governors Island, NY?: Recruiting Publicity Bureau, 1944. 4p. W3.2:W84/16.

1851. U.S. Army. *Women's Place in War, Women's Army Corps, Army of the United States.* Governors Island, NY?: Recruiting Publicity Bureau, 1944. 33p. W3.2:W84/12. Recruiting booklet provides a sample of work women do in the various branches of the WAC and presents information on basic qualifications and pay.

1852. U.S. Army Air Forces. Headquarters. *Women's Army Corps Inspection Manual, April 10, 1944.* AAF Manual 120-2. Washington, DC: GPO, 1944. 13p. W108.22:120-2. Defines the role of the inspector in the Women's Army Corps and sets forth the questions to be answered in the course of inspection. Topics covered include headquarters operation, officers and detachment relations, utilization of personnel, medical service, training, punishment records and recreation.

1853. U.S. Army Service Forces. Ninth Service Command. Special Services Division. Service Command Librarian's Office. *Bibliography on Postwar Readjustment for Service Men and Women, Basic List, July 1944.* Fort Douglas, Utah: Army Service Forces, 1944. 49p. W109.102:R22. Revised edition issued August 1945. Bibliography of books and articles on the readjustment of service personnel after World War II includes items on readjustment problems and programs and on vocational guidance sources. The focus is on servicemen, but some references on readjustment of servicewomen are included.

1854. U.S. Army Service Forces. Special Services Division. *P.F.C. Mary Brown, a WAC Musical Revue.* Washington, DC: GPO, 1944. various paging. W109.102:P93. Scripts, musical numbers, and stage directions for a GI show about life in the WAC.

1855. U.S. Bureau of Naval Personnel. *Bring Him Home Sooner, Join the WAVES.* Washington, DC?: Navy Recruiting Bureau, 1944. poster. N17.23/2:W36/9.

1856. U.S. Bureau of Naval Personnel. *Don't Miss Your Great Opportunity, Navy Needs You in the WAVES.* Washington, DC?: Navy Recruiting Bureau, 1944. poster. N17.23/2:W36/8.

1857. U.S. Bureau of Naval Personnel. *Have You Got What It Takes to Fill an Important Job Like This? Enlist in WAVES.* Washington, DC?: Navy Recruiting Bureau, 1944. poster. N17.23/2:W36/5.

1858. U.S. Bureau of Naval Personnel. *Schools and Rates for Navy Women.* Washington, DC: GPO, 1944. 20p. N17.2:Sch6/3. Describes the types of positions open to women in the Navy, the training required, and training provided by the Navy.

1859. U.S. Bureau of Naval Personnel. *You'll Be Happy Too, and Feel So Proud Serving as a WAVE in the Navy.* Washington, DC?: Navy Recruiting Bureau, 1944. poster. N17.23/2:W36/7.

1860. U.S. Bureau of Naval Personnel. *Will Your Name Be There? Serving in the WAVES.* Washington, DC?: Navy Recruiting Bureau, 1944. poster. N17.23/2:W36/10.

1861. U.S. Bureau of Naval Personnel. *Wish I Could Join Too! Serve Your Country In the WAVES.* Washington, DC?: Navy Recruiting Bureau, 1944. poster. N17.23/2:W36/6.

1862. U.S. Coast Guard. *Facts about SPARS.* Washington, DC: GPO, 1944. 24p. N24.2:Sp2/2/944. Heavily illustrated recruiting booklet covers the usual uniform, pay, qualifications, and job opportunity information.

1863. U.S. Congress. House. Committee on Military Affairs. *Providing for the Appointment of Female Pilots and Aviation Cadets of the Army Air Forces, Hearings on H.R. 4219.* 78th Cong., 2d sess., 22 Mar. 1944. 10p. Y4.M59/1:P64. Statement of General Henry H. Arnold supports the appointment of women as pilots and aviation cadets in the air forces of the Army for the duration of World War II. Arnold's statement discusses the serious manpower shortage and supports women's ability to perform duties such as ferrying plans

and towing aerial targets. Among the topics of questioning are the standards for female pilots, their capabilities, and their current utilization in a civilian status.

1864. U.S. Congress. House. Committee on Military Affairs. *Providing for the Appointment of Female Pilots and Aviation Cadets of the Army Air Forces, Report to Accompany H.R. 4219.* H. Rept. 1277, 78th Cong., 2d sess., 1944. 3p. Serial 10845. Favorable report on a bill providing for the appointment to female pilots and aviation cadets for non-combat duty notes that over 500 women pilots were already employed, but that the arrangement was unsatisfactory.

1865. U.S. Congress. House. Committee on Naval Affairs. *Amending the Naval Reserve Act of 1938 as Amended and the Coast Guard Auxiliary Reserve Act of 1941 as Amended so as to Permit Foreign Service to Members of the Women's Reserves upon Certain Conditions, Report to Accompany H.R. 5067.* H. Rept. 1724, 78th Cong., 2d sess., 1944. 4p. Serial 10847. Favorable report on a bill to change the regulations of the WAVES and SPARS to permit duty outside of the continental United States reprints the Navy Department correspondence urging passage of the measure.

1866. U.S. Congress. House. Committee on Naval Affairs. *Report Covering Various Assignments Pertaining to the Women in the Naval Services.* Sundry Legislation Affecting the Naval Establishment, 1944, no. 271. 78th Cong., 2d sess., 24 Nov. 1944. 2487-2492pp. Y4.N22/1a:943-44/271. Summary report on the WAVES, SPARS and Women Marines by Margaret Chase Smith was based on a tour of their facilities in locations around the country. Recommendations of the report are for better housing options and for more domestic and recreation facilities.

1867. U.S. Congress. House. Committee on the Civil Service. *Investigation of Civilian Employment: Concerning Inquiries Made of Certain Proposals for the Expansion and Change in Civil Service Status of the WASPs, Interim Report Pursuant to H.Res. 16.* H. Rept. 1600, 78th Cong., 2d sess., 1944. 14p. Serial 10846. Report of an investigation into the necessity of the Women's Air Service Pilots (WASP) concluded that there was a surplus of male pilots qualified for ferrying and training purposes and that the training of inexperienced women for those jobs would be a waste of resources both human and monetary. The expense of training women pilots and the pilot ratings of those trained are examined closely. Also discussed are differences in air hours requirements for men and women. Recommends that WASP recruitment and training be stopped, that trained WASP's continue to be utilized, that provisions for hospitalization and insurance be made, and that the existing surplus of male pilot personnel be used.

1868. U.S. Congress. Senate. Committee on Naval Affairs. *Amending the Naval Reserve Act of 1938 as Amended and the Coast Guard Auxiliary Reserve Act of 1941 as Amended, so as to Permit Foreign Service to Members of the Women's Reserves upon Certain Conditions, Report to Accompany S. 2028.* S. Rept. 1089, 78th Cong., 2d sess., 1944. 2p. Serial 10842. Favorable report on a bill to alter restrictions on assignment of WAVE members to duties outside the continental U.S. is put forward primarily to allow service in Hawaii.

1869. U.S. Forces European Theater. Information and Education Division. *The WAC: The Story of the WAC in the ETO.* N.p., 1944? 33p. W109.202:W84. Description of the role played by the WAC in the European Theater of Operations includes brief notes on individual women and a general description of the contribution of the WAC to winning the war in Europe.

1870. U.S. Office of Education. *Educational Level of Men and Women in the Armed Forces.* Washington, DC: The Office, 1944. 4p. FS5.2:Ar5/2. Provides statistics on the

educational attainment of members of the armed forces for the purpose of predicting post-war educational demands. Data is broken down by sex and branch of service.

1871. U.S. Marine Corps. *Ain't Sis and I Salty! Marine Corps Women's Reserve.* Washington, DC: The Corps, 1944. [4]p. leaflet. N9.2:M33/10.

1872. U.S. Marine Corps. *So Proudly We Serve.* Washington, DC: The Corps, 1944. 32p. N9.2:M33/6/944. Recruiting booklet describes in some detail the duties, training, possible assignments, and enlistment in the Marine Corps Women's Reserve. Also covers qualifications, pay, and rank, and illustrates the uniforms.

1873. U.S. Marine Corps. *So Proudly We Serve, Marine Corps Women's Reserve.* Camden, N.J.: Alpha Lithograph Co., 1944. poster. N9.17:M33/6.

1874. U.S. War Dept. *Mobilization Training Program for WAC Detachments in the Field; October 15, 1944.* Mobilization Training Program no. 35-2. Washington, DC: The Department, 1944. 4p. W1.37:35-2. Describes the course of instruction for WAC detachments in the field though a chart showing subject and scope of instruction.

1875. U.S. War Dept. *Mobilization Training Program for WAC Enlisted Personnel of Army Service Forces, July 1, 1944.* Mobilization Training Program 35-10. Washington, DC: The Department, 1944. 14p. W1.37:35-10. Details the training programs for WAC personnel including general training, basic military training, motor vehicle operators' course, cooks' course, and clerks' course. A schedule is provided for each training segment including hours per week for each subject.

1876. U.S. War Dept. *Personnel: Prescribed Service Uniform, Army Hostess and Librarian Services; Feb. 25, 1944.* Army Regulations 600-36. Washington, DC: GPO, 1944. 8p. W1.6:600-36/2. Earlier regulations issued July 7, 1942.

1877. U.S. War Dept. *Personnel: Prescribed Service Uniform, Women's Army Corps; Aug. 4, 1944.* Army Regulations 600-39. Washington, DC: GPO, 1944. 14p. W1.6:600-39/2. Earlier regulations issued Jan. 5, 1944.

1878. U.S. War Dept. *Women's Army Auxiliary Corps Training Centers; Nov. 6, 1944.* Table of Allowances 35-1. Washington, DC: GPO, 1944. 10p. W1.28:35-1/2. Earlier edition issued April 1, 1943.

1879. U.S. Adjutant General's Department. *Women, Our Wounded Need Your Care! Join a Hospital Company, Women's Army Corps.* Governors Island, NY?: Recruiting Publicity Bureau, 1945. poster. W3.46/1:H79.

1880. U.S. Army. *Our Wounded Need Care! Women...You Can Help To Give It! Join a Hospital Company.* Governors Island, NY?: Recruiting Publicity Bureau, 1945. 13p. W3.2:H79. Describes medical technician opportunities in the WAC.

1881. U.S. Army. *Women, Our Wounded Need Your Care! Join a Hospital Company, Women's Army Corps.* Governors Island, NY?: Recruiting Publicity Bureau, 1945. poster. W3.46/8:164.

1882. U.S. Bureau of Naval Personnel. *That Was the Day I Joined the WAVES.* Washington, DC?: Navy Recruiting Bureau, 1945. poster. N17.23/2:W36/11.

1883. U.S. Bureau of Naval Personnel. *United States Navy Rating Description, Seaman (WAVES), 1st and 2d Class.* Washington, DC: The Bureau, 1945. 8p. N17.2:R18/3.

1884. U.S. Congress. House. Committee on Naval Affairs. *To Establish a United States Women's Naval Academy (H.R. 3402).* Sundry Legislation Affecting the Naval Establishment, 1945, no. 97. 79th Cong., 1st sess., 11 Aug 1945. p.977. [1p.] Y4.N22/1a:945-46/97. Report from the Navy Department opposes the establishment of a Women's Naval Academy on the grounds that the duties of women in the Women's Reserve were such that extensive military training was not necessary.

1885. U.S. Congress. Senate. Committee on Military Affairs. *Reemployment Benefits to Former Members of the Women's Army Auxiliary Corps, Report to Accompany S. 1560.* S. Rept. 746, 79th Cong., 1st sess., 1945. 2p. Serial 10927. Favorable report on a bill which extends reemployment benefits under Section 8 of the Selective Training and Service Act of 1940 to women who left employment to join the Women's Army Auxiliary Corps.

1886. U.S. Quartermaster General of the Army. General Services Division. Historical Section. *Wardrobe for Women of the Army.* by Erma Risch. QMG Historical Studies no. 12. Washington, DC: The Division, 1945. 156p. W77.36:12. Illustrated history of the evolution of the uniforms worn by the WAAC and the Army Nurse Corps includes, among more expected topics, a chapter on criticism and modification of WAAC undergarments. Discusses the design, fabric, and color of the clothing, and its utility. Provides extensive footnotes and an index.

1887. U.S. Treasury Department. War Finance Division. *Tribute to Service Women, October 10, 1945.* Washington, DC: The Department, 1945. poster. T66.2:W84/2/945. Pictures of 12 meritorious service women, each with a short paragraph on her accomplishments, are followed by a plea to buy Victory Bonds.

1888. U.S. Treasury Department. War Finance Division. *Tribute to Service Women, November 10, 1945.* Washington, DC: The Department, 1945. poster. T66.2:W84/2/945-2. See 1887 for abstract.

1889. U.S. War Dept. *Catalog of Clothing and Uniforms for Women.* Supply Bulletin 10-160. Washington, DC: GPO, 1945. W1.61:10-160.

1890. U.S. War Dept. *Disposition of Women's Worn Clothing Items; May 1945.* Supply Bulletin 10-177. Washington, DC: GPO, 1945. 2p. W1.61:10-177.

1891. U.S. War Dept. *For Women Overseas.* War Department Pamphlet 35-4. Washington, DC: GPO, 1945. 2p. W1.43:35-4. Basic message of this pamphlet for women stationed overseas is don't let your country down by catching a venereal disease.

1892. U.S. War Dept. *Personnel: Prescribed Service Uniform, Women Personnel of Army; April 16, 1945.* Army Regulations 600-37. Washington, DC: GPO, 1945. 31p. W1.6:600-37/2. Changes issued May 10, Sept. 7, and Sept. 27, 1945; Mar. 25, Apr. 10, and May 19, 1946; May 19, 1947 and May 27, 1949.

1893. U.S. War Dept. *Supply of Clothing to Women's Army Corps; Dec. 19, 1945.* Supply Bulletin 10-262. Washington, DC: GPO, 1945. 2p. W1.61:10-262.

1894. U.S. War Dept. *WAC Life.* Army Pamphlet 35-3. Washington, DC: The Department, 1945. 199p. W1.43:35-3. Handbook for members of the WAC provides an orientation to the lifestyle, rules, and regulations of military life. Covers military drills, sick call, insignia and decorations, forms of address, and Army organization.

1895. U.S. War Dept. *The WAC Officer, Guide to Successful Leadership*. Army Pamphlet 35-2. Washington, DC: The Department, 1945. 70p. W1.43:35-2. Advice to the WAC officer on providing leadership to her unit covers handling personnel problems, setting the moral standard, and dealing with lesbians in her command.

1896. U.S. Bureau of Naval Personnel. *Navy's Women in White*. Washington, DC?: Navy Recruiting Bureau, 1946? poster. N17.23/1:374.

1897. U.S. Coast Guard Headquarters. Public Information Division. Historical Section. *Women's Reserve*. Coast Guard at War no. 22A. Washington, DC: The Section, 1946. 259p. N24.39:22A In-depth history of the Coast Guard Women's Reserve details organization, recruitment, training, selection of officers, and duty assignments. Basic background on characteristics of SPAR enlisted women and officers is provided and personnel policies are reviewed. Housing, promotion policies, and uniforms are among the other topics covered.

1898. U.S. Congress. House. Committee on Military Affairs. *Reemployment of Former Members of the WAAC, Report to Accompany S. 1560*. H. Rept. 1492, 79th Cong., 2d sess., 1946. 3p. Serial 11022. Reports a bill to correct a technical omission from the Selective Training and Service Act of 1940 for women who served in the WAAC and then entered the WAC without holding a permanent job in between. The section amended secures reemployment rights.

1899. U.S. Congress. House. Committee on Naval Affairs. *Amending the Naval Reserve Act of 1938, as Amended so as to Establish the Women's Reserves on a Permanent Basis, Report to Accompany H.R. 5915*. H. Rept. 2098, 79th Cong., 2d sess., 1946. 5p. Serial 11024. Favorable report on a bill establishing a permanent women's reserve in the Navy provides details on the strength, rank, limits on duty assignments, and benefits of the Women's Reserves.

1900. U.S. Veterans Administration. Office of Coordination and Planning. Research Service. *The Woman Veteran: Readjustment Experience and Problems Met Three to Four Months after Separation, Survey of Enlisted Women Discharged from Army and Navy in February 1946*. Washington, DC: The Administration, 1946. 10p. VA1.2:W84. Study of women veterans after separation from the armed services showed differences between their employment status prior to enlistment and after discharge, and highlights differences between the male and female veteran experience in the job market. Utilization of service-acquired skills was examined by type of skill, as was return to preservice employer. Utilization of veteran benefits such as aid for education and loans to purchase homes and business were also surveyed. Finally, the study examined success in carrying out plans made while in the service and reasons for being unable to carry out those plans.

1901. U.S. War Dept. *Women's Army Corps, Information Separation Pamphlet*. Army Pamphlet 35-5. Washington, DC: GPO, 1946. 8p. W1.43:35-5. Pamphlet intended to ease the transition to civil life is primarily devoted to topics of maternity care access after separation and war bonds, with a few notes on attitudes toward civilian life.

1902. U.S. Congress. House. Committee on Armed Services. *Relating to Credit for Service Rendered in the Women's Army Auxiliary Corps by Members of the Women's Army Corps (H.R. 244)*. Sundry Legislation Affecting the Naval and Military Establishment, 1947, no. 86. 80th Cong., 1st. sess., 2 Mar. 1947. 1255-1256pp. Y4.Ar5/2a:947-48/86. Report from the War Department opposes legislation to grant members of the WAC who also served in the WAAC credit for the purpose of longevity pay, retirement, and other benefits for the time served in the WAAC.

1903. U.S. Congress. House. Committee on Armed Services. *To Authorize the Enlistment and Appointment of Women in the Regular Navy and Marine Corps and the Naval and Marine Corps Reserve.* Sundry Legislation Affecting the Naval and Military Establishments, 1947, no. 167. 80th Cong., 1st sess., 20 June 1947. 3283-3291pp. Y4.Ar5/2a:947-48/167. Section-by-section summary of a bill to authorize the enlistment of women in the Navy and Marine Corps sets forth the limitations of such appointments. Numbers, grades, promotion, assignments, clothing, and retirement are detailed.

1904. U.S. Congress. House. Committee on Armed Services. *To Establish the Women's Army Corps in the Regular Army, and for Other Purposes (H.R. 3054).* Sundry Legislation Affecting the Naval and Military Establishment, 1947, no. 105. 80th Cong., 1st sess., 12 Apr. 1947. 1349-1351pp. Y4.Ar5/2a:947-48/105. Transmits a War Department draft of a bill to establish the Women's Army Corps as a permanent corps in the Regular Army and the Organized Reserve Corps.

1905. U.S. Congress. House. Committee on Armed Services. *To Provide Military Status for Women Who Served Overseas with the Army of the United States during World War I (H.R. 471).* Sundry Legislation Affecting the Naval and Military Establishment, 1947, no. 66. 80th Cong., 1st sess., 5 Mar. 1947. 929-930pp. Y4.Ar5/2a:947-48/66. Statement from the War Department opposes a bill to grant veteran status to women who served in uniform, but as civilians, with the Army overseas during WWI.

1906. U.S. Congress. Senate. Committee on Armed Services. *Women's Armed Services Integration Act of 1947, Report to Accompany S. 1641.* S. Rept. 567, 80th Cong., 1st sess., 1947. 10p. Serial 11116. Reports a bill to authorize enlistment and appointment of women in the Regular Army, Navy, and Marine Corps, similar to the incorporation of women into the armed forces during WWII. The bulk of the report consists of correspondence from the War and Navy Departments expressing their support for the bill and explaining the provisions of the legislation they proposed which were incorporated into this bill.

1907. U.S. Army. *Personnel: Prescribed Service Uniform, Army and Air Force Hostess - Librarian Service; April 8, 1948.* Army Regulation 600-36. Washington, DC: GPO, 1948. 12p. M101.9:600-36. Earlier regulations issued Feb. 25, 1944. Change sheet issued December 20, 1948.

1908. U.S. Army. *Women's Army Corps Training Center; Feb. 27, 1948.* Army Table of Allowances 35-1. Washington, DC: GPO, 1948. 7p. M101.29:35-1.

1909. U.S. Congress. House. *Women's Armed Services Integration Act of 1948, Conference Report to Accompany S. 1641.* H. Rept. 2051, 80th Cong., 2d sess., 1948. 29p. Serial 11212. Conference report details House amendments to S. 1641, a bill establishing the Women's Army Corps and governing the enlistment and appointment of women in the Regular Navy and Marine Corps and the Naval and Marine Corps Reserve.

1910. U.S. Congress. House. Committee on Armed Services. *Authorizing the Enlistment and Appointment of Women in the Reserve Components of the Army, Navy, Air Force, and Marine Corps and for Other Purposes, Report to Accompany S. 1641.* H. Rept. 1616, 80th Cong., 2d sess., 1948. 6p. Serial 11210. Reports, with numerous amendments, legislation to authorize the enlistment and appointment of women in the reserve components of the Army, Navy, Air Force, and Marine Corps.

1911. U.S. Congress. House. Committee on Armed Services. *Subcommittee Hearing on S. 1641, to Establish the Women's Army Corps in the Regular Army, to Authorize the Enlistment and Appointment of Women in the Regular Navy and Marine Corps and the*

Naval and Marine Corps Reserve, and for Other Purposes. Sundry Legislation Affecting the Naval and Military Establishments, 1948, no. 238. 80th Cong., 2d sess., 18 Feb. - 3 Mar. 1948. 5563-5747pp. Y4.Ar5/2a:947-48/238. Hearing on the establishment of a permanent status for women in the armed forces provokes much discussion on the role of women in the armed services, which is clearly clerical from most witnesses point of view, and on whether women should be in the Regular Army or only the Reserves. Testimony describes the utilization of WACs, WAVES, etc. during WWII, and comments on the related administrative considerations. Proposed utilization of women in the Army, Marine Corps, Navy, and Air Force is discussed in detail. Statements opposing the bill express concern over the militarization the future mothers of America.

1912. U.S. Air Force. *Air Provost Marshal: Apprehension and Confinement of Women in Air Force; July 27, 1949.* Air Force Regulation 125-7. Washington, DC: The Department, 1949. 2p. M301.6:125-7/2. Change sheet issued Feb. 20, 1950 under SuDoc D301.6:125-7A.

1913. U.S. Army. *Organized Reserve Corps: Appointments in the WAC Section, Organized Reserve Corps, for Subsequent Commission in Women's Army Corps, Regular Army.* Army Special Regulation 140-105-25. Washington, DC: GPO, 1949. 6p. D101.10:140-105-25. Change sheets issued Feb. 14, 1950; Dec. 28, 1950; and Feb. 2, 1951.

1914. U.S. Army. *Personnel: Detention of Women Personnel of Army; Aug. 8, 1949.* Army Regulation 600-325. Washington, DC: GPO, 1949. 2p. M101.9:600-325.

1915. U.S. Army. *Personnel: Women's Army Uniform; June 13, 1949.* Army Special Regulation 600-37-1. Washington, DC: GPO, 1949. 8p. M101.32:600-37-1. Change sheets issued May 5, Sept.15, and Oct. 4, 1950.

1916. U.S. Army. *Women's Army Corps Administrative and Training Positions for Officers; Jan. 27, 1949.* Army Special Regulation 625-10-5. Washington, DC: GPO, 1949. 1p. M101.32:625-10-5.

1917. U.S. Army. *Women's Army Corps and Women in the Air Force: Enlistment and Reenlistment; Sept. 9, 1949.* Army Special Regulation 625-120-1. Washington, DC: GPO, 1949. 10p. D101.10:625-120-1. Change sheet issued Feb. 28, 1950.

1918. U.S. Army. *Women's Army Corps: Discharge of Officers and Warrant Officers for Marriage and Pregnancy; Jan. 11, 1949.* Army Special Regulation 625-5-5. Washington, DC: GPO, 1949. 3p. M101.32:625-5-5. Change sheet issued May 12, 1950.

1919. U.S. Army. *Women's Army Corps: Enlistment in Regular Army of Enlisted Personnel Serving in Army; Mar. 16, 1949.* Army Special Regulation 625-120-5. Washington, DC: GPO, 1949. 5p. M101.32:625-120-5.

1920. U.S. Army. *Women's Army Corps: General Provisions; Jan. 25, 1949.* Army Regulation 625-5. Washington, DC: GPO, 1949. 8p. M101.9:625-5. Change sheets issued Nov. 8, 1949; June 13, 1950; Aug. 30, 1950; and Aug. 21, 1951.

1921. U.S. Army. *Women's Army Corps: Utilization of Enlisted WAC Personnel under Career Guidance Program; Sept. 20, 1949.* Army Special Regulation 625-225-10. Washington, DC: GPO, 1949. 4p. D101.10:625-225-10. Earlier regulation issued April 18, 1949 under SuDoc number M101.32:625-225-10.

1922. U.S. Congress. House. Committee on Merchant Marine and Fisheries. *Amending the Act of February 19, 1941, as Amended, so as to Establish a Women's Reserve as a Branch of*

the Coast Guard Reserve, Report to Accompany H.R. 4470. H. Rept. 578, 81st Cong., 1st sess., 1949. 2p. Serial 11298. Favorable report on the establishment of a permanent women's reserve in the Coast Guard cites the utilization of women in the SPARs during WWII in support of the legislation.

1923. U.S. Congress. House. Committee on Merchant Marine and Fisheries. *Providing for the Establishment of a Women's Reserve of the Coast Guard Reserve, Report to Accompany H.R. 1823.* H. Rept. 203, 81st Cong., 1st sess., 1949. 3p. Serial 11296. Favorable report on legislation establishing a permanent women's reserve in the Coast Guard provides correspondence from the Department of the Treasury, which has authority over the Coast Guard, supporting the continuation of the Women's Coast Guard Reserve on a permanent basis.

1924. U.S. Air Force. *Commissioned Officers: Release or Discharge of Female Officers, Marriage or Pregnancy; Aug. 30, 1950.* Air Force Regulation 36-36. Washington, DC: The Department, 1950. 5p. D301.6:36-36.

1925. U.S. Army. *Education and Training: Army Officer Candidate Courses, Women's Army Corps, Jan. 6, 1950.* Army Special Regulation 350-350-40. Washington, DC: GPO, 1950. 24p. D101.10:350-350-40. Change sheet issued June 20, 1950. Later regulations were incorporated into the general regulation with a paragraph on selection of female candidates.

1926. U.S. Army. *Enlisted Personnel: Discharge, Marriage and Pregnancy, August 30, 1950.* Army Regulation 615-361. Washington, DC: GPO, 1950. 4p. D101.9:615-361. Change sheets issued Aug. 3, 1951 and Feb. 1 and Mar. 26, 1952.

1927. U.S. Army. *Organized Reserve Corps: Utilization and Training of WAC Members of Active Reserve in ORC Program.* Army Special Regulation 140-190-1. Washington, DC: GPO, 1950. 2p. D101.10:140-190-1/2.

1928. U.S. Air Force. *Commissioned Officers: Appointment of Women in Air Force Reserve; April 27, 1951.* Air Force Letter 36-4. Washington, DC: The Department, 1951. 4p. D301.24:36-4.

1929. U.S. Air Force. *Military Personnel: Administration of WAF Personnel; Nov. 27, 1951.* Air Force Regulation 35-44. Washington, DC: The Department, 1951. 3p. D301.6:35-44/2. Earlier regulation issued Oct. 25, 1949.

1930. U.S. Army. *Enlisted Personnel: WAC MOS Assignment; Dec. 10, 1951.* Army Special Regulation 615-25-36. Washington, DC: GPO, 1951. 12p. D101.10:615-25-36/2. Earlier Special Regulation issued Nov. 15, 1950.

1931. U.S. Army. *Personnel: Detention of Women Personnel of Army, Effective May 31, 1951, April 16, 1951.* Army Regulation 600-325. Washington, DC: GPO, 1951. 2p. D101.9:600-325.

1932. U.S. Army. *Personnel: Service Uniform for Women Army Personnel; July 17, 1951.* Army Special Regulation 600-37-2. Washington, DC: GPO, 1951. 45p. D101.10:600-37-2. Change sheets issued Jan. 2,1952; Oct.7, 1952; Jan.5, 1953; Jan.12, 1953; May 25, 1953; and May 13, 1954.

1933. U.S. Army. *Organized Reserve Corps: Appointment in Women's Army Corps Section; May 21, 1951.* Washington, DC: GPO, 1951. 4p. D101.10:140-105/7/2. Change sheets issued Sept. 21, 1951 and Nov. 16, 1954.

1934. U.S. Army. *Troop Topics: Leave It to the WAC.* Washington, DC: The Department, 1951. 14p. D101.22:20-138. The role of the WAC in Army operations, particularly the need to use women when possible to free men for combat, is described in this talk aimed at paving the way for WAC acceptance by male troops. The diversity of jobs performed by WACs, many of whom have advanced degrees and specialized training, is stressed. Also provides some general organizational information on the WAC, and a defense of using WACs instead of employing civilians.

1935. U.S. Army. *Women's Army Corps: Appointment of Officers in Regular Army; June 22, 1951.* Army Special Regulation 625-5-1. Washington, DC: GPO, 1951. 10p. D101.10:625-5-1/2. Change sheet issued May 12, 1950 relates to marriage release.

1936. U.S. Air Force. *Enlisted Personnel: Discharge for Marriage, Pregnancy, and Minor Children; March 20, 1952.* Air Force Regulation 39-11. Washington, DC: The Department, 1952. 3p. D301.6:39-11/2. Change sheets issued Jan. 13, and Mar. 24, 1954 and Oct. 31, 1955. Earlier regulations issued December 30, 1949.

1937. U.S. Army. *Organized Reserve Corps: Items of Uniforms for ORC Enlisted Women in the Active Reserve.* Army Special Regulation 140-460-20. Washington, DC: GPO, 1952. 1p. D101.10:140-460-20.

1938. U.S. Army. *Personnel: Evening Dress Uniform for Women Personnel; Sept. 16, 1952.* Army Special Regulation 600-37-10. Washington, DC: GPO, 1952. 10p. D101.10:600-37-10.

1939. U.S. Dept. of Defense. *Women in the Armed Forces.* Armed Forces Talk no. 425. Washington, DC: GPO, 1952. 15p. D2.7:425. Brief history of women in the WAC, WAVES, WAF, Women Marines, and SPARS also serves as a recruiting talk.

1940. U.S. Air Force. *Officer Personnel: Discharge of Female Officers, Marriage, Pregnancy, Minor Children; Mar. 27, 1953.* Air Force Regulation 36-36. Washington, DC: The Department, 1953. 8p. D301.6:36-36/2. Changes issued July 27, 1954 and Oct. 31, 1955.

1941. U.S. Air Force. Human Resources Research Center, Air Researched Development Command, Lackland Air Force Base. *Study in Applicability of Some Minimum Qualifying Scores for Technical Schools to White Male, WAF, and Negro Males.* by Mary Agnes Gordon. N.p., Lackland Air Force Base, 1953. 25p. D301.36/2:53-34.

1942. U.S. Army. *Army Reserve: Appointment as Reserve Commissioned Officer of the Army of Assignment to Women's Army Corps Branch; Mar. 25, 1953.* Army Special Regulation 140-105-7. Washington, DC: GPO, 1953. 4p. D101.10:140-105-7. Change sheets issued Sept. 1953, Nov. 1954, June 1955.

1943. U.S. Army. *Education and Training: Training of Enlisted Women in Field Units.* Army Special Regulation 350-565-1. Washington, DC: GPO, 1953. 4p. D101.10:350-565-1. Regulations on programs of physical exercise and other training of WAC field units does not cover full-time or on-the-job training programs.

1944. U.S. Army. *Officers: Appointment in Women's Army Corps, Regular Army.* Army Special Regulation 605-25-25. Washington, DC: GPO, 1953. 13p. D101.10:605-25-25. Change sheets issued March 23, July 15, and Sept. 20, 1954.

1945. U.S. Army. *Women's Army Corps: General Provisions, Feb. 16, 1953.* Army Regulation 625-5. Washington, DC: GPO, 1953. 8p. D101.9:625-5. Change sheet issued March 10, 1954.

1946. U.S. Congress. Senate. Committee on Armed Services. *Appointment or Retention of Certain Female Reserve Personnel with Minor Children, Hearing before a Subcommittee on S. 1492.* 83rd Cong., 1st sess., 14-15 May 1953. 57p. Y4.Ar5/3:P43. Witnesses testify in favor of a bill which would eliminate an armed forces policy prohibiting women with children under 18 from serving in the Reserve. Testimony opposing the bill is presented by Col. Irene O. Gallaway, Director of the Women's Army Corps and representing the Department of Defense.

1947. U.S. Congress. Senate. Committee on Armed Services. *Appointment or Retention of Certain Female Reserve Personnel with Minor or Dependent Children, Report to Accompany S. 1492.* S. Rept. 393, 83d Cong., 1st sess., 1953. 3p. Serial 11660. Reports a bill to ensure that female Reserve officers and enlisted personnel would not be declared ineligible for service due solely to the presence of minor or dependent children and that they would not be involuntarily discharged because of the birth of a child.

1948. U.S. Air Force. *Enlisted Personnel: WAF Enlisted Personnel; Jan. 14, 1954.* Air Force Regulation 39-60. Washington, DC: The Department, 1954. 2p. D301.6:39-60.

1949. U.S. Army. *Enlisted Personnel: Discharge, Marriage, Pregnancy or Parenthood, Sept. 21, 1954.* Army Regulation 615-361. Washington, DC: GPO, 1954. 6p. D101.9:615-361/2.

1950. U.S. Army. *Officers: Release of Women Officers Because of Marriage, Pregnancy, or Parenthood; June 17, 1954.* Army Special Regulation 605-225-10. Washington, DC: GPO, 1954. D101.10:605-225 10.

1951. U.S. Army. *Personnel: Prescribed Service Uniform for Army Special Services Women Personnel; June 15, 1954.* Army Special Regulation 600-37-20. Washington, DC: GPO, 1954. 18p. D101.10:600-37-20. Change sheets issued May 21 and Nov. 27, 1956.

1952. U.S. Army. Office of the Chief of Military History. *The Women's Army Corps.* by Mattie E. Tredwell. Washington, DC: GPO, 1954. 841p. D114.7:W84. Comprehensive history of the WAC through WWII details the formation, organization, and early problems in the establishment of the Women's Army Corps. In particular the book focuses on the problem of the rapid recruitment of women during WWII, WAC activities in WWII theaters of operations, Department of Army policies that affected WAC's in particular, and demobilization.

1953. U.S. Congress. House. Committee on Veteran's Affairs. *Benefits for Certain Veterans of Service in Women's Army Auxiliary Corps, Report to Accompany H.R. 8041.* H. Rept. 1594, 83d Cong., 2d sess., 1954. 4p. Serial 11739. Favorable report on a bill to provide veterans benefits under certain conditions to women who served in the WAAC is accompanied by correspondence from the VA describing the implications of the bill.

1954. U.S. Congress. Senate. Committee on Armed Services. *Defining Service as a Member of the Women's Army Auxiliary Corps as Active Military Service under Certain Conditions, Report to Accompany S. 2040.* S. Rept. 1031, 83d Cong., 2d sess., 1954. 7p. Serial 11727. Report supports a bill to count service in the WAAC as military service for those women who subsequently served in the military in WWII. Arguments supporting the consideration of WAAC service as essentially military service is presented. Correspondence appended to the report communicates the Department of Defense and Veteran's Administration views on the measure.

1955. U.S. Congress. Senate. Committee on Finance. *Providing Benefits under the Laws Administered by the Veterans' Administration Based upon Service in the Women's Army*

Auxiliary Corps under Certain Conditions, Report to Accompany H.R. 8041. S. Rept. 1910, 83d Cong., 2d sess., 1954. 4p. Serial 11730. Favorable report recommends legislation to count service in the WAAC as military service for the purpose of veteran's benefits provided certain conditions were met. The report gives a concise summary of legislation affecting benefits to WAAC members, and VA correspondence discusses the implications of extending VA benefits to former WAACs.

1956. U.S. Government Printing Office. *WAC's Wartime Story, Women's Army Corps, Another in the Series, United States Army in World War 2.* Washington, DC: GPO, 1954. 2p. GP3.21:W84. Advertizing flyer for the United States Army in World War 2 series.

1957. U.S. Air Force Personnel and Training Research Center. *Comparison of Supervisor, Co-Worker, and Self-Ratings of WAF Job Performance.* by Marvin H. Berkely. San Antonio, TX: The Center, 1955. 25p. D301.36/6:55-25. Research Report AFPTRC-TN-55-25. Study found little difference between WAF performance evaluation by supervisors and co-workers, and no significant difference based on the sex of the rater.

1958. U.S. Army. *Education and Training: Institute for Officers of Women's Medical Specialist Corps, Fiscal Year 1955.* Army Circular 621-6. Washington, DC: GPO, 1955. 2p. D101.4:621-6.

1959. U.S. Army. *Education and Training: Women's Army Corps School, June 23, 1955.* Army Regulation 350-170. Washington, DC: GPO, 1955. 3p. D101.9:350-170.

1960. U.S. Army. *Personnel Procurement: Appointment in Basic Branches and Women's Army Corps, Regular Army, July 21, 1955.* Army Regulation 601-100. Washington, DC: GPO, 1955. 36p. D101.9:601-100. Change sheets issued Oct. 6, 1955; Oct. 12, 1955; Jan. 17, 1956; Apr. 24, 1956; and Jan. 18, 1957; and Apr. 5, 1957.

1961. U.S. Army. *Recommended List for Temporary Promotion to Grade of Lieutenant Colonel, Women's Army Corps.* Army Circular 624-27. Washington, DC: GPO, 1955. 2p. D101.4:624-27.

1962. U.S. Army. *Recommended Lists for Promotion to Lieutenant Colonel, Regular Army, Chaplains, Women's Army Corps and Army Medical Service.* Army Circular 624-26. Washington, DC: GPO, 1955. 14p. D101.4:624-26.

1963. U.S. Army. *Recommended Lists for Promotion to Major, Regular Army, and Major and Captain, Chaplains, Women's Army Corps and Army Medical Service.* Army Circular 624-33. Washington, DC: GPO, 1955. 27p. D101.4:624-33.

1964. U.S. Dept. of Defense and U.S. Dept. of Labor. *Careers for Women in the Armed Forces.* Washington, DC: The Department, 1955. 46p. D1.2:W84. Basically a recruiting pamphlet, this booklet provides information on enlistment, basic training, and military life, as well as information on training opportunities open to women.

1965. U.S. Air Force Personnel and Training Research Center. *Mental Qualification Tests for Women of the Armed Forces.* by Jane McReynolds. Development Report AFPTRC-TN-56-87. San Antonio, TX: The Center, 1956. 7p. D301.36/6:56-87. Based on the assumption that most women in the military would be assigned clerical tasks, this research reports on development and use of tests of verbal and quantitative skills for the selection of female personnel.

1966. U.S. Air Force Personnel and Training Research Center. *Stability of WAF Attitudes as Measured by WAF Attitude Survey BE-CE501GX.* by Marvin H. Berkeley and Leland D. Brokaw. Development Report AFPTRC-TN-56-72. San Antonio, TX: The Center, 1956. 7p. D301.36/7:56-72. Study of attitudes of WAFs in basic training and after permanent assignment found that the permanent WAF was more concerned with the working and living aspects of the situation than with the strictly military components. The permanent WAF was also found to be less happy about her work situation, her job and the training she received, and her educational and recreational opportunities.

1967. U.S. Army. *Education and Training: Women's Army Corps School, Dec. 14, 1956.* Army Regulation 350-170. Washington, DC: GPO, 1956. 3p. D101.9:350-170/2.

1968. U.S. Army. *Physical Training, Women's Army Corps.* Army Field Manual 35-20. Washington, DC: The Department, 1956. 111p. D101.20:35-20/2.

1969. U.S. Army. *Uniform and Insignia: Uniform Allowances for Army Special Services Female Personnel; June 26, 1956.* Army Regulation 670-340-7. Washington, DC: GPO, 1956. 2p. D101.9:670-340-7. Earlier regulations issued March 7, 1956.

1970. U.S. Congress. House. Committee on Armed Services. *Amend Title II of the Women's Armed Services Integration Act of 1948, Report to Accompany H.R. 8477.* H. Rept. 1904, 84th Cong., 2d sess., 1956. 16p. Serial 11897. Reports legislation to reduce the cluster of women at the grade of lieutenant by changing the requirements on the distribution of officers in the grade of commander and lieutenant commander, and to head off the forced discharge of lieutenants with thirteen years of service who were not on the promotion list by changing the act's requirement to fifteen years of service before discharge became mandatory.

1971. U.S. Congress. Senate. Committee on Armed Services. *Amending Title II of the Women's Armed Services Integration Act of 1948, Report to Accompany H.R. 8477.* S. Rept. 2052, 84th Cong., 2d sess., 1956. 13p. Serial 11888. See 1970 for abstract.

1972. U.S. Dept. of Defense. *Your Daughter's Role in Today's World: What Every Parent Should Know about Opportunities for Women in the Armed Forces.* Washington, DC: The Department, 1956. 12p. D1.2:D26/956. Booklet was designed to reassure parents and answer their questions about the opportunities, influences, and living conditions their daughter would be exposed to in the armed forces.

1973. U.S. Navy. *Chart Your Future as a Navy Officer.* Washington, DC: GPO, 1956. 22p. D208.2:Of2/2. Outlines opportunities for college educated women as navy officers.

1974. U.S. Adjutant General's Office. Personnel Research Branch. *Mental Screening Tests for Women in the Armed Forces.* by M. A. Mortaon, et al. PRB Technical Research Report 1103. Washington, DC: The Office, 1957. 16p. D102.27/2:1103. Describes the process for evaluating the Armed Forces Women's Selection Tests and the Women's Enlistment Screening Tests.

1975. U.S. Air Force. *Women in the Air Force, Enlisted Personnel.* Air Force Manual 39-5. Washington, DC: The Department, 1957. 16p. D301.7:39-5. Manual sets forth the administration of the WAF and covers legal authority, objectives, and organization. The specific responsibilities of WAF commanders are delineated.

1976. U.S. Congress. House. Committee on Government Operations. *Providing for the Relief of Certain Females Members of the Air Force, Report to Accompany H.R. 3028.* H. Rept. 144, 85th Cong., 1st sess., 1957. 13p. Serial 11984. Reports a bill to validate payment

of allowances for living quarters made to female Air Force personnel whose military husbands were stationed nearby. The General Accounting Office had determined that the allowance was not allowable, and that the women should pay the money back.

1977. U.S. Congress. Senate. Committee on Armed Services. *Amending Title 10, United States Code, with Respect to Auditing Certain Service as a Member of the Women's Army Auxiliary Corps, Report to Accompany S. 2305.* S. Rept. 1006, 85th Cong., 1st sess., 1957. 5p. Serial 11979. Favorable report on a bill to ensure that women who served in the WAAC, and subsequently served on active duty in any of the Armed Forces, received credit for their WAAC services. In particular the bill affected longevity and retirement pay.

1978. U.S. Congress. Senate. Committee on Armed Services. *Providing for the Relief of Certain Female Members of the Air Force, Report to Accompany H.R. 3028.* S. Rept. 1112, 85th Cong., 1st sess., 1957. 3p. Serial 11979. Reports a bill to allow female Air Force members married to other Air Force members at the same base to keep a housing allowance paid to them. The GAO had determined that legally the payments should not have been made and that the women were required to pay back the allowance.

1979. U.S. Congress. Senate. Committee on the Judiciary. *Providing for the Relief of Certain Female Members of the Air Force, Report to Accompany H.J. 3028.* S. Rept. 820, 85th Cong., 1st sess., 1957. 27p. Serial 11978. Favorable report on a bill to clarify the situation where female Air Force personnel, married to male personnel at the same base, were paid an allowance for quarters, then later told by the General Accounting Office to pay the money back.

1980. U.S. Marine Corps. *Young Women - Make Note of Your Future as a U.S. Marine Officer.* Washington, DC: The Corps, 1957. leaflet. D214.2:W84. Promotes opportunities for college educated women in the U.S. Marine Corps.

1981. U.S. Navy. *Close-Up of You in Navy Blue.* Washington, DC: GPO, 1957. leaflet. D208.2:N22/6.

1982. U.S. Navy. *Red, White and You in Navy Blue.* Washington, DC: GPO, 1957. leaflet. D208.2:N22/5. Answers the questions of potential WAVES such as, "How can I reassure my mother regarding living conditions that prevail for WAVES?" and, "Will I be able to retain my femininity in military life?"

1983. U.S. Navy. *Training for Teamwork.* Washington, DC: GPO, 1958. leaflet. D208.2:T68/3. Illustrates life at Recruits Training Command or "Boot Camp" for WAVES.

1984. U.S. Bureau of Naval Personnel. *Introduction to the Challenge, Navy Wave Officer Candidate.* Washington, DC: GPO, 1959. leaflet. D208.2:W36.

1985. U.S. Bureau of Naval Personnel. *Look at You in United States Navy.* Washington, DC: GPO, 1959. [16]p. pamphlet. D208.2:N22/8.

1986. U.S. Congress. House. Committee on Armed Services. *Amending Title 10, United States Code, with Respect to Crediting Certain Service as a Member of the Women's Army Auxiliary Corps, Reports to Accompany H.R. 3321.* H. Rept. 393, 86th Cong., 1st sess., 1959. 11p. Serial 12160. Reports legislation to credit service in the WAAC as active military service for women who subsequently served on active duty with the armed forces. The bill would put former WAAC members on an equal footing with women who served in the WAVES, SPARS or Women Marines for the purpose of promotion and VA benefits.

1987. U.S. Congress. Senate. Committee on Armed Services. *Amending Title 10, United States Code, with Respect to Crediting Certain Service as a Member of the Women's Army Auxiliary Corps, Report to Accompany H.R. 3321.* S. Rept. 568, 86th Cong., 1st sess., 1959. 6p. Serial 12151. Favorable report on legislation to credit service with the WAAC as active military duty for any women who subsequently served on active duty in any of the armed forces explains the implications of the status of the WAAC for promotion and benefits.

1988. U.S. Navy. *A Starring Role...In America's Global Navy.* Washington, DC: GPO, 1959. leaflet. D208.2:R64.

1989. U.S. Air Research and Development Command. Wright Air Development Division. *Factor Analysis of WAF Peer Nominations.* by Lois Lawrence Elliot. Technical report WADD-TN-60-217. San Antonio, TX?: The Division, 1960. 11p. D301.45/13:60-217. Analyzes the inter-correlation of 30 peer nomination variables, aptitude, age, and success or failure for WAF in basic training. Seven factors resulted including leadership, heterosexual adjustment, agreeableness, motivation, emotional maturity, neatness, and feminine interests.

1990. U.S. Air Research and Development Command. Wright Air Development Division. *Prediction of Success on WAF Basic Training by Two Background Inventories.* by Lois Lawrence Elliot. Technical report WADD-TN-60-216. San Antonio, TX?: The Division, 1960. 15p. D301.45/13:60-216. Keys were developed to predict success in basic training after administering the Biographical Inventory of the Airman Classification Battery and the WAF Self Report Inventory to six months' input of WAF basic trainees.

1991. U.S. Air Research and Development Command. Wright Air Development Division. *WAF Performance on the California Psychological Inventory.* by Lois Lawrence Elliot. Technical report WADD-TN-60-218. San Antonio, TX?: The Division, 1960. 8p. D301.45/13:60-218. Results of WAF basic trainees on the California Psychological Inventory were compared to norms for high-school women. WAF scores exceeded norms on all scales except social presence, socialization, flexibility, and femininity.

1992. U.S. Army. *Education and Training: United States Women's Army Corps School, Apr. 11, 1960.* Army Regulation 350-170. Washington, DC: GPO, 1960. 2p. D101.9:350-170/3.

1993. U.S. Air Force Systems Command. Personnel Laboratory, Aeronautical Systems Division. *Development of Screening and Selection Tests for Women.* Lackland Air Force Base, TX: The Division, 1961. 15p. D301.45/26:61-54. Reports on the development and standardization of replacement forms for the Armed Forces Women's Selection Test and the Women's Enlistment Screening Test.

1994. U.S. Air Force. *Your Daughter in the U.S. Air Force.* Washington, DC: GPO, 1962. 10p. D301.2:Ai7/7. Recruiting booklet aimed at the parents of young women considering the Air Force stresses the career opportunities, the wholesome influences of Air Force life, and the proper people to which their daughter would be exposed.

1995. U.S. Army. *Selected for Success.* Washington, DC: GPO, 1962. 44p. D101.2:Se4/2. Glossy recruiting booklet for the WAC stresses personal and career growth, travel opportunities, and Army life, and also mentions the opportunity to find a husband.

1996. U.S. Congress. House. Committee on Merchant Marine and Fisheries. *Granting Constructive Service to Members of the Coast Guard Women's Reserve for the Period from July 25, 1947, to November 1, 1949, Report to Accompany H.R. 4783.* H. Rept. 1448,

87th Cong., 2d sess., 1962. 4p. Serial 12429. Reports a bill to credit as constructive service the period from July 25, 1947 to November 1, 1949. The authority to continue the Coast Guard Women's Reserve was inadvertently terminated in 1947 and new legislation was not enacted until 1949.

1997. U.S. Congress. Senate. Committee on Commerce. *Authorizing Grant of Constructive Service to Certain Members of the Coast Guard Woman's Reserve, Report to Accompany H. R. 4783.* S. Rept. 1529, 87th Cong., 2d sess., 1962. 6p. Serial 12417. Favorable report on legislation providing for the period from July 25, 1947 to November 1, 1949 to be credited as constructive service for women who served at least one year in the Coast Guard Women's Reserve prior to July 25, 1947 and were also members of the Reserve between November 1, 1949 and July 1, 1956. The background situation is explained and supporting correspondence from the Treasury Department and Navy Department, and correspondence objecting from the Comptroller General, is appended.

1998. U.S. Civil War Centennial Commission. *Our Women of the Sixties.* Washington, DC: The Commission, 1963. 44p. Y3.C49/2:2W84. The role of women in the Civil War as soldiers, spies, soldier's wives, and civilians are related in this short history. Quotes from the letters and diaries of women on both sides of the conflict lend a personal note. Sources of information and quotes are not cited.

1999. U.S. Navy. *Navy WAVES, Share a Proud Tradition.* Washington, DC: GPO, 1964. 3p. D208.2:W36/2.

2000. U.S. Armed Forces Information Service. *Women in the Armed Forces.* Washington, DC: GPO, 1966. 11p. D2.14:GEN-24. A brief overview traces the history of women in the armed forces from the Revolutionary War through the early 1960s. The section on the modern role of women gives a few paragraphs on each of the corps.

2001. U.S. Army. *Physical Fitness Program for Female Special Staff Personnel and TD Organizations.* Army Pamphlet 21-2. Washington, DC: GPO, 1965. 37p. D101.22:21-2/2. Illustrated exercises in the physical fitness program for women in the Army includes a modified program for women over 40. Also includes the Army Minimum Physical Fitness Test - Female.

2002. U.S. Army Personnel Research Office. *Restandardization of Armed Forces Women's Section Test, AFWST 5 and 6.* USAPRO Technical Report AD614400. Washington, DC: The Office, 1965. 18p. D101.60/2:1141. Reports on restandardization of the norms on the Armed Forces Women's Section Test. Results showed the AFWST to be an effective predictor of success in basic training in the clerical course.

2003. U.S. Congress. House. Committee on Armed Services. *To Remove Promotion Restrictions on Women in the Armed Forces, and for Other Purposes, Report to Accompany H.R. 16000.* H. Rept. 2192, 89th Cong., 2d sess., 1966. 108p. Serial 12713-7. Reports, with amendments, a bill amending the U.S. Code to remove restrictions which limit the promotion opportunities for women officers in the Army, Navy, Air Force, and Marine Corps, including nurses. The report reviews the existing limitations and the justification for the bill, while noting that the bill does not provide for complete equity between men and women in the Armed Forces. Correspondence from the Department of Defense explains some of the details of the bill. The bulk of the report shows the changes in the existing law.

2004. U.S. Defense Advisory Committee on Women in Services. *For You, Officer's Career in Armed Forces.* Washington, DC: GPO, 1966. 32p. D1.2:Of2. Career oriented guide describes employment opportunities for college women in the armed forces.

2005. U.S. Air Force. *Jobs That Count in the Air Force.* Washington, DC: GPO, 1967. 12p. D301.2:J57. Heavily illustrated recruiting booklet describes qualifications, career opportunities, social life, and uniforms for women in the Air Force.

2006. U.S. Congress. House. Committee on Armed Services. *Removing Promotion Restriction on Women in the Armed Forces, and for Other Purposes, Report to Accompany H.R. 5894.* H. Rept. 216, 90th Cong., 1st sess., 1967. 106p. Serial 12753-2. Favorable report on a bill removing restrictions on the promotion of female officers of the Army, Navy, Air Force, and Marine Corps is essentially the same report as H. Rept. 89-2192 (2003). The effect of the bill on nurses, and the promotion of women to flag rank, is specifically discussed. Most of the report is a section-by-section analysis of the bill and the text of the law showing proposed changes.

2007. U.S. Congress. House. Committee on Armed Services. Subcommittee No. 1. *Subcommittee No. 1 Consideration of H.R. 5894, to Amend Titles 10, 32, and 37, United States Code, to Remove Restrictions on the Careers of Female Officers in the Army, Navy, Air Force, and Marine Corps, and for Other Purposes.* Hearings and Special Reports on Subjects Affecting the Naval and Military Establishments, 1967, no. 7. 90th Cong., 1st sess., 20 Apr. 1967. 373-386pp. Y4.Ar5/2a:967-68/7. Brief testimony examines a bill to remove barriers to the promotion of women officers in the armed forces and to place their promotion and career advancement opportunities on an equal basis with male officers.

2008. U.S. Congress. Senate. Committee on Armed Services. *Removing Promotion Restrictions on Women in the Armed Forces, and for Other Purposes, Report to Accompany H.R. 5894.* S. Rept. 676, 90th Cong., 1st sess., 1967. 17p. Serial 12750-4. Favorable report on legislation to remove promotion restrictions on women in the armed forces provides background on existing restrictions and a sectional analysis of the bill.

2009. U.S. Congress. Senate. Committee on Armed Services. *Savings Allotments, Female Officer Promotions, Ryukyu Islands, Hearing on H.R. 4772, H.R. 4903, H.R. 5894.* 90th Cong., 1st sess., 19 Oct. 1967. 49p. Y4.Ar5/3:Sa9. Hearing considers H.R. 5894, a bill to remove provisions of the U.S. Code which limit the promotional opportunities and restrict the career tenure of women officers in the Army, the Navy, the Air Force, and the Marine Corps. Areas covered by the bill include grades, number in each grade, and retirement provisions. The issue of pregnancy and immediate dismissal is briefly explored.

2010. U.S. Marine Corps. *Serving America as a Woman Marine.* Washington, DC: GPO, 1967. 4p. D214.2:W84/2.

2011. U.S. Marine Corps. *The Woman Officer in the United States Marine Corps.* Washington, DC: GPO, 1967. D214.2:W84/3. Officer recruiting pamphlet targets recent college graduates.

2012. U.S. Air Force. *Get with It, United States Air Force.* Washington, DC: GPO, 1968. 7p. D301.2:G23.

2013. U.S. Army. *A New Life, a New World, Today's Women's Army Corps.* Washington, DC: GPO, 1968. 26p. D101.2:W84. Recruiting booklet provides standard information on career opportunities, benefits, and uniforms for women in the WAC.

2014. U.S. Marine Corps. *The Woman Marine Officer Candidate, Information for a Woman Officer Candidate.* Washington, DC: The Corps, 1968? 11p. D214.2:W84/4. Information on the requirements of the Woman Officer Candidate Course for college women covers academic requirements, training, and commissioning.

2015. U.S. Marine Corps. Historical Branch. *Marine Corps Women's Reserve in World War II.* by Pat Meid. Washington, DC: The Corps, 1968. 98p. D214.14/2:W84. History of the Marine Corps Women's reserve in World War II. Provides information on the formation of and early recruitment for the corps, training and job assignments, and administration and policies. Describes the uniforms, overseas duties, and demobilization, and highlights the major personalities in the corps. Finally, the report profiles characteristics of women reservists including age, state of residence, and educational attainment.

2016. U.S. Naval Medical Field Research Laboratory. *Physical Fitness Test Standards for Women Marines.* by Ann Jewett. Naval Medical Field Research Laboratory Report, v. 18, no. 6. Washington, DC?: The Laboratory, 1968. 17p. D206.19:18/6. Analysis of the findings of four previous reports on the physical fitness of Women Marines. Focuses on the improvement of physical fitness testing and recommends physical fitness standards for Women Marines in the 18-24 and 25-34 age categories.

2017. U.S. Air Force. *That Special Look, Air Force.* Randolph Air Force Base, TX: Air Force Recruiting Service, 1969. 8p. leaflet. D301.2:Sp3.

2018. U.S. Air Force. *Women Officers in the U.S. Air Force.* Washington, DC: GPO, 1969. 13p. D301.2:W84/969. Describes career paths open to women as officers in the Air Force. Earlier edition published in 1968.

2019. U.S. Marine Corps. *Women Marine Officer Candidates: Information for a Woman Officer Candidate.* Washington, DC: The Corps. 1969. 12p. D214.2:W84/4. Answers to commonly asked questions about the Woman Officer Candidate course cover college requirements, training, commissions, and other rules and regulations of the program.

2020. U.S. Air Force. *Find Yourself Going Places as an Officer in the United States Air Force.* Washington, DC: GPO, 1970. leaflet. D301.2:Of2/3.

2021. U.S. Air Force. *Who Says Men Don't Listen When a Woman Talks! Women Officers in the Air Force.* Washington, DC: GPO, 1970. 5p. D301.2:W84/2.

2022. U.S. Army. *Begin as an Executive.* Washington, DC: GPO, 1970. [36]p. D101.2:Ex3/3. Heavily illustrated recruiting booklet for the Women's Army Corps covers career and travel opportunities, military life, and the uniforms.

2023. U.S. Army. *Educational Opportunities, Exciting Jobs: Women's Army Corps.* Washington, DC: GPO, 1970. 10p. D101.2:Ed8/4. Recruiting pamphlet describes job opportunities and training available to women in the WAC.

2024. U.S. Naval Ship Engineering Center. *Careers for Women in NAVSEC.* Washington, DC: The Center, 197? leaflet. D201.2:C18. Describes educational and career opportunities for civilian women with the nation's ship building program at NAVSEC.

2025. U.S. Air Force. *Discover the World: Women in the Air Force.* Washington, DC: GPO, 1971. 11p. D301.2:W84/3/971. Recruiting booklet highlights career opportunities in the WAF for high school graduates.

2026. U.S. Air National Guard. *The Air Guard Belongs, Women Belong in the Air Guard.* Washington, DC: GPO, 1971. 2p. leaflet. D12.2:Ai7.

2027. U.S. Army. *Personnel Procurement: Women's Army Corps Student Officer Program.* Army Regulation 601-115. Washington, DC: GPO, 1971. 9p. D101.9:601-115.

2028. U.S. Army. *Start as an Officer.* Washington, DC: GPO, 1971. leaflet. D101.2:Of2/3.

2029. U.S. Air Force. *Tomorrow is Now...in the United States Air Force.* Washington, DC: GPO, 1972. 11p. D301.2:W84/4. Informational booklet targets potential women enlistees in the Air Force.

2030. U.S. Army. *After High School, a Bright Future.* Washington, DC: GPO, 1972. leaflet. D101.2:W84/3.

2031. U.S. Army. *College Junior Program/Student Officer Program.* Washington, DC: GPO, 1972. 6p. D101.2:C68/3. Describes the College Junior Program, where one month of the summer was spent getting a taste of life in the WAC; and the Student Officer Program, where seniors received pay while finishing college and a commission upon graduation.

2032. U.S. Army. *Educational Opportunities, Exciting Jobs.* Washington, DC: GPO, 1972. 13p. D101.2:W84/4.

2033. U.S. Army. *Let Yourself Grow.* Washington, DC: GPO, 1972. 22p. D101.2:Y8/3. Basic recruiting information for women considering the Army outlines job opportunities, travel, and uniform regulations.

2034. U.S. Army. *Parent's Guide to Women's Army Corps.* Washington, DC: GPO, 1972. 8p. D101.6/5:W84.

2035. U.S. Army. *Start as an Officer.* Washington, DC: GPO, 1972. leaflet. D101.2:W84/2.

2036. U.S. Congress. House. Committee on Armed Services. Special Subcommittee on Utilization of Military Manpower. *Hearing before the Special Subcommittee on the Utilization of Manpower in the Military.* 92d Cong., 1st and 2d sess., 13 Oct. 1971 - 6 Mar. 1972. 12225-12503pp. Y4.Ar5/2a:971-72/51. One topic in this series of hearings on military manpower utilization is the role of women in the armed forces. Issues of equal opportunity and suitability of women for nontraditional roles in the military are debated. Detailed information on the assignment of women in the military is provided by senior women officers, who also discuss recruitment and enlistment standards. Promotion opportunities and the distribution of women by grade are discussed.

2037. U.S. Congress. House. Committee on Armed Services. Special Subcommittee on Utilization of Military Manpower. *Report of the Special Subcommittee on the Utilization of Manpower in the Military.* 92d Cong., 2d sess., 1972. Committee print. 14631-14663pp. Y4.Ar5/2a:971-72/58. Summary report on the utilization of military manpower calls the existing utilization of women "tokenism" and urges stronger recruitment efforts and better job opportunities for women in the armed forces. The status of women in the military, and the inequities in opportunities and benefits, are summarized.

2038. U.S. Dept. of Transportation. Aviation Medicine Officer. *Preliminary Study of Maximal Control Force Capability of Female Pilots.* by Bonne Kerim, et al. Technical report FAA-AM-72-27. Washington, DC: The Office, 1972. 21p. TD4.210:72-27. Study of the maximal voluntary force which a sample of 25 female pilots could exert on each flight control. The percent of maximal strength versus endurance relationship was established and compared with the results of other investigations.

2039. U.S. Congress. House. Committee on Armed Services. *Enhancing Female Participation in the Junior Reserve Officer Training Corps Program, Report to Accompany H.R. 8187.* H. Rept. 93-537, 93d Cong., 1st sess., 1973. 6p. Serial 13020-5. Report supports a bill to remove language from Title 10 of the U.S. Code which required a minimum of 100

male students to form a Junior ROTC unit. The bill officially recognized the inclusion of girls in the Junior ROTC program.

2040. U.S. Congress. House. Committee on Armed Services. *Establishing Uniform Original Enlistment Qualifications for Male and Female Persons, Report to Accompany H.R. 3418.* H. Rept. 93-718, 93d Cong., 1st sess., 1973. 5p. Serial 13020-8. Legislation equalizing armed forces standards for men and women relating to age, parental consent, and time of enlistment options is reported.

2041. U.S. Congress. House. Committee on Armed Services. Subcommittee No. 2. *Hearing on H.R. 3418 to Amend Section 505 of Title 10, United States Code, to Establish Uniform Original Enlistment Qualifications for Male and Female Persons; H.R. 10345, to Amend Title 10, United States Code, to Realign Naval Districts and for Other Purposes.* 93d Cong., 1st sess., 14 Nov. 1973. 30p. Y4.Ar5/2a:973-74/31. Brief hearing examines a bill to change the enlistment qualifications to create equal requirements for men and women with age of enlistment being the primary change. Differences in mental qualifications for men and women and the utilization of women in the military are briefly discussed.

2042. U.S. Congress. House. Committee on Armed Services. Subcommittee No. 2. *Hearing on H.R. 7582, H.R. 8187, and H.J. Res. 735.* 93d Cong., 1st sess., 26 Sept. 1973. 27p. Y4.Ar5/2a:973-74/23. Brief testimony supports H.R. 8187, a bill which would remove language specifying a minimum number of physically fit "male" students for Junior ROTC units. Testimony notes that under existing law young women were participating in the ROTC program, but that the women did not count in enrollment numbers. The proposed bill would make the enrollment of women official.

2043. U.S. Congress. House. Committee on Merchant Marine and Fisheries. *Women in the Coast Guard Reserve, Report to Accompany H.R. 9575.* H. Rept. 93-499, 93d Cong., 1st sess., 1973. 7p. Serial 13020-5. Supporting correspondence from the Secretary of Transportation is included in this bill to integrate the Women's Reserve of the Coast Guard into the Coast Guard Reserve.

2044. U.S. Congress. House. Committee on Merchant Marine and Fisheries. Subcommittee on Coast Guard and Navigation. *Coast Guard Miscellaneous, Hearings on H.R. 9293, H.R. 9575, H.R. 5384, S. 1352.* 93d Cong., 1st sess., 31 July, 1 Aug. 1973. 58p. Y4.M53:93-12. A significant portion of this hearing is devoted to discussion of H.R. 9575, a bill to authorize the enlistment and commissioning of women in the Coast Guard Reserve. At issue is whether women should be enrolled in a separate women's reserve or integrated into one Coast Guard Reserve. Restrictions on women in the Coast Guard and their career opportunities are discussed.

2045. U.S. Congress. Senate. Committee on Armed Service. *Enhancing Female Participation in the Junior Reserve Officer Training Corps Program, Report to Accompany H.R. 8187.* S. Rept. 93-515, 93d Cong., 1st sess., 1973. 4p. Serial 13017-4. Legislation favorably reported here would allow girls to officially participate in the Junior Reserve program at high schools and preparatory schools.

2046. U.S. Congress. Senate. Committee on Commerce. *Women in the Coast Guard Reserve, Report to Accompany H.R. 9575.* S. Rept. 93-550, 93d Cong., 1st sess., 1973. 7p. Serial 13017-7. Favorable report on integration of the Coast Guard Women's Reserves into the Coast Guard Reserve describes briefly the need to remove the discrimination against women in the Coast Guard resulting from their separate branch status.

2047. U.S. Congress. Senate. Committee on Commerce. Subcommittee on Merchant Marine. *Miscellaneous Coast Guard Bills, Hearing on S. 1734 and H.R. 9293, S. 2268, and H.R.*

9575. 93d Cong., 1st sess., 12 Oct. 1973. 41p. Y4.C73/2:93-42. One of the measures discussed provides for the enlistment and commissioning of women in the Coast Guard Reserve. The role of women in the Coast Guard is reviewed, and the possibility of admitting women to the Coast Guard Academy is discussed.

2048. U.S. National Guard Bureau. *Spend a Weekend with the Boys.* Washington, DC: GPO, 1973. 11p. leaflet. D12.2:Ar5/5.

2049. U.S. National Guard Bureau. *A Woman's Place is in the Guard.* Washington, DC: GPO, 1973. leaflet. D12.2:W84.

2050. U.S. Congress. House. Committee on Armed Services. Subcommittee No. 2. *Hearing on H.R. 9832, H.R. 10705, H.R. 11267, H.R. 11268, H.R. 11711, and H.R. 13729.* 93d Cong., 2d sess., 29 May -8 Aug. 1974. 304p. Y4.Ar5/2a:975-76/9. Hearing on bills to require nondiscrimination in admission to military academies deals primarily with the issue the of admission of women. Arguments focus on the women's effect on the atmosphere of the academies, women's ability to lead, and the utilization of women in combat positions. One of the witnesses opposing the admission of women is Jacqueline Cochran, head of the WASP pilot training program in WWII.

2051. U.S. Congress. Senate. Committee on Armed Services. *Establishing Uniform Original Enlistment Qualifications for Male and Female Persons, Report to Accompany H.R. 3418.* S. Rept. 93-839, 93d Cong., 2d sess., 1974. 4p. Serial 13057-3. Reports legislation providing for uniform enlistment qualifications for men and women by removing differences in age, parental consent, and duration of enlistment regulations.

2052. U.S. Air Force Human Resources Laboratory. *Characteristics of Women in the Air Force 1970 through 1973.* by Bart M. Vitola, Cecil J. Mullins, Joseph L. Weeks. Technical Report AFHRL-TR-74-59. Lackland Air Force Base, TX: The Laboratory, 1974. 16p. D301.45/27:74-59.

2053. U.S. Marine Corps. History and Museums Division. *Women Marines in World War I.* by Linda L. Hewitt. Washington, DC: The Corps, 1974. 80p. D214.13:W84. The history of the recruitment and military life of women marines in World War I was compiled based on correspondence and recollections of those first female marines. Archival photos help tell the story of the Marine Reserves (F), and appendices include a bibliography and a partial roster of women enrolled in the WWI Marine Corps.

2054. U.S. National Guard Bureau. *A Great Field for a Woman.* Washington, DC: GPO, 1974. leaflet. D12.2:W84/2. Recruiting pamphlet points out the opportunities for women in the Air National Guard. Earlier edition published in 1973 under SuDoc number D12.2:Ai7/4.

2055. U.S. Air Force Academy. Library. *Women in the Military.* Special Bibliography Series no. 51. N.p., 1975. 60p. D305.12:51. Bibliography on women in the armed forces lists books, periodical articles, technical reports, and government documents on the history of military women both in the U.S. and in foreign countries. Also lists citations on women in aviation and women in the service academies.

2056. U.S. Congress. House. Committee on Armed Services. Subcommittee on Military Compensation. *H.R. 7486, Defense Officer Personnel Management Act (DOPMA), Hearings.* 94th Cong., 1st sess., 11 June - 11 July 1975. 472p. Y4.Ar4/2a:975-76/20. Throughout this hearing on a revised officer personnel management structure is discussion of the promotion system for women in the Air Force. The policy of counting time during a female officer's pregnancy leave toward service obligations is also reviewed.

2057. U.S. Congress. House. Committee on Merchant Marine and Fisheries. *Nondiscriminatory Appointment of Cadets to the Coast Guard Academy, Report to Accompany H.R. 10192.* H. Rept. 94-1109, 94th Cong., 2d sess., 1976. 7p. Serial 13134-6. A summary history of women in the Coast Guard from the establishment of SPARs in WWII up to the present is included in this report on a bill to insert an anti-discrimination clause in Title 14 of the U.S. Code governing appointment of cadets to the United States Coast Guard Academy.

2058. U.S. Congress. House. Committee on Merchant Marine and Fisheries. Subcommittee on Coast Guard and Navigation. *Coast Guard Miscellaneous, Part 3, Hearings.* 94th Cong., 1st and 2d sess., 21 Nov. - 3 Aug. 1976. 350p. Y4.M53:94-33. Hearing on miscellaneous Coast Guard bills includes a brief section on H.R. 8414 and related bills which authorized the appointment of women applicants to the Coast Guard Academy. The academy's admission process and the plans for the integration of women into the academy are reviewed. The issue of athletic recruitment and women at the academy is also discussed.

2059. U.S. National Guard Bureau. *Army National Guard Affirmative Actions Plan.* Washington, DC: GPO, 1976. 29p. D12.2:Af2. Presents the goal and timetable-based affirmative action plan for minorities and women in the Army National Guard with objectives and brief background information.

2060. U.S. National Guard Bureau. *Women, the Next Thing You Know, They'll Want To Be Officers in the Army National Guard.* Washington, DC: GPO, 1976. 6p. D12.2:W84/3. Recruiting booklet describes requirements and training opportunities for women officers in the Army National Guard.

2061. U.S. Congress. House. Committee on Veterans' Affairs. Select Subcommittee to Review WASP Bills. *To Provide Recognition to the Women's Air Force Service Pilots for Their Service during World War II by Decreeing Such Service to Have Been Active Duty in the Armed Forces of the United States for Purposes of Laws Administered by the Veterans Administration.* 95th Cong., 1st sess., 20 Sept. 1977. 461p. Y4.V64/3:W84. Hearing considers granting women who served as Women Air Force Service Pilots (WASPs) the veterans benefits received by active duty Army personnel of WWII. Included in the hearing is a legislative history compiled by the Congressional Research Service, and reprints of the 1942 hearings on the Women's Army Auxiliary Corps. Testimony highlights the military nature of the duties of the WASPs and the inequities in the benefits they received as civil service rather than military personnel. Also reprints 1944 hearings *Providing for the Appointment of Female Pilots and Aviation Cadets of the Army Air Forces* (1863) and House Report 78-1277 (1864) of the same title.

2062. U.S. Congress. Joint Economic Committee. Subcommittee on Priorities and Economy in Government. *The Role of Women in the Military, Hearings.* 95th Cong., 1st sess., 22 July, 1 Sept. 1977. 143p. Y4.Ec7:W84/3. First day of the hearings features representatives from the Army, Navy, and Air Force testifying on recent changes in the utilization and opportunities for women in the military, and on present policies which affect women's opportunities. The second day of hearings presents testimony from the women's organization point of view with statements from the Women's Rights Project, a former director of the Women's Army Corps, the National Coalition for Women in Defense, and NOW. Witnesses focus on the extent to which opportunities in the military were still denied to women based on sex.

2063. U.S. Congress. Senate. Committee on Veterans' Affairs. *Recognition for Purposes of VA Benefits, Hearing on S. 247, S. 1414, S. 129, and Related Bills.* 95th Cong., 1st sess., 25 May 1977. 386p. Y4.V64/4:B43/3. Lengthy debate surrounds bills to recognize, for the purpose of veterans benefits, the military nature of services provided by the Women's

Air Forces Service Pilots (WASPs) and the women in the U.S. Signal Corps. Testimony includes opposition from the VA and support from NOW and former WASP members. The role played by the WASPs in WWII, their pay, training, and the conditions under which they worked, are detailed by supporters of the bill.

2064. U.S. Army Research Institute for the Behavioral and Social Sciences. *Male and Female Factors on the Cadet Evaluation Battery.* by Michael G. Rumsey and E. Sue Mohr. Technical Paper 331. Alexandria, Virginia: The Institute, 1978. 30p. D101.60:331. The study examined the Cadet Evaluation Battery (CEB), a test used to determine officer potential among cadets and which was based on a factor analysis of responses of male officers between 1961 and 1963. Factor analysis of the Cadet Evaluation Test (CET) found a wide divergence between male and female factors. Implications of the findings are discussed.

2065. U.S. Army Research Institute for the Behavioral and Social Sciences. *Women and ROTC Summer Camp, 1975.* by E.S. Mohr, G.P. Rowen, and R.F. Reidy. Technical Paper 293. Alexandria, Virginia: The Institute, 1978. 12p. D101.60:293. Study of sex differences in leadership and performance of cadets at the 1975 ROTC Advanced Summer Camp found that female cadets scored lower on most physically demanding exercises, and received lower ratings for leadership performance. Female cadets scored as well or better than male cadets on exercises based on cognitive and motivational abilities. Report discusses the possibility of sex bias in the measures used.

2066. U.S. Congress. House. Committee on Armed Services. *Hearings on Military Posture and H.R. 10929, Department of Defense Authorization for Appropriation for Fiscal Year 1979, Also H.R. 7431, Assignment of Women on Navy Ships, Part 5, Military Personnel - Title III, Active Forces; Title IV, Reserve Forces; Title V, Civilian Personnel; Title VI, Military Training Student Loans.* 95th Cong., 2d sess., 15 Feb. - 22 Mar. 1978. 1741p. Y4.Ar5/2a:977-78/56/pt.5. Sprinkled throughout this hearing on military personnel are references to the recruitment, accession rate, and training of women. Some specific statements address expanding the role of women in the armed forces, noting their admission to the service academies and discussing their exclusion from combat. Particular attention is paid to expanding the role of women in the Navy, where there assignment options are more limited. A plan for the assignment of women to sea duty is provided.

2067. U.S. Air Force Systems Command. Air Force Human Resources Laboratory. *Air Force Female Pilots Program: Initial Performance and Attitudes.* by Jeffery E. Kantor, et al. Technical report AFHRL-TR-78-67. Brooks Air Force Base, TX: The Laboratory, 1979. 38p. D301.45/27:78-67. In order to determine if measures used to predict the success of male pilot trainees are different from female trainees, the Air Force compared men and women on pre-training pencil-and-paper tests, psychomotor tests, and simulator flying, and on training success based on surveys. The only significant difference was found in flight instructor's evaluation of the relative abilities of female versus male trainees.

2068. U.S. Army Research Institute for the Behavioral and Social Sciences. *Male and Female Soldiers' Belief about the "Appropriateness" of Various Jobs for Women in the Army.* by Joel M. Savell, John C. Woelfel, Barry E. Collins and Peter M. Bentler. Technical Paper 352. Alexandria, VA: The Institute, 1979. 18p. D101.60:352. A 1974 study of attitudes about the appropriateness of 24 traditional and non-traditional jobs found that only "Rifle-carrying foot soldier" was considered inappropriate by a majority of soldiers. Willingness to accept women in non-traditional jobs was found to be related to sex and education of the respondents.

2069. U.S. Congress. Senate. Committee on Armed Services. Subcommittee on Manpower and Personnel. *Reinstitution of Procedures for Registration under the Military Selective Service*

Act, Hearing. 96th Cong., 1st sess., 13 Mar. - 10 July 1979. 239p. Y4.Ar5/3:M59/17. Witnesses testifying on reinstitution of selective service registration are generally opposed. The question of the registration of women is raised repeatedly. Military forces representatives briefly describe the status of women in the armed forces and reject the need to register and draft women.

2070. U.S. Congress. House. *Selective Service Reform; Message from the President of the United States Transmitting His Proposal for Selective Service Reform, Together with a Draft Proposed Legislation to Amend the Military Selective Service Act to Allow the Registration of Both Men and Women, Pursuant to Section 811 of Public Law 96-107.* H. Doc. 96-265, 96th Cong., 2d sess., 1980. 62p. Serial 13337. President's recommendation on reform of the Selective Service System includes the recommendation that women be registered for the military draft along with men. The proposal suggests that men and women would be drafted in proportion to the ability of the armed forces to use them effectively. Background on current armed forces laws and policy regarding the utilization of women in provided. The increase in the voluntary enlistment of women is also noted.

2071. U.S. Congress. House. Committee on Armed Services. *Hearings on Military Posture and H.R. 6495 [H.R. 6974] Department of Defense Authorization for Appropriations for Fiscal Year 1981, Part 1, Military Posture.* 96th Cong., 2d sess., 25 Jan. - 3 Mar. 1980. 1024pp. Y4.Ar5/2a:979-80/37/pt.1. Hearing on the status of the military establishment includes discussion of the role of women in the armed forces and of the possibility of eliminating the combat restriction for women.

2072. U.S. Congress. House. Committee on Armed Services. Subcommittee on Military Personnel. *Hearing on H.R. 6569, Registration of Women.* 96th Cong., 2d sess., 5,6 Mar. 1980. 131p. Y4.Ar5/2a:979-80/68. Hearing on the issue of draft registration for women discusses how such a draft would operate in wartime and examines the issue of combat duty. The constitutionality of an all-male draft is also examined. Testimony on the experience of the armed forces with women recruits describes their backgrounds, utilization, and retention. Opposition witnesses argued that a female draft would weaken the armed forces. The issue is discussed both from the standpoint of defense requirements and equal rights.

2073. U.S. Congress. House. Committee on Armed Services. Subcommittee on Military Personnel. *Women in the Military, Hearings.* 96th Cong., 1st and 2d sess., 13-16 Nov. 1979, 11 Feb. 1980. 369p. Y4.Ar5/2a:979-80/72. Hearing on the issue of allowing women in combat positions presents arguments that women cannot command, that they will distract male personnel, that they cannot stand the stress of combat, and that male military personnel will perform less effectively due to a desire to protect female combat troops.

2074. U.S. Congress. House. Committee on the Budget. Task Force on Defense and International Affairs. *Selective Service Registration, Hearing.* 96th Cong., 2d sess., 20 Feb. 1980. 77p. Y4.B85/3:R26. The registration of women for selective service is the focus of hearing testimony. Women's organization representatives testify against the registration of men or women and focus on the discrimination against women in the all-volunteer armed forces. The hearing also includes a lengthy exchange on the treatment of military women with dependents and the services which should be provided them.

2075. U.S. Congress. House. Committee on the Judiciary. Subcommittee on Courts, Civil Liberties, and the Administration of Justice. *Judiciary Implications of Draft Registration - 1980, Hearings.* 96th Cong., 2d sess., 14 Apr. - 22 May 1980. 390p. Y4.J89/1:96/45. Testimony on the issue of draft registration includes witnesses for and against registration and presents differing views on the registration of women. Representatives of NOW testify

against registration and a draft, but support the equal application of registration, if passed, to both sexes. The prohibition of women in combat is also discussed.

2076. U.S. Congress. Senate. Committee on Armed Services. *Department of Defense Authorization for Appropriations for Fiscal Year 1981, Hearings on S. 2294, Part 3, Manpower and Personnel.* 96th Cong., 2d sess., 19 Feb. - 2 Apr. 1980. 1911p. Y4.Ar5/3:D36/7/981/pt.3. Hearing on manpower aspects of the fiscal year 1981 Department of Defense authorization bill includes significant testimony on the role of women in the armed forces, specifically addressing the issue of sex discrimination and the combat restriction. One day of hearings focused on the issue of selective service registration of women. Most witnesses reject the concept of a draft for anyone, with witnesses split over whether draft registration, if legislated, should include women.

2077. U.S. Defense Advisory Committee on Women in the Service. *Changing Roles of Women in the Armed Forces.* Washington, DC: The Committee, 1980? 73p. D1.2:W84/3. Report of the fall meeting of the Defense Advisory Committee on Women in the Service includes text of speeches addressing the general role of women in the armed forces and a brief discussion of possible sex bias in the Armed Services Vocational Aptitude Battery.

2078. U.S. Air Force Systems Command. Air Force Human Resources Laboratory. *Introduction of Women into Titan II Missile Operations.* by Dana R. Ideen and Jeffrey E. Kantor. Technical Report AFHRL-TR-80-55. Brooks Air Force Base, TX: Air Force Human Resources Laboratory, 1981. 50p. D301.45/27:80-55. The attitudes, perceptions and performance of women versus men in Titan II missile training and operations were studied to determine if significant differences existed. The only major difference found was the perception of the number of women required to meet the physical requirement of a missile crew.

2079. U.S. Congress. House. Committee on Veterans' Affairs. Subcommittee on Oversight and Investigations. *Implementation of Title IV of Public Law 95-202, Relating to WASPs and Similarly Situated Groups, Hearing.* 97th Cong., 1st sess., 29 Sept. 1981. 79p. Y4.V64/3:97-37. Hearing on implementation of P.L.95-202, which made certain civilian groups serving under the armed forces in WWII eligible for VA benefits, focuses on the types of benefits due the WASPs and other groups retroactively assigned veteran status. At issue was the ability of a former WASP to qualify for veteran's preference and educational benefits under the G.I. Bill. The appendix includes correspondence regarding WASP eligibility and the texts of DoD decisions on the eligibility of specific groups for benefits under P.L.95-202.

2080. U.S. Army. Office of the Deputy Chief of Staff for Personnel. *Women in the Army Policy Review.* Washington, DC: The Office, 1982. 251p. D101.2:W84/5. Report of the Women in the Army Policy Review Group takes an in-depth look at assignment of women to Military Occupational Specialties and assesses the physical demands of each position and the likelihood of participation in direct combat.

2081. U.S. Congress. House. Committee on Veterans' Affairs. *Veterans' Administration Health Programs Amendments of 1983, Report to Accompany H.R. 2920.* H. Rept. 98-117, 98th Cong., 1st sess., 1983. 24p. Serial 13536. A review of the deficiencies of the VA provision of health care for female veterans is included in this favorable report on a bill for the improvement of VA health programs. The proposed legislation establishes an Advisory Committee on Women Veterans within the VA.

2082. U.S. Congress. House. Committee on Veterans' Affairs. Subcommittee on Hospitals and Health Care. *VA Health Care for Women and H.R. 1137, Hearings.* 98th Cong., 1st sess., 3 Mar. 1983. 175p. Y4.V64/3:98-4. Hearing considers the current status and

projected need for VA health care services for women veterans and discusses H.R. 1137, a bill to establish, by statute, a women's advisory committee within the Veterans Administration. Testimony talks about inequities in VA health care services for women, the need for the VA to do a better job of informing women veterans of services, the lack of studies of women veterans, and the need for further study.

2083. U.S. Congress. Senate. Committee on Veterans' Affairs. *Veterans' Health Care and Programs Improvement Act of 1983, Hearing on S. 11, S. 567, S. 578, S. 629, S. 664 and Related Bills.* 98th Cong., 1st sess., 9-10 Mar. 1983. 510p. Y4.V64/4:S.hrg.98-433. General hearing on the improvement of veterans health care and programs includes discussion of the need for better VA health care services for women veterans. The need for more studies of the female veteran population is specifically noted.

2084. U.S. Congress. Senate. Committee on Veterans' Affairs. *Veterans' Health Care and Programs Improvement Act of 1983, Report to Accompany S. 578.* S. Rept. 98-145, 98th Cong., 1st sess., 1983. 171p. Serial 13507. Favorable report on a bill to provide improved Veterans' Health Care programs includes the establishment of an Advisory Committee on Women Veterans. The case for such a group to study the needs of women veterans and make recommendation on programs, services, and benefits is made through a reviews of hearing testimony and the GAO report *Actions Needed to Insure that Female Veterans Have Equal Access to VA Benefits.* The opposition of the VA to the establishment of the advisory committee is also documented. The bill includes a provision directing the VA to provide fee-based outpatient care for the "nonservice-connected gender-specific disability of a woman veteran." The report discusses the general inadequacy of VA health care for women with gender-related health needs.

2085. U.S. National Guard Bureau. *On Guard: for the Best of Your Life: Opportunities for Women in the Army National Guard.* Washington, DC: The Bureau, 1983. [12]p. D12.12:82-105. Recruiting leaflet highlights opportunities for women in the Army National Guard.

2086. U.S. Congress. House. Committee on the Judiciary. Subcommittee on Administrative Law and Governmental Relations. *Women's Army Corps Veterans' Association, Hearing on H.R. 4966.* 98th Cong., 2d sess., 1 Aug. 1984. 16p. Y4.J89/1:98/75. Brief hearing on a proposed federal charter for the Women's Army Corps Veterans' Association reviews its history, organization, and objectives.

2087. U.S. Dept. of Defense. *Going Strong! Women in Defense.* Washington, DC: GPO, 1984. 28p. D1.2:W84/5. Overview of the roles women play in the various branches of the armed forces presents short profiles of individual women and reviews the work of civilian women and military wives.

2088. U.S. Veterans Administration. *Women Veterans.* Washington, DC: The Administration, 1984. [2]p. leaflet. VA1.19:06-85-1. Provides information on entitlements for women veterans.

2089. U.S. Veterans Administration. Office of Information Management and Statistics. *Women Veterans: Usage of VA Hospitalization.* by William F. Page and Donald Stockford. Biometrics Monograph no. 19. Washington, DC: The Administration, 1984. 28p. VA1.67:19. Analysis of data on women veterans' usage of VA hospitals compares male and female veterans in the areas of discharges, usage by age, military service-connected disability status, and principle medical diagnosis.

2090. U.S. Veterans Administration. Statistical Policy and Research Service. *The Aging Female Veteran: Follow-Up Analysis from the Survey of Aging Veterans.* Washington, DC:

The Administration, 1984. 8p. VA1.2:V64/10. Examines data on the income, family support, and health care needs of female veterans over age 55.

2091. U.S. Veterans Administration. Statistical Policy and Research Service. *The Female Veteran Population.* by Mark S. Russell. Reports and Statistics Monograph no. 70-84-1. Washington, DC: GPO, 1984. 15p. VA1.2:F34. Presents data for 1983 on characteristics of female veterans including age and period of military service. Estimates of the female veteran population by age, 1983 - 2030, is furnished.

2092. U.S. Air Force. Headquarters. USAF Special Study Team. *An Analysis of the Effects of Varying Male and Female Force Levels.* by Syllogistics, Inc. Washington, DC: GPO, 1985. various paging. D301.2:F74/annex 1. Report presents a model for Air Force enlistments by sex and Air Force specialties based on factors of enlistment requirements, individual ability, and interest in military service.

2093. U.S. Air Force. Headquarters. USAF Special Study Team. *United States Air Force Personnel Force Composition Study: An Analysis of the Effects of Varying Male and Female Force Levels.* Washington, DC: GPO, 1985. various paging. D301.2:F74. Study prepared for the House Committee on Armed Services examines the ability of the Air Force to increase its utilization of women. The projected pool for Air Force recruits and the probability of shifting male applicants to other branches of the armed services is examined. The role of the combat exclusion for the Air Force is also considered. Management aspects of increased utilization of women are explored. Appendices include a description of the historical development of USAF policy on the utilization of women and the Strategic Air Command study of females on Minuteman/Peacekeeper Crews.

2094. U.S. Air Force. Headquarters. USAF Special Study Team. *United States Air Force Personnel Force Composition Study: An Analysis of the Effects of Varying Male and Female Force Levels, Annex Five: Organizational Assessment Study.* by Systems Research and Applications Corporation. Washington, DC: GPO, 1985. various paging. D301.2:F74/annex 5. Report presents analysis of factors which might affect Air Force performance if the ratio of men and women in the Air Force were changed. The areas examined in depth include commitment to a work group and to an Air Force career, the ability to deploy quickly and lost work time, morale, "work around", and sexual harassment. Other factors considered in assessing the impact of increased utilization of women include sex and quality of group supervisors, the sex-marital-dependent status mix of the group, physical demands and the work environment, and personal characteristics. Results highlight the areas in which gender differences among Air Force personnel were found, and areas where no gender difference was evident.

2095. U.S. Congress. House. Committee on House Administration. *Memorial to Honor Women Who Have Served in or with the Armed Forces, Report to Accompany H.J.Res. 36.* H. Rept. 99-342, 99th Cong., 1st sess., 1985. 3p. Serial 13656. Favorable report on a bill granting authority to the Women in Military Service for America Memorial Foundation to erect on federal land in the Washington, D.C. area a memorial to women who served with or in the military establishment.

2096. U.S. Congress. Senate. Committee on Energy and Natural Resources. Subcommittee on Public Lands, Reserved Water and Resource Conservation. *Memorials and Monuments, Hearing on S. 1107, S. 1223, S. 1379, S.J.Res. 143, S.J.Res. 156, S.J.Res. 184.* 99th Cong., 1st sess., 29 Oct. 1985. 380p. Y4.En2:S.hrg.99-424. Hearing considers several bills authorizing the erection of memorials or monuments including S.J. Res. 156, to establish a memorial to women who served in the armed forces. The Department of the Interior opposed the bill as contrary to policy while other witnesses contended that a memorial to the women of the armed services was long overdue.

2097. U.S. Veterans Administration. Office of Information Management and Statistics. *Survey of Female Veterans: A Study of the Needs, Attitudes and Experiences of Women Veterans.* Washington, DC: GPO, 1985. 284p. VA1.2:F34/5. Survey of female veterans collected information on the length and nature of military service, reason for leaving the service, age, race, educational attainment, employment, occupation, income, problems faced, health status, marital status, fertility, household composition, and use of VA programs and services.

2098. U.S. Veterans Administration. Office of Information Management and Statistics. Statistical Policy and Research Services. *Demographic and Socioeconomic Data on Female Veterans.* by Wandakay J. Wells. Washington, DC: GPO, 1985. 21p. VA1.2:F34/3. Statistical profile of female veterans looks at age, period of service, race/ethnicity, marital status and presence of children, educational attainment, employment status, and income.

2099. U.S. Congress. Senate. Committee on Energy and Natural Resources. *Authorizing a Memorial to Women Who Have Served in the Armed Forces of the United States, Report to Accompany H.J. Res. 36.* H. Rept. 99-461, 99th Cong., 2d sess., 1986. 9p. Serial 13662. Reports a bill authorizing the erection on federal land of a memorial to women who served in the armed forces.

2100. U.S. Marine Corps. *Women Marines in the 1980s.* Washington, DC: The Corps, 1986. 18p. D214.2:W84/5. Presents the basics on training and deployment of women marines plus a short history of women in the Marines Corps.

2101. U.S. Marine Corps. History and Museums Division. *A History of the Women Marines, 1946-1977.* by Mary V. Stremlow. Washington, DC: GPO, 1986. 250p. D214.13:W84/2. History of the Women Marines chronicles the process of integrating women into the regular Marine Corps. The information on training and deployment of Women Marines was obtained through interviews with the women and archival records. Biographical information on the Sergeants Major and Directors of the Women Marines is included.

2102. U.S. Army. *Opportunities for Women.* Washington, DC: The Army, 1987. leaflet. D101.43/2:288. Recruiting brochure for the Army highlights career opportunities for women in non-traditional fields.

2103. U.S. Congress. House. Committee on Veterans' Affairs. Subcommittee on Oversight and Investigations. *Status and Concerns of Women Veterans, Hearing.* 100th Cong., 1st sess., 2 Apr. 1987. 169p. Y4.V64/3:100-6. Hearing on the status of women veterans looks at trends in the number of women veterans and at their knowledge of services available to them. Barriers to women's use of VA health care services and the government's sensitivity to identifying women veterans and their needs are highlighted.

2104. U.S. General Accounting Office. *Combat Exclusion Laws for Women in the Military: Statement of Martin F. Ferber, Senior Associate Director, National Security and International Affairs Division before the Subcommittee on Military Personnel and Compensation, House Armed Services Committee, United States House of Representatives.* Washington, DC: The Office, 1987. 16p. GA1.5/2:T-NSIAD-88-8. A brief historical overview of the limitations placed on utilization of women in the armed forces accompanies testimony on the current application of combat exclusion statutes and the impact of the polices of the effective management of military personnel.

2105. U.S. Naval Academy. *Opportunities for Women.* Annapolis, MD?: The Academy, 1987. 5p. D208.102:W84. Glossy recruiting publication for the Naval Academy describes the

physical and academic demands of the academy and addresses specific concerns of women regarding academy life.

2106. U.S. Congress. House. Committee on Armed Services. Military Personnel and Compensation Subcommittee. *Women in the Military, Hearings.* 100th Cong., 1st and 2d sess., 1 Oct. 1987 - 4 Feb. 1988. 224p. Y4.Ar5/2a:987-88/52. Review of the status of women in the military discusses attitudes prejudicial to women, sexual harassment, and the combat exclusion. A proposal to test the role of women in combat positions in the Army is also examined. The impact of the constant moves on wives' employment is discussed in testimony on the problems of military spouses.

2107. U.S. Congress. House. Committee on House Administration. *Vietnam Women's Memorial, Report to Accompany S. 2042.* H. Rept. 100-948, 100th Cong., 2d sess., 1988. 6p. Serial 13902. Reports a measure to authorize construction of a statue at the Vietnam Veterans Memorial to honor the women who served in Vietnam. A brief history of the Vietnam Veterans Memorial and the movement to have a memorial honoring the women who served is provided.

2108. U.S. Congress. Senate. Committee on Energy and Natural Resources. *Vietnam Women's Memorial, Report Together with Additional Views to Accompany S. 2042.* S. Rept. 100-371, 100th Cong., 2d sess., 1988. 12p. Serial 13861. Brief background information on the Vietnam Veterans' Memorial is provided in this favorable report on the proposed addition of a statue honoring the women who served in Vietnam.

2109. U.S. Congress. Senate. Committee on Energy and Natural Resources. Subcommittee on Public Lands, National Parks and Forests. *Vietnam Women's Memorial, Hearing on S. 2042.* 100th Cong., 2d sess., 23 Feb. 1988. 155p. Y4.En2:S.hrg.100-617. Presents testimony for and against a bill authorizing a statue of a woman at the Vietnam Memorial in commemoration of the 10,000 women who served in Vietnam.

2110. U.S. General Accounting Office. *Women in the Military: More Military Jobs Can Be Opened under Current Statutes.* Washington, DC: The Office, 1988. 57p. GA.13:NSIAD-88-222. The effect of combat exclusion provisions and service accession goals on opportunities for women in the military are examined. The report details the exclusion of women from many military jobs due to policies and procedures of the various branches rather than the combat exclusion. Recommendations to open more opportunities to women are made.

2111. U.S. Army. Center of Military History. *The Women's Army Corps, 1945-1978.* by Bettie J. Morden. Washington, DC: GPO, 1989. 543p. D114.19:W84. This post-V-J-Day history of the Women's Army Corps describes the struggle for equal status and benefits for women in the Army. The politics and policies of the WAC are the main focus as the areas of recruitment, retention, training, utilization, and entry to service academies are addressed. The status of the corps and its image are also examined in depth. The changing policies toward pregnancy and abortion are documented within the context of the times. The events leading up to the elimination of the WAC and the integration of women into the Regular Army, with a combat exclusion policy, are documented. Photographs of high-ranking WAC officers and important moments in corps history accompany the text.

2112. U.S. Congress. House. *Authorizing Appropriations for Fiscal Year 1990 for Military Activities for the Department of Defense, for Military Construction, and for Defense Activities of the Department of Energy, to Prescribe Personnel Strengths for Such Fiscal Year for the Armed Forces, and for Other Purposes, Conference Report to Accompany H.R. 2461.* H. Rept. 101-331, 101st Cong., 1st sess., 1989. 773p. The bill reported makes modifications in armed forces policies in numerous areas including compensation

and utilization of nurses, health benefits for former spouses, the survivor benefit plan, and military child care.

2113. U.S. Congress. House. Committee on Veterans' Affairs. Subcommittee on Oversight and Investigations. *Status and Concerns of Women Veterans, Hearing.* 101st Cong., 1st sess., 22 June 1989. 132p. Y4.V64/3:101-20. Overview of the status of women veterans looks at utilization of VA services and employment experience. Efforts by VA medical facilities to better meet the needs of women veterans are described while also noting needed improvements. Use by women of civil service veterans preference benefits are detailed. The proposed study of the health effects of Vietnam service on women veterans is also discussed.

2114. U.S. Dept. of Veterans Affairs. *Women are Veterans, Too!* Washington, DC: The Dept., 1989? [6]p. VA1.19:10-109. Reviews VA benefits for women veterans. Earlier edition published in 1986 under SuDoc number VA1.19:W84.

2115. U.S. General Accounting Office. *Housing Allowances: Equity Issues for Certain Military Members.* Washington, DC: The Office, 1989. 40p. GA1.13:NSIAD-89-134. Perceived inequities in military housing allowance options for dual-service career couples and divorced service members paying child support are reviewed.

2116. U.S. Army. *Army Opportunities for Women.* Washington, DC: GPO, 1990. leaflet. D101.43/2:288/990-2.

2117. U.S. Coast Guard. *Women in the Coast Guard Study.* Washington, DC: GPO, 1990. various paging. TD5.2:W84. Report of a detailed study of women in the Coast Guard examines recruiting and retention, performance in training, advancement, and quality of life. The attitudes of men and women towards service in the Coast Guard and the treatment of women are reported. Pregnancy and sexual harassment are examined along with child care and fraternization issues.

2118. U.S. Congress. House. Committee on Armed Services. Military Personnel and Compensation Subcommittee. *Women and the Military, Hearing.* 101st Cong., 2d sess., 20 Mar. 1990. 93p. Y4.Ar5/2a:989-90/63. Hearing explores the combat exclusion for women in the military and participants discuss a proposal to test the assignment of women to combat positions in the Army. The performance of military women in Operation Just Cause in Panama is reviewed along with an examination of the experience in the Netherlands with expanded military roles for women. The arguments against women in combat are addressed and the effect of the exclusion on the careers of military women are reviewed. The incidence of sexual harassment of women in the armed forces is noted.

SERIALS

2119. U.S. Dept. of Defense. *Military Women in the Department of Defense.* Washington, DC: GPO, 1983 - . annual. D1.2:W84/4/vol. or D1.90:year. Annual report provides a graphic presentation of the utilization of women in the armed forces and their characteristics, with comparisons to male personnel. Retention, advancement, grade distribution, marital status, and minority distribution data is presented.

2120. U.S. Veterans Administration. Statistical Policy and Research Service. *Data on Female Veterans, Fiscal Year ...* by Robert H. Fetz and Steven R. McCollom. Washington, DC: GPO, 1983-. irreg. VA1.2/12:year. Information on female veterans includes age, period of military service, females in VA medical centers and hospitals, pensions and disability compensation, and usage of education benefits.

2121. U.S. War Dept. *WAAC Circular.* Washington, DC: GPO, 1942. nos. 1-15? Weekly? W1.39:942/no. Circulars transmit administrative rules governing the Women's Army Auxiliary Corps.

12

War Work and Civil Defense

Many of the government publications detailing the role of women in times of war are found in other chapters on more specific topics such as women in the armed forces, medical careers, and labor legislation. The documents in this chapter deal more generally with the role of women in the "war effort" and in civil defense. This chapter is also arranged somewhat differently from the other chapters in that the documents are grouped into time periods reflecting major conflicts, and serials are listed at the end of each section, rather than at the end of the chapter.

The few non-nursing documents on women's role in the Civil War are House and Senate reports on the erection of a memorial to the service of women in the war. The role of women in World War One is represented somewhat better. The Women's Committee on National Defense is described in several documents (2128, 2150, 2158) and the Committee on Public Information issued a survey of war work done by college women (2134-2135). The Department of Agriculture urged women to consider farm work (2138-2139), and the Treasury Department and the National Woman's Liberty Loan Committee issued reports on women's activities in war bond campaigns (2142, 2148). Housing of war workers in the Washington, D.C. area was considered in a Senate hearing on the U.S. Housing Corporation (2146).

The massive mobilization of women for military and civilian work in World War Two is thoroughly documented through agency reports. Speeches, reports, and recruiting posters and leaflets reflect the importance placed on the utilization of womanpower in World War Two. A few of the significant reports include the Civil Service Commission's *The First Year: A Study of Women's Participation in Federal Defense Activities* (2162) and *The Second Year: A Study of Women's Participation in War Activities of the Federal Government* (2204), and the Bureau of Employment Security's 1942 report, *Employment of Women in War Production* (2168). A 1944 Office of War Information survey on the attitudes toward the employment of women in wartime describes objections and expectations of the general public (2250).

Community services for war workers were the focus of many reports, and the Women's Bureau looked to Great Britain as an example in *British Policies and Methods in Employing Women in Wartime* (2261). The Women's Land Army, both in the U.S. and abroad, was the topic of several Department of Agriculture reports, while the practice of employing nonfarm women for farm work was examined in greater detail in two Women's Bureau documents (2272, 2287). The role of black women in World War Two is examined in a Women's Bureau Bulletin *Negro Women War Workers* (2286). Although some documents are listed here on the postwar adjustment of women workers, the majority of those reports are found in Chapter 1. Two histories of women in World War Two are among the government documents. One of these documents reviews *The Role of Women in Wartime Britain, 1939-1945* (2294), and the other examines the role of Womanpower Committees in the U.S. (2295).

The documents since 1950 focus on community services for defense workers during the Korean Conflict (2296) and on the utilization of women in defense industries (2299, 2301). Another common theme is the role of the average woman in civil defense as she prepares home and community for nuclear attack (2303, 2305).

CIVIL WAR

2122. U.S. Congress. House. Committee on Public Buildings and Grounds. *Memorial to the Loyal Women of the United States, No. 23, Hearings Relating to a Monument to Commemorate the Services and Sacrifices of the Women of the Country in the Cause of the Union during the Civil War.* 62d Cong., 2d sess., 12,13 July 1912. 25p. Y4.P96/6:62-3/23. Hearing considers a proposal to erect a building to house the American National Red Cross which would be dedicated as a memorial to the women who gave their efforts and sometimes their lives in the Civil War. Testimony describes the contributions of women as fund raisers and nurses, and notes the emotional toll on women who sent husbands and sons off to war. Also describes the work of the Red Cross.

2123. U.S. Congress. House. Committee on Public Buildings and Grounds. *Memorial to the Loyal Women of the United States, Report to Accompany H.J. Res. 289.* H. Rept. 1244, 62d Cong., 2d sess, 1912. 16p. Serial 6133. Reports, with minor amendments, a resolution allocating funds for the erection of a monument to the "loyal women" of the Unites States during the Civil War. The building would serve as national headquarters for the Red Cross. The hearing before the Senate Committee on the Library held May 20, 1912 (2124), is reprinted.

2124. U.S. Congress. Senate. Committee on the Library. *Memorial to the Loyal Women of the United States, Hearing on S.J. Res. 95.* 62d Cong., 2d sess., 20 May 1912. 15p. Y4.L61/3:W84. Hearing considers a bill to fund a memorial building commemorating the "Services and sacrifices of the women of the country to the Union during the Civil War," said building to be used as the headquarters of the American Red Cross. The hearing record includes excerpts from "Women's Work in the Civil War."

2125. U.S. Congress. Senate. Committee on the Library. *Memorial to the Loyal Women of the United States, Report to Accompany S.J. Res. 95.* S. Rept. 908, 62d Cong., 2d sess., 1912. 15p. Serial 6122. See 2123 for abstract.

2126. U.S. Congress. Senate. Committee on Appropriations. *Urgent Deficiency Appropriations Bill, Hearing on H.R. 7898.* 63rd Cong., 1st sess., 22-26 Sept. 1913. 348p. Y4.Ap6/2:D36/913. Within this emergency appropriations hearing is an appeal for appropriations for a memorial building dedicated to the service given by women in the Civil War and intended to serve as national headquarters for the American National Red Cross.

WORLD WAR ONE

2127. U.S. Bureau of Labor Statistics. *Employment of Women and Juveniles in Great Britain during the War.* Bulletin no. 223. Washington, DC: GPO, 1917. 121p. L2.3:223. Reprints of the memoranda of the British Health of Munitions Workers Committee cover a variety of topics including data on the replacement of men by women in certain occupations, the women's wages and their acceptance into male trade-unions, war-time migration of women's labor, employment and remuneration of women in munitions,

women in munitions work in France and their wages, and the employment of women in munitions work in Italy.

2128. U.S. Council of National Defense. Woman's Committee. *Woman's Committee of the Council of National Defense.* Washington, DC: The Council, 1917? 4p. Y3.C83:63/1. Question and answer format provides information on the organization and objectives of the Woman's Committee of the Council of National Defense. The purpose of the committee was defined as the co-ordination of the "activities and the resources of the organized and unorganized women of the country that their power may be immediately utilized in time of need."

2129. U.S. Dept. of Agriculture. *Appeal to Women.* Food Thrift Series no. 4. Washington, DC: The Dept., 1917. 8p. A1.24:4.

2130. U.S. Dept. of the Treasury. *Information Folder for Use of Women Liberty Loan Workers.* Washington, DC: The Dept., 1917? [3]p. leaflet. T1.25/5:In3.

2131. U.S. Dept. of the Treasury. *Women and the Liberty Loan.* Press Notice no. 1. Washington, DC: The Dept., 1917. 1p. T1.25/5:P92.

2132. U.S. Dept. of the Treasury. *Women! Help America's Sons Win the War.* 2d Liberty Loan Poster no. 11. Chicago, IL: Edwards & Deutsch Litho. Co., 1917. poster. T1.25/7:2/11.

2133. U.S. Food Administration. *Official Uniform Especially Designed for Women of the Food Administration.* N.p, 1917?. pattern. Y3.F73/2:Un3/2.

2134. U.S. Committee on Public Information. *War Work of Women in Colleges.* Washington, DC: GPO, 1918. 11p. Y3.P96/3:2W19/1. Report of a survey of college women and war work describes bond selling, physical and mental preparedness programs, knitting, and farm work.

2135. U.S. Committee on Public Information. *War Work of Women in Colleges.* Press edition. Washington, DC: GPO, 1918. 21p. Y3.P96/3:2W19/2. Describes "war courses" to train women for rehabilitation work after the war, home economics focusing on conservation, agricultural work, bond drives, industrial training, and Red Cross work. Includes a list of war work opportunities for women.

2136. U.S. Council of National Defense. Committee on Women's Defense Work. News Dept. *Woman in the War: A Bibliography.* by Marion R. Nims. Washington, DC: GPO, 1918. 77p. Y3.C83:62W19/4. Briefly annotated, comprehensive bibliography lists articles and publications on all aspects of women as participants in WWI and as victims of the war. The bibliography is international in scope and includes U.S. and European publications.

2137. U.S. Council of National Defense. Woman's Committee. *War Work for Women.* Washington, DC: GPO, 1918. 46p. Y3.C83:62W19 or Y3.C83:62W19/3. List of employment opportunities for women by job title describes the demand for workers and where to seek additional information. Pay information for civil service positions is also provided. Includes foreign service opportunities as well as opportunities on the home front.

2138. U.S. Dept. of Agriculture. *City Woman Who Found Her War Job on a Farm.* by Reinette Lovewell. Washington, DC: The Dept., 1918. 10p. A1.2:W84/2. Reprint of an article, "A Woman Who Needs You," from the May 1818 issue of *Designer* is accompanied by a Department of Agriculture comment. The article tells the story of a city woman who finds her place in the war effort helping an overworked farm woman with household

chores. The department comment consists of an appeal to those suited to country life and housework to help farm women. Also available in the microfiche set, *Pamphlets in American History*, no. EW143.

2139. U.S. Dept. of Agriculture. *Women on the Farm, Address before the Women's Committee, Council of National Defense, May 13, 1918, Washington, D.C.* by Clarence Ousley. Washington, DC: The Dept., 1918. 11p. A1.40:Ou8. Speech urges women to use their influence to get men in useless and "unmanly" jobs to go to work where they are needed to do a "man's job." Ousley asserts that women can, by their censure, get men to go work on the farm and that, in some instances, women can do farm labor. Applauds the role of the budding home demonstration service in teaching farm women canning and preserving, thus freeing commercial products for transport overseas. City women are urged to go help farm wives with the burdens of kitchen and farm.

2140. U.S. Dept. of Labor. Women in Industry Service. *Proposed Employment of Women during the War in the Industries of Niagara Falls, N.Y.* Bulletin no. 1. Washington, DC: GPO, 1918. 16p. L13.3:1. Study of the working conditions in the Niagara Falls area looks at hazards in the abrasive and battery industries which would prevent the introduction of more women workers. The investigation was made in response to a request to use women for night work due to a shortage of workers in the war industries.

2141. U.S. Dept. of the Treasury. *Equal Partners, Address Delivered by W.G. McAdoo, Secretary of Treasury, to Women Liberty Loan Workers at Richmond, Va., April 8, 1918.* Washington, DC: GPO, 1918. 4p. I1.25/5:M11. Speech stresses the need to organize women as a force in the Liberty Loan campaigns in order to keep the bond sales moving beyond the set quota.

2142. U.S. Dept. of the Treasury. *Primer of National Women's Liberty Loan Committee for Use of Women Speakers.* Washington, DC: The Dept., 1918. 4p. T1.25/5:P93. Mimeograph sheets answer questions on the organization of the National Women's Liberty Loan Committee, stressing that it is not an auxiliary or subcommittee of a men's organization. The power of state chairmen and Federal Reserve district chairmen is reviewed, and the cooperative relationship with the Woman's Committee of the National Council of National Defense is noted. Also summarizes the financial operation of the Women's Liberty Loan campaigns.

2143. U.S. National Woman's Liberty Loan Committee. *Report of the National Woman's Liberty Loan Committee for the 1st and 2d Liberty Loan Campaign.* Washington, DC: The Committee, 1918. 43p. T1.25/5:R29. Report describes the National Woman's Liberty Loan Committee, lists the women involved in leadership positions in the state and national liberty loan campaigns, and describes some the local activities to sell bonds.

2144. U.S. National Woman's Liberty Loan Committee. *Report of the National Woman's Liberty Loan Committee for the 3d Liberty Loan Campaign, April 6 - May 4, 1918.* Washington, DC: The Committee, 1918. 32p. T1.25/5:R29/2. See 2143 for abstract.

2145. U.S. National Woman's Liberty Loan Committee. *Report of the National Woman's Liberty Loan Committee for the 4th Liberty Loan Campaign, Sept. 28 - Oct. 19, 1918.* by Mrs. Kellogg Fairbank. Washington, DC: The Committee, 1918. 32p. T1.27/12:R29/1. See 2143 for abstract.

2146. U.S. Congress. Senate. Committee on Public Buildings and Grounds. *U.S. Housing Corporation, Hearings Pursuant to S. Res. 210, Part 2.* 66th Cong., 1st sess., 5-17 Nov. 1919. 257-680pp. Y4.P96/7:H81/3-2. Includes testimony of Miss Harlean James, manager of the Plaza project and the Station project, hotels for working women in

Washington. Questioning reveals the cost and services of the hotels and some of their policies regarding the women war workers living there. Testimony is given in reference to decisions on continuing the operation of the hotels in light of the end of the war.

2147. U.S. Council of National Defense. *Statement of Work of the State and Territorial Councils of Defense and the State and Territorial Divisions of the Women's Committee of the Council of National Defense throughout the War, a Tribute and a Look into the Future.* by Grosvenor B. Clarkson. Washington, DC: GPO, 1919. 15p. Y3.C83:2T73. Praises the work done by state and local councils of defense and women's committees in the war effort through information programs, recruiting of soldiers, nurses, and other war workers, organization of social services, and public health activities. The continuing role of these organizations after the war is stressed.

2148. U.S. National Women's Liberty Loan Committee. *American Women and Victory Liberty Loan.* by Carter Glass. Washington, DC: GPO, 1919. 4p. leaflet. T1.27/12:V66/2. Secretary of the Treasury Carter Glass praises the traits and work of women in war loan campaigns and exhorts them to the same level of service for the Victory Liberty Loan campaign.

2149. U.S. National Women's Liberty Loan Committee. *Women and Victory.* by Anna Howard Shaw. Washington, DC: The Committee, 1919. 3p. T1.27/12:V66. Pamphlet by Dr. Anna Howard Shaw appeals to women's pride in citizenship in helping with the Victory Library Loan campaign.

2150. U.S. Council of National Defense. Woman's Committee. *The Women's Committee, United States Council of National Defense, an Interpretive Report, April 21, 1917 to February 27, 1919.* Washington, DC: GPO, 1920. 150p. Y3.C83:61/917-919. Accompanied by the usual patriotic rhetoric, this report details the formation and activities of the Women's Committee of the United States Council of National Defense as it went about its mission to rouse the women of the U.S. to contribute to victory. Describes the administrative wrangling over territory between the committee and other agencies such as the Labor Department's Women in Industry Service. Much of the report deals with the organizational problems of coordinating all of the nation's women's groups and of connecting women up with the services they could provide. Discusses the process of registering women by occupation to determine the labor pool and describes issues of education, food conservation, protection of women workers, and the Student Nurse Reserve campaign.

2151. U.S. National Women's Liberty Loan Committee. *Report of the National Woman's Liberty Loan Committee for Victory Loan Campaign, April 21-May 10, 1919.* Washington, DC: The Committee, 1920. 171p. T1.27/12:R29/2. See 1243 for abstract.

2152. U.S. Congress. House. Committee on the Library. *American Red Cross Memorial Building, Report to Accompany H.J. Res. 417.* H. Rept. 1736, 76th Cong., 4th sess, 1923. 2p. Serial 8158. Favorable report on the erection of a monument to the services and sacrifices of the women of the U.S. in the World War. The monument would serve as a model chapter house for the American Red Cross.

2153. U.S. Congress. Senate. Committee on the Library. *Monument to Women of the United States in the World War, Report to Accompany S.J. Res. 168.* S. Rept. 1158, 67th Cong., 4th sess, 1923. 3p. Serial 8155. Appropriations for a matching grant to the American Red Cross to erect a monument to the women of the U.S. who contributed to the war effort is favorably reported.

2154. U.S. Congress. House. Committee on the Library. *Monument to Commemorate Service and Sacrifices of Women in World War, Report to Accompany H.J. Res. 107.* H. Rept. 107, 68th Cong., 1st sess., 1924. 2p. Serial 8226. Favorable report on an appropriation of $150,000 in matching funds for the erection of a monument to the service and sacrifices of women in World War I. Notes the proposed use as a model chapter house for the American Red Cross.

2155. U.S. Congress. House. *Memorial to the Sacrifices and Services in the World War of the Women of the United States and Its Insular Possessions; Communication from the President of the United States Transmitting a Supplemental Estimate of Appropriation for the Fiscal Year Ending June 30, 1925, for the Commission on the Memorial to the Sacrifices and Services in the World War of the Women of the United States of American and Its Insular Possessions, $150,000.* H. Doc. 576, 68th Cong., 2d sess., 1925. 2p. Serial 8445.

2156. U.S. Congress. House. *Memorial to Women of the World War: Communication from the President of the United States Transmitting a Supplemental Estimate of Appropriation for the Legislative Establishment for the Fiscal Year 1929, in the Sum of $50,000.* H. Doc. 204, 70th Cong., 1st sess., 1928. 2p. Serial 8898.

2157. U.S. Congress. House. Committee on the Library. *Authorizing Additional Appropriation for Memorial to the Heroic Women of the World War, Report to Accompany S.J. Res. 66.* H. Rept. 458, 70th Cong., 1st sess., 1928. 1p. Serial 8835.

2158. U.S. Council of National Defense. Women's Committee. *News Letter.* Washington, DC: The Council, September 14, 1917 - 1918? biweekly. Y3.C83:65/no. Items on women's contribution to the war effort from newspapers around the world are summarized.

WORLD WAR TWO

2159. U.S. National Defense Advisory Commission. *Woman's Part in Defense Plans, Address by Harriet Elliott, Commissioner in Charge of Consumer Protection Division of National Defense Advisory Commission Delivered before New York Herald Tribune Forum, Waldorf Astoria Hotel, October 22, 1940.* Washington, DC: The Commissions, 1940. 9p. Y3.C831:108E158/2. Speech on "total defense" exhorts women to take part by keeping informed and taking an active role in community improvement, particularly welfare, social services, and recreation activities.

2160. U.S. Women's Bureau. *Effective Industrial Use of Women in the Defense Program.* Special Bulletin no. 1. Washington, DC: GPO, 1940. 22p. L13.10:1. Presents the characteristics of employment most suitable for women and considerations for protecting the health of women with the defense industries in mind. Reviews the standards for women's factory work supported by the Women's Bureau based on their investigations. Also discusses personnel and training policies for women in defense industries.

2161. U.S. Women's Bureau. *Women Available for Defense Work.* Washington, DC: The Bureau, 1940. 8p. L13.2:W84/4. Report on the number of women seeking employment in defense industries in April 1940 by type of work and state notes the number of women available for metal-work occupations by occupation and region. Also reports on women employed on WPA projects with skills transferable to defense work by state and type of project.

2162. U.S. Civil Service Commission. *The First Year: A Study of Women's Participation in Federal Defense Activities.* by Lucille Foster. Washington, DC: GPO, 1941. 39p. CS1.2:W84/2. The "limited national emergency" declared in May 1940 brought 227,377 women into federal civil employment. Overview of women in defense work provides

examples of the type of work performed by women and the history of women in war work. Some women who held key positions in the war effort are highlighted. Includes data for 1941 on the civil employment in the executive branch of the government by sex.

2163. U.S. Dept. of the Treasury. *Madam Chairman: Program of Defense Savings for Women's Clubs.* Washington, DC: The Dept., 1941. 16p. T1.102:B64/4/941.

2164. U.S. Office of Education. *March of Education, March 1941, Supplement 1: Women Train for National Defense.* Washington, DC: The Office, 1941. 4p. FS5.19:24/supp.1. Summaries from around the country of activities to train women for national defense highlight vocational training, civil defense training, and training activities of national organizations.

2165. U.S. Office of Education. *Women's Contributions in Wartime.* Misc. Pub. no. 2951. Washington, DC: GPO, 1941? 7p. FS5.11:2951. Brief annotated bibliography cites articles from trade and professional journals and newsletters, government documents, and books on women's contributions to the war effort.

2166. U.S. Office of Education. Occupational Information and Guidance Service. Vocational Division. *Women and National Defense.* by Marguerite W. Zapolean. Washington, DC: The Office, 1941. 12p. FS5.11:2546. Documents the beginning of women's entry into war industries and other ways in which women made a contribution to the early war effort. Particular stress is placed on war training noting that most programs did not involve women in great numbers yet. The role of women's organizations and the formation of women's volunteer service groups are reviewed.

2167. U.S. Board of Mobilization of Women. *Women's Survey.* by L.C. Stoll. N.p,1942? 13p. L7.2:W84. Outlines the procedures followed in setting up the organizational program for the inventory of the skills and availability of the women in Oregon for regular and emergency labor needs. The system of filing setup in the various offices is described. Provides data from Oregon on available women workers by occupation, marital status, and employment status.

2168. U.S. Bureau of Employment Security. Reports and Analysis Division. *Employment of Women in War Production.* Washington, DC: The Bureau, 1942. 39p. FS3.102:W19. Examination of the labor supply and the employment of women in light of the growing demand for war production workers highlights the expectations of future shortages as the war continued. The employment of women in WWI is briefly reviewed and the age and occupational distribution of women workers is examined in order to assess the potential female labor reserve. Also discussed are factors such as day care and state labor laws as they relate to the potential for utilizing female labor. Provides data on placement of women in 1940 and 1941 by occupation and industry and registration of women with employment offices. Finally, the report reviews occupations in which women were or would be employed in defense establishments with data on anticipated hires. Enrollment by sex in vocational training courses in 1942 is also examined.

2169. U.S. Bureau of Employment Security. United States Employment Service. *Occupations Suitable for Women.* Washington, DC: GPO, 1942. 103p. FS3.102:Oc1/2. Occupations in war industries considered "suitable" for women are listed. Each entry includes a designation indicating whether women were currently employed in the occupation, apparently suitable for the occupation, or partially suitable for the occupation.

2170. U.S. Dept. of Agriculture. *Farm Women, Part in War, Address by Grover B. Hill.* Washington, DC: The Dept., 1942. 6p. A1.40:H55/6. Speech before the National Home Demonstration Council and the U.S. Liaison Committee of the Associated Country Women

on the World extols the contribution of farm women to the war effort through their tireless efforts in the home, in the fields, and in the community.

2171. U.S. Dept. of Agriculture. *Work Clothes for Women.* Farmers' Bulletin no. 1905. Washington, DC: GPO, 1942. 16p. A1.9:1905/1-2. The move of women into nontraditional "war jobs" motivated the publication of these suggestions for appropriate clothing for different types of work. Includes everything from a mechanics suit to a nurses uniform.

2172. U.S. Dept. of the Treasury. *Minute Women at War Week, November 22-28, 1942.* Washington, DC: The Dept., 1942. 50p. T1.102:W84. Publicity booklet on a war bond drive was aimed at women's organizations and included how-to tips on activities and promotions.

2173. U.S. Extension Service. *Farm Women in Wartime.* by Florence L. Hall. Lecture for Slidefilm no. 629. Washington, DC: The Service, 1942. 8p. A43.19:629. Script for a slide show tells how home demonstration agents helped farm families do their part for the war effort, primarily through efforts to conserve.

2174. U.S. Extension Service. *National Summary of Inquiry into Changes in the Work of Farm Women and Girls Caused by War Labor Shortages.* Extension Service Circular no. 395. Washington, DC: The Service, 1942. 10p. A43.4:395. According to a survey of home demonstration agents, the number of women doing farm chores doubled from 1941 to 1942 and the number operating tractors and other power machinery tripled. To meet the needs of these women, programs were developed on streamlining housework, suitable clothing, tractor driving, and building moral.

2175. U.S. Library of Congress. Division of Bibliography. *Women's Part in World War II, and List of References.* by Florence S. Hellman. Washington, DC: The Library, 1942. 84p. LC2.2:W84/2/942. List of books, articles, and government documents on women's role in WWII in the U.S. and overseas is arranged by country and subject with an index to authors and selected subjects. Includes references to the *Congressional Record.*

2176. U.S. Office of Civilian Defense. *What Work is There for Women Volunteers in Civilian Defense?* Washington, DC: GPO, 1942? 4p. Pr32.4413:W84. Prepared speech for women's organizations describes how women could participate in civil defense through "civilian protection measures," first aid services, and community service.

2177. U.S. Office of Education. *Safety Clothing for Women Training for War Production Industries.* Misc. Pub. no. 3534. Washington, DC: The Office, 1942. 1p. FS5.11:3534.

2178. U.S. Office of Education. Vocational Division. Occupational Information and Guidance Service. *Women of the United States and the War.* by Marguerite W. Zapoleon. Misc. Pub. no. 2977. Washington, DC: The Office, 1942. 14p. FS5.11:2977. Review of women's contribution to the war effort highlights work in the armed services, the Red Cross, volunteer organizations, high schools and colleges, Girl Scouts, and 4-H. Briefly describes the role of women in civilian air defense.

2179. U.S. Office of War Information. Magazine Section. *War Jobs for Women.* Washington, DC: GPO, 1942. 48p. Pr32.5002:W84. Information for magazine editors on all types of employment opportunities for women promotes war jobs in civil service, military service, and private sector employment. Includes data on the number of women employed and expected to be employed in various war related industries. Also provides information on employment policies such as equal pay, provision of day care, and general working

conditions, and describes training programs and the types of work most suited to women in industry. Ways for women to contribute through volunteer work are also summarized.

2180. U.S. Social Security Board. *Women on Production Front, Factory & Farm, Address by Ellen S. Woodward, Member, Social Security Board, Delivered before Regional Conference on Women and War, Sponsored by Women's Division, Democratic National Committee, Boston, Mass., June 15, 1942*. Washington, DC: The Board, 1942. 7p. FS3.10:W84. The gist of this speech is that women could do their job in war production but that recruitment of women should be a local drive since demand was very localized. The situation in many places, where more women were registered for work than there were available jobs, is noted.

2181. U.S. War Manpower Commission. *Get a War Job to Help Him Fight*. Washington, DC: The Commission, 1942. poster. Pr32.5213:J57.

2182. U.S. War Manpower Commission. *Women in the War, We Can't Win without Them*. Washington, DC: The Commission, 1942. poster. Pr32.5213:W84.

2183. U.S. War Production Board. Labor Division. Training Within Industry. *Increasing War Production through Employment of Women*. Washington, DC: The Board, 1942? 4p. Pr4816:7. Tips for employing women in manufacturing provides summary information on employment laws, supervision, selection and placement, and training.

2184. U.S. Women's Bureau. *Arms and Women Help with Defense*. Washington, DC: The Bureau, 1942. poster. L13.9:Ar5.

2185. U.S. Women's Bureau. *The Employment of and Demand for Women Workers in the Manufacture of Instruments - Aircraft, Optical and Fire-Control, and Surgical and Dental*. Bulletin no. 189-4. Washington, DC: GPO, 1942. 20p. L13.3:189-4. Overview of the types of work performed by women in the manufacture of aircraft, optical, fire-control, and surgical and dental instruments notes areas where the utilization of women could be increased. The negative attitudes expressed by management of some plants toward the hiring of women are also discussed.

2186. U.S. Women's Bureau. *Employment of Women in the Manufacture of Artillery Ammunition*. Bulletin no. 189-3. Washington, DC: GPO, 1942. 17p. L13.3:189-3. Describes the operations in the manufacture of artillery ammunition which could be done by women, or where the proportion of women preforming the work could be expanded.

2187. U.S. Women's Bureau. *Employment of Women in the Manufacture of Small-Arms Ammunition*. Bulletin no. 189-2. Washington, DC: GPO, 1942. 11p. L13.3:189-2. Describes the various processes in the manufacture of small-arms ammunition which would be suitable for women's employment.

2188. U.S. Women's Bureau. *Front Lines of Labor Help Win the War*. Washington, DC: The Bureau, 1942. poster. L13.9:F92.

2189. U.S. Women's Bureau. *Guides for Wartime Use of Women on Farms*. Special Bulletin no. 8. Washington, DC: GPO, 1942. 11p. L13.10:8. Advice on organizing the recruitment of women for farm work in the "food-for-victory" program provides labor standards for women in farm work and suggests ways that women's organizations could aid in the program.

2190. U.S. Women's Bureau. *Hazards to Women Employed in War Plants on Abrasive-Wheel Jobs*. Special Bulletin no. 7. Washington, DC: GPO, 1942. 6p. L13.10:7. Review of

the physiological hazards to women employed in grinding and polishing operations promotes preventive measures to reduce hazards.

2191. U.S. Women's Bureau. *More and More Women Work on Aircraft.* Washington, DC: The Bureau, 1942. poster. L13.9:Ai7.

2192. U.S. Women's Bureau. *Night Work for Women and Shift Rotation in War Plants.* Special Bulletin no. 6. Washington, DC: GPO, 1942. 8p. L13.10:6. Informational pamphlet for employers of women involved in night work describes ways to reduce health dangers and factors to be considered in shift rotation of women.

2193. U.S. Women's Bureau. *Recreation and Housing for Women War Workers: A Handbook on Standards.* by Mary V. Robinson. Bulletin no. 190. Washington, DC: GPO, 1942. 40p. L13.3:190. Description of the recreation and housing needs of women war workers presents special program standards based on the varying needs of different women with different jobs. Also discusses transportation and social welfare programs for women war workers.

2194. U.S. Women's Bureau. *Roles for Women in War Work.* by Mary Anderson. Washington, DC: The Bureau, 1942? 4p. No SuDoc number. Motivational speech before the Oregon Board of Mobilization of Women speaks in broad terms of the labor women can perform in the war effort and specifically notes opportunities in the Oregon-based industries of shipping and canning. Includes some supportive quotes from military leaders on women's ability to perform formerly "men's work."

2195. U.S. Women's Bureau. *Women Make Army and Navy Equipment.* Washington, DC: The Bureau, 1942. poster. L13.9:Ar5/2.

2196. U.S. Women's Bureau. *Women of All Ages Do War Work.* Washington, DC: The Bureau, 1942. poster. L13.9:W19.

2197. U.S. Women's Bureau. *Women's Effective War Work Requires Time for Meals and Rest.* Special Bulletin no. 5. Washington, DC: GPO, 1942. leaflet. L13.10:5.

2198. U.S. Women's Bureau. *Women's Employment in Aircraft Assembly Plants in 1942.* Bulletin no. 192-1. Washington, DC: GPO, 1942. 23p. L13.3:192-1. Survey of the employment of women in aircraft assembly plants describes the types of work and extent to which women were utilized in each operation. Information is also presented on training provided for women workers and on their hours and rates of pay. Other personnel policies discussed include employment testing, age, marital status, and work clothing standards.

2199. U.S. Women's Bureau. *Women's Employment in Artillery Ammunition Plants, 1942.* by Martha J. Ziegler. Bulletin no. 192-2. Washington, DC: GPO, 1942. 19p. L13.3:192-2. Description of the occupations in the manufacture of artillery ammunition in which women were employed in 1942 notes possibilities for future employment. Training, rates of pay, hours of work, hiring requirements, food service, uniforms, and general working conditions are also discussed.

2200. U.S. Women's Bureau. *Women's Factory Employment in an Expanding Aircraft Production Program.* Bulletin no. 189-1. Washington, DC: GPO, 1942. 12p. L13.3:189-1. Describes the various occupations and processes in aircraft production which are suitable for the employment of women.

2201. U.S. Women's Bureau. *Your Questions as to Women in War Industries.* Bulletin no. 194. Washington, DC: GPO, 1942. 10p. L13.3:194. Very brief description of the employment

of women in war industries. Topics covered include type of job, replacement of men by women, employment and unemployment, employers' attitudes, wages, training, wages of men and women, and the British experience.

2202. U.S. Bureau of Labor Statistics. Employment and Occupational Outlook Branch. *Wartime Employment of Women in Manufacturing Industries, June 1943.* Washington, DC: The Bureau, 1943. 19p. L2.2:W84. Provides a statistical profile of the employment of women in manufacturing between 1939 and 1943 using graphs and tables. A short summary notes the rapid entry of women into the labor market, and into non-traditional occupations and industries, as a result of the war. Provides statistics on employment of women wage earners by manufacturing industry; employment of women in manufacturing by specified month, 1939-1943; employment of women in durable and nondurable manufacturing industries and specified months, 1939-1943; women per 100 wage earners by manufacturing industry in specified months, 1939-1943; and number of women per 100 wage earners in manufacturing by industry, January through June 1943.

2203. U.S. Civil Service Commission. *Calling Women for Federal War Work.* Washington, DC: GPO, 1943. 2p. CS1.2:W84/3.

2204. U.S. Civil Service Commission. *The Second Year: A Study of Women's Participation in War Activities of the Federal Government.* Washington, DC: GPO, 1943. 71p. CS1.2:W84/2/942. Chronicles civilian war work between July 1941 and June 1942 for the 500,000-plus women federal workers. Includes a look at supervisors views on women mechanics, the types of work performed, particularly mechanical and assembly work, and the wages received. Provided statistics on employment of women in the federal civil service and number of women applicants by examination and the number qualified and appointed.

2205. U.S. Dept. of Agriculture. Office of Information. *Advice for Women and Girls Doing Farm Work.* Food Information Series no. 47. Washington, DC: The Dept., 1943. 5p. A21.18:47. Information for women not accustomed to farm work includes getting in condition, using muscles correctly, proper clothing, handling animals, and health tips.

2206. U.S. Dept. of Agriculture. Office of Information. *Questions and Answers on Women's Land Army of the U.S. Crop Corps.* Food Information Series no. 5. Washington, DC: The Office, 1943. 4p. A21.18:5. Basic information on the Women's Land Army covers training, duties, pay, housing, uniforms, and eligibility requirements.

2207. U.S. Dept. of Agriculture. Office of Information. *Some of the Farm Jobs Which City and Town Women Might Do.* Food Information Series no. 11. Washington, DC: The Dept., 1943. 3p. A21.18:11. To help recruit city women for the Women's Land Army, this publication briefly describes farm work women can perform from inspecting eggs and driving produce to market, to doing the housework so that the farm wife can work in the field. Women's assets, such as accuracy and patriotism, are described as they relate to agricultural work.

2208. U.S. Dept. of Agriculture. Office of Information. *The Women's Land Army in Australia.* Food Information Series no. 8. Washington, DC: The Dept., 1943. 2p. A21.18:8. Australia began compulsory registration of women for war work in October 15, 1942 and eventually enrolled approximately 1,900 women. Highlighted here is the structure, benefits, regulations, and training of the Women's Land Army in New South Wales.

2209. U.S. Dept. of Agriculture. Office of Information. *The Women's Land Army of Great Britain.* Food Information Series no. 9. Washington, DC: The Dept., 1943. 3p. A21.18:9. Organized in 1939, the British Women's Land Army recruited 52,000 women

for year-round agricultural work for the duration of the war. Recruitment of women 20 to 24, based on a registration similar to the draft, concentrated on those not already employed in farm labor.

2210. U.S. Dept. of Agriculture. Office of Information. *Women's Land Brigades in Canada.* Food Information Series no. 10. Washington, DC: The Dept., 1943. 3p. A21.18:10. Describes the Ontario Farm Service Force to provide farm labor during WWII. The force counted over 13,000 women and girls in its ranks.

2211. U.S. Extension Service. *Safety Checklist for Women and Girls Doing Farm Work for the First Time.* Washington, DC: The Service, 1943. 2p. leaflet. A1.59:31.

2212. U.S. Extension Service. *Women's Land Army of the U.S. Crop Corps Needs Workers: 10,000 Needed for Year-Round Work, 50,000 Needed for Seasonal Work.* Washington, DC: The Service, 1943? [5]p. leaflet. A1.59:50.

2213. U.S. Office of Education. Vocational Division. *Wanted - Women War Production Workers.* Misc. Pub. no. 3646. Washington, DC: The Office, 1943. 22p. FS5.11:3646. Guide for vocational counselors of girls and women provides information on the areas needing women war production workers. Discusses ways of determining local needs for war production workers and of determining possibilities for individual girls and women. Also covered is the transition from wartime to peace time jobs.

2214. U.S. Office of War Information. *Homemaker's War Guide, Victory Begins at Home, Do Your Part.* Washington, DC: The Office, 1943. poster. Pr32.5015:30.

2215. U.S. Office of War Information. *The More Women at Work the Sooner We Win!* Washington, DC: The Office, 1943. poster. Pr32.5015:52.

2216. U.S. Office of War Information. *Willingness of Women to Take War Jobs.* Special Memorandum no. 93. Washington, DC: The Dept., 1943. 5p. Pr32.5031:93. Presents summary results of a survey examining women's knowledge of labor shortages and their willingness to take war jobs. Reasons why women were not willing to work were also reviewed.

2217. U.S. Office of War Information. Magazine Division. *You Are Cordially Invited to Participate In an Important Wartime Information Program Devoted to the Use of the National Magazine Covers on the Theme of Women in Necessary Civilian Jobs for Labor Day, 1943.* Washington, DC: GPO, 1943? 4p. Pr32.5002:W84/2. Information for magazine editors promotes a contest to depict women in full-time employment, not manufacturing, on the cover of September 1943 issues of magazines. The magazine cover campaign was intended to encourage women to go to work in civilian retail and clerical positions.

2218. U.S. Office of War Information. Office of Program Coordination. *Basic Program Plan for Womanpower.* Washington, DC: The Office, 1943. 9p. Pr32.5002:W84/3. Mimeograph presents the case for women war workers describing the demand for additional workers, the need to convince women in labor shortage areas to go to work, employer attitudes toward women workers, and women's home and child care responsibilities. The last part of the document describes campaign approaches to recruiting women workers and presents an overview of the planned national media campaign.

2219. U.S. War Dept. Ordnance Dept. *The Girl He Left Behind is Still Behind Him, She's a WOW, Woman Ordinance Worker.* Washington, DC: The Dept., 1943. poster. W34.29/1:G44.

2220. U.S. War Dept. Ordnance Dept. *My Girl's a WOW, Woman Ordinance Worker.* Washington, DC: The Dept., 1943. poster. W34.29/1:G44/3.

2221. U.S. War Manpower Administration. *Answers to Questions Women Ask about War Work.* Washington, DC: GPO, 1943. 9p. Pr32.5202:W84. Promotional pamphlet urged women to enter factory work in order to free men for military service.

2222. U.S. War Manpower Administration. *Working Women Win Wars, Campaign to Recruit Women War Workers in Portland Oregon.* Washington, DC: The Commission, 1943. poster. Pr32.5213:W84/2.

2223. U.S. War Manpower Commission. *America at War Needs Women at Work.* Washington, DC: The Commission, 1943. 8p. Pr32.5206:W84. Practical guide for persons conducting information campaigns for the recruitment of women war workers. Suggests advertising approaches and special gimmicks to appeal to women.

2224. U.S. War Manpower Commission. *I Want a War Job! Shall I Be a Welder, Bus Driver, Teacher, Nurse, Typist, WAAC, WAVE.* Washington, DC: The Commission, 1943. 16p. Pr32.5202:J57.

2225. U.S. War Manpower Commission. *Training Womanpower.* Washington, DC: The Commission, 1943. 26p. Pr32.5202:W84/3. Report describes the activities in 1943 of the Rural War Production Training Program, the Engineering, Science, Management War Training Program, Training Within Industry Program, and the Apprentice Training Service. Regional reports focus on paid training programs for women and provide specific examples of functioning training programs and of individual women training for war work.

2226. U.S. War Manpower Commission. *War-Time Employment of Women in Iron and Steel Industry in Great Britain, Interpretation of Jobs in Which Women are Successfully Employed in British Iron and Steel Industry into Terminology and Code Structure of Dictionary of Occupational Titles.* Washington, DC: The Commission, 1943. 40p. Pr32.5202:W84/8. Brief introductory remarks describe the utilization of women in the iron and steel industry in Britain. The remainder of the report lists occupations in which women were successfully employed, converting the British job titles to a *Dictionary of Occupational Titles* classification and arranging them by group in the iron and steel industry.

2227. U.S. War Manpower Commission. Bureau of Training. *Training Women for War Work, Methods and Suggestions for Expediting the Job.* Washington, DC: GPO, 1943. 19p. Pr32.5202:W84/2. Booklet on employing women gives advice on adapting plant facilities, preparing supervisors and current workers for supporting the introduction of women workers, training considerations, and the provision of a woman counselor in the plant.

2228. U.S. War Production Board. Salvage Division. *A Job Only a Woman Can Do!* Washington, DC: The Board, 1943. 15p. Pr32.4802:W84. Appeals to homemakers to save fats to contribute to the war effort.

2229. U.S. Women's Bureau. *Boarding Homes for Women War Workers.* Special Bulletin no. 11. Washington, DC: GPO, 1943. leaflet. L13.10:11. Brief guidelines describe services and facilities for persons considering opening a boarding house for women war workers.

2230. U.S. Women's Bureau. *Choosing Women for War-Industry Jobs.* Special Bulletin no. 12. Washington, DC: GPO, 1943. 10p. L13.10:12. Guide to hiring women in war plants. Reviews topics of selecting jobs suitable for women, application and interview procedures, and employment tests. Includes a brief reading list.

2231. U.S. Women's Bureau. *Employment of Women in the Machine-Tool Industry, 1942.* by Dorothy K. Newman and Martha J. Ziegler. Bulletin no. 192-4. Washington, DC: GPO, 1943. 42p. L13.3:192-4. Report of a survey of women employed in the machine-tool industry provides a description of the tasks at which women are employed and the numbers in which they are employed. Also discusses hours, wages, and personnel practices and problems.

2232. U.S. Women's Bureau. *Employment of Women in the Manufacture of Cannon and Small Arms in 1942.* by Margaret Kay Anderson. Bulletin no. 192-3. Washington, DC: GPO, 1943. 36p. L13.3:192-3. Describes the work and the number of women employed in the manufacture of small arms and the tasks women performed in cannon manufacturing. Provides information on wages and hours as well as personnel policies relating to age, marital status, and experience. Training of women workers is also discussed.

2233. U.S. Women's Bureau. *Part-Time Employment of Women in Wartime.* Special Bulletin no. 13. Washington, DC: GPO, 1943. 17p. L13.10:13. Bulletin describes the "victory shift" for women unable to work full-time in areas where there was a shortage of women workers. Provides guidelines on shift divisions, short weeks, and wages, and reviews women workers' need for community services.

2234. U.S. Women's Bureau. *Report of a Conference on Women in War Industries.* Washington, DC: The Bureau, 1943. 71p. L13.2:W84/10.

2235. U.S. Women's Bureau. *Scientifically Trained Women in War Jobs.* Washington, DC: The Bureau, 1943. poster. L13.9:W19/2.

2236. U.S. Women's Bureau. *Wartime Reminders to Women Who Work.* Washington, DC: GPO, 1943. 8p. L13.2:W26. Information pamphlet gives tips to boarders and "hostesses" on helping the war effort and on being courteous to other household members in a war rooming house.

2237. U.S. Women's Bureau. *What Job Is Mine on the Victory Line?* Leaflet no. 1. Washington, DC: The Bureau, 1943. 6p. L13.11:1.

2238. U.S. Women's Bureau. *Women Answer Manpower Shortages.* Washington, DC: The Bureau, 1943. poster. L13.9:M31.

2239. U.S. Women's Bureau. *Women in Personnel and Industrial Relations Work in War Industries.* Washington, DC: The Bureau, 1943. 22p. L13.2:W84/6. Outlines the duties of the "women's counselor" in war production plants and supports their role through brief personal accounts. Also discusses the promotion of women to administrative personnel and line supervisor positions. Gives a general idea of the role and prevalence of women in these positions in war industries.

2240. U.S. Women's Bureau. *Women of All Ages Work on War Jobs.* Washington, DC: The Bureau, 1943. poster. L13.9:W19/3.

2241. U.S. Women's Bureau. *Women Workers in Some Expanding Wartime Industries, New Jersey, 1942.* Bulletin no. 197. Washington, DC: GPO, 1943. 44p. L13.3:197. Survey of plants engaged in wartime industries in New Jersey in the summer of 1942 revealed information on number of women employed, the growth of women's employment overall and in specific industries, and the hiring of women for jobs usually filled by men. Considerable attention in the report is given to the conditions of work in the factories, the hours of labor, wages, and exposure to health hazards.

2242. U.S. Women's Bureau. *Women's Effective War Work Requires Good Posture.* Special Bulletin no. 10. Washington, DC: GPO, 1943. 6p. L13.10:10. Guidelines for employers suggests ways to adapt work environments to encourage good posture and reduce fatigue of women workers.

2243. U.S. Women's Bureau. *Women's Hands Speed War Production.* Washington, DC: The Bureau, 1943. poster. L13.9:W19/4.

2244. U.S. Bureau of Agricultural Economics. *Experience of 30 Reporting Companies with Victory Farm Volunteer and Women's Land Army Accident Policy in 1943.* Washington, DC: The Bureau, 1944. 4p. A36.2:V66/943. Reports statistics on insurance policies written and claims filed for members of the Victory Farm Volunteers and the Women's Land Army. Only two out of 434 policies were for the Women's Land Army and the data for them is not reported separately. Basic data reported includes age and sex of insured, claims paid by state, age, and sex of insured, claims paid by state, age, sex, part of body affected, place of accident, and total amount of claim.

2245. U.S. Bureau of Labor Statistics. *Employment of Women in Manufacturing Industries.* Washington, DC: The Bureau, 1944. 9p. L2.2:W84/2. Statistical report on the wartime changes in the employment of women in manufacturing reports data on employment of women in manufacturing, Nov. 1943 - Aug. 1944; number and percentage of women employed in all manufacturing and in durable and nondurable goods, Oct. 1939 - Aug. 1944, by month; and number and percentage of women workers in manufacturing by industry group, Aug. 1943 - Aug. 1944.

2246. U.S. Bureau of Labor Statistics. *Women in the Railroad Industry during and after World War I.* by Mary Frost Jessup. Historical Study no. 70. Washington, DC: GPO, 1944. 47p. L2.15:70. Report on the employment of women in the railroad industry during WWI and the period following describes the types of jobs held by women and provides statistics on their employment by occupation during and after the war. An analysis of case histories provides insight into discrimination against women in the railroad industry once the war labor shortage was past.

2247. U.S. Dept. of the Treasury. *Women Will Work, Here's What They Can Do.* Washington, DC: The Dept., 1944. 4p. T66.2:W84. Advice to the women's committees of the fifth war loan drive offers suggestions on gimmicks to sell more bonds.

2248. U.S. Office of Education. *Wartime Work for Girls and Women, Selected References, June 1940 to July 1943.* Vocational Division Bulletin no. 227. Washington, DC: GPO, 1944. 66p. FS5.123:227. Bibliography list books, pamphlets, and journal articles on vocational guidance for women in wartime industry. Some of the topics represented are occupational biographies and fiction, training opportunities, guidance and employment of women, and surveys. A subject index is included.

2249. U.S. Office of Price Administration. *Here's the Answer, Some Replies to Questions Farm Women Are Asking about Price Control and Rationing.* Washington, DC: The Office, 1944. 8p. Pr32.4202:P93/16. Answers questions about rationing of canning sugar, selling canned and preserved products under rationing, egg price ceilings, dairy product sales under rationing, and clothing prices.

2250. U.S. Office of War Information. *Wartime Employment of Women.* Washington, DC: The Office, 1944. 39p. No SuDoc number. Results of a survey of attitudes toward the wartime employment of women shows disapproval of working women in general and definite disapproval of mothers of young children in the labor force. Childless, unmarried women were criticized for not working. Some of the objections to women working are

described as are some of the obstacles to women's employment. Day care availability, women's absenteeism and turnover, and inducement to work are some of the key topics discussed. The report is liberally supplemented by quotes illustrating the attitudes of workers, employers, and the public.

2251. U.S. Office of War Information. *Women in the War, for Final Push to Victory, Women Needed in War Plants, in Essential Civilian Jobs, and in Women's Reserves of Armed Forces.* Washington, DC: The Office, 1944. 10p. Pr32.5002:W84/5. Information compiled for the media for use in recruiting women for war activities provides responses to common objections of women to taking civilian war jobs or to joining the military. Also provides a brief history of the women's units of the armed forces.

2252. U.S. Office of War Information. *Women in War Campaign, O.W.I.* N.p.: Army Recruiting Publicity Bureau, 1944. 48p. Pr32.5002:W84/6. Oversized publication of poster-like sheets tells the story of how the war manpower recruitment message is broadcast to women. The publication appears to be designed as a presentation flip chart.

2253. U.S. War Food Administration. *Pitch In and Help! Join the Women's Land Army of U.S. Crop Corps.* Washington, DC: The Administration, 1944. poster. A80.308:W84.

2254. U.S. War Food Administration. *Pitch In and Help! The Women's Land Army Calls 800,000 Women to the Farm in 1944.* Washington, DC: GPO, 1944. [3]p. leaflet. A1.59:101.

2255. U.S. War Food Administration. *The Women's Land Army of the U.S. Corp Corps, 1944.* Washington, DC: GPO, 1944. 8p. A1.59:102. Background on the Women's Land Army describes the women participants' characteristics, what they did, and where the lived. Also describes the characteristics of a good worker, training, wages, clothing, and accident insurance.

2256. U.S. War Manpower Administration. *Women, There's Work To Be Done and a War To Be Won, Now!* Washington, DC: The Administration, 1944. poster. Pr32.5213:W84/3 through Pr32.5213:W84/7. Issued in various sizes, each assigned a separate SuDoc number.

2257. U.S. War Manpower Commission. *I'm Proud My Husband Wants Me to Do My Part, See Your U.S. Employment Service.* Washington, DC: The Commission, 1944. poster. Pr32.5213:Em7.

2258. U.S. War Manpower Commission. *Twenty Appeals for Women War Workers.* Washington, DC: The Commission, 1944. 21p. Pr32.5202:W84/7. Transcripts of twenty one-minute radio spot announcements appeal to women to learn a skill, earn good money, and contribute to the war effort by getting a war job.

2259. U.S. War Manpower Commission. *Wartime Responsibility of Women's Organizations.* Washington, DC: The Commission, 1944. 7p. Pr32.5202:W84/4. Report on the role of women's organizations in the war effort focuses on ways the organizations could assist in the recruitment and retention of war workers through local womanpower committees.

2260. U.S. Women's Bureau. *Attack Turnover, You in the Plant, in the Union, in the Community, Help Her Stay on the Job!* by Virginia C. Abbott. Washington, DC: The Bureau, 1944. 12p. L13.2:T86. Leaflet aimed primarily at management discusses the reasons women quit their jobs with an emphasis on keeping women in defense industries until the war was won. Notes ways for management to improve retention rates for women

and also notes factors which unions and communities could alter to encourage women to stay on the job.

2261. U.S. Women's Bureau. *British Policies and Methods in Employing Women in Wartime.* Bulletin no. 200. Washington, DC: GPO, 1944. 44p. L13.3:200. Description of the evolution of British policies and practices relating to the employment of women during WWII. Covers the utilization of women and hours regulations, and the provision of necessary services such as shopping, child care, and laundry. The compulsory employment of women and the structure of the program is reviewed. Planning for the postwar role of women and anticipated manpower needs are also examined. Appendix A provides a chronology of the British Womanpower Program, and appendix B provides statistics by sex on unemployment, union membership, and increases in the average weekly earnings for the war years.

2262. U.S. Women's Bureau. *Changes in Women's Employment during the War.* Special Bulletin no. 20. Washington, DC: GPO, 1944. 29p. L13.10:20. Special study conducted by the Census Bureau collected data on women's employment status in December 1941 and March 1944 in an effort to discern the effect of the war on women's labor force participation. Data reported includes employment, occupation, marital status, and age in 1941 and 1944. Trends in employment by industry and labor force activity by age and marital status are analyzed.

2263. U.S. Women's Bureau. *Community Services for Women War Workers.* Special Bulletin no. 15. Washington, DC: GPO, 1944. 11p. L13.10:15. Presents findings of the Women's Bureau on some of the problems encountered by women workers such as finding time to do shopping when stores were open, handling laundry and child care, and finding recreation opportunities. Describes some of the efforts made by communities to meet the service needs of women war workers.

2264. U.S. Women's Bureau. *Employment of Women in Shipyards.* Bulletin no. 192-6. Washington, DC: GPO, 1944. 83p. L13.3:192-6. Report on considerations to be taken into account in hiring women to work in shipyards. Focuses on ensuring the safety of the women and avoiding turnover problems. Discussion includes selecting the workers and the jobs, wages, hours, employee counseling, training, and food service and restroom facilities.

2265. U.S. Women's Bureau. *Employment Opportunities in Characteristic Industrial Occupations of Women.* by Elizabeth D. Benham. Bulletin no. 210. Washington, DC: GPO, 1944. 50p. L13.3:210. The types of work performed by women in war plants and at which they were perceived as being particularly well suited are described in this report. The opportunities for women to utilize their skills in post war industries is discussed based on projections of product demand.

2266. U.S. Women's Bureau. *Health Tips to Women War Workers.* Washington, DC: The Bureau, 1944. poster. L13.9:H34.

2267. U.S. Women's Bureau. *Keeping War Workers Well and Fit.* Washington, DC: The Bureau, 1944. poster. L13.9:W19/5.

2268. U.S. Women's Bureau. *Maintaining War Workers' Morale.* Washington, DC: The Bureau, 1944. poster. L13.9:W19/7.

2269. U.S. Women's Bureau. *A Preview as to Women Workers in Transition from War to Peace.* by Mary Elizabeth Pidgeon. Special Bulletin no. 18. Washington, DC: GPO, 1944. 26p. L13.10:18. Discussion of the factors that would affect the employment of women after

the war gives projections of the need for women workers after the war and their economic responsibilities. Factors which could affect the retention of women workers included their skills, employer attitudes, seniority status, and plant modifications made to accommodate women. Policy statements from government authorities and women's organizations on the employment of women after the war are furnished.

2270. U.S. Women's Bureau. *Progress Report on Women War Workers' Housing.* Special Bulletin no. 17. Washington, DC: GPO, 1944. 10p. L13.10:17. Describes the problems faced by unattached women seeking housing in war industry areas. Some examples of community projects to alleviate the housing problems are summarized.

2271. U.S. Women's Bureau. *Publications Relating to Women in War Industries.* Washington, DC: The Bureau, September 1944. 4p. L13.2:P96/3/Sept.1944. Earlier edition issued in April 1944.

2272. U.S. Women's Bureau. *Successful Practices in the Employment of Nonfarm Women on Farms in the Northeastern States, 1943.* by Frances W. Valentine. Bulletin no. 199. Washington, DC: GPO, 1944. 44p. L13.3:199. Description of the experience of using nonfarm women for farm work in 1943 reports on recruiting, types of work performed, working conditions, living conditions, transportation, and recreation. The study of the 1943 program is the basis for recommendations for recruiting, employment conditions, and housing for 1944.

2273. U.S. Women's Bureau. *War Industries.* Washington, DC: The Bureau, 1944. poster. L13.9:W19/6.

2274. U.S. Women's Bureau. *The Woman Counselor in War Industries: An Effective System.* Special Bulletin no. 16. Washington, DC: GPO, 1944. 13p. L13.10:16. Describes the need for women personnel officers in war industries employing large numbers of women and the functions and qualifications of the women's counselor. In addition, the personnel programs for women employed in shipyards are described.

2275. U.S. Women's Bureau. *Women in Farm Work.* Washington, DC: The Bureau, 1944. poster. L13.9:F22.

2276. U.S. Women's Bureau. *Women's Employment in Foundries, 1943.* by Frances E.P. Harnish. Bulletin no. 192-7. Washington, DC: GPO, 1944. 28p. L13.3:192-7. Description of the types of work performed by women in foundries notes the extent to which women are employed in each department. The hazards of foundry employment are discussed and basic data is provided on wages, hours, and working condition. Also discusses perceptions of turnover rates and absenteeism, and personnel policies including hiring and training.

2277. U.S. Women's Bureau. *Women's Employment in the Making of Steel, 1943.* by Ethel Erickson. Bulletin no. 192-5. Washington, DC: GPO, 1944. 39p. L13.3:192-5. Describes the operation of steel mills and the areas in which women are employed. Working hours, wages, and employment policies are reported along with information on turnover and absenteeism.

2278. U.S. Women's Bureau. *Women's Wages in Wartime.* by Elizabeth D. Benham. Washington, DC: GPO, 1944. 11p. L13.2:W12/9. Report on wages from a number of sources including the National Industrial Conference Board and individual state reports compares wages of men and women as beginners and as they gain experience. Both manufacturing and non-manufacturing industries are covered. Earnings are compared to the cost of living for New York State. Reports on earnings by industry for war and non-

war industries, and provides data on wages by occupation for power laundries and clerical workers.

2279. U.S. Bureau of the Census and U.S. Bureau of Agricultural Economics. *Off-Farm Work of Farm Operators and Members of Their Households: 1943.* Washington, DC: The Bureau, 1945. 4p. C3.201:6. Report details data on members of farm households who worked off the farm by sex and age.

2280. U.S. Dept. of Agriculture. Office of Information. *Needed, 25 Million Women Like This! How Advertisers Can Help Solve the Food Problems.* Washington, DC: The Office, 1945. 4p. A21.2:W84. Leaflet encourages home canning.

2281. U.S. War Food Administration. *Harvest War Crops, Women's Land Army of the U.S. Crop Corps.* Washington, DC: Office of War Information, 1945. poster. A80.308:H26/3.

2282. U.S. War Food Administration. *Women's Land Army Call to Farms for Women of America.* Washington, DC: The Administration, 1945. 4p. leaflet. A1.59:111.

2283. U.S. War Food Administration. *The Women's Land Army Works for Victory.* Washington, DC: GPO, 1945. 8p. A1.59:113. Description of the work women did in the Women's Land Army provides information on organization and training, and presents quotes from participants and farmers on the program.

2284. U.S. War Manpower Commission. *History of Women's Advisory Committee, War Manpower Commission.* Washington, DC: The Commission, 1945. 13p. Pr32.5202:W84/10/945. History of the Women's Advisory Committee describes the impetus for the committee, and its composition, organization, and functions. The policy recommendations of the committee on recruitment, training, and employment of women workers are summarized. Also gives summaries of committee actions and policy statements on issues such as child care, household help, and postwar layoffs.

2285. U.S. Women's Bureau. *Employment of Women in Army Supply Depots in 1943.* Special Bulletin no. 192-8. Washington, DC: GPO, 1945. 33p. L13.3:192-8. Survey of the employment of women in Army supply depots in 1943 describes the jobs performed by women and the hiring requirements and training of women workers. Also describes personnel issues such as wages, hours, absenteeism, turnover, and accidents. Ways in which the housing, recreation, and transportation needs of the women workers were met are also described.

2286. U.S. Women's Bureau. *Negro Women War Workers.* Bulletin no. 205. Washington, DC: GPO, 1945. 23p. L13.3:205. Information on black women workers collected from various studies conducted by the Women's Bureau on war industries is pulled together in this report. The work of black women in war-related industries, civilian industry, and transportation is reviewed. The role of black nurses in the armed forces and the American Red Cross is also summarized. Charts illustrate changes in the employment of black women between 1940 and 1944.

2287. U.S. Women's Bureau. *Women's Emergency Farm Service on the Pacific Coast in 1943.* Bulletin no. 204. Washington, DC: GPO, 1945. 36p. L13.3:204. Description of the employment of nonfarm women for agricultural work in 1943 in California, Oregon, and Washington covers recruitment, types of work performed, wages, hours, and transportation.

2288. U.S. Women's Bureau. *Women's Wages in Wartime, Supplement, February 1945.* Washington, DC: GPO, 1045. 8p. L13.2:W12/9/supp. See 2278 for abstract.

2289. U.S. Women's Bureau. *Women's Wartime Jobs in Cane-Sugar Refineries.* Bulletin no. 192-9. Washington, DC: GPO, 1945. 20p. L13.3:192-9. Primary focus of this report is the types of jobs performed by women in cane-sugar refineries and the extent to which women were used to perform these jobs. Wages, hours, absenteeism, turn-over, labor unions, and personnel policies are briefly covered.

2290. U.S. Dept. of the Treasury. *Women's Work in War Finance, 1941-1945.* Washington, DC: GPO, 1946. 39p. T66.2:W84/3. The report describes the history of the Women's Section of the War Finance Division and the programs it sponsored. The section coordinated the war bond efforts of women's organizations.

2291. U.S. Women's Bureau. *Women Workers in Ten War Production Areas and Their Postwar Employment Plans.* Bulletin no. 209. Washington, DC: GPO, 1946. 56p. L13.3:209. Study of the employment of women before and during WWII analyzes the relation of pre-war employment to postwar employment plans. Data is included on marital status, age, race, education, and responsibility for family support of women war workers. Detailed statistics are given on women and employment changes between 1940 and 1944-45 including numbers, personal characteristics, industry and occupation, contribution to family support, and presence and care of children.

2292. U.S. Women's Bureau. *Women's Wartime Hours of Work: The Effect on Their Factory Performance and Home Life.* Bulletin no. 208. Washington, DC: GPO, 1947. 187p. L13.3:208. Study of women line workers at thirteen manufacturing plants looks at home responsibilities and hours of work. Interviews with women and absentee rates reflect the stress of long hours and household chores on women workers. The effect of marital status and living arrangements on preferred hours is also discussed.

2293. U.S. War Production Board. Conservation and Salvage Division. *Utah Minute Women in World War II, 1942-1945.* Washington, DC: The Board, 194? 64p. Pr32.4802:Ut1. Describes the salvage program for war materials conducted by the Utah Minute Women, a statewide organization under the auspices of the Utah Women's Salvage Division. Some documents of the organization are reprinted and portraits of state and county leaders are included.

2294. U.S. Women's Bureau. *The Role of Women in Wartime Britain, 1939-1945.* Washington, DC: The Bureau, 1950. 16p. L13.2:W84/30. Overview of the role played by women in Great Britain during WWII covers the mobilization of women under the Emergency Powers Act and the number of women mobilized. Provides background on making employment assignments, training, and working conditions. In addition, the role of women in the armed forces and civil defense is reviewed. Noted problems of working women mobilized for the war include shopping, child care, transportation, laundry, and transfers away from home. Also discusses the role played by voluntary organizations.

2295. U.S. Women's Bureau. *Womanpower Committees during World War II.* Bulletin no. 244. Washington, DC: GPO, 1953. 73p. L13.3:244. History of three womanpower committees during WWII, the Women's Advisory Committee to the War Manpower Commission in the U.S. and the Woman Power Committee and the Woman's Consultative Committee in Great Britain, describes their organization and the problems with which they dealt.

1950 TO THE PRESENT

2296. U.S. Women's Bureau. *Community Problems Relating to the Increased Employment of Women in Defense Areas.* Washington, DC: The Bureau, 1951. 15p. L13.2:D34. Describes the problems of housing, day care, and access to services faced by women

working in defense industries. Looks at the problems encountered during WWII and the problems in 1951. Outlines programs to alleviate the problems, particularly the day care shortage, and summarizes the Defense Housing and Community Facilities and Services Act of 1951.

2297. U.S. Women's Bureau. *Employment of Women in an Emergency Period.* Washington, DC: The Bureau, 1951. 14p. L13.2:Em7/7.

2298. U.S. Federal Civil Defense Administration. *Women in Civil Defense.* Washington, DC: GPO, 1952. 20p. FCD1.10:2. According to this booklet a woman's role in civil defense is "to act at once to educate [her] family in self-protection against modern weapons, and to make [her] home as safe as possible against the dangers of enemy attack." The booklet goes on to describe how to help prepare the home and the community.

2299. U.S. Women's Advisory Committee on Defense Manpower. *Annual Report, Women's Advisory Committee on Defense Manpower, May 1951 to May 1952.* Washington, DC: The Committee, 1952. 10p. L27.2:W84/951-52. Report of the first year's activities of the Women's Advisory Committee on Defense Manpower consists primarily of a list of recommendations related to equal pay and community facilities.

2300. U.S. Women's Bureau. *Employment of Women in an Emergency Period.* Bulletin no. 241. Washington, DC: GPO, 1952. 13p. L13.3:241. Drawing on the experience of WWI and WWII, this document reviews the status of women workers in the 1950s and discusses the recruitment, placement, and training of women in a time of war. Stresses the importance of working conditions and community facilities to the utilization of women workers.

2301. U.S. Defense Manpower Administration. *Second Annual Report of Women's Advisory Committee on Defense Manpower, May 1952 - May 1953.* Washington, DC: The Administration, 1953. 5p. L27.2:W84/952-53. Briefly reviews the function of the Women's Advisory Committee on Defense Manpower and its activities in 1952-53. The committee's study of the utilization of a womanpower advisory committee in an emergency period, informational material for the Secretary of Labor on unemployed women in labor surplus areas, and factors contributing to the shortage of nurses and teachers are summarized. The report ends with the recommendation that the committee be placed on standby.

2302. U.S. Women's Bureau. *Women's Bureau Conference, January 27, 1954 [Conference Program].* Washington, DC: The Bureau, 1954. 4p. L13.2:C76/954.

2303. U.S. Federal Civil Defense Administration. National Women's Advisory Committee. *A Report on the Washington Conference of the National Women's Advisory Committee, Federal Civil Defense Administration, October 26, 27, 1954.* Washington, DC: The Administration, 1955? 56p. FCD1.2:C74/4. Conference speakers discuss emergency services needed in the event of a nuclear attack and the role of women volunteers in emergency planning. Several speakers from British women's civil defense organizations describe women's involvement in civil defense in Great Britain.

2304. U.S. Federal Civil Defense Administration. National Women's Advisory Committee. *A Report on the 1955 Washington Conference of the National Women's Advisory Committee, November 3,4, 1955.* Washington, DC: GPO, 1956. 74p. FCD1.2:C74/4/975. Speakers at the conference cover a wide array of civil defense issues including the role of welfare, evacuation, and delegation of authority, while other speakers address military topics, particularly air defense.

2305. U.S. Federal Civil Defense Administration. National Women's Advisory Committee. *A Report on the 1956 Washington Conference of the National Women's Advisory Committee.* Washington, DC: The Administration, 1957. 74p. FCD1.18/2:956. Topics of the conference include "Women's role in atomic warfare" and a panel discussion on "How to tell the civil defense story to women."

2306. U.S. Women's Bureau. *Civil Defense Begins at Home, Address by Mrs. Alice K. Leopold, Assistant to Secretary of Labor before the National Women's Advisory Committee to the Office of Civil and Defense Mobilization, Washington, D.C., September 23, 1958.* by Alice K. Leopold. Washington, DC: The Bureau, 1958. 7p. L13.12:L55/5. Reviews the role of the homemaker in preparing her home and her community for an emergency.

13

Women in Government Employment

Most of the government documents cited in this chapter deal with the federal civil service. A particularly interesting early publication is a 1892 House Miscellaneous Document which presents the Civil Service Commission's explanation of its policy on hiring women typists and stenographers (2309). Blatant gender discrimination is evident in the response. Gender discrimination is also evident in the 1920 report on *Women in the Government Service* (2321), where departmental attitudes toward the employment of women are detailed. The status of women in the civil service was examined again in 1925 with an emphasis on women in jobs requiring a college degree (2328). The effect of the Economy Act of 1932 on women's employment in the federal government is examined in a Women's Bureau document which details dismissals by sex (2333).

Two significant documents on women in the civil service were published in 1941, an illustrated history of women in the federal service (2337) and an analysis of data on the employment of women in 1938 and 1939 by agency and occupation (2338). Trends in the employment of women in the federal service between 1923 and 1947 are analyzed in part one of a two part report (2347, 2350). Other reports examining the occupations and salaries of federally employed women were published in 1957 (2357) and 1962 (2358).

One of the most important reports is the *Report of the Committee on Federal Employment to the President's Commission on the Status of Women,* which reviews the history of women in the civil service and examines policies and programs affecting women (2360). The big topic of 1965 was the repeal of an 1870 law designed to allow the appointment of women to clerkships, but which was later interpreted as condoning gender discrimination (2363-2365).

The Federal Women's Program and the enforcement of equal employment opportunity and affirmative action laws in specific federal agencies is the focus of most documents published since 1969. The goals of the Federal Women's Program are set out in the Civil Service Commission's *Guidelines for Federal Women's Program Coordinators* (2395). A plan to move EEO enforcement in the civil service to the EEOC is considered in 1978 Congressional hearings (2454, 2459). Federal EEO policies in the 1981 reduction-in-force environment was the topic of a House hearing (2505). The extension of anti-discrimination laws to Congress was the topic of several hearings (2458, 2489, 2556).

While earlier documents reported on the extension of veterans preference laws to dependent female relatives of servicemen and women, by 1977 the negative impact of veterans preference laws on the employment of women was under discussion (2436). The problem of sexual harassment in the federal government was explored in House hearings held in 1979 (2477) and in a House committee print issued in 1980 (2494). The results of a 1981 Merit System Protection Board survey describe the extent to which sexual harassment presents a problem in the federal

work place (2508). In 1973 the Senate considered legislation to ensure the practice of flexible hours in federal employment (2391). Alternative work schedules for federal employees were considered again in 1975 (2412), in 1977 (2437), and in 1978 (2457).

The employment of women in the Foreign Service is detailed in numerous documents beginning with *Women in American Foreign Affairs* (2439), an examination of the trends in the 1960s and 1970s. Hearings held in 1979 considered reform of the Foreign Service system to improve opportunities for minorities and women (2476). EEO in the Foreign Service was the focus of a 1981 Commission on Civil Rights report (2504), and affirmative action and equal employment opportunity were again the topics of congressional hearings in 1982 (2517) and 1987 (2540). A series of hearings in 1989, *The Department of State in the 21st Century* (2552-2553) and the *Underrepresentation of Women in Minorities in the Foreign Service - State Department* (2554), and a GAO report (2557) also discuss ways to improve the hiring and promotion of women and minorities, and testimony at the 1990 hearings on the Foreign Service Personnel System described the Foreign Service as an "old boy" network (2562). The appointment of women and minorities by Presidents Carter and Reagan is compared in *Equal Opportunity in Presidential Appointments* (2520) and their appointments to the federal bench are compared in a 1988 hearing (2546).

Reports on the employment of women in state and local government are mostly statistical reports with some Civil Rights Commission studies. Employment in 1943 is detailed in a Census Bureau report (2346) and a series of EEOC statistical reports detail the employment of women in functional departments of state and local governments in 1973 (2398-2399, 2425-2431). Other EEOC reports detail the occupations and salaries of women and minorities in state and local government between 1974 and 1985 (2440-2441, 2499, 2547). Commission on Civil Rights reports on specific government agencies cover the Kentucky State Police (2450), Oklahoma state government (2451), and Salt Lake City's criminal justice agencies (2452). An EEOC report on affirmative action in state governments in Iowa, Kansas, Missouri, and Nebraska was issued in 1978 and updated in 1982 and 1983 (2465, 2513, 2521). More Civil Rights Commission reports examine state employment in Alaska (2490), Alabama (2475), and California (2491), and local government employment in Tacoma, Washington (2492), Indianapolis (2514), Michigan (2515), and Knoxville and Oak Ridge, Tennessee (2516).

2307. U.S. Congress. House. Committee on Printing. *Female Employees of the Bureau of Engraving and Printing, Report to Accompany H. Res. 318.* H. Rept. 1733, 46th Cong., 2d sess., 1880. 1p. Serial 1938. Reports a bill authorizing payment of wages to female employees of the Bureau of Engraving and Printing during an office move, provided that the period did not exceed twelve working days.

2308. U.S. Congress. Senate. *Letter from the Secretary of the Interior, Transmitting Letter of the Commissioner of Indian Affairs Relative to the Employment of Matrons at Agencies.* S. Ex. Doc. 160, 50th Cong., 1st sess., 1888. 3p. Serial 2513. Correspondence relates to the employment of women by Indian agencies to teach domestic skills to Native American women.

2309. U.S. Congress. House. *Letter from the Civil Service Commission, Transmitting, in Response to Resolution of May 27, Information Relating to the Appointment of Stenographers and Typewriters in the Various Departments.* H. Misc. Doc. 270, 52d Cong., 1st sess., 1892. 8p. Serial 2959. Response to a House resolution directing the Civil Service Commission to answer questions regarding the policies of hiring women stenographers and typists. The inquiry was the result of a *Washington Daily Star* advertisement for male stenographers and typewriters. The commission explained that departments were allowed to designate gender in their requests and that men were requested more often than women, resulting in a shortage of eligible men for employment.

An interesting point made by the commission is the role of the low salaries paid to clerical workers in creating the shortage of male applicants.

2310. U.S. Congress. House. Committee on Reform in the Civil Service. *Amending Section 1754, Revised Statutes, Report to Accompany H.R. 5635.* H. Rept. 517, 54th Cong., 1st sess., 1896. 1p. Serial 3458. The bill in question extends the hiring preference given to veterans of the Civil War to include their widows, while noting that so few women were appointed to civil service positions that such a preference would present no "danger of any impairment of the public service."

2311. U.S. Congress. House. Committee on Accounts. *Employment of Janitors, Clerks, Etc., Report to Accompany H. Res. 182.* H. Rept. 526, 59th Cong., 1st sess., 1906. 7p. Serial 4908-A. Among the activities authorized to the Doorkeeper of the House is the employment of a female attendant at the rate of $60 a month for the Ladies Reception Room in Statuary Hall.

2312. U.S. Civil Service Commission. *Affidavit of Woman Claiming Legal Residence Other Than that of Husband.* Washington, DC: The Commission, May 1907. Reprinted 1916. 1p. CS1.2:L52. Form 1643, an affidavit of a married woman claiming to be separated from her husband, was required with the application of certain married women for federal employment.

2313. U.S. Congress. House. Committee on Accounts. *Female Attendant for Ladies' Reception Room of House, Report to Accompany H. Res. 128.* H. Rept. 279, 60th Cong., 1st sess., 1908. 1p. Serial 5229. Authorizes the appointment at $60 a month of a female attendant for the Ladies Reception Room, as was done in the 59th Congress.

2314. U.S. Congress. House. Committee on Accounts. *Attendant in Ladies' Reception Room at the Capitol, Report to Accompany H. Res. 94.* H. Rept. 27, 62d Cong., 1st sess., 1911. 1p. Serial 6134. Favorable report on the continued authorization of a female attendant for the Ladies Reception Room in the Statuary Hall.

2315. U.S. Congress. House. Committee on Accounts. *Attendant for Ladies' Reception Room, Report to Accompany H. Res. 54.* H. Rept. 10, 63d Cong., 1st sess., 1913. 1p. Serial 6515. Favorable report on continuing the position of female attendant for the Ladies' Reception Room.

2316. U.S. Congress. House. Committee on Accounts. *Attendant for Ladies Retiring Room, Report to Accompany H. Res. 678.* H. Rept. 1235, 63d Cong., 3d sess., 1914. 1p. Serial 6767. Recommends employment of a woman attendant for the Ladies Retiring Room.

2317. U.S. Congress. House. Committee on Accounts. *Janitors for Committees, Report to Accompany H. Res. 39.* H. Rept. 2, 64th Cong., 1st sess., 1915. 1p. Serial 6907. Recommends adoption of a resolution which authorizes the appointment of an attendant for the ladies' reception room of the House.

2318. U.S. Congress. House. Committee on Accounts. *Attendant for Ladies' Reception Room, House of Representatives, Report to Accompany H. Res. 43.* H. Rept. 24, 65th Cong., 1st sess., 1917. 1p. Serial 7254.

2319. U.S. Congress. House. Committee on Accounts. *Attendant for Ladies' Reception Room of the House, Report to Accompany H. Res. 82.* H. Rept. 59, 66th Cong., 1st sess., 1919. 1p. Serial 7594. Amendment of a bill to authorize the appointment of Mrs. Mary C. Adams as attendant for the Ladies' Reception Room at a rate of $100 a month strikes out the name of the individual to be appointed.

2320. U.S. Congress. Senate. Committee on Public Buildings and Grounds. *Repeal of the Housing Corporation Act, Hearings on H.R. 7656.* 66th Cong., 2d sess., 12 Jan. 1920. 38p. Y4.P96/7:H81/4. Hearing discusses the management of the federally owned dormitories for women workers in Washington, D.C. and the need for such buildings given the low wages paid to some women in the federal civil service. A representative of the women living in the Plaza project points out deficiencies in the operation of the dormitories.

2321. U.S. Women's Bureau. *Women in the Government Service.* by Bertha M. Nienburg. Bulletin no. 8. Washington, DC: GPO, 1920. 37p. L13.3:8. Report describes positions open to women in the federal civil service before and after WWI, exams open only to men, only to women, or open to both, and salaries of male and female federal employees by sex. Describes some of the work performed by women and identifies specific departments' attitudes toward employing women. Provides data on the distribution of employees by salary and sex.

2322. U.S. Congress. Senate. Committee on Accounts. *Attendant for Ladies Reception Room, Report to Accompany H. Res. 44.* H. Rept. 7, 67th Cong., 1st sess., 1921. 1p. Serial 7923.

2323. U.S. Women's Bureau. *Status of Women as State Labor Officials.* Baltimore, MD: A. Hoen & Co., 1921. map. L13.6:1. Also included in Women's Bureau Bulletin no. 16 (728).

2324. U.S. Congress. House. Committee on Accounts. *Compensation for Female Attendant in Ladies Retiring Rooms in House Office Building, Report to Accompany H. Res. 430.* H. Rept. 1248, 67th Cong., 2d sess., 1922. 1p. Serial 7959. The bill reported "equalizes" the salary paid to the attendant in the House Office Building by adding $60 a month, but does not indicate whose salary it was made equal to.

2325. U.S. Congress. House. Committee on Accounts. *Compensation for Female Attendant in Ladies' Retiring Rooms, Report to Accompany H. Res. 413.* H. Rept. 1216, 67th Cong., 2d sess., 1922. 1p. Serial 7959. Equalizes salaries paid to the attendants of the ladies' retiring rooms.

2326. U.S. Congress. House. Committee on Accounts. *Attendant for Ladies Reception Room, Report to Accompany H. Res. 46.* H. Rept. 9, 68th Cong., 1st sess., 1923. 1p. Serial 8230. The resolution reported continued the position of lady attendant for the Ladies' Reception Room, Statuary Hall.

2327. U.S. Congress. Senate. Committee on the District of Columbia. *Cooperative Hotel for Government Women Employees in the District of Columbia, Hearing.* 68th Cong., 1st sess., 25 April 1924. 14p. Y4.D63/2:H79. Hearing considers a request from a group of women employed by the federal government for a $600,000 loan to construct a residence for federally employed women in Washington, D.C. The proposed unit was to house 400 women and the loan was to be repaid through hotel profits.

2328. U.S. Women's Bureau. *The Status of Women in the Government Service in 1925.* by Bertha M. Nienburg. Bulletin no. 53. Washington, DC: GPO, 1926. 103p. L13.3:53. Study examined the employment of women by the U.S. government in the Washington, D.C. area after the 1919 decision to open all civil service examinations to women. The study was limited to women employees earning $1,860 a year, the minimum salary for positions requiring a college degree. The two major areas examined were the character of the work performed by the women and the distribution of salaries by occupation, with some comparison to men.

2329. U.S. Congress. House. Committee on Accounts. *Attendant for Retiring Room of Female Members of House of Representatives, Report to Accompany H. Res. 442.* H. Rept. 2314, 69th Cong., 2d sess., 1927. 1p. Serial 8690.

2330. U.S. Congress. House. Committee on Economy. *To Effect Economies in the National Government, Report to Accompany H.R. 11597.* H. Rept. 1126, 72d Cong., 1st sess., 1932. 27p. Serial 9492. Report on the Economy Act describes its provisions. Section 209 required the dismissal of the husband or wife if both husband and wife were employed in a class of federal employees targeted for reduction.

2331. U.S. Congress. Senate. Committee on Appropriations. Subcommittee in Charge of Economy Provisions of Legislative Act. *Legislative Establishment Appropriations Act of 1933, Part II - To Effect Economies in the National Government, Hearings on Senate Resolution Numbered 279.* 72d Cong., 2d sess., 1-16 Dec. 1932. 325p. Y4.Ap6/2:L52/933-2. Representatives of government agencies and federal employees discussed the provisions of the Economy Act of 1932. The hearing is characterized by criticism of the handling of the act and rejects many of its provisions. Section 213, the married persons clause, was briefly discussed and numerous agencies, including the Civil Service Commission, urged its repeal.

2332. U.S. Civil Service Commission. *Separation of Husband and Wife under Section 213 of Economy Act of June 30, 1932.* Department Circular 115. Washington, DC: The Commission, 1933. 1p. CS1.4:115. Memo to department heads stresses the requirement to prove actual separation of husband and wife to ensure that the separation was not solely for the purpose of evading dismissal under Section 213 of the Economy Act of 1932.

2333. U.S. Woman's Bureau. *Preliminary Study on Application of Section 213 of Economy Act of June 30, 1932 [Married Person Clause].* Washington, DC: The Bureau, 1935. 9p. L13.2:M34. Results of an investigation into the approach taken by the federal agencies to Section 213 of the Economy Act of June 30, 1932 includes statistics by sex on dismissals and reassignments due to the act by department or agency. The operation of the act and the incidence of married women resigning to save their husbands from dismissal is noted. Chart illustrates that women made up to 16 percent of those employed by the federal service but made up 78 percent of the separations due to Section 213. Salary as a factor in determining separations was also examined.

2334. U.S. Civil Service Commission. *Employment of Women in Federal Service in Positions Paying $2,000 and Above.* Department Circular no. 199. Washington, DC: The Commission, 1939 3p. CS1.4:199. Memo directs department heads to provide information on the number of women employed in the federal service in positions paying $2,000 or more per year.

2335. U.S. Dept. of Agriculture. Personnel Office. *Opportunities for Professional Women in Agricultural Services, Remarks by Roy F. Hendrickson, Director of Personal, Department of Agriculture, Scheduled for Delivery, Nov. 11, 1939, before Institute of Women's Professional Relations, at Washington, D.C.* by Roy F. Hendrickson. Washington, DC: The Dept., 1940. 9p. A49.2:Ag8. The outlook for the employment of women in agricultural public service work, particularly in relation to home economics and at the Department of Agriculture, is highlighted in this speech before the Institute of Women's Professional Relations. Numbers of women and types of positions held are described, justifying the areas where few women are employed and the lack of women in higher grades at the Department of Agriculture.

2336. U.S. Civil Service Commission. *Increased Employment of Women.* Department Circular no. 266. Washington, DC: The Commission, 1941. 1p. CS1.4:266. Memo to department

heads encourages departments to abandon the practice of requesting males only in response to the shortage of men due to military service. Women's suitability for almost all kinds of work and the successful replacement of men by women in industry in other countries at war is stressed.

2337. U.S. Civil Service Commission. *Women in the Federal Service.* Washington, DC: GPO, 1941. 53p. CS1.2:W84/941. Illustrated history of women in the federal civil service looks at the types of jobs women have held, the question of married women's employment, and the status of women in government employment in 1941. Earlier edition published in 1938.

2338. U.S. Women's Bureau. *Employment of Women in the Federal Government, 1923 to 1939.* by Rachel Fesler Nyswander and Janet M. Hooks. Bulletin no. 182. Washington, DC: GPO, 1941. 60p. L13.3:182. Report based primarily on Civil Service Commission data for 1938 and 1939 looks at the number of women employed by the federal government and their distribution by agency and occupation. The report also studies data on the proportion of women appointees between 1930 and 1939 by occupation, on the age distribution of women employees in 1938 by detailed occupation, and on average salaries by age and occupation.

2339. U.S. Office of Price Administration. *Government Girl Budget Book.* Washington, DC: The Office, 1943. Pr32.4202:B85.

2340. U.S. Bureau of the Census. *Women in State and Local Government Employment in 1943.* State and Local Government Quarterly Employment Survey, 4th Quarter, 1943, vol.4 no. 20. Washington, DC: The Bureau, 1944. 6p. C3.140:4/20. Statistics on changes in the number of women employed in state and local government between 1942 and 1943 are presented by size of city and by full-time and part-time status.

2341. U.S. Congress. House. Committee on Post Office and Civil Service. *Extending Veterans' Preference Benefits to Widowed Mothers of Certain Ex-Servicemen, Report to Accompany H.R. 1426.* H. Rept. 697, 80th Cong., 1st sess., 1947. 4p. Serial 11121. Reports a bill to include certain widowed mothers of deceased or disabled ex-servicemen in legislation granting special preference in competition for civil service positions.

2342. U.S. Congress. Senate. Committee on Civil Service. *Extending Veterans' Preference Benefits to Widowed Mothers of Certain Ex-Servicemen, Report to Accompany S. 416.* S. Rept. 480, 80th Cong., 1st sess., 1947. 3p. Serial 11116. Reports a bill to include certain unremarried widowed mothers of ex-servicemen and servicewomen under legislation granting preference in civil service examinations.

2343. U.S. Congress. House. Committee on Post Office and Civil Service. *Amending the Veteran's Preference Act of 1944, Report to Accompany H.R. 5508.* H. Rept. 1841, 80th Cong., 2d sess., 1948. 3p. Serial 11211. Reports a proposed amendment to the Veterans' Preference Act of 1944 to include certain widowed mothers not otherwise included, and to provide that a divorced or dependent mother need not be legally separated. Eligibility for civil service preference was at issue.

2344. U.S. Dept. of Treasury. *Address by Secretary Snyder before Biennial Convention of National Federation of Business and Professional Women's Clubs in Coliseum of Will Rogers Memorial, Fort Worth, Texas.* Washington, DC: Treasury, 1948. 5p. T1.31:N21/11. Employment of women in government positions, particularly progress made in the level of positions held, is reviewed in this speech focusing on women with the Treasury Department.

2345. U.S. Congress. House. Committee on Post Office and Civil Service. *Amending the Veteran's Preference Act of 1944 with Respect to Certain Mothers of Veterans, Report to Accompany S. 974.* H. Rept. 1154, 81st Cong., 1st sess., 1949. 4p. Serial 11300. Favorable report on legislation which provides for the mothers of veterans who were eligible under the Veterans Preference Act of 1944 prior to remarriage, to regain their eligibility upon divorce or death of the spouse.

2346. U.S. Congress. Senate. Committee on Post Office and Civil Service. *Amending the Veterans' Preference Act of 1944 with Respect to Certain Mothers of Veterans, Report to Accompany S. 974.* S. Rept. 500, 81st Cong., 1st sess., 1949. 3p. Serial 11292. Reports a bill amending the Veterans Preference Act by including the remarried mother of an ex-serviceman or woman under the act at such time as she was again widowed or divorced.

2347. U.S. Women's Bureau. *Women in the Federal Service, 1923-1947, Part 1, Trends in Employment.* Bulletin no. 230-1. Washington, DC: GPO, 1949. 82p. L13.3:230-1. Detailed study examines the employment of women by the federal government before, during, and after WWII. Data is presented and analyzed on the grade level and departments employing women. Particular attention is paid to part-time work and turnover rates. The effect of the policy after WWII of giving preference to veterans is also examined. Data on salary distribution of women workers by age and length of service is furnished.

2348. U.S. Congress. House. Committee on Post Office and Civil Service. *Granting Veterans' Preference to Mothers of Deceased or Disabled Veterans Whose Husband Are Permanently and Totally Disabled, Report to Accompany S. 3263.* H. Rept. 3145, 81st Cong., 2d sess., 1950. 4p. Serial 11385. Report supports an amendment of the Veterans' Preference Act of 1944 to extend civil service examination preference to mothers of disabled or deceased veterans if the husband was disabled.

2349. U.S. Congress. Senate. Committee on Post Office and Civil Service. *Granting Veterans' Preference to Mothers of Deceased or Disabled Veterans Whose Husbands Are Permanently and Totally Disabled, Report to Accompany S. 3263.* S. Rept. 2184, 81st Cong., 2d sess., 1950. 5p. Serial 11371. Reports a bill to include in civil service preference provisions the mothers of deceased or disabled veterans in cases where the mother's husband was totally or permanently disabled. The classes of mothers included under the preference act are reviewed, and correspondence from the Civil Service Commission points to the administrative difficulties connected to the bill.

2350. U.S. Women's Bureau. *Women in the Federal Service, Part II: Occupational Information.* Bulletin no. 230-2. Washington, DC: GPO, 1950. 87p. L13.3:230-2. Part two of a report on employment of women in the executive branch of the federal government shows the occupations of a selected group of women at the higher levels of salary and responsibility, and reviews their training, age, and length of service at the time of reaching the upper levels. Gives data on age, occupation, grade, and length of service.

2351. U.S. Army. *Civilian Personnel: Employment of Pregnant Women, Jan. 15, 1952.* Army Regulation 620-90. Washington, DC: GPO, 1952. 2p. D101.9:620-90. Superseded by Army Reg. 616-390 (2354).

2352. U.S. Bureau of Human Nutrition and Home Economics. *...How to Make a Spending Plan, Suggestions for Single Government Women in Washington, D.C.* Washington, DC: The Bureau, 1952. 2p. A77.702:Sp3. Suggestions for single women on how to plan in order to live comfortably in Washington, D.C. Gives a good idea of the lifestyle single female government workers were supposed to live, and the cost of that lifestyle.

2353. U.S. Government Printing Office. *Change in Title and the Establishment of a Pay Plan for Female Employees Formerly Designated as Bindery Operatives.* Administrative Order no. 80. Washington, DC: GPO, 1952. 1p. GP1.16:80.

2354. U.S. Army. *Personnel Utilization: Employment of Pregnant Women, Feb. 9, 1955.* Army Regulation 616-390. Washington, DC: GPO, 1955. 2p. D101.9:616-390. Supersedes Army regulation 620-90 (2351).

2355. U.S. Women's Bureau. *Women in the Federal Service - 1954.* Pamphlet no. 4. Washington, DC: GPO, 1956. 15p. L13.19:4. Report on the number of women employed by the federal government in 1954. Provides data on occupations and salaries.

2356. U.S. Internal Revenue Service. *High School Graduates.* Washington, DC: GPO, 1957. 8p. leaflet. T22.2:Sch6. Recruiting leaflet, obviously geared toward women, describes the advantages of a clerical job at the IRS.

2357. U.S. Women's Bureau. *Government Careers for Women : A Study of the Salaries and Positions of Women White-Collar Employees in the Federal Service, 1954.* Washington, DC: GPO, 1957. 69p. L13.2:G74. Examination of the employment of women in the federal service looks at trends in number employed, occupation, agency, and salary. Includes statistics on number of women employed by agency, job grade and agency, occupation and agency, and salary and grade distribution by occupation.

2358. U.S. Civil Service Commission. *Occupations and Salaries of Women in Federal Service, Oct. 31, 1959.* Pamphlet no. 62. Washington, DC: The Commission, 1962. 63p. CS1.48:62. Analysis by occupation of employment and salaries of women in civil service positions notes which agencies were the largest employers of women. A brief history of employment of women in the civil service is included and detailed tables show number of women employed in full-time white collar occupations by area in 1954 and 1959 (continental U.S. and D.C. metro), by agency for 1959, and by grade for 1959. Tables show number of women employed in blue collar occupation by agency in 1959 and by scheduled and grade in 1959.

2359. U.S. Women's Bureau. *Women in the Federal Service, 1939-1959.* Pamphlet no. 4, revised. Washington, DC: GPO, 1962. 21p. L13.19:4/2. Brief discussion of trends in the employment of women by the federal government between 1939 and 1959 provides summary information on job locations, occupations, and salaries of women in the federal service.

2360. U.S. President's Commission on the Status of Women. *Report of Committee on Federal Employment to the President's Commission on the Status of Women.* Washington, DC: GPO, 1963. 195p. Pr35.8:W84/Em7. Lengthy report on the status of the employment of women in the federal government includes a history of women in the civil service and reviews current policies and programs. Issues of promotion, training and turnover, part-time employment, and insurance and benefits are explored. Also looks at women in military service including the Nurse Corps, the Foreign Service, and political executive positions. The appendix includes results of a study of state and city government policies restricting positions to one sex, and results of a survey of reasons for turnover among women in the federal service.

2361. U.S. Government Printing Office. *Equal Employment and Advancement Opportunities for Women.* Administrative Order no. 231. Washington, DC: GPO, 1964. 1p. GP1.16:231.

2362. U.S. Women's Bureau. *In the Federal Service: Equal Opportunity and Equal Pay.* Washington, DC: The Bureau, 1964. 6p. L13.2:F31. Short history with anecdotes on the

employment of women in the federal service. Focuses on the debate over allowing women to hold certain jobs over the years and on the issue of equal pay.

2363. U.S. Congress. House. Committee on Post Office and Civil Service. *Repeal of Law Relating to Appointment of Women to Executive Department Clerkships, Report to Accompany H.R. 6165.* H. Rept. 772, 89th Cong., 1st sess, 1965. 2p. Serial 12665-5. Report supports the repeal of Section 165 of the Revised Statutes (5 USC 33) which allowed sex discrimination in appointments to clerkships. Correspondence from the Civil Service Commission summarizes the history of the law.

2364. U.S. Congress. House. Committee on Post Office and Civil Service. Subcommittee on Civil Service. *Appointment of Women to Clerkships in the Executive Departments, Hearing on H.R. 6165.* 89th Cong., 1st sess., 29 June 1965. 18p. Y4.P84/10:W84. Hearing considers bills to repeal section 165 of the United States Revised Statutes (5U.S.33) which allowed department heads to appoint women to clerkships but which was later interpreted as allowing department heads to limit a position to one sex.

2365. U.S. Congress. Senate. Committee on Post Office and Civil Service. *Repeal of Laws Relating to Appointment of Women to Executive Clerkships, Report to Accompany H.R. 6165.* S. Rept. 795, 89th Cong., 1st sess., 1965. 3p. Serial 12662-5. Report supports the repeal of Section 165 of the Revised Statutes (5 USC 33), an 1870 law designed to ensure equal pay to women clerks in the federal service but which was later interpreted as allowing departments to limit positions to one sex.

2366. U.S. Congress. Senate. Committee on Post Office and Civil Service. *Women Clerkships in the Executive Department, Hearing on S. 1769 and H.R. 6165.* 89th Cong., 1st sess., 21 Sept. 1965. 11p. Y4.P84/11:W84. Brief hearing considers a bill to remove a 1870 law which provided that women could, at the discretion of the department head, be appointed to clerkships in the federal civil service. The law is characterized as a anachronism that should be repealed.

2367. U.S. Dept. of Commerce. *Address by Secretary of Commerce John T. Connor, Prepared for Delivery at Graduation Exercises of Kent Place School, Summit, N.J., June 9, 1965.* by John T. Connor. Washington, DC: Commerce, 1965. 7p. C1.18:C76/21. Graduation speech encourages the girls to consider work in the civil service or politics at some point in their lives. Highlighted are some of the ways women contribute to government affairs as wives of government officials and as professional women.

2368. U.S. Women's Bureau. *In the Federal Service: Equal Opportunity and Equal Pay.* Washington, DC: The Bureau, 1965. 6p. L13.2:F31/965. Update with minor revisions of a 1964 document (2362).

2369. U.S. Civil Service Commission. *Federal Employment of Women.* Washington, DC: GPO, 1966. 22p. CS1.74:966/1. Analysis of the employment of women in the federal government for the Interdepartmental Committee on the Status of Women looks at utilization of women with an emphasis on the higher grades.

2370. U.S. Forest Service. *Women's Work in the Forest Service.* Miscellaneous Pub. 1058. Washington, DC: GPO, 1967. [8]p. A1.38:1058. Earlier edition of *Women in the Forest Service* (2387).

2371. U.S. Bureau of Reclamation. *Equal Opportunity in the Bureau of Reclamation: An Affirmative Program of Manpower Utilization.* Washington, DC: GPO, 1969. 16p. I27.2:Eq2/969. Action plans for the Bureau of Reclamation to ensure equal opportunity for minorities and women focus on recruitment, utilization, training and development, and

community relations. Part II specifically sets forth the plan of action for the Federal Women's Program at the bureau.

2372. U.S. Civil Service Commission. Bureau of Recruiting and Examining. *Changing Patterns: A Report on the 1969 Federal Women's Program Review Seminar.* Washington, DC: GPO, 1969. 33p. CS1.2: P27. Conference speakers examine the employment situation of women in the federal civil service and the existing attitudes toward women employees. The progress of the Federal Women's Program is highlighted.

2373. U.S. Federal Aviation Administration. *Equal Opportunity in FAA Employment.* Washington, DC: GPO, 1969. 67p. TD4.8/2:3300.6A. Management handbook provides an overview of EEO personnel structure, policies, and complaint procedures, and describes ways to sell EEO to FAA personnel and to communities. Includes a brief version of the FAA equal employment opportunity action plan and of a local affirmative action plan.

2374. U.S. Government Printing Office. *Equal Employment Opportunity Program in the Government Printing Office.* Administrative Order no. 114. Washington, DC: GPO, 1969. 8p. GP1.16:114/4. Details responsibilities and procedures for filing complaints under the GPO equal employment opportunity program. The administrative order specifically states that appointing officers shall not discriminate on the basis of marital status "as nearly as conditions of good administration warrant."

2375. U.S. Office of Federal Equal Employment Opportunity Programs. Federal Women's Program. *Expanding Opportunities...Women in the Federal Government.* Washington, DC: GPO, 1970. 16p. CS1.48:BRE-25. Summary of the status of women in the federal civil service during the 1960s focuses on advancements and is geared toward recruiting college women.

2376. U.S. Congress. House. Committee on Post Office and Civil Service. *Equality of Treatment for Married Women Federal Employees, Report to Accompany H.R. 3628.* H. Rept. 92-415, 92d Cong., 1st sess., 1971. 11p. Serial 12932-3. Favorable report with amendment on legislation to remove language which discriminates against married women federal employees with respect to preference eligibility, employment benefits, cost-of-living allowances in foreign areas, and regulations concerning marital status generally. In most cases the effect of the bill is to amend the language of Title 5, U.S. Code, to include husband and widower under laws relating to wife or widow.

2377. U.S. Congress. House. Committee on Post Office and Civil Service. Subcommittee on Manpower and Civil Service. *Federal Employee Benefits, Hearings on H.R. 3628, H.R. 8085, H.R. 8983, and H.R. 9778.* 92d Cong., 1st sess., 20,21 July 1971. 64p. Y4.P84/10:92-19. Brief hearing on a number of bills affecting federal employment benefits includes discussion of H.R. 3628, a bill to remove discrimination against married women in eligibility for benefits. Most of the changes would extend benefits to the spouse of a female employee on the same basis as male employees, primarily affecting veterans' preference rules and overseas allowances. Some of the inequities in the civil service system toward married women are noted.

2378. U.S. Congress. Senate. Committee on Post Office and Civil Service. *Discrimination in Federal Employment, Report to Accompany H.R. 3628.* S. Rept. 92-528, 92d Cong., 1st sess., 1971. 3p. Serial 12929-6. Reports proposed amendments to Title 5 of the U.S. Code in order to clearly indicate that preference provisions and cost-of-living allowances for federal employment apply equally to men and women.

2379. U.S. Congress. Senate. Committee on Rules and Administration. *Appointment of Senate Pages without Discrimination on Account of Sex, Report to Accompany S. Res. 112.* S.

Rept. 91-101, 92d Cong., 1st sess., 1971. 4p. Serial 12929-1. Report on a resolution clearly approving the appointment of Senate pages without regard to sex notes the safety concerns arising from the crime rate in the capitol area, and reprints the report of the Ad Hoc Subcommittee to Consider the Appointment of Female Pages.

2380. U.S. Congress. Senate. Committee on Rules and Administration. Ad Hoc Subcommittee to Consider the Appointment of Female Pages. *Appointment of Female Senate Pages, Hearing.* 92d Cong., 1st sess., 4 March 1971. 47p. Y4.R86/2:F34. Debate on appointing female Senate pages focuses on age, supervision, and safety aspects particularly in relation to working late hours.

2381. U.S. Dept. of Labor. EEO Task Force. *Final Report on the Status of Minorities and Women in the Department of Labor.* Washington, DC: The Dept., 1971. 795p. L1.2:M66/2. Report of the investigation of the status of minorities and women in the Department of Labor conducted by the Secretary's EEO Task Force provides an in-depth analysis of the utilization of women and minorities and of upward mobility and recruitment programs. Provides extensive data on distribution of women and minority employees by grade and salary, length of service, time-in-grade, age, and education.

2382. U.S. Dept. of Transportation. *The Federal Women's Program, An Integral Part of the Overall Equal Opportunity Program of the Department of Transportation.* Washington, DC: The Dept., 1971. 3p. TD1.2:W84.

2383. U.S. Civil Service Commission. *A Point of View: The Federal Women's Program.* Washington, DC: GPO, 1972. 14p. CS1.2:W84/5. Women's opportunities in federal employment and the history of women in the civil service are briefly presented.

2384. U.S. Civil Service Commission. Bureau of Manpower Information Systems. Manpower Statistics Division. *Federal Civilian Personnel Statistics: Federal Civilian Employment by Minority Group and Sex.* Washington, DC: GPO, 1972. 37p. CS1.48:SM72-100. Presents data for minorities and women in federal civilian employment by agency, GS level and regions in 1972.

2385. U.S. Equal Employment Opportunity Commission. *Hearing before the United States Equal Employment Opportunity Commission on Utilization of Minority and Women Workers in Public Utilities Industry.* Washington, DC: GPO, 1972. 559p. Y3.Eq2:2M66/4. Testimony of witnesses at an EEOC hearing on the utilization of women and minorities in the public utilities industry highlights hiring, recruitment, and promotion practices, and reveals attitudes behind these practices as they affect women and minorities.

2386. U.S. Federal Aviation Administration. Aviation Medicine Office. FAA Civil Aeromedical Institute. *Comparative Study of Female and Male Air Traffic Controller Trainees.* Technical report FAA-AM 72-22. by Bart B. Cobb, John J. Matthews, and Carolyn D. Lay. Washington,DC: The Office, 1972. 29p.TD4.210:72-22. Study of trainees at the FAA Academy for air traffic controllers found few significant sex differences in age and educational level, training course performance measures, or in academy attrition rate. Post-academy attrition rates were 33.3 percent for women and 19.1 percent for men.

2387. U.S. Forest Service. *Women in the Forest Service.* Washington, DC: GPO, 1972. [14]p. A1.38:1058/3. Highlights career opportunities for women in the Forest Service.

2388. U.S. National Oceanic and Atmospheric Administration. Environmental Research Laboratories. *The Federal Women's Program.* Washington, DC: The Administration, 1972. 27p. C55.614:D41. Speech presented at the Federal Women's Program Conference, Honolulu, Hawaii, April 3, 1972, covers many aspects of women's employment,

particularly in the federal service. Provides some guidelines on the components of a good Federal Women's Program operation for agency FWP coordinators and gives basic supporting statistics on women's pay and grades in the federal service.

2389. U.S. Women's Bureau. *Calling All Women in Federal Service.* Leaflet no. 53. Washington, DC: GPO, 1972. 11p. L36.110:53. Describes the makeup of the federal service labor force and notes ways women in civil service positions can advance.

2390. U.S. Civil Service Commission. *Expanding Opportunities...Women in the Federal Government.* Washington, DC: GPO, 1973. 17p. CS1.2:W84/6. Report notes that women work out of economic necessity and make up an increasing portion of the work force. The varied occupations of women in the federal civil service are highlighted.

2391. U.S. Congress. Senate. Committee on Post Office and Civil Service. *Flexible Hours of Employment, Hearing on S. 2022.* 93d Cong., 1st sess., 26 Sept. 1973. 152p. Y4.P84/11:H81. Brief hearing on a bill to solidify the practice of flexible hour options for federal employees consist primarily of articles on the advantages of alternative work schedules. Witnesses and statements from the Postal Service and the AFL-CIO express concern over provisions requiring a certain percentage of part-time positions and over the effect of the bill on collective bargaining. Witnesses supporting the bill point to the advantage of part-time employment opportunities for working mothers.

2392. U.S. Dept. of Commerce. Office of Personnel. *Eight Essential Obligations for Successful Federal Women's Program: Managers Guide.* Washington, DC: The Dept., 1973. 27p. C1.8/3:W84. Guide for managers outlines obligation under the Federal Women's Program and notes specific actions to address issues related to the utilization of women in the work force. Includes a chronology of employment opportunities for women in the federal service since 1773.

2393. U.S. Dept. of Labor. Federal Women's Program Committee. *Employment of Women in the Department of Labor.* Washington, DC: The Dept., 1973. 25p. L36.102:W84. Overview of problems and progress in the employment of women within the Department of Labor and its agencies concentrates on professional women. Includes data on utilization of women and on hires and separations of professional women employees.

2394. U.S. Small Business Administration. *SBA's Equal Employment Opportunity Compliance Program.* Washington, DC: GPO, 1973. 2p. leaflet. SBA1.2:Eq2/2.

2395. U.S. Civil Service Commission. *Guidelines for Federal Women's Program Coordinators.* Personnel Management Series no. 25. Washington, DC: GPO, 1974. 11p. CS1.54:25. Outline for FWP coordinators highlights the responsibilities and the general goals of the Federal Women's Program. Describes some approaches to dealing with those reluctant to support the FWP, and discusses the proper role of the coordinator in the complaint process.

2396. U.S. Congress. House. Committee on the Judiciary. Subcommittee on Civil Rights and Constitutional Rights. *NASA's Equal Opportunity Program, Hearings.* 93d Cong., 2d sess., 13,14 March 1974. 274p. Y4.J89/1:93-56. Examination of NASA's commitment to equal opportunity reviews the composition of the NASA work force and criticizes the EEO environment at NASA, particularly in regard to racial minorities.

2397. U.S. Dept. of Transportation. Departmental Office of Civil Rights. *Summary of Equal Employment Opportunity Field Conferences, April, May 1974.* Washington, DC: The Dept., 1974. 34p. TD1.2:Em7. Summary report describes regional workshops on

improving the DOT's recruitment and retention of minority and female employees and on implementation of upward mobility programs.

2398. U.S. Equal Employment Opportunity Commission. *State and Local Government Functional Profile Series 1973, Part 2: Streets and Highways.* Washington, DC: GPO, 1974. 12p. Y3.Eq2:14/973/pt.2. Presents summary data for the United States on employment of women and minorities in street and highway departments of state and local governments by job category, salary, and type of jurisdiction.

2399. U.S. Equal Employment Opportunity Commission. *Minorities and Women in State and Local Government 1973.* 11 vol. Washington, DC: GPO, 1974. Y3.Eq2:2St2/973/v.1-11. Detailed statistical report on employment of women and minorities in state and local government furnishes data by government function, job category, and salary. Volume I is a U.S. summary; volumes 2 - 11 provide regional data.

2400. U.S. Federal Aviation Administration. Aviation Medicine Office. *Sex Comparisons of Reasons for Attrition of Non-Journeyman FAA Air Traffic Controllers.* by John J. Mathews, William E. Collins, Bart B. Cobb. Technical report FAA-AM-74-2. Washington, DC: The Office, 1974. 19p. TD4.210:74-2. Reasons for higher attrition rates of female non-journeymen air traffic controllers was primarily accounted for by family-related reasons. Sex discrimination was cited as a reason for attrition in 18 percent of the females interviewed.

2401. U.S. Federal Aviation Administration. Civil Aeromedical Institute. *Job-Related Attitudes of Non-Journeyman FAA Air Traffic Controller and Formers Controllers, Sex Comparisons.* by John J. Matthews, William E. Collins, and Bart B. Cobb. Technical report FAA-AM-74-7. Washington, DC: The Institute, 1974. 27p. TD4.210:74-7. Attitudes of male and female air traffic controllers and former controllers are examined to determine reasons for dissatisfaction leading to higher resignation rates of women.

2402. U.S. Office of the Assistant Secretary of the Army for Manpower and Reserve Affairs. *The Utilization of Civilian Women Employees within the Department of the Army: Executive Summary of the Final Report.* Civilian Personnel Pamphlet no. 78. Washington, DC: GPO, 1974. 40p. D101.37:78. See 2403 for abstract.

2403. U.S. Office of the Assistant Secretary of the Army for Manpower and Reserve Affairs. *The Utilization of Civilian Women Employees within the Department of the Army: Final Report.* Civilian Personnel Pamphlet no. 79. Washington, DC: GPO, 1974. 550p. D101.37:79. In-depth research report on the status of women civilian employees of the Department of the Army found current practices which greatly impact the career patterns of women and result in their continued concentration in the lower grade levels. In addition to assessing the current employment situation, the report looks at possible remedies and at the role of the Federal Women's Program.

2404. U.S. Tennessee Valley Authority. Office of the General Managers. *Federal Women's Program Conference, Knoxville, Tennessee, May 2-3, 1974.* Knoxville, TN?:Tennessee Valley Authority, 1974? 15p. Y3.T25:2W84. Conference summary highlights topics of women in the business world, employment discrimination, and women in the federal service, and summarizes workshops on improving job opportunities for women in the Tennessee Valley Authority.

2405. U.S. Army. Corps of Engineers. *The Women: Up from Soapsuds Row.* Pamphlet EP360-17775-5. Washington, DC: The Corps, 1975. 10p. D103.43:360-17775-5.

2406. U.S. Army Medical Department. Equal Employment Opportunity Office. *Walter Reed Army Medical Center Affirmative Action Plan, 1975.* Washington, DC: GPO, 1975. 247p. D104.2:Af2/975. Includes data on employees and promotions by race, sex, and grade, and reviews progress in meeting affirmative action program objectives.

2407. U.S. Bureau of Radiological Health. *Affirmative Action Plan for Equal Employment Opportunity, July 1, 1975 - September 30, 1976.* Rockville, MD: The Bureau, 1975. 26p. HE20.4102:Af3. Objectives and action plan for EEO at the Bureau of Radiological Health provides statistics on current minority and female employment.

2408. U.S. Bureau of the Public Debt. *Focus on Women '75 at Bureau of the Public Debt.* Washington, DC: The Bureau, 1975? 17p. T63.202:W84. Highlights women in leadership positions at the Bureau of the Public Debt.

2409. U.S. Civil Service Commission. Philadelphia Region. *Manager's/Supervisor's Role in Equal Opportunity, Participant Manual.* Washington, DC: GPO, 1975. 277p. CS1.7/4:Su7/5. Background information for supervisors on AA/EEO covers the Federal Women's Program, the Upward Mobility Program, and supervisor's EEO responsibilities.

2410. U.S. Congress. House. *Communication from the Deputy Director, Office of Management and Budget, Executive Office of the President, Transmitting a Report on Recommendations and Actions Related There to Contained in the Report of the President's Advisory Council on Management Improvement Entitled "Women in Government," Pursuant to Section 6(b) of the Federal Advisory Committee Act.* H. Doc. 94-146, 94th Cong., 1st sess., 1975. 5p. Serial 13109-2. The report "Women in Government, January 1973," of the President's Advisory Council on Management Improvement, presents twelve recommendations on actions which federal agencies should take to improve the opportunities for women in federal service. Each recommendation is followed by Civil Service Commission comments describing actions taken related to the recommendations. The Federal Women's Program is the focus of many of the recommendations.

2411. U.S. Congress. House. Committee on International Relations. Subcommittee on International Operations. *U.S. Information Agency Authorization for Fiscal Year 1976, Hearings.* 94th Cong., 1st sess., 15 May - 4 Nov. 1975. 123p. Y4.In8/16:Un35/6/976. Within discussion focusing primarily on Voice of America is recurrent questioning on the utilization of women in the USIA work force and in foreign affairs positions in general.

2412. U.S. Congress. House. Committee on Post Office and Civil Service. Subcommittee on Manpower and Civil Service. *Alternate Work Schedules and Part-Time Career Opportunities in the Federal Government, Hearing on H.R. 6350, H.R. 9043, H.R. 3925, and S.792.* 94th Cong., 1st sess., 29 Sept. - 7 Oct. 1975. 174p. Y4.P84/10:94-53. Hearing on bills to permit flexible work schedules and to increase part-time employment opportunities in the civil service discusses the costs and benefits of the proposals. The benefits for working mothers of part-time employment opportunities are stressed. Anticipated management problems connected with the proposals are examined.

2413. U.S. Customs Service. *Headquarters, U.S. Customs Service Equal Opportunity Affirmative Action Plan, Fiscal Year 1976, Extended to Cover the Period July 1, 1975 through September 30, 1976.* Washington, DC: The Service, 1975? 28p. T17.2:Eq2. Report presents accomplishments toward meeting fiscal year 1975 affirmative action objectives, reports statistics on number of women and minority employees by GS grade at headquarters, and states the affirmative action plan for fiscal year 1976.

2414. U.S. Dept. of Agriculture. *Ladies in Grading.* Picture Story no. 285. Washington, DC: The Dept., 1975. 6p. A1.100:285. Profile of some of the women working in commodity grading activities consists mostly of pictures.

2415. U.S. Equal Employment Opportunity Commission. *A Managers Guide to EEO in the Federal Government.* Washington, DC: GPO, 1975. 21p. Y3.Eq2:8M31. Provides basic information and answers to common questions about EEO and affirmative action in the civil service. Special federal programs for women and minorities are described along with management tips on recruitment and upward mobility.

2416. U.S. Federal Railroad Administration. Office of Civil Rights. *Pre-Seminar Manual for F.R.A. Equal Employment Opportunity Awareness Seminar.* Washington, DC: GPO, 1975. 160p. TD3.2:Eq2. Supporting and background materials for a managers seminar on EEO in the Department of Transportation and the Federal Railroad Administration highlight the goals of EEO and state why special action is needed. Specifically addresses the need for EEO programs by type of protected class, including women. A chronology of federal EEO efforts is presented.

2417. U.S. Manpower Administration. *Equal Employment Opportunity Affirmative Action Plan Fiscal Year 1976.* Washington, DC: The Administration, 1975? 29p. L1.2:Eq2/2/976. Outlines past actions and the fiscal year 1976 plan of action to address EEO/AA problems at the Manpower Administration.

2418. U.S. National Credit Union Administration. *Equal Employment Opportunity Affirmative Action Plan for Fiscal Year 1976.* Washington, DC: The Administration, 1975. 70p. NCU1.2:Af2. Reviews the National Credit Union Administration fiscal year 1975 EEO/AA plan of action and accomplishments and presents the fiscal year 1976 plan. Topics covered are recruitment, utilization, upward mobility, training, and program evaluation. Includes data on the NCUA work force composition by race/ethnicity/sex and GS grade nationwide and for regions.

2419. U.S. Army Corps of Engineers. *Equal Employment Opportunity Plan of Action.* Pamphlet no. 690-1-2. Washington, DC: GPO, 1976. 129p. D103.43:690-1-2. Program report on EEO at the Corps of Engineers for 1975 reviews the goals of the plan and specific accomplishments.

2420. U.S. Army Corps of Engineers. *Equal Employment Opportunity Plan of Action.* Regulation no. 690-1-2. Washington, DC: The Dept., October 1976. 91p. D103.6/4:690-1-2. The objectives, program, and target dates of the Corps of Engineers EEO plan are described in addition to statements of achievement and a statistical analysis of gains and losses of employees, and promotions by grade in protected groups. Also provides data on number and percentage of women employees by occupation.

2421. U.S. Civil Service Commission. *Readings on Minorities and Women.* Washington, DC: GPO, 1976. 48p. CS1.2:M66/2. Collection of five articles includes "The Federal Women's Program" reprinted from *Public Administration Review.*

2422. U.S. Customs Service. *U.S. Custom Service Equal Opportunity Affirmative Action Plan, Fiscal Year 1976, Extended to Cover the Period July 1,1975 through September 30,1975.* Washington, DC: The Service, 1976? 50p. T17.2:Eq2/2. Report and plan of action for EEO/AA at the Customs Service nationwide includes a summary of the allocation of personnel and resources to EEO/AA, a report of accomplishments under the previous affirmative action plan, and a detailed assessment of the current EEO situation. The specific actions to be taken in fiscal year 1976 to address affirmative action concerns are

delineated. Statistics on female and minority employment in the Customs Service by region and GS grade are furnished.

2423. U.S. Defense Fuel Supply Center. *An Introduction of the DFSC Federal Women's Program Committee.* Alexandria, VA: The Center, 1976? leaflet. D7.2:W84.

2424. U.S. Dept. of Housing and Urban Development. *HUD Federal Women's Program.* Washington, DC: GPO, 1976. leaflet. HH1.2:W84/5.

2425. U.S. Equal Employment Opportunity Commission. *State and Local Government Functional Profile Series 1973, Part 5: Fire Protection.* Washington, DC: GPO, 1976. 18p. Y3.Eq2:11/976-47-5. See 2429 for abstract.

2426. U.S. Equal Employment Opportunity Commission. *State and Local Government Functional Profile Series 1973, Part 6: Natural Resources/ Parks and Recreation.* Washington, DC: GPO, 1976. 14p. Y3.Eq2:11/976-47-6. See 2429 for abstract.

2427. U.S. Equal Employment Opportunity Commission. *State and Local Government Functional Profile Series 1973, Part 9: Housing.* Washington, DC: GPO, 1976. 19p. Y3.Eq2:11/976-47-9. See 2429 for abstract.

2428. U.S. Equal Employment Opportunity Commission. *State and Local Government Functional Profile Series 1973, Part 8: Health.* Washington, DC: GPO, 1976. 16p. Y3.Eq2:11/976-47-8. See 2429 for abstract.

2429. U.S. Equal Employment Opportunity Commission. *State and Local Government Functional Profile Series 1973, Part 10: Community Development.* Washington, DC: GPO, 1976. 19p. Y3.Eq2:11/976-47-10. Presents summary data for the United States on employment of women and minorities in functional areas of state and local governments by job category, salary and type of jurisdiction.

2430. U.S. Equal Employment Opportunity Commission. *State and Local Government Functional Profile Series 1973, Part 11: Corrections.* Washington, DC: GPO, 1976. 18p. Y3.Eq2:11/976-47-11. See 2429 for abstract.

2431. U.S. Equal Employment Opportunity Commission. *State and Local Government Functional Profile Series 1973, Part 13: Sanitation and Sewage.* Washington, DC: GPO, 1976. 14p. Y3.Eq2:11/976-47-13. See 2429 for abstract.

2432. U.S. Federal Aviation Administration. Office of Civil Rights. Internal Programs Division. *Federal Aviation Administration Status of Equal Employment Opportunity Program, June 30, 1976.* Washington, DC: The Administration, 1976? 21p. TD4.2:Em7. Overview of FAA employment and promotions for minorities and women in 1976 is presented in graph form.

2433. U.S. Secret Service. *United States Secret Service Agency-Wide Equal Employment Opportunity Affirmative Action Plan for Fiscal Year 1976.* Washington, DC: The Service, 1976? 26p. T34.2:Af2/976. Assessment of past EEO/AA accomplishments and the current EEO situation is followed by a list of specific problems and corresponding action for the 1976 fiscal year. Includes 1975 statistics on the Secret Service work force by race/ethnicity and sex with further breakdowns by grade level.

2434. U.S. Bureau of Intergovernmental Personnel Programs. *Fair Treatment: Grant Projects in Equal Employment Opportunity.* Washington, DC: The Commission, 1977. 28p.

CS1.2:F15. Selected grants to state and local government to encourage equal employment opportunities for minorities and women under the Intergovernmental Personnel Act are summarized.

2435. U.S. Civil Service Commission. Bureau of Manpower Information Systems. *Educational Attainment of General Schedule Employees by Minority Group and Sex.* Washington, DC: GPO, 1977. 77p. CS1.48:SM74-200. Provides data on the educational attainment of minorities and women employed in General Schedule positions by level and occupation.

2436. U.S. Congress. House. Committee on Post Office and Civil Service. Subcommittee on Civil Service. *Veterans' Preference Oversight Hearings.* 95th Cong., 1st sess., 4,5 Oct. 1977. 99p. Y4.P84/10:95-43. Hearing examines the veterans' preference system in the civil service and discusses the impact of the preference system on equal employment opportunity, particularly for women. Witnesses present evidence that veterans' preference keeps women off the top end of employment registers and therefor has a significant impact on employment of women in managerial grades.

2437. U.S. Congress. House. Committee on Post Office and Civil Service. Subcommittee on Employee Ethics and Utilization. *Part-Time Employment and Flexible Work Hours, Hearings on H.R. 1627, H.R. 2732, H.R. 2930.* 95th Cong., 1st sess., 24 May - 4 Oct. 1977. 319p. Y4.P84/10:95-28. Witnesses in support of bills to encourage part-time and flextime options for federal employees stress the need for alternative work schedules for working mothers. Many witnesses describe the problems of working women with ridged work schedules, and support alternative work schedules as a way to promote equal employment opportunity for women. Representatives of companies and of federal and state agencies implementing part-time and flextime options report positive attitudes on the part of employers and employees.

2438. U.S. Congress. Senate. Committee on Government Operations. *Handling of Discrimination Complaints in the Senate, Hearing.* 95th Cong., 1st sess., 3 Aug. 1977. 139p. Y4.G74/9:D63/2. Witnesses discuss proposals for an enforcement mechanism for Rule 50 of the Senate Code of Conduct, which prohibits employment discrimination on the basis of race, religion, sex, national origin, age, or handicap. Evidence of sex and race discrimination in Senate employment is presented noting the representation of women and minorities in various positions, and the wag gap between male and female employees.

2439. U.S. Department of State. *Women in American Foreign Affairs.* by Homer L. Calkin. Washington, DC: The Dept., 1977. 311p. S1.2:W84. History of women employed in the Department of State and in the Foreign Service. Chronicles the bureaucratic barriers to the employment of women and the effects of WWII on their acceptance. The impact of government programs and policy changes on women in the Foreign Service in the 1960s and 1970s is reviewed. Includes data on women by pay plan and number and percentage of women at senior, middle junior, and support levels, 1957-1976.

2440. U.S. Equal Employment Opportunity Commission. *Minorities and Women in State and Local Government 1974.* Washington, DC: GPO, 1977. 6 vol. Y3.Eq2:2St2/974/v.1-6. Report presents a statistical analysis of the employment of women and minorities in state and local government by government function, job category, and salary. Vol. 1 - U.S. Summary; Vol. 2 - State Governments; Vol. 3 - County Governments; Vol. 4 - Municipal Governments; Vol. 5 - Township Governments; Vol. 6 - Special Districts.

2441. U.S. Equal Employment Opportunity Commission. *Minorities and Women in State and Local Government.* Washington, DC: GPO, 1977. 7 vol. Y3.Eq2:2St2/975/v.1-7. Data for 1975 profiles occupational distribution and salary distribution of women and minorities employed by state and local government broken down by government function. Vol. 1-

U.S. Summary; Vol. 2 - Type of Government Summary; Vol. 3 through 7 - State Summaries.

2442. U.S. Federal Highway Administration. Task Force on Women. *FHWA Task Force on Women: Executive Summary.* Washington, DC: GPO, 1977. 73p. TD2.2:W84/summ. See 2443 for abstract.

2443. U.S. Federal Highway Administration. Task Force on Women. *FHWA Task Force on Women: Study Report.* Washington, DC: GPO, 1977. 339p. TD2.2:W84. In-depth study of the status of women in the FHWA surveyed attitudes toward women, the representation of women in the FHWA work force, and the personnel policies and practices which affect women. Looks specifically at issues of employee development and upward mobility.

2444. U.S. Internal Revenue Service. Federal Women's Program. *Opportunities for Women with the Internal Revenue Service.* Washington, DC: The Service, 1977. 5p. T22.2:W84/977. Outline of the objectives of the IRS Federal Women's Program and highlights of career opportunities with the IRS characterize this revision of a 1975 publication.

2445. U.S. National Advisory Council on Women's Educational Programs. *Women's Participation in Management and Policy Development in the Education Division.* by JoAnn Steiger and Eleanor S. Szanton. Washington, DC: The Council, 1977. 89p. Y3.Ed8/6:2M31. Study of the representation of women in the management levels of the HEW Education Division notes the agency practices which block their advancement. Also identifies practices which encourage the inclusion of women in policy development. Provides statistics on percentage of women by grade in the Education Division and number of women, by state, on advisory committees.

2446. U.S. National Guard Bureau. *Federal Women's Program Handbook.* Technical Personnel Pamphlet 713-4. Washington, DC: GPO, 1977. 27p. D18.8/2:713-4. Manual for Federal Women's Program coordinators provides background information on equal employment opportunity and the FWP. Includes a resource list of pamphlets, books, articles, and films on women of possible interest to FWP coordinators.

2447. U.S. National Institute of Dental Research. *Equal Opportunity Assessment and Affirmative Action Plan for 1977-1978.* Washington, DC: GPO, 1977. 21p. HE20.3402:Af2/977-78. Analysis of the NIDR work force by race and sex, GS grade, and type of appointment is followed by a list of actions to address EEO/AA problems.

2448. U.S. Urban Mass Transportation Administration. *Plan of Action to Assure Equal Employment Opportunity.* Washington, DC: The Administration, 1977. [200]p. TD7.2:Em7. Review of efforts and accomplishments of the Urban Mass Transportation Administration in implementing EEO. Provides regional and subagency data on employment of women and minorities by GS level and management/professional status. Describes the objectives, actions, and target dates for the administration's EEO plan.

2449. U.S. Commission on Civil Rights. *Recent Developments, New Opportunities in Civil Rights and Women's Rights: A Report of the Proceedings of the Western Regional Civil Rights and Women's Rights Conference IV, Sponsored by the U.S. Commission on Civil Rights in San Francisco, California, June 29 - July 1,1977.* Washington, DC: GPO, 1978? 178p. CR1.2:D49. Report on a conference of workers in federal, state, and local civil rights agencies in seventeen western states covers the state of civil rights and women's rights in government agencies with particular emphasis on equal employment opportunities.

2450. U.S. Commission on Civil Rights. Kentucky Advisory Committee. *A Paper Commitment: Equal Employment Opportunity in the Kentucky Bureau of State Police.* Washington, DC:

GPO, 1978. 19p. CR1.2:Em7/11. Harshly critical report on equal employment opportunity in the Kentucky Bureau of State Police recommends that the U.S. Attorney General take action against the bureau for its continued exclusion of women and underrepresentation of minorities. Includes data on the bureau work force by race and sex.

2451. U.S. Commission on Civil Rights. Oklahoma Advisory Committee. *The Quest for Equal Employment Opportunity in Oklahoma State Government.* Washington, DC: GPO, 1978. 77p. CR1.2:Em7/10. Investigation of the status of women and minorities in Oklahoma state government found traditional patterns of employment with women and minorities underrepresented and concentrated in the lowest paying jobs. Analysis of state agency affirmative action plans found deficiencies in areas needed to ensure effectiveness. Includes data on merit system employment by race and gender, occupational groups by gender, and salary distribution by race and gender.

2452. U.S. Commission on Civil Rights. Utah Advisory Committee. *Affirmative Action in Salt Lake's Criminal Justice Agencies.* Washington, DC: The Commission, 1978. 31p. CR1.2:C86/3. Study of affirmative action efforts in Salt Lake City's criminal justice agencies found no effort to ensure opportunities for women and minorities. Includes supporting date by agency detailing the work force by sex, race/ethnicity, and job category.

2453. U.S. Congress. House. Committee on Education and Labor. Subcommittee on Employment Opportunities. *Staff Report Comparing Figures for Minority and Female Employment in the Federal Government, 1975 and 1977, and in Forty-Four Selected Agencies, 1977.* 95th Cong., 2d sess., 1978. 37p. CIS-78-H342-10. Data on civil service employment of women and minorities in 1977 is presented by grade range for 44 agencies, and summary data for the entire civil service is provided for 1975 and 1977.

2454. U.S. Congress. House. Committee on Post Office and Civil Service. Subcommittee on Investigations. *Discrimination in the Federal Government, Hearing.* 95th Cong., 2d sess., 30 Mar. 1978. 98p. Y4.P84/10:95-56. Hearing presents testimony from civil rights organizations, unions, and government agency representatives on ways to improve antidiscrimination efforts within the civil service system. Testimony centers around a plan to move EEO enforcement for federal employees from the Civil Service Commission to the EEOC.

2455. U.S. Congress. House. Committee on the Judiciary. Subcommittee on Civil and Constitutional Rights. *GAO Report on EEO Action Programs at the Department of Justice, Hearing.* 95th Cong., 2d sess., 12 Apr., 12 July 1978. 694p. Y4.J89/1:95/81. Hearing provides reprints of GAO reports describing the progress and the limitations of affirmative action efforts in Justice Department agencies. Brief testimony stresses the GAO findings and recommendations.

2456. U.S. Congress. House. Committee on Veterans' Affairs. Subcommittee on Education and Training. *Veterans' Employment Programs, Hearings.* 95th Cong., 2d sess., 5 Apr. - 3 May 1978. 694p. Y4.V64/3:Em7/978. Extensive hearing on the continuation of the veterans preference system for federal employment includes discussion of the representation of women and minorities in the civil service, and the effect of veterans' preference on the hiring and promotion of women.

2457. U.S. Congress. Senate. Committee on Governmental Affairs. *Flextime and Part-Time Legislation, Hearing on S. 517, S. 518, H.R. 7814, H.R. 10126.* 95th Cong., 2d sess., 29 June 1978. 452p. Y4.G74/9:F63. Hearing on bills to authorize flexible work schedules and increased part-time employment opportunities in the federal civil service explores the arguments for and against alternative work schedules and the workability of

such options in theory and practice. The benefits of alternative hours for women with children are noted.

2458. U.S. Congress. Senate. Committee on Governmental Affairs. *Handling of Discrimination Complaints in the Senate, Part 2, Hearings.* 95th Cong., 2d sess., 9 Feb. 1978. 368p. Y4.G74/9:D63/2/pt.2. Hearing on implementation of Rule L, prohibiting employment discrimination in the Senate, describes the underrepresentation of women and minorities among congressional staff and discusses possible remedies when discrimination is found to exist. Proposed procedures for investigating discrimination complaints are examined. The basic principles of anti-discrimination laws applied to the private sector are reviewed, and the subtleties of interpretation are presented. The issue of reverse discrimination is also raised.

2459. U.S. Congress. Senate. Committee on Governmental Affairs. *Reorganization Plan No. 1 of 1978, Hearings.* 95th Cong., 2d sess., 6-13 Mar. 1978. 833p. Y4.G74/9:R29/978/no.1. Hearing on a plan to centralize federal equal employment opportunity functions under the EEOC presents witnesses from special interest groups including women's organizations. Current enforcement of antidiscrimination laws such as Title VII and the Equal Pay Act are examined, and the proposed relationship between the Civil Service Commission and the EEOC in cases involving federal employee complaints is discussed.

2460. U.S. Dept. of Energy. Office of Equal Opportunity. *Equal Employment Opportunity Plan Development Guidance.* Washington, DC: GPO, 1978. 56p. E1.8:Em7. Presents basic requirements for EEO plans at the Department of Energy, and provides statistics on women and minorities in the department labor force.

2461. U.S. Dept. of Energy. Office of Equal Opportunity. *National Equal Employment Opportunity Plan, June 15, 1978 - September 30, 1979.* Washington, DC: The Office, 1978. 49p. E1.60:0002. Equal employment opportunity plan for the Department of Energy sets goals for hiring more minorities and increasing the number of women in middle and upper-level positions. Provides background statistics on department employees by race and sex and by grade level.

2462. U.S. Dept. of State. Office of the Deputy. *Women in the Department of State: Their Role in American Foreign Affairs.* Department and Foreign Service Series no. 166. Washington, DC: GPO, 1978. 322p. S1.69:166. Revised edition of S1.2:W84, *Women in American Foreign Affairs* (2439).

2463. U.S. Dept. of the Interior. *Doors to the Future: Careers for Women.* Washington, DC: GPO, 1978. 58p. I1.2:W84. Profiles of women working at the Department of the Interior is accompanied by a description of the activities of its bureaus and departmental offices.

2464. U.S. Dept. of Transportation. *Guidelines, Special Emphasis Programs: Federal Women's Program: Hispanic Employment Program.* Washington DC: Transportation, 1978. 25p. TD1.8:W84/2.

2465. U.S. Equal Employment Opportunity Commission. *State Government Affirmative Action in Mid-America.* Washington, DC: GPO, 1978. 107p. CR1.2:Af2/2. Report of the advisory committees of Iowa, Kansas, Missouri and Nebraska examines the utilization of women and minorities as state employees and the effectiveness of affirmative actions plans. The inadequate enforcement role of federal agencies is reviewed. Provides supporting statistics on the state government work force by race, sex, and occupational class.

2466. U.S. Food and Drug Administration. *Equal Employment Opportunity Plan, Food and Drug Administration.* Washington, DC: GPO, 1978. 77p. HE20.4002:Af2. Very specific affirmative action plan for the FDA reviews accomplishments and presents objectives, actions, and time tables to address problems identified in a work force analysis.

2467. U.S. General Accounting Office. *The Affirmative Action Programs in Three Bureaus of the Department of Justice Should Be Improved.* Washington, DC: The Office, 1978. 63p. GA1.13:FPCD-78-53. Report highlights findings that women and minorities in the Justice Department's offices, boards, and divisions, in the Federal Prison System, and in the Law Enforcement Assistance Administration, continued to be concentrated in nonprofessional occupations. The GAO recommends that the bureaus' affirmative action programs be strengthened to address the situation.

2468. U.S. General Accounting Office. *The Drug Enforcement Administration's Affirmative Action Programs Should Be Improved.* Washington, DC: The Office, 1978. 55p. GA1.13:FPCD-78-31. Study of EEO efforts found that improvements were needed in the Drug Enforcement Administration's affirmative action program in order to correct underrepresentation of women and minorities at higher pay grades.

2469. U.S. General Accounting Office. *The Federal Bureau of Investigation Needs Better Representation of Women and Minorities.* Washington, DC: GPO, 1978. 44p. GA1.13:FPCD-78-58. The Department of Justice's affirmative action program at the FBI received high marks for providing equal opportunity to job candidates, but deficiencies were noted in the representation of women and minorities in professional and higher pay grade positions.

2470. U.S. General Accounting Office. *The Immigration and Naturalization Service Affirmative Action Program Should be Improved.* Washington, DC: The Office, 1978. 42p. GA1.13:FPCD-78-18. Report notes progress in INS employment of women and minorities, but stresses the improvements needed in order to increase female and minority representation at higher pay grades.

2471. U.S. Law Enforcement Assistance Administration. National Institute of Law Enforcement and Criminal Justice. *Women on Patrol: A Pilot Study of Police Performance in New York City.* by Joyce L. Sichel, et al. Washington, DC:GPO, 1978. 80p. J1.44:W84/2. Report of a study of gender differences in police performance in New York City noted similarities and slight differences in performance when officers were matched by factors of experience and type of precinct.

2472. U.S. National Credit Union Administration. *Equal Employment Opportunity Affirmative Action Plan, Fiscal Year 1979.* Washington, DC: GPO, 1978. various pagings. NCU1.2:Eq2/2/979. National Credit Union Administration affirmative action plan identifies problems and sets out specific corrective actions. Data on the percentage distribution of minorities and women by occupation and series in the NCUA is furnished.

2473. U.S. National Institute of Neurological and Communicative Disorders and Stroke. *Affirmative Action Plan for Equal Opportunity, 1978-1980.* Bethesda, MD: The Institute, 1978? 17p. HE20.3502:Af2/978-80. Problems, goals, and actions for EEO at the National Institute of Neurological and Communicative Disorders and Stroke are presented.

2474. U.S. Bureau of Intergovernmental Personnel Programs. *EEO Statistical Report on Employment in State and Local Government: Employment Security, Health, and Welfare Programs, Comparison of 1970, 1974, 1976.* Washington, DC: GPO, 1979. 51p. PM1.2:Eq2. Analysis of progress in providing equal opportunity in federal grant-aided programs covered by the Merit System Standards is based on data from the EE0-4

questionnaire. Progress in hiring women and minorities is examined through analysis of statistics on the total number of minorities and women, the total in professional positions, and the total in technical jobs by function. Appendix charts provide statistics for minority and women employees showing distribution of full-time employees, new hires, occupational categories, and government function.

2475. U.S. Commission on Civil Rights. Alabama Advisory Committee. *Where Are the Women and Blacks? Patterns of Employment in Alabama Government.* Washington, DC: GPO, 1979. 26p. CR1.2:W84/4. Investigation of the utilization of women and minorities in Alabama state employment found minorities underrepresented in all job categories and women underrepresented in all categories but office-clerical. Women in professional positions were concentrated in the lowest paying jobs. A lack of commitment to affirmative action at the governor's level was indicated by the lack of appointments of women and minorities to boards and commissions. Provides data on the occupational distribution of Alabama state and local government employees by sex and race from 1973 to 1977.

2476. U.S. Congress. House. Committee on Foreign Affairs. Subcommittee on International Operations and U.S. Congress. House. Committee on Post Office and Civil Service. Subcommittee on Civil Service. *The Foreign Service Act, Hearings on H.R. 4674.* 96th Cong., 1st sess., 21 June - 16 Oct. 1979. 1065p. Y4.F76/1:F76/58. Hearing on reform of the Foreign Service personnel system discusses, among other things, the lack of opportunity for women and minorities under the existing system. Career opportunities for women within the Foreign Service agencies are discussed as are opportunities for the spouses of Foreign Service officers posted overseas. The legitimacy of selection tests and evidence of sex discrimination in promotion opportunities are discussed. The problems faced by Foreign Service wives are illustrated and the issue of survivor benefits and the ex-wife's claim to a portion of the pension are discussed.

2477. U.S. Congress. House. Committee on Post Office and Civil Service. Subcommittee on Investigations. *Sexual Harassment in the Federal Government, Hearings.* 96th Cong., 1st sess., 23 Oct., 1,13 Nov. 1979. 176p. Y4.P84/10:96-57. Testimony highlights the extent of sexual harassment in the federal work place and notes indications of a serious problem. Discusses the need for employment and management training sessions on recognizing and eliminating sexual harassment and explores the adequacy of the sexual harassment grievance process. Testimony of Diane Rennay Williams illustrates the problem of sexual harassment as she describes her suit against the federal government.

2478. U.S. Congress. Senate. Committee on the Judiciary. *Selection and Confirmation of Federal Judges, Part 1, Hearing.* 96th Cong., 1st sess., 25 Jan. 1979. 148p. Y4.J89/2:96-21/pt.1. Senators and witnesses discuss the process for selection and confirmation of federal judges with particular emphasis on appointment of minorities and women. The question of "best qualified" is examined in relation to affirmative action.

2479. U.S. Dept. of Transportation. *Guidelines, Special Emphasis Programs, Federal Women's Program, Spanish Speaking Program.* Washington, DC: The Dept., 1979? 28p. TD1.8:W84/3. Presents guidelines for implementing the Federal Women's Program and the Spanish Speaking Program at the DOT.

2480. U.S. Dept. of Transportation. Office of Civil Rights. *Equal Employment Opportunity Affirmative Action Plan, Fiscal Years 1979 through 1981.* Washington, DC: The Office, 1979? 74p. TD1.2:Em7/3/979-81. Report on programs and problems related to administration of EEO activities reviews 1978 areas of concern and objectives and the progress towards achieving those objectives. Sets forth the EEO/AA problem statements

and action plan for fiscal years 1979 and 1981. Includes statistics on Department of Transportation employment of women and minorities by GS grade and occupation.

2481. U.S. Forest Service. Alaska Region. *Federal Women's Program.* [Juneau, Alaska]: Forest Service, 1979. 4p. A13.2:W84/2.

2482. U.S. Forest Service. Pacific Northwest Region. *The Federal Women's Program.* Washington, DC: GPO, 1979. [6]p. leaflet. A13.66/2:W84.

2483. U.S. General Accounting Office. *The Department of Justice Should Improve Its Equal Employment Opportunity Programs.* Washington, DC: The Office, 1979. 98p. GA1.13:FPCD-78-79. Study of EEO programs at the Department of Justice found that women and minorities were underrepresented at high levels. Recommendations urge the Department of Justice to put more effort into its EEO program.

2484. U.S. National Aeronautics and Space Administration. Office of Equal Opportunity Programs. *Women at Work in NASA.* Washington, DC: GPO, 1979. 16p. NAS1.2:W84. Brief list of positions held by women at NASA accompanies pictures and descriptions of job responsibilities for some NASA women employees.

2485. U.S. National Science Foundation. Division of Science Resources Studies. Utilization Studies Group. *Sex and Ethnic Differentials in Employment and Salaries among the Federal Scientists and Engineers.* Reviews of Data on Science Resources no. 34. Washington, DC: GPO, 1979. 11p. NS1.11/2:34. Report provides analysis of data on employment and salaries of women and minorities employed as scientists and engineers in the civil service. Salary differentials showed that women and racial/ethnic minorities earned less than white males in similar positions, but that these differentials were lower in the civil service that in the economy as a whole.

2486. U.S. Office of Personnel Management. *Putting Women in Their Place.* Washington, DC: GPO, 1979. 20p. PM1.2:W84. Overview of the Federal Women's Program accompanies a brief history of women in the federal service.

2487. U.S. Women's Bureau. *Native American Women and Equal Opportunity: How to Get Ahead in the Federal Government.* Washington, DC: GPO, 1979. 81p. L36.102:N21. Report of a one-day seminar on the employment needs and problems of Native American women focuses on federal employment and private employment. Includes discussion of avenues for addressing employment discrimination grievances and recommendations on addressing the needs of Native American women from the conference workshops.

2488. U.S. Bureau of Mines. *Opportunities for Women in the Bureau of Mines.* Washington, DC: The Bureau, 1980? leaflet. I28.2:W84.

2489. U.S. Commission on Civil Rights. *Extending Equal Employment Opportunity Law to Congress.* Washington, DC: GPO, 1980. 37p. CR1.2:Em7/14. Report examines the complex structure of the federal legislative branch as it relates to equal employment opportunity. The limitations of current coverage and the need to expand Title VII of the Civil Rights Act of 1964 to cover legislative branch employees are explored, as are the steps needed to ensure effective enforcement.

2490. U.S. Commission on Civil Right. Alaska Advisory Committee. *Changing Commitment into Action : Employment of Women and Minorities in Alaska State Government.* Washington, DC: GPO, 1980. 105p. CR1.2:C73/2. Study examined the employment patterns of women and minorities in the departments of the State of Alaska and found both groups underrepresented, particularly in top management and administrative positions. The

state's affirmative action plan was found to be inadequate, and the commitment to equal employment opportunity at higher levels was not communicated to lower level management and supervisors. Supporting statistics give employee distribution by salary range for minorities and women, and employment by race and sex for departments.

2491. U.S. Commission on Civil Rights. California Advisory Committee. *California State Employment.* Washington, DC: The Commission, 1980. 26p. CR1.2:C12/4. Discrimination against women and minorities in California civil service is illustrated through statistics on the distribution of women and minorities in civil service positions, salaries, new hires, and promotions.

2492. U.S. Commission on Civil Rights. Washington Advisory Committee. *Equal Employment Opportunity in Tacoma Area Local Government.* Washington, DC: GPO, 1980. 48p. CR1.2:Em7/13. An inquiry into the status of minorities, women, and the handicapped in Tacoma city government found that the number of minorities had improved since 1973, but that they were still underrepresented. Women were underrepresented in management positions and in fire, police, and skilled craft jobs. Statistics on the percentage of minorities and women in city departments and in independent agencies are furnished.

2493. U.S. Congress. House. Committee on Education and Labor. Subcommittee on Employment Opportunities. *Comparison of Employment Trends for Women and Minorities in Forty-Five Selected Federal Agencies, 1980.* 96th Cong., 2d sess., 1980. Committee print. 192p. Y4.Ed8/1:Em7/32. Statistical profile of the employment of women and minorities in federal agencies furnishes tables for each agency showing the total number of employees by sex and race/ethnicity in each grade range for 1976 and 1979.

2494. U.S. Congress. House. Committee on Post Office and Civil Service. Subcommittee on Investigations. *Sexual Harassment in the Federal Government.* 96th Cong., 2d sess., 1980. Committee print. 32p. Y4.P84/10:Se9. Summary of an investigation of the problem of sexual harassment in the federal government is followed by the response of the Office of Personnel Management and various agencies. Memoranda from agency's to their personnel and management employees on the subject of sexual harassment are reprinted. The factors which contribute to the underreporting of sexual harassment are reviewed and the EEOC's policy on sexual harassment under Title VII is examined. The committee presents conclusions and recommendations on sexual harassment in the federal work place. A bibliography of government documents, books, and journal articles on sexual harassment is furnished.

2495. U.S. Congress. House. Committee on the Judiciary. Subcommittee on Civil and Constitutional Rights. *Equal Employment Opportunity Practices in the Federal Judiciary, Hearings.* 96th Cong., 1st and 2d sess., 10 May 1979 - 19 Nov. 1980. 578p. Y4.J89/1:96/88. Detailed investigation of the employment of women and minorities in the federal judiciary examines both judgeships and support staff positions. Data on employment in district courts is provided by district, position, race, and sex. The lengthy report of the Southern Regional Council, "Blacks and Women in Southern Federal Courts" details the underrepresentation of blacks and women. Approaches to ensuring equal opportunity for minorities and women in federal court employment are discussed.

2496. U.S. Dept. of Agriculture. *People Serving People: Women and Minorities Working in the U.S. Department of Agriculture.* Washington, DC: The Dept., 1980. 45p. A1.2:P39. Designed primarily as a recruiting tool, this publication describes the types of jobs available in the various divisions of the USDA and profiles some of the women and minorities employed by the department.

2497. U.S. Dept. of Housing and Urban Development. *Women in Public Service, Volume I: Women in Municipal Management: Choice, Challenge, and Change.* by Ruth Ann Burns, Center for American Women and Politics. Washington, DC: GPO, 1980. 256p. HH1.2:W84/9/v.1. Examination of the status of women serving as municipal managers highlights the career paths and barriers related to the success of women in these positions. The report also examines the relationship between women elective and women administrative officials serving in the same communities. Provides data on race, age, marital status, and number of children of male and female municipal managers, salaries of municipal managers by occupation and sex, and female municipal managers' education by age and occupation.

2498. U.S. Dept. of Justice. Office of Civil Rights Compliance. *Civil Rights Enforcement under the Crime Control Act of 1976 and the Justice System Improvement Act of 1979: Progress Report, 1976-1980.* Washington, DC: GPO, 1980. 47p. J1.2:C49/9. Report describes the activities of the Office of Civil Rights Compliance in ensuring nondiscrimination among the recipients of grant funds from the Law Enforcement Assistance Administration.

2499. U.S. Equal Employment Opportunity Commission. *Minorities and Women in State and Local Government: A Statistical Summary by Type of Government, 1978 Report.* Washington, DC: GPO, 1980. 628p. Y3.Eq2:2St2/978. Presents data on occupational distribution and salary distribution of women and minority state and local government employees by type of government and government function.

2500. U.S. Fire Administration. *The Role of Women in the Fire Service.* Washington, DC: The Administration, 1980. 39p. FEM1.102:W84. Overview of the issues surrounding the employment of women in the Fire Service talks about qualifications and training standards, and discusses avenues for promotion as they affect women. Men and women who have successfully helped expand the role of women in the Fire Service are profiled.

2501. U.S. General Accounting Office. *How to Make Special Emphasis Program an Effective Part of Agencies' EEO Activities.* Washington, DC: GPO, 1980. 26p. GA1.13:FPCD-80-55. Report concludes that special emphasis programs such as the Federal Women's Program need better coordination with agencies and should be included in affirmative action plans.

2502. U.S. General Accounting Office. *The National Institute of Education Should Further Increase Minority and Female Participation in Its Activities.* Washington, DC: The Office, 1980. 36p. GA1.13:HRD-81-3. Findings of the GAO study show that EEO activities at the National Institute of Education have been successful as have been efforts to encourage research oriented toward women and minorities. Inequities still existed in the employment patterns of grantees, and in grant and contract awards to minority- and women-operated institutions.

2503. U.S. Office of Personnel Management. *Women on the Way Up: The Federal Women's Program.* Washington, DC: GPO, 1980. 12p. PM1.2:W84/2. Information highlights the benefits for women of federal employment and provides a brief overview of the Federal Women's Program.

2504. U.S. Commission on Civil Rights. *Equal Opportunity in the Foreign Service.* Washington, DC: GPO, 1981. 26p. CR1.2:F76. The State Department's progress in recruiting minorities and women is noted, but their continued underutilization, particularly in the middle and top level appointed positions, is also stressed. The report provides data on commissioned Foreign Service officers and Foreign Service reserve employees by race/ethnicity/sex and grade level.

2505. U.S. Congress. House. Committee on Post Office and Civil Service. Subcommittee on Civil Service. *Oversight on Federal Equal Employment Opportunity Activities, Hearings.* 97th Cong., 1st sess., 1 Oct. 1981. 96p. Y4.P84/10:97-45. Examination of affirmative action and equal employment opportunity policies in the federal government focuses specifically on the budget reduction environment of fiscal year 1982. Past GAO reports on affirmative action are reviewed, noting the ineffectiveness of the system. Witnesses evaluate the accomplishments under the Federal Equal Opportunity Recruitment Program (FEORP) and address the anticipated impact of reduction-in-force on gains made by minorities and women.

2506. U.S. Defense Contract Administration. Los Angeles Service Region. *DCASR, Los Angeles, Equal Employment Opportunity Affirmative Action Plan.* Washington, DC: GPO, 1981. 160p. D7.2:Af2/981. Provides an analysis of the work force by sex and race/ethnicity, determines underrepresentation by SMSA's in the Los Angeles Service Region, and presents the DCA affirmative action plan for targeted occupations.

2507. U.S. Federal Aviation Administration. Office of Civil Rights. *Federal Aviation Administration Status of Equal Employment Opportunity Program, September 30, 1980.* Washington, DC: GPO, 1981. 61p. TD4.2:Em7/3. Graphs and tables illustrate the employment of women and minorities in the FAA by occupation and region. Data on EEO complaints filed is provided.

2508. U.S. Merit Systems Protection Board. Office of Merit Systems Review and Studies. *Sexual Harassment in the Federal Workplace: Is It a Problem?* Washington, DC: GPO, 1981. 204p. MS1.2:Se9. Survey of the extent to which sexual harassment is a problem among federal employees collected information on attitudes toward sexual harassment in the federal workplace and on personal and organizational characteristics of harassment and harassers. The impact and cost of harassment and possible remedies are also examined.

2509. U.S. Small Business Administration. Public Communications Division. *SBA's Equal Employment Opportunity Compliance Program.* Washington, DC: The Administration, 1981. leaflet. SBA1.2:Eq2/2/981.

2510. U.S. Administrative Office of the United States Courts. *Equal Employment Opportunity in the Federal Courts: 1981 Annual Report.* Washington, DC: GPO, 1982. 165p. Ju10.22:981. Description of the first year of the equal employment opportunity program in the federal courts is accompanied by statistical tables detailing the personnel activities of each of the federal courts and employment data by sex, race/ethnicity, and handicapping conditions.

2511. U.S. Administrative Office of the United States Courts. *Equal Employment Opportunity in the Federal Courts: 1981 Annual Report, Appendix.* Washington, DC: GPO, 1982. 409p. Ju10.22:981/app. Appendix to the report on EEO in the federal courts (2510) contains each court's evaluation of their activities.

2512. U.S. Administrative Office of the United States Courts. *Equal Employment Opportunity in the Federal Courts: 1982 Annual Report, Appendix.* Washington, DC: GPO, 1982. 411p. Ju10.22:982/app. Reports affirmative action plans and accomplishments of U.S. district courts, courts of appeal, and bankruptcy courts.

2513. U.S. Commission on Civil Rights. *State Government Affirmative Action in Mid-America: An Update.* Washington, DC: GPO, 1982. 299p. CR1.2:Af2/2/982. Follow-up to the 1978 study of affirmative action in the state governments of Iowa, Kansas, Missouri and Nebraska found improvements in new hires and gubernatorial appointments of women and minorities. Problems remained in the representation of women and minorities in

administrative positions. Strengths and weaknesses of each state affirmative action plan are examined.

2514. U.S. Commission on Civil Rights. Indiana Advisory Committee. *Equal Employment Opportunity in Indianapolis Area Government.* Washington, DC: GPO, 1982. 90p. CR1.2:Em7/15. While minorities were adequately represented in the Indianapolis government work force, women were found to be underrepresented, and both were more likely to be in lower paying jobs. The report closely examines the adequacy of the of the city's affirmative action plan and the level of commitment to equal employment opportunity among administrators.

2515. U.S. Commission on Civil Rights. Michigan Advisory Committee. *Affirmative Action in Michigan Cities.* Washington, DC: GPO, 1982. 56p. CR1.2:Af2/5. Study of the years of affirmative action in municipal government employment in Michigan found improvements in the employment of women and blacks but no gains for American Indians or Hispanics. The problems of maintaining recent gains through times of budgetary cutbacks are briefly addressed. Gives statistics on the employment of women, blacks, and Hispanics, 1970 to 1980, for the cities of Detroit, Ann Arbor, Flint, Grand Rapids, Holland, Kalamazoo, Lansing, Saginaw, Sault Ste. Marie, and Warren.

2516. U.S. Commission on Civil Rights. Tennessee Advisory Committee. *Affirmative Action and Equal Employment, Knoxville and Oak Ridge.* Washington, DC: GPO, 1982. 63p. CR1.2:Af2/4. Investigation of the utilization of women and minorities at major employers in Knoxville and Oak Ridge provides data on employees by race, sex, job category, and salary for the University of Tennessee, the Tennessee Valley Authority, and the City of Knoxville. Also discusses the federal role in AA/EEO in the area through contract compliance programs.

2517. U.S. Congress. House. Committee on Foreign Affairs. Subcommittee on International Operations. *Oversight of the Foreign Service Act of 1980, Hearings.* 97th Cong., 2d sess., 3 June - 22 Sept. 1982. 332p. Y4.F76/1:F76/61. Hearing focuses on affirmative action in the Foreign Service with witnesses discussing the representation of minorities and women and the effect of recent hiring and training programs. Promotion rates for women and minorities are explored and ways the career structure may be used to discriminate against minorities and women are discussed. The treatment of spouses of Foreign Service officers is also reviewed with an emphasis on the lack of employment opportunities and pension benefits. The utilization of women in the Department of State, the Agency for International Development, and the International Communication Agency are specifically addressed.

2518. U.S. Equal Employment Opportunity Commission. *Job Patterns for Minorities and Women in State and Local Government,1980.* Washington, DC: GPO, 1982. 290p. Y3.Eq2:12-4/980. See Y3.Eq2:2St2/978, *Minorities and Women in State and Local Government* (2499).

2519. U.S. National Library of Medicine. *National Library of Medicine Affirmative Action Plan for Equal Employment Opportunity.* Washington, DC: GPO, 1982. 36p. HE20.3602:Af2. The National Library of Medicine's affirmative action plan specifies action steps and target dates. Relevant laws and executive orders are included.

2520. U.S. Commission on Civil Rights. *Equal Opportunity in Presidential Appointments.* Washington, DC: GPO, 1983. 22p. CR1.2:P92. Of President Carter's full-time appointments 12.2% were black and 12% were women compared to 4.1% and 8% respectively for the first three years of the Reagan administration. Appointments of both presidents were lacking in certain departments, e.g. Agriculture, Commerce, and State.

Statistics on presidential appointments by race, ethnic origin, and sex to federal departments, the federal judiciary, the U.S. Attorney, the U.S. Marshal, and ambassadorships are provided.

2521. U.S. Commission on Civil Rights. *Federal Affirmative Action Efforts in Mid-America.* Washington, DC: GPO, 1983. 68p. CR1.2:Af2/6. Assessment of federal agency affirmative action efforts in Region VII was conducted by the Iowa, Kansas, Missouri, and Nebraska Advisory Committees on Civil Rights. The committees found underrepresentation of women and minorities particularly at the higher classifications and indications that little progress was made between 1974 and 1980. Affirmative action plans and federal personnel cuts are examined as they affect federal employment of minorities and women. Provides data on the federal work force in Region VII by race and sex, and by grade level, major occupational category, and agency.

2522. U.S. Dept. of Justice. National Institute of Justice. *Women Employed in Corrections.* by Jane Roberts Chapman, et al. Washington, D.C., 1983. 149p. J28.2:W84. Report describes a study of the employment of women in corrections and its findings. Provides a profile of women employed in corrections, the mobility potential and career paths, and legal aids and barriers to the employment of women in corrections. Statistics provided include women in employed civilian labor force by occupation, 1973 and 1979; employment in adult and juvenile correctional systems, by gender, for selected states; type of work setting by state, occupation, and gender; age, marital status and education of participants in study by state and gender; reasons for taking a position in corrections, by state and gender; annual salaries by state, occupation and gender; length of time in current position, by state, occupation, and gender; and training provided by the organization, by state, occupation and gender.

2523. U.S. Forest Service. Pacific Northwest Region. *Civil Rights Questions and Answers.* Washington, DC: GPO, 1983? leaflet. A13.2:C49. Addresses questions of affirmative action, reverse discrimination, and representation of women and minorities in the Forest Service, and provides a concise overview of laws and court decisions which form the basis of the civil rights program.

2524. U.S. National Bureau of Standards. *Multi-Year Affirmative Action Program for Women and Minorities for Fiscal Year 1982 through 1986 Washington, D.C. and Boulder, CO: Executive Summary.* Washington, DC: The Bureau, 1983. 24p. C13.58:83-2798. Guide for managers implementing the affirmative action program briefly reviews occupations where minorities and women were underrepresented and comparative national availability data. States the hiring goals of NBS and summarizes the barriers to improving representation and programs aimed at removing these barriers.

2525. U.S. Alcohol, Drug Abuse and Mental Health Administration. Federal Women's Program. Office of Equal Employment Opportunity. *Sexual Harassment in the Workplace: It Is a Problem.* Washington, DC: The Administration, 1984? leaflet. HE20.8002:Se9/2.

2526. U.S. Congress. House. Committee on Education and Labor. Subcommittee on Employment Opportunities. *The State of Affirmative Action in the Federal Government: Staff Report Analyzing 1980 and 1983 Employment Profiles.* 98th Cong., 2d sess., 1984. Committee print. 200p. Y4.Ed8/1:Af2. Compiles statistics on the federal department, agency, and commission labor force by sex, race, and grade level in 1983 and provides a graphic comparison of 1980 and 1983 figures. A table and chart is presented for each governmental unit.

2527. U.S. Congress. House. Committee on Government Operations. Government Activities and Transportation Subcommittee. *National Endowment for the Humanities and the Equal*

Employment Opportunity Commission Hiring Policies, Hearing. 98th Cong., 2d sess., 25 July 1984. 248p. Y4.G74/7:N21e. Hearing on the failure of the National Endowment for the Humanities to submit an affirmative action plan discusses the hiring policies of NEH and the representation of women and minorities in high level positions. Some general discussion of affirmative action in the wake of the *Stotts* decision is included.

2528. U.S. Congress. House. Committee on Post Office and Civil Service. Subcommittee on Postal Personnel and Modernization. *Study of United States Postal Service Promotion Policies and Practices Together with Appendix: Final Report.* 98th Cong., 2d sess., 1984. Committee print. 422p. Y4.P84/10:P84/53/final. Detailed study of the promotion policies and practices of the U.S. Postal Service looks at how women and minorities have fared under the system in the past twenty years. In addition to examining promotions and separations, the study also examined employee attitudes toward the fairness of promotion policy from the perspective of sex/race groups and pay levels. USPS EEO/AA policies and organization are also examined.

2529. U.S. Congress. House. Committee on Post Office and Civil Service. Subcommittee on Postal Personnel and Modernization. *U.S. Postal Service Discriminatory Promotion Policies and Practices and Effectiveness of EEO Procedures, Hearing.* 98th Cong., 2d sess., 28 June 1984. 51p. Y4.P84/10:98-36. Brief hearing provides background on the motivation and outcome of the *Study of United States Postal Service Promotion Policies and Practices* (2528). Exhibits include reports and correspondence relating to the Board of Governors action on the EEO situation at USPS.

2530. U.S. Congress. House. Committee on Post Office and Civil Service. Subcommittee on Postal Service Promotion Policies and Practices. *Study of United States Postal Service Promotion Policies and Practices.* 98th Cong., 2d sess., 1984. Committee print. 55p. Y4.P84/10:P84/53. Report of a study by Clark, Phipps, Clark and Harris, Inc. on the effectiveness of the USPS promotion policies and practices for equal employment opportunity and affirmative action. The situation which spurred the increased EEO/AA complaint activity is examined both through statistical analysis and reports of employee attitudes. The major finding of the report was that USPS had not communicated its commitment to EEO/AA to its managers, and that it did not reward EEO/AA actions. Organization of EEO at USPS was also reviewed.

2531. U.S. Dept. of Justice. *Women in Federal Law Enforcement.* Washington, DC: GPO, 1984? leaflet. J1.14/2:W84.

2532. U.S. Congress. House. Committee on Education and Labor. Subcommittee on Employment Opportunities. *The Equal Employment Opportunity Commission Collection of Federal Affirmative Action Goals and Timetables and Enforcement of Federal Sector EEO Complaints, Hearing.* 99th Cong., 1st sess., 23 July 1985. 209p. Y4.Ed8/1:99-24. Progress in achieving better representation of women and minorities in federal agencies focuses primarily on NEH, the Department of Education, and the Justice Department. An EEOC representative testified as to the enforcement effort in federal employment sectors. Complaint processing is examined in some depth and the status of women and blacks in federal employment is reviewed.

2533. U.S. Congress. House. Committee on Government Operations. *National Endowment for the Humanities and the Equal Employment Opportunities Commission, Sixth Report Together with Dissenting, Additional, and Additional Dissenting Views.* H. Rept. 99-56, 99th Cong., 1st sess., 1985. 35p. Serial 13645. Report explores the issue of the NEH's refusal to submit affirmative action goals and timetables to the EEOC along with background on the EEOC and affirmative action in federal agencies. An excellent summary of the differences between goals and quotas is provided along with a history of

Justice Department and NEH refusals to comply with EEOC affirmative action plan regulations. The distribution of female and minority employees at NEH by grade is reviewed as evidence of the need for an affirmative action plan.

2534. U.S. Congress. House. Committee on Post Office and Civil Service. Subcommittee on Compensation and Employee Benefits. *Review of Issues Relating to Pay, Retirement, and Health Benefits (Albany, New York), Hearing.* 99th Cong., 1st sess., 8 July 1985. 68p. Y4.P84/10:99-25. Brief hearing on federal personnel issues includes testimony on the status of women in the federal service and notes the concentration of women in low pay grades with little opportunity for advancement. The wage gap and the call for pay equity are briefly covered.

2535. U.S. Dept. of Justice and U.S. Dept. of the Treasury. *Interagency Committee on Women in Federal Law Enforcement, First Annual Training Conference, July 11, 1984, Conference Proceedings.* Washington, DC: The Dept. of Justice, 1985. 65p. J1.2:W84/2/984. Conference speakers and sessions address issues such as acculturating women into law enforcement careers; balancing work, family and personal lives; stress in the lives of female law enforcement officials; and the realities of women correctional officers in male correctional institutions.

2536. U.S. Dept. of State. Forum of the Association of American Foreign Service Women. Role of the Spouse Committee. *Report on the Role of the Spouse in the Foreign Service: A Study of Attitudes and Perceptions of Spouses Toward Foreign Service Life: A Research Study of Spouses in Five Foreign Affairs Agencies.* Washington, DC?: The Dept.?, 1985. 84p. S1.2:Sp6. Survey results provide insight into the satisfaction of wives with foreign service life. Areas addressed by the survey include morale, community spirit, financial concerns, family expectations, employment, diplomatic representation expectations, and preparation for living abroad. One of the areas closely examined is the representational demands placed on the Foreign Service spouse. Quoted opinions from wives of senior Foreign Service officers and ambassadors highlight the sense that wives should be compensated for the entertainment and "volunteer" activities which are expected of them. Much of the report centers on spouses' feelings toward the level of support provided them and their families when posted outside the States.

2537. U.S. Congress. House. Committee on Foreign Affairs. Subcommittee on International Operations. *Equal Employment Opportunity in the Department of State, Agency for International Development, and the U.S. Information Agency, Hearing.* 99th Cong., 2d sess., 17 Sept. 1986. 130p. Y4.F76/1:Em7. Affirmative action efforts in areas of recruitment and promotion in the Department of State, AID, and USIA are reviewed. The status of women and minorities in the agencies is examined noting changes in representation in recent years and promotion rates within agencies. Witnesses discuss the reasons for the lack of minorities, particularly minority women, in policy making and upper management positions.

2538. U.S. Office of Personnel Management. Office of Training and Development. Executive Programs Division. *Women's Executive Leadership Program; FY87.* Washington, DC: The Division, 1986. [4]p. PM1.19/4:W84. An outline of the Women's Executive Leadership Program, a 12-month management training program for full-time civil service employees in grades GS 9 - 12, describes program objectives and components.

2539. U.S. Army. Belvoir Research Development and Engineering Center. *Equal Opportunity.* Fort Belvoir, VA: The Center, 1987. various paging. D101.6/10:600-2. Booklet describes the Army EEO policy and covers affirmative action and sexual harassment. The primary focus is on civilian employees.

2540. U.S. Congress. House. Committee on Foreign Affairs. Subcommittee on International Operations and Subcommittee on Western Hemisphere Affairs. *Equal Employment Opportunities in the Foreign Affairs Agencies, Hearings.* 100th Cong., 1st sess., 29,30 July 1987. 157p. Y4.F76/1:Em7/2. The representation of women and minorities in the high level ranks of the Foreign Service is the topic of hearing testimony which highlights what many view as backsliding on progress made during the Carter administration. Charges of discrimination by promotion panels, particularly against minorities, are made. The need for flexibility by agencies to address the needs of dual career couples is stressed as necessary to achieve equal opportunity for women in Foreign Service careers.

2541. U.S. Congress. Senate. Committee on Governmental Affairs. Subcommittee on Federal Services, Post Office, and Civil Service. *Postal Employee Appeal Rights, Hearing on S. 541.* 100th Cong., 1st sess., 27 April 1987. 99p. Y4.G74/9:S.hrg.100-135. Hearing examines a bill to allow all nonunionized Postal Service employees to file grievances with the Merit System Protection Board. Under the existing law only veterans had the option of filing an appeal with the MSPB. Witnesses note the negative effect of the rule on female postmasters since they were unlikely to be veterans and could not unionize.

2542. U.S. Customs Service. Special Assistant to the Commissioner. *Equal Employment Opportunity - Managerial Function.* Washington, DC: The Service, 1987. 64p. T17.2:Eq2/3. Good overview of EEO and AA explains the basic concepts of each, defines different types of discrimination with a focus on sexual harassment, and explains the complaint process. Also gives an overview of special emphasis programs such as the Federal Women's Program, and briefly describes the Custom Service EEO program structure.

2543. U.S. Congress. House. Committee on Education and Labor. Subcommittee on Employment Opportunities. *Hearing on H.R. 3330, the Federal Equal Employment Act, Hearing.* 100th Cong., 2d sess., 9 Feb. 1988. 127p. Y4.Ed8/1:100-62. Criticism of federal agency refusals to submit affirmative action plans mark this hearing on EEOC's opposition to goals and timetables. The representation of women and minorities in the civil service is reviewed, and EEOC enforcement performance is discussed. The bill under consideration required agencies to submit affirmative action plans.

2544. U.S. Congress. House. Committee on Government Operations. *Allegations of Race and Sex Discrimination at Chicago O'Hare Air Traffic Control Facility, Sixty-Fifth Report by the Committee on Government Operations Together with Additional Views.* H. Rept. 100-1050, 100th Cong., 2d sess., 4 Oct. 1988. 16p. Report reviews evidence from hearings on charges of race and gender discrimination in the hiring of air traffic controllers at Chicago Air Traffic Control Facility. The blatant discrimination against blacks is the focus of the report although charges of gender discrimination are also supported.

2545. U.S. Congress. House. Committee on the Judiciary. Subcommittee on Civil and Constitutional Rights. *FBI Affirmative Action and Equal Employment Opportunity Efforts, Hearings.* 100th Cong., 2d sess., 31 Mar., 8 June 1988. 544p. Y4.J89/1:100-118. Hearing explores allegations of employment discrimination in the FBI and examines the lack of commitment to affirmative action. The primary focus is on discrimination against Hispanic and black males, although specific cases of sex discrimination are noted.

2546. U.S. Congress. Senate. Committee on the Judiciary. *The Performance of the Reagan Administration in Nominating Women and Minorities to the Federal Bench, Hearing.* 100th Cong., 2d sess., 2 Feb. 1988. 244p. Y4.J89/2:S.hrg.100-1082. Hearing debate centers on the sharp decline in the percentage of women and minority nominees to the federal bench under the Reagan administration. The administration witnesses defend the record on the ground that there aren't enough qualified female and minority lawyers and

stress that more women and minorities were appointed than during the administrations of Ford, Nixon, and Johnson. The bulk of the hearing is criticism of the overwhelming white male nominations and the failure of the Reagan administration to seek out qualified women, blacks and Hispanics.

2547. U.S. Equal Employment Opportunity Commission. *Job Patterns for Minorities and Women in State and Local Government, 1985.* Washington, DC: GPO, 1988. 221p. Y3.Eq2:12-4/985. See Y3.Eq2:2St2/978, *Minorities and Women in State and Local Government* (2499).

2548. U.S. Health Care Financing Administration. Equal Opportunity Office. *Federal Women's Program Handbook.* Baltimore, MD: The Administration, 1988. [5]p. HE22.8:W84. Booklet provides basic information on the goals of the Federal Women's Program and on the role of the FWP manager and supervisor in the Health Care Financing Administration's implementation of the program.

2549. U.S. Internal Revenue Service. *Equal Employment Opportunity Handbook.* Washington, DC: The Service, 1988. 14p. T22.19/2:Eq2/3. Handbook describes the IRS nondiscrimination and affirmative action policies and summarizes special emphasis programs such as the Federal Women's Program.

2550. U.S. Merit Systems Protection Board. *Sexual Harassment in the Federal Government: An Update.* Washington, DC: GPO, 1988. 61p. MS1.2:Se9/2. Results of a 1987 survey and study of sexual harassment in the federal workplace provides comparisons to data gathered in a 1980 study (2494). The focus of the study was on employee attitudes and experiences with sexual harassment, and on the efforts of federal agencies to reduce harassment. Relevant case law between 1980 and 1987 is reviewed.

2551. U.S. Urban Mass Transportation Administration. *Equal Employment Opportunity Program Guidelines for Grant Recipients.* UMTA Circular 4704.1 Washington, DC: GPO, 1988. various paging. TD7.4:4704.1. Guidelines for assessing UMTA grant recipients' compliance with EEO laws describes the coverage of the guidelines, the necessary components of grantee EEO programs, compliance reviews, and enforcement procedures. The discrimination complaint process and investigation process is also detailed.

2552. U.S. Congress. House. Committee on Foreign Affairs. Subcommittee on International Operations and U.S. Congress. House. Committee on Post Office and Civil Service. Subcommittee on the Civil Service. *The Department of State in the 21st Century (Vol. I), Joint Hearing.* 101st Cong., 1st sess., 12 Oct. 1989. 97p. Y4.F76/1:St2/13/v.1. Brief hearing on personnel issues at the Department of State highlights problems of discrimination against minorities, women, and the disabled. The existing system, particularly the areas of assignment and promotion, is examined.

2553. U.S. Congress. House. Committee on Foreign Affairs. Subcommittee on International Operations and U.S. Congress. House. Committee on Post Office and Civil Service. Subcommittee on the Civil Service. *The Department of State in the 21st Century (Vol. II), Joint Hearing.* 101st Cong., 1st sess., 17 Oct. 1989. 161p. Y4.F76/1:St2/13/v.2. Hearing to consider work force issues at the Department of State centers on affirmative action and the operation of equal employment opportunity. Charges that the State Department failed to promote women and minorities and that EEO complaints were virtually ignored by management are explored. The problems encountered by Foreign Service spouses in building a career are also briefly considered.

2554. U.S. Congress. House. Committee on Post Office and Civil Service. Subcommittee on the Civil Service. *Underrepresentation of Women and Minorities in the Foreign Service - State*

Department, Hearing. 101st Cong., 1st sess., 22 Sept. 1989. 50p. Y4.P84/10:101-28. Hearing explores the findings of the GAO report *State Department - Women and Minorities are Underrepresented in the Foreign Service.* The problems with Foreign Service exams in hiring and the discrimination in appointment to positions experienced by minorities and women are explored by State Department and GAO representatives.

2555. U.S. Congress. House. Committee on Standards of Official Conduct. *In the Matter of Representative Jim Bates, Report.* H. Rept. 101-293, 101st Cong., 1st sess., 18 Oct. 1989. 58p. Report details the investigation of sexual harassment charges against Representative Jim Bates.

2556. U.S. Congress. Senate. Committee on Governmental Affairs. *Congressional Civil Rights Bills, Hearing on S. 272 and S. 1165.* 101st Cong., 1st sess., 14 Sept. 1989. 177p. Y4.G74/9:S.hrg.101-516. Bringing Congress under the employment rights laws is the topic of hearing testimony discussing the employment practices of congressional offices and units. The underrepresentation of women and minorities in upper level positions and the possibilities for extending equal employment opportunity laws to the different types of congressional employees is noted. The major point of debate is not the existence of a problem, but rather the methods of enforcing equal opportunity in politically sensitive positions.

2557. U.S. General Accounting Office. *State Department: Minorities and Women are Underrepresented in the Foreign Service.* Washington, DC: The Office, 1989. 57p. GA1.13:NSIAD-89-146. Report details the lack of an effective affirmative action plan for minorities and women in the Foreign Service. Data on representation of minorities and women in the Foreign Service between 1981 and 1987 is reviewed by grade level and type of position. Barriers to the hiring and promotion of women and minorities are described.

2558. U.S. Internal Revenue Service. National EEO Office. *EEO Notebook.* Washington, DC: GPO, 1989. 12p. T22.2/15:7459. Booklet provides an overview of EEO structure and processes for the IRS policy on sexual harassment.

2559. U.S. Congress. House. Committee on Education and Labor. Subcommittee on Employment Opportunities. *Hearing to Review Issues Relating to Equal Employment Opportunities in the California Utilities Industry, Hearing Held in City of Commerce, CA.* 101st Cong., 2d sess., 13 Feb. 1990. 178p. Y4.Ed8/1:101-80. Hearing panel participants describe the position of minorities and women in the utilities industry in California from the 1970s to the present. The failure of Southern Cal Edison to hire minorities and to promote women, and the affirmative action efforts of Los Angeles City Department of Water and Power are reviewed. The primary focus of testimony is the promotion of women and minorities to middle management and upper level management positions and the efforts of utility companies in this area. Some affirmative action statistics are included in statements.

2560. U.S. Congress. House. Committee on Education and Labor. Subcommittee on Employment Opportunities and U.S. Congress. House. Committee on Post Office and Civil Service. Subcommittee on Civil Service. *Joint Oversight Hearing on the Federal Equal Employment Opportunity Complaint Process, Joint Hearing.* 101st Cong., 2d sess., 1 Aug. 1900. 68p. Y4.Ed8/1:101-117. Oversight hearing on the EEO complaint process in federal employment details cases of sex discrimination and sexual harassment and the failure of the process to protect victims in federal agencies.

2561. U.S. Congress. House. Committee on Foreign Affairs. Subcommittee on International Operations. *Employment Practices at Voice of America, Hearing.* 101st Cong., 2d sess., 19 June 1990. 148p. Y4.F76/1:Em7/4. Hearing exploring employment and management issues at the Voice of America focus primarily on discrimination in promotional

opportunities for foreign-born nationals. The issue of female and minority representation at higher grades is also explored with an emphasis on the clustering of female employees at the lower ranks.

2562. U.S. Congress. House. Committee on Foreign Affairs. Subcommittee on International Operations and U.S. Congress. House. Committee on Post Office and Civil Service. Subcommittee on the Civil Service. *The Foreign Service Personnel System at the Department of State, Joint Hearing.* 101st Cong., 2d sess., 2 Oct. 1990. 92p. Y4.F76/1:P43/11. Testimony describes the Foreign Service as an "old boy" network that operates to exclude women and minorities from senior level positions through blatant discrimination.

2563. U.S. Congress. House. Committee on Standards of Official Conduct. *In the Matter of Representative Gus Savage, Report.* H. Rept. 101-397, 101st Cong., 2d sess., 1990. 19p. Details the findings of the committee investigation into the charges by a Peace Corps volunteer in Zaire that Representative Gus Savage made improper sexual advances while on a visit to that country.

2564. U.S. Defense Fuel Supply Center. *Equal Employment Opportunity Handbook.* Washington, DC: GPO, 1990. various paging. D7.6/4:Em7. Handbook describes the EEO process at the DFSC, reviews the Federal Women's Program and the Hispanic Employment Program, and details the policy on sexual harassment.

2565. U.S. Dept. of Agriculture. *Building the Framework for Change: Work Force Diversity and Delivery of Programs.* Washington, DC: The Dept., 1990. 19p. A1.2:F84/2. Glossy booklet highlights the efforts of the USDA divisions in achieving diversity in employment and program participation.

2566. U.S. Dept. of Agriculture. *Framework for Change: Work Force Diversity and Delivery of Programs.* Washington, DC: The Dept., 1990. leaflet. A1.2:F84. Statement sets out USDA policy on equal opportunity and civil rights in department employment and programs.

2567. U.S. Dept. of Defense. *The Department of Defense Human Goals Program.* Washington, DC: The Dept., 1990. [24]p. D1.2:H88. Commemorative booklet celebrates the DoD Human Goals Charter and outlines it's equal opportunity policy. The 1990 Equal Opportunity Policy Statements are reprinted in the booklet and an historical overview of the charter is provided.

2568. U.S. Dept. of the Interior. *Profile of Women at Work in the U.S. Department of the Interior.* Washington, DC: The Dept., 1990. 75p. I1.2:W84/2. Glossy publication provides half-page profiles of women working in traditional and non-traditional occupations in the agencies of the Department of the Interior.

2569. U.S. Internal Revenue Service. *Strength in Diversity: Strategic Initiative ERR-16, Minorities & Women within IRS, a Plan for the Future.* Washington, DC: The Service, 1990? poster. T22.41:St8.

SERIALS

2570. U.S. Alcohol, Drug Abuse and Mental Health Administration. ADAMHA Women's Council. *Report to the Administrator.* Washington, DC: The Administration, 1985 - . annual. HE20.8017:year. Report of the ADAMHA Women's Council reviews the status of women in the agency's work force with particular emphasis on the effect of agency

downsizing on women's employment. Data on the gender composition of employees by grade is provided for the Office of the Administrator, the National Institute of Alcohol Abuse and Alcoholism, the National Institute of Mental Health, and the National Institute on Drug Abuse.

2571. U.S. Bureau of Mines. *Federal Women's Program Newsletter*. Washington, DC?: The Bureau, 1986? - . irreg. I28.170:nos.

2572. U.S. Civil Service Commission. *EEO Spotlight*. Washington, DC: The Commission, Jan/Feb. 1974 - Jan./Feb. 1979. v. 6 - v. 11, no. 2. bimonthly. CS1.76:vol./no. News notes on equal employment opportunity activities in the federal service. Continued by *Spotlight* (2587).

2573. U.S. Civil Service Commission. *Equal Employment Opportunity Statistics*. Washington, DC: GPO, 1976-1977. annual. CS1.48:SM70-(year)B. Continues *Study of Employment of Women in the Federal Government* (2580), continued by *Equal Employment Opportunity Statistics* (2586).

2574. U.S. Civil Service Commission. *Federal Careers for Women*. Washington, DC: GPO, 1961 - 1967. irregular. CS1.48:35/no. Pamphlet designed to recruit women to the federal civil service briefly recites the history of women in the civil service and notes the types of jobs women typically enter. The focus changed between 1961 and 1967 with secretarial positions downplayed by the 1967 edition.

2575. U.S. Civil Service Commission. *Opportunities for Women in the Federal Service*. Washington, DC: GPO, 1948-1952. irregular. CS1.48:35/no. Opportunities for women in federal civil service as librarians, engineers, social workers and stenographers are highlighted. Pamphlet describes the salaries and how appointments are made in each area.

2576. U.S. Civil Service Commission. *Semi-Annual Personnel Statistics Report as of...* Washington, DC: The Commission, 1936 - 1939. semiannual. CS1.33:year/no. Continues *Semi-Annual Statement of Number of Civil Officers and Employees...* (2578), continued by *Semi-Annual Report of Employment, Executive Branch of the Federal Government* (2577).

2577. U.S. Civil Service Commission. *Semi-Annual Report of Employment, Executive Branch of the Federal Government.* Washington, DC: The Commission, 1940 - 1941. semiannual. CS1.33:year/no. Provides data by sex on number of employees by agency and sex for the years 1923 to date. Data is broken down by employment inside and outside of the District of Columbia. Continues *Semi-Annual Personnel Statistics Report as of...* (2576).

2578. U.S. Civil Service Commission. *Semi-Annual Statement of Number of Civil Officers and Employees in Regular, New Emergency or Relief and Works Program Agencies of Federal Government, by Sex, as of...* Washington,DC: The Commission, 1935-1936. semiannual. CS1.33:year/no. Continued by *Semi-Annual Personnel Statistics Report as of...* (2576).

2579. U.S. Civil Service Commission. *Statistics on Number of Employees in Each Branch of the Civil Service by Sex and Whether Employed in D.C. or Outside of the D.C. Area.* Washington, DC: The Commission, December 31, 1933 - December 31, 1934. semiannual. CS1.33:year/no. Details number of civil officers and employees in the executive branch of the federal government by sex, with a summary of such employment since 1918. December 1933 issue titled *Number of Officers and Employees in Each Branch of Federal Executive Civil Service by Sex, with Summary of Federal Employment*

Since 1918. Continued by *Semi-Annual Statement of Number of Civil Officers and Employees...* (2578).

2580. U.S. Civil Service Commission. *Study of Employment of Women in the Federal Government.* Washington, DC: GPO, 1966 - 1975. annual. CS1.48:SM62-no. Reports covering 1966 and 1967 were issued under SuDoc number CS1.2:W84/4/year. Statistical report on the employment of women in the federal civil service provides data by agency, grade, and occupational group. Continued by *Equal Employment Opportunity Statistics* (2573).

2581. U.S. Civil Service Commission. *Women in Action.* Washington, DC: GPO, 1971 - 1978. irregular. CS1.74/2:vol./no. February 1979 through 1981 issues published by the U.S. Office of Personnel Management (2590). Newsletter of the Federal Women's Program provides advice on career counseling, information on legislative action, and profiles of successful programs and people. A "Resources Review" column lists new books, pamphlets, and media on employment of women.

2582. U.S. Dept. of Transportation. Departmental Office of Civil Rights. *Report on Minority Group and Female Employment in Department of Transportation.* Washington, DC: The Office, 1969-197? annual. TD1.2:M66/year. Graphs illustrate statistics on minority and female employment in the Department of Transportation by pay category, organization, and GS grade.

2583. U.S. Equal Employment Opportunity Commission. Office of Program Operations. *Annual Report on the Employment of Minorities, Women and Handicapped Individuals in the Federal Government.* Washington, DC: GPO, 1982/83 - 1983/84. annual. Y3.Eq2:12-5/year. Statistical report analyzes the employment of minorities, women, and the handicapped in the federal government by agency and major occupational group, and by grade level.

2584. U.S. Federal Highway Administration. Office of Civil Rights. *Annual Report on the Status of the Equal Employment Opportunity Program, in Response to Request from Subcommittee on Roads, Committee on Public Works, United States Senate.* Washington, DC: The Administration, 1969 - 1973. 1st. - 5th. annual. TD2.2:Em7/2/year. Summary of EEO efforts of the Federal Highway Administration reviews programs and activities in contract compliance programs and internal employment programs. Supporting data on the race/sex composition of the FHWA work force by grade level is furnished.

2585. U.S. Office of Personnel Management. *Affirmative Action Statistics.* Washington, DC: GPO, 1982 - . biennial. PM1.10/2:Af2; PM1.10/2-3:year. Statistical report presents detailed employment statistics for federal agencies, councils, and boards by pay system with minority and sex breakdowns. Also provides data for federal employees by SMSA and sex/minority status. Continues *Equal Employment Opportunity Statistics* (2586).

2586. U.S. Office of Personnel Management. *Equal Employment Opportunity Statistics.* Washington, DC: GPO, 1978-1980. annual. PM1.10:SM-70-78B; PM1.10/2:Eq2/year. Continued by *Affirmative Action Statistics* (2585).

2587. U.S. Office of Personnel Management. Office of Affirmative Employment Programs. *Spotlight.* Washington, DC: OPM, 1979-1981. v. 11, no. 3 (Mar/Apr 1979) - v. 13, no. 5 (July/Aug. 1981) bimonthly. PM1.18:v/no. Continues *EEO Spotlight* (2572), continued by *Spotlight on Affirmative Employment Programs* (2588).

2588. U.S. Office of Personnel Management. *Spotlight on Affirmative Employment Programs.* Washington, DC: The Office, 1982 -1983. v. 1, no. 1 (July 1982) - v. 1, no. 5 (Feb.

1983). monthly. PM1.15/3:vol./no. Newsletter on affirmative action activities and issues emphasizes federal programs such as the Special Emphasis Programs. Title was formed by the merger of *Women in Action* (2590), *Mesa Redonda*, and *Spotlight* (2587). Continued by *Spotlight on Affirmative Employment Programs* (2589).

2589. U.S. Office of Personnel Management. *Spotlight on Affirmative Employment Programs.* Washington, DC: GPO, v. 1, no. 1 (Fall 1983) - . quarterly. PM1.18/4:vol./no. News items on civil service programs and activities are interspersed with occasional pieces relating to women and EEO/AA. Continues a monthly publications also called *Spotlight on Affirmative Employment Programs* (2588).

2590. U.S. Office of Personnel Management. *Women in Action.* Washington, DC: The Office, Feb. 1979. - July/Aug. 1981. mostly bi-monthly. PM1.20:v/no. See 2581 for abstract. Continued by *Spotlight on Affirmative Employment Programs* (2588).

14

Household Employment

The status of household workers was an ongoing concern of the Women's Bureau from the 1920s through the 1970s. The reports of the 1920s focused mainly on training household workers and include the results of several studies of the employment and characteristics of private household workers in various cities (2592-2593). Unique among the documents cited is a 1934 report on a German program to address unemployment by placing young women in unpaid household service for a year (2594). Plans for training household workers in the U.S. were linked to raising the status of the profession in an effort to alleviate the shortage of workers (2596).

The effect of World War Two on the supply of household workers is explored in *Wartime Shifts of Household Employees into Other Industries* (2604). The inclusion of household workers under labor laws was a continuing concern of the Women's Bureau (2601, 2603, 2608), and in 1953 it published a substantial report on standards of household employment in Sweden (2609). The status of household workers was the focus of four Women's Bureau-sponsored meetings from 1965 to 1969 (2612-2613, 2617-2618). The 1970s saw considerable attention again focused on extending labor laws, particularly minimum wage, to household workers (2620, 2624-2625).

2591. U.S. Women's Bureau. *Domestic Workers and Their Employment Relations: a Study Based on the Records of the Domestic Efficiency Association of Baltimore, Maryland.* by Mary V. Robinson. Bulletin no. 39. Washington, DC: GPO, 1924. 87p. L13.3:39. Discussion of the working patterns of women in domestic service examined the reasons women choose to leave domestic service. The Domestic Efficiency Association functioned as an employment agency for domestic workers and the study examined its records to determine causes of the high turnover rate in domestic service. Data on applicants to the association by age, sex, race, occupation, preference regarding living in or out, length of service, reasons for termination, and wage rates is provided.

2592. U.S. Women's Bureau. *Household Employment in Philadelphia.* by Amy E. Watson. Bulletin no. 93. Washington, DC: GPO, 1932. 88p. L13.3:93. Survey of domestic workers and their employers in the Philadelphia area collected data on the age, race, sex, marital status, and occupations of the workers. Employers reported on hours of work and wages paid to their domestic employees and on their training and experience. Information on hiring, firing, and vacation policies was also solicited. The employees themselves provided information on their schooling, hours, wages, and employment history. Includes case histories and a brief summary of the hazards of household employment.

2593. U.S. Women's Bureau. *Household Employment in Chicago.* by B. Eleanor Johnson. Bulletin no. 106. Washington, DC: GPO, 1933. 62p. L13.3:106. Reports results a study

of domestic workers and their employers in Chicago. Part I describes the employing households and the type of work for which help was hired with data on income, size of family, and number of household employees. Collected data on the characteristics preferred by employers includes race and nativity, domicile status, and personality traits. Part II describes the occupations, race and nativity, age, marital status, and schooling of the household employees. Other areas studied are training, wages, types of housework preferred by workers, and desired personality of employers. Some of the major problems reported by employers and employees are described.

2594. U.S. Office of Education. *German Plans for a Year's Voluntary Household Work for Girls Graduating from Public Schools.* Washington, DC: The Office, 1934. 4p. I16.54/5:1565. Details a plan to teach German girls a work ethic and keep them from unemployment through a year of household "employment" during which the girl did housework for a family and, in return, received room and board. After the year was up the girls would receive a reference from the family which she could then use to secure paid household employment, which the government considered to be the most suitable occupation for women of all classes.

2595. U.S. Women's Bureau. *Standards of Placement Agencies for Household Employees.* by Marie Correll. Bulletin no. 112. Washington, DC: GPO, 1934. 68p. L13.3:112. Survey collected information on standards for employment of women household workers from non-profit placement agencies and solicited their opinion of the "Suggested Minimum Standards for the General Homeworker" proposed by the National Committee on Employer-Employee Relationships in the Home. Standards for placing women household workers cover wages, hours, time off and living conditions for workers over 21 and for those 21 years of age and under. Existing labor legislation affecting household workers is reported.

2596. U.S. Office of Education. Vocational Education Division. *Vocational Training for Household Employment.* Washington, DC: The Office, 1935. 11p. I16.54/5:1613. Brief report promotes part-time training programs for persons going into private household service as a means of alleviating the domestic help shortage and as a way to elevate the status of the occupation. Suggests units of instruction and qualifications for teachers and recommends discussion groups for employers to acquaint them with changes affecting household employment. The application of the National Vocational Education Act of 1917 (Smith-Hughes Act) to such courses is also reviewed.

2597. U.S. Women's Bureau. *Reading List of References on Household Employment.* Bulletin no. 138. Washington, DC: GPO, 1936. 15p. L13.3:138. Unannotated list of books, pamphlets, and periodical articles on household employment covers topics of standards, training, placement, employee's and employer's viewpoints, legislation, and black household workers. Citations cover the period from 1825 to 1935.

2598. U.S. Office of Education. Vocational Division. *Household Employment Problems: A Handbook for Round- Table Discussions among Household Employers.* Misc. Pub. 1971. Washington, DC: The Office, 1937. 58p. I16.54/5:1971. Overview of the shortage of household employees examines the contribution of immigration restrictions and the social status of household workers to the problem. A primary focus of the publication is the training of household workers, which was seen as both a way to provide skilled help and to address the status question. Brief descriptions are provided for national and local programs relating to standards and training of household employees and on sponsoring employer discussion groups. Information on selecting employers, delegation of work, standards for employment, factors influencing the cost of household assistance, and training courses for employees is included. Provides a brief bibliography.

2599. U.S. Works Progress Administration. Division of Women's and Professional Projects. *Household Service Demonstration Projects.* Washington, DC: The Division, 1937. 37p. Y3.W89/2:44/1. Describes the organization of a state project to train unemployed women in domestic service and details the staff levels required and the curriculum.

2600. U.S. Women's Bureau. *Reading List of References on Household Employment.* Bulletin no. 154. Washington, DC: GPO, 1938. 17p. L13.3:154. Revision and update of Bulletin 138 (2597) covers publications from 1927 to 1937.

2601. U.S. Women's Bureau. *Old-Age Insurance for Household Workers.* Washington, DC: The Bureau, 1945? 18p. L13.2:In7. The need for the inclusion of household workers in the old-age insurance provisions of Social Security is highlighted by a close examination of the wage structure for household workers, the practice of wages "in kind," and the lack of overtime pay. Benefit issues discussed include unemployment, work related accidents, and illness. Presents information on household workers as heads of families. The general lack of coverage for household workers under state and federal labor laws is noted.

2602. U.S. Women's Bureau. *Can We Lure Martha Back to the Kitchen? That is the Problem as Plans are Made to Put Household Service on a Sounder Basis.* by Frieda S. Miller. Washington, DC: The Bureau, 1946. 4p. L13.2:K64. Reprint of an article published in the *New York Times Magazine* (Aug. 11, 1946) describes the shortage of household workers and efforts to upgrade the profession in order to entice workers back to household employment.

2603. U.S. Women's Bureau. *Household Employment: A Digest of Current Information.* Washington, DC: The Bureau, 1946. 75p. L13.2:H81/7. Review of the state of domestic service in the U.S. discusses the problems of household workers and employers. Coverage of domestic workers in state workmen's compensation, wage payment, and social security laws are reviewed, and data on trends in the wages of household workers is given for 1899-1939 and for the World War II period. Also briefly covers household employment in Great Britain and Canada, and the suggestions of the ILO Committee on Women's Work. Includes a brief bibliography.

2604. U.S. Women's Bureau. *Wartime Shifts of Household Employees into Other Industries.* Washington, DC: The Bureau, 1946. 3p. L13.2:H81/6. Describes the shift of female domestic service workers into other industries and looks at the wage differentials and hours of work which may have contributed to the shift. Comments of women planning to return to household employment after the war provide insight into the employment expectations of black women in the post-war years.

2605. U.S. Women's Bureau. *Legislation Affecting Household Employees, As of October 1, 1947.* Washington, DC: The Bureau, 1947. 5p. L13.2:H81/8. See 2608 for abstract.

2606. U.S. Women's Bureau. *Old-Age Insurance for Household Workers.* Bulletin no. 220. Washington, DC: The Bureau, 1947. 20p. L13.3:220. Argument for the extension of old age insurance to household workers provides information on pay structures and wage rates of household employees. The problems of unemployment, disabilities, and family responsibilities are reviewed.

2607. U.S. Women's Bureau. *Community Household Employment Programs.* Bulletin no. 221. Washington, DC: GPO, 1948. 70p. L13.3:221. Information gathered in 19 cities sheds light on community efforts to alleviate problems of household workers and their employers. Describes training courses for workers, placement services, and local efforts to set wage and hour standards.

2608. U.S. Women's Bureau. *Legislation Affecting Household Employees (as of November 15, 1950)*. Washington, DC: The Bureau, 1951. 5p. L13.2:Em7/6. Summary information describes state maximum hours, minimum wage, and workmen's compensation laws which cover household employment. More specific information is provided on Wisconsin and New York laws.

2609. U.S. Women's Bureau. *Toward Standards for Household Workers, Experience in Sweden*. Washington, DC: The Bureau, 1953. 72p. L13.2:H81/9. Detailed account of the status of household employment in Sweden is based on extensive studies of the problem since Sweden passed the Domestic Workers Act in 1944. The types of private household workers in Sweden, the supply and demand, and wages paid are reported. Considerable information on the provisions of the Domestic Workers Act of 1944 and its coverage gaps is also given. Includes basic statistics on household workers and their employers in Sweden, and a chronology of events related to household employment.

2610. U.S. Bureau of Old-Age and Survivors Insurance. *Facts for Household Workers, the 1954 Amendments to the Social Security Law*. Washington, DC: GPO, 1955. 4p. leaflet. FS3.25/2:954/5/rev. First issued in 1954.

2611. U.S. Women's Bureau. *Minimum Wage Coverage of Domestic Workers, Present Status*. Washington, DC: The Bureau, 1964. 2p. L13.2:D71/2.

2612. U.S. Women's Bureau. *Private-Household Employment, Summary of Second Consultation, February 8, 1965*. Washington, DC: The Bureau, 1965. 25p. L13.2:H81/13. A second consultation on household employment reviewed the activities of women's organizations and government agencies to improve the employment prospects in household service, primarily through training programs. Details the formation of an ad hoc National Committee on Household Employment and outlines a plan to conduct a survey of private household workers and their employers. Provides a list of consultation participants, a fact sheet on women private household workers, and a news release on the formation of the national committee.

2613. U.S. Women's Bureau. *Summary of the Consultation on Private-Household Workers, June 2, 1964*. Washington, DC: The Bureau, 1965. 8p. L13.2:H81/12. Summary of the proceedings of a consultation on the status of private-household workers notes some of the problems, particularly low wages and low status, connected with the occupation. The activities summarized primarily involve training and placement programs, noting problems in placement and wages of traineeship graduates. Recommendations from the consultation relate to information gathering, reaching possible trainees, establishing and enlarging training programs, and possible Women's Bureau publications and research topics. Includes a list of consultation participants.

2614. U.S. Women's Bureau. *To Improve the Status of Private-Household Work*. Washington, DC: The Bureau, 1965. 3p. L13.2:H81/11. Very brief overview of the results of a Women's Bureau consultation on the status of private household workers focuses on wages and training programs.

2615. U.S. Women's Bureau. *Fact Sheet on Illinois Labor Laws Relating to Private-Household Workers*. Washington, DC: The Bureau, 1967. 3p. L13.2:Il6. Illinois laws relating to wages, hours of work, equal pay, wage payment and collection, unemployment compensation, and workmen's compensation for household workers are summarized.

2616. U.S. Social Security Administration. Office of Research and Statistics. *Social Security Household Worker Statistics, 1964, Household Workers and Their Employers under Old-Age, Survivors, Disability and Health Insurance*. Washington, DC: The Office, 1968.

31p. FS3.2:H81/964. Data on household workers includes sex, race, age, wages, and Social Security insurance status.

2617. U.S. Women's Bureau. *Report of a Consultation on the Status of Household Employment Held at Chicago Circle Campus, University of Illinois, May 20, 1967.* Washington, DC: GPO, 1968. 67p. L13.2:H81/15. Proceedings of a meeting on household employment focuses on the need for household services and the needs of women engaged in household work. Some topics covered include day care for working mothers, training, and housekeeping as a business. One of the panelist is sociologist Dr. Alice S. Rossi.

2618. U.S. Women's Bureau. *Household Employment, Quiet Revolution, Address by Elizabeth Duncan Koontz, Director, Women's Bureau, Department of Labor, before Northern Virginia Conference on Household Employment, Alexandria, VA, April 14, 1969.* Washington, DC: The Bureau, 1969. 8p. L13.12:K83. The problem of upgrading the field of household employment both in terms of wages and respect are the focus of a speech which congratulates the conference attendees on taking the first step in providing trained household help. The availability of fringe benefits and the application of employment standards to household help is discussed. The idea of a workers' cooperative for household help to handle hiring and benefits is promoted.

2619. U.S. Women's Bureau. *If Only I Could Get Some Household Help!* Leaflet no. 50. Washington, DC: GPO, 1969. leaflet. L13.11:51.

2620. U.S. Women's Bureau. *Labor Laws Affecting Private Household Workers.* Washington, DC: The Bureau, 1970. 6p. L13.2:H81/14/970. Summary of state and federal laws related to household workers. Covers topics of wages, hours of work, wage payment and collection, unemployment compensation, workmen's compensation and Social Security. Earlier editions issued in 1967 and 1969.

2621. U.S. Women's Bureau. *Women Private Household Workers Fact Sheet.* Washington, DC: The Bureau, 1971. 6p. L13.2:H81/10/971. Basic statistics are reported on wages, employment patterns, head of family status, race, place of residence, age, marital status, and educational attainment of household workers. Also briefly summarizes labor legislation coverage of household workers and highlights the deficiencies. Earlier editions issued in 1965, 1967, 1968, and 1970.

2622. U.S. Women's Bureau. *Report of Consultation on Business in Household Employment and Follow Up Survey of Participating Firms.* Washington, DC: The Bureau, 1973. 13p. L36.102:H81/2. Consultation and follow up survey report provides a profile of housekeeping businesses and their problems of training, recruitment, and taxes. Also discusses the need to upgrade the image of the profession.

2623. U.S. Employment Standards Administration. *Private Household Workers, Data Pertinent to Evaluation of Feasibility of Extending Minimum Wage and Overtime Coverage under Fair Labor Standards Act, Submitted to Congress 1974.* Washington, DC: The Administration, 1974. 103p. L36.2:H81. Study of the characteristics and employment of domestic workers looked at race, household relationship, age, number of employers, and family income. Hourly wage is examined and implications for the extension of minimum wage and overtime coverage to domestic employees are noted. Information on perquisites and fringe benefits was also collected. Most of the data collected is reported for the U.S, South and non-South.

2624. U.S. Women's Bureau. *Women Private Household Workers: A Statistical and Legislative Profile.* Washington, DC: GPO, 1978. 12p. L36.102:H81/4. Overview of the status of women private household workers in 1977 includes statistics on age, marital status,

educational attainment, wages, work experience, family status, and geographic location. The legislative profile summarizes the status of household workers under Social Security, unemployment insurance, minimum wage and hours laws, and workmen's compensation laws.

2625. U.S. Employment Standards Administration. *Domestic Service Employees.* Washington, DC: GPO, 1979. 191p. L36.2:D71. Report on the characteristics and earnings of domestic service employees examines the impact of extending federal minimum wage coverage to these workers. Separate information is also provided on work force characteristics and wages of babysitters. Briefly covers state minimum wage laws which apply to domestic service employees. Gives statistics on occupational group, race, sex, household status, and age.

2626. U.S. Employment Standards Administration. Wage and Hour Division. *How the Fair Labor Standards Act Applies to Domestic Service Workers.* Washington, DC: GPO, 1979. 5p. leaflet. L36.202:F15/4. Earlier edition issued in 1977.

SERIALS:

2627. U.S. Federal Security Agency. *Good News for Household Workers, Your Earnings Now Can Bring Monthly Social Security Checks Later on for You and Your Family.* Washington, DC: GPO, 1957-1967. Revised irregularly. FS3.35:24/ rev. no.

15

Clerical Workers

The government documents on women as clerical workers primarily fall into the category of wage and hour studies. The 1950s focus on older women in the work force is reflected in documents such as *"Older" Women as Office Workers* (2662). The outlook for women in clerical occupations is described in the Women's Bureau Bulletin *Clerical Occupations for Women Today and Tomorrow* (2666). The impact of automation on office workers, both from a career perspective and an occupation health view, are explored in 1985 and 1986 Women's Bureau publications (2671-2672).

2628.　U.S. Women's Bureau. *Bookkeepers, Stenographers and Office Clerks in Ohio 1914 to 1929.* by Amy G. Maher. Bulletin no. 95. Washington, DC: GPO, 1932. 31p. L13.3:95. Study of records on the gender and wages of clerical workers in Ohio between 1914 and 1929. Documents the growing proportion of women in bookkeeper, stenographer, and office clerk positions. The wide difference between salaries of male and female clerical workers is examined and possible factors are analyzed. Employment figures are given for clerical workers in factories, offices, and stores by sex, and money wage rates by sex and industry between 1914 and 1929 are reported.

2629.　U.S. Women's Bureau. *Women Office Workers in Philadelphia.* by Harriet A. Byrne. Bulletin no. 96. Washington, DC: GPO, 1932. 17p. L13.3:96. Report of an investigation of the employment of women clerical workers in banks, insurance companies, investment houses, public utilities, and publishing firms in Philadelphia in 1930. Presents information on rate of pay by detailed occupation, age, educational attainment, and job tenure. Also provides data on hours of work and on compensation other than wages.

2630.　U.S. Women's Bureau. *The Employment of Women in Offices.* by Ethel Erickson. Bulletin no. 120. Washington, DC: GPO, 1934. 126p. L13.3:120. Detailed study reports data on characteristics of the employment of women in office work in New York, Philadelphia, Atlanta, Chicago, St. Louis, and in the insurance offices in Hartford and Des Moines. Data collected includes salary rate by type of office, occupation, age and education; training and experience; marital status; and hours. Also reports on personnel policies including promotions, bonuses, lunch periods, vacations, paid sick leave, overtime, pensions, and insurance. Finally, the report looks at the extent and effect of mechanization.

2631.　U.S. Women's Bureau. *Women Who Work in Offices: I. Study of Employed Women, II. Study of Women Seeking Employment.* by Harriet A. Byrne. Bulletin no. 132. Washington, DC: GPO, 1935. 27p. L13.3:132. Presents results of two surveys related

to women office workers in 1930 and 1931. The first survey looks at characteristics and wages of women employed in office work and examined age, occupation, education and training, hours, and wages. Wages are analyzed by factors of age, occupation, self-support, education, and training. A survey of women seeking employment conducted in 1931 and 1932 provides information on age, marital status, education and training, type of business, occupation, and duration of unemployment. Data on past wages of job seeking women is analyzed by age, marital status, education and training, experience, and occupation.

2632. U.S. Women's Bureau. *Women Office Workers: Median of Monthly Salary Rates by Age, 34,695 Women, by Experience 22,494 Women.* Washington, DC: The Bureau, 1936. poster. L13.9:Of2/no.6. Reprinted in 1939 under SuDoc number L13.9:Of2/1-2 no.6.

2633. U.S. Women's Bureau. *Women Office Workers: Median of Monthly Salary Rates by City, 27,465 Women.* Washington, DC: The Bureau, 1936. poster. L13.9:Of2/no.4. Reprinted in 1939 under SuDoc number L13.9:Of2/1-2 no.4.

2634. U.S. Women's Bureau. *Women Office Workers: Median of Monthly Salary Rates by Occupation, 40,209 Women.* Washington, DC: The Bureau, 1936. poster. L13.9:Of2/no.3. Reprinted in 1939 under SuDoc number L13.9:Of2/1-2 no.3.

2635. U.S. Women's Bureau. *Women Office Workers: Monthly Salary Rates by Occupation, 40,209 Women.* Washington, DC: The Bureau, 1936. poster. L13.9:Of2/no.2. Reprinted in 1939 under SuDoc number L13.9:Of2/1-2 no.2.

2636. U.S. Women's Bureau. *Women Office Workers: Monthly Salary Rates by Type of Office, 44,326 Women.* Washington, DC: The Bureau, 1936. poster. L13.9:Of2/no.5. Reprinted in 1939 under SuDoc number L13.9:Of2/1-2 no.5.

2637. U.S. Women's Bureau. *Women Office Workers: Most Common Hour Schedule, 5 Cities.* Washington, DC: The Bureau, 1936. poster. L13.9:Of2/no.1. Reprinted in 1939 under SuDoc number L13.9:Of2/1-2 no.1.

2638. U.S. Women's Bureau. *Women Office Workers in Chicago, Median of Monthly Salary Rates, 7,016 Men, 8,909 Women.* Washington, DC: The Bureau, 1936. poster. L13.9:Of2/no.7. Reprinted in 1939 under SuDoc number L13.9:Of2/1-2 no.7.

2639. U.S. Women's Bureau. *Wages of Office Workers 1940.* Washington, DC: GPO, 1941. 31p. L13.2:Of2. Report of a survey of office workers in Philadelphia, Los Angeles, Kansas City, Houston, and Richmond provides data by sex on average monthly salary rates, distribution by monthly salary rate and type of office, average monthly salary rate by occupation, and distribution by monthly salary rate and occupation.

2640. U.S. Women's Bureau. *Office Work in Houston 1940.* Bulletin no. 188-1. Washington, DC: GPO, 1942. 58p. L13.3:188-1. Study of office workers looks at the relationship of education, experience, and earnings by office occupation, and reports on hours of work and personnel policies. Supporting tables include data on earnings by age, sex, occupation, and type of office.

2641. U.S. Women's Bureau. *Office Work in Kansas City 1940.* Bulletin no. 188-3. Washington, DC: GPO, 1942. 74p. L13.3:188-3. See 2640 for abstract.

2642. U.S. Women's Bureau. *Office Work in Los Angeles 1940.* Bulletin no. 188-2. Washington, DC: GPO, 1942. 64p. L13.3:188-2. See 2640 for abstract.

2643. U.S. Women's Bureau. *Office Work in Philadelphia 1940.* Bulletin no. 188-5. Washington, DC: GPO, 1942. 102p. L13.3:188-5. See 2640 for abstract.

2644. U.S. Women's Bureau. *Office Work in Richmond 1940.* Bulletin no. 188-4. Washington, DC: GPO, 1942. 61p. L13.3:188-4. See 2640 for abstract.

2645. U.S. Women's Bureau. *Women Office Workers.* Washington, DC: The Bureau, 1942. 2p. L13.2:Of2/2. Presents two charts, "Average monthly salary rates in selected occupations, five cities - 1940" and "Average monthly salary rates by type of office, five cities - 1940."

2646. U.S. Civil Service Commission. *Typists, Stenographers, and Clerks, Washington Needs You!* Washington, DC: GPO, 1944. [16]p. leaflet. CS1.2:198.

2647. U.S. Women's Bureau. *Women White-Collar Workers, "Re-Tool Your Thinking" for Your Job Tomorrow.* Leaflet A. Washington, DC: GPO, 1945. leaflet. L13.11:A.

2648. U.S. Bureau of Labor Statistics. *Wages of Office Workers in Metalworking Industries, January 1945.* Bulletin no. 886. Washington, DC: GPO, 1946. 7p. L2.3:886. Reports statistics on the number of employees and average hourly earnings of office workers in metalworking industries by occupation and sex, and by region. Also gives information on vacations, sick leave, and insurance provisions.

2649. U.S. Bureau of Labor Statistics. *Salaries of Office Workers in Selected Large Cities.* Bulletin no. 943. Washington, DC: GPO, 1948. 32p. L2.3:943. Summary of a study of office workers' salaries in eleven large cities provides data for each city on average hourly rates by occupation and sex, distribution of office workers in selected occupations by weekly salary and sex, and average weekly salary and average weekly scheduled hours of work in industry groups, by occupation and sex.

2650. U.S. Bureau of Labor Statistics. *Salaries of Office Workers in Large Cities, 1949.* 4 vol. Bulletin no. 960. Washington, DC: GPO, 1949-1950. L2.3:960-(part no.). Report of a study provides data on salaries and weekly scheduled hours of work by sex, occupation and industry division; distribution of workers in selected occupations by sex and weekly salary; and weekly salaries by occupation, sex, and size of establishment. Also describes the average work week for women by industry, and the provision of benefits such as sick leave, vacations, holidays, insurance and pension plans. Part I covers Hartford, Los Angeles, New Orleans, Philadelphia, and St. Louis; Part II covers Atlanta, Boston, Chicago, New York and Seattle; Part III includes the cities of Cleveland, Minneapolis-St.Paul, Portland, OR, and Richmond; and Part IV covers Cincinnati, Dallas, and Washington, DC.

2651. U.S. Bureau of Labor Statistics. *Office Workers: Salaries, Hours of Work, Supplementary Benefits: Atlanta.* Bulletin no. 986. Washington, DC: GPO, 1950. 20p. L2.3:986. Results of a survey of office workers by city provides statistics by sex, occupation, and industry division on weekly salary, weekly scheduled hours, and hourly rate. Also presents data on distribution of workers in selected occupations by weekly salary and sex, weekly hours of women by industry, and scheduled days in a work week for women by industry. Describes the provision of benefits such as paid vacations and holidays, sick leave, nonproduction bonuses, insurance, and pension plans by industry.

2652. U.S. Bureau of Labor Statistics. *Office Workers: Salaries, Hours of Work, Supplementary Benefits: Boston, Mass.* Bulletin no. 992. Washington, DC: GPO, 1950. 23p. L2.3:992. See 2651 for abstract.

2653. U.S. Bureau of Labor Statistics. *Office Workers: Salaries, Hours of Work, Supplementary Benefits: Chicago, Il.* Bulletin no. 995. Washington, DC: GPO, 1950. 24p. L2.3:995. See 2651 for abstract.

2654. U.S. Bureau of Labor Statistics. *Office Workers: Salaries, Hours of Work, Supplementary Benefits: Detroit, Mich.* Bulletin no. 999. Washington, DC: GPO, 1950. 24p. L2.3:999. See 2651 for abstract.

2655. U.S. Bureau of Labor Statistics. *Office Workers: Salaries, Hours of Work, Supplementary Benefits: Indianapolis, Ind.* Bulletin no. 987. Washington, DC: GPO, 1950. 20p. L2.3:987. See 2651 for abstract.

2656. U.S. Bureau of Labor Statistics. *Office Workers: Salaries, Hours of Work, Supplementary Benefits: Los Angeles, CA.* Bulletin no. 1002. Washington, DC: GPO, 1950. 20p. L2.3:1002. See 2651 for abstract.

2657. U.S. Bureau of Labor Statistics. *Office Workers: Salaries, Hours of Work, Supplementary Benefits: Memphis, Tenn.* Bulletin no. 988. Washington, DC: GPO, 1950. 18p. L2.3:988. See 2651 for abstract.

2658. U.S. Bureau of Labor Statistics. *Office Workers: Salaries, Hours of Work, Supplementary Benefits: Milwaukee, Wisc.* Bulletin no. 990. Washington, DC: GPO, 1950. 20p. L2.3:990. See 2651 for abstract.

2659. U.S. Bureau of Labor Statistics. *Office Workers: Salaries, Hours of Work, Supplementary Benefits: New York, N.Y.* Bulletin no. 997. Washington, DC: GPO, 1950. 28p. L2.3:997. See 2651 for abstract.

2660. U.S. Bureau of Labor Statistics. *Office Workers: Salaries, Hours of Work, Supplementary Benefits: Oklahoma City, Okla.* Bulletin no. 989. Washington, DC: GPO, 1950. 18p. L2.3:989. See 2651 for abstract.

2661. U.S. Bureau of Labor Statistics. *Office Workers: Salaries, Hours of Work, Supplementary Benefits: Providence, R.I.* Bulletin no. 1006. Washington, DC: GPO, 1950. 18p. L2.3:1006. See 2651 for abstract.

2662. U.S. Women's Bureau. *"Older" Women as Office Workers.* Bulletin no. 248. Washington, DC: GPO, 1953. 64p. L13.3:248. Part one of this bulletin describes four training programs for mature women to prepare them for office work. Part two looks more generally at older women and office work and includes discussion of age restrictions, the increasing number of older women in the population, the number of older women in the work force, the distribution of women in clerical operations, and part-time work by older women.

2663. U.S. Bureau of Labor Statistics. *Clerical Workers, About 1 Out of Every 4 Employed Women Holds a Clerical Job...* Wall Chart, 1957-58 Series, no. 4. Washington, DC: The Bureau, 1957. poster. L2.70/3:957-58/4.

2664. U.S. Bureau of Labor Statistics. *Comparative Job Performance by Age: Office Workers.* Bulletin no. 1273. Washington, DC: GPO, 1960. 36p. L2.3:1273. Study reports on the output of office workers by sex, age, and type of employer.

2665. U.S. Public Health Service. *Opportunities for Typists and Stenographers in Washington, D.C.* Washington, DC: GPO, 1964. 8p. leaflet. FS2.2:T98/3.

2666. U.S. Women's Bureau. *Clerical Occupations for Women Today and Tomorrow.* Bulletin no. 289. Washington, DC: GPO, 1964. 69p. L13.3:289. Report presents general information on the number of women employed in clerical occupations, their earnings, and the employment outlook. Provides detailed descriptions of duties and educational training for occupations such as secretary, stenographer, typist, receptionist, cashier, and electronic computer operating personnel. Appendix lists related associations, labor unions, and accrediting agencies. Background data on average earnings of women in selected office occupations is furnished.

2667. U.S. Internal Revenue Service. *Opportunities Unlimited, Secretarial Careers in Washington, D.C.* Washington, DC: GPO, 1967. 14p. T22.2:Se2/967. Recruiting brochure promotes opportunities as a Washington secretary, describes all the exciting things to do in Washington, and provides advice on how to budget a secretarial salary. Also published in 1965.

2668. U.S. Social Security Administration. *Clerical Opportunities, Social Security Administration.* Washington, DC: GPO, 1968. 14p. FS3.2:C59.

2669. U.S. Civil Service Commission. *Lost in the Crowd? Typists and Stenographers, Don't Stay in a Crowd, Go Government!* Washington, DC: GPO, 1970. 20p. CS1.48:BRE-26. Recruiting leaflet for secretarial and typist opportunities at for a number of government commissions.

2670. U.S. Internal Revenue Service. *Secretarial Careers.* Washington, DC: GPO, 1970. leaflet. T22.2:Se2/2.

2671. U.S. Women's Bureau. *Women and Office Automation: Issues for the Decade Ahead.* Washington, DC: GPO, 1985. 48p. L36.W84/8. Review of the impact of office automation on women workers examines issues of quality of work, professional opportunity, acceptance of automation and training opportunities, job design, and wages. Also reviews the possible impact of home-based clerical work and the health and safety issues of VDT work, and provides a good bibliography.

2672. U.S. Women's Bureau. *Women, Clerical Work, and Office Automation: Issues for Research.* Washington, DC: GPO, 1986. 64p. L36.102:Au8. Report of a conference co-sponsored by the National Research Council's Panel on Technology and Women's Employment, which set as its goal the identification of needed areas of research related to the impact of automation on clerical workers. Some of the areas discussed are pay equity, retraining, working conditions, and home-based work.

16

Women Entrepreneurs

The situation of women business owners did not appear regularly in government documents until the 1970s. A few earlier documents exist, most notably the reports by the Patent Office and the Women's Bureau on women as patent holders (2673, 2675-2676). The first significant report on the problems of women business owners was the 1975 Civil Rights Commission study of government contractors (2682). Most of the documents which followed discuss the Small Business Administration (SBA) programs for women and the inclusion of women in federal contract set-aside programs. The 1976 Senate hearing, *Women and the Small Business Administration* (2684) was the first document to focus on the use of SBA programs by women. Extensive House hearings in 1977 also considered the problems of women in business and SBA's response to their needs (2687).

The most detailed report on the problems of women as owners of small businesses is found in the 1978 report on the President's Interagency Task Force on Women Business Owners, *The Bottom Line: Unequal Enterprise in America* (2694). Hearings held nearly every year continued to discuss the problems of women business owners and suggest federal policy and programs. Federal transportation construction funds and Women's Business Enterprise programs are also regular topics of debate. The hearings on such set-aside programs were often characterized by a tendency to place programs for minorities and women in competition against each other (2738, 2742).

Access to credit is another recurring theme throughout the documents. Of particular note in this area are the 1977 Treasury Department report, *Credit and Capital Formation* (2693), the 1985 House hearing on removing the business credit exemption from the Equal Credit Opportunity Act (2725), and the House Select Committee on Hunger's 1988 hearing, *Self-Employment for the Poor: The Potential for Micro-Enterprise Credit Programs* (2739).

Several documents provide statistical profiles of women business owners and women-owned businesses. Among them are *Selected Characteristics of Women-Owned Businesses, 1977* (2697); *Women-Owned Businesses*, a detailed Census report issued every five years (2758); and a series of brief statistical profiles of minority women business owners (2746-2747, 2757). The inadequacy of federal data gathering activities on women business owners is examined in a 1990 SBA report to Congress (2755). Some early discussions of women as operators of business concerns are found in the documents on married women's rights described in Volume I.

2673. U.S. Patent Office. Commissioner of Patents. *Women Inventors to Whom Patents Have Been Granted by the United States Government, 1790 to July 1, 1888.* Washington, DC: GPO, 1888. 44p. I23.5:W84/1. List by patent number of patents granted to women gives the inventor's name, title of invention, and date of patent.

2674. U.S. Congress. Senate. Committee on the District of Columbia. *Report to Accompany S. 2280 [To Define Status of Married Women in District of Columbia].* S. Rept. 357, 52d Cong., 1st sess., 1892. 1p. Serial 2912. Report describes the limitations placed on married business women in the District of Columbia under existing laws and recommends passage of a bill to define the status of married women in business for themselves.

2675. U.S. Patent Office. Commissioner of Patents. *Women Inventors to Whom Patents Have Been Granted by the United States Government, July 1, 1888 to October 1, 1892, Appendix no. 1.* Washington, DC: GPO, 1892. 18p. I23.5:W84/2. Supplement updates the original document (2673) through 1892..

2676. U.S. Women's Bureau. *Women's Contributions in the Field of Invention: A Study of the Records of the United States Patent Office.* Bulletin no. 28. Washington, DC: GPO, 1923. 51p. L13.3:28. Information from records of the Patent Office lists devices patented by women, provides data on the number of patents issued to women by category of invention, and notes the percentage of patents issued to women.

2677. U.S. Farm Credit Administration. Cooperative Division. *Case Study of Montgomery Farm Women's Cooperative Market, Inc.* Special Report no. 13. Washington, DC: The Administration, 1938. 47p. FCA1.21:13.

2678. U.S. Office of Education. *Gallant American Women #23, From Tavern to Tearoom, April 9, 1940.* by Jane Ashman. Washington, DC: The Office, 1940. 23p. FS5.15:23. Radio script tells the story of women in food service from the colonial tavern to the modern airline food service. A list of materials consulted is included.

2679. U.S. Office of Education. *Gallant American Women #33, Women in Commerce and Trade, June 17, 1940.* by Jane Ashman. Washington, DC: The Office, 1940. 22p. FS5.15:33. The story of women shop owners in Nantucket begins this radio script on women in commerce and trade. The invention of the typewriter and the training of women to use it is also a focus of this episode.

2680. U.S. Farmer Cooperative Service. *Women and Cooperatives.* by Joseph G. Knapp. Washington, DC: The Service, 1965. 36p. A89.15:50. Reprints two speeches given at the Eleventh Triennial Conference of the Associated Country Women of the World, Dublin, Ireland, Sept. 14-24, 1965. "Education for Cooperation" focuses on the development of the agricultural extension service and the role women have played world wide. The second speech, "Production, purchasing, and marketing," focuses on the benefits of women's cooperatives for women as partners in the farm.

2681. U.S. Congress. House. *Amending the Small Business Act, Conference Report to Accompany S. 1672.* H. Rept. 93-428, 93d Cong., 1st sess., 1973. 6p. Serial 13020-4. Conference committee report resolves differences between House and Senate versions of S. 1672, a bill amending the Small Business Act. The House version included an amendment prohibiting sex discrimination in SBA programs.

2682. U.S. Commission on Civil Rights. *Minorities and Women as Government Contractors.* Washington, DC: GPO, 1975. 189p. CR1.2:C76/7. Study of government contractors found that minority contractors represented only 0.7 percent of all federal procurement and, although data on women contractors was lacking, it appeared that representation of women-owned businesses was even lower. Special programs to encourage minority contractors did not include white females. State and local government procurement followed similar patterns.

2683. U.S. Congress. Senate. Select Committee on Small Business. *The Effects of Government Regulations on Small Business in the Southwestern United States, Hearing.* 94th Cong., 2d sess., 8 Oct. 1976. Oklahoma City. 213p. Y4.Sm1/2:W84/2. Hearing held in Oklahoma City on the problems of small businesses relative to government regulations focuses on the problems of women and minority owned businesses. Women- and minority-owned businesses are profiled, and SBA programs for minority businesses are discussed. The attitudes women must overcome in securing assistance in starting a small business are examined.

2684. U.S. Congress. Senate. Select Committee on Small Business. *Women and the Small Business Administration, Hearing.* 94th Cong., 2d sess., 24 Feb. 1976. 132p. Y4.Sm1/2:W84. Hearing examining SBA programs and their utilization by women discusses a proposal to treat women as a minority for the purpose of special SBA programs. Data on the employment of women by the SBA is presented with discussion of the absence of women at top policy making levels. Data on SBA loans to women in fiscal years 1975 and 1976, and on SBA employees by GS level, is presented.

2685. U.S. Small Business Administration. *The Facts about Women as Users of SBA Services: Fiscal Years 1974, 1975, 1976.* Washington, DC: The Administration, 1976. [7]p. leaflet. SBA1.2:W84/2/974-76.

2686. U.S. Congress. House. Committee on Small Business. Subcommittee on Minority Enterprise and General Oversight. *Women in Business, a Report.* H. Rept. 95-604, 95th Cong., 1st sess., 1977. 27p. Serial 13174-1. Report summarizes information gathered in hearings on the barriers faced by female entrepreneurs and on the need for federal action to address their problems. Basic data is presented on firms owned by women and firms owned by minority women in 1972. Part of the discussion centers on the accuracy of data in the Census report on women-owned businesses (2758). The exposure of high school girls to business is noted. Hearings also explored the unresponsiveness of SBA to minority businesswomen and to the needs of women entrepreneurs in general. The committee recommends action by the Department of Commerce, the SBA, the Civil Rights Commission, and Congress.

2687. U.S. Congress. House. Committee on Small Business. Subcommittee on Minority Enterprise and General Oversight. *Women in Business, Hearings.* 95th Cong., 1st sess., 5 Apr.- 7 June 1977. 111p. Y4.Sm1:W84. Hearing testimony explores SBA's response to the needs of women business owners and to women as potential business owners. The problems of women in business and possible administrative or legislative changes to address those problems are highlighted. Reprints *Facts about Women as Users of SBA Services, Fiscal Years 1974, 1975, 1976* (2685) and provides data on SBA loans to women by program, industry and race. Also discusses the underutilization of women in the SBA work force.

2688. U.S. Congress. Senate. Select Committee on Small Business. *Associate Administrator for Women's Business Enterprise within the Small Business Administration, Report to Accompany S. 1526.* S. Rept. 95-406, 95th Cong., 1st sess., 1977. 4p. Serial 13168-8. Findings of Senate hearings on the problems of women as owners of small businesses and the shortcomings of the SBA in meeting their needs are summarized in this report on a bill to establish the position of Associate Administrator for Women's Business Enterprise within the SBA.

2689. U.S. Congress. Senate. Select Committee on Small Business. *Establish an Associate Administrator at SBA for Women's Business Enterprise, Hearing on S. 1526.* 95th Cong., 1st sess., 16 June 1977. 68p. Y4.Sm1/2:W84/3. Hearing considers a measure to create the position of Associate Administrator for Women's Business Enterprise at SBA to ensure

that the SBA is taking appropriate action to meet the needs of women business owners. All of the testimony indicates a need for better targeting of women by the SBA, but differs on the best means of accomplishing this goal.

2690. U.S. Congress. Joint Economic Committee. *Conference on Measuring Progress and Participation by Minority and Female Contractors in Federal Procurement.* 95th Cong., 2d sess., 1978. Committee print. 89p. Y4.Ec7:M66. Presents a dialogue between representatives of the GSA, the Office of Minority Business Enterprise, the Commission of Civil Rights, the National Association of Minority Contractors, and procurement officials of numerous government agencies on the current efforts to encourage awarding of federal procurement contracts to minority and female owned businesses. Prepared responses of agencies address both the issue of encouraging contract awards to minority- and female-owned firms, and the need to collect EEO data on government contracts given to women-owned business.

2691. U.S. Congress. Senate. Committee on Banking, Housing and Urban Affairs. *Expressing the Sense of the Senate that Further Efforts be Made by Federal Departments and Agencies to Channel Additional Deposits to Minority-Owned Commercial Banks and Savings and Loan Associations, Report to Accompany S. Res. 411.* S. Rept. 95-1261, 95th Cong., 2d sess., 1978. 2p. Serial 13197-12. Expresses the desire of Congress that federal agencies make a greater effort to deposit money in minority-owned banks and savings and loans, including within the definition of "minority-owned" those owned by women.

2692. U.S. Congress. Senate. Select Committee on Small Business. Subcommittee on Economic Development, Marketing, and the Family Farmer. *Small Business and Capital Ownership Development Act of 1978, Hearings.* 95th Cong., 2d sess., 16,20 Mar. 1978, 146p. Y4.Sm1/2:Sm1/19. The shortcomings of the SBA's 8(a) minority business development program are examined by hearing witnesses. Among those testifying are representatives of women-owned businesses who state the case for greater inclusion of women in the federal contract and business development program. The lack of statistics on women business owners and managers is noted.

2693. U.S. Dept. of the Treasury. *Credit and Capital Formation: A Report to the President's Interagency Task Force on Women Business Owners.* Washington, DC: GPO, 1978. 162p. T1.2:C86/4. Study of women seeking credit to open a small business surveyed women business owners and conducted discussion groups and interviews with banking officials. The report highlights the financial needs of women business owners and the barriers to meeting those needs. Also discussed are programs and legislation targeted to women business owners. Includes a brief bibliography on women and credit.

2694. U.S. President's Interagency Task Force on Women Business Owners. *The Bottom Line: Unequal Enterprise in America: Report of the President's Interagency Task Force on Women Business Owners.* Washington, DC: The Task Force, 1978. 221p. Pr39.8:W84/En8. Report on the status of women as entrepreneurs. Presents demographic information on women business owners and the barriers sex discrimination places in the path of women wishing to start a business. The study also looked at the effect sex discrimination in education and training has on female entrepreneurship. The extent to which federal programs are helping women is also examined. Report includes a lengthy bibliography and background statistics on employment status by sex; occupations of women; income of workers by sex and occupation; income of workers by educational attainment; self-employed women by race and age; self-employed women by occupational group and race; and earnings, marital status and educational attainment of self-employed women and men.

2695. U.S. Small Business Administration. *Women & the U.S. Small Business Administration.*
 Washington, DC: The Administration, 1978. 4p. SBA1.2:W84. Describes SBA programs
 and services of potential help to women business owners.

2696. U.S. General Services Administration. Region 10. *Women + Business: A Directory of
 Women-Owned Businesses in Washington, Oregon, Idaho, and Alaska.* Washington, DC:
 GPO, 1979. 63p. GS1.2:W84. Directory of women-owned businesses in GSA Region 10
 is arranged by type of business.

2697. U.S. Bureau of the Census. *Selected Characteristics of Women-Owned Businesses, 1977.*
 Washington, DC: GPO, 1980. 59p. C3.250:77-2. Statistical charts and tables provide a
 profile of women-owned businesses and women business owners. Includes data on age,
 marital status, race and ethnicity, educational attainment, major field of post-secondary
 study, work experience, management participation, and income from the business for
 women business owners by characteristics of the business. Also provides data on the
 business itself including financing, income or loss, full-time employees, and part-time
 employees by industry.

2698. U.S. Congress. House. Committee on Small Business. Subcommittee on General Oversight
 and Minority Enterprise. *Women in Business, Hearing.* 96th Cong., 2d sess., 18 Sept.
 1980. 178p. Y4.Sm1:W84/980. Hearing on federal efforts to assist women-owned
 businesses focuses on the problems of women as small business owners. Federal contract
 compliance, and the need for a separate SBA program for women business-owners is
 stressed. Testimony provides a good overview of the President's Interagency Committee
 on Women's Business Enterprise and of the activities of the Office of Women's Business
 Enterprise. The extent to which women-owned businesses have been able to secure federal
 contracts is reviewed, and statistics on women-owned firms, including number of firms,
 receipts, number of employees, and payroll by industry, is furnished.

2699. U.S. Congress. Senate. Select Committee on Small Business. *Women-in-Business
 Programs in the Federal Government, Hearing.* 96th Cong., 2d sess., 29 May 1980.
 207p. Y4.Sm1/2:W84/4. Discussion of the obstacles and attitudes faced by women
 starting a small business predominate in this hearing examining federal support for women
 entrepreneurs. Problems in arranging financing are noted repeatedly, and the attitude of
 officials that women are naive is a recurring theme. Witnesses support inclusion of women
 as a category in the 8(a) program by amending P.L.95-507, and suggest ways the SBA
 could be more supportive of women entrepreneurs.

2700. U.S. Dept. of Commerce. *The Guide to the U.S. Department of Commerce for Women
 Business Owners.* Washington, DC: GPO, 1980. 42p. C1.8/3:W84/2. Guide to the
 agencies of the Department of Commerce which provide assistance to women business
 owners details the services provided.

2701. U.S. General Services Administration. Region 2. *Directory of Women Business Owners.*
 Washington, DC: GPO, 1980. 26p. GS1.2:W84/2. Directory of businesses owned by
 women is arranged by commodity/service and apparently was designed for federal
 procurement. Provides name and address of company, but no explanatory text on the
 purpose or scope of the directory.

2702. U.S. General Services Administration. Region 6. *Women Owned Business Directory:
 Iowa, Kansas, Missouri, Nebraska.* [Kansas City, MO.]: The Administration, 1980. 37p.
 GS1.2:W84/3. Directory of women-owned companies in Iowa, Kansas, Missouri, and
 Nebraska is arranged by product or service.

2703. U.S. Interagency Committee on Women's Business Enterprise. *Annual Report to the President, Interagency Committee on Women's Enterprise.* Washington, DC: The Committee, 1980. 66p. SBA1.31:980. Report on the first year of the Interagency Committee on Women's Enterprise reviews progress by federal agencies in addressing the problems of women business owners since Executive Order 12138 was issued May 18, 1979.

2704. U.S. Small Business Administration. *A Directory of Federal Government Business Assistance Programs for Women Business Owners.* Washington, DC: GPO, 1980. 71p. C1.8/3:Sm1. Overview of federal programs providing information and assistance to small businesses outlines federal loan and grant programs and federal procurement policies as they relate to women-owned businesses.

2705. U.S. Congress. House. Committee on Small Business. Subcommittee on SBA and SBIC Authority, Minority Enterprise and General Small Business Problems. *Outer Continental Shelf Leasing Policies, Hearing.* 97th Cong., 1st sess., 12 Nov. 1981. 38p. Y4.Sm1:C76/5. Focus of testimony is on non-discrimination regulations in the Outer Continental Shelf leasing program, and witnesses review the need for government regulations to ensure opportunities for minority and women-owned businesses. Affirmative action programs and progress in major petroleum companies, particularly purchase of supplies from minority firms, is highlighted. The need for regulation, and the authority of the Department of the Interior to write regulations to implement section 604 of the 1978 Outer Continental Shelf Amendments, are debated. Some testimony opposes grouping MBE and WBE together under regulations, arguing that such an arrangement is detrimental to MBEs. Witnesses also argue that voluntary cooperation is working, and that regulations would work against minority and women-owned businesses.

2706. U.S. Congress. House. Committee on Government Operations. *Improving the Department of Transportation Programs for Minority, Women, and Disadvantaged Businesses.* H. Rept. 98-585, 98th Cong., 1st sess., 1983. 29p. Serial 13546. Report provides some background on the Surface Transportation Assistance Act of 1982 which designated that 10% of the funds go to small businesses owned or controlled by minorities, women, or other disadvantaged firms. The chances that the Disadvantaged Business Enterprise Program in the DOT would be able to produce the contracts for such businesses are reviewed in the report with a negative conclusion. The legality of such set-asides and the problems within the DBE are discussed, and the state of the Women's Business Enterprise Program is described as appalling.

2707. U.S. Congress. Senate. Committee on Small Business. *Federal Contracting Opportunities for Minority and Women-Owned Businesses: An Examination of the 8(d) Subcontracting Program, Hearings.* 98th Cong., 1st sess., 19,21 Dec. 1983. Tacoma, WA and Pasco, WA. 253p. Y4.Sm1/2:S.hrg.98-570. Hearing focusing on the operation of the 8(d) MBE/WBE program in Washington State explores contract compliance, the establishment of procedures, and charges of reverse discrimination. The ability of small women-owned companies to compete for contracts under the existing system, and the loopholes which allow these companies to be effectively screened out of the process, are reviewed.

2708. U.S. Dept. of Energy. Office of Small and Disadvantaged Business Utilization. *Directory of Women-Owned Businesses in Energy-Related and Other Fields.* by the National Association of Women Federal Contractors. Washington, DC: GPO, 1983. 268p. E.1.49:10108-2. Directory of women-owned businesses provides access by key words, SIC codes, and geographic regions. Information on each firm includes address, type of business, service area, and number of years in business. Companies cover a wide range of business interests.

2709. U.S. Small Business Administration. *For Women: Managing Your Business: A Resource and Information Handbook.* by Linda S. Mitchell, Pennsylvania Small Business Development Centers. Washington, DC: GPO, 1983. 230p. SBA1.2:W84/3. Information on starting and operating a small business is directed at women.

2710. U.S. Small Business Administration. *The Ohio Women Entrepreneurs Directory.* Washington, DC: GPO, 1983. 39p. SBA1.13/4:W84/2. Directory lists women business owners in Ohio.

2711. U.S. Small Business Administration. Office of Management Assistance. *Women's Handbook: How SBA Can Help You Go into Business.* Washington, DC: The Administration, 1983. 17p. SBA1.19:W84/983. Provides some general information on starting a small business and reviews SBA programs to assist women business owners in setting up business and bidding on government contracts. Earlier edition published in 1982.

2712. U.S. Congress. House. Committee on Small Business. *National Commission on Women's Business Ownership, H.R. 3832, Hearing.* 98th Cong., 2d sess., 12 Apr. 1984. 73p. Y4.Sm1:W84/2. The establishment of a National Commission on Women's Business Ownership is the topic of this hearing. Witnesses review the position of women in the field of business and explore the barriers of education and social attitudes to greater achievement. The problems of minority women business owners are specifically addressed. Opponents of the bill point out the number of existing government entities dealing with the issue of women business owners. Provides a list of the top women-owned companies in the United States.

2713. U.S. Congress. House. Committee on Small Business. *Women's Small Business Ownership Act of 1984, Report to Accompany H.R. 3832.* H. Rept. 98-750, part 1, 98th Cong., 2d sess., 1984. 14p. Serial 13591. Reports a bill to establish a National Commission on Women's Business Ownership charged with studying the state of women-owned small business in the United States. The commission authorization would last no more the 26 months and its charge included examining the factors related to the success of small business and collecting and evaluating data on women-owned businesses.

2714. U.S. Congress. Senate. Committee on Small Business. *Women Entrepreneurs: Their Success and Problems, Hearing.* 98th Cong., 2d sess., 30 May 1984. Eugene, OR. 98p. Y4.Sm1/2:S.hrg.98-849. Issues of access to credit, education and training, and exclusion from the old boy network of local men's service and social organizations are highlighted in this hearing which explores the barriers to women's entrepreneurship. The value of SBA workshops on small business and the problem of sex discrimination in credit practices are stressed throughout testimony.

2715. U.S. Dept. of Commerce. Office of the Secretary. *Ask US: U.S. Department of Commerce Programs to Aid Women Business Owners.* Washington, DC: GPO, 1984. leaflet. C3.2:W84/3. Guide lists various programs that can help women business owners by providing services and identifying potential agency clients.

2716. U.S. Dept. of Housing and Urban Development. *Guide for Minority, Women Owned, and Small Businesses Doing Business with HUD.* Washington, DC: GPO, 1984. 22p. HH1.6/3:B96/3. Provides information on procurement opportunities and sources of assistance from HUD for minority, women-owned, and small businesses.

2717. U.S. Small Business Administration. Office of Women's Business Ownership. *Focus on Survival: Leader's Guide.* Washington, DC: The Office, 1984? 73p. SBA1.2:Su7/2/guide. Guide to conducting a workshop on management for women owners

of small businesses notes the need to include successful women entrepreneurs in the program. The bulk of the guide outlines the topics covered in workshop sessions.

2718. U.S. Small Business Administration. Office of Women's Business Ownership. *Focus on Survival: Workbook.* Washington, DC: The Office, 1984. 59p. SBA1.2:Su7/2/work. Participant workbook for a workshop series designed for women business owners. See 2717 for leader's guide.

2719. U.S. Army Electronics Research and Development Command. Office of Small and Disadvantaged Business Utilization. *Disadvantaged and Women Owned Business Directory.* Adelphi, Md: The Office, 1985. 103p. D101.22/8:715-2. Directory lists disadvantaged and women-owned small businesses which produce products or services of possible interest to Army procurement offices.

2720. U.S. Commission on Civil Rights. *Selected Affirmative Action Topics in Employment and Business Set Asides: A Consultation Hearing of the United States Commission on Civil Rights, March 6-7, 1985, Volume 1.* Washington, DC: GPO, 1985. 330p. CR1.2:Af2/8/v.1. This volume presents the papers submitted to the commission as part of a consultation on the form affirmative action should take. Primary focus is on set-asides and the question of whether underrepresentation/underutilization is an indicator of discrimination. Includes statistics on employees of Michigan Bell Telephone Company by sex and clerical and craft occupations, 1970-83; women operated firms by industry; and percentage of government contracts to women-owned businesses.

2721. U.S. Congress. House. Committee on Small Business. Subcommittee on SBA and SBIC Authority, Minority Enterprise and General Small Business Problems. *Review of the 10-Percent Set-Aside Program (Section 105(f)) of the Surface Transportation Assistance Act of 1982 (April 17, 1985 - Alaska, Florida, Louisiana, Oklahoma) June 5, 1985 - Department of Transportation), Hearings.* 99th Cong., 1st sess., 17 April, 5 June 1985. 462p. Y4.Sm1:T68/2. Representatives of the Departments of Transportation of Alaska, Florida, Louisiana, and Oklahoma review their implementation of the federal highway DBE and WBE set aside programs. Information on certification and data on contracts awarded to DBEs and WBEs is presented. Officials of federal DOT agencies review state 105(f) requirements and barriers to DBE participation on federal highway contracts.

2722. U.S. Congress. House. Committee on Small Business. Subcommittee on SBA and SBIC Authority, Minority Enterprise and General Small Business Problems. *Review of the 10-Percent Set-Aside Program (Section 105(f)) of the Surface Transportation Assistance Act of 1982 (October 22, 1985 - Idaho, North Carolina, Pennsylvania, Wisconsin) Hearing.* 99th Cong., 1st sess., 22 Oct. 1985. 232p. Y4.Sm1:T68/3. Hearing looks at practices and problems in the implementation of the Section 105(f) programs in Idaho, North Carolina, Pennsylvania, and Wisconsin. Specifically, state DOT representatives discuss certification of DBEs and WBEs and efforts to encourage the participation of minority and women contractors in federal highway projects. Detailed statistics on DBE and WBE participation in Pennsylvania road construction projects are provided.

2723. U.S. Congress. Senate. Committee on Environment and Public Works. Subcommittee on Transportation. *The Disadvantaged Business Enterprise Program of the Federal-Aid Highway Act, Hearing.* 99th Cong., 1st sess., 19 Nov, 1985. 462p. Y4.P96/10:S.hrg.99-389. Examination of the operation of the Federal-Aid Highway Program for Disadvantaged Business Enterprises and Women's Business Enterprises provides testimony both for and against the program. Supporters point to the success of the program in improving DBE and WBE participation in government contracts, although representatives of women and minority construction contractors point to deficiencies in the operation of the program. Opponents argue that DBE and WBE provisions result in contract awards

to companies unable to complete the work. Submissions for the record include a study by
Castle Construction Corporation which provides evidence of discrimination against WBEs
in contracting. The need to include women as a significant part of the DBE legislation is
stressed.

2724. U.S. Women's Bureau. *From Homemaking to Entrepreneurship: A Readiness Training
Program.* Washington, DC: GPO, 1985. 60p. L36.102:H75/2. Guide provides assistance
in setting up training programs in entrepreneurship for displaced homemakers.

2725. U.S. Congress. House. Committee on Banking, Finance and Urban Affairs. Subcommittee
on Consumer Affairs and Coinage. *To Amend the Equal Credit Opportunity Act, Hearing
on H.R. 1575.* 99th Cong., 2d sess., 12 Aug. 1986. 222p. Y4.B22/1:99-91. Hearing
considers legislation to force the Federal Reserve Board to reexamine the exemption of
business credit from the provisions of the Equal Credit Opportunity Act. Testimony is
dominated by the views of the banking industry which considers the exception necessary
due to the nature of business credit transactions.

2726. U.S. Congress. House. Committee on Energy and Commerce. Subcommittee on
Telecommunications, Consumer Protection, and Finance. *Minority-Owned Broadcast
Stations, Hearing.* 99th Cong., 2d sess., 2 Oct. 1986. 165p. Y4.En2/3:99-173. Hearing
debates FCC broadcast license policies and preference schemes for minority and women-
owned stations and examines their constitutionality. The *Steele v. FCC* case, which
concerned the FCC's limited preference for integrated ownership-management by women
applicants, is the focus of much of the debate. Witnesses also discuss discrimination
against minority-owned stations by advertisers and supports legislation to amend the
Internal Revenue Code so as to deny advertising deductions to companies that discriminate
against minorities in advertising.

2727. U.S. Congress. House. Committee on Government Operations. Subcommittee on
Government Activities and Transportation. *Implementation of the Disadvantaged Business
Enterprise Program in Federally Funded Transit Projects in New York City, Hearing.* 99th
Cong., 2d sess., 10 Oct. 1986. 437p. Y4.G74/7:B96/4. Charges that the New York City
Transit Authority and the New York Metropolitan Transit Authority failed to comply with
the DOT's DBE and WBE programs are examined. Certification of MBE and WBE
contractors and the compliance review process are examined. Among the charges are
allegations that the Transit Authority conspired with prime contractors to withhold
payments and otherwise discriminate against minority and women-owned firms. Two
complaints filed by women-owned firms charging the Transit Authority with failure to
enforce payment requirements to subcontractors are examined in detail.

2728. U.S. Dept. of Commerce. *U.S. Department of Commerce Programs to Aid Women
Business Owners.* by Judy Maruca Edner, et al. Washington, DC: The Dept., 1986. 41p.
C1.2:W84/986. Booklet describes the various Commerce Department agencies, lists
supplies and services they purchase, and describes assistance programs under their
oversight which could assist women business owners. A brief section on selling to the
government and a directory of regional agency offices is provided.

2729. U.S. Dept. of Commerce. *Women and Business Ownership: An Annotated Bibliography.*
corrected print. Washington, DC: GPO, 1986. 174p. C1.54:W84/corr. Detailed review
of the literature on women's business ownership examines barriers to entrepreneurship for
women, legal status of women business owners, government assistance programs, and
research needs. Accompanying annotated bibliography lists books, articles, government
documents, and unpublished papers and manuscripts. Background statistics relating to
women's business ownership are furnished.

2730. U.S. Small Business Administration. *Directory of Women Business Owners in Federal Acquisition.* Washington, DC: The Administration, 1986. 59p. SBA 1.13/4:W84. Directory of women business owners involved in federal procurement was compiled from the MEGAMARKETPLACE I conference which brought women business owners together with federal procurement officers.

2731. U.S. Small Business Administration. *Women's Business Ownership.* Washington, DC: The Administration, 1986. 6p. + folder. SBA1.2:W84/5. Information folder describes the purpose of the SBA and the role of the Office of Women's Business Ownership. Basic statistics on women-owned business and Federal Prime Contract Awards is provided as is a list of SBA services.

2732. U.S. Congress. Senate. Committee on Commerce, Science and Transportation. Subcommittee on Communication. *Broadcasting Improvements Act of 1987, Hearing on S. 1277.* 100th Cong., 1st sess., 17,20 July 1987. 169p. Y4.C73/7:S.hrg.100-314. Hearing on regulation of the granting of broadcast licenses examines the need for standards of programming in the public interest and for special emphasis programs to encourage station ownership by minorities and women.

2733. U.S. Interagency Committee on Women's Business Enterprise. *Women Business Owners: Selling to the Federal Government.* Washington, DC: GPO, 1987. 66p. SBA1.2:W84/4. Guide for women business owners marketing goods and services to the federal government.

2734. U.S. Congress. House. Committee on Small Business. *New Economic Realities: The Rise of Women Entrepreneurs.* H. Rept. 100-736, 100th Cong., 2d sess, 1988. 77p. Serial 13897. The growth of women in the work force and the struggles of women to succeed as owners of small businesses are explored in this report which focuses on the failure of the federal government to support women-owned business. Testimony of women business owners summarized here highlights the problems of access to credit and participation in federal procurement activities. Statistics showing the number of women in the work force and their earnings through the 1970s and 1980s are provided.

2735. U.S. Congress. House. Committee on Small Business. *New Economic Realities: The Role of Women Entrepreneurs, Hearings.* 100th Cong., 2d sess., 26 Apr. - 19 May 1988. 788p. Y4.Sm1:100-53. The barriers faced by women as they try to start businesses and to get government contracts are explored at a series of hearings on women entrepreneurs. Witnesses detail the problems of women-owned businesses in getting certified for 8(a) programs and highlight difficulties encountered in the transition from reliance on government contracts to private sector clients. A Michigan program to help women get access to capital is described in detail. Discrimination faced by women seeking business loans is described by numerous women business owners. Other materials provide background on the status of women owned business.

2736. U.S. Congress. House. Committee on Small Business. *Selected Documents Pertaining to the Women's Business Ownership Act of 1988 (Public Law 100-533).* 100th Cong., 2d sess., 1988. Committee print. 87p. Y4.Sm1:W84/3. Provides analysis of provisions and discussion of major issues in the Women's Business Ownership Act of 1988.

2737. U.S. Congress. House. Committee on Small Business. *Women's Business Ownership Act of 1988, Report to Accompany H.R.5050.* H. Rept. 100-955, 100th Cong., 2d sess., 1988. 56p. Serial 13902. Reports a bill to promote women's equality of business opportunity through access to credit, participation in federal procurement opportunities, and the development of management and technical skills. The bill also would establish a National Women's Business Council, and would direct federal data collection agencies to improve

data gathering and reporting on women-owned businesses. The report reviews the problems of women entrepreneurs in support of the focus programs proposed.

2738. U.S. Congress. House. Committee on Small Business. Subcommittee on Procurement, Innovation, and Minority Enterprise Development. *Disadvantaged Business Set-Asides in Transportation Construction Projects, Hearing.* 100th Cong., 2d sess., 4 May, 8 Aug. 1988. 453p. Y4.Sm1:100-65. Competition between women-owned and minority-owned businesses under the 10 percent set aside in section 106c of the Surface Transportation Uniform Relocation Assistance Act of 1987 is considered by hearing witnesses. The importance of the set-aside to securing participation of women and minority contractors in federal construction projects is described while the problems caused by a combined 10 percent goal are stressed. The desirability of separate goals for MBE and WBE are discussed with disagreement over an acceptable goal for WBE participation. The experience under the DBE program, particularly the speed with which state's moved to include women in the transportation contracting goals, is examined. The operation of the DBE program in Illinois, specifically the Dan Ryan Freeway project, is examined. Testimony and submitted materials describe the experience of women-owned construction companies under WBE/MBE programs and the combined DBE goals.

2739. U.S. Congress. House. Select Committee on Hunger. *Self-Employment for the Poor: The Potential of Micro-Enterprise Credit Programs, Hearing.* 100th Cong., 2d sess., 20 April 1988. 145p. Y4.H89:100-25. Hearing explores possible models for innovative funding programs for small business start-up. Many of the beneficiaries highlighted in testimony are women who might otherwise be on public assistance if not for access to small amounts of credit to start their own small enterprise. Federal support for micro-enterprise credit programs is explored along with opinions on the reasons for high failure rates among such enterprises.

2740. U.S. Urban Mass Transportation Administration. *Disadvantaged Business Enterprise Requirements for Recipients and Transit Vehicle Manufacturers.* UMTA Circular 4716.1A. Washington, DC: GPO, 1988. various paging. TD7.4:4716.1A. Transmittal provides procedural guidelines for the Disadvantaged Business Enterprise Program in the Department of Transportation. The requirements for contractors and the definition of "socially and economically disadvantaged individuals" for eligibility are set out in detail. Included in guidelines are recommended program elements with information goals, certification, and recipient-subrecipient relations. Compliance and enforcement are also covered.

2741. U.S. Congress. House. Committee on Small Business. Subcommittee on Procurement, Tourism, and Rural Development. *H.R. 2351, the Women's Business Equity Act, Hearing on H.R. 2351.* 101st Cong., 1st sess., 3 Oct. 1989. 131p. Y4.Sm1:101-30. The need for strong federal support for women's business ownership is discussed in hearings on a bill to establish a permanent Office of Women Business Ownership and to simplify the certification process for the Women Business Enterprise program. While witnesses support the ideas behind the bill's provisions, they note problems with the bill itself for both the SBA and for women business owners. Mush of the testimony focuses on the concerns of women owners of construction companies.

2742. U.S. Congress. House. Committee on Small Business. Subcommittee on SBA, the General Economy, and Minority Enterprise Development. *Minority Construction Contracting, Hearing.* 101st Cong., 1st sess., 8 Dec. 1989. Chicago, IL. 120p. Y4.Sm1:101-43. Hearing explores the effect of the 1987 addition of women business enterprise to the 10 percent minority set aside for federal road construction projects. Witnesses present evidence that more than half of DBE subcontracting is going to women contractors and

express the view that WBE should be separate from MBE set asides under the 8(a) program.

2743. U.S. Congress. Senate. Committee on Commerce, Science, and Transportation. Subcommittee on Communications. *Minority Ownership of Broadcast Stations, Hearing.* 101st Cong., 1st sess., 15 Sept., 1989. 188p. Y4.C73/7:S.hrg.101-339. The effect of the 1989 U.S. Court of Appeals for the District of Columbia's decision on FCC minority and female preferences is discussed in hearing testimony. Most witnesses focus on the need to foster diversity through minority ownership of broadcast stations and the operation of the distress sale and tax certificate program aimed at promoting such ownership. Although the focus is on minorities, female ownership of stations is also discussed.

2744. U.S. Small Business Administration. *The Office of Women's Business Ownership.* Washington, DC: The Administration, 1989? 1p. SBA1.2:W84/6. Describes the responsibilities of the Office of Women's Business Ownership.

2745. U.S. Small Business Administration. *Resources for Women Business Owners.* Washington, DC: The Administration, 1989? 1p. SBA1.2:W84/7. List briefly describes the programs and positions available to assist women business owners.

2746. U.S. Women's Bureau. *Asian American Women Business Owners.* Facts on Working Women no. 89-8. Washington, DC: GPO, 1989. 2p. L36.114/3:89-8. Brief statistical report profiles Asian American women business owners with a focus on business characteristics and personal characteristics.

2747. U.S. Women's Bureau. *Black Women Business Owners.* Facts on Working Women no. 89-7. Washington, DC: GPO, 1989. 4p. L36.114/3:89-7. Profile of black women business owners describes characteristics of the women and their businesses.

2748. U.S. Congress. House. Committee on Small Business. *Small Business Administration's Budget for Fiscal Year 1991, Hearing.* 101st Cong., 2d sess., 20 Mar. 1990. 117p. Y4.Sm1:101-48. Examination of SBA funding for fiscal year 1991 discusses budgets for the National Women's Business Council and other programs under the Women's Business Ownership Act of 1988.

2749. U.S. Congress. House. Committee on Small Business. Subcommittee on Exports, Tax Policy, and Special Problems. *Women-Owned Businesses: Special Problems and Access to Credit, Hearing.* 101st Cong., 2d sess., 12 Mar. 1990. Goldsboro, N.C. 157p. Y4.Sm1:101-49. The problems faced by potential women business owners in securing business loans are explored in hearings. Many witnesses identify the types of businesses started by women as a major factor, both because they are often service industries with little collateral and because they have lower profit potential. Options for encouraging investors to put money into women's business enterprise are explored.

2750. U.S. Congress. Senate. Committee on Governmental Affairs. *To Amend the Civil Rights Act of 1964: Permitting Minority Set-Asides, Hearing on S. 1235.* 101st Cong., 2d sess., 16 May 1990. 134p. Y4.G74/9:S.hrg.101-933. The issue of minority contractor set-asides is considered in a hearing on legislation to reverse the effect of the *City of Richmond v. J.A. Croson Co.* decision on such programs. Most testimony focuses on the need for set-asides to give racial minorities a fair chance at government contracts, but the need for set-asides to address discrimination against women-owned businesses is also noted.

2751. U.S. Congress. Senate. Committee on Small Business. *The Administration's Budget Proposal for the SBA for Fiscal Year 1991, Hearing, Part 1.* 101st Cong., 2d sess., 8 Mar. 1990. 121p. Y4.Sm1/2:S.hrg.101-635/pt.1. Hearing on the proposed budget for the

SBA includes discussion of program funding for the Office of Women's Business Ownership, Women's Business Ownership Act programs, and the National Women's Business Council.

2752. U.S. Congress. Senate. Committee on Small Business. Subcommittee on Urban and Minority-Owned Business Development. *City of Richmond v. J.A. Croson: Impact and Response, Hearing.* 101st Cong., 2d sess., 1 Aug. 1990. 300p. Y4.Sm1/2:S.hrg.101-1280. Hearing provides an in-depth analysis of the Supreme Court's decision in *City of Richmond v. J.A. Croson Company* and its implications for minority and women contractor set aside programs. Past discrimination and contracting opportunities are discussed with the focus on minority contractors, but with some notice of women-owned business. The results of studies of racial and gender discrimination in business ownership and contracting in Atlanta and Louisiana are presented.

2753. U.S. Dept. of Defense. Office of the Secretary of Defense. *Small Business Specialists to Assist Small Business, Small Disadvantaged Business, Women-Owned Small Business, and Labor Surplus Area Business Firms.* Washington, DC: GPO, 1990. 77p. D1.2:Sm1/3/990. Brief description of Defense Department programs to assist small business participation in DoD contracting precedes a listing of DoD small business specialists.

2754. U.S. Small Business Administration. *Industry-Small Business Profile, Child Day-Care Services.* Washington, DC: The Administration, 1990? 29p. SBA1.2:P94/8. Information for potential day care operators covers the market for day care services, government-sponsored programs, regulation, liability, and start-up considerations. The various models of child day care and the advantages and drawbacks of each as a small business concern are reviewed. A list of references on child care and a resource list of state regulatory agencies and national associations are provided.

2755. U.S. Small Business Administration. Office of the Chief Counsel for Advocacy. *A Status Report to Congress: Statistical Information on Women in Business.* Washington, DC: The Administration, 1990. 34p. SBA1.2:W84/8. Report examining the current and future collection of data on women-owned businesses presents data from the Census Bureau's Survey of Women-Owned Business and the Federal Reserve System's National Survey of Small Business Finance. The shortcomings of these reports for assessing the status of women in business are described. Options for addressing the statistics gathering requirements of the Women's Business Ownership Act of 1988 and the Small Business Administration Reauthorization and Amendment Act are set forth.

2756. U.S. Small Business Administration. Office of Women's Business Ownership. *Women Business Owners: Selling to the Federal Government.* Washington, DC: GPO, 1990. 52p. SBA1.2:W84/4/990. Booklet for women business owners interested in government contracts briefly reviews SBA support for women business owners. Most of the publication is devoted to describing the basics of doing business with federal agencies.

2757. U.S. Women's Bureau. *American Indian/Alaska Native Women Business Owners.* Facts on Working Women no. 89-9. Washington, DC: GPO, 1990. 2p. L36.114/3:89-9. Statistical profile of American Indian and Alaska Native women-owned businesses summarizes company characteristics and opportunities for women business owners under the Women's Business Ownership Act of 1988.

SERIALS

2758. U.S. Bureau of the Census. *Women-Owned Businesses.* Washington, DC: GPO, 1972 - . issued every five years. C3.250:year-no. Data from the census of women-owned businesses includes number of firms, sales and receipts, employees, and annual payroll by industry, major industry group, and state, SMSA, county, and places with 250 or more women-owned businesses; by industry and legal form of organization; by industry and receipts; and by industry and employment size.

2759. U.S. Dept. of Commerce. *Directory of Women Business Owners.* Washington, DC: The Department, 1987 - . annual. C1.37/3:year. Directory of women business owners for the use of federal purchasing agents. Also identifies federal procurement opportunities for women business owners seeking to do business with the federal government.

2760. U.S. Dept. of Commerce. *Membership Roster, The National Association of Women Business Owners.* by the National Association of Women Business Owners. Washington, DC: The Dept., 1985/86 - . annual. C1.85:year or C1.2:M51/year. Directory of the National Association of Women Business Owners lists chapter members and gives name, business name, address, and telephone number of each person.

2761. U.S. Dept. of Commerce. Mega Market Place East. *Directory of Women Business Owners: Megamarketplace East/West.* Washington, DC: GPO, 1987 - . annual. C1.37/2:year. Directory of women-owned businesses includes an index by product/service and lists prime contractors as possible purchasers of the products and services of WBE's. Federal agencies and the products and services they routinely contract for are also listed. Business entries indicate whether the firm is 8(a) certified as well as its type of business.

2762. U.S. Small Business Administration. Women's Business Enterprise Division. *Women along Business Lines.* Washington, DC: The Administration, 1980? - 1981. quarterly. SBA1.41/2:year/no. Newsletter highlights government action, conferences, and publications on women business owners.

17

Careers and Career Guidance

Two distinctly different types of documents characterize government documents on career guidance. The most common documents through the 1960s were the Women's Bureau publications highlighting career opportunities in various fields. While most of these documents are listed in this chapter, those focusing on health care fields or clerical employment are listed in their respective chapters.

Other documents directly addressed the question of the direction of vocational guidance for girls and women. The earliest of these is the 1916 plan for a Women and Girls Division of the United States Employment Service (2763). Between 1920 and 1950 few documents dealt directly with the topic of vocational guidance. The most notable trend in the 1950s was the focus on older women workers. That trend is reflected in the documents on the Earnings Opportunity Forums for Mature Women, a series of locally sponsored opportunities for older women to learn about employment opportunities (2808, 2813, 2816, 2822).

The 1960s brought a new intensity to the question of how to counsel girls. The changing focus of vocational counseling for girls and women is expressed in reports on the World of Work Conference on Career and Job Opportunities (2830), a summary of a Women's Bureau-sponsored consultation with school guidance officials (2834), and excerpts from the reports of the President's Commission on the Status of Women (2836), just to cite a few. Many of these documents stress the changing employment patterns of women and the need to incorporate the information into career counseling. Those considerations are expressed particularly well in the 1967 Manpower Administration report, *Counseling Girls and Women: Awareness, Analysis, Action* (2845).

While the 1960's documents focused on helping girls plan for work and marriage, the documents in the 1970s began to discuss ways to channel girls into nontraditional careers. There also was discussion of gender-bias in career counseling with a particular focus on career interest inventories (2868, 2871) and the requirements of Title IX of the Education Amendments of 1972 (2874-2876). Encouraging girls to enter nontraditional occupations carries through as a theme from the late 1970s to the 1980s. Some documents on nontraditional careers include a 1978 guide for community conferences (2879), hearings on National Science Foundation women in science programs (2884), and a Women's Bureau training program, *Women in Nontraditional Careers (WINC)* (2893-2895). The conservative backlash of the 1980s is also seen in the documents, most notably in the 1983 Senate hearing, *Women's Career Choice Equity Legislation* (2891), which presents objections to federal support of career education that encouraged negative attitudes toward full-time homemaking. The changing vocational expectations of women are also evident in the documents in Chapter 18, which covers vocational education and job training programs.

2763. U.S. Employment Service. Information Division. *United States Employment Service, Women and Girls' Division, Plan.* Washington, DC: The Service, 1916. 4p. L3.6/2:W84. General objectives and instructions for the establishment of a women and girls division of the United States Employment Service includes how to go about placing women over sixteen and vocational guidance for girls approaching sixteen.

2764. U.S. Office of Education. *Service Jobs Which Home Economics Trained Students Should Be Able to Turn to Account for Pay.* Washington, DC: The Office, 1934. 3p. I16.54/5:1614. Lists jobs, generally of a small scale, personal service nature, which students with home economics training could undertake.

2765. U.S. Office of Education. Vocational Division. *Bibliography of References on Vocational Guidance for Girls and Women.* Misc. Publication no. 1595. Washington, DC: The Office, 1936. 14p. I16.54/5:1595. Bibliography on vocational guidance for girls and women includes magazine articles, books, and publications of women's organizations, government agencies, trade and professional organizations, and local school boards.

2766. U.S. Office of Education. *Opportunities for Service Jobs That May be Open to Home Economics Training Students.* Misc. Publication No. 1614, revised. Washington, DC: The Office, 1937. 10p. I16.54/5:1614/2. Revision of Office of Education Miscellaneous Publication 1614 (2764).

2767. U.S. Office of Education. Vocational Division. *Selected References on Occupations for Girls and Women, Excerpt from References and Related Information on Vocational Guidance for Girls and Women.* Washington, DC: The Office, 1940. 56p. FS5.11:2518. Annotated bibliography with a subject index provides 221 references to books, journal articles, pamphlets, and government documents on occupations for women.

2768. U.S. Veterans Administration. *Which Is the Best Work for You? A Map of Vocational Opportunities for Women.* by John M. Brewer. Washington, DC: The Administration, 194? 2p. VA1.2:V85. Two sided wall chart lists occupations open to men on one side and to women on the other, and provides data on the approximate number of women and men employed in major occupational fields as of the 1940 Census.

2769. U.S. Dept. of Labor. Labor Standards Division. *Apprenticable Trades for Women.* Washington, DC: The Division, 1941. 1p. L16.2:Ap6/11.

2770. U.S. Office of Education. Vocational Division. *Vocational Guidance for Girls and Women: References and Related Information.* by Marguerite W. Zapoleon and Louise Moore. Bulletin no. 214. Washington, DC: GPO, 1941. 162p. FS5.123:214. Bibliography of 1193 books, periodical articles, and pamphlets includes career and job seeking information for older women as well as young women. In addition to the usual career information, biographies of successful women are also listed. Publications date from 1935 to 1940, and entries are annotated and indexed.

2771. U.S. Office of Education. *Occupations for Girls and Women in Wartime, Selected References.* Misc. Publication no. 3618. Washington, DC: The Office, 1943. 19p. FS5.11:3618.

2772. U.S. Women's Bureau. *Women in Aviation.* Washington, DC: The Bureau, 1946. 10p. L13.2:Av5. Information on opportunities for women in aviation. Discourages women from pursuing careers as pilots except in the capacity of small plane sales persons. Describes opportunities as stewardesses, ticket agents, and secretaries, and provides brief biographical sketches of women with aviation careers.

2773. U.S. Women's Bureau. *Typical Women's Jobs in the Telephone Industry.* Bulletin no. 207-A. Washington, DC: GPO, 1947. 52p. L13.3:207-A. Describes jobs in the telephone industry, as operators and clerical workers, and notes the career path to each position.

2774. U.S. Women's Bureau. *Women in Radio.* Washington, DC: The Bureau, 1947. 38p. L13.2:R11. Describes the types of jobs held by women in radio from commentator to manager to advertising time buyer. Single paragraph to full page biographical sketches highlight women with successful radio careers.

2775. U.S. Women's Bureau. *Women in Radio Illustrated by Biographical Sketches.* Bulletin no. 222. Washington, DC: GPO, 1947. 30p. L13.3:222. The various occupations open to women in radio broadcasting are illustrated through brief biographies of successful women in each occupation.

2776. U.S. Women's Bureau. *Your Job Future after College.* Washington, DC: GPO, 1947. 8p. L13.2:J57. Postwar guide to choosing a course through college gives advice on choosing a career and urges women to take courses that would be beneficial even if they dropped out, and to only enter a male dominated fields if they were exceptional and could take the pressure.

2777. U.S. Women's Bureau. *The Outlook for Women in Architecture and Engineering.* Bulletin no. 223-5. Washington, DC: GPO, 1948. 88p. L13.3:223-5. Information highlights the prewar distribution and wartime changes in the representation of women in architecture, landscape architecture, engineering, engineering aids, and draftsman. Provides information on number of women, earnings and advancement, and the job outlook. Major professional organizations and educational requirements are noted.

2778. U.S. Women's Bureau. *Opportunities for Negro Women in Science.* Washington, DC: The Bureau, 1948? 3p. No SuDoc number. Provides information on the number of black women receiving college degrees in the sciences and the job opportunities available for these women. Describes the problems of finding schools who admit blacks and which offer training in the sciences.

2779. U.S. Women's Bureau. *The Outlook for Women in Chemistry.* Bulletin no. 223-2. Washington, DC: GPO, 1948. 65p. L13.3:223-2. Information on the outlook for women as chemists provides data on the prewar distribution of women chemists and wartime changes in the demand for chemists. Also provides information on hours and earnings, future outlook, professional organizations, and educational requirements. Includes data on distribution of men and women chemists by occupation and employer, and on number of graduate and undergraduate students in chemistry by sex.

2780. U.S. Women's Bureau. *The Outlook for Women in Geology, Geography, and Meteorology.* Bulletin no. 223-7. Washington, DC: GPO, 1948. 52p. L13.3:223-7. Prewar distribution and wartime changes in the number of women in geology, geography, and meteorology are discussed along with an overview of the future outlook, earnings, and advancement potential. Requirements for membership in the major professional organizations in each field are listed.

2781. U.S. Women's Bureau. *The Outlook for Women in Mathematics and Statistics.* Bulletin no. 223-4. Washington, DC: GPO, 1948. 21p. L13.3:223-4. Information on women in mathematics and statistics. Covers prewar distribution, wartime changes, earnings and advancement, and the employment outlook. Also lists major professional organizations and educational requirements.

2782. U.S. Women's Bureau. *The Outlook for Women in Occupations Related to Science.* Bulletin no. 223-8. Washington, DC: GPO, 1948. 33p. L13.3:223-8. Describes changes in the employment of women and trends affecting job outlook for women in the areas of technical library work, patent work, technical writing and editing, technical illustration, and technical secretarial work. Experience and education requirements for related federal civil service positions are noted.

2783. U.S. Women's Bureau. *The Outlook for Women in Physics and Astronomy.* Bulletin no. 223-6. Washington, DC: GPO, 1948. 32p. L13.3:223-6. Outlook for women in physics and astronomy provides information on prewar and wartime distribution of women, earnings and advancement, professional organizations, and educational requirements.

2784. U.S. Women's Bureau. *The Outlook for Women in the Biological Sciences.* Bulletin no. 223-3. Washington, DC: GPO, 1948. 87p. L13.3:223-3. Information on the outlook for women in botany, bacteriology, zoology, and general biology is presented along with information on the status of women in biology before and during WWII, and their present hours and earnings. The major organizations in each field and the number of women members is also given.

2785. U.S. Women's Bureau. *Occupations for Girls and Women: Selected References, July 1943 - June 1948.* Bulletin no. 229. Washington, DC: GPO, 1949. 105p. L13.3:229. Extensive bibliography on career options for girls and women includes books, articles, and pamphlets published between July 1943 and June 1948. Includes works about occupations, biographies of women in particular occupations, fictional works describing the profession, and information on training opportunities and vocational guidance programs relating to women.

2786. U.S. Women's Bureau. *The Outlook for Women in Police Work.* Bulletin no. 231. Washington, DC: GPO, 1949. 31p. L13.3:231. Report describes the number of women employed in police work and the types of work they perform. Most of the job tasks described are of a social welfare nature, particularly work dealing with women and children. Job outlook is analyzed by geographic region and for special groups such as older, married, and black women.

2787. U.S. Women's Bureau. *The Outlook for Women in Science.* Bulletin no. 223-1. Washington, DC: GPO, 1949. 81p. L13.3:223-1. Overview of information on the outlook for women in the sciences looks at supply and demand and summarizes information on the principle scientific fields which are covered in more depth in Bulletins 223-2 through 223-8 (2777, 2779-2784).

2788. U.S. Women's Bureau. *Your Job Future after High School.* Washington, DC: GPO, 1949. 8p. L13.2:J57/2. Booklet on planning for a job after high school encourages girls to consider planning for a job, even if they plan to marry, and offers suggestions on traditional careers.

2789. U.S. Women's Bureau. *The Outlook for Women in Dietetics.* Bulletin no. 234-1. Washington, DC: GPO, 1950. 80p. L13.3:234-1. Publication on the employment outlook for dieticians and nutritionists includes information on demand, supply, training and education, earnings and opportunities for advancement, and related organizations. Appendices provide information on minimum requirements for related federal civil service positions.

2790. U.S. Women's Bureau. *The Outlook for Women in Social Case Work in a Medical Setting.* Bulletin no. 235-1. Washington, DC: GPO, 1950. 58p. L13.3:235-1. Information highlights the supply and demand for social case workers in 1949, and the training and

financial aid available to interested women. Also discusses hours, earnings, and opportunities for advancement. Summarizes the employment of social case workers before WWII and the effect of the war. Related professional organizations, approved schools of social work, and minimum requirements for federal civil service positions are listed.

2791. U.S. Women's Bureau. *The Outlook for Women in Social Case Work in a Psychiatric Setting.* Bulletin no. 235-2. Washington, DC: GPO, 1950. 60p. L13.3:235-2. See 2790 for abstract.

2792. U.S. Women's Bureau. *The Outlook for Women in Community Organization in Social Work.* Bulletin no. 235-5. Washington, DC: GPO, 1951. 41p. L13.3:235-5. See 2790 for abstract.

2793. U.S. Women's Bureau. *The Outlook for Women in Social Case Work with Children.* Bulletin no. 235-3. Washington, DC: GPO, 1951. 72p. L13.3:235-3. See 2790 for abstract.

2794. U.S. Women's Bureau. *The Outlook for Women in Social Case Work with Families.* Bulletin no. 235-4. Washington, DC: GPO, 1951. 84p. L13.3:235-4. See 2790 for abstract.

2795. U.S. Women's Bureau. *The Outlook for Women in Social Group Work.* Bulletin no. 235-7. Washington, DC: GPO, 1951. 41p. L13.3:235-7. See 2790 for abstract.

2796. U.S. Women's Bureau. *The Outlook for Women in Social Work Administration, Teaching, and Research.* Bulletin no. 235-6. Washington, DC: GPO, 1951. 83p. L13.3:235-6. See 2790 for abstract.

2797. U.S. Women's Bureau. *The Outlook for Women as Food-Service Managers and Supervisors.* Bulletin no. 234-2. Washington, DC: GPO, 1952. 54p. L13.3:234-2. Employment opportunities for women as food service managers and supervisors are explored in this informational publication. Provides information on the demand for women in these fields and in varying occupational settings, and reviews the supply, training and education, earnings, working conditions, and opportunities for advancement.

2798. U.S. Women's Bureau. *The Outlook for Women in Social Work.* Bulletin no. 235-8. Washington, DC: GPO, 1952. 93p. L13.3:235-8. Summary of information contained in the first seven bulletins in the Social Work Series (2790-2796). Describes the supply and demand for social workers and the outlook for women in the major areas of specialization. Also discusses the social work outlook for women with special employment problems including older, married, black, and handicapped women. Provides data on number of social workers by sex and type position and salaries by position and sex.

2799. U.S. Women's Bureau. *Your Job Future after College.* Leaflet no. 9. Washington, DC: GPO, 1952. 8p. L13.11:9. Information on choosing a career highlights factors such as number of women in the field, job stability, and local opportunities.

2800. U.S. Naval Personnel Bureau. *U.S. Navy Occupational Handbook for Women, Manual for Civilian Guidance Counselors, Schools, Librarians, Employment and Youth Agencies.* Washington, DC: The Bureau, 1953. 66p. D208.6:Oc1/3/953. Summary sheets on occupations for women in the Navy explain the duties, qualifications, training, and path of advancement for positions such as electronics technician, opticalman, photographer's mate, printer, journalist, machine accountant, and nurse.

2801. U.S. Women's Bureau. *Occupational Therapy as a Career.* Leaflet no. 16. Washington, DC: GPO, 1953. 8p. leaflet. L13.11:16.

2802. U.S. Women's Bureau. *Employment Opportunities for Women in Professional Engineering.* Bulletin no. 254. Washington, DC: GPO, 1954. 38p. L13.3:254. Discussion of the outlook for engineers and the opportunities for women as engineers notes the prejudicial attitudes toward women in engineering. Summary of information on characteristics of women engineers from a 1953 survey of the Society of Women Engineers is presented and includes information on employment status, level of training, field of preparation, time lapse between degree and first job, starting salary, salary in 1953, age, and marital status.

2803. U.S. Women's Bureau. *Marilyn Wants to Know, after High School What?* Leaflet no. 8. Washington, DC: GPO, 1954. 13p. L13.11:8/2. Advises high school girls to train for a job even if they plan to marry. Addresses questions such as whether to stay in school, whether to get a part-time job, and how to find a job.

2804. U.S. Office of Education. Vocational Division. *Girls' and Women's Occupations: Selected References, July 1948-September 1954.* by Louise Moore. Bulletin no. 257. Washington, DC: GPO, 1955. 99p. FS5.123:257. Bibliography of books, periodical articles, and pamphlets covers all aspects of career information for women including descriptions of occupations, biographies of women in different fields, directories of schools and colleges, scholarships, career planning, and job seeking guides.

2805. U.S. Women's Bureau. *Employment Opportunities for Women in Professional Accounting.* Bulletin no. 258. Washington, DC: GPO, 1955. 40p. L13.3:258. Describes the training to become a professional accountant and the outlook for women in the field. Also summarizes the results of a survey of women accountants which collected data on age, marital status and children, education, certification, types of employment, and salaries.

2806. U.S. Women's Bureau. *Employment Opportunities for Women in Beauty Service.* Bulletin no. 260. Washington, DC: GPO, 1956. 51p. L13.3:260. Information on employment opportunities for women as beauticians and in related fields looks at type of work performed and at the distribution of women in beauty service by age and by marital status. Also covered are educational requirements, licensing, and earnings.

2807. U.S. Women's Bureau. *Employment Opportunities for Women Mathematicians and Statisticians.* Bulletin no. 262. Washington, DC: GPO, 1956. 37p. L13.3:262. Revision of Bulletin no. 223-4, *The Outlook for Women in Mathematics and Statistics* (2781).

2808. U.S. Women's Bureau. *How to Conduct an Earning Opportunity Forum in Your Community.* Leaflet no. 25. Washington, DC: GPO, 1956. 15p. L13.11:25. Provides information on organizing an earning opportunity forum to appraise mature women of job opportunities in their community.

2809. U.S. Women's Bureau. *Employment Opportunities for Women as Secretaries, Stenographers, Typists and as Office-Machine Operators and Cashiers.* Bulletin no. 263. Washington, DC: GPO, 1957. 30p. L13.3:263. Outlook for women in office work describes typical jobs, outlook, training, earnings and hours, advancement opportunities, and major organizations in the field.

2810. U.S. Women's Bureau. *Is "Math" in the Stars for You?* Leaflet no. 28. Washington, DC: GPO, 1957. 6p. leaflet. L13.11:28.

2811. U.S. Women's Bureau. *Job Horizons for the College Woman.* Pamphlet no. 1. Washington, DC: GPO, 1957. 53p. L13.19:1. Career suggestions for college educated women provides helpful hints on job-finding. Briefly addresses the issue of having a career and marriage and a family.

2812. U.S. Women's Bureau. *Employment Opportunities for Women in Legal Work.* Bulletin no. 265. Washington, DC: GPO, 1958. 34p. L13.3:265. Furnishes background information on women in the legal field and notes their progress and prospective opportunities as attorneys and in salaried positions where legal training is required. Provides data on employed lawyers and judges, by region and by sex.

2813. U.S. Women's Bureau. *Grant County, Washington, Earning Opportunities Forum.* Washington, DC: The Bureau, 1958. 3p. L13.2:G76. Summary of the first rural "Earning Opportunities Forum" for mature women describes the needs of the participants, most of whom were employed or seeking employment. Quotes from speakers and participants reveal the positive attitude toward employment of mature women generated by the forum. Briefly describes programs and actions resulting from the forum.

2814. U.S. Women's Bureau. *Planning Training for Future Womanpower, Address of Mrs. Stella P. Manor, Chief, Program Planning, Analysis and Reports Division, at American Technical Education Association Convention, Buffalo, New York, August 11, 1958.* Washington, DC: The Bureau, 1958. 10p. L13.12:M31. Speech profiles the occupational distribution of women workers and discusses future career opportunities for women. Specifically addresses the future of clerical workers and production workers. Trends in the age of women workers and in part-time work are also reviewed. The need for education and training to fit women for the jobs of the future is only briefly covered.

2815. U.S. Women's Bureau. *Careers for Women in the Physical Sciences.* Bulletin no. 270. Washington, DC: GPO, 1959. 77p. L13.3:270. Update of Bulletins 223-2 (2779), 223-6 (2783), and 223-7 (2780) covers the fields of chemistry, physics, geology, astronomy and meteorology. Does not include the information on organizations which was included in the previous bulletin series.

2816. U.S. Women's Bureau. *Report of St. Petersburg Earning Opportunities Forum.* Washington, DC: The Bureau, 1959. 22p. L13.2:Sa2 Detailed information reviews the planning and outcomes of the St. Petersburg Earning Opportunities Forum, a conference designed to make women aware of traditional and nontraditional opportunities to earn a living. Reports on individual committees provide detailed information on the mechanics of the forum.

2817. U.S. Women's Bureau. *Science Futures for Girls.* Leaflet no. 32. Washington, DC: GPO, 1959. 7p. leaflet. L13.11:32.

2818. U.S. Women's Bureau. *Suggestions to Women and Girls on Training for Future Employment.* Leaflet no. 33. Washington, DC: GPO, 1960. 11p. leaflet. L13.11:33.

2819. U.S. National Science Foundation. *Women in Scientific Careers.* Washington, DC: GPO, 1961. 18p. NS1.2:W84. Study of the employment of women in scientific fields. Notes the factors which contribute to the low number of women entering the sciences as a career. Provides basic data on women's labor force participation and educational attainment, and specific information on fellowships, employment distribution, degrees conferred, and annual salaries for women in the sciences by field of study. Economic, academic, and social factors are among the areas discussed in relation to recruiting women to the sciences.

2820. U.S. Women's Bureau. *Careers for Women as Life Underwriters.* Bulletin no. 279. Washington, DC: GPO, 1961. 35p. L13.3:279. Overview of the career opportunities in life insurance underwriting reviews the structure of the field in the areas of hours of work, methods of compensation, and working arrangements. Data on the limited number of women in the field is examined. Also describes training and advancement opportunities and the major professional organizations.

2821. U.S. Women's Bureau. *Careers for Women in the Biological Sciences.* Bulletin no. 278. Washington, DC: GPO, 1961. 86p. L13.3:278. Revision of Bulletin 223-3 (2784) focuses on types of work, the nature of the job, and career preparation. Provides data on degrees granted in the biological sciences by sex, women employed in life sciences by age and salary, and average salaries by employer.

2822. U.S. Women's Bureau. *The Earnings Opportunities Forum.* Washington, DC: The Bureau, 1961. 3p. L13.2:Ea7. General information on the purpose of the Earning Opportunities Forum program for mature women workers cites the broad support for the one day forums and briefly describes the character of the nearly 30 forums already conducted.

2823. U.S. Women's Bureau. *Job Futures for Girls in Biology.* Leaflet no. 35. Washington, DC: GPO, 1961. 7p. leaflet. L13.11:35.

2824. U.S. Women's Bureau. *Life Insurance Selling: Careers of Women as Life Underwriters.* Leaflet no. 36. Washington, DC: GPO, 1961. 7p. leaflet. L13.11:36.

2825. U.S. Women's Bureau. *Careers for Women as Technicians.* Bulletin no. 282. Washington, DC: GPO, 1962. 28p. L13.3:282. Study of the opportunities for women as technicians looked at characteristics of the work, principle employers, and training requirements. The study also examined the opportunities and obstacles to women in the field. Includes data on women employed by the federal government in technical classifications, women graduates of engineering-related curriculum, and average annual salaries and grades of women federal employees in technical classifications.

2826. U.S. Women's Bureau. *Job Opportunities, Foreign, Linguistic, Travel.* Washington, DC: The Bureau, 1962. 4p. L13.18/2:J57. Lists booklets on career opportunities oversees from government and non-government sources.

2827. U.S. Women's Bureau. *Memo on Job-Finding for the Mature Woman.* Leaflet no. 13. Washington, DC: GPO, 1962. 2p. leaflet. L13.11:13/4. Earlier editions published in 1955 and 1960.

2828. U.S. Women's Bureau. *Careers for Women in Retailing.* Bulletin no. 271, revised. Washington, DC: GPO, 1963. 52p. L13.3:271/2. Focus of retail career information presented here is on higher level department store positions in merchandising, personnel, sales promotion, financial control, and store operations. The outlook, earnings, working conditions, and educational requirements are considered, and small retail store ownership is discussed.

2829. U.S. Women's Bureau. *Present and Perspective Opportunities for Women in Science, Presented by Beatrice McConnell, Deputy Director, at the Conference on Role of Women in Science, Sponsored by Marymount College, Tarrytown, New York, under Auspices of Office of Emergency Planning, January 31, 1963.* Washington, DC: The Bureau, 1963. 10p. L13.12:M13. The status of women's employment in the sciences and the factors which contribute to their low representation are reviewed in this paper which stresses career opportunities for women in the sciences. The need to interest girls in the sciences

early on, and to encourage their interest, is viewed as key to meeting the nation's demand for scientists. Also addresses the argument that girls do not have the aptitude for science, and that the cost of training women scientists is wasted because they will quit to marry.

2830. U.S. Women's Bureau. *Report of World of Work Conference on Career and Job Opportunities.* Washington, DC: GPO, 1963. 36p. L13.2:W89/9. Speakers and workshops at a conference held at Howard University focus on career opportunities for high school and college girls. Workshops covered choosing a career, preparation for a career and occupation, and getting and holding a job. Speakers also cover financial aid and employment opportunities in government service.

2831. U.S. Women's Bureau. *Employment Opportunities Involving Jobs Overseas, Foreign Languages, Travel.* Washington, DC: The Bureau, 1964. 5p. L13.18/2:Em7. Lists sources of information on overseas employment.

2832. U.S. Women's Bureau. *Job Horizons for College Women in the 1960's.* by Rose Terlin. Bulletin no. 288. Washington, DC: GPO, 1964. 78p. L13.3:288. See 2850 for abstract.

2833. U.S. Women's Bureau. *New Horizons for Women, a Talk by Mary Dublin Keyserling, Director, Women's Bureau, U.S. Department of Labor, to the National Home Demonstration Agents' Association, Washington, D.C., November 15, 1964.* Washington, DC: The Bureau, 1964. 15p. L13.12:K52/4. Overview of the changing pattern of women's lives. Stresses the need to provide better wages, greater occupational opportunity, and part-time employment and education opportunities. Home demonstration agents are urged to help girls realize that they will probably work after marriage and to help parents see the importance of education for their daughters. Reviews the provisions of the Economic Opportunity Act and encourages volunteer participation of agents.

2834. U.S. Women's Bureau. *Summary of Consultation, July 20-21, 1964, Women's Bureau and the Office of Education with State School Guidance Officials on Vocational Guidance for Girls.* Washington, DC: The Bureau, 1964. 9p. L13.2:G44/2. Summary of consultation proceedings on the problems of counseling girls focuses on ways to improve vocational counseling. Some of the recurring themes are the message sent to girls stressing marriage as their goal and the need to make girls more aware of the role employment will play in their lives. Reaching teachers and parents so that they are aware of their role in creating a receptive environment for women's career education is discussed along with the role of the school guidance counselor in informing and motivating girls. Materials which should be developed to help get the women and career message across are outlined. The recommendations of the consultation include a series of regional and state conferences.

2835. U.S. Women's Bureau. *Address by Rose Terlin, Women's Bureau, Department of Labor, at Spring Convention of Maryland State Personnel and Guidance Association, Annapolis, MD, May 2, 1964.* Washington, DC: The Bureau, 1965. 9p. L13.12:T27. Speech to guidance counselors stresses the changing labor force participation patterns of women and the need to convince high school and college girls that they must seriously prepare for a job. The occupational outlook for traditional female-dominated fields like teaching, social work, nursing, and clerical work is reviewed along with a longer look at the opportunities for women in science, engineering, and mathematics.

2836. U.S. Women's Bureau. *Excerpts on Counseling and Guidance from Report of the President's Commission on the Status of Women and Report of Committee on Education.* Washington, DC: The Bureau, 1965. 8p. L13.2:C83. Recommendations and related discussion on counseling and guidance for girls and women from *American Women* (Vol. I - 58) and from *Report of the Committee on Education* (Vol. I - 60) are summarized. The

need for more and better trained counselors and for more support materials to encourage a full occupational choice for women are stressed. Reissued in 1967 without changes.

2837. U.S. Women's Bureau. *Summary of Consultation, Women's Bureau, Department of Labor, with Staff of National Youth-Serving Organizations, Washington, D.C., April 15, 1964.* Washington, DC: The Bureau, 1965. 6p. L13.2:Y8. Summary report of a consultation on preparing teenage girls for a life which includes both family and work. Briefly describes projects aimed at disadvantaged girls sponsored by the Camp Fire Girls, Girl Scouts, and YWCA. Ways that youth-serving organizations can help girls prepare for dual roles, and ways that the Women's Bureau can help the organizations, are summarized.

2838. U.S. Women's Bureau. *Summary of Speech by Mary Dublin Keyserling, Director, Women's Bureau, Department of Labor, October 15, 1965, 8th Annual Fall Conference for Guidance Counselors, Kentucky Personnel and Guidance Association, Cumberland Fall, Ky.* Washington, DC: The Bureau, 1965. 4p. L13.12:K52/12. Noting working women's concentration in low-skilled, low-paying occupations, guidance counselors are urged to play a role in improving the status of women by helping young women to see all of their career options.

2839. U.S. Women's Bureau and U.S. Office of Education. *New Approaches to Counseling Girls in the 1960's: A Report of the Midwest Regional Pilot Conference.* Washington, DC: GPO, 1965. 88p. L13.2:C83/2. Proceedings of a conference on the issues of career counseling for girls provides insight into the 1960's view of the role of women. Speeches include "Facing facts about women's lives today" and "Counseling today's girls for tomorrow's womanhood." Reviews the results of workshop sessions on the effect of parents, the curriculum, teachers' attributes, sex-role expectations, and counseling on girls' career choices. Also included are reports from governors' commissions on the status of women in the areas of education and counseling for the states of Illinois, Indiana, Michigan, Missouri, and Wisconsin.

2840. U.S. Women's Bureau. *Future Jobs for High School Girls.* Pamphlet no. 7, revised. Washington, DC: GPO, 1966. 67p. L13.19:7/4. Basic information on getting a job and choosing a job emphasizes health services and clerical work. Earlier editions published in 1959 and 1965.

2841. U.S. Women's Bureau. *Opportunities for Girls in Crafts and Trades.* by Janice N. Hedges. Washington, DC: The Bureau, 1966. 6p. L13.12:H35. Speech at the "Parents' Conference: Need College be the Only Answer?" outlines opportunities for girls in crafts and trades such as appliance repair, watch and jewelry repair, and optical technician.

2842. U.S. Women's Bureau. *Selected Readings on Employment and Training Opportunities in Professions.* Washington, DC: The Bureau, 1966. 2p. L13.18/2:Em7/2.

2843. U.S. Women's Bureau. *Womanpower Needed, Address by Mary Dublin Keyserling, Director of Women's Bureau, Department of Labor, April 4, 1966, National Convention, American Personnel and Guidance Association Workshop, Counseling Girls in the 1960's.* Washington, DC: The Bureau, 1966. 7p. L13.12:K52/20. The need for women as active participants in the labor force to meet manpower needs, and the reality that 8 or 9 out of every 10 high school girls will be in paid employment sometime in their lives, are the key points in this speech. As guidance personnel, the audience is urged to encourage girls to think of the long-term in their vocational choices.

2844. U.S. Women's Bureau and U.S. Office of Education. *Counseling Girls Toward New Perspectives: A Report of the Middle Atlantic Regional Pilot Conference Held in Philadelphia, PA, December 2-4, 1965.* Washington, DC: GPO, 1966. 96p.

L13.2:C83/3. Proceedings of a conference on women's role in society and on potential approaches to career counseling for girls focuses on the societal pressures placed on young women and how these can affect their career growth.

2845. U.S. Manpower Administration. *Counseling Girls and Women: Awareness, Analysis, Action.* Washington, DC: GPO, 1967. 71p. L7.2:C83/4. Overview for employment counselors reviews the changing labor force patterns of women and the counseling needs of various groups of women, such as single women, working wives and mothers, and older workers. Stresses the need to take husband's attitude toward the working wife into account. Also discusses employer attitudes towards hiring women and sex discrimination.

2846. U.S. Office of Economic Opportunity. Job Corps Center for Women. *So...You Want to Be a Cosmetologist.* Washington, DC: GPO, 1967. [6]p. leaflet. PrEx10.20:C82.

2847. U.S. Office of Economic Opportunity. Job Corps Center for Women. *So...You Want to Be a Licensed Practical Nurse.* Washington, DC: GPO, 1967. [6]p. leaflet. PrEx10.20:N93.

2848. U.S. Office of Economic Opportunity. Job Corps Center for Women. *So...You Want to Be a Secretary.* Washington, DC: GPO, 1967. [6]p. leaflet. PrEx10.20:Se2.

2849. U.S. Women's Bureau. *Counseling and Vocational Guidance Services for New York City Women.* Washington, DC: The Bureau, 1967. 3p. L13.2:C83/4. Lists government and nongovernment agencies and organizations in New York City who provide vocational and employment counseling services.

2850. U.S. Women's Bureau. *Job Horizons for College Women.* Bulletin no. 288, revised. Washington, DC: GPO, 1967. 83p. L13.3:288/2. Information from the *Occupational Outlook Handbook* and from professional women's organizations is blended to create a list of career ideas and employment outlooks for women.

2851. U.S. Women's Bureau. *Why Not Be a Mathematician? Careers for Women.* Leaflet no. 45. Washington, DC: GPO, 1968. leaflet. L13.11:45.

2852. U.S. Women's Bureau. *Why Not Be a Personnel Specialist? Careers for Women.* Leaflet no. 48. Washington, DC: GPO, 1968. leaflet. L13.11:48.

2853. U.S. Women's Bureau. *Why Not Be a Pharmacist? Careers for Women.* Leaflet no. 43. Washington, DC: GPO, 1968. leaflet. L13.11:43.

2854. U.S. Women's Bureau. *Why Not Be an Optometrist? Careers for Women.* Leaflet no. 42. Washington, DC: GPO, 1968. leaflet. L13.11:42.

2855. U.S. Women's Bureau. *Careers for Women in Conservation.* Leaflet no. 50. Washington, DC: GPO, 1969. [9]p. leaflet. L13.11:50.

2856. U.S. Women's Bureau. *Job Training Suggestions for Women and Girls.* Leaflet no. 40, revised. Washington, DC: GPO, 1970. [15]p. leaflet. L13.11:40/3. Replaces Leaflet 33, earlier editions published in 1965 and 1968.

2857. U.S. Women's Bureau. *Why Not Be a Public Relations Worker? Careers for Women.* Leaflet no. 46, revised. Washington, DC: GPO, 1970. [7]p. leaflet. L13.11:46/2. Earlier edition published in 1968.

2858. U.S. Women's Bureau. *Why Not Be an Apprentice? And Become a Skilled Craftsman.* Leaflet no. 52. Washington, DC: GPO, 1970. leaflet. L13.11:52.

2859. U.S. Women's Bureau. *Why Not Be an Urban Planner? Careers for Women.* Leaflet no. 49. Washington, DC: GPO, 1970. leaflet. L13.11:49.

2860. U.S. Women's Bureau. *Expanding Opportunities for Girls: Their Special Counseling Needs.* Washington, DC: GPO, 1971. 4p. L36.102:G44. Some basic facts on labor force trends for women are presented with a view towards encouraging girls to plan for a career as well as for family responsibilities. Earlier editions published in 1967, 1969 and 1970 under SuDoc number L13.2:G44/3.

2861. U.S. Women's Bureau. *Why Not Be a Medical Technologist? Careers for Women.* Leaflet no. 44, revised. Washington, DC: GPO, 1971. leaflet. L36.110:44. Earlier edition published in 1968 under SuDoc Number L13.11:44.

2862. U.S. Women's Bureau. *Why Not Be a Technical Writer? Careers for Women.* Leaflet no. 47, revised. Washington, DC: GPO, 1971. [6]p. leaflet. L36.110:47. Earlier edition published in 1968 under SuDoc Number L13.11:47.

2863. U.S. Women's Bureau. *Why Not Be an Engineer? Careers for Women.* Leaflet no. 41, revised. Washington, DC: GPO, 1971. leaflet. L13.11:41/2. Earlier edition published in 1967.

2864. U.S. National Institute of Education. *Women in the Work Force, Development and Field Testing of Curriculum Materials, Planning Ahead for the World of Work.* by Louise Vetter and Barbara J. Sethney, Center for Vocational and Technical Education, Ohio State University. Research and Development Series no. 81. Washington, DC: GPO, 1972. 59p. HE18.11:81. Describes the evaluation of curriculum materials designed to make secondary school aged girls more aware of vocational opportunities and to help prepare for balancing personal and occupational goals. The study found that girls were more knowledgeable after the unit, and that more of them expected to work after marriage, but that occupational choices were not significantly altered.

2865. U.S. Women's Bureau. *Careers for Women in the 70's.* Washington, DC: GPO, 1973. 14p. L36.102:C18. Review of statistics on the employment outlook for various occupations briefly outlines how women can take advantage of the demand for skilled workers in each occupational category.

2866. U.S. Women's Bureau. *Selected Sources of Career Information.* Washington, DC: The Bureau, 1974. 6p. L36.102:C18.2. Briefly annotated list identifies government agency and private organization sources of career information, some of which are geared toward women.

2867. U.S. Civil Service Commission. Federal Women's Program. *Career Counseling for Women in the Federal Government: A Handbook.* Personnel Management Series no. 27. Washington, DC: GPO, 1975. 68p. CS1.54:27. Handbook on career counseling for women discusses the reasons such counseling is desirable and describes specific counseling techniques. Resource lists include support organizations, books, journals, and films.

2868. U.S. National Institute of Education. Career Education Program. *Issues of Sex Bias and Sex Fairness in Career Interest Measurement.* Edited by Esther E. Diamond. Washington, DC: The Institute, 1975. 219p. HE19.202:Se9. Collection of readings on the issues of sex bias and sex fairness in career interest inventories looks at both the technical merits of the measures themselves and at the way the are used.

2869. U.S. Employment and Training Administration. *Improving Employment Opportunities for Female Black Teenagers in New York City.* R & D Monograph no. 47. Washington, DC: GPO, 1977. 262p. L37.14:47. Study examined the effect of a peer group support program on the labor market knowledge, job seeking, and career planning skills of young black women aged 16 to 19. The difference in attitudes between in-school and out-of-school women toward jobs is analyzed.

2870. U.S. National Advisory Council on Women's Educational Programs. *Sex Discrimination in Guidance and Counseling: Report Review and Action Recommendations.* Washington, DC: The Council, 1977. 10p. Y3.Ed8/6:2D63. Summary of a national study of sex discrimination in guidance and counseling is followed by the recommendations of the National Advisory Council to the Commissioner of Education to address the inequities found in the study.

2871. U.S. National Institute of Education. *Sex-Fair Interest Measurement Research and Implications.* Edited by Carol Kehr Tittle and Donald G. Zytowski. Washington, DC: GPO, 1978. 169p. HE19.202:Se9/2. Anthology of articles on sex-bias and sex-fairness in career interest measurement tools provides an overview of research on the validity of the inventories with some discussion of the implications of sex-bias in career interest measurement.

2872. U.S. National Science Foundation. Division of Scientific Personnel Improvement. *Women in Science, Science Career Workshops: Guide for Preparation of Proposals and Project Operation.* Washington, DC: The Foundation, 1978. 23p. NS1.20/2:SE-79-26. Presents information on submitting proposals for the Science Career Workshops, part of the Women in Science Program whose aim is to increase the number of women entering science as a career. Workshops were held at universities and were aimed primarily at freshmen and sophomore women.

2873. U.S. Office of Education. *Exploring Division, Boy Scouts of America, Girl Scouts of the U.S.A., and Career Education.* by Kenneth B. Hoyt. Washington, DC: GPO, 1978. 24p. HE19.111/2:Ex7. Summary presents ideas generated by a discussion of the contribution Girls Scouts and Boy Scouts can make to career education.

2874. U.S. Office of Education. *Implementing Title IX and Attaining Sex Equity: A Workshop Package for Elementary-Secondary Educators - Attaining Sex Equity in Counseling Programs and Practices.* by Linda Stebbins and Nancy L. Ames, Resource Center on Sex Roles in Education. Washington, DC: GPO, 1978. 78p. HE19.141/2:Se9. Provides materials for a workshop for elementary and secondary school counselors on the negative effects of sex discrimination and sex-role stereotyping in counseling. Reviews the regulations, recommendations for creating a sex-fair guidance program, and information on interpreting career interest inventories, and includes a bibliography and resource guide.

2875. U.S. Office of Education. *Implementing Title IX and Attaining Sex Equity: A Workshop Package for Elementary-Secondary Educators - The Counselor's Role.* by Shirley McCune, et. al., Resource Center on Sex Roles in Education. Washington, DC: GPO, 1978. 152p. HE19.141/2:C83. Guide for the facilitator of a workshop on eliminating sex bias in counseling outlines sessions on identifying bias in counseling programs and materials.

2876. U.S. Office of Education. *Implementing Title IX and Attaining Sex Equity: A Workshop Package for Postsecondary Educators - The Counselor's Role.* by Shirley McCune, et. al., Resource Center on Sex Roles in Education. Washington, DC: GPO, 1978. 153p. HE19.141:C83. Counselors are the focus group for this collection of workshop materials on implementing Title IX for sex equity. Sessions look at sex bias in counseling,

counseling programs and materials, and possible actions to eliminate these biases. Also includes information on sex bias in career interest inventories.

2877. U.S. Office of Education. *The National Federation of Business and Professional Women's Clubs and Career Education.* by Kenneth B. Hoyt. Washington, DC: GPO, 1978. 19p. HE19.111/2:B96. Description of the structure of the National Federation of Business and Professional Women's Clubs (BPW) accompanies highlights of BPW career education activities at the national and local level. Suggests some further areas in which BPW could participate in career education for girls.

2878. U.S. Office of Education. *Women's American ORT and Career Education.* by Kenneth B. Hoyt. Washington, DC: GPO, 1978. 20p. HE19.111/2:W84. Reports a discussion on how the Women's American ORT (Organization for Rehabilitation Through Training), an organization of American Jewish women, could assist in local programs of career education.

2879. U.S. Women's Bureau. *Women in Nontraditional Jobs, A Conference Guide: Increasing Job Options for Women.* Washington, DC: GPO, 1978. 32p. L36.108:J58. Guide for organizations planning community level conferences on expanding job opportunities for women in nontraditional occupations outlines the steps in the planning process and highlights successful Women's Bureau-sponsored conferences. Includes a brief list of publications and audio-visual materials on women in nontraditional employment.

2880. U.S. Federal Aviation Administration. Office of Aviation Policy. Aviation Education Programs Division. *Women in Non-Traditional Aviation and Space Careers: An Overview.* by Mary Jo Oliver. Washington, DC: GPO, 1979. 7p. TD4.25:W84. Overview information on women in aerospace and aviation careers focuses on women's aviation careers in the armed forces.

2881. U.S. National Center for Research in Vocational Education. *Guidance Needs of Women.* by Lenore W. Harmon. Information Series no. 149. Washington, DC: GPO, 1979. 16p. HE19.143:149. Reviews the literature on sex differences as they relate to career potential and the literature on research and theories of guidance counseling and career development, particularly in reference to counseling women for career development.

2882. U.S. National Science Foundation. Division of Scientific Personnel Improvement. *Women in Science, Science Career Workshops, Science Career Facilities Projects: Guide for Preparation of Proposals and Project and Award Management.* Washington, DC: The Foundation, 1979. 30p. NS1.20/2:SE80-26. Describes programs to facilitate the reentry of women with science degrees into science related jobs or advanced degree programs, and to encourage freshmen and sophomore women to pursue degrees in the sciences. Includes guidelines for preparing a proposal and management of awards.

2883. U.S. Office of Education. Office of Career Education. *Reducing Sex Stereotyping in Career Education: Some Promising Approaches to Persistent Problems.* by Mary Ellen Verheyden-Hilliard. Washington, DC: GPO, 1979. 67p. HE19.102:Se9/2. Information on successful projects geared toward reducing sex-role stereotyping in primary and secondary school career education is analyzed in order to identify persistent problems and promising new approaches.

2884. U.S. Congress. House. *National Science Foundation Authorization and Equal Opportunities in Science and Technology, Conference Report to Accompany S. 568.* H. Rept. 96-1474, 96th Cong., 2d sess., 1980. 29p. Serial 13381. Also issued as S. Rept.96-1028, Serial 13332. Both House and Senate National Science Foundation authorization bills contained special emphasis programs to encourage the participation of women in the

sciences. Differences in details between the two programs are settled in this conference report which clearly indicates the situation of women and minorities in science and technology and the emphasis of programs to be carried out under this act. The final version supports women in the sciences though education program at all levels and through the development of existing female scientists.

2885. U.S. Congress. Senate. Committee on Labor and Human Resources. *National Science Foundation and Women in Science Authorization Act of Fiscal Years 1981 and 1982, Report, Together with Additional Views, to Accompany S. 568.* S. Rept. 96-713, 96th Cong., 2d sess., 1980. 66p. Serial 13324. The status of women in science and technology fields are highlighted in this report on legislation creating a comprehensive Women in Science program to encourage the education of girls and women in the sciences and to support career opportunities for women in science research. Supporting data illustrates the decline in the number of females pursuing science through the educational process, and the experience of female scientists in the labor markets.

2886. U.S. Federal Aviation Administration. Office of Aviation Policy. *Women in Aviation and Space.* by Chris Buethe. Washington, DC: The Office, 1980. 14p. TD4.2:Av5/6. Provides one page profiles of women in a variety of aviation and aerospace occupations.

2887. U.S. National Science Foundation. Division of Scientific Personnel improvement. *Women in Science, Career Workshops, Career Facilitation Projects: Guide for Preparation of Proposals and Project Award Management.* Washington, DC: The Foundation, 1980? 26p. NS1.20/2:SE81-26. See NS1.20/2:SE80-26.

2888. U.S. Office of Vocational and Adult Education. Office of Employment and Education. Division of Program Improvement. Curriculum Development Branch. *Vocational Counseling for Displaced Homemakers: A Manual.* Newton, MA: Education Development Center, 1980. 34p. ED1.8:V85. Guide to assessing skills of displaced homemakers to help them obtain gainful employment also outlines needed support services.

2889. U.S. Women's Bureau. *Job Options for Women in the 80's.* Pamphlet no. 18. Washington, DC: GPO, 1980. 22p. L36.112:18. Booklet for women making career decisions provides an overview of the status of women in the work force, describes factors that affect women's employment, and gives information on resources for job hunting and employment counseling.

2890. U.S. Congress. House. Committee on Science and Technology. Subcommittee on Science, Research and Technology. *Symposium on Minorities and Women in Science and Technology.* 97th Cong., 2d sess., 1982. Committee print. 86p. Y4.Sci2:97/AA. Record of the proceedings of a symposium sponsored by the Congressional Black Caucus to review the implementation of the Science and Technology Equal Opportunities Act of 1980 focuses on ways to encourage women and minorities to enter college in science and technology fields. Primary focus is on minority student programs.

2891. U.S. Congress. Senate. Committee on Finance. Subcommittee on Social Security and Income Maintenance Programs. *Women's Career Choice Equity Legislation, Hearing.* 98th Cong., 1st sess., 28 July 1983. 47p. Y4.F49:S.hrg.98-318. Hearing testimony focuses on the continuing provisions of the Social Security system which work against women, particularly women who spend part of their lives as full-time homemakers and part as paid workers. Phyllis Schlafly testifies in support of changing the Income Tax Code to allow career homemakers equal IRA tax advantages with employed women. Much of the discussion expresses the viewpoint that women are not presented with homemaking as a full-time career option, and Schlafly's testimony raises objections to the use of federal

funds to promote career education which encourages a negative attitude toward homemaking.

2892. U.S. Employment and Training Administration. Division of Counseling and Test Development. *The Effect of Sex on General Aptitude Test Battery Validity and Test Scores.* USES Test Research Report no. 49. Washington, DC: The Administration, 1984. 23p. L37.312:49. Research results from a study to determine if there are gender differences in the validity and test scores on the General Aptitude Test Battery indicated no difference in validity. Differences in test scores are analyzed.

2893. U.S. Women's Bureau. *Women in Nontraditional Careers (WINC): Curriculum Guide.* Washington, DC: GPO, 1984. 652p. L36.108:C93. Informational guide for school personnel on widening career horizons for young people stresses improving students' knowledge of the school to work transition and the value of long-range career plans. Activities and accompanying resources cover topics of women's labor history, women and work today, sex role stereotyping, career information, job hunting for nontraditional jobs, and career and life planning. Bibliographies accompany each unit.

2894. U.S. Women's Bureau. *Women in Nontraditional Careers (WINC): Journal.* Washington, DC: GPO, 1984. 66p. L36.108:C93/journal. Journal for participants in the WINC program includes brief exercises to stimulate awareness of sex-role stereotyping and self awareness for young women participants in the program.

2895. U.S. Women's Bureau. *Women in Nontraditional Careers (WINC): A Training Program Manual.* Washington, DC: GPO, 1985. 58p. L36.108:J58/2. Manual for a training program for school personnel describes the program to help young women make realistic career plans. The aim of the WINC program was to ensure a more successful school-to-work transition, and an element of that program was making school personnel aware of the need for nontraditional career planning for young women.

2896. U.S. Urban Mass Transportation Administration. *Preparing for a Career in Transit: A Guide for Minority Women.* by the National Council of Negro Women, Inc. Washington, DC: The Administration, 1986? 60p. TD7.8:C18. As background for information on careers in the transportation industry, this booklet describes the underrepresentation of women in the transportation field. Also noted is the information gathered to date on the mass transit needs of women. The need to recruit minority women in order to shape transit systems to meet women's needs is stressed. The majority of the book is devoted to describing the career opportunities and educational requirements of the field.

2897. U.S. Women's Bureau. *Jobs for the Future.* Washington, DC: GPO, 1987. 76p. L36.102:J57/3. Provides information on choosing an occupation and on the cost and benefits, job availability, and working conditions for specific occupations.

2898. U.S. Task Force on Women, Minorities, and the Handicapped in Science and Technology. *Changing America: The New Face of Science and Engineering: Interim Report.* Washington, DC: The Task Force, 1988. 66p. Y3.W84/3:2Am3. Report highlights the need to bring more students, particularly women, minorities, and the disabled, into professional fields in science and engineering. Includes profiles for each group with information on numbers in the population, labor force, and science and engineering positions; their educational paths; and model education programs.

2899. U.S. Federal Aviation Administration. *Women in Aviation and Space.* by Sandra H. Flowers. Washington, DC: GPO, 1990. 23p. TD4.2:Av5/6/990. Booklet designed to interest girls in pursuing a career in aviation highlights women who have made careers as pilots and in aviation support careers such as aviation education, FAA administration, and

aviation maintenance technology. In addition to the brief biographies, the booklet provides a list of aviation associations, and a short bibliography on women in aviation.

2900. U.S. Job Corps. *Hats Off to Today's Building Professionals: If You're Wondering about Your Future, Think about an Exciting Career in the Construction Trades! More Than Ever, Women are Becoming Successful Building Professionals, Enroll in Construction Trades Training Today!* Washington, DC: The Corps, 1990. poster. L37.2:H28.

2901. U.S. Job Corps. *In Step with Success: Today's Working Women Can Make Her Own Way, Choose a Career Where You Can Be Independent, Earn a Great Salary and Take Pride in Seeing a Job Well Done, Step Into a Career in the Construction Trades!* Washington, DC: The Corps, 1990. poster. L37.2:Su1.

2902. U.S. Job Corps. *Make Your Own Fashion Statement: for Today's Woman, Having a Great Career Is Always in Style, Construction Trades Are an Excellent Way for You to Learn a Lifetime Skill, Earn a Good Salary and Be Your Own Person.* Washington, DC: The Corps, 1990. poster. L37.2:F26.

2903. U.S. Job Corps. *Smart Accessories for Today's Working Women: Choosing the Right Career, Shop Smart and Enroll in a Construction Trades Program Today!* Washington, DC: The Corps, 1990. poster. L37.2:Ac2.

2904. U.S. Women's Bureau. *Women on the Job: Careers in the Electronic Media.* by the Women's Bureau and American Women in Radio and Television, Inc. Washington, DC: GPO, 1990. 27p. L36.102:J57/4. Booklet on career opportunities in electronic media describes basic duties and educational requirements.

18

Vocational Education and Employment Training Programs

Vocational education and employment training programs were a regular topic of government documents beginning in the 1910s. The early documents primarily describe existing training programs, in particular trade schools for girls in Massachusetts (2906, 2909). Two more general reports were issued in 1920 by the Federal Board for Vocational Education (2912) and in 1922 by the Women's Bureau (2913), both focusing on the need for vocational education programs for women and girls. Vocational training of women in defense industries was the primary topic of the 1940's documents.

Most of the remaining documents focus either on gender equity in vocation education or on government employment and training programs for the disadvantaged. Documents on welfare-related programs begin in the 1930s with publications on educational camps for unemployed women (2915-2922). The experience of women and girls under various government programs are documented in spite of a tendency of such programs to ignore women unless a congressional mandate forced their inclusion. The experience of women under MDTA is documented in *Occupational Training of Women under the Manpower Development and Training Act* (2935). The lengthy series of hearings held between 1965 and 1967 on the war on poverty programs often ignored women in discussions of training programs, but some did include testimony specific to the inclusion of women in the Job Corps (2938, 2944-2945) and the MDTA (2941) programs. Programs for women were also the topic of documents on specific Job Corps sites (2947, 2949-2951).

Recipients of AFDC and their experience under the Work Incentive Program (WIN) is a recurrent topic with many of the documents detailing the failure of WIN to address women's need and the role of day care in making programs successful. Although there are many documents on WIN, among the most significant are the 1970 report of a survey of welfare administrators on WIN referrals and the role of day care availability (2955), the detailed assessment of the WIN program by the Auerbach Corporation (2957), a literature review on WIN (2980), a 1980 analysis of WIN by the Employment and Training Administration (3002), and a 1982 General Accounting Office review of WIN objectives and accomplishments (3021). The focus of congressional hearings in 1987 and 1988 on welfare reform incorporating a strong work requirement produced numerous documents highlighting WIN demonstration projects targeting women.

Two other programs receiving significant attention in government documents relating to women were the Comprehensive Employment and Training Act (CETA) program and the Job Training Partnership Act (JTPA) program. Discrimination against women in CETA programs is explored in 1977 hearings (2978) and again in a 1980 GAO report (3004). The inclusion of displaced homemakers under CETA is the topic of several documents (2984, 2989) and was a focus in the late 1980s of reports on displaced homemakers (3050-3051, 3058). The failure of agencies

to serve the needs of women under JTPA programs is documented in several reports, but most notably in the hearings on legislation to provide incentives to target persons at high risk of dependency in JTPA programs (3039, 3041, 3043, 3046-3047).

On a more general level, documents in 1975 mark the beginning of government concern over gender-bias and sex role stereotyping in vocational education. In that year the House Committee on Education and Labor held hearings on the topic (2970), and the Secretary's Advisory Task Force on the Rights and Responsibilities of Women issued its report, *Vocational Preparation of Women* (2971). In 1978 four documents were produced under contract to the Office of Education on sex-fairness in vocational education (2981-2982, 2987-2988). Strategies for achieving sex-fairness were the focus of 1979 reports (2994-2994), and series of 1981 documents act a planning guides for promoting sex equity in specific disciplines (3009-3016). Also in 1981, the House of Representative specifically considered the question of sex equity in its hearings on reauthorization of the Vocational Education Act of 1963 (3008), and the report *Increasing Sex Equity: The Impact of the 1976 Vocational Education Amendments on Sex Equity in vocational Education* (3017) was issued. Sex equity was raised again in 1989 hearings on reauthorization of the Carl D. Perkins Vocational Education Act (3057). Additional documents on vocational education are cited in Volume I chapters on education and home economics.

2905. U.S. Congress. Senate. Committee on Education and Labor. *Notes of a Hearing on the Proposed Establishment of a School under the Direction of the Industrial Christian Home Association of Utah, to Provide Means of Self-Support for the Dependent Classes in That Territory, and to Aid in the Suppression of Polygamy Therein.* 49th Cong., 1st sess., 7 May 1886. 46p. Greenwood SEd 49-A. Hearing discusses a proposal for a school to teach domestic industries, e.g. cooking and dressmaking, and mechanical industries, e.g. typewriting, telegraphy, and stenography, to homeless women in Utah. The idea was to help women who wished to escape from polygamy, and the testimony primarily centers on the evils of the Mormon practice of polygamy.

2906. U.S. Bureau of Education. *A Trade School for Girls: A Preliminary Investigation in Typical Manufacturing City, Worcester, Mass.* Bulletin, 1913 no. 17. Washington, DC: GPO, 1913. 59p. I16.3:913/17. Report of an investigation into the work situation in Cambridge, Somerville, and Worcester, Massachusetts focuses on women and young girls 14 to 16 years old. Girls who had left school at 14 were studied as were the industrial opportunities open to them in the Worcester area and their working conditions. This information is used to suggest a possible focus for a trade school for girls.

2907. U.S. Bureau of Labor Statistics. *Short-Unit Courses for Wager Earners and a Factory School Experiment.* Bulletin no. 159. Washington, DC: GPO, 1915. 93p. L2.3:159. Describes the organization and purpose of a short-unit course for wage earners, both male and female, and provides examples of courses offered in various cities. The second part of the publication describes an educational program established by the public school system in New York City to teach illiterate foreign-born women and girls at the factories where they were employed.

2908. U.S. Bureau of Education. *Department Store Education: An Account of the Training Methods Developed at the Boston School of Salesmanship under the Direction of Lucinda Wyman Prince.* by Helen Rich Norton. Washington, DC: GPO, 1917. 79p. I16.3:917/9. Describes a training course for girls who desired to become saleswomen in department stores.

2909. U.S. Bureau of Labor Statistics. *Industrial Experience of Trade-School Girls in Massachusetts.* Bulletin no. 215. Washington, DC: GPO, 1917. 275p. L2.3:215. The growth of trade schools for girls in Massachusetts motivated this study of the effectiveness

of trade school training. Characteristics of girls include age and previous schooling when entering trade school, length of trade school course and use of training, reasons for leaving trade school, and cooperation between trade schools and employers. The industrial experience of trade school girls is examined including use of the trade for which they were trained and stability of the trade. Also looks at wage advancement in relation to trade school attendance. Details the characteristics of the trade school girls' family and the industries for which the schools trained.

2910. U.S. Bureau of Labor Statistics. *Vocational Education Survey of Minneapolis, Minn.* Washington, DC: GPO, 1917. 592p. L2.3:199. Study of the extent of vocational education offered in Minneapolis, Minnesota, examined the need for vocational education in the various industries, including laundries, garment trade, dressmaking and millinery, knitting mills, department stores, and retail sales, and for office workers and homeworkers.

2911. U.S. Dept. of Labor. Training Service. *Training in Paper-Box Industry.* Training Bulletin no. 15. Washington, DC: The Service, 1919. 75p. L12.3:15. Details on setting up a training department in a paper-box factory discusses administration, staffing, selection of personnel, record keeping, and employee motivation. The bulletin assumes female trainers and employees.

2912. U.S. Federal Board for Vocational Education. *Trade and Industrial Education for Girls and Women.* Washington, DC: GPO, 1920. 106p. VE1.3:58. Part one of this document examines the need for vocational education for girls and women and explores ways the Vocational Education Act could be used to expand programs. Discusses social attitudes toward women's employment, particularly as they relate to preparing girls to work outside the home. Part II provides information on organizing and administrating vocational education programs for girls and women.

2913. U.S. Women's Bureau. *Industrial Opportunities and Training for Women and Girls.* Bulletin no. 13. Washington, DC: GPO, 1922. 48p. L13.3:13/2. Discussion of the need for vocational education for women and girls centers on changes in the female labor force as a result of World War I. Reviews industrial training received by women in public schools and existing training facilities for new crafts. Identifies states where women made significant progress in industrial employment during the war, and where vocational training would be most beneficial. Earlier editions published in 1920 and 1921.

2914. U.S. Federal Board for Vocational Education. *Report of Trade and Industrial Conference, Casper, Wyoming, Trade and Industrial Education for Girls and Women.* by Anna L. Burdick. Washington, DC: The Board, 1927? 5p. VE1.15:859. As a last minute part of the Trade and Industrial Conference, the work being done to provide vocational training for girls and women was discussed. Briefly outlined are training programs related to nursing, power sewing machine operation, millinery, beauty parlor trades, chemistry and laboratory assistants, and food-related industries.

2915. U.S. Federal Emergency Relief Administration. *Memorandum on Standards and Procedures in Establishing Educational Camps for Unemployed Women.* Washington, DC: The Administration, 1935. 4p. Y3.F31/5:2Ed8. Guidelines for establishing educational camps for unemployed women suggest makeup of the state advisory committee, eligibility requirements for camp attendees, types of camps and curriculum, camp staffing and budgets.

2916. U.S. Federal Emergency Relief Administration. *Report of Resident Schools and Educational Camps for Unemployed Women 1934 and 1935.* Washington, DC: The Administration, 1936. 63p. No Sudoc number. Report describes the structure, strengths, and problems of educational camps for unemployed women between the ages of 16 and 25

which were established in 1934 and again in 1935. The report discusses in detail the students and the success of the program. The curriculum and ways to improve it to meet the needs of the women are scrutinized. Includes some data on the characteristics of the students and excerpts from their impressions of the program.

2917. U.S. National Youth Administration. *Manual, Educational Camps for Unemployed Young Women: Chapter I, Suggestions for Procedure of Camp Directors.* NYA Circular no. 8, chap.1. Washington, DC: The Administration, 1936. 6p. Y3.N21/14:4/8/chap.1. Administrative considerations of educational camps for unemployed young women are described in chapter one of the manual and include such topics as selection of applicants, facilities and site selection, and staff selection. Also reviews the educational program and ways to relate the program to the girls' social situation.

2918. U.S. National Youth Administration. *Manual, Educational Camps for Unemployed Young Women: Chapter II, Work of the Camp Counselor.* NYA Circular no. 8, chap. 2. Washington, DC: The Administration, 1936. 5p. Y3.N21/14:4/8/chap.2. The role of the camp counselor is reviewed in chapter two which discusses interviewing the girls and working with the community. The camp to work transition is also discussed.

2919. U.S. National Youth Administration. *Manual, Educational Camps for Unemployed Young Women: Chapter III, Physical Examinations.* NYA Circular no. 8, chap. 3. Washington, DC: The Administration, 1936. 8p. Y3.N21/14:4/8/chap.3. Administration of the physical examination of girls at educational camps is reviewed.

2920. U.S. National Youth Administration. *Manual, Educational Camps for Unemployed Young Women: Chapter IV, Food Estimate for One Month.* NYA Circular no. 8, chap. 4. Washington, DC: The Administration, 1936. 4p. Y3.N21/14:4/8/chap.4.

2921. U.S. National Youth Administration. *Manual, Educational Camps for Unemployed Young Women: Chapter V, Suggestions Concerning Work Projects.* NYA Circular no. 8, chap. 5. Washington, DC: The Administration, 1936. 5p. Y3.N21/14:4/8/chap.5. Suggested work projects for young women in employment training camps include making braille books, production of teaching aids, forestry projects, local interest signs for highways, construction of toys and recreational supplies, and making hospital supplies and household supplies for local institutions.

2922. U.S. National Youth Administration. *Manual, Educational Camps for Unemployed Young Women: Chapter VI, Safety Regulation for NYA Camps for Unemployed Young Women.* NYA Circular no. 8, chap. 6. Washington, DC: The Administration, 1936. 5p. Y3.N21/14:4/8/chap.6.

2923. U.S. Office of Education. Vocational Division. *Partial List of Public Day Trade or Vocational Schools for Girls, or Schools which Have Girls' Department.* Washington, DC: The Office, 1938. 10p. I16.54/5:2052. Directory lists, by state, trade and vocational schools giving the name, address, principle, and girls division head.

2924. U.S. Women's Bureau. *Report of the Conference on Vocational Training of Women under the Defense Program Called by the Women's Bureau of the U.S. Department of Labor November 7, 1940.* Washington, DC: The Bureau, 1940. 6p. L13.2:W84/5. Summary report of a conference on the vocational training of women under the defense program documents the exclusion of women from the federal vocational training programs and the delegates indignation at this exclusion.

2925. U.S. Women's Bureau. *Women's Vocational Training Needs in the Defense Industries.* Washington, DC: The Bureau, 1940. L13.2:W84/3? Jobs which women could fill,

particularly factory jobs, are examined in light of women's ability to perform the task. Jobs for which some form of training is needed are noted. Although the concentration is on war industries, opportunities in health and service areas are also noted.

2926. U.S. Office of Education. *Vocational, Related, and Other Necessary Instruction in the Field of Trades and Industry for Girls on National Youth Administration Work Projects, Resident and Non-Resident.* Washington, DC: The Office, 1941. 11p. FS5.11:2709. Discusses integration of basic education into vocational training and the general employment skills each girl needs to learn. Techniques of job seeking, the basics of labor legislation and trade unions, and training for job advancement are all briefly noted as curriculum necessities.

2927. U.S. War Management Commission. Bureau of Training. *Training Women Workers, a 3-Plant Study.* Washington, DC: The Commission, 1943. 16p. Pr32.5202:W84/6. The policies successfully used at three war production plants to train women in machine operation are described in order to help other plant managers who were introducing women to operations formerly performed by men. Talks about trainee selection, orientation, placement, on the job training, and supervision. Also reviews shifts and working hours, absenteeism and turnover, and safety. This pamphlet was reprinted in the journals *Personnel* and *Factory Management and Maintenance.*

2928. U.S. Women's Bureau. *Training for Jobs for Women and Girls, Working, Looking for Work.* Leaflet no. 1. Washington, DC: GPO, 1947. 2p. leaflet. L13.11:947/1.

2929. U.S. Women's Bureau. *Job Training for Women and Girls Offered by Local Trade and High Schools.* Leaflet no. 7. Washington, DC: GPO, 1951. 11p. leaflet. L13.11:7.

2930. U.S. Women's Bureau. *A Short-Term Training Program in a Aircraft Engine Plant.* Bulletin no. 245. Washington, DC: GPO, 1953. 11p. L13.3:245. Describes a short-term, single-purpose training program offered by an aircraft engine manufacturer designed to teach women skills for specific line jobs in metal working.

2931. U.S. Women's Bureau. *Training Mature Women for Employment: The Story of 23 Local Programs.* Bulletin no. 256. Washington, DC: GPO, 1955. 46p. L13.3:256. Describes programs at the local level designed to train middle-aged and older women in industrial and commercial sewing, institutional housekeeping, housework and related service jobs, food service, cosmetology, retail sales, nursing occupations, and electronics industry industrial work.

2932. U.S. Women's Bureau. *What a Community Can Do to Train Mature Women for Jobs.* Leaflet no. 22. Washington, DC: GPO, 1955. leaflet. L13.11:22.

2933. U.S. Office of Education. *Trade and Industrial Education for Girls and Women: A Directory of Training Programs.* Washington, DC: GPO, 1960. 65p. FS5.284:84002. Lists schools and trade and industrial training programs offered for girls and women.

2934. U.S. Women's Bureau. *Training Opportunities for Women and Girls: Preemployment Course, Initial Training Programs.* Bulletin no. 274. Washington, DC: GPO, 1960. 64p. L13.3:274. Discussion of training opportunities for women in general and in specific fields such as office work, industrial work, nursing, and housekeeping provide brief examples of programs in various cities.

2935. U.S. Office of Manpower, Automation and Training. *Occupational Training of Women under the Manpower Development and Training Act.* Manpower Evaluation Report no. 3. Washington, DC: GPO, 1964. 19p. L1.39/2:3. Evaluation of the Manpower

Development and Training Act of 1962 in relation to the needs of unemployed women focuses on the upgrading of women's skills, particularly those of nonwhite women. Race, age, and education of the women trainees are detailed along with information on their family situation. The occupations for which women were trained, by race, and the employment of the women after training are described.

2936. U.S. Women's Bureau. *Economic Opportunity, Challenge to Community [Address by] Mary Dublin Keyserling, Director, Women's Bureau, Department of Labor, [to] National Council of Jewish Women, Wilmington Section, November 24, 1964.* Washington, DC: The Bureau, 1964. 14p. L13.12:K52/6. Speech on the war on poverty describes the goals and philosophy of the Job Corps centers for girls in providing homemaking and vocational training. In reviewing Economic Opportunity Act programs, Keyserling notes areas where local volunteers can contribute to the effort. The need for minimum wage legislation to address the problems of the working poor is also discussed in relation to the Delaware Commission on the Status of Women.

2937. U.S. Women's Bureau. *Who Are the Disadvantaged Girls 16-21 Years Old?* Washington, DC: The Bureau, 1964. 8p. L13.2:G44. Analysis of census data identified the potential number of women 16-21 years old who could benefit from the Job Corps. Includes data on unemployed girls and girls not in school and not in the labor force. Factors such as race and region are also noted.

2938. U.S. Congress. House. Committee on Education and Labor. Subcommittee on the War on Poverty Program. *Examination of the War on Poverty.* 89th Cong., 1st sess., 12-30 Apr. 1965. 854p. Y4.Ed8/1:P86/2. Examination of the Economic Opportunity Act of 1964 in practice looks at the effectiveness of the program and problems which surfaced in implementation. Although hearings on the act barely discuss the ADC program, testimony does touch on the effect of the Economic Opportunity Act on ADC and female-headed households. The hearing also covers the recruitment of girls for the Job Corps, a topic virtually ignored in the original hearings on the act. Describes community action programs initiated with a focus on youth programs.

2939. U.S. Office of Economic Opportunity. *Every Girl Needs a Chance to Become Somebody.* Washington, DC: GPO, 1966. [22]p. PrEx10.2:G44. Mostly pictorial informational booklet is geared toward potential female Job Corps participants.

2940. U.S. Office of Economic Opportunity. *Job Corps Centers for Women.* Washington, DC: GPO, 1966. 4p. PrEx10.2:J57/4. Basic information on the structure and operation of Job Corps centers for women outlines qualifications for applicants, types of training, recruiting techniques, allowances for enrollees, and community relations.

2941. U.S. Congress. Senate. Committee on Labor and Public Welfare. Subcommittee on Employment, Manpower, and Poverty. *Examination of the War on Poverty, Hearings, Part 3.* 90th Cong., 1st sess., 24 Apr. 1967. 1067-1286pp. Y4.L11/2:P86/4/pt.3. Hearing held in Albuquerque, New Mexico focuses on poverty and anti-poverty programs with the Native American population, and includes information on MDTA programs aimed at women. Also highlights family planning as part of the anti-poverty program.

2942. U.S. Congress. Senate. Committee on Labor and Public Welfare. Subcommittee on Employment, Manpower, and Poverty. *Examination of the War on Poverty, Hearings, Part 4.* 90th Cong., 1st sess., 27 Apr. - 2 May 1967. 1287-1596pp. Y4.L11/2:P86/4/pt.4. Hearings held in Washington, D.C. highlight family planning and day care assistant training as part of the war on poverty. Provides data on sex, race, and number of children for training applicants.

2943. U.S. Congress. Senate. Committee on Labor and Public Welfare. Subcommittee on Employment, Manpower, and Poverty. *Examination of the War on Poverty, Hearings, Part 6.* 90th Cong., 1st sess., 8-9 May 1967. New York, NY. 1749-2045pp. Y4.L11/2:P86/4/pt.6. Continued war on poverty site hearings examine the training needs of welfare mothers. The role of family planning and day care are noted by some witnesses, as is the availability of medical care.

2944. U.S. Congress. Senate. Committee on Labor and Public Welfare. Subcommittee on Employment, Manpower, and Poverty. *Examination of the War on Poverty, Hearings, Part 10.* 90th Cong., 1st sess., 10-18 July 1967. 3027-3435pp. Y4.L11/2:P86/4/pt.10. Hearings examine the successes and failures under the job training programs of the Economic Opportunity Act. Particularly stressed is the transition from training to employment, with issues of day care availability and family planning briefly considered. Some testimony provides information on Job Corps programs aimed at girls.

2945. U.S. Congress. Senate. Committee on Labor and Public Welfare. Subcommittee on Employment, Manpower, and Poverty. *Examination of the War on Poverty, Hearings, Part 15.* 90th Cong., 1st sess., 1,2 June 1967. 4483-4787pp. Y4.L11/2:P86/4/pt.15. Testimony at hearings held in Boston, Springfield, and New Bedford, Massachusetts presents an overview of Massachusetts OEO programs, particularly Job Corps and community action programs, and describes several programs which primarily serve women.

2946. U.S. Office of Economic Opportunity. *Facts on Women's Centers of Job Corps.* Washington, DC: GPO, 1967. 4p. PrEx10.2:J57/10. Overview of the function of Job Corps women's centers describes the selection of the young women and the basic program of education, training, health, and recreation services.

2947. U.S. General Accounting Office. *Review of Establishment and Operation of the St. Petersburg Job Corps Center for Women, St. Petersburg, FL., Office of Economic Opportunity.* Washington, DC: The Office, 1968. 67p. GS1.13:Sa2p. Detailed study examined program cost and operation of the first women's training center established under the Job Corps. The center was in operation from April 1965 through July 1966. The primary concern of the report is with cost rather that programs.

2948. U.S. Manpower Administration. *Work Incentive Program, from Welfare to Wages.* Washington, DC: GPO, 1968. [8]p. leaflet. L1.2:W89/17.

2949. U.S. Congress. House. Committee on Education and Labor. Ad Hoc Hearing Task Force on Poverty. *Economic Opportunity Amendments of 1969, Hearings on H.R. 513.* 91st Cong., 1st sess., 24 Mar.- 29 Apr. 1969. 2 vol. 1442p. Y4.Ed8/1:Ec7/969/pt.1-2. Extensive hearings examined the programs of the Economic Opportunity Act of 1964 with a particular emphasis on Job Corps, Head Start, and Community Action Programs. Very little discussion of women in relation to these programs is found in part one, however, part two presents testimony on specific Job Corps programs for women in several states.

2950. U.S. General Accounting Office. *Effectiveness and Administration of Albuquerque Job Corps Center for Women under the Economic Opportunity Act of 1964, Albuquerque, N. Mex., Office of Economic Opportunity.* Washington, DC: The Office, 1969. 80p. GA1.13:Al1b.

2951. U.S. General Accounting Office. *Effectiveness and Administration of the Keystone Job Corps Center for Women under the Economic Opportunity Act of 1964, Drums, Pennsylvania.* Washington, DC: The Office, 1969. 67p. GA1.13:K52/2. Review of the effectiveness of the Job Corps program studied the residential Job Corps Center for

Women operated by the RCA Service Company. Among the factors analyzed were length of stay, graduate placement, educational development programs, and center staff salaries and qualifications.

2952. U.S. Manpower Administration. *How Skilled Will She Be When She Leaves Job Corps? Stenographers, Clerks, Typists, Business Machine Operators.* Washington, DC: GPO, 1969. 6p. leaflet. L1.2:St4/2.

2953. U.S. Manpower Administration. *Work Incentive Program: from Welfare to Wages.* Washington, DC: GPO, 1969. 4p. leaflet. L1.2:W89/7/969. Earlier edition published in 1968.

2954. U.S. Office of Economic Opportunity. *Job Corps Women's Centers Vocational Programs.* Job Corps Handbook 440W. Washington, DC: GPO, 1969. 10p. PrEx10.10:440(w). Charts list occupations for which women can train at 17 Job Corps centers around the country. Also includes a directory of Job Corps Women's Centers, Placement Officers and Contractors, and Job-Corps-YWCA Extension Residence Programs.

2955. U.S. Congress. House. Committee on Ways and Means. *Work Incentive Program: Survey of Selected Welfare and Employment Service Agencies (January 1970).* 91st Cong., 2d sess., 1970. Committee print. 551p. Y4.W36:W89/5. Presents results of a questionnaire sent to WIN project directors and state and local welfare administrators in 29 jurisdictions. Specific questions target information on WIN assessments and referrals by category (father, mother, older child), assistance on providing day care, and type of child care arrangements. Officials were asked to estimate AFDC referrals to WIN if day care arrangements could be made.

2956. U.S. Congress. Senate. Committee on Finance. *Material Related to Work and Training Provisions of Administration Revision of H.R. 16311.* 91st Cong., 2d sess., 1970. Committee print. 39p. Y4.F49:F21/6. Charts and short summaries describe the characteristics of employment and training programs for welfare recipients. Mostly the data illustrates the failure of states to fully implement the WIN program for AFDC recipients. Problems in state implementation of WIN are highlighted.

2957. U.S. Congress. Senate. Committee on Finance. *Reports on the Work Incentive Program by the Department of Labor and the Department of Health, Education, and Welfare.* 91st Cong., 2d sess., 1970. Committee print. 345p. Y4.F49:W89/8. The first report on the WIN program describes the structure, goals, and operation of the program, and assesses the progress to date. The problems encountered in implementing the program are discussed and needed improvements are noted. Among the areas targeted for improvement is child care support services. The HEW portion of the report also reviews state level implementation of family planning services to AFDC recipients and the goal of reducing illegitimacy. Data on referrals to manpower agencies under WIN by age and sex for states is provided. A detailed assessment of the WIN program by the Auerbach Corporation, reprinted here, examines the reasons for the failure of the program to serve mothers with preschool age children.

2958. U.S. Congress. House. *Lump-Sum Death Payment, Provision Relating to Work Incentive Program, Intermediate Care Facilities Coverage under Medicaid, and Public Assistance Income Disregard, Conference Report to Accompany H.R. 10604.* H. Rept. 747, 92d Cong., 1st sess., 1971. 10p. Serial 12932-6. The disagreement between House and Senate versions of this bill relate to administrative provision of the Work Incentive Program for AFDC recipients.

2959. U.S. Manpower Administration. *Tiene Ustad Una Hija? Usted Puede Ayudarla [Anime a Su Hija a Que Ingrese en el Job Corps].* Washington, DC: The Administration, 1971. 8p. leaflet. L1.2:J57/21/spanish.

2960. U.S. Manpower Administration. *Usted Puede [Ingresar en el Job Corps].* Washington, DC: The Administration, 1971. 8p. leaflet. L1.2:J57/22/spanish.

2961. U.S. Manpower Administration. *You Can [Join the Job Corps].* Washington, DC: GPO, 1971. 8p. leaflet. L1.2:J57/22.

2962. U.S. Manpower Administration. *You Can Help Her [Join the Job Corps.]* Washington, DC: The Administration, 1971. 8p. leaflet. L1.2:J57/21.

2963. U.S. Congress. Joint Economic Committee. Subcommittee on Fiscal Policy. *The Effectiveness of Manpower Training Programs: A Review of Research on the Impact on the Poor.* Studies in Public Welfare Paper no. 3. 92d Cong., 2d sess., 1972. Committee print. 70p. Y4.Ec7:W45/paper 3. Examination of the effectiveness of five manpower training programs, Manpower Development and Training Act, Neighborhood Youth Corps, Job Corps, Opportunities in the Business Sector, and the Work Incentive Program, analyzes outcomes for men and women.

2964. U.S. Congress. Senate. Committee on Finance. *Work Incentive Program, Hearing.* 92d Cong., 2d sess., 27 June 1972. 76p. Y4.F49:W89/11. Hearing on the Talmadge amendments to the Work Incentive Program focuses on WIN operations and success. Minimal information is provided on the child care issue.

2965. U.S. Manpower Administration. *The WIN II Program: A Way for Everyone to Win.* Washington, DC: GPO, 1972. 10p. L1.2:W89/12. Basic description of the amended WIN program.

2966. U.S. Manpower Administration. *Your Rights under the New Work Incentive Program.* Washington, DC: GPO, 1972. 12p. L1.2:W89/11. Information for persons under the WIN program describes who must register, how the program works, payment, and grievances.

2967. U.S. Women's Bureau. *Help Improve Vocational Education for Women and Girls in Your Community.* Washington, DC: GPO, 1972. 5p. L36.102:V85/972. Summary information reviews how the Vocational Education Amendments of 1968 can help open opportunities for women to enter higher paying occupations. Also suggests opportunities under related community action programs. Earlier edition published in 1971.

2968. U.S. Manpower Administration. *Women in Apprenticeship - Why Not?* by Norma Briggs. Manpower Research Monograph no. 33. Washington, DC: GPO, 1974. L1.39/3:33. Demonstration project in Wisconsin explored the possibilities of more fully utilizing women in apprenticable trades. As the project progressed, it also focused on minimizing barriers in the attitudes and procedures of persons in government agencies and educational systems toward women in apprenticeships. As part of the study a survey was conducted to determine the attitudes of skilled trade shops to the employment of women and the women entering into the apprenticeship program in the first two years.

2969. U.S. Manpower Administration. Office of Research and Development. *Black Teenage Girl Project In-School Neighborhood Youth Corps, Memphis, Tenn., Final Report.* Technical report PB231-184. Washington, DC: The Office, 1974. 196p. L1.2:N31/7. Study examined the effects of participation in a low-income structured work program on the functional level of black teenage girls.

2970. U.S. Congress. House. Committee on Education and Labor. Subcommittee on Elementary, Secondary, and Vocational Education. *Sex Discrimination and Sex Stereotyping in Vocational Education, Hearings.* 94th Cong., 1st sess., 17 Mar.- 28 Apr. 1975. 405p. Y4.Ed8/1:Se9. Examination of current practices of sex discrimination and sex stereotyping in vocational education programs discusses the impact of these practices on women's employment and earning potential. Explores HEW's Title IX enforcement and control of discrimination practices in educational programs. Appendix includes a reprint of "Women in Vocational Education: Project Baseline Supplemental Report," which includes data on employment and occupation by sex.

2971. U.S. Dept. of Health, Education and Welfare. *The Vocational Preparation of Women: Report and Recommendations of the Secretary's Advisory Committee on the Rights and Responsibilities of Women, 1975.* by JoAnn M. Steiger and Sara Cooper. Washington, DC: GPO, 1975. 82p. HE1.2:W84/4/975. Analyzes the education of working women and how education affects their employment opportunities. Specifically examines women's participation in vocational education programs and presents recommendations on federal policy to encourage vocational opportunities for women. Appendix provides summaries of HEW and state supported research and development projects dealing with career and vocational education for women. Provides statistics on educational attainment and earnings by sex in selected occupations; occupational distribution by education, sex, and income; enrollment in vocational education programs by sex and field of study; and total and percentage female enrollment in each vocational field of study by detailed occupational program.

2972. U.S. Office of Manpower. *Title XX and CETA: A Coordination Guide for Title XX Administrators.* Washington, DC: GPO, 1976. 43p. HE1.6/3:C73/4. Report explores ways the CETA program and Title XX programs can work together to provide services such as child day care services, social service support units, and comprehensive employment and family services.

2973. U.S. Bureau of Occupational and Adult Education. Vocational Education Research Branch. *A Model to Retrain Women Teachers and Skilled Women as Teachers in Nontraditional Vocational Programs.* by Roslyn D. Kane, et al. Washington, DC: GPO, 1977. 119p. HE19.108:M72. Discussion of the rationale for retraining women teachers in vocational education teaching accompanies a model for retraining. Statistics on the percentage of women enrolled in male-intensive trade and industrial courses, by state, and teacher needs and supply in vocational education are presented.

2974. U.S. Congress. House. Committee on Agriculture, U.S. Congress. House. Committee on Education and Labor, and U.S. Congress. House. Committee on Ways and Means. Welfare Reform Subcommittee. *Administration's Welfare Reform Proposal: Joint Hearings on H.R. 9030, Part V, Public Witnesses, New York, NY.* 95th Cong., 1st. sess., 9-10 Nov. 1977. 740p. Y4.Ag8/1:W45/pt.5. Public testimony responds to welfare reform proposals which eliminate existing welfare programs and replace them with a cash benefit program and a workfare component. Issues discussed include problems with current benefits, work programs and child care, minimum wage and workfare, job training, and housing. Current program discussion focuses on the adequacy of CETA and AFDC. The plight of the elderly is also discussed.

2975. U.S. Congress. House. Committee on Agriculture, U.S. Congress. House. Committee on Education and Labor and U.S. Congress. House. Committee on Ways and Means. Welfare Reform Subcommittee. *Administration's Welfare Reform Proposal: Joint Hearings on H.R. 9030, Part VII, Public Witnesses.* 95th Cong., 1st. sess., 16,17 Nov. 1977. Minneapolis, MN; West Memphis, AR. 704p. Y4.Ag8/1:W45/pt.7. Site hearings explore issues of

benefit levels, workfare, and the CETA and WIN programs in relation to H.R. 9030, the welfare reform proposal.

2976. U.S. Congress. House. Committee on Agriculture, U.S. Congress. House. Committee on Education and Labor and U.S. Congress. House. Committee on Ways and Means. Welfare Reform Subcommittee. *Administration's Welfare Reform Proposal: Joint Hearings on H.R. 9030, Part VIII, Public Witnesses.* 95th Cong., 1st. sess., 17,18 Nov. 1977. Los Angeles, CA. 367p. Y4.Ag8/1:W45/pt.8. Hearing on welfare reform proposals looks at workfare, benefit levels and accounting methods, the adequacy of current CETA programs, and family life issues. Also gives the Hispanic perspective on the proposals.

2977. U.S. Congress. House. Committee on Agriculture, U.S. Congress. House. Committee on Education and Labor and U.S. Congress. House. Committee on Ways and Means. Welfare Reform Subcommittee. *Administration's Welfare Reform Proposal: Joint Hearings on H.R. 9030, Part IX, Public Witnesses.* 95th Cong., 1st. sess., 21-23 Nov. 1977. 294p. Y4.Ag8/1:W45/pt.9. Hearings held in Miami, Harrisburg, PA, and Hawaii focused on the administration's workfare proposals. Common themes among witnesses are the problems of welfare mothers and chronic dependency issues, and the CETA program.

2978. U.S. Congress. House. Committee on Education and Labor. Subcommittee on Employment Opportunities. *Comprehensive Employment and Training Act, Hearing.* 95th Cong., 1st sess., 16 Nov. 1977. Oakland, CA. 339p. Y4.Ed8/1:C73/14. Hearing considers revamping the Comprehensive Employment and Training Act. Includes testimony on discrimination against women in CETA programs. The problems of older workers, particularly older women and displaced homemakers, are described amid accusations that the CETA program gives their needs low priority. Provision of services such as education and child care are also briefly addressed. The CETA program is criticized for replacing public sector service jobs with low paid CETA positions, adversely affecting women and minorities who hold the majority of these positions.

2979. U.S. Employment and Training Administration. *WIN Handbook.* ET Handbook no. 318. Washington, DC: GPO, 1977. 406p. L37.8/2:318. Later editions published in 1984 (3028).

2980. U.S. Employment and Training Administration. *The Work Incentive (WIN) Program and Related Experiences.* Washington, DC: GPO, 1977. 46p. L37.14:49. Literature review summarizes research conducted on the WIN program and related research on low-income families. Topics represented include work potential and orientation of welfare persons, impact of WIN, family structure and personal motivation, and policy alternatives placed in historical perspective.

2981. U.S. Bureau of Occupational and Adult Education. *An Equal Chance, A Parent's Introduction to Sex Fairness in Vocational Education.* by Martha Matthews and Shirley McCune, Resource Center on Sex Roles in Education. Washington, DC: GPO, 1978. 23p. HE19.102:Eq2. Simplistic guide tells parents why they should encourage their boys and girls to consider non-traditional occupations for vocational training.

2982. U.S. Bureau of Occupational and Adult Education. *Steps toward Sex Equity in Vocational Education: An Inservice Training Design.* by Joyce Kaser, et al., Resource Center on Sex Roles in Education. Washington, DC: GPO, 1978. 209p. HE19.102:V85/2. Workshop outline on sex equity in vocational education reviews the legal context of sex equity, recognizing sex bias in vocational education programs, and designing programs to eliminate sex bias and promote equity. Includes training for participants.

2983. U.S. Commission on Civil Rights. Iowa Advisory Committee. *The CETA Program in Des Moines.* Washington, DC: GPO, 1978. 44p. CR1.2:D46. Iowa Advisory Committee study focused on the operation of the central Iowa CETA programs and assessed the ability of the system to meet the needs of the disadvantaged. Provides statistics on Des Moines area CETA program participants by sex, proportion of women and minorities hired under the Public Service Employment Program, and transitions to city or private employment by sex and race.

2984. U.S. Congress. Senate. Committee on Human Resources. *Comprehensive Employment and Training Act Amendments of 1978, Report to Accompany S. 2570.* S. Rept. 95-891, 95th Cong., 2d sess., 1978. 275p. Serial 13197-6. Among the amendments to the CETA program included in S. 2570 is the inclusion of displaced homemakers on the list of special groups with particular labor market disadvantages. The need for special focus programs for displaced homemakers job training is briefly summarized. Several CETA projects are described including Pierce County Rape Relief Project, a preschool support service project of the Rehabilitation Center, Inc., the Career Development Center for Displaced Homemakers in Pueblo County, Colorado, and a "Shelter for Battered Women" project in Bangor, Maine.

2985. U.S. Employment and Training Administration. *Layoff Time Training: A Key to Upgrading Workforce Utilization and EEO Affirmative Action: A Case Study in the Northern California Canning Industry.* R & D Monograph no. 61. Washington, DC: GPO, 1978. 117p. L37.14:61. Describes and evaluates a project to provide education and training to laid-off cannery workers in California so that they could move on to high-paying, less seasonal jobs in the canning industry. The program was incorporated into a court ruling which resulted from an EEO suit brought against the company by a class of workers primarily made up of Spanish-speaking women.

2986. U.S. National Center for Educational Statistics. *Women in Vocational Education.* by Evelyn R. Kay. Washington, DC: GPO, 1978. 9p. HE19.302:W84/3. Brief analysis of statistics on women enrolled in vocational education schools looks at enrollment of women and of men at different age intervals. Also looks at race/ethnicity and full-time versus part-time status, and at labor force participation of students by sex.

2987. U.S. Office of Education. *Implementing Title IX and Attaining Sex Equity: A Workshop Package for Elementary-Secondary Educators - The Vocational Educator's Role.* by Joyce Kaser, et al., Resource Center on Sex Roles in Education. Washington, DC: GPO, 1978. 183p. HE19.141/2:V85. Materials and outline for conducting a Title IX workshop for vocational educators in elementary and secondary schools reviews the law and addresses the need for eliminating sex bias from vocational education programs. One session focuses on identifying sex-bias and taking action to eliminate it.

2988. U.S. Office of Education. *Try It, You'll Like It!: A Student's Introduction to Nonsexist Vocational Education.* by Martha Matthews and Shirley McCune, Resource Center on Sex Roles in Education. Washington, DC: GPO, 1978. 57p. HE19.102:T78. Information on career choices and vocational education is presented in a format that leads students to question sex role stereotypes and to consider nontraditional vocational choices. Presents some basic facts on work force composition and women and minority labor force status. Short quizzes help reinforce information presented.

2989. U.S. Women's Bureau. *Displaced Homemakers: A CETA Program Model, Fitchburg, Massachusetts.* Washington, DC: GPO, 1978. 52p. L36.102:H75. Describes a program of counseling and job placement services for low income displaced homemakers in Fitchburg, Massachusetts.

2990. U.S. Women's Bureau. *A Woman's Guide to Apprenticeship.* Washington, DC: The Bureau, 1978. 24p. L36.108:Ap6. Information for women on the apprenticeship system highlights some of the barriers women can encounter when trying to enter apprenticeship.

2991. U.S. Women's Bureau. *Women in Nontraditional Jobs: A Program Model, Boston: Nontraditional Occupations Program for Women.* Washington, DC: GPO, 1978. 79p. L36.102:J57b. Describes a CETA Nontraditional Occupations Program pilot project in Boston, which provided classroom training and work experience in the building maintenance skilled trades for low income women.

2992. U.S. Women's Bureau. *Women in Nontraditional Jobs, A Program Model, Denver: Better Jobs for Women.* Washington, DC: GPO, 1978. 60p. L36.102:J57d. Describes a Denver program for placing women in apprenticeships and apprenticeship programs. Details are provided on intake and orientation procedures, tutoring and prevocational counseling, and job development, placement, and post-placement objectives. Appendix includes job descriptions, a trade interest inventory, an occupational interest checklist, an enroller procedure guide, and sample forms.

2993. U.S. Congress. House. Committee on Education and Labor. Subcommittee on Employment Opportunities. *Welfare Jobs Legislation, Hearing on H.R. 4425 and H.R. 4426.* 96th Cong., 1st sess., 25 Oct. 1979. 125p. Y4.Ed8/1:W45/11. Hearing considers a work and training bill for AFDC recipients. The primary focus is on the CETA program and two-parent families and the relationship between CETA and WIN. Although the bill is aimed at AFDC recipients, there is little discussion of the proposal in relation to female heads of households.

2994. U.S. National Center for Research in Vocational Education. *Fostering Sex Fairness in Vocational Education: Strategies for Administrators.* by JoAnn M. Steiger, et al. Information Series no. 147. Washington, DC: GPO, 1979. 24p. HE19.143:147. Practical guide to sex fairness in vocational education defines the need for legislated sex fairness and reviews the relevant laws. Provides information on specific actions to foster sex-fairness in the vocational education environment.

2995. U.S. National Center for Research in Vocational Education. *Professional Development Programs for Sex Equity in Vocational Education.* by Mary Ellen Verheyden-Hilliard. Information Series no. 148. Washington, DC: GPO, 1979. 21p. HE19.143:148. Review of the need for sex equity in vocational education describes how professional development can help achieve this goal. Notes current professional development activities and recommends future directions.

2996. U.S. National Institute of Education. *Vocational Education Sex Equity Strategies.* by Louise Vetter, et al. Research and Development Series no. 144. Washington, DC: GPO, 1979. 258p. HE19.218:144. Guide for an eight-hour workshop on sex equity strategies for vocational education. Addresses issues such as creating awareness, recruiting and retaining students for nontraditional classes, and interacting with the community. Reprints materials from numerous sources and provides an annotated bibliography.

2997. U.S. Office of Education. *Guidelines for Sex-Fair Vocational Education Materials.* by Women on Words and Images. Washington, DC: GPO, 1979. 32p. HE19.108:Se9/2. Provides examples of sex-biased approaches found in educational materials and suggests sex-fair alternatives.

2998. U.S. Women's Bureau. *Training for Child Care Work: Project Fresh Start.* Washington, DC: GPO, 1979. 48p. L36.102:C43/2. Describes a CETA sponsored program in Worcester, Massachusetts, to train economically disadvantaged women in child care skills.

2999. U.S. Women's Bureau and U.S. Bureau of Occupational and Adult Education. *A Guide to Coordinating CETA/Vocational Education Legislation Affecting Displaced Homemaker Programs.* Washington, DC: GPO, 1979. 38p. L36.108:C73. Overview of federally sponsored programs with components applicable to training and job development for displaced homemakers reprints relevant sections of the Vocational Education Act of 1963 and the Comprehensive Employment and Training Act Amendments of 1978.

3000. U.S. Agency for International Development. *Bringing Women In: Towards a New Direction in Occupational Skills Training for Women.* by International Center for Research on Women. Washington, DC: The Agency, 1980. 31p. S18.55:Oc1. Report examines the rationale for vocational training for women and identifies barriers to obtaining and utilizing such training. Women's employment and income-generating skills training from the viewpoint of the Agency for International Development and development assistance is explored.

3001. U.S. Congress. House. Committee on Education and Labor. Subcommittee on Employment Opportunities. *Welfare Jobs Legislation, Part 2, Mark Up/Hearings on H.R. 4425.* 96th Cong., 2d sess., 13, 27 Feb. 1980. 212p. Y4.Ed8/1:W45/11/pt.2. Continued hearing on a welfare jobs bill takes a closer look at what is needed to make CETA and WIN programs work for AFDC recipients and at the practical problems of federally sponsored job training programs.

3002. U.S. Employment and Training Administration. *Implementing Welfare-Employment Programs: An Institutional Analysis of the Work Incentive (WIN) Program.* R & D Monograph no. 78. Washington, DC: GPO, 1980. 346p. L37.14:78. Report takes a close look at the organizational structure, management, and operation of the WIN program from the federal to the state and local level. The study specifically identified WIN programs which were particularly successful, and identified factors which were related to successful programs.

3003. U.S. Employment and Training Administration. Office of Information. *Work Incentive Program.* Washington, DC: The Office, 1980. [5]p. leaflet. L37.21:W89.

3004. U.S. General Accounting Office. *Need to Ensure Nondiscrimination in CETA Programs.* Washington, DC: The Office, 1980. 34p. GA1.13:HRD-80-75. Study of state and local governments acting as prime sponsors in the CETA program found that they did not adequately serve women, the handicapped, persons over 45, or some minorities. Department of Labor efforts and new CETA regulations to improve nondiscrimination efforts are described.

3005. U.S. Women's Bureau. *CETA Journey: A Walk on the Women's Side.* Pamphlet no. 19. Washington, DC: GPO, 1980. 36p. L36.112:19. Highlights the sections of the CETA regulations that are most pertinent to women and women's groups and serves as a guide for women's organizations desiring to take an active role in local CETA programs.

3006. U.S. Women's Bureau. *A Woman's Guide to Apprenticeship.* Pamphlet no. 17. Washington, DC: GPO, 1980. 30p. L36.112:17. Presents information on the apprenticeship system and the current status of women as apprentices, and notes barriers that exist for women in becoming apprentices. Federal legislation affecting apprenticeship is highlighted.

3007. U.S. Women's Bureau. *Women in Apprenticeship...There's a Future In It!* Leaflet no. 58. Washington, DC: GPO, 1980. [7]p. L36.110:58.

3008. U.S. Congress. House. Committee on Education and Labor. Subcommittee on Elementary, Secondary, and Vocational Education. *Hearings on Reauthorization of the Vocational Education Act of 1963, Part 11, Sex Equity in Vocational Education, Hearings on H.R. 66.* 97th Cong., 1st sess., 16-17 Dec. 1981. 430p. Y4.Ed8/1:V85/9/pt.11. A panel of witnesses discuss progress made since the 1976 amendments to the Vocational Education Act to eliminate sex bias and sex stereotyping in vocational education. Areas where improvement was still needed are noted. Primarily the advances in enrolling women in nontraditional courses and in fields not linked to a specific sex are noted, and the lack of specific actions on the part of state advisory councils are highlighted. Special attention is paid in testimony to the failure to encourage sex equity in government sponsored job training programs such as CETA. The lengthy report of the National Advisory Council on Vocational Education and the National Advisory Council on Women's Education Programs, *Increasing Sex Equity, The Impact of the 1976 Vocational Education Amendments on Sex Equity in Vocational Education* (3017) is reprinted.

3009. U.S. National Advisory Council on Vocational Education. *Building Your Own Scenario: Part 1, Home Economics, Sex Equity, and Alternative Futures.* by Louise Vetter, Rodney K. Spain, and Maureen E. Kelly. Washington, DC: GPO, 1981. 20p. ED1.2:Sce6/set/pt.1. Planning guides for educators to make them more aware of sex equity issues encourages integration of the concepts into vocational education programs. Each part includes exercises to define the community and the educational agency in terms of sex equity issues, future scenarios for discussion, and planning exercises to meet sex equity objectives. Includes a bibliography.

3010. U.S. National Advisory Council on Vocational Education. *Building Your Own Scenario: Part 2, Trade and Industry, Sex Equity, and Alternative Futures.* by Louise Vetter, Rodney K. Spain, and Maureen E. Kelly. Washington, DC: GPO, 1981. 20p. ED1.2:Sce6/set/pt.2. See 3009 for abstract. Accompanied by a facilitator's guide, ED1.2:Sce6/set/pt.2/guide.

3011. U.S. National Advisory Council on Vocational Education. *Building Your Own Scenario: Part 3, Health Occupations, Sex Equity, and Alternative Futures.* by Louise Vetter, Rodney K. Spain, and Maureen E. Kelly. Washington, DC: GPO, 1981. 20p. ED1.2:Sce6/set/pt.3. See 3009 for abstract.

3012. U.S. National Advisory Council on Vocational Education. *Building Your Own Scenario: Part 4, Business and Office Occupations, Sex Equity, and Alternative Futures.* by Louise Vetter, Rodney K. Spain, and Maureen E. Kelly. Washington, DC: GPO, 1981. 20p. ED1.2:Sce6/set/pt.4. See 3009 for abstract.

3013. U.S. National Advisory Council on Vocational Education. *Building Your Own Scenario: Part 5, Agriculture, Sex Equity, and Alternative Futures.* by Louise Vetter, Rodney K. Spain, and Maureen E. Kelly. Washington, DC: GPO, 1981. 20p. ED1.2:Sce6/set/pt.5. See 3009 for abstract.

3014. U.S. National Advisory Council on Vocational Education. *Building Your Own Scenario: Part 6, Marketing and Distributive Education, Sex Equity, and Alternative Futures.* by Louise Vetter, Rodney K. Spain, and Maureen E. Kelly. Washington, DC: GPO, 1981. 20p. ED1.2:Sce6/set/pt.6. See 3009 for abstract.

3015. U.S. National Advisory Council on Vocational Education. *Building Your Own Scenario: Part 7, Technical Education, Sex Equity, and Alternative Futures.* by Louise Vetter, Rodney K. Spain, and Maureen E. Kelly. Washington, DC: GPO, 1981. 20p. ED1.2:Sce6/set/pt.7. See 3009 for abstract.

3016. U.S. National Advisory Council on Vocational Education. *Building Your Own Scenario: Part 8, Industrial Arts, Sex Equity, and Alternative Futures.* by Louise Vetter, Rodney K. Spain, and Maureen E. Kelly. Washington, DC: GPO, 1981. 20p. ED1.2:Sce6/set/pt.8. See 3009 for abstract.

3017. U.S. National Advisory Council on Vocational Education and the National Advisory Council on Women's Educational Programs. *Increasing Sex Equity: The Impact of the 1976 Vocational Education Amendments on Sex Equity in Vocational Education.* Washington, DC: GPO, 1981. 191p. Y3.V85:2Se9. Analysis of the impact of the sex equity provisions of the 1976 Vocational Education Amendments looks at the implications of funding mechanisms, federal and state roles, and local implementation for success enrolling women and girls in non-traditional vocational programs. Specifically examines enrollment data and reports from the 15 states representing 55 percent of all vocational enrollments. The report was also included in a 1981 House hearing (3008).

3018. U.S. National Commission for Employment Policy. *Increasing the Earnings of Disadvantaged Women.* Washington, DC: GPO, 1981. 175p. Y3.Em7/3:10/11. Recommendations to improve the employment outlook of disadvantaged women are based on an analysis of the problems faced by women finding jobs, particularly jobs with adequate wages. The report recommends policies and programs to address the education and training needs of disadvantaged women. Sex equity issues and the experience of women in federally sponsored employment and training programs are reviewed.

3019. U.S. Social Security Administration. Office of Research and Statistics. *Using Private Employment Agencies to Place Welfare Recipients in Jobs: Final Report of the Michigan Private Employment Agency Report.* by Michigan Department of Social Services. Washington, DC: GPO, 1981. 156p. HE3.2:Us4/final. An evaluation of the effectiveness of using private employment agencies to place welfare recipients in jobs is based on a program in Oakland and Wayne Counties in Michigan targeting AFDC recipients in the WIN program. The results showed very limited success with this type of approach to placement.

3020. U.S. Congress. Senate. Committee on Labor and Human Resources. Subcommittee on Education, Arts, and Humanities. *Vocational and Adult Education Consolidation Act, Hearing on S. 2325.* 97th Cong., 2d sess., 1 July 1982. 303p. Y4.L11/4:V85/3. Within this hearing on legislation to consolidate vocational and adult education grant programs is discussion of sex equity within vocational education programs.

3021. U.S. General Accounting Office. *An Overview of the WIN Program: Its Objectives, Accomplishments, and Problems.* Washington, DC: GPO, 1982. 62p. GA1.13:HRD-82-55. Overview of the WIN program looks at the number of AFDC recipients required to register for WIN, number of WIN participants who entered employment and left AFDC, and characteristics of AFDC recipients who entered employment.

3022. U.S. Commission on Civil Rights. Wisconsin Advisory Committee. *Vocational Education: Where Are the Minorities and Women?* Washington, DC: GPO, 1983. 41p. CR1.2:Ed8/10. Study of Milwaukee Area Technical College students looked at enrollment patterns of minorities and women and at job placement of students. Minorities and women were concentrated in classes with low income potential, and progress designed to address the inequities were found to be ineffective. Background statistics provided include enrollment in programs by income level of graduates, by sex and minority status, and by daytime or evening class attendance.

3023. U.S. Congress. House. Committee on Education and Labor. Subcommittee on Elementary, Secondary, and Vocational Education. *Vocational-Technical Education Act of 1983,*

Hearings on H.R. 4164. 98th Cong., 1st sess., 1-9 Nov. 1983. 547p. Y4.Ed8/1:V85/13/983. Hearing on a new vocational education bill discusses the need for strong ties between vocational education programs and the JTPA. Witnesses also explore the problem of sex discrimination in vocational education and the need to continue efforts to recruit minorities and women into better paying vocational and technical fields. The need to allocate funds to overcome sex bias in vocational education and to support displaced homemaker programs is stressed.

3024. U.S. Congress. Senate. Committee on Labor and Human Resources. *Women in Transition, 1983, Hearing on Examination of Problems Faced by Women in Transition from Work without Pay to Economic Self-Sufficiency.* 98th Cong., 1st sess., 8 Nov. 1983. 189p. Y4.L11/4:S.hrg.98-624. Displaced homemakers and the need for job training and support services are the focus of this hearing on the transition from full-time homemaker to worker. The need to ensure that federal job training programs, particularly JTPA, are serving the needs of displaced homemakers is stressed. Also noted in testimony is the added burden of sex discrimination faced by former homemakers entering the job market. Several women with first hand experience of the problems discussed testify as to their experience with target programs.

3025. U.S. General Accounting Office. *Does AFDC Workfare Work? Information Is Not Yet Available from HHS's Demonstration Projects.* Washington, DC: GPO, 1983. 27p. GA1.13:IPE-83-3. Describes the funding of Health and Human Services's AFDC workfare programs and examines the need for adequate evaluation of the success of these programs.

3026. U.S. Congress. House. Committee on Education and Labor. *Vocational-Technical Education Amendments of 1984, Report Together with Minority, Dissenting, and Additional Views to Accompany H.R. 4164.* H. Rept. 98-612, 98th Cong., 2d sess., 1984. 38p. Serial 13587. Favorable report on continuing state grants for the encouragement of vocational education includes a new provision setting aside 5 percent of grants for programs on overcoming sex bias and providing support services for women participating in vocational education programs. Basic data on the participation of women in the labor force and in vocational education programs is furnished. The case for targeting activities for the elimination of sex bias and sex stereotyping is presented.

3027. U.S. Congress. Senate. Committee on Labor and Human Resources. *The Vocational Education Act of 1984, Report Together with Additional and Supplemental Views to Accompany S. 2341.* S. Rept. 98-507, 98th Cong., 2d sess., 1984. 42p. Serial 13560. Report on a bill to improve access to and quality of vocational education discusses the shortcomings of vocational education in meeting the needs of women and individuals with special needs. Programs for single parents and homemakers are mandated by the bill which also directs each state to employ a full-time coordinator for promoting sex equity and administering vocational education programs focused on women. An amendment to the bill continues authorization of the Women's Educational Equity Act.

3028. U.S. Dept. of Labor and U.S. Dept. of Health and Human Services. *WIN Handbook.* 4th ed. ET Handbook 318. Washington, DC: The Dept., 1984. looseleaf. L37.8/2:318/2. Policy and program guidance for state WIN operators updates earlier editions published in 1977.

3029. U.S. General Accounting Office. *CWEP's Implementation Results to Date Raise Questions about the Administration's Proposed Mandatory Workfare Program.* Washington, DC: GPO, 1984. 45p. GA1.13:PEMD-84-2. GAO studied the success of Community Work Experience Programs in reducing AFDC program costs. GAO found major differences

between the Administration's CWEP-based plan to replace the WIN program and the structure of existing CWEPs.

3030. U.S. Congress. House. Committee on Government Operations. Subcommittee on Human Relations and Intergovernmental Relations. *Barriers to Self-Sufficiency for Single Female Heads of Families.* 99th Cong., 1st sess., 9-10 July 1985. 825p. Y4.G74/7:F21. Work force proposals and ways to move AFDC mothers off of welfare dependency is the topic of hearing testimony. Reagan era welfare policies and programs, and their implications for female headed households, are examined, and exemplary state programs are highlighted. Issues of education and child care are discussed in depth. Emphasis is on WIN and AFDC programs with considerable discussion of the Employment and Training CHOICES program in Massachusetts.

3031. U.S. Office of Technology Assessment. *Displaced Homemakers: Programs and Policy, An Interim Report.* Washington, DC: GPO, 1985. 35p. Y3.T22/2:2H75. Reviews programs to address the employment and training needs of displaced homemakers, and describes the characteristics of displaced homemakers and their income support needs during training. Possibilities for displaced homemaker programs under the Perkins Vocational Education Act and the JTPA are summarized. Services offered in displaced homemaker programs and their effectiveness are examined.

3032. U.S. Women's Bureau. *The Coal Employment Project: How Women Can Make Breakthroughs into Nontraditional Industries.* Washington, DC: GPO, 1985. 44p. L36.102:C63. Describes the Coal Employment Project, a demonstration project in Tennessee whose goal was to assist women in preparing for and gaining entry into the coal mining industry. The report is written as a program model on which programs for other male dominated industries can be based.

3033. U.S. Women's Bureau. *Job Training in Food Services for Immigrant, Entrant, and Refugee Women.* Washington, DC:GPO, 1985. 34p. L36.102:J57/2. Report describes a project to train Chinese immigrant and refugee women in food service job skills and to develop techniques which could be transferred to similar programs for other immigrant and refugee groups.

3034. U.S. Women's Bureau. *National Women's Employment and Education Project.* Washington, DC: GPO, 1985. 106p. L36.102:W84/9. Describes the National Women's Employment and Education Project, a program designed to assist female heads of families become self-supporting through traditional and nontraditional skills training and employment. Aspects of the program include employment readiness skills development, job finding assistance, skills training by employers, follow-up support services, and upward mobility assistance.

3035. U.S. Congress. House. Committee on Ways and Means. Subcommittee on Public Assistance and Unemployment Compensation. *Work, Education, and Training Opportunities for Welfare Recipients, Hearings.* 99th Cong., 2d sess., 13 Mar.- 17 June 1986. 537p. Y4.W36:99-91. Hearings examine work, training, and education opportunities for AFDC recipients. Also considers the relationship between welfare and teenage pregnancy. The benefits and the limitations of the WIN programs is a recurring theme through out the hearings. State sponsored work, training, and workfare programs are examined, particularly programs in California and Massachusetts.

3036. U.S. Congress. Senate. Committee on Labor and Human Resources. *Amending the Job Training Partnership Act, Report to Accompany S. 2069.* S. Rept. 99-317, 99th Cong., 2d sess., 1986. 31p. Serial 13675. Proposed amendment to the Job Training Partnership Act includes a requirement that the Secretary use Title IV-D research, demonstration, and

pilot project funds to target populations with multiple barriers to employment, specifically displaced homemakers. The problems faced by displaced homemakers in the labor market are briefly set out.

3037. U.S. Office of Vocational and Adult Education. *Outcomes of Vocational Education for Women, Minorities, the Handicapped, and the Poor.* by Paul B. Campbell, et al., National Center for Research in Vocational Education, Ohio State University. Washington, DC: The Office, 1986. 204p. ED1.33:Ou8. Research examines the effect of socioeconomic group, race/ethnicity, gender, and handicapped condition on high school curriculum choices and education beyond high school with specific reference to vocational education. Labor force participation and earnings are also examined. Changes in federal policy to meet the vocational education needs of these groups are recommended.

3038. U.S. Congress. House. Committee on Education and Labor. Subcommittee on Employment Opportunities. *Child Care Services for Job Corps, Hearing.* 100th Cong., 1st sess., 23 July 1987. 70p. Y4.Ed8/1:100-39. Hearing notes that, although the Job Corps is supposed to serve equal numbers of men and women, lack of child care services keep young women from participating. Witnesses describe the effect of the lack of child care on female participation in Job Corps programs and the potential of the Job Corps to change the lives of poor, unwed, teenage mothers.

3039. U.S. Congress. House. Committee on Education and Labor. Subcommittee on Employment Opportunities. *H.R. 2246, the Jobs for Employable Dependent Individuals Act (JEDI) and the Proposed Substitute Amendment Thereto, Hearings.* 100th Cong., 1st sess., 8 July - 3 Nov. 1987. 220p. Y4.Ed8/1:100-56. Hearing on a bill to provide incentives to states to focus JTPA programs on the long term dependent welfare population describes the need to break the dependency cycle. The program would reward states for developing programs for welfare recipients lacking the education and job skills to find and hold employment. A successful Indiana program, Sisters, which pairs young unwed mothers with successful women from similar backgrounds, is described. Most testimony centers on the structure of the state bonus program.

3040. U.S. Congress. Senate. Committee on Finance. Subcommittee on Social Security and Family Policy. *Welfare: Reform or Replacement? (Work and Welfare), Hearing.* 100th Cong., 1st sess., 23 Feb. 1987. 412p. Y4.F49:S.hrg.100-320. One of a series of hearings on welfare reform examines the issue of work requirements and the prospects for avoiding long-term dependency through employment and training programs. Background information on the WIN program is provided with a brief review of the implementation of WIN by state. Work training and incentive programs, including the GAIN program in California, are discussed. The various work incentive schemes are explored with reference to job training, taxes, and child care and health care costs. The need to move AFDC mothers into higher paying jobs is also discussed.

3041. U.S. Congress. Senate. Committee on Labor and Human Resources. *Jobs for Employable Dependent Individuals Act, Report Together with Additional Views.* S. Rept. 100-20, 100th Cong., 1st sess., 1987. 42p. Serial 13731. The long-term AFDC recipient is the target of this job training proposal which provides bonuses to states successfully placing long-term AFDC recipients in unsubsidized employment. The report notes that programs such as WIN and the Job Training Partnership Act tend to serve low income persons who are easily trained and placed in jobs. The target groups for this bill are youths, AFDC mothers, and the disabled.

3042. U.S. Congress. Senate. Committee on Labor and Human Resources. *Work and Welfare, Hearings on Reviewing the Extent of Long-Term Poverty and Dependency, Focusing on Job Training and Employment Services Provided by the Government.* 100th Cong., 1st sess.,

21 Jan.- 4 Feb. 1987. 292p. Y4.L11/4:S.hrg.100-37. Hearing testimony highlights elements of successful workfare programs.

3043. U.S. Congress. Senate. Committee on Labor and Human Resources. Subcommittee on Employment and Productivity. *Jobs for Employable Dependent Individuals Act, Hearing on S. 514.* 100th Cong., 1st sess., 6 Mar. 1987. 40p. Y4.L11/4:S.hrg.100-163. Brief hearing on a bill to provide incentives to states successfully targeting individuals at risk of long-term welfare dependency in JTPA programs focuses on the special needs of youths and particularly of young unwed mothers. The basic educational needs of this population are stressed, and the tendency of JTPA programs to enroll only those easily trained and placed is noted.

3044. U.S. Congressional Budget Office. *Work-Related Programs for Welfare Recipients.* Washington, DC: GPO, 1987. 80p. Y10.2:W89/2. Report on the structure and effectiveness of welfare work program policies examines the outcomes for welfare mothers under job training and placement programs. The operation of JTPA and WIN programs are described and the characteristics of state WIN demonstration programs are summarized. Issues in AFDC work policies include day care, participation by mothers of young children, the role of workfare, education and training programs, and transitional assistance payments.

3045. U.S. General Accounting Office. *Work and Welfare: Current AFDC Work Programs and Implications for Federal Policy.* Washington, DC: GPO, 1987. 170p. GA1.13:HRD-87-34. Review of AFDC work programs examines program results with specific discussion of the role of services, such as child care, in program success. Program characteristics and the populations they serve are reviewed. Specific problems in the WIN program and other such programs are listed for congressional consideration. Some state WIN demonstration programs are highlighted.

3046. U.S. Congress. House. Committee on Education and Labor. *H.R. 2246, Jobs for Employable Dependent Individuals [JEDI], Hearing.* 100th Cong., 2d sess., 25 May 1988. 116p. Y4.Ed8/1:100-88. The particular education and service needs of the long term dependent are the focus of much of the testimony given on the proposed Jobs for Employable Dependent Individuals Act. The administrative details of the program designed to encourage states to target JTPA programs to the long-term dependent are also debated at length. The possibilities for JEDI to address the needs of women and chronic poverty are also debated.

3047. U.S. Congress. House. Committee on Education and Labor. Subcommittee on Employment Opportunities. *Hearing on H.R. 2246, Jobs for Employable Dependent Individuals "JEDI."* 100th Cong., 2d sess., 20 April 1988. 39p. Y4.Ed8/1:100-69. Brief hearing on JEDI, an act to reward states for targeting JTPA programs to long-term dependent welfare recipients, highlights the necessary programs needed for single mothers to successfully enter the job market. Day care availability and basic literacy and education services are stressed.

3048. U.S. General Accounting Office. *Work and Welfare: Analysis of AFDC Employment Programs in Four States.* Washington, DC: The Office, 1988. 112p. GA1.13:HRD-88-33FS. Review of WIN demonstration programs examines Massachusetts' Employment and Training Choices (ET), Michigan Opportunity and Skills Training (MOST), the JOBS program in Oregon, and Texas' Employment Services Program. Information provided on each program include funding, participants and target populations, assessment of needs and assignment to activities, employment-related activities, coordination with other agencies, child care assistance, and program results.

3049. U.S. Congress. House. Committee on Education and Labor. *Applied Technology Education Amendments of 1989, Report Together with Individual and Separate Views to Accompany H.R. 7.* H. Rept. 101-41, 101st Cong., 1st sess., 1989. 145p. Report on reauthorization of the Carl D. Perkins Vocational Education Act highlight the bill's provisions including sex equity and displaced homemaker programs.

3050. U.S. Congress. House. Committee on Education and Labor. *Hearings on H.R. 2039, The Jobs Training Partnership Act Amendments of 1989, Hearings.* 101st Cong., 1st sess., 29 June 1989 - 12 January 1990. 866p. Y4.Ed8/1:101-70. Hearing on reform of the JTPA discusses the need to focus program resources on the less job ready population and to provide moderate or high skill training. Some testimony specifically addresses the feminization of poverty and the problems of displaced homemakers. Data on placements under JTPA by sex and race are presented and the need to target groups at risk of long-term welfare dependency is discussed.

3051. U.S. Congress. House. Committee on Education and Labor. Subcommittee on Employment Opportunities. *Hearing on H.R. 3069, The Displaced Self-Sufficient Act of 1989.* 101st Cong., 1st sess., 28 Sept. 1989. 120p. Y4.Ed8/1:101-52. Witnesses at a hearing on a bill to create a separate title in the JTPA to address the needs of displaced homemakers describe the devastating effect of divorce on full-time homemakers. The need for job training programs along with a full range of support services is stressed. Personal accounts highlight the role of displaced homemaker programs in helping these women achieve self-sufficiency.

3052. U.S. Congress. House. Committee on Ways and Means. Subcommittee on Human Resources. *Oversight of the Family Support Act of 1988, Hearing.* 101st Cong., 1st sess., 25 May 1989. 194p. Y4.W36:101-27. Hearing considers the proposed regulations for the JOBS program and debates the perceived restrictiveness of the regulations for states. Participation requirements, proposed rules on child care, measuring program effectiveness, and the potential for moving families off the welfare rolls are the central topics of discussion. The number of AFDC recipients actively participating in the JOBS programs is reviewed.

3053. U.S. Congress. Senate. Committee on Labor and Human Resources. *The Job Training and Basic Skills Act, Report Together with Additional Views to Accompany S. 543.* S. Rept. 101-129, 101st Cong., 1st sess., 1989. 142p. Report provides details of a bill amending the JTPA. Some specific areas addressed by the bill are incentives to enroll persons most a risk of long-term dependency and a special initiative on displaced homemakers.

3054. U.S. Congress. Senate. Committee on Labor and Human Resources. *The Labor Shortage - Poverty and Educational Aspects, Hearings.* 101st Cong., 1st sess., 26-27 Jan. 1989, 341p. Y4.L11/4:S.hrg.101-13. Hearing to address the predicted labor shortage in the year 2000 centers primarily on the need to invest in education for disadvantaged children and to improve literacy. The prospects for a growing poverty population while mid- and high-skill jobs remain unfilled are explored. Existing programs to provide education and training for welfare mothers are discussed and the need for employers now and in the future to accommodate the needs of working mothers is stressed.

3055. U.S. Congress. Senate. Committee on Labor and Human Resources. *Nontraditional Employment for Women Act, Hearing on S. 975.* 101st Cong., 1st sess., 8 June 1989. 114p. Y4.L11/4:S.hrg.101-201. Hearing considers a bill to encourage the training of women in nontraditional occupations through the Job Training Partnership Act and the Carl D. Perkins Vocational Education Act. Testimony reveals the effect of occupational segregation on women's economic futures and discusses the channeling of women into

traditional fields under JTPA and Perkins funded programs. Successful programs to train women in nontraditional areas and to recruit women for vocational education in the higher paying male-dominated occupations are described.

3056. U.S. Congress. Senate. Committee on Labor and Human Resources. *The Nontraditional Employment for Women Act, Report to Accompany S. 975.* S. Rept. 101-90, 101st Cong., 1st sess., 1989. 30p. Report provides background on the experience of women under the JTPA and stresses the tendency to train women participants in low-paying, female dominated occupations. The bill reported would encourage JTPA programs to train women in nontraditional, higher paying occupations.

3057. U.S. Congress. Senate. Committee on Labor and Human Resources. Subcommittee on Education, Arts and Humanities. *Reauthorization of the Carl D. Perkins Vocational Education Act, Hearings on S. 1109.* 101st Cong., 1st sess., 22 June - 27 July 1989. 1123p. Y4.L11/4:S.hrg.101-317. Extensive hearings held around the country explore the proposed reauthorization of the Carl D. Perkins Vocational Education Act. A recurring theme throughout the hearings and supporting materials is the need to ensure sex equity in vocational education and to encourage women to train in nontraditional areas. The role of state councils on vocation education and the need to coordinate vocational education programs with public assistance-linked jobs training programs such as JTPA are discussed. Programs for the handicapped and the need to improve career guidance are also common themes.

3058. U.S. Congress. Senate. Committee on Labor and Human Resources. Subcommittee on employment and Productivity. *Tish Sommers and Laurie Shields Displaced Homemakers Training and Economic Self-Sufficiency Assistance Act of 1989, Hearing on S. 1107.* 101st Cong., 1st sess., 1 June 1989. 95p. Y4.L11/4:S.hrg.101-219. Hearing considers a bill to target Department of Labor funding, particularly JTPA funds, to training programs for displaced homemakers. Witnesses include displaced homemakers and program directors who describe the special counseling and job training needs of these women and the need to recognize their training as being of equal importance to retraining displaced workers.

3059. U.S. General Accounting Office. *Job Training Partnership Act: Information on Training, Placements, and Wages of Male and Female Participants.* Washington, DC: The Office, 1989. 21p. GA1.13:HRD-89-152FS. Review of data on the experience of men and women under the JTPA compares skill level of training and occupational placement and wages of male and female participants. The training and placement of women in moderate level positions is noted, however, the overall higher wages of men regardless of skill level of training is also documented. Detailed data on training and placement by occupation is provided.

3060. U.S. Congress. House. Committee on Education and Labor. *Job Training Partnership Act Amendments of 1990, Report Together with Minority, Individual, and Additional Views to Accompany H.R. 2039.* H. Rept. 101-747, 101st Cong., 2d sess., 1990. 117p. Report on amendment of the JTPA to improve service to hard-to-serve adults and youth describes the need to target AFDC recipients and school dropouts, and to encourage JTPA programs to train women in higher paying nontraditional occupations.

3061. U.S. Congress. Senate. Committee of Finance. Subcommittee on Social Security and Family Policy. *Implementation of the JOBS Program, Hearing.* 101st Cong., 2d sess., 26 Feb. 1990. 94p. Y4.F49:S.hrg.101-816. Hearing on implementation of the JOBS program discusses the basic education needs of AFDC parents and state commitment of funds to child care. Experience in states with JOBS programs already in place is described focusing on employment placement and attachment to the labor force. Sanctioning,

withholding AFDC from teenage mothers who do not finish high school, is also examined in practice. Existing state welfare-to-work programs are reviewed.

SERIALS

3062. U.S. Dept. of Labor. *WIN: Annual Report to the Congress.* Washington, DC: GPO, 1970-1979. annual. L1.71:year. Describes activities under the WIN program with supporting data on the number of registrants by sex and race/ethnicity; hourly wages by sex and ethnic group; and occupation by sex and ethnic group. Also provides data on support services, including day care services. The 1978 report provides an overview for the years 1968 to 1978. The first four reports were issued as House Ways and Means committee prints under SuDoc number Y4.W36:W89/4/year.

3063. U.S. National Center for Social Statistics. *Assessments Completed and Referrals to Manpower Agencies by Welfare Agencies under Work Incentive Program for AFDC Recipients.* Washington, DC: The Center, 1970 - 1972. quarterly. HE17.619: date. Data on assessment and referrals of AFDC recipients includes referrals by state, sex, and age, and reason individuals were found not appropriate for WIN referrals including categories relating to availability of child care and age and number of children at home.

3064. U.S. National Center for Social Statistics. *Work Incentive Program.* Washington, DC: GPO, June 1974 - Dec. 1975. monthly. HE17.619/2:date. Monthly statistics by state on the WIN program provides data on reasons for exemption of some AFDC recipients, AFDC payment reductions, social services such as family planning and home management initiated for participants, and day care services initiated for participants.

19

Child Care
and Eldercare

The documents described below represent only some of the government documents on the care of children outside the home. Documents were selected based on the extent to which they reflected day care as a women's employment issue. Documents approaching child care from a purely child development perspective, including most of the documents on Head Start, were not included.

The first documents on child care report on Emergency Nursery Schools during the Depression years (3065-3068). The World War Two years saw the publication of dozens of documents on child care for war workers. Some of the standouts include the proceedings of a 1941 conference on day care in defense areas (3071), a review of federal efforts to support day care written for the War Manpower Commission (3074), and the 1943 Senate hearing on *Wartime Care and Protection of Children of Employed Mothers* (3082). The continued employment of women with children after World War Two was discussed at the 1945 conference on the problems of youth in the transition period (3098). The status of day care in industrial growth areas in 1953 accompanies a review of day care in times of economic stress including World War One, the Great Depression, and World War Two (3104).

The war on poverty programs of the 1960s included day care as a component, as detailed in *Guide to States Welfare Agencies for the Development of Day Care Services* (3115). Sessions on the need for day care, attitudes, and legislation characterize the proceedings of a 1965 conference on day care (3127) and of a 1968 Women's Bureau consultation (3132). Federal funding for day care is reviewed in *Federal Funds for Day Care Projects* (3140). Day care and public assistance is linked in several documents including a compilation of background materials for the Senate Committee on Finance, *Child Care, Data and Materials* (3148, 3170, 3194). Hearings and committee prints linking welfare and child care were held in 1971 (3146, 3149, 3152-3153), in 1973 (3163), and in 1974 (3172, 3176). Other hearings discussing AFDC and child care are found in Chapter 18, Vocational Education and Employment Training Programs, and in Volume I.

During the 1970s and 1980s significant documents on day care were regularly produced. Industry's involvement in day care was the focus of reports by the Women's Bureau in 1971 (3157), 1982 (3214), and 1989 (3292); in congressional hearings held in 1983 (3217, 3219); in a GAO report in 1986 (3242); and a 1988 hearing where the focus was small business (3259-3260).

Among the more unique documents of the 1970's and 1980's are an Office of Economic Opportunity study of the effect of day care on the labor force participation of low-income women (3166), the nine-part hearing on the Child and Family Services Act (3176), the report of the National Childcare Consumer Study (3177), and a collection of papers, *Policy Issues in Day Care*

(3196). A House Select Committee on Children, Youth, and Families report, *Families and Child Care: Improving the Options* (3229) provides a good overview of the issues as of 1984 and pulls together much of the information from the extensive hearings held that same year (3230). In 1988 and 1989 Congress considered the Act for Better Child Care and held a series of in-depth hearings on child care and the best methods of government support.

In the late 1980s Congress also began to consider the impact on working women of caring for elderly parents. Congressional publications such as *Double Duty: Caring for Children and the Elderly* (3263) and *Sharing the Caring: Options for the 90s and Beyond* (3300) discuss the stress on working women of eldercare and ways for the federal government and for employers to ease the burden. Other topics regularly covered in documents include tax credits for child care, latchkey programs, and child care for federal employees. A substantial number of documents related to child care are also described in Volume I.

3065. U.S. Children's Bureau. *Care of Children in Day Nurseries.* by Glenn Steele. Washington, DC: GPO, 1932. 11p. L5.20:209/sep. Presents data on use of day nurseries and on number of families receiving free use of day nurseries for 32 metropolitan areas.

3066. U.S. Office of Education. Advisory Committee on Emergency Nursing Schools. *Bulletin of Information for Emergency Nursery Schools: Administration and Program.* Bulletin no. 1. Washington, DC: The Office, 1934. 32p. I16.2:N93/no.1. Guidelines on staffing, health considerations, and program activities for emergency nursery schools are presented along with basic information on child development theory.

3067. U.S. Office of Education. Advisory Committee on Emergency Nursery Schools. *Emergency Nursery Schools during 1st Year, 1933-34.* Washington, DC: The Committee, 1934? 63p. I16.2:N93/2/933-34.

3068. U.S. Office of Education. Advisory Committee on Emergency Nursery Schools. *Emergency Nursery Schools during 2nd Year, 1934-35.* Washington, DC: The Committee, 1935? 114p. I16.2:N93/2/934-35.

3069. U.S. Children's Bureau. *Recommendations Adopted by Conference on Day Care of Children of Working Mothers, Held under the Auspices of the Children's Bureau, July 31-Aug. 1941.* Washington, DC: The Bureau, 1941? 3p. L5.2:D33.

3070. U.S. Children's Bureau. *Children Bear Promise of a Better World: Are We Safeguarding Those Whose Mothers Work?* Defense of Children Series no. 2. Washington DC: GPO, 1942. 12p. L5.41:2. Reviews day care issues related to employment of women in war industries. Talks generally about factors a mother should consider before going to work, about standards for day care, and about community involvement in day care.

3071. U.S. Children's Bureau. *Proceedings of Conference on Day Care of Children of Working Mothers with Special Reference to Defense Areas Held in Washington, DC: July 31 and August 1, 1941.* Publication no. 281. Washington DC: GPO, 1942. 84p. L5.20:281. Conference meetings discuss the need for child day care in light of the expected rise in the number of mothers of young children entering employment in the war industries. The experience of the British with this problem is outlined and organizational structures for setting up day care programs are discussed.

3072. U.S. Office of Civilian Defense. *Volunteers in Child Care.* Washington, DC: GPO, 1942. 12p. Pr32.4402:C43/prelim. Suggests approaches to organizing and training volunteer child care workers.

3073. U.S. Office of Defense Health and Welfare Services. *Day-Care Program of Federal Government.* Washington, DC: The Office, 1942. 5p. Pr32.4502:D33. The fact that wartime employment demands cannot be met without employing a large number of women is stressed in the introduction to this overview of day care needs. Organizing day care to meet the various needs is reviewed with suggestions on types of day care. The federal program to aid in the establishment of local day care programs and coordination of activities is described.

3074. U.S. Office of Defense Health and Welfare Services. Day Care Section. *Report to War Manpower Commission on Development of Services for Children of Working Mothers, Dec. 26, 1942.* Washington, DC: The Office, 1942. 27p. Pr32.4502:M85 or Pr32.4502:C43. Details of federal efforts to coordinate and support provision of day care services for children of working mothers are provided in this report which also presents recommendations to improve the program. The status of cooperative activities among federal agencies and with the states is reviewed, and the status of child care facilities is summarized. Financial resources to support day care are described and the case for additional federal funding is made. Details the problems with the Lanham Act as a federal aid source for day care. Brief overviews are given of 21 state plans for services to children of working mothers, and the results of a survey of the local ability to meet wartime day care needs are presented.

3075. U.S. Office of Education. *Colleges and Universities Reporting Nursery School and/or Kindergarten Laboratories, 1942.* Washington, DC: The Office, 1942. 13p. FS5.2:N93. Lists nursery schools and kindergarten laboratories at colleges and universities.

3076. U.S. Office of Education. *Extended School Services for Children of Working Mothers.* Washington, DC: GPO, 1942. 2p. FS5.2:C43/2. Review of the need for child care services for working mothers provides information on establishing school services. Reprinted from *Education for Victory* (September 15,1942).

3077. U.S. Children's Bureau. *Brief Summary on Day Care Program for Children of Working Mothers in 13 Representative Communities.* Washington, DC: The Bureau, 1943. 15p. L5.2:C43/26. Results of a survey profile 13 communities which had well-rounded child day care programs, all of which were "war-impacted" areas. Illustrates the details of organizing such services and discusses financing, staffing, use of services, and location of services. The main services examined include counselling and referral services, foster family day care, and group-care centers. Factors key to the success of a program are identified.

3078. U.S. Children's Bureau. *Supervised Homemaker Service: A Method of Child Care.* Publication no. 296. Washington, DC: GPO, 1943. 36p. L5.20:296. Describes the philosophy and procedures of homemaker service programs including qualifications and supervision of homemakers and personnel practices.

3079. U.S. Children's Bureau and U.S. Office of Civilian Defense. *The Selection and Training for Volunteers in Child Care.* Publication no. 299. Washington, DC: GPO, 1943. 36p. L5.20:299.

3080. U.S. Congress. House. *Supplemental Estimates of Appropriation for the Office for Emergency Management: Communication from the President of the United States Transmitting Supplemental Estimates of Appropriation for the Office of Emergency Management Amounting to $2,973,000 for the Fiscal Year 1943.* H. Doc. 113, 78th Cong., 1st sess., 1943. 3p. Serial 10792. Requests a supplemental appropriation to fund child care programs for mothers employed in war industries.

3081. U.S. Congress. Senate. Committee on Education and Labor. *Providing for the Care of Children of Mothers Employed in War Areas, Report to Accompany S. 1130.* S. Rept. 363, 78th Cong., 1st sess., 1943. 9p. Serial 10756. Reports a proposed war areas child care act which would provide federal funds to states for the provision of day care to mothers employed in war industries. Provides a history of the legislation and reviews the purpose and importance of the bill. Testimony from the hearing is very briefly summarized.

3082. U.S. Congress. Senate. Committee on Education and Labor. *Wartime Care and Protection of Children of Employed Mothers, Hearing on S. 876 and S. 1130.* 78th Cong., 1st sess., 8 June 1943. 113p. Y4.Ed8/3:C43/3. Hearing considers bills to provide federal funds to state and local government for use in providing day care facilities or extended school services for employed mothers. Briefly reviews existing federal child care programs such as those operated for low income women through the WPA and the Lanham Act. Presents some information on the number of working mothers and the resultant need for day care services, and on the types of services currently utilized. Successful extended school programs and company day care facilities are highlighted. The racial implications of federal grants to states as opposed to direct federal funding is pointed out in opposition to the bill.

3083. U.S. Office of Civilian Defense. *Services for Children of Working Mothers in War Time, a Manual for Child Care Committees of Local Defense Councils.* Washington, DC: GPO, 1943. 23p. Pr32.4406:C43. Guide to planning child care services describes the need for wartime child care and the types of services to consider. Suggests possible facilities and community resources and notes sources of federal financial assistance.

3084. U.S. Office of Defense Health and Welfare Services. *The Care of Children of Working Mothers.* Washington, DC: The Office, 1943. 4p. Pr32.4502:C43/2. Describes the various types of day care services required from school services to homemakers services. Also covers briefly the role of a day care committee as part of a local defense council.

3085. U.S. Office of Defense Health and Welfare Services. *Services to Children of Working Mothers in Region 4 ODHWS, April 27, 1943.* Washington, DC: The Office, 1943. [15]p. Pr32.4502:C43/3.

3086. U.S. Office of Education. *All-Day School Programs for Children of Working Mothers.* School Children in the War Series Leaflet no. 2 Washington, DC: GPO, 1943. 12p. FS5.32:2. Advice on conducting a survey to determine the need for extended school services for children of working mothers is accompanied by basic information on structuring a program.

3087. U.S. Office of Education. *Legal Provisions Affecting Extended School Services for Children in Wartime.* Washington, DC: The Office, 1943. 11p. FS5.2:C43/4. Summarizes the legal reasoning used to allow schools to utilize funds and facilities for day care services for working parents.

3088. U.S. Office of Education. *Nursery Schools Vital to America's War Effort.* School Children and the War Series Leaflet no. 3. Washington, DC: GPO, 1943. 15p. FS5.32:3. Review of the basics on why America needs nursery schools for the children of working mothers accompanies guidelines on setting up facilities and staffing.

3089. U.S. Office of Education. *School Services for Children of Working Mothers: Why? What? How? Where? When?* School Children and the War Series Leaflet no. 1. Washington, DC: GPO, 1943. 6p. FS5.32:1. Presents tips on organizing extended school services for children of mothers working in the war industries.

3090. U.S. Office of Education. *Suggestions for State Staff on Extended School Services for Children of Working Mothers.* Washington, DC: The Office, 1943? 13p. FS5.2:C43/3. Guide for administrators describes implementing extended school services for the children of working mothers engaged in war work.

3091. U.S. Office of Emergency Management. Office of War Information. *Does Our Community Need to Provide Day Care for Children of Working Mothers? Discussion Leaflet from Office of War Information.* Washington, DC: GPO, 1943. 4p. Pr32.5018:3. Describes the work a community committee can do in establishing day care programs for children of working mothers and notes help available from the federal government. Includes a list of day care reference works and films.

3092. U.S. Bureau of Manpower Utilization. Plant and Community Services Section. *Questions and Answers on Development of Programs for Care of Children of Working Mothers.* Washington,DC: The Bureau, 1944. 11p. Pr32.5202:C43. Basic information on community child care programs for children of war workers reviews methods of determining need, organization, financing including use of government funds, types of child care services, and recreation services for school-age children. Also briefly covers employer participation in child care.

3093. U.S. Children's Bureau. *Mothers and Children Come First in Good Community Daycare Programs.* Washington, DC: The Bureau, 1944. 3p. L5.2:M85/6. (under L5.2:M85/7 National Archives). Information on community support for day care services to working mothers describes four types of services, counselling, foster-family day care, day care centers, and extended school services. Ends with a list of questions to asses the adequacy of the local day care program.

3094. U.S. Children's Bureau. *Policy of Children's Bureau on Care of Infants Whose Mothers Are Employed.* by Katharine F. Lenroot. Washington, DC: The Bureau, 1944. 2p. L5.2:C43/33. Recommendations of the Children's Bureau on care of children under three whose mothers are employed stresses the need for individual attention, preferably from the mother, but in a foster-family setting if the mother must work.

3095. U.S. Federal Security Agency. Division of Personnel Supervision and Management. Employee Counseling and Services Section. *Information on Public Day Care Facilities for Children of Working Mothers.* Washington, DC: The Agency, 1944? 4p. FS1.2:C43. Summary report of a survey of day care needs conducted by the Children's Bureau defines types of day care, with rates and entrance requirements, and lists specific day care centers in the Washington, D.C. area.

3096. U.S. Office of Community War Services. *9-Point Publicity Program for Use of Local Day Care Committees.* Washington, DC: The Office, 1944. 4p. leaflet. FS9.2:D33.

3097. U.S. Office of Education. *Report on Extended School Centers in 54 Communities in War Areas, Dec. 1943.* Washington, DC: The Office, 1944. 8p. FS5.2:Sch65/8. Overview of the operation of extended school services for children of working mothers reports on capacity, attendance, and fees. Factors affecting utilization of the centers such as location, program standards, fees, and hours of operations are described. Provides a list of communities reporting for the survey.

3098. U.S. Children's Bureau. *Report of the Conference of Labor-Union Women with the Children's Bureau on Problems of Youth in the Transition Period.* Washington, DC: The Bureau, 1945. 12p. L5.2:Y8/12. Among the child welfare issues discussed at length at this meeting of women representing 23 unions and the Children's Bureau is the need for day care services for children of working mothers. That many of the mothers who worked

during the war would continue to do so after the war is noted, and the high cost and lack of child care facilities is discussed. Federal aid and community coordinated services were seen as key factors in addressing the problem.

3099. U.S. Children's Bureau. *Family Day Care, Suggested Bibliography.* Washington, DC: The Bureau, 1946. 1p. L5.2:D33/2/946.

3100. U.S. Children's Bureau. *Homemaker Service, Method of Child Care.* Publication no. 296. Washington, DC: GPO, 1946. 39p. FS3.209:296. Describes the philosophy behind homemaker services and outlines personnel practices for operating agencies.

3101. U.S. Children's Bureau. *Mothers for a Day: The Care of Children in Families Other Than Their Own.* by Bessie E. Trout and Dorothy E. Bradbury. Publication no. 318. Washington, DC: GPO, 1946. 37p. FS3.209:318. Information on the organization of family day care programs and on selecting a family day care home includes a chart of typical fee schedules for family day care.

3102. U.S. Department of State. *El Cuidado del Nino Durante e Dia [Normas Utiles Para Atender a Los Ninos de Madres que no Pueden Cuidarlos Durante el Dia.]* Washington, DC: GPO, 1950. 27p. S16.7:295. Presents standards for day care of children of working mothers.

3103. U.S. Department of State. *Ocuidao da Crinca Durante a Dia [Normas Uties para Cuidar das Criancas\ Cujas Maes Nao Podem Quida-las Durante a Dia].* Washington, DC: GPO, 1951. 29p. S16.7:306. Presents standards for day care of children of working mothers.

3104. U.S. Women's Bureau. *Employed Mothers and Child Care.* Bulletin no. 246. Washington, DC: GPO, 1953. 92p. L13.3:246. Study examined the employment of mothers and related day care needs in 27 cities identified as areas of recent industrial growth. Part I of the report assesses the overall picture of mothers' employment and child care and reviews the child care provisions in past periods of economic stress including WWI, the depression, and WWII. City studies look at existing child care facilities and evidence of present and future need.

3105. U.S. Women's Bureau. *Provisions for Income Tax Deductions for Child Care and Housekeeping Services in Legislation Introduced in 83rd Congress (1953).* Washington, DC: The Bureau, 1953. 11p. L13.2:In2/1. Summary in chart form reviews the provisions of bills to provide tax deductions for child care and housekeeping services for working parents.

3106. U.S. Women's Bureau and U.S. Interdepartmental Committee on Children and Youth. *Planning Services for Children of Employed Mothers.* Washington, DC: GPO, 1953. 62p. L13.2:P69. Reviews federal agency experience in providing advisory services and administering funds for child care and educational programs for young children. State programs for the education and care of young children are examined and data on trends in family life, the child population, and the employment of women are furnished.

3107. U.S. Children's Bureau. *Survey Methods for Determining the Need for Services to Children of Working Mothers.* by Jack Wiener. Washington, DC: GPO, 1956. 48p. FS3.202:Se6/2. Presents results of a pilot study to evaluate methods of assessing day care needs of working mothers. Discusses how to determine different needs and notes the variance to be expected from different survey styles.

3108. U.S. Children's Bureau. *Child Care Arrangements of Full-Time Working Mothers.* Publication no. 378. Washington, DC: GPO, 1959. 26p. FS3.209:378. Detailed look at

full-time working mothers and their children provides data on race, age, occupation, and marital status of working mothers, and child care arrangements by region, occupation, race, and marital status of mother.

3109. U.S. Children's Bureau. *Day Care Services.* Folder no. 51. Washington, DC: GPO, 1960. 62p. FS3.210:51. Primarily deals with day care center operations, but also presents various situations where day care is necessary.

3110. U.S. Children' Bureau and U.S. Women's Bureau. *Day Care Services Form and Substance: A Report of a Conference, November 17-18, 1960.* by Gertrude L. Hoffman. Children's Bureau Bulletin no. 393; Women's Bureau Bulletin no. 281. Washington, DC: GPO, 1961. 55p. FS3.209:393 or L13.3:281. Proceedings of a conference on day care addresses the need for day care services, standards, community responsibility, and financing.

3111. U.S. Women's Bureau. *Day Care, What It Is and Why It Is Important.* Washington, DC: The Bureau, 1961. 3p. L13.2:D33. Background information sheet on the need for day care for working mothers, migrant families, and other groups covers the benefits of day care, standards, and financing. A list of questions to determine the day care situation in a community is appended.

3112. U.S. Children's Bureau. *Day Care, Working Mothers and Day Care Services in United States, Facts about Children.* Washington, DC: The Bureau, 1962. 5p. FS3.202:D33/3. Fact sheets on day care of children of working mothers presents basic statistics on number of employed mothers, marital status and employment of mothers, ages of children of employed mothers, racial differences in employment of mothers, why mothers work, and child care arrangements and costs. Two tables present statistics for states on the labor force status of women by marital status, and the labor force status of women with children under six.

3113. U.S. Children's Bureau. *Licensed Day Care Facilities for Children.* by Seth Low. Washington, DC: GPO, 1962. 29p. FS3.202:D33/2. Results of a survey of licensed day care facilities describes state agency responsibilities for licensing, and age and number of children served for which licensing is required. Also surveyed center capacity, number of day care centers, population of community, length of service day, and source of day care center funding.

3114. U.S. Congress. House. Committee on Ways and Means. *Income Tax Deductions for Child-Care Expenses in Case of Woman Deserted by Husband, Report to Accompany H.R. 12470.* H. Rept. 2465, 87th Cong., 2d sess., 1962. 3p. Serial 12434. Reports a bill to amend the Internal Revenue Code of 1954 to allow a woman deserted by her husband to deduct child care expenses on the same basis as a single woman.

3115. U.S. Children's Bureau. *Guides to State Welfare Agencies for the Development of Day Care Services.* Washington, DC: The Bureau, 1963. 23p. FS14.108:D33/2. Guidelines on the development and administration of day care programs describes standards development, determining family needs, facilities, and determining cost and ability of parents to pay for day care services. The requirements of the 1962 Public Welfare Amendments are incorporated into the guidelines.

3116. U.S. Congress. House. Committee on Ways and Means. *Income Tax Deductions for Child-Care Expenses in Case of Woman Deserted by Husband, Report to Accompany H.R. 2085.* H. Rept. 27, 88th Cong., 1st sess., 1963. 3p. Serial 12540. Favorable report on amending the Internal Revenue Code supports an exemption for a woman deserted by her husband from the requirement that she file a joint return in order to claim child care

expenses. The amendment would give the deserted mother the same child care deduction as a single woman.

3117. U.S. Congress. Senate. Committee on Finance. *Income Tax Deduction for Child-Care Expenses in Case of Woman Deserted by Husband, Report to Accompany H.R. 2085.* S. Rept. 69, 88th Cong., 1st sess., 1963. 4p. Serial 12532. Reports a bill to allow a deserted mother to claim a tax deduction for child care expenses on the same basis as a single woman. Under existing law a working wife was required to file a joint return and to reduce the allowable deduction by $1 for each dollar of the couples income over $4,500. The bill relieved the deserted woman of the necessity of filing a joint return in order to take the deduction.

3118. U.S. Children's Bureau. *Day Care Services, Why, What, Where, When, How.* Publication no. 420. Washington, DC: GPO, 1964. 44p. FS14.111:420. Day care basics covers why day care is needed, staffing, and programs.

3119. U.S. Children's Bureau. *Determining Fees for Day Care Services.* Washington, DC: GPO, 1964. 14p. FS14.108:D33/964 or FS14.102:D33/964. Information on fee structures for day care services is related to parents' attitude toward day care selection. Earlier edition issued in 1963.

3120. U.S. Dept. of Health, Education and Welfare. *National Need for Day Care Programs.* by Ellen Winston. Washington, DC: The Department, 1964. 18p. FS14.11:W73/2. Speech given at the 1964 Children's Bureau Day Care Conference discusses the needed for day care, particularly in reference to the poor, and the quality of day care facilities. Also describes methods of developing local day care providers.

3121. U.S. Children's Bureau. *A Pilot Study of Day-Care Centers and Their Clientele.* by Elizabeth Prescott. Publication no. 428. Washington, DC: GPO, 1965. 40p. FS14.111:428. Study looks at attitudes toward child rearing of mothers and teachers of children in day care by socio-economic status and types of day care.

3122. U.S. Children's Bureau. *A Selected Bibliography on Day Care Services.* Washington, DC: GPO, 1965. 94p. FS14.112:D33. Annotated bibliography on all aspects of day care includes books, articles, and government documents primarily from the late 1950s and early 1960s.

3123. U.S. Children's Bureau and U.S. Women's Bureau. *Child Care Arrangements of the Nation's Working Mothers, 1965, a Preliminary Report.* Washington, DC: Children's Bureau, 1965. 14p. FS14.102:C43/3. Preliminary report on a survey of child care arrangements of working mothers presents data on number of children of working mothers by age of children and by family income, child care arrangements by age of child and family income, and amount paid per child per week for child care.

3124. U.S. Welfare Administration. *Spotlight on Day Care.* by Ellen Winston. Washington, DC: The Administration, 1965. 9p. FS14.11:W73/15. Speech delivered at the National Conference on Day Care Services, Washington, D.C., May 13, 1965, highlights changing attitudes on the community need to ensure day care services for children of working mothers and notes growing federal support for day care services.

3125. U.S. Women's Bureau. *Nation's Working Mothers, and the Need for Day Care, Address by Mary Dublin Keyserling, Director, Women's Bureau, U.S. Department of Labor, [to] National Conference on Day Care Services, Washington, D.C., May 14, 1965.* Washington, DC: The Bureau, 1965. 6p. L13.12:K52/9. Comparisons are drawn between the high level of government support for day care for working mothers during World War

II and the decline of that support to almost nothing in 1965 in spite of an increase in mothers' participation in the labor force. The role of financial need in a mother's decision to work is advanced as a primary argument for greater support for day care facilities. The status of child care arrangements in 1965 and 1958 are summarized.

3126. U.S. Bureau of Family Services and U.S. Children's Bureau. *Criteria for Assessing Feasibility of Mother's Employment and Adequacy of Child-Care Plans.* Washington, DC: The Bureau, 1966. 12p. FS14.108:M85. Discussion of reasons for low income mother's seeking employment accompanies guidelines for assessing child care needs and the feasibility of employment. Within the discussion the problems of low income women, employment, and child care cost and availability are highlighted.

3127. U.S. Children's Bureau. *Spotlight on Day Care: Proceedings of the National Conference on Day Care Services, May 13-15, 1965.* Publication no. 438. Washington, DC: GPO, 1966. 173p. FS14.111:438. Address before the General Session of the conference gives a broad overview of attitudes and legislation related to day care. Other sessions dealt with working mothers and the need for day care, the meaning of day care for business and industry, and the image and reality of the American family.

3128. U.S. Women's Bureau. *Day Care and Working Mother, the Magnitude of the Problem on a National Scale, Talk by Mary Dublin Keyserling, Director, Women's Bureau, Department of Labor, [at] Amalgamated Clothing Workers of America, Conference on Day Care and the Working Mother, June 17, 1967, Baltimore, Md.* by Mary Dublin Keyserling. Washington, DC: The Bureau, 1967. 6p. L13.12:K52/25. The fact that mothers work out of necessity and that more day care facilities are needed is the key topic of this speech given at the ground breaking for a day care center built under the auspices of the Baltimore Regional Joint Board of the Amalgamated Clothing Workers of America.

3129. U.S. Women's Bureau and U.S. Children's Bureau. *Preliminary Report of a Consultation on Working Women and Day Care Needs.* Washington, DC: The Bureau, 1967. 28p. L13.2:W84/46/prelim. Three speeches given at the Consultation on Working Women and Day Care Needs held June 1,1967, at Washington, D.C., cover the need for federal day care assistance, day care from the child development perspective, and pending legislation related to child day care.

3130. U.S. Children's Bureau. *Child Care Arrangements of Working Mothers in the United States.* by Seth Low and Pearl G. Spindler. Children's Bureau Publication no. 461. Washington, DC: GPO, 1968. 115p. FS17.210:461. Statistical report profiles working mothers and their child care arrangements. Data provided on mothers includes age, marital status, occupation, education, family income, and reasons for working. Child care arrangements are analyzed by characteristics of mother and data is reported on amount paid for child care and hours of child care per week.

3131. U.S. Congress. House. Committee on Education and Labor. Special Subcommittee on Labor. *Trust Funds for Educational Scholarships and Child Care Centers, Hearing on H.R. 14314.* 90th Cong., 2d sess., 27 Mar. 1968. 56p. Y4.Ed8/1:T77. Hearing considers a bill that would amend the Labor-Management Relations Act to permit employer contributions to trust funds to provide educational scholarships for employees and their dependents, or to establish child care centers for young children of employees. Union representatives discuss the need for these types of employer sponsored ventures, and an Amalgamated Clothing Workers of America sponsored day care project in Baltimore is described.

3132. U.S. Women's Bureau. *Report of a Consultation on Working Women and Day Care Needs.* Washington, DC: GPO, 1968. 86p. L13.2:W84/46. Consultation on day care

needs includes sessions on the need for expanded day care, legislative approaches to the day care problem, and a panel on innovative approaches to the day care shortage. Discusses approaches to training child care workers and the role of Head Start in meeting day care needs.

3133. U.S. Women's Bureau. *Working Mothers and the Need for Child Care Services.* Washington, DC: The Bureau, 1968. 20p. L13.2:M85/3/968 or L13.2:M85/4. Overview of the employment status of mothers and the resulting need for child care provides charts showing basic data on characteristics of working mothers and the type, size, and income of their families. Earlier edition issued in 1967.

3134. U.S. Children's Bureau. *Who Will Take Care of Your Child When You Are in Training or on the Job?* Washington, DC: GPO, 1969. 12p. FS17.210:467. Provides basic information for low income mothers on locating day care providers for children using the local welfare department or community day care council.

3135. U.S. Congress. House. Committee on Education and Labor. Special Subcommittee on Labor. *Joint Labor-Management Trust Funds for Scholarships and Child Care Centers, Hearings on H.R. 4314.* 91st Cong., 1st sess., 7 May 1969. 18p. Y4.Ed8/1:T77/2. Brief hearing presents testimony and statements primarily from union representatives on the need to amend the Labor-Management Relations Act to allow the establishment of joint labor-management trust funds to support scholarship programs and child care centers for employees.

3136. U.S. Congress. Senate. Committee on Labor and Public Welfare. *Joint Labor Management Trust Funds for Scholarships and Child Care Centers, Report to Accompany S. 2068.* S. Rept. 293, 91st Cong., 1st sess., 1969. 5p. Serial 12834-2. Favorable report on changing the Labor-Management Relations Act to allow employers to contribute money to employee trust funds for educational scholarships or day care centers highlights the need for financial assistance in providing access to education and affordable day care.

3137. U.S. Congress. Senate. Committee on Labor and Public Welfare. Subcommittee on Labor. *Employer Contributions for Child-Care Centers and Scholarships under NLRA, Hearing on S. 2068.* 91st Cong., 1st sess., 8 May 1969. 38p. Y4.L11/2:C43. Hearing on amendment of the National Labor-Management Relations Act to permit contributions for day care centers and scholarship trust funds highlights the efforts of the Amalgamated Clothing Workers of America, AFL-CIO, to establish child care services.

3138. U.S. Women's Bureau. *Day Care Fact Sheet.* Washington, DC: The Bureau, 1969. 7p. L13.2:D33/3. Basic profile of day care facts provides a short bibliography.

3139. U.S. Women's Bureau. *Facts about Day Care.* Washington, DC: GPO, 1969. 9p. L13.2:D33/4. Earlier version of *Day Care Facts* (3144).

3140. U.S. Women's Bureau. *Federal Funds for Day Care Projects.* Washington, DC: GPO, 1969. 73p. L13.2:D33/2/969. Federal grant programs for day care projects are listed by administering agency with information on statutory authority, eligibility requirements, proportion that may be granted or limits on funds that may be lent, and the review procedure. Earlier editions issued February 1967 and April 1967.

3141. U.S. Congress. House. Committee on Education and Labor. Select Subcommittee on Education. *Comprehensive Preschool Education and Child Day-Care Act of 1969, Hearings on H.R. 13520.* 91st Cong., 1st and 2d sess. 18 Nov. 1969 - 4 Mar. 1970. 1071p. Y4.Ed8/1:P92/2. Primary focus of this hearing is the benefit of preschool and structured day care for children. Some discussion centers on the day care needs of

working mothers, both those classed as poor and those considered middle class. As a whole, the witnesses are primarily concerned with educational benefits to children.

3142. U.S. Congress. Senate. Committee on the District of Columbia. *Public Day-Care Services in the District of Columbia, Report to Accompany S. 3010.* S. Rept. 1303, 91st Cong., 2d sess., 1970. 3p. Serial 12881-6. Reports legislation authorizing the provision of child day care services to low income parents who are working, seeking work, or in training in the District of Columbia. The need for the bill and its relationship to the Work Incentive Program is described.

3143. U.S. Women's Bureau. *Child Care Services Provided by Hospitals.* Bulletin no. 295. Washington, DC: GPO, 1970. 34p. L13.3:295. Survey of large hospitals collected information on child care centers run by hospitals for their employees and on the negative and positive results of such an arrangement. Provides data on occupation of parents, number and age of children, and fees charged.

3144. U.S. Women's Bureau. *Day Care Facts.* Washington, DC: GPO, 1970. 15p. L13.2:D33/3/970. Short overview of day care presents basic statistics on working mothers and their child care arrangements. Federal programs that provide funding for day care projects are reviewed and the activities of the Federal Panel on Early Childhood are summarized. Gives short profiles of innovative day care programs at federal, state and local levels.

3145. U.S. Children's Bureau. *Day Care, Everybody's Problem, Volunteer to Help in Your Community.* Washington, DC: GPO, 1971. 6p. leaflet. HE21.102:D33/971.

3146. U.S. Congress. House. Committee on Education and Labor. Select Subcommittee on Education. *Comprehensive Child Development Act of 1971, Hearings on H.R. 6748 and Related Bills.* 92d Cong., 1st sess., 17 May - 3 June 1971. 544p. Y4.Ed8/1:C43/8. Child development theory and the need for affordable, quality child care for working mothers are topics discussed by witnesses. The structure of state and federal supported day care and the role of day care in welfare programs is stressed. The inadequacy of funding for day care and early child development at both the state and federal level is noted by many witnesses. The results of a research and demonstration program for day care services for M.I.T. employees are reported.

3147. U.S. Congress. Senate. Committee on Finance. *Additional Materials Related to Child Care Legislation.* 92d Cong., 1st sess., 1971. Committee print. 54p. Y4.F49:C43/3/add. Collection of materials on day care includes excerpts from H.R. 1, the welfare reform bill, relating to child care; excerpts on day care from the HEW annual report on AFDC; and the proposed revision of the federal day care requirements.

3148. U.S. Congress. Senate. Committee on Finance. *Child Care, Data and Materials.* 92d Cong., 1st sess., 1971. Committee print. 156p. Y4.F49:C43/2. Compilation of background information on child day care focuses on day care and government assistance programs. Statistical data covers labor force participation of mothers of young children, AFDC families by age of children, number and capacity of licensed day care facilities by state, distribution of parents with children in day care by income, cost of federal child care programs, number of children in federally funded child care, child care and Work Incentive Program enrollees, and children in day care by type of arrangement.

3149. U.S. Congress. Senate. Committee on Finance. *Child Care, Hearings on S. 2003, Child Care Provisions of H.R. 1, and Title VI of Printed Amendment 318 to H.R. 1.* 92d Cong., 1st sess., 21-24 Sept. 1971. 513p. Y4.F49:C43/4. Hearings on child care proposals primarily focuses on the child care provisions of H.R. 1, the welfare reform bill.

Statements by HEW officials and public witnesses focus on the need for child care and on the role the federal government should play in subsidizing child care. The industry-based concept of child care is discussed.

3150. U.S. Congress. Senate. Committee on Finance. *Material Related to Child Care Legislation.* 92d Cong., 1st sess., 1971. Committee print. 47p. Y4.F49:C43/3. Background information on welfare mothers and child care. Highlights the working mother's need for day care. Summarizes child care programs already authorized and child care provisions of pending legislation. Supporting statistics on day care demand, AFDC families by age of children, day care availability and cost, and child care arrangements under WIN are presented.

3151. U.S. Congress. Senate. Committee on Government Operations. Subcommittee on Executive Reorganization and Government Research. "Day Care and Preschool Services: Trends in the 1960's and Issues for the 1970's" in *Government Research on the Problems of Children and Youth: Background Papers Prepared for the 1970-71 White House Conference on Children and Youth.* 92d Cong., 1st sess., 1971. Committee print. 484p. Y4.G74/6:C43. Paper from a compilation of reports on children and youth. Discusses the various goals of day care, noting its value as a developmental program for disadvantaged children as well as demands for affordable care options for working mothers. The government role in day care and policy options for the future are reviewed.

3152. U.S. Congress. Senate. Committee on Labor and Public Welfare. Subcommittee on Employment, Manpower and Poverty and Subcommittee on Children and Youth. *Comprehensive Child Development Act of 1971, Part 2, Hearing on S. 1512.* 92d Cong., 1st sess., 25,26 May 1971. 433-672pp. Y4.L11/2:C43/2/pt.2. Hearing on a comprehensive child care bill includes discussion of the role of unions in providing child care and on the need to accompany work requirements for welfare mothers with a strong developmental day care component. Day care programs of the Amalgamated Clothing Workers of America, AFL-CIO, are examined. The need to fund child care programs that provide health care and developmental programs is stressed. Local control and the advisability of welfare work requirements for mothers of young children are discussed.

3153. U.S. Congress. Senate. Committee on Labor and Public Welfare. Subcommittee on Employment, Manpower and Poverty and Subcommittee on Children and Youth. *Comprehensive Child Development Act of 1971, Part 3, Hearings.* 92d Cong., 1st sess., 22 May, 16 June 1971. 673-930pp. Y4.L11/2:C43/2/pt.3. Continued hearing on a comprehensive child care funding bill features witnesses urging subsidized care for children of families above as well as below the poverty line. Funding levels and the role of prime sponsors are discussed and the "Federal Interagency Day Care Requirements" are reprinted. Parental participation in child care programs and the need to encourage companies to provide child care are also covered.

3154. U.S. Executive Office of the President. Office of Economic Opportunity. *Day Care, Resources for Decisions.* by Edith H. Grotberg. OEO Pamphlet 6106-1. Washington, DC: GPO, 1971. 484p. PrEx10.23:6106-1. Collection of papers on day care primarily focuses on child development. Some papers on approaches to day care outside of the United States and on the need for diversity in day care options in the United States are included.

3155. U.S. Office of Child Development. *Guide for Resources for Community Coordinated Child Care Program.* Washington, DC: GPO, 1971. 141p. HE21.8:C73. Guide to organizing and operating a community coordinated child care program. Identifies funding sources and provides sample documents from existing programs.

3156. U.S. Office of Child Development. *Report on Preschool Programs: The Effects of Preschool Programs on Disadvantaged Children and Their Families.* Washington, DC: GPO, 1971. 190p. HE21.2:P92. Research review examines the Head Start program and its effect on preschooler development and on families. Family studies focus on the description of employment and training aspects of Head Start which mainly affect low income mothers.

3157. U.S. Women's Bureau. *Day Care Services: Industry's Involvement.* Bulletin no. 296. Washington, DC: GPO, 1971. 33p. L13.3:296. General discussion on the provision of day care services for working mothers examines the labor force participation of women and the day care problem. Industry operated day care centers are examined along with other roles industry can take in securing child care for workers. Presents the historical background on the development of industry day care programs during WWII, and examines the cost and tax benefits of establishing an industry day care program.

3158. U.S. Congress. House. Committee on Education and Labor. *Comprehensive Child Development Act, Report Together with Minority and Additional Views to Accompany H.R. 6748.* H. Rept. 92-1570, 92d Cong., 2d sess., 1972. 64p. Serial 12974-7. Report with opposing views on legislation to establish and expand federal support for developmental day care facilities. Emphasizes the need for child care for low and moderate income families and relates the proposal to welfare reform. The effect of such programs on family relationships is discussed.

3159. U.S. Congress. Senate. Committee on Labor and Public Welfare. *Comprehensive Headstart, Child Development, and Family Services Act of 1972, Report Together with Supplemental and Individual Views to Accompany S. 3617.* S. Rept. 92-793, 92d Cong., 2d sess., 1972. 60p. Serial 12971-3. Report on the federal developmental day care program Head Start. Highlights the developmental aspects of day care while stressing the unavailability of such day care for children of working mothers.

3160. U.S. Congress. Senate. Committee on Labor and Public Welfare. Subcommittee on Children and Youth. *Rights of Children, 1972, Part 2: Appendix - Selected Readings on Child Abuse and Day Care.* 9d Cong., 2d sess., 1972. Committee print. 231-823pp. Y4.L11/2:C43/6/972/pt.2. The focus of this collection of readings is on child abuse, however, it also reprints a lengthy report by Mary Dublin Keyserling for the National Council of Jewish Women, "Windows on Day Care." The report is the result of an extensive survey by the council which collected information on day care needs of working women, the extent to which day care availability was a barrier to employment, and the quality of existing day care facilities. The transition from training to employment for women in poverty, and the need for day care subsidies after the transition to paid employment, are stressed.

3161. U.S. General Accounting Office. Comptroller General. *Study of Child-Care Activities in the District of Columbia: Report to the Committee on Education and Labor, House of Representatives.* Washington, DC: The Office, 1972. 15p. GA1.13:C43/10. Study of the coordination of child care funding under federal programs. Includes charts showing the legislative sources of day-care funding and the agencies responsible for day care programs. Also studies the distribution of day care services within the D.C. area.

3162. U.S. Women's Bureau. *Federal Funds for Day Care Projects.* Pamphlet no. 14. Washington, DC: GPO, 1972. 91p. L36.112:14. See 3140 for abstract.

3163. U.S. Congress. Joint Economic Committee. Subcommittee on Fiscal Policy. *Studies in Public Welfare, Paper No. 7, Issues in the Coordination of Public Welfare Programs.* 93d Cong., 1st sess., 1973. Committee print. 255p. Y4.Ec7:W45/paper 7. Collection of

papers on public welfare programs discusses work incentives, Social Security retirement, unemployment insurance, Medicare and Medicaid, and day care. The two papers on welfare describe the supply and demand for day care, the costs and benefits to society, and the cost to families. The integration of day care into welfare programs and the role of the federal government in encouraging day care availability are explored. The benefits of day care to mothers and children in the welfare family are reviewed and a history of the rationale for day care is presented. The point at which it is less costly for the government to pay the mother to stay at home is explored.

3164. U.S. Congress. Senate. Committee on Labor and Public Welfare. Subcommittee on Employment, Poverty, and Migratory Labor and Subcommittee on Human Resources. *Impact of the Proposed Budget Cuts on Local Manpower, Emergency Employment Act, Child Care, and Poverty Programs, 1973, Joint Hearings.* 93d Cong., 1st sess., 15-16 June 1973. 288p. Y4.L11/2:B85. A major focus of this hearing on the impact of proposed budget cuts is the continued need for federal support of child care as expressed in testimony by day care professionals and parents of day care children.

3165. U.S. General Accounting Office. Comptroller General. *Some Problems in Contracting for Federally Assisted Child-Care Services: Report to the Congress.* Washington, DC: The Office, 1973. 51p. GA1.13:C43/11. In studying the problems of federal contracting of child care services the GAO looked at the use of these services by AFDC and WIN recipients, eligibility requirements, and the cost recovery from financially able families.

3166. U.S. Office of Economic Opportunity. Office of Planning, Research and Evaluation. *A Study of Day Care's Effect on the Labor Force Participation of Low-Income Mothers.* by Jack Ditmore and W.R. Prosser. Washington, DC: The Office, 1973. 107p. PrEx10.2:D33. Review of research on the relationship between employment of low-income mothers and the availability of adequate child care forms the basis of discussion of the possible effect of government subsidized day care on the employment rate of welfare mothers. Reviews statistics on labor force participation of mothers and child care arrangements.

3167. U.S. Women's Bureau. *Children on Campus: A Survey of Pre-Kindergarten Programs at Institutions of Higher Education in the United States.* Washington, DC: GPO, 1973. 108p. L36.102:C43. Survey of day care programs at a sample of coeducational colleges and universities collected data on the number and types of programs, the average number of children enrolled, and the average fee charged. Information was also solicited on whether programs were enrolled to capacity and length of waiting lists. In addition, data on physical facilities, funding sources, management, and the effect of the campus admissions and program schedules was collected.

3168. U.S. Women's Bureau. *Day Care Facts.* Pamphlet no. 16. Washington, DC: GPO, 1973. 16p. L36.112:16. Revised edition of L13.2:D33/3/970.

3169. U.S. Children's Bureau. *Day Care for Your Children.* Washington, DC: GPO, 1974. 14p. HE1.452:D33. Information for parents on matching their day care needs with the appropriate type of care.

3170. U.S. Congress. Senate. Committee on Finance. *Child Care: Data and Materials.* 93rd Cong., 2d sess., 1974. Committee print. 258p. Y4.F49:C43/2/974. Update of an earlier committee print (3148) includes statistics and information on child care arrangements and costs, standards and licensing, and child care and welfare reform.

3171. U.S. Congress. Senate. Committee on Labor and Public Welfare. Subcommittee on Children and Youth. *Child and Family Services Act of 1974, S. 3754, Background*

Material, Section-by-Section Analysis, and Bill Text. 93rd Cong., 2d sess., 1974. Committee print. 80p. Y4.L11/2:C43/8. Presents the text of the bill, brief section-by-section analysis, and introductory statements on the Child and Family Services Act of 1974, a measure authorizing educational day care programs and health and nutrition programs.

3172. U.S. Congress. Senate. Committee on Labor and Public Welfare. Subcommittee on Employment, Poverty, and Migratory Labor and U.S. Congress. House. Committee on Education and Labor. Select Subcommittee on Education. *Child and Family Services Act, 1974, Joint Hearings on S. 3754.* 93rd Cong., 2d sess., 8-9 Aug. 1974. 451p. Y4.L11/2:C43/10/974. Hearings examine the need for day care programs with educational components for both working mothers and for children of nutritionally and educationally deprived environments.

3173. U.S. Congress. House. Committee on Ways and Means. *Temporary Postponement of Certain Staffing Requirements for Child Day Care Centers under Social Services Program, Report to Accompany H.R. 9803.* H. Rept. 94-511, 94th Cong., 1st sess., 1975. 5p. Serial 13099-7. Committee report supports legislation to delay enforcement of Title XX day care staffing requirements for six months. The postponement was due to concern that centers unable to meet the Federal Interagency Day Care Standards would be denied federal funding.

3174. U.S. Congress. Senate. Committee on Finance. *Child Care Staffing Requirements, Hearing on S. 2425.* 94th Cong., 1st sess., 8 Oct. 1975. 105p. Y4.F49:C43/6. Witnesses discuss the child care staffing standards for Title XX programs and the financial impact of those standards. A bill to provide incentives to hire welfare recipients as child care workers is explored in terms of impact on AFDC and on child care costs. The inadequacy of funding for day care, particularly in light of the staffing standards, is a recurring theme.

3175. U.S. Congress. Senate. Committee on Finance. *Data and Materials on Proposals Relating to Child Care Staffing Requirements.* 94th Cong., 1st sess., 1975. Committee print. 21p. CIS75-S362-25. Report reviews state minimum staffing requirements for child care centers, and examines proposed and existing federal legislation on child care staffing requirements for facilities receiving federal funding.

3176. U.S. Congress. Senate. Committee on Labor and Public Welfare. Subcommittee on Children and Youth, Subcommittee on Employment, Poverty and Migratory Labor, and U.S. Congress. House. Committee on Education and Labor. Subcommittee on Select Education. *Child and Family Services Act, 1975, Joint Hearings on S. 626 and H.R. 2966.* 94th Cong., 1st sess., 20 Feb.- 15 July 1975. 2482p. 9 vol. Y4.L11/2:C43/10/975/pt.1-9. Nine part hearing on bills to provide funds to state and local government to upgrade and expand services to families examines day care provisions in-depth. Part one gives the text of the bills and presents testimony from the Women's Bureau, women's organizations, and pediatrics organizations on the need for child care. In part two testimony focuses on educational child care and early identification of handicapping conditions. Working mothers and the need for available, affordable child care is the focus of part three. In part four witnesses from religious groups and parent-teacher organizations testify. Part five presents a panel discussion on the role of profit-making child care organizations. Testimony from a hearing held in Vermont on the need for quality child care is presented in part six. The role of public schools is examined in part seven through testimony from child development organizations and child support service agencies. Part eight testimony explores reports of adverse effects of day care, the best type of child care if the mother must work, and the role of family education programs. The ninth hearing covers all aspects of the bill including the need for day care, child

development, identification of handicapping conditions, funding for day care, after school programs, and appropriate methods of day care provision.

3177. U.S. Office of Child Development. *National Childcare Consumer Study, 1975.* Washington, DC: The Office, 1975? 4 vol. HE1.402:C76/975/v.1-4. Extensive study of child care in the U.S. examined patterns of child care use and parental preferences in child care. In the study data was collected on household characteristics, child care usage, reasons for child care usage, satisfaction and selection factors, and cost of transportation. Household characteristics reported include age, marital status, educational attainment, and race/ethnicity of respondents, and data on family size, children in household, age of children, sources of financial support, household income, employment and enrollment status of respondents, and spouse's employment status. Includes data on type of care, and time of care by type of care.

3178. U.S. Office of Child Development. Division of Research and Evaluation. *Child-Care Programs in Nine Countries.* Washington, DC: The Office, 1975? 83p. HE1.402:C43/4. Summary of the organization and funding of day care in Canada, France, Germany, Israel, Poland, Sweden, United Kingdom, United States, and Yugoslavia looks specifically at eligibility requirements for state supported programs.

3179. U.S. Bureau of the Census. *Daytime Care of Children, October 1974 and February 1975.* Current Population Reports Series P-20 no. 298. Washington, DC: GPO, 1976. 23p. C3.186:P-20/298. Presents statistics on arrangements made for daytime care of children 3 to 13 years old by age of child, labor force status of mother, marital status of mother, race, family income, and school enrollment of child.

3180. U.S. Congress. House. *Child Day Care Services under Title XX of the Social Security Act, Conference Report to Accompany H.R. 9803.* H. Rept. 94-885, 94th Cong., 2d sess., 1976. 9p. Serial 13134-2. Conference report resolves House and Senate differences on postponing the application of day care staffing requirements under Title XX of the Social Security Act. Points of contention include increased funding to help states meet the requirements and reimbursement to day care providers for employing welfare recipients as child care providers.

3181. U.S. Congress. House. *Child Day Care Services under Title XX of the Social Security Act, Conference Report to Accompany H.R. 12455.* H. Rept. 94-1317, 94th Cong., 2d sess., 1976. 8p. Serial 13134-9. Describes conference committee action on the conflicting versions of H.R. 12455, a bill to defer application of federal day care standards under Title XX, to increase funding for child care programs, and to provide incentives for hiring welfare recipients as child care workers.

3182. U.S. Congress. House. *Message from the President of the United States Vetoing H.R. 9803, an Act to Facilitate and Encourage the Implementation by States of Child Care Services Programs Conducted Pursuant to Title XX of the Social Security Act, and to Promote the Employment of Welfare Recipients in the Provision of Child Day Care Services and for Other Purposes.* H. Doc. 94-440, 94th Cong., 2d sess., 1976. 6p. Serial 13145-2. Veto message of President Ford rejects the imposition of federal day care standards on states as a requirement for Title XX funding and recommends extending the moratorium on the standards to give Congress time to pass his social services proposal, the Federal Assistance for Community Services Act.

3183. U.S. Congress. House. Committee on Education and Labor. Subcommittee on Select Education. *Background Material Concerning Child and Family Services Act, 1975, H.R. 2966.* 94th Cong., 2d sess., 1976. 215p. Y4.Ed8/1:C43/11. Reprints newspaper and magazine articles on the smear campaign aimed at the Child and Family Services Act of

1975 and presents statements of members of Congress in response to the campaign. A widely distributed, unsigned flyer with false information was the basis of the smear campaign.

3184. U.S. Congress. House. Committee on Ways and Means. Subcommittee on Public Assistance. *Federal Assistance for Community Services Act, Hearings on H.R. 12175.* 94th Cong., 2d sess., 21 May, 11 June 1976. 150p. Y4.W36:F31/3. Discussion of Title XX programs explores the need for federal support of social services, particularly day care, but focuses primarily on the pros and cons of the block grant approach. The Federal Interagency Day Care Requirements are debated at length.

3185. U.S. Congress. Senate. Committee on Finance. *Assistance in Meeting Federal Child Care Standards, Report Together with Minority and Additional Views, to Accompany H.R. 9803.* S. Rept. 94-592, 94th Cong., 2d sess., 1976. 36p. Serial 13130-1. The Senate amended version of a bill temporarily suspending the Title XX child care staffing requirements includes incentives for day care centers to hire welfare recipients as child care staff. Charts provide data on state staffing requirements, increased costs to meet Title XX staffing requirements, and federal funding allocations by state for social services. Appended minority and additional views reject the Federal Interagency Day Care Requirements for staffing arguing that they needed more study and had no research to give them credence.

3186. U.S. Congress. Senate. Committee on Finance. *Child Care and Social Services Programs, Report to Accompany H.R. 12455.* S. Rept. 94-857, 94th Cong., 2d sess., 1976. 26p. Serial 13130-5. Reports a bill giving states flexibility in determining eligibility for social services, suspending federal child care staffing standards, and providing additional child care funding. The additional child care funding is intended to help states upgrade child care standards to meet the Federal Interagency Day Care Requirements. Correspondence from the Secretary of Health, Education, and Welfare stresses the need to suspend the day care staffing requirements to prevent most states from losing federal funding under Title XX of the Social Security Act.

3187. U.S. Congress. Senate. Committee on Finance. *Data and Materials Relating to Federal Child Care Standards.* 94th Cong., 2d sess., 1976. Committee print. 20p. Y4.F49:C43/9. Summary of four child care standards bills accompanies data on staffing and costs.

3188. U.S. Congress. Senate. Committee on Finance and U.S. Congress. Senate. Committee on Ways and Means. *H.R. 9803, Assistance in Meeting Federal Child Care Standards; Treatment of Drug Abuse and Alcoholism; Brief Description of Senate Amendments.* 94th Cong., 2d sess., 1976. Committee print. 16p. Y4.C76/1:C43. Description of Senate amendments relating to public assistance and child care is presented with tables on child care staff requirements and government costs.

3189. U.S. Congress. Senate. Committee on Finance and U.S. Congress. Senate. Committee on Ways and Means. *H.R. 12455, Child Care; Social Services Eligibility; Treatment of Drug Abuse and Alcoholism; Brief Description of Senate Amendments.* 94th Cong., 2d sess., 1976. Committee print. 18p. Y4.C76/1:C43/3. Presents amendments to H.R.12455 and supplies tables showing costs and presenting data on employment of welfare recipients.

3190. U.S. Congress. Senate. Committee on Labor and Public Welfare. Subcommittee on Children and Youth. *Background Materials Concerning Child and Family Services Act, 1975, S. 626.* 94th Cong., 2d sess., 1976. 96p. Committee print. Y4.L11/2:C43/13/975. Rebuttals discredit an intensive smear campaign against the Child and Family Services Act of 1975. The unsigned flyer attacking the bill charged that the act, which provides federal

funds to local groups for day care and child health programs, undermines parental authority.

3191. U.S. Dept. of Health, Education and Welfare. Secretary's Advisory Committee on the Rights and Responsibilities of Women. *Child Care and the Working Woman.* by Jane Gold. Washington, DC: GPO, 1976. 54p. HE1.2:W84/5/975. Report presents the recommendations from a 1975 conference on child care and working women sponsored by the committee. Some of the topics covered are the availability, advantages, and disadvantages of various types of day care, economic and tax issues in child care, and the organization of child care services.

3192. U.S. Office of Child Development. *Statistical Highlights from the National Child Care Consumer Study.* Washington, DC: The Office, 1976. 28p. HE1.402:C43/8. Study of the reasons parents choose a type of child care furnishes supporting data on users of child care services by marital status, employment status, poverty status, and race/ethnicity.

3193. U.S. Congress. House. Committee on Ways and Means. *"Tax Home" of State Legislators and Deductibility of Expenses Allocated to Use of Dwelling to Provide Day Care Services, Hearing on H.R. 3812, H.R. 4007, H.R. 4611, and H.R. 3340.* 95th Cong., 1st sess., 28 Mar. 1977. 185p. Y4.W36:95-15. Hearing on bills relating to the 1976 Tax Reform Act examines the hardship for family day care providers caused by the existing deducibility rules for use of a home for business. Much of the debate centers around state and federal day care licensing requirements and the need for the proposed legislation to help lower child care costs. Considerable correspondence from day care providers illustrates the problems they face under the existing laws.

3194. U.S. Congress. Senate. Committee on Finance. *Child Care Data and Materials.* 95th Cong., 1st sess., 1977. Committee print. 316p. Y4.F49:C43/2/977. Background data on child care for working mothers includes number of children by age, race, and labor force status of mother; number of children by age, type of family, and labor force status of mother; number of mothers in the labor force by age of children, 1966-1976; child care arrangements by age of child and marital status of mother; number and capacity of day care facilities; child care cost per week; federal funding for child care; and standards and licensing requirements.

3195. U.S. Congress. Senate. Committee on Finance. *Extension and Waiver Provisions Related to Social Services, Medicaid, Aid to Families with Dependent Children Programs, Report to Accompany H.R. 3387.* S. Rept. 95-456, 95th Cong., 1st sess., 1977. 9p. Serial 13168-9. Specific social service amendments attached to a bill related to tariff duties include additional funding for Title XX child care programs, incentives to hire welfare recipients as child care workers, and continued suspension of federal child care staffing standards.

3196. U.S. Dept. of Health, Education, and Welfare. Office of the Assistant Secretary for Planning and Evaluation. *Policy Issues in Day Care: Summaries of 21 Papers.* by Center for Systems and Program Development. Washington, DC: The Dept., 1977. 148p. HE1.2:D33/2. Papers cover topics of the history of the Federal Interagency Day Care Requirements, federal day care standards, federal and state approaches to day care standard setting, enforcement of licensing standards; licensing standards in Europe, Canada, and Israel; effects of day care on children and families; and supply and demand in the child care market.

3197. U.S. National Commission on the Observance of International Women's Year. *Child Care: a Workshop Guide.* Washington, DC: GPO, 1977. 82p. Y3.W84:10/2. Guide to conducting a workshop on child care includes suggestions on format, fact sheets, and a resource list of persons and publications.

3198. U.S. Administration for Children, Youth, and Families. *Federal Interagency Day Care Requirements: Pursuant to Sec. 522(d) of the Economic Opportunity Act as Approved by U.S. Department of Health, Education, and Welfare, U.S. Office of Economic Opportunity, U.S. Department of Labor, September 23, 1968.* Washington, DC: The Administration, 1978. 17p. HE1.2:F31/4. Presents details of federal requirements for day care facilities and staffing in order to meet eligibility for federal funds. Criteria is given for family day care homes, group day care homes, and day care centers.

3199. U.S. Bureau of the Census. *Nursery School and Kindergarten Enrollment of Children and Labor Force Status of Their Mothers', October 1967 to October 1976.* by Edith Kirby. Current Population Reports Series P-20, no. 318. Washington, DC: GPO, 1978. 27p. C3.186:P-20/318. Presents data on enrollment of 3 to 5 year olds in preprimary schools by race, type of school, labor force status of mother, educational attainment of mother, and occupation of employed mother.

3200. U.S. Congress. House. Committee on Ways and Means. *Social Services Amendments of 1978, Report to Accompany H.R. 12973.* H. Rept. 95-1312, 95th Cong., 2d sess., 1978. 28p. Serial 13201-9. Favorable report on amendment to social service program laws highlights changes relative to Title XX social services. Areas changed include the ceiling for federal funds, state coordination measures, extension of target funds for day care, and allowing use of funds for adult emergency shelters.

3201. U.S. Congress. Senate. Committee on Human Resources. Subcommittee on Child and Human Development. *Child Care and Child Development Programs, 1977-78, Hearings.* 95th Cong., 1st and 2d sess., 25 Nov. 1977 - 20 Feb. 1978. 1378p. 2 vol. Y4.H88:C43/2/977-78/pt.1-2. Two part hearing examines the role of the federal government in child care and child development programs. Part one testimony highlights the need for quality child care, successful day care programs, various methods of providing child care, and the role of federal child care assistance in relation to local needs and community control. Also discusses women's financial need to work versus the cost and availability of child care. Part two discusses the inadequacy of a single approach model applicable to all child care needs, and includes information on child care support in Sweden, Israel, and France. Also discussed in several places are the very low wages of child care workers.

3202. U.S. Congressional Budget Office. *Childcare and Preschool: Options for Federal Support.* Washington, DC: GPO, 1978. 65p. Y10.9:C43. Analysis of federal support for child care and preschool describes current childcare arrangements made by families and the factors that affect their choices, child development issues and the impact of current federal programs on development, and the labor force participation of mothers and the impact of child care on employment decisions. The cost and effects of federal policy changes, including the welfare reform proposal, are examined. Provides supporting statistics.

3203. U.S. Dept. of Health, Education and Welfare. Office of the Assistant Secretary for Planning and Evaluation. *The Appropriateness of the Federal Interagency Day Care Requirements: Report of Findings and Recommendations.* Washington, DC: GPO, 1978. 304p. HE1.2:D33/3. Study of the federal regulations regarding HEW-supported day care looks specifically at current Federal Interagency Day Care Requirements in the areas of caregiver qualifications, educational services, facilities, health and nutrition, parental involvement, and social services.

3204. U.S. Bureau of Community Health Services. *The New York City Infant Day Care Study.* Washington, DC: GPO, 1979. 195p. HE20.5102:In3/11. The primary focus of this longitudinal study of the effects of infant day care is on the physical and mental

development of the child. The study also looks at the relationship between infant day care and family development and found that day care had little effect on family structure or income, and that day care programs did not get families off of welfare.

3205. U.S. Congress. Senate. Committee on Human Resources. Subcommittee on Child and Human Development. *Child Care Act of 1979, Hearing on S. 4.* 96th Cong., 1st sess., 6,21 Feb. 1979. 732p. Y4.L11/4:C43/3. Hearing on a bill to provide assistance and coordination in the provision of child care services for working parents highlights the need for assistance in finding quality child care. Key points in the testimony are allowing parents to choose the type of child care, licensing, day care assistance for lower income families, and the difficulty of locating quality child care programs.

3206. U.S. Congress. House. Committee on House Administration. *Establishing the Congressional Child Care Center, Report to Accompany H. Res. 515.* H. Rept. 96-868, 96th Cong., 2d sess., 1980. 3p. Serial 13362. House Resolution 515 would provide for a self-supporting child care center for children of House and Senate employees and would establish the basic financial operation of the center.

3207. U.S. Dept. of Health and Human Services. Office of the Assistant Secretary for Planning and Evaluation. Project SHARE. *Child Care Services - Day Care.* Washington, DC: GPO, 1980. 31p. HE1.18/4:C43/2. Annotated bibliography cites books, technical reports, and journal articles on current issues in the provision of day care.

3208. U.S. White House Conference on Families. *Families and Human Needs: Delegate Workbook.* Washington, DC: The Conference, 1980? 102p. Y3.W58/22:2F21/2/wkbk. Workbook for delegates to the White House Conference on Families includes issue briefs on education, health, housing, child care, and handicapping conditions. Each issue brief contains background information and major recommendations from the state reports.

3209. U.S. Administration for Children, Youth and Families. Day Care Division. *Family Day Care in the United States: Summary of Findings.* Washington, DC: GPO, 1981. 128p. HE23.1002:D33/2. Summary of the information from the National Day Care Home Study covers the design of the study, state regulations, characteristics of day care providers, day care children and their parents, day care costs, and observations made in family day care homes.

3210. U.S. Commission on Civil Rights. *Child Care and Equal Employment Opportunity for Women.* Washington, DC: GPO, 1981. 51p. CR1.10:67. Extensive review of the literature describes the effect child care responsibilities have on women's employment. Examines federal child care programs and policies related to social services, education and child development, and taxes. Also details the failure of federal educational assistance programs to take the situation of women with children into account.

3211. U.S. Congress. Senate. Committee on Governmental Affairs. Subcommittee on Intergovernmental Relations. *Alternative Service Delivery, Hearing, Part 3, Child Care.* 97th Cong., 1st sess., 26 Oct. 1981. St. Paul, MN. 142p. Y4.G74/9:D37/2/pt.3. Hearing on support for child care programs explores the issue of availability and the role the private sector can play in day care provision. Witnesses note that the government needs to take a leadership role to encourage standards for day care. Company referral systems, on-site day care, and voucher programs are discussed by company representatives. The report of the Honeywell Working Parents Task Force is reprinted. School districts and extended day programs are also explored.

3212. U.S. Bureau of the Census. *Trends in Child Care Arrangements of Working Mothers.* Current Population Reports Series P-23, no. 117. Washington, DC: GPO, 1982. 73p.

C3.186:P-23/117. Survey on mothers and child care examines labor force trends in the U.S. and reports on child care arrangements from 1958 to 1977. Also looks at the cost of child care and its effect on working mothers and wives. Child care in Sweden and the Federal Republic of Germany is also examined. Provides statistics on type of child care arrangements by family characteristics.

3213. U.S. Congress. Senate. Committee on Labor and Human Resources. Subcommittee on Aging, Family, and Human Services. *The Extended Family: Society's Forgotten Resources, Hearing*. 97th Cong., 2d sess., 11 May 1982. 65p. Y4.L11/4:F21/4. Hearing on social welfare policy and the extended family discusses child care issues, with an emphasis on teenage mothers and other federal policy issues relating to family life.

3214. U.S. Women's Bureau. *Employers and Child Care: Establishing Services through the Workplace*. Pamphlet no. 23. Washington, DC: GPO, 1982. 83p. rev. ed. L36.112:23/2. Expanded pamphlet outlines the benefits of various child care related polices and benefits that support working parents. In addition to more traditional policies, "family-oriented" policies are also discussed. Ideas and advice on planning and funding services are presented focusing on tax issues and employer-sponsored child care services.

3215. U.S. Bureau of the Census. *Child Care Arrangements of Working Mothers: June 1982*. Current Population Reports Series P-23, no. 129. Washington, DC: GPO, 1983. 49p. C3.186:P-23/129.

3216. U.S. Congress. House. Committee on Education and Labor. Subcommittee on Human Resources. *Hearing on Child Care Information and Referral Services Act, Hearing on H.R. 2242*. 98th Cong., 1st sess., 15 Sept. 1983. 376p. Y4.Ed8/1:C43/26. Basic information on child care issues is supplemented by an extensive collection of information on local efforts to provide information and referral services for working parents seeking day care for their children. Also includes information on choosing child care and on the problems of after school care.

3217. U.S. Congress. House. Select Committee on Children, Youth, and Families. *Child Care: Exploring Private and Public Sector Approaches, Hearing Held in Irving, TX*. 98th Cong., 2d sess., 21 May 1983. 174p. Y4.C43/2:C43/12. Witnesses describe public and private approaches to providing child care such as corporate development funds, local government vender-voucher programs, resources and referral services, and after-school programs. Among the programs discussed are the Air Force child care program and YWCA programs. Methods of lowering the cost to working parents are also discussed as are training and wages of child care workers.

3218. U.S. Congress. House. Select Committee on Children, Youth, and Families. *Demographic and Social Trends: Implications for Federal Support of Dependent-Care Services for Children and the Elderly, Committee Print with Additional Views*. 98th Cong., 1st sess., 1983. Committee print. 84p. Y4.C43/2:D39. Household composition, working mothers, and poverty rates are among the trends examined in this staff analysis report prepared by the Congressional Budget Office. Factors which affect support demands on the federal government and approaches to providing child and elderly care services to reduce federal costs are examined. The federal role is examined from several angles.

3219. U.S. Congress. Senate. Committee on Labor and Human Resources. *Private Sector Initiatives, Hearing*. 98th Cong., 1st sess., 16 Nov. 1983. 344p. Y4.L11/4:S.hrg.98-634. Review of private sector initiatives relating to families includes a review of the problems of working parents and child care. Corporate policies to assist families, such as flextime, parental leave, and child care assistance are reviewed. Ways the public sector can encourage and cooperate with the private sector in supporting the family and providing

social services is explored. The establishment of day care centers through private support in corporations is a recurring theme.

3220. U.S. Congress. Senate. Committee on Rules and Administration. *Day Care Center for Children of Senate Employees, Report to Accompany S. Res. 269.* S. Rept. 98-298, 98th Cong., 1st sess., 1983. 3p. Serial 13513. Letters of support describing the desire to start a day care center for Senate employees are followed by a summary of committee action on a resolution to appropriate start-up funds.

3221. U.S. Congress. House. Committee on Education and Labor. *Human Services Amendments of 1984, Report Together with Republican, Separate, and Additional Views to Accompany H.R. 5154.* H. Rept. 98-740, 98th Cong., 2d sess., 1984. 44p. Serial 13590. Reports a bill to reauthorize the Head Start program, the Follow Through Program, and the Community Services Block Grant program. The bill also authorizes the Child Care Information and Referral Act, a grant program to establish centralized child care referral services.

3222. U.S. Congress. House. Committee on Education and Labor. *School Facilities Child Care Act, Report Together with Supplemental Views to Accompany H.R. 4193.* H. Rept. 98-745, 98th Cong., 2d sess., 1984. 12p. Serial 13590. Reports a bill authorizing a federal grant program to establish before and after school child care services utilizing existing school and community center facilities. The problems of working mothers with child care are reviewed as justification of this program.

3223. U.S. Congress. House. Committee on Education and Labor. Subcommittee on Elementary, Secondary, and Vocational Education. *Oversight Hearing on Federal Education Programs, Hearing.* 98th Cong., 2d sess., 13 May 1984. Upper Darby, PA. 73p. Y4.Ed8/1:Ed8/69. Brief hearing on selected education programs includes support for funding to encourage the use of school facilities for latchkey programs.

3224. U.S. Congress. House. Committee on Education and Labor. Subcommittee on Elementary, Secondary, and Vocational Education. *School Facilities Child Care Act, Hearing H.R. 4193.* 98th Cong., 2d sess., 30 Apr. 1984. 63p. Y4.Ed8/1:Sch6/42. Successful child care programs for children before and after school are described in hearings on a bill to support use of school facilities for latchkey programs. The need for affordable child care and cuts in Title XX programs are highlighted.

3225. U.S. Congress. House. Committee on Education and Labor. Subcommittee on Human Resources. *Authorizations for Head Start, Follow Through, Community Services, and Establish Child Care Information and Referral Services, Hearing on H.R. 5145.* 98th Cong., 2d sess., 21 March 1984. 285p. Y4.Ed8/1:H34/9. The need for child care referral services is briefly mentioned in hearing testimony focusing on support for Head Start and the growth of the poverty population. The effect of Reagan administration policy and statistics on poverty are the topics of appendix material.

3226. U.S. Congress. House. Committee on Post Office and Civil Service. *Cost Saving Disclosure Awards Extension and Dependent Care Study Act, Report to Accompany H.R. 5646.* H. Rept. 98-1053, 98th Cong., 2d sess., 1984. 17p. Serial 13602. Incorporated into a measure extending cash award programs for identification of fraud and waste in government programs is a directive to the Comptroller General to conduct a study and cost-benefit analysis of options for providing dependent care benefits to federal employees.

3227. U.S. Congress. House. Select Committee on Children, Youth and Families. *Child Care: Beginning a National Initiative, Hearing Held in Washington, D.C.* 98th Cong., 2d sess., 4 Apr. 1984. 109p. Y4.C43/2:C43/11. Issues of day care availability, affordability, and

quality are addressed from a nation-wide perspective in this hearing which presents differing views on the extent of the child care problem. Labor force participation rates of mothers and existing patterns of child care arrangements are discussed with some witnesses contending that there is no day care shortage and that the lack of day care does not prevent women from working. The need for, and proper nature of, government aid to day care is explored.

3228. U.S. Congress. House. Select Committee on Children, Youth, and Families. *Child Care: Exploring Private and Public Sector Approaches, Hearings.* 98th Cong., 2d sess., 18 June 1984. 223p. Y4.C43/2:C43/13. Hearing held in San Francisco examines childcare availability, sick child care programs, latch key programs, and employer-sponsored programs. Services to special groups such as Hispanics and migrant workers are examined, and the desire for supportive policies for mothers who wish to stay home is expressed.

3229. U.S. Congress. House. Select Committee on Children, Youth, and Families. *Families and Child Care: Improving the Options, a Report with Additional Views.* H. Rept. 98-1180, 98th Cong., 2d sess., 1984. 162p. Serial 13605. Current child care arrangements and availability are explored in this report on options for child care provision. The need for, and the effect of day care for infants, preschool, and school-aged children are reviewed, and the issue of child care affordability and employment is explored. The current state of employer-assisted care, state, local and federal government support, and private service group efforts are discussed, and successful programs are highlighted. Additional views appended to the report highlight the issue of military child care, quality of child care issues, the desire to provide incentives for mothers to stay at home and care for their children, and the adverse effects of child care arrangements on child development.

3230. U.S. Congress. House. Select Committee on Children, Youth, and Families. *Improving Child Care Services: What Can Be Done?, Hearings Held in Washington, D.C.* 98th Cong., 2d sess., 5-6 Sept. 1984. 949p. Y4.C43/2:C43/14. Extensive hearings on child care issues covers all of the major topics including the federal role in funding, availability and options, child abuse, day care standards, and tax policies. Federal funding cuts and their effects on day care services are stressed by several witnesses. Family versus center-based day care is also debated.

3231. U.S. Congress. House. Select Committee on Children, Youth and Families. *Working Families: Issues for the 80's, Hearing.* 98th Cong., 2d sess., 13 Apr. 1984. Hamden, CT. 97p. Y4.C43/2:F21/4. The needs of dual wage-earner families are examined in hearing testimony which emphasizes the importance of day care availability. The effect of increased family responsibilities on men in dual career families is also explored. General discussion of the needs of working mothers focuses on medical benefits and child care. The possibilities of moving AFDC mothers into the work force and the barriers to their employment are explored.

3232. U.S. Congress. Senate. Committee on Labor and Human Resources. *School Facilities Child Care Act, Report Together with Additional Views to Accompany S. 1531.* S. Rept. 98-494, 98th Cong., 2d sess., 1984. 22p. Serial 13559. The need for child care facilities for school-age children is emphasized in a favorable report on a grant program to encourage the use of schools and community centers for before and after school child care programs.

3233. U.S. Congress. Senate. Committee on Labor and Human Resources. Subcommittee on Education, Arts, and Humanities. *School Facilities Child Care Act, Hearing on S. 1531.* 98th Cong., 2d sess., 27 Apr. 1984. Seminole, FL. 58p. Y4.L11/4:S.hrg. 98-1101. The availability and administration of latchkey programs are explored in this hearing on

legislation to authorized funding for school age child care primarily in school buildings. The hearing highlights successful school-based latchkey programs in Florida.

3234. U.S. Congress. House. Select Committee on Children, Youth, and Families. *Child Care: The Emerging Insurance Crisis, Hearings.* 99th Cong., 1st sess., 18,30 July 1985. 211p. Y4.C43/2:C43/15. Hearings explore the economics of day care with emphasis on the cost and availability of insurance. The effect of insurance availability and costs on child care availability and affordability, and options for child care providers, are discussed.

3235. U.S. Congress. House. Select Committee on Children, Youth, and Families. *Report on the Activities in the 98th Congress of the Select Committee on Children, Youth, and Families, Years 1983, and 1984.* H. Rept. 98-1195, 98th Cong., 2d sess., 1985. 59p. Serial 13606. Summary of Select Committee on Children, Youth, and Families hearings held during the 98th Congress covers topics such as the effect of unemployment on families, child abuse, child care, parents and education, and family violence. Six of the twelve hearings summarized dealt with the issue of child care options and availability.

3236. U.S. Congress. Senate. Committee on Labor and Human Resources. Subcommittee on Children, Family, Drugs and Alcoholism. *Child Care-Supportive Services, Hearing Examining the Role of Child Care as a Supportive Service to Ensure Access to Education, Job Training, and the Labor Market.* 99th Cong., 1st sess., 2 Dec. 1985. Fort Lauderdale, FL. 59p. Y4.L11/4:S.hrg.99-602. The role of child care services in making education and job training programs available to displaced homemakers is described drawing on the experience of program administrators and participants in Florida.

3237. U.S. Congress. House. *Human Services Reauthorization Act of 1986, Conference Report to Accompany H.R. 4421.* H. Rept. 99-815, 99th Cong., 2d sess., 1986. 31p. Serial 13707. Conference report resolves House and Senate differences on a bill to reauthorize Head Start, Follow Through, Dependent Care State Grant Program, Community Services Block Grant Program, Child Development Associate Scholarship Assistance Program, and other grant programs.

3238. U.S. Congress. House. Committee on Education and Labor. *Community Services Program Amendments of 1986, Report Together with Supplemental and Additional View to Accompany H.R. 4421.* H. Rept. 99-545, 99th Cong., 2d sess., 1986. 20p. Serial 13699. Programs authorized by H.R. 4421 include Head Start, Follow Through, State Grants for Dependent Care, and Community Services Block Grant. The dependent care grant program, a program designed to encourage child care referral services and school-year child care programs, is the topic of objections voiced in the supplemental views.

3239. U.S. Congress. House. Committee on Education and Labor. Subcommittee on Human Resources. *Reauthorization of the Head Start Program, Hearing.* 99th Cong., 2d sess., 14 Feb. 1986. Cedar Rapids, IA. 138p. Y4.Ed8/1:99-100. Hearing on the importance of Head Start programs and the effect of budget cuts emphasizes the importance of the program to the development of high risk children. The role of parental involvement in Head Start in the development of confidence and self esteem of mothers is also noted. General discussion highlights the need for federal support for child care.

3240. U.S. Congress. Senate. Committee on Labor and Human Resources. *Human Services Reauthorization Act Amendments of 1986, Report to Accompany S. 2444.* S. Rept. 99-327, 99th Cong., 2d sess., 1986. 61p. Serial 13676. Among the human service programs reauthorized in the legislation reported are Head Start and the Dependent Care Act. The bill also authorizes a new program, the Child Development Associate Scholarship Act. The Dependent Care Act funded programs for child care referral services and school-based child care programs.

3241. U.S. Congress. Senate. Committee on Labor and Human Resources. Subcommittee on Children, Family, Drugs, and Alcoholism. *Reauthorization for Dependent Care Programs, Hearing.* 99th Cong., 2d sess., 6 Mar. 1986. 75p. Y4.L11/4:S.hrg.99-697. The importance of "latchkey" programs for school age children of working parents is stressed in testimony supporting reauthorization for funding of dependent care programs. The issue of the Department of Health and Human Service's failure to write regulations and distribute the funds for the School Age Child Care Program and Dependent Care Information and Referral Program is explored.

3242. U.S. General Accounting Office. *Child Care: Employer Assistance for Private Sector and Federal Employees: Report to Congressional Requestors.* Washington, DC: GAO, 1986. 72p. GA1.13:GGD-86-38. Results of a GAO survey of employer-assisted child care outlines the costs, perceived benefits, and current trends. Options such as on-site care, consortium arrangements, child care vouchers systems, and vendor programs are explored. The costs and problems associated with federal agency child care programs are examined. The existing research literature on the benefits to employers of sponsored child care is reviewed.

3243. U.S. Bureau of the Census. *After-School Care of School-Age Children: December 1984.* by Rosalind R. Bruno. Current Population Reports P-23, no. 149. Washington, DC: GPO, 1987. 27p. C3.186:P-23/149. Study of after-school child care arrangements provides data on caretaker and household characteristics, hours of care, and children regularly not in adult care by household characteristics.

3244. U.S. Congress. House. Committee on Banking, Finance, and Urban Affairs. *Housing, Community Development, and Homelessness Prevention Act of 1987, Report Together with Minority, Supplemental, and Additional Views to Accompany H.R. 4.* H. Rept. 100-122, 100th Cong., 1st sess., 1987. 300p. Serial 13801. Among the housing assistance programs authorized by H.R. 4 is a program of public housing child care grants. The committee argument for the Public Housing Child Care Demonstration Program points to the need for affordable child care if very low income families are to achieve self-sufficiency. The grant would fund establishment of child care facilities in public housing projects.

3245. U.S. Congress. House. Committee on Education and Labor. Subcommittee on Human Resources. *Hearing on Child Care.* 100th Cong., 1st sess., 8 July 1987. 68p. Y4.Ed8/1:100-26. Hearing on child care issues considers the role of child care in welfare reform. Child care availability and funding are discussed as are appropriate standards for day care services. Witnesses note that day care services not only help families leave AFDC, but that it also promotes family stability. The particular problems of providing quality affordable infant care are also described.

3246. U.S. Congress. House. Committee on Government Operations. *Child Care in Federal Buildings, Twenty-first Report Based on a Study by the Government Activities and Transportation Subcommittee.* H. Rept. 100-333, 100th Cong., 1st sess., 1987. 18p. Serial 13807. Review of the legal authority for on-site child care for federal employees and the role of the General Services Administration in supporting such facilities form the basis of this report on the extent of child care in federal building. Successful child care programs in federal buildings around the country are described, and agencies supporting the policy are noted. The appendix provides a chart showing day care centers housed in GSA space by location and sponsoring agency.

3247. U.S. Congress. House. Committee on Government Operations. Subcommittee on Employment and Housing. *Meeting the Need for Child Care: Problems and Progress, Hearing.* 100th Cong., 1st sess., 11 Sept. 1987. 273p. Y4.G74/7:C43/3. Hearing

reviews the state of child care providing testimony on the day care supply and demand, corporate response to employee's child care needs, and after school programs for school-age children. The problem of day care costs for women in low paying jobs and the need for day care subsidies from federal or state agencies are discussed.

3248. U.S. Congress. House. Committee on Government Operations. Subcommittee on Government Activities and Transportation. *Department of Defense Onsite Child Care Initiative, Hearing.* 100th Cong., 1st sess., 15 Dec. 1987. 88p. Y4.G74/7:C43/4. Official correspondence and reports accompany testimony on provision of child care services at federal worksites. Child care programs of the General Services Administration and the Department of Defense are examined in detail. The affordability of day care and the Department if Defense's policy of subsidizing onsite child care costs are examined.

3249. U.S. Congress. House. Committee on Government Operations. Subcommittee on Government Activities and Transportation. *Establishing Child Care Centers in Federal Buildings: GSA's Role, Hearing.* 100th Cong., 1st sess., 28 May 1987. 112p. Y4.G74/7:C43/2. Witnesses, primarily from federal agencies, discuss the role of the General Services Administration in providing child care services for federal workers. Experience at the IRS and at the National Oceanic and Atmospheric Administration with providing onsite day care is described, and the problems with a Social Security Administration plan for a nationwide daycare referral program are examined.

3250. U.S. Congress. House. Select Committee on Children, Youth and Families. *Child Care: Key to Employment in a Changing Economy.* 100th Cong., 1st sess., 10 Mar. 1987. 191p. Y4.C43/2:C43/19. Public-private partnerships to provide child care, particularly for low income women, are the focus of hearing testimony. Philosophies of welfare and workfare are examined as they relate to the child care issue.

3251. U.S. Congress. House. Select Committee on Children, Youth and Families. *Florida's Economic Future and the Child Care Crisis for Families.* 100th Cong., 1st sess., 22 June 1987. Miami, FL. 143p. Y4.C43/2:F66. Examination of the severe shortage of child care facilities and subsidized child care in Florida is interspersed with discussion of programs to encourage employer child care programs and other methods of addressing the child care shortage.

3252. U.S. Congress. Senate. Committee on Labor and Human Resources. Subcommittee on Children, Family, Drugs and Alcoholism. *Child Care, Hearing.* 100th Cong., 1st sess., 11 June 1987. 154p. Y4.L11/4:S.hrg.100-476. General hearing on child care includes testimony on training and wages of child care workers, assistance to low income families, employer support of child care, the shortage of subsidized child care, and child care costs.

3253. U.S. Congress. Senate. Committee on Labor and Human Resources. Subcommittee on Labor. *Day Care for Working Families Act of 1987, Hearing on S. 1271.* 100th Cong., 1st sess., 22 May 1987. Toledo, OH. 130p. Y4.L11/4:S.hrg.100-195. Testimony from the women who use child care and from child care center operators describes the importance of accessible child care if women are to get ahead economically.

3254. U.S. Congress. House. Committee on Education and Labor. *Act for Better Child Care Services of 1988, Report Together with Dissenting, Additional, and Individual Views to Accompany H. R. 3660.* H. Rept. 100-985, part 1, 100th Cong., 2d sess., 1988. 43p. Serial 13903. Numerous additional dissenting views take issue with this child care bill. The majority report stresses the need for federal action to help assure the availability and quality of day care and describes the proposed ABC program of state matching grants to assist families with child care costs. Separation of church and state and Title IX of the Education Amendment of 1972 in relation to the bill are discussed in individual views.

3255. U.S. Congress. House. Committee on Education and Labor. Subcommittee on Human Resources. *Child Care, Hearing.* 100th Cong., 2d sess., 21 April 1988. 423p. Y4.Ed8/1:100-91. General hearing on child care needs and innovative programs also discusses the pending Act for Better Child Care (ABC). Issues of availability, affordability and safety are addressed as is the federal role in subsidizing child care. A recurring theme of testimony is the perceived bias in government policy and programs against mothers who stay at home to care for their children and the adverse effects on children of day care.

3256. U.S. Congress. House. Committee on Education and Labor. Subcommittee on Human Resources. *H.R. 3660, the Act for Better Child Care, Hearing.* 100th Cong., 2d sess., 23 Apr. 1988. Louisville, KY. 122p. Y4.Ed8/1:100-90. One of a series of hearings on ABC, a federal child care funding and regulation bill, stresses the need for safe, affordable child care. Options for promoting the availability of day care are explored. Much of the testimony focuses on unsafe child care conditions and the proper role of the federal government in regulating day care. The benefits of on-site day care for employers is also discussed.

3257. U.S. Congress. House. Committee on Education and Labor. Subcommittee on Human Resources. *Hearing on H.R. 3660, the Act for Better Child Care Service.* 100th Cong., 2d sess., 25 Feb. 1988. 301p. Y4.Ed8/1:100-74. Issues of quality and affordability of child care for working mothers are explored by hearing witnesses. Tragic stories of children left unsupervised are used to highlight the need for increasing affordable day care options. Developmental aspects of day care and the role of federal standards are also discussed. The roles of nonprofit organizations, employers, and the government in funding day care are explored, and the place of day care in the welfare to work transition is examined.

3258. U.S. Congress. House. Committee on Government Operations. Subcommittee on Employment and Housing. *Coping with Eldercare: A Growing Challenge in the Workplace, Hearing.* 100th Cong., 2d sess., 28 Oct. 1988. 186p. Y4.G74/7:El2/6. The stress in caregivers' jobs and lives is revealed in hearing testimony from caregivers and large employers. Ways businesses can support caregiver employees and ways the government can encourage non-institutional living options for the elderly are explored. The particular impact that the demands of eldercare has on wives and adult daughters is discussed.

3259. U.S. Congress. House. Committee on Small Business. Subcommittee on Exports, Tourism, and Special Problems. *Day Care: Its Importance to Small Business, Hearing.* 100th Cong., 2d sess., 8 June 1988. 197p. Y4.Sm1:100-66. Hearing on day care and small business focuses on ways to help small businesses support child care for employees. An innovative after school program in Murfreesboro, Tennessee, is described. Cooperative child care arrangements among groups of small businesses are also examined.

3260. U.S. Congress. House. Committee on Small Business. Subcommittee on Regulation and Business Opportunities. *Child Care and Small Business, Hearing.* 100th Cong., 2d sess., 5 Mar. 1988. Portland, OR. 114p. Y4.Sm1:100-63. Hearing on child care and small business examines the issues from both the perspective of child care as a small business and child care benefits for employees of small businesses. The problem of child care providers in obtaining loans and other small business assistance is discussed. Owners of small businesses detail the benefits of supporting working mothers by offering flexible scheduling and child care.

3261. U.S. Congress. House. Committee on Ways and Means. Subcommittee on Public Assistance and Unemployment Compensation. *Child Care Needs of Low-Income Families, Hearing.* 100th Cong., 2d sess., 9 June 1988. 154p. Y4.W36:100-73. Representatives

of child welfare organizations testify regarding the need to establish federal policy and programs that help low-income working families afford quality child care. Recurring themes in testimony are the need for federal day care standards, freedom of choice in type of day care provider, making child care tax credits refundable, and supporting mothers who stay home to care for young children.

3262. U.S. Congress. House. Select Committee on Aging. Subcommittee on Human Services. *Future Directions in Title V: Community Service Employment for Older Americans, Hearing.* 100th Cong., 2d sess., 2 Aug. 1988. 129p. Y4.Ag4/2:Em7/7. Options for encouraging the use of Title V of the Older Americans Act for training and employment of older persons in day care is explored. Successful inter-generational day care programs are described.

3263. U.S. Congress. House. Select Committee on Children, Youth, and Families. *Double Duty: Caring for Children and the Elderly, Hearing.* 100th Cong., 2d sess., 3 May 1988. 134p. Y4.C43/2:D95. Hearing explores the financial and psychological pressures on families caring for children and elderly parents. The effect of the demands on working women is particularly noted.

3264. U.S. Congress. Joint Economic Committee. Subcommittee on Education and Health. *Latchkey Children, Hearing.* 100th Cong., 2d sess., 11 Mar. 1988. 126p. Y4.Ec7:L34/7. The problem of working mothers and school-age child care is explored in hearing testimony focusing on latchkey programs in New Mexico. Possible program structure and the need for funding is discussed as witnesses point out the barriers to obtaining care for school-age children.

3265. U.S. Congress. Senate. Committee on Appropriations. Subcommittee on Departments of Labor, Health and Human Services, Education and Related Agencies. *Federal Role in Child Care, Special Hearing.* 100th Cong., 2d sess., 13 Feb. 1988. Las Vegas, Nev. 118p. Y4.Ap6/2:S.hrg.100-682. Hearing on S. 1885, the Act for Better Child Care Services of 1987, discusses the problems of working mothers and the lack of affordable, quality child care with specific reference to the situation in Nevada. The developmental benefits of quality care for children and the role of child care in helping AFDC mothers leave the welfare ranks are discussed. Witnesses stress the need for federal action on the child care issue.

3266. U.S. Congress. Senate. Committee on Finance. *Federal Roles in Child Care, Hearing.* 100th Cong., 2d sess., 22 Sept. 1988. 231p. Y4.F49:S.hrg.100-1032. The entry of large numbers of mothers into the labor force and the resulting demand for child care is explored in hearings on the federal role in child care. Helping families afford child care and the use of standards to ensure quality are two main topics. Conservative groups testify against current child care bills on the grounds that they tax the poorer single-earner families in order to subsidize child care for more affluent two-income families.

3267. U.S. Congress. Senate. Committee on Labor and Human Resources. *Act for Better Child Care Services of 1988, Report Together with Additional Views to Accompany S. 1885.* S. Rept. 100-484, 100th Cong., 2d sess., 1988. 99p. Serial 13865. The problems faced by working parents in locating quality and affordable child care are highlighted in this committee report on a federal child care funding measure which stresses local aid for provision of services to low and moderate income families. One of the points of debate is the provision of child care in informal settings and the stress of the bill on licensed facilities.

3268. U.S. Congress. Senate. Committee on Labor and Human Resources. *Day Care - a National Priority, Hearing.* 100th Cong., 2d sess., 22 Jan. 1988. Cleveland, OH. 35p.

Y4.L11/4:S.hrg.100-665. Information gathering hearing on child care explores the nature of the problem and ways to secure high quality and affordable child care. Includes information on day care costs, employer sponsored referral systems, and Title XX support.

3269. U.S. Congress. Senate. Committee on Labor and Human Resources. Subcommittee on Children, Family, Drugs and Alcoholism. *Act for Better Child Care Services of 1987, Hearings on S. 1885.* 100th Cong., 2d sess., 15 Mar., 28 June 1988. 380p. Y4.L11/4:S.hrg.100-882. Hearing examines the availability and quality of child care in relation to a bill to implement a federal child care program. Topics highlighted include salaries of child care workers, long term effects of child care quality, and the government role in child care provision.

3270. U.S. Congress. Senate. Committee on the Budget. *Child Care Services in Tennessee, Hearing.* 100th Cong., 2d sess., 7 May 1988. Nashville, TN. 64p. Y4.B85/2:S.hrg.100-696. Witnesses discuss the child care situation in Nashville and express strong support for federal funding for day care. Various roles for the government support of quality child care are outlined, and ways to encourage employer supported day care are examined.

3271. U.S. Dept. of Labor. *Child Care, a Workforce Issue: Report of the Secretary's Task Force.* Washington, DC: GPO, 1988. 182p. L1.2:C43/5. Report of an investigation of the child care issue in America. Examines the need, availability, and affordability of child care. The federal, state, and employer role in assisting parents in securing adequate child care is reviewed, and a concise summary of existing federal programs and program funding is furnished.

3272. U.S. Congress. House. *Proposed Legislation: Working Family Child Care Assistance Act of 1989 and Head Start Amendments of 1989, Message from the President of the United States Transmitting Drafts of Child Care Legislative Proposals Prepared by the Secretaries of the Treasury and Health and Human Services.* H. Doc. 101-37, 101st Cong., 1st sess., 1989. 12p. Provides drafts of a child care tax credit bill and a Head Start appropriations bill.

3273. U.S. Congress. House. Committee on Armed Services. Military Personnel and Compensation Subcommittee. *Military Child Care, Hearing.* 101st Cong., 1st sess., 13 Apr. 1989. 77p. Y4.Ar5/2a:989-90/20. Representatives of the Navy, Air Force, Army and Department of Defense briefly review efforts to provide quality child care for military families.

3274. U.S. Congress. House. Committee on Education and Labor. *Early Childhood Education and Development Act of 1989, Report Together with Dissenting, Additional, and Individual Views to Accompany H.R. 3.* H. Rept. 101-190, part 1, 101st Cong., 1st sess., 1989. 121p. Report on a bill to expand Head Start and programs under the Elementary and Secondary Education Act of 1985 to include child care services details the provisions of the block grant programs. The demand for child care and the barriers often faced by parents are described. School-based programs and incentives for business-provided child care are part of the bill. Views in addition to the majority report focus on parental choice of provider and on provider standards.

3275. U.S. Congress. House. Committee on Education and Labor. *Hearing on Child Care.* 101st Cong., 1st sess., 9 Feb. - 5 Apr. 1989. 505p. Y4.Ed8/1:101-18. Hearing on legislative approaches to the child care shortage explores the extent of the shortage and the child care programs already in place. The primary topic of debate is the separation of church and state and possibilities for supporting church-run day care services. Quality of child care, possibilities for using public school buildings, and parental choice are also discussed.

3276. U.S. Congress. House. Committee on Government Operations. Government Activities and Transportation Subcommittee. *Child Care in Federal Buildings: GSA Oversight, Hearing.* 101st Cong., 1st sess., 8 Mar. 1989. 22p. Y4.G74/7:C43/5. Brief hearing explores the level of commitment in the GSA to encouraging onsite child care for federal employees. At the center of debate is confusion over which agency, GSA or OPM, should take the leadership role in ensuring child care availability for government employees.

3277. U.S. Congress. House. Committee on Ways and Means. *Early Childhood Education and Development Act of 1989, Report Together with Additional and Dissenting Views to Accompany H.R. 3.* H. Rept. 101-190, part 2, 101st Cong., 1st sess., 12 Sept. 1989. 92p. Favorable report on block grants under Title XX for child care programs briefly reviews the need for federal child care funding and details the provisions of the bill. An expansion of the Earned Income Tax Credit is described and areas of required child care standards are set out. Dissenting committee member views focus on federal intrusion in child care standards and the cost of the bill.

3278. U.S. Congress. House. Committee on Ways and Means. Subcommittee on Human Resources. *How to Help the Working Poor; the Problems of the Working Poor, Hearings.* 101st Cong., 1st sess., 28 Feb. - 27 Apr. 1989. 275p. Y4.W36:101-5. Discussion of strategies to aid the working poor focuses on income tax programs such as the Earned Income Tax Credit and the Dependent Care Tax Credit. Debate on how to help working families with low incomes take advantage of these tax programs and the program's effectiveness in improving the situation of such families is presented. Child care cost is a major issue as are other employment versus welfare issues including health insurance.

3279. U.S. Congress. House. Select Committee on Aging. Subcommittee on Retirement Income and Employment. *Better Utilizing an Older Workforce: A Focus on Intergenerational Day Care, Hearing.* 101st Cong., 1st sess., 13 Sept. 1989. 245p. Y4.Ag4/2:Ol1/38. The factors which encourage workers to retire early and which penalize them for working part-time after retirement are reviewed in hearing testimony. Proposals to exempt day care earnings of older workers from rules which reduce their Social Security income in proportion to such earnings are reviewed.

3280. U.S. Congress. House. Select Committee on Children, Youth, and Families. *U.S. Children and Their Families: Current Conditions and Recent Trends, 1989, a Report Together with Additional Views.* 101st Cong., 1st sess., 1989. Committee print. 297p. Y4.C43/2:C43/989. Report pulls together statistical data reflecting the living conditions and trends affecting children. Topics covered in detail include family environment, parental employment and child care, families with children in poverty, eduction, and health. Other specific areas detailed are teenage sexual activity and abortion, prenatal care, child support, and teenage rape victims.

3281. U.S. Congress. Senate. Committee on Finance. *Child Care and Health Insurance Act of 1989, Report to Accompany S. 1185.* S. Rept. 101-51, 101st Cong., 1st sess., 1989. 40p. Reports a bill to make child care tax credits refundable and to make other changes in the Internal Revenue Code of 1986.

3282. U.S. Congress. Senate. Committee on Finance. *Child Care Health Initiative, Hearing.* 101st Cong., 1st sess., 12 June 1989. 134p. Y4.F49:S.hrg.101-524. Hearing on proposed changes in the Dependent Care Tax Credit and a proposed child health tax credit centers on the issue of refundability to low income parents who do not owe taxes. Ways to make health insurance and child care affordable for low-income families through the tax system are explored.

3283. U.S. Congress. Senate. Committee on Finance. *Child Care Welfare Programs and Tax Credit Proposals, Hearings on S. 55, S. 159, S. 187, S. 364, S. 392, S. 409, S. 412, S. 569, S. 601, and S. 692.* 101st Cong., 1st sess., 18-19 Apr. 1989. 303p. Y4.F49:S.hrg.101-291. Testimony considers various legislative approaches to improving child care for working mothers. Federal subsidies to child care providers, tax deductions to parents, and other forms of federal support for child care providers are explored. Witnesses describe day care shortages and day care costs across the socioeconomic spectrum. Types of child care, principally day care centers and family day care homes, are examined in relations to costs, availability, licensing, and parental preference.

3284. U.S. Congress. Senate. Committee on Labor and Human Resources. *Act for Better Child Care Services of 1989, Report Together with Minority Views to Accompany S. 5.* S. Rept. 101-17, 101st Cong., 1st sess., 1989. 73p. Report describes problems of day care availability, affordability, and quality as background for a bill to provide child care assistance to low- and moderate-income families. Additional and minority views support the concept of the federal role in child care, but reject the bill presented. The issue of federal support and child care provided by religious organizations is raised.

3285. U.S. Congress. Senate. Committee on Labor and Human Resources. Subcommittee on Children, Family, Drugs and Alcoholism. *Act for Better Child Care Services of 1989, Hearing on S. 5.* 101st Cong., 1st sess., 24 June 1989. 175p. Y4.L11/4:S.hrg.101-135. Issues of whether to subsidize child care, how to subsidize it, and licensing standards are debated in hearings to consider the proposed Act for Better Child Care Services. Primary areas of disagreement are a perceived bias against family-based care in favor of licensed day care centers and objections to taxing "traditional" lower income families in order to subsidize child care to higher income two-earner families.

3286. U.S. Dept. of Labor. Child Care Liability Insurance Task Force. *Employer Centers and Child Care Liability Insurance.* Washington, DC: GPO, 1989. 101p. L1.2:Em7/22. In-depth report on the role of liability insurance availability on employer decisions to provide child care examines the attitudes of employers toward liability and risk reduction. Rules governing child care centers are reviewed and actions in response to the liability insurance crisis are examined. Recommendations for employer-run child care emphasize risk control.

3287. U.S. General Accounting Office. *Child Care: Selected Bibliography.* Washington, DC: The Office, 1989. 157p. GA1.13:HRD-89-88FS. Bibliography provides 386 citations, mostly annotated, from a computerized literature search of business, education, sociological, and legal databases on child care. The bibliography covers print materials published between 1978 and 1988.

3288. U.S. General Accounting Office. *Military Child Care: Extensive, Diverse, Growing.* Washington, DC: The Office, 1989. 88p. GA1.13:HRD-89-3. Review of military child care programs looks at administration, funding, characteristics of CONUS services and characteristics of children participating. Criticism of DoD child care in a 1982 GAO report is reviewed and progress made in the intervening years is noted. The adequacy of CONUS to meet the demand for child care for military families is also discussed.

3289. U.S. Internal Revenue Service. *Establishing a Child Care Facility.* IRS Document 7437. Washington, DC: The Service, 1989. various paging. T22.2/15:7437. Handbook on establishing child care centers for IRS offices reviews the rationale for employer-supported child care. Types and standards of care and liability issues are covered. The legislation enabling IRS offices to establish day care facilities is detailed in reprinted IRS memoranda.

3290. U.S. Small Business Administration. *Quality Child Care Makes Good Business Sense.* Washington, DC: The Administration, 1989? poster. SBA1.33/2:C43. Smaller poster issued under SuDoc number SBA1/33/2:C43/small.

3291. U.S. Women's Bureau. *CHOICES: Clearinghouse on Implementation of Child Care and Eldercare Services.* Washington, DC: GPO, 1989. [8]p. L36.102:C45. Brochure describes the CHOICES database, an information and referral service for employers to help them deal with child care and eldercare issues.

3292. U.S. Women's Bureau. *Employers and Child Care: Benefiting Work and Family.* Washington, DC: GPO, 1989. 76p. L36.102:Em7/7. Primer on employer supported child care reviews the problems faced by working mothers in securing care for their children. The bulk of the report focuses on employer initiatives to assist employees with child care issues. Research on benefits of employer-sponsored child care programs is reviewed and examples of successful programs are provided. In addition to child care, the report highlights other family-oriented work policies such as allowing personal calls, family time off, maternity and paternity leaves, flexible scheduling, and job sharing. Also included are suggested approaches to determining employee's family-related needs and financial incentives to companies providing child care support.

3293. U.S. Women's Bureau. *Working Mothers and Their Children.* Facts on Working Women no. 89-3. Washington, DC: The Bureau, 1989. L36.114/3:89-3. Provides a concise summary of the characteristics of working mothers and their children including marital status, income, race/ethnicity, and employer's reaction to child care.

3294. U.S. Bureau of the Census. *Who's Minding the Kids? Child Care Arrangements, Winter 1986-87.* by Martin O'Connell and Amara Bachu. Current Population Reports Series P-70, Household Economics Studies no. 20. Washington, DC: GPO, 1990. 36p. C3.186:P70/2/no.20. Analysis of statistics on child care arrangements of working mothers identifies trends, economic impact factors, and child care expenditures. Statistical tables provide data on type of arrangement by the characteristics of the mother, child care arrangements used by employed fathers or male guardians, secondary care arrangements by age of child and type of primary care arrangement; and child care arrangements for school age children. Also detailed are weekly child care expenditures and part of parent's income paid for child care by family characteristics, and time lost from work by employed women due to failed child care arrangements, by characteristics of the mother.

3295. U.S. Congress. House. Committee on Education and Labor. *Hearing on H.R. 3, Early Childhood Education and Development Act, Hearing.* 101st Cong., 2d sess., 19 Jan. 1990. San Francisco, CA. 169p. Y4.Ed8/1:101-72. Testimony in support of a federal child care funding bill centers on the existing state supported child care program in California. Witnesses describe the need to provide quality, education-oriented day care, not just the lowest cost custodial care. Some discussion also centers on placement of the program under Title XX of the Social Security Act.

3296. U.S. Congress. House. Committee on Education and Labor. *Human Services Reauthorization Act of 1990, Report Together with Supplemental and Additional Views to Accompany H.R. 4151.* H. Rept. 101-480, 101st Cong., 2d sess., 9 May 1990. 86p. Reports a bill authorizing numerous human services programs including Head Start and Community Services Block Grants. Among the programs affected is the State Dependent Care Development Grants Act with its focus on after school programs for latchkey children.

3297. U.S. Congress. House. Committee on Education and Labor. Subcommittee on Human Resources. *Hearing on the Reauthorization of the Child Development Associate*

Scholarship Assistance Act of 1985 and State Dependent Care Development Grants Act, Hearing. 101st Cong., 2d sess., 20 Feb. 1990. 54p. Y4.Ed8/1:101-97. Brief hearing considers reauthorization of a program of financial aid to help low-income persons, primarily women, achieve credentials as Child Development Associates and of the State Dependent Care Development Grants Act, a program to fund child care resource and referral programs and latchkey children programs. Testimony reviews the accomplishments of the programs and the need for continued funding.

3298. U.S. Congress. House. Committee on Veterans' Affairs. Subcommittee on Oversight and Investigations. *DVA Child Care Centers and Employee Child Care Services, Hearing.* 101st Cong., 2d sess., 11 July 1990. 173p. Y4.V64/3:101-54. Hearing reviews progress in establishing child care services for Department of Veterans Affairs employees. In addition to general discussion of the entry of women into the labor force and the resulting demand for child care, witnesses also discuss the need for child care as a recruiting and retention tool for VA nurses.

3299. U.S. Congress. House. Select Committee on Aging. Subcommittee on Housing and Consumer Interests. *Mothers, Wives, and Daughters: Who is Caring for Tennessee Caregivers? Hearing.* 101st Cong., 2d sess., 14 May 1990. Chattanooga, TN. 144p. Y4.Ag4/2:M85. Caregivers, representatives of associations on aging, and employers discuss the demands of caring for elderly parents and ways employers and communities can assist caregivers. Background information includes a profile of caregiver characteristics. Witnesses describe coping with the double burden of caring for parents and children and detail the difficulties of maintaining both a job and the caregiver role. Medicare and Medicaid policies which could be changed to assist caregivers are noted.

3300. U.S. Congress. House. Select Committee on Aging. Subcommittee on Human Services. *Sharing the Caring: Options for the 90s and Beyond, a Policy Forum.* 101st Cong., 2d sess., 1990. Committee print. 188p. Y4.Ag4/2:C18/4. The growing problem of working caregivers and homecare of the elderly is explored in a forum format. Both government and employer policy options to ease the strain of caregivers are explored highlighting existing homecare projects. Research on the caregiver population and corporate executive attitudes on employees as caregivers are noted.

3301. U.S. Congress. Senate. Committee on Energy and Natural Resources. *Allowing a Certain Parcel of Land in Rockingham County, Virginia, To Be Used as a Child Care Center, Report to Accompany H.R. 3888.* S. Rept. 101-525, 101st Cong., 2d sess., 1990. 5p.

3302. U.S. Dept. of Transportation. Office of the Secretary. *D.O.T. Child Care: Resource and Referral Directory.* Washington, DC: The Department, 1990. 70p. TD1.9/4:C43. Directory of child care referral agencies arranged by state. Also provides basic information on selecting a child care provider.

3303. U.S. Financial Management Service. *The Financial Management Service Is Pleased to Office Practical Help for Your Child Care Concerns..."* Washington, DC: The Service, 1990. leaflet. T63.102:F49/7. Leaflet describes a nationwide resource and referral service, the ChildCare Solution.

3304. U.S. National Center for Health Statistics. *Child Care Arrangements: Health of Our Nation's Children, United States, 1988.* by Deborah A. Dawson and Virginia S. Cain. NCHS Advanced Data no. 187. Washington, DC: The Center, 1990. 12p. HE20.6209/3:187. Presents results of a survey on child care and health with a focus on child care arrangements of both employed and non-employed mothers. Factors such as family income, mother's education and employment status, source of care, stability of care arrangements, and number of children sharing care are examined.

SERIALS

3305. U.S. Federal Regional Council. Region X. Child Care Task Force. *Foresight, Community Coordinated Child Care.* Seattle, Wa.: Federal Regional Council, Nov. 1974? - Jan. 1975?. Pr37.8:R26/F76.

3306. U.S. Government Printing Office. Superintendent of Documents. *Day Care.* Washington, DC: GPO, 1977 - . irregular. GP3.22/2:092/year. Short list of documents available from the Superintendent of Documents on day care.

3307. U.S. Internal Revenue Service. *Child and Dependent Care Credit.* IRS Publication 503. Washington, DC: The Service, 1968 - . irregular. T22.44/2:503/no. Earlier issues called *Child and Disabled Dependent Care.* Instructions for claiming child and dependent care credit on income tax forms.

3308. U.S. National Center for Social Statistics. *Child Care Arrangements of AFDC Recipients under the Work Incentive Program as of the Last Day of the Quarter...* Washington, DC: The Center, Dec. 1969 - Sept. 1975. Quarterly. HE17.609:date. Quarterly statistics by state detail the number of mothers in the WIN program, child care arrangements by age, and mothers not certified for the WIN program due solely to unavailability of child care.

3309. U.S. Office of Education. *News Exchange, Extended School Services for Children of Working Mothers.* Washington, DC: The Office, May 1943 - Nov. 1944. monthly. FS5.36:no.

20

The Women's Bureau

Many of the documents which describe the work of the Women's Bureau are scattered throughout the two volumes of this bibliography. Documents very specific to the Women's Bureau are listed below. The first documents record the congressional debate over the establishment of a separate bureau to study the employment of women (3311-3314). The remainder of the documents are primarily short pieces on goals and activities or publication lists. Also included are nominations hearings for the Women's Bureau directors, usually nothing more than a short biography and statement of goals. A brief history of the Women's Bureau with highlights of the contributions of each of the directors was published for the 65th anniversary (3352).

In 1984 the Women's Bureau came under the scrutiny of the House Committee on Government Operations. The committee's hearing and report, *The Women's Bureau: Is It Meeting the Needs of Women Workers?* (3350-3351), criticize the bureau for abandoning its long history of leadership on women's issues and for its ineffectiveness in the 1980s.

3310. U.S. Congress. Senate. *Bureau of Woman Labor: Letter from Flora McDonald Thompson Petitioning the Secretary of Labor for the Establishment of a Bureau of Woman Labor in the Department of Labor.* S. Doc. 38, 63d Cong., 1st sess., 1913. 6p. Serial 6535. Petition for the creation of a Bureau of Woman Labor stresses the need to study women's occupation in the home. The author sees the primary role of the bureau as developing and applying home economics in order to make homemaking profitable to women.

3311. U.S. Congress. House. Committee on Labor. *Woman's Division in Department of Labor, Report to Accompany H.R. 16358.* H. Rept. 1205, 64th Cong., 2d sess., 1916. 6p. Serial 7110. House report recommends passage of a bill to create a woman's division in the Department of Labor and details the need for a unit to collect information on women workers. Also describes the physical differences between women and men which make particular attention to the problems of women in industry appropriate. Organizations backing the bill are noted.

3312. U.S. Congress. Senate. Committee on Education and Labor. *Women's Division, Department of Labor, Report to Accompany S. 5408.* S. Rept. 897, 64th Cong., 2d sess., 1917. 1p. Serial 7106. Favorable report on the establishment of a Women's Division in the Department of Labor amends the bill by reducing staff and salaries.

3313. U.S. Congress. House. Committee on Labor. *To Establish a Women's Bureau, Report to Accompany H.R. 13229.* H. Rept. 783, 66th Cong., 2d sess., 1920. 3p. Serial 7653. The

committee recommends passage of a bill to continue the work of the Department of Labor's Women in Industry Service through a permanently established Women's Bureau.

3314. U.S. Congress. House. Committee on Labor and U.S. Congress. Senate. Committee on Labor. *Women's Bureau, Hearings before the Joint Committee...on S. 4002...H.R. 1134...H.R. 12679.* 66th Cong., 2d sess., 4,5 March 1920. 88p. Y4.L11:W84. Hearing considers various bills, all of which would establish a women's division or bureau within the Department of Labor on a permanent basis. The investigatory, not regulatory, nature of the proposed bureau and its intended functions are stressed. One point of discussion is whether the bureau would only hire women, and the appointment of women in other areas of the Labor Department. A good part of the hearing focuses on the question of duplication between the Children's Bureau, the Bureau of Labor Statistics, and the proposed Women's Bureau. Testimony of Mary Van Kleek highlights the operation of the Women in Industry Service during her tenure as chief. Also outlined in testimony is the state of trade unionism among women, particularly in reference to the Women's Trade Union League.

3315. U.S. Congress. Senate. Committee on Education and Labor. *Women's Bureau, Report to Accompany H.R. 13229.* S. Rept. 572, 66th Cong., 2d sess., 1920. 3p. Serial 7649. Favorable report on the establishment of the Women's Bureau reprints the House Report 783 (3313) on the same bill.

3316. U.S. Congress. Senate. *The Women in Industry Bureau of the Department of Labor: Letter from the Secretary of the Treasury, Transmitting a Communication from the Secretary of Labor Submitting a Deficiency Estimate of Appropriation Required by the Department of Labor for the Women in Industry Bureau Fiscal Year 1920.* S. Doc. 381, 66th Cong., 3d sess., 1921. 2p. Serial 7794.

3317. U.S. Women's Bureau. *Bulletins, Women's Bureau, Dept. of Labor, Washington, D.C.* Folder no. 2. Washington, DC: The Bureau, 1923. [6]p. leaflet. L13.7:2.

3318. U.S. Women's Bureau. *What Industry Means to Women Workers.* by Mary Van Kleek. Bulletin no. 31. Washington, DC: GPO, 1923. 10p. L13.3:31. Address given at the Women's Industrial Conference sponsored by the Women's Bureau presents the philosophical basis for improving the situation of women workers and highlights the goals of the Women's Bureau.

3319. U.S. Women's Bureau. *Women Workers and the Federal Government.* Washington, DC: The Bureau, 1926. [6]p. leaflet. L13.2:W84. Also issued as Women's Bureau Folder no.4, L13.7:4. Reviews the activities of the bureau and lists its publications.

3320. U.S. Women's Bureau. *La Oficina de la Mujer, Departamento de Trabajo de los Estados Unidos, Lo Que Hace, Lo Que Publica.* Washington, DC: The Bureau, 1928. 8p. leaflet. L13.2:P96. Spanish edition of *The Women's Bureau of the Department of Labor: What It Is, What It Does, What It Publishes* (3362).

3321. U.S. Women's Bureau. *Activities of the Women's Bureau of the United States.* Bulletin no. 86. Washington, DC: GPO, 1931. 15p. L13.3:86. Briefly reviews the history and accomplishments of the Women's Bureau.

3322. U.S. Women's Bureau. *Fact Finding with the Women's Bureau.* Bulletin no. 84. Washington, DC: GPO, 1931. 37p. L13.3:84. Bulletin provides an overview of the issues studied by the Women's Bureau.

3323. U.S. Women's Bureau. *Health Problems of Women in Industry.* by Mary N. Winslow. Bulletin no. 18, revised. Washington, DC: GPO, 1931. 6p. L13.3:18/2. Overview presents the issues of concern to the Women's Bureau such as hours of labor, working conditions, and the wages which women receive for their work. Earlier edition published in 1921.

3324. U.S. Congress. House. *Communication from the President of the United States Transmitting a Supplemental Estimate of Appropriation for the Department of Labor for the Fiscal Year 1942, Amounting to $40,600.* H. Doc. 370, 77th Cong., 1st sess., 1941. 2p. Serial 10599. Request for additional funds for the Women's Bureau stresses its necessity due to the need to investigation of problems of women employed in defense industries.

3325. U.S. Women's Bureau. *Women's Bureau at Work.* by Frieda S. Miller. Washington, DC: The Bureau, 1945. 4p. L13.2:W84/13. Review of the concerns of the Women's Bureau during WWII highlights briefly the bureau's special studies. Part two looks specifically at the Women's Bureau's connection to labor laws relating to working standards, minimum wage, and the effect of the war on hours. Post war readjustment is also a brief topic of discussion.

3326. U.S. Dept. of Labor. *Introductory Remarks by the Secretary of Labor, L.B. Scwellenbach, at Conference on Employment Problems of Women, 10:00 am, Thursday, March 14, 1946.* Washington, DC: The Dept., 1946. 2p. L1.13:Em7/2. Speech highlights the contributions of the Women's Bureau during WWII.

3327. U.S. Women's Bureau. *Current Publications on Women Workers.* Washington, DC: GPO, Dec. 1946. 2p. L13.2:P96/4/946-2. Earlier edition issued Sept. 1946.

3328. U.S. Women's Bureau. *Organizations, Labor Advisory Committee and Individuals Invited to Attend the Conference on the American Woman - Her Changing Role - Worker, Homemaker, Citizen, Held by the Women's Bureau, U.S. Department of Labor, Washington, D.C., February 17, 18, 19 1948.* Washington, DC: The Bureau, 1948. 7p. L13.2:Am3/2. Lists names of invited attendees and their affiliation.

3329. U.S. Women's Bureau. *Women's Bureau, What It Is, What It Does.* Washington, DC: The Bureau, 1949. 1p. L13.2:W84/27.

3330. U.S. Women's Bureau. *Bureau's International Activities.* Washington, DC: The Bureau, 1950. 6p. L13.2:In85. Presents the history of Women's Bureau involvement in the International Labor Organization and other international efforts to improve the status of women, particularly women workers, around the world. The consulting activities of the bureau, its international outreach programs to develop women leaders, and its role as a model for other countries are also detailed. Bureau participation in the development of labor programs for occupied countries after WWII is also briefly mentioned.

3331. U.S. Women's Bureau. *Topical List of Numbered Bulletins of the Women's Bureau, Department of Labor, 1919-50.* Washington, DC: The Bureau, 1950. 10p. L13.2:B87/prelim.

3332. U.S. Women's Bureau. *Women's Bureau, 1919 - 1950.* Washington, DC: The Bureau, 1950. 4p. L13.2:W84/31. Brief review of programs relating to the areas of concern of the Women's Bureau from 1919 to 1950 include hours, homework, minimum wage, equal pay, and the economic status of women.

3333. U.S. Women's Bureau. *The Women's Bureau, Its Purpose Its Functions.* Washington, DC: GPO, 1950. leaflet. L13.2:W84/20/950. Earlier editions issued in 1946.

3334. U.S. Women's Bureau. *Women's Bureau Publications in the Field of Employment Outlook for Women.* Leaflet no. 17. Washington, DC: GPO, 1953. 6p. leaflet. L13.11:17.

3335. U.S. Congress. Senate. Committee on Labor and Public Welfare. *Nomination of Alice K. Leopold to be Director of the Women's Bureau, Department of Labor.* 83d Cong., 2d sess., 18 Jan. 1954. 7p. Y4.L11/2:L55. Nomination hearing of Alice K. Leopold to be director of the Women's Bureau includes a biographical sketch and statements supporting her nomination from members of the committee.

3336. U.S. Women's Bureau. *Publications of the Women's Bureau on Employment Opportunities for Women.* Leaflet no. 17, revised. Washington, DC: GPO, 1954. 6p. L13.11:17/954.

3337. U.S. Women's Bureau. *Current Publication of the Women's Bureau.* Washington, DC: The Bureau, 1956. 4p. L13.18:956.

3338. U.S. Women's Bureau. *Programs and Services of the Women's Bureau, How to Use Them...* Washington, DC: GPO, 1960. 16p. L13.2:P94/2/960. Overview of the Women's Bureau provides background on the history of the Women's Bureau and its activities. Its relationship with employers and unions, schools and colleges, employment offices, state labor departments and national organizations are described, and assistance provided to international programs is noted. Earlier edition published in 1955.

3339. U.S. Congress. Senate. Committee on Labor and Public Welfare. *Nominations, Hearing on the Nomination of W. Willard Wirtz to be Under Secretary of Labor, Jerry R. Holleman to be Assistant Secretary of Labor, Mrs. Esther Peterson to be Director of the Women's Bureau, Department of Labor.* 87th Cong., 1st sess., 25 Jan. 1961. 12p. Y4.L11/2:N72/5/961.

3340. U.S. Women's Bureau. *List of Publications.* Washington, DC: The Bureau, 1963. 16p. L13.18/2:P96/963.

3341. U.S. Congress. Senate. Committee on Labor and Public Welfare. *Nomination, Hearing on Mary Dublin Keyserling, of the District of Columbia, to be a Director of the Women's Bureau, Department of Labor, Vice Mrs. Esther Peterson, Elevated.* 88th Cong., 2d sess., 3 April 1964. 7p. Y4.L11/2:N72/5/964. Presents background and biographical information on Mary Dublin Keyserling.

3342. U.S. Women's Bureau. *The Women's Bureau, Its Functions and Services.* Leaflet no. 1, revised. Washington, DC: GPO, 1965. leaflet. L13.11:1/3. Earlier edition issued in 1955.

3343. U.S. Congress. Senate. Committee on Labor and Public Welfare. *Nominations, Hearing on James D. Hodgsen, of California, to be Undersecretary of Labor; Arnold R. Weber, of Illinois, to be Assistant Secretary of Labor; Elizabeth Duncan Koontz, of North Carolina, to be Director of Women's Bureau, Department of Labor.* 91st Cong., 1st sess., 6 Feb. 1969. 26p. Y4.L11/2:N72/5/969-3.

3344. U.S. Women's Bureau. *To Benefit Women at Work.* Washington, DC: The Bureau, 1969. 10p. L13.2:B43. Overview of the history of the Women's Bureau, its structure, and early work accompanies a brief discussion of current issues of importance to the bureau. The report reviews international interest in promoting the health and rights of women workers and notes the activities of the President's Commission on the Status of Women.

3345. U.S. Dept. of Labor. *Opening Address, 50th Anniversary Celebration of the Women's Bureau, U.S. Dept. of Labor, by James D. Hodgson, Undersecretary of Labor, Washington Hilton, Washington, D.C., June 12, 1970.* Washington, DC: The Dept., 1970. 7p. L1.13:H66. Cursory treatment of the Labor Department's approach to the problems of working women characterize the speech.

3346. U.S. Congress. Senate. Committee on Labor and Public Welfare. *Nomination Hearing on Carmen R. Maymi, of the District of Columbia, to be Director of the Women's Bureau, Department of Labor.* 93d Cong., 1st sess., 4 June 1973. 5p. Y4.L11/2:N72/5/973-11. Biographical background on Carmen R. Maymi is presented with a brief statement on the history of the Women's Bureau and on her program focus if confirmed as Director.

3347. U.S. Congress. Senate. Committee on Human Resources. *Nominations, Hearing on Dr. Eula Bingham, of Ohio, to be Assistant Secretary of Labor for Occupational Safety and Health; Francis X. Burkhardt, of Maryland, to be Assistant Secretary of Labor for Labor-Management Relations; Arnold H. Packer, of Maryland, to be Assistant Secretary of Labor for Policy, Evaluation and Research; and Alexis Herman, of Georgia, to be Director of the Women's Bureau.* 95th Cong., 1st sess., 15 Mar. 1977. 77p. Y4.H88:N72.

3348. U.S. Women's Bureau. *The Women's Bureau: Working for Equality in Employment for Women.* Leaflet no. 1, revised. Washington, DC: GPO, 1979. [8]p. leaflet. L36.110:1. Later edition issued in 1982.

3349. U.S. Congress. Senate. Committee on Labor and Human Resources. *Nominations, Hearing on John F. Cogan, of California, to be Assistant Secretary of Labor; Lenora Cole-Alexander, of the District of Columbia, to be Director, Women's Bureau, Department of Labor; Rosemary M. Collyer, of Colorado, to be Commissioner, Federal Mine Safety and Health Review Commission; Ford B. Ford, of California, to be Assistant Secretary of Labor.* 97th Cong., 1st sess., 14 Oct. 1981. 75p. Y4.L11/4:N72/981-10.

3350. U.S. Congress. House. Committee on Government Operations. *The Women's Bureau: Is It Meeting the Needs of Women Workers? Report.* H. Rept. 98-1145, 98th Cong., 2d sess., 1984. 20p. Serial 13602. Background on the history of the Women's Bureau, its past reputation as the authoritative source of statistics on working women, and concern over its lack of voice on current working women's issues characterize this report which summarizes opinions gathered on current Women's Bureau operations. The controversy over the dismissal of the two women who were sharing the Region IX administrator position, and the subsequent advertisement of a full-time administrator position, is explored in the report. The report is highly critical of the bureau's use of its resources, cut backs in publications, and lack of leadership efforts on Department of Labor policy and outreach activities, yet is supportive of the overall mission and goals of the bureau.

3351. U.S. Congress. House. Committee on Government Operations. Manpower and Housing Subcommittee. *The Women's Bureau: Is It Meeting the Needs of Women Workers?* 98th Cong., 2d sess., 26 July 1984. 304p. Y4.G74/7:W84/2. Testimony highlights the objectives of the Women's Bureau and its past programs and accomplishments while addressing the question of the effectiveness of the bureau under the Reagan administration. In particular, the dismissal of Madaline Mixer and Gay Cobb, co-directors of the Women's Bureau Region IX office, is examined as evidence of the bureau's failure to support innovations such as job sharing for working women. The dismissals were seen as an attempt to remove two effective women's advocates from the bureau. Policies of the bureau since 1980 which hampered regional office activities are highlighted.

3352. U.S. Women's Bureau. *Milestones: The Women's Bureau Celebrates 65 Years of Women's Labor History.* Washington, DC: The Bureau, 1985? 35p. L36.102:M59. The focus of

this document is on the women who served as director of the Women's Bureau and the progress of the bureau under their direction. A brief chronology of events from women's labor history and the history of the Women's Bureau is presented.

3353. U.S. Women's Bureau. *Women's Bureau: Meeting the Challenges of the 80's.* Washington, DC: GPO, 1985. 17p. L36.102:C35. Summary of the activities of the Women's Bureau in the early 1980's highlights programs on child care, middle-aged minority women, displaced homemakers, and the effect of technology on clerical jobs.

3354. U.S. Women's Bureau. *Publications of the Women's Bureau.* Washington, DC: The Bureau, 1988. 4p. L36.102:P96/2. Lists Women's Bureau publications from the late 1970s and 1980s.

3355. U.S. Women's Bureau. *The Women's Bureau: A Voice for Working Women.* Washington, DC: The Bureau, 1988? 8p. L36.102:V87. Summary states the purpose of the Women's Bureau and its present and future concerns.

3356. U.S. Women's Bureau. *Publications of the Women's Bureau.* Washington, DC: The Bureau, 1990. leaflet. L36.114/3:P96. Brief listing of current bureau publications.

3357. U.S. Women's Bureau. *Women's Bureau Workplan, Fiscal Year 1990.* Washington, DC: GPO, 1990. 32p. L36.102:W89/7. Fiscal year 1990 work plan for the Women's Bureau highlights policy initiatives and planned programs and publications focusing on the areas of work and family, training, affirmative action, and health and safety. Most of the plan centers on conferences and workshops for women workers and employers. Child care, displaced homemakers, nontraditional occupations, federal job training, older women, math and science education, minority women, and reproductive hazards are among the topics covered. International activities of the bureau are also noted.

SERIALS

3358. U.S. Women's Bureau. *Annual Report of the Director of the Women's Bureau.* Washington, DC: GPO, 1919 - 1932. 1st - 14th. annual. L13.1: year. The 1919 report was titled *Annual Report of the Director of the Women in Industry Service.* Reviews the activities and major investigations of the Women's Bureau for the fiscal year.

3359. U.S. Women's Bureau. *Current Publications of the Women's Bureau.* [title varies] Washington, DC: The Bureau, 1943 - 1949. irregular. L13.2:P96/2/year.

3360. U.S. Women's Bureau. *Current Publications of the Women's Bureau.* [title varies] Washington, DC: The Bureau, 1949 - 1955. irregular. L13.2:P96/5/year.

3361. U.S. Women's Bureau. *Publications of the Women's Bureau.* [title varies] Leaflet no. 10. Washington, DC: The Bureau, 1952 - 1977. irregular. L13.11:10/no.; L36.110:10/no.

3362. U.S. Women's Bureau. *The Women's Bureau of the Department of Labor: What It Is, What It Does, What It Publishes.* Folder nos. 5 - 14. Washington, DC: GPO, 1927 - 1941. irregular. L13.7:no. Leaflet briefly describes the charge and activities of the Women's Bureau and provides a list of publications.

Personal Author Index

Abbott, Virginia C., 2260
Ackroyd, Margaret F., 829
Ames, Nancy L., 2874
Anderson, Margaret Kay, 2232
Anderson, Mary, 41, 96, 2194
Andrews, John B., 11
Ashman, Jane, 74, 75, 82, 1208-1209, 2678-2679

Bachu, Amara, 3294
Bailey, Eleanor C., 1304
Bailey, J. Powell, 281
Bender, Cynthia, 1500
Benham, Elizabeth D., 80, 2265, 2278
Benter, Pater M., 2068
Berkely, Marvin H., 1957, 1966
Best, Ethel L., 44, 47, 52, 56, 744, 863, 1013, 1024, 1040, 1048
Beyer, Clara M., 738
Bixby, Lenore E., 237
Blair, Bertha, 752, 1037, 1043, 1045
Bliss, D. P., 11
Bonner, H. R., 1196
Boquist, Constance, 1433
Bradbury, Dorothy E., 3101
Brady, Dorothy S., 518, 520
Brennan, Peter J., 251
Bretz, Judith S., 237
Brewer, John M., 2768
Briggs, Norma, 2968
Brokaw, Leland D., 1966
Brown, David L., 1153
Brown, Emily C., 740, 860-861
Brown, Jean C., 69
Bruno, Rosalind R., 3243
Buethe, Chris, 2886
Burdick, Anna L., 2914
Burns, Ruth Ann, 2497

Byrne, Harriet A., 51, 57, 62, 70, 752, 869, 1020, 1047, 2629, 2631

Cadoree, Michelle, 325
Cain, Virginia S., 3304
Calkin, Homer L., 2439
Campbell, Paul B., 3037
Cannon, Mary M., 122
Carter, Constance, 299
Chaney, Lucian W., 849
Channing, Alice, 1019, 1023
Chapman, Jane Roberts, 443, 2522
Church, Roberta, 170
Clarkson, Grosvenor B., 2147
Cleveland, Robert W., 1166
Cobb, Bart B., 2386, 2400-2401
Cohen, Wilbur J., 224
Collins, Barry E., 2068
Collins, William E., 2400-2401
Connor, John T., 2367
Conyngton, Mary K., 14
Cooper, Sara, 2971
Correll, Marie, 862, 864-865, 2595
Crane, Jane L., 582
Cymrot, Donald, 1136

Davidson, Janice L., 296
Dawson, Deborah A., 3304
Dempsey, Mary L., 46
Diamond, Esther E., 2867
Dickensen, Gladys, 132
Ditmore, Jack, 3166
Douty, Agnes M., 205

Edge, Cornelia, 93
Edner, Judy Maruca, 2728
Elliot, Lois Lawrence, 1989-1991
Elliott, Harriet, 2159

Subject Index

Abortion, 458, 921-922, 3280
 adolescents, 3280
 and employee health insurance, 921-922
 Rehnquist nomination, 458
Abrasives industry:
 hazards, 2140
 utilization of women, 2140
Absenteeism and turnover, 15, 90, 198, 216,
 238, 254, 507, 511, 530, 532, 890,
 967, 996, 1007-1008, 1111, 2250,
 2276-2277, 2285, 2289, 2347, 2360,
 2400-2401
 among air traffic controllers, 2400-2401
 in army supply depots, 2285
 causes, 996, 1007-1008
 cotton mills, 996, 1007-1008
 federal civil service, 2347, 2360
 gender differences, 216, 238, 507, 511,
 530, 532, 1007, 1111, 2400-2401
 predictors, 238
 statistics, 90, 198, 890, 1111
 Virginia, 967
 and war industries, 15, 2250, 2276-
 2277, 2285, 2289
Accounting:
 career opportunities, 2805
Actresses:
 age discrimination, 413
Adolescents:
 pregnancy, 287, 3035, 3213
 sexual activity, 3280
 sexual assault victims, 3280
Advisory Committee on the Economic Role
 of Women, 246
Aeronautics and aerospace:
 bibliography, 85
 career opportunities, 2772, 2880, 2886,
 2899

government contractors, 1179
history, 2055
utilization of women, 350, 474-475,
 1179
Affiliated Schools for Workers, 76
Affirmative action, 317, 366, 372, 374-375,
 377, 384, 387, 390, 394-395, 401-402,
 407, 409, 411-412, 418-419, 423-424,
 426-427, 429, 430, 437, 442, 452-455,
 457-462, 466, 471-472, 479, 481, 574,
 2059, 2371, 2373-2374, 2406-2407,
 2409, 2413, 2415, 2417-2420, 2422-
 2423, 2432-2433, 2455, 2447-2448,
 2451-2452, 2461, 2464-2470, 2472-
 2473, 2475, 2478, 2480, 2490-2492,
 2495, 2501, 2506, 2510-2516, 2517,
 2519, 2521, 2523-2524, 2526-2530,
 2532-2533, 2537, 2539, 2542-2543,
 2545, 2549, 2552-2554, 2557, 2565-
 2566, 2569, 2588-2590, 2720, 2985
 and African-American women, 460
 Agency for International Development,
 2537
 Alabama state government, 2475
 Alaska state government, 2490
 Army civilian employees, 2539
 Army Corps of Engineers, 2419-2420
 Army National Guard, 2059
 bibliography, 418
 Bureau of Radiological Health, 2407
 Bureau of Reclamation, 2371
 California state government, 2491
 and CETA, 375
 in Cleveland, 402
 constitutionality, 462
 in criminal justice system, 418
 court cases, 390, 411, 419, 458, 2423
 Customs Service, 2413, 2422, 2542

Affirmative action (cont.)
 data sources, 407
 damage awards, 472
 Defense Contract Administration, 2506
 Department of Agriculture, 2565-2566
 Department of Education, 2532
 Department of Energy, 2461
 Department of Justice, 454, 2455, 2467-2469, 2532
 Department of State, 2537, 2552-2554, 2557
 Department of Transportation, 2480
 Drug Enforcement Administration, 2468
 and economic depressions, 2515
 and the EEOC, 366, 574, 2527, 2532-2533, 2543
 effect on women, 458
 employer guidebook, 374
 enforcement, 390, 426-427, 437, 442, 455, 2465
 federal agencies, 412, 2409, 2415, 2501, 2521, 2526, 2532-2533, 2543, 2588-2590
 federal contractors, 2720
 Federal Aviation Administration, 2373, 2432
 Federal Bureau of Investigation, 2469, 2545
 federal judges and courts, 2478, 2495, 2510-2512, 2546
 Federal Prison System, 2467
 Food and Drug Administration, 2466
 Foreign Service, 2517, 2553
 goals and timetables, 429, 453, 457
 Government Printing Office, 2373
 in higher education, 372, 377, 387
 history, 460
 Immigration and Naturalization Service, 2470
 Indianapolis city government, 2514
 Internal Revenue Service, 2549, 2569
 Knoxville (Tenn.), 2516
 Law Enforcement Assistance Administration, 2467
 and layoffs, 2985
 Manpower Administration, 2417
 Michigan cities, 2515
 in motion picture industry, 394, 401
 National Bureau of Standards, 2524
 National Credit Union Administration, 2418, 2472
 National Endowment for the Humanities, 2527, 2532-2533
 National Institute of Dental Research, 2447
 National Institute of Neurological and Communicative Disorders and Stroke, 2473
 National Library of Medicine, 2519
 nontraditional occupations, 426
 Oak Ridge (Tenn.), 2516
 Oklahoma state government, 2451
 Omaha, NE, 409
 Pacific Bell, 466
 Postal Service, 2528-2530
 private sector, 409
 programs, 366, 407
 and quotas, 453, 479, 481
 Reagan administration policy, 426-427, 437, 452, 455, 461
 results, 460
 and reverse discrimination, 426, 457
 Rehnquist nomination, 459
 Salt Lake City criminal justice agencies, 2452
 Secret Service, 2433
 and seniority, 384, 395
 and set asides, 2720
 Southern Cal Edison, 466
 Southern California Gas Co., 466
 state governments, 2465, 2513
 at the State University of New York, 387
 and *Stotts* decision, 454-455, 457, 574, 2527
 Tacoma (Wash.) government, 2492
 and unions, 427
 United States Information Agency, 2537
 Urban Mass Transportation Administration, 2448
 utility companies, 466
 Walter Reed Army Medical Center, 2406
African-American women, 19-20, 32, 48, 69, 81, 112, 125, 128, 155, 170, 206, 215, 227, 231, 253, 277, 308, 323, 1018, 1120, 1124, 1292, 2286, 2747, 2778, 2786, 2869, 2969. *See also* Minority women; and under specific topics
 business owners, 2747
 career planning, 2869
 earnings, 32, 215, 227, 1018, 1124, 2286
 education, 215, 227, 231, 2778
 effect of discrimination, 323
 employment, 19-20, 32, 48, 69, 81, 155, 170, 206, 215, 227, 231, 253, 277, 1120, 1124, 2786, 2869
 employment history, 323

Congress, House of Representatives:
 House Office Building attendant, 2324
 Ladies Reception Room attendant, 2311,
 2313-2319, 2322, 2325-2326, 2329
 maternity leaves for employees, 940
Congress, Senate:
 appointment of female pages, 2379-2380
 child care center, 3220
 sex discrimination in Senate
 employment, 2438, 2459
Conservation work:
 career opportunities, 2855
Construction industry, 255, 314, 1135, 1145,
 2738, 2741-2742, 2900-2903, 2721-
 2723
 career opportunities, 2900-2903
Contingent work force, 316
Contraception and family planning:
 and AFDC program, 2938, 2941-2944
Convict labor:
 effect on women workers, 8
Corrections:
 employment of women, 443, 2522, 2535
 employment statistics, 2522
Cosmetology:
 career opportunities, 2806, 2846
 hours and wages, 1003
 worker characteristics, 1033
Cost of living for working women 610, 614,
 624, 638-639, 642-643, 646, 648-649,
 662-663, 672, 675, 2339, 2352
 California, 662
 District of Columbia, 601, 649, 663
 federal civil service employees, 2339,
 2352
 Maine, 642
 New Jersey, 638, 643, 675
 New York State, 648
 Pennsylvania, 672
 Utah, 639
Cotton mills. *See* Textile and cotton mills
Council of National Defense, Woman's
 Committee, 2128, 2142, 2147, 2150,
 2158
Council on Women's Education (Long
 Island, NY), 391
County of Washington v. Gunther, 565, 567-
 568, 570, 574
Credit:
 sex discrimination, 2714, 2725
 and women entrepreneurs, 2693, 2714,
 2725, 2735-2737, 2739, 2749
Criminal justice system:
 affirmative action, 418, 2452
Customs service:

affirmative action plan, 2413, 2422,
 2542
work force statistics, 2413, 2422

Defense Contract Administration, Los
 Angeles Service Region:
 affirmative action plan, 2506
Defense, Department of. *See also* Armed
 forces:
 EEO policy, 2567
 Human Goals Program, 2567
 women-owned small business programs,
 2753
Defense Fuel Supply Center:
 EEO handbook, 2564
 Federal Women's Program, 2423, 2564
Defense planning and civil defense:
 Great Britain, 2303
 manpower planning, 2299, 2301
 women's role, 2159, 2176, 2298, 2303-
 2306
 in WWII, 2164, 2175, 2178
Delaware:
 migratory labor, 1068
Dental hygienists:
 career paths, 1434
 employment outlook, 1274, 1287
Dentists and dentistry:
 Air Force appointments, 1684-1685,
 1688-1691
 Army commissions, 1675, 1677-1678,
 1684-1685, 1688-1691
 career paths, 1434
 characteristics, 1327
 educational barriers, 1417-1418, 1421
 employment outlook, 1281, 1287
 enrollment and graduation data, 1413,
 1445, 1465
 historical bibliography, 1433
 Navy appointments, 1688-1691
 salaries, 1320
 student characteristics, 1429-1430
 work force data, 1320, 1327
Dentist's assistant:
 employment outlook, 1287-1288
Department. *See* other part of name
Depressions, economic. *See* Economic
 depressions and recessions
Dictionary of Occupational Titles:
 gender bias, 382
Dieticians:
 armed forces, 1720, 1742
 career opportunities, 1701, 2789
 Navy, 1711, 1713
 with Public Health Service, 1367

About the Author

MARY ELLEN HULS is assistant professor and head of the Information Services Department at the College of St. Catherine Library. She is the author of *Food Additives and Their Impact on Health: A Bibliography* (1988).

DATE DUE